THE GEORGE GUND FOUNDATION
IMPRINT IN AFRICAN AMERICAN STUDIES

The George Gund Foundation has endowed
this imprint to advance understanding of
the history, culture, and current issues
of African Americans.

The publisher gratefully acknowledges the generous support of the African American Studies Endowment Fund of the University of California Press Foundation, which was established by a major gift from the George Gund Foundation.

Negro Building

Negro Building

*Black Americans in the World
of Fairs and Museums*

Mabel O. Wilson

UNIVERSITY OF CALIFORNIA PRESS

University of California Press, one of the most distin-
guished university presses in the United States, enriches
lives around the world by advancing scholarship in the
humanities, social sciences, and natural sciences. Its
activities are supported by the UC Press Foundation
and by philanthropic contributions from individuals
and institutions. For more information, visit
www.ucpress.edu.

University of California Press
Oakland, California

© 2012 by The Regents of the University of California

First Paperback Printing 2020

Library of Congress Cataloging-in-Publication Data

Wilson, Mabel (Mabel O.).
 Negro building : Black Americans in the world of fairs
and museums / Mabel O. Wilson.
 p. cm.
 Includes bibliographical references and index.
 ISBN 978-0-520-26842-5 (cloth : alk. paper);
 978-0-520-38307-4 (pbk. : alk. paper)
 1. African
 Americans—Exhibitions—History.
 2. African Americans—Museums—History.
 3. Exhibitions—Social aspects—United States—History.
 4. Museums—Social aspects—United States—History.
 5. Memory—Social aspects—United States—History.
 6. Public history—United States—History. 7. Slaves—
 Emancipation—United States. 8. African Americans—
 Civil rights—History. 9. Anti-racism—United States—
 History. 10. United States—Race relations—History.
 I. Title.
 E185.53.A1W55 2012
 305.896'073—dc23 2011046242

Manufactured in the United States of America

25 24 23 22 21 20
10 9 8 7 6 5 4 3 2 1

For my parents, Frank W. Wilson Jr. and Ivery Outterbridge Wilson

Contents

Figures

Acknowledgments

The extensive scope of this book would not have been possible without the generosity of several institutions and many individuals. I would like to acknowledge their support in my completing this ten-year project. Funding to research and write this book came from numerous sources, including the Dean's Office at Columbia University's School of Architecture, Planning and Preservation; Columbia University's Office of the Vice Provost for Diversity Initiatives; the California College of the Arts in San Francisco; the Black Metropolis Research Consortium in Chicago; and, in this book's early phases, New York University's American Studies Program. Because I work as a scholar, artist, and architectural designer, it is fitting that I started researching this book with a three-month visiting scholar's fellowship at the Getty Research Institute in Los Angeles and completed writing the draft manuscript at a five-week artist's residency at the MacDowell Colony in New Hampshire.

I culled a wealth of research material from various archives and libraries, whose contents were brought to life by the research staff at the Atlanta History Center; Auburn Avenue Research Library; Emory University's Manuscript, Archives, and Rare Books Library; the Getty Research Institute; the Library of Congress's Prints and Photographs Division and Rare Books and Special Collections; New York Public Library's Schomburg Center for Research in Black Culture; University of Michigan's Bentley Historical Library; and Wayne State University's Walter P. Reuther Library. Archivists proved an invaluable conduit to finding the

buildings, people, events, and institutions that animate this book's narrative. Those archivists who shared their encyclopedic knowledge include Tammy Lau at the Special Collections Research Center at California State University, Fresno; Linda Evans at the Chicago History Museum; Bea Julian at the Hampton University Archives; Ida Jones at the Moorland-Spingarn Research Center at Howard University; and Georgette May at the College of Charleston's Avery Research Center for Afro-American History and Culture. I would·like to give my special thanks to the extraordinary Michael Flug of the Vivian G. Harsh Research Collection at the Chicago Public Library's Carter G. Woodson Branch for his incomparable archival skills that linked my vague inquiries to people, places, and dates.

Since black history and culture museums form the subject of this book, there are staff and administrators associated with the institutions that I studied to whom I owe my gratitude. My success achieved in Detroit during the several weeks spent in the archives of the Charles H. Wright Museum of African American History (CWMAAH) would not have been possible without the aid of Bamidele Demerson. The late Margaret Ward, the keeper of the CWMAAH's archives for many years, generously volunteered to assist with reviewing the private papers of Charles Wright and of the museum. Ward, an exceptional archivist and keeper of institutional memory, contributed much of the anecdotal history that helped me vivify life in Detroit in the mid-twentieth century. I also want to thank Roberta Hughes Wright for taking time to talk to me about her recollections of her late husband, Dr. Charles Wright. I am grateful to anthropologist Dr. Audrey Smedley, a trailblazer for black women in the social sciences, for opening her personal papers for my review. On a snowy afternoon, Dr. Smedley told me her inspiring life's story and offered insights into the activism of building a black museum during Detroit's turbulent civil rights era. And lastly, I want to thank the brilliant artist, poet, activist, and museum founder, the late Margaret Burroughs, for taking time to share her early memories of the American Negro Exposition and reflect on her prodigious efforts at creating the first black public museum in the United States, Chicago's DuSable Museum. Her genius and accomplishments continue to inspire.

I thank Neils Hooper for ensuring that the breadth of this fascinating history has made it to publication. It has been a privilege to work with Suzanne Knott, Eric Schmidt, Julie Van Pelt, and others at the University of California Press. Rosalyn Deutsche, Lisa Duggan, Adam Green, Robin

D. G. Kelley, and Tavia Nyong'o offered insightful commentary on versions of this manuscript. Christopher Reed shared his superb scholarship and research on black Chicago. The multitalented scholar and artist Deborah Willis pointed me toward important archival discoveries, and I appreciate her early aid in piecing this historical puzzle together. I owe a special thanks to Andrew Ross, who shepherded me through many messy chapter drafts and advised me along the way to publication. Without his first-rate mentoring, I could have never become a confident public intellectual who contributes to her multiple communities.

I am indebted to my many colleagues, students, friends, and family whose input along this journey has propelled this research and book forward. My project owes much of its intellectual backbone to the discussions shared with my talented NYU classmates, especially Davarian Baldwin, Donette Francis, Kitty Krupat, Pat McCreery, and Jerry Philogene. I offer special thanks to Mia Mask for her excellent advice given in the back of a cab that helped me divine this rich topic. Mark Wigley, David Hinkle, Steve Beal, and Michael Roth have my gratitude for lending their institutional support. I wish to thank those who read and commented on excerpts from this book, including my brilliant colleagues in the Engendering the Archive group at Columbia University's Center for the Critical Analysis of Social Difference; with special thanks to Saidiya Hartman and Marianne Hirsch. Gavin Browning's perceptive reviews sharpened the focus of my research at a critical moment in its evolution. The intellectual bounty shared by colleagues, friends, and students from my various academic homes was crucial to my success in completing this book: Craig Barton, Sunil Bald, Nat Belcher, David Brown, Michael Cranfill, Chris Crolle, Yolande Daniels, Felecia Davis, Thom Faulders, Lisa Findley, Karen Fiss, Ron Flynn, Jordan Geiger, Robert Gonzalez, Mario Gooden, Leslie Gill, Paul Gunther, Veronica Jackson, Ariela Katz, Laura Kurgan, Leslie Lokko, Reinhold Martin, Lydia Matthews, Adrienne Montgomery, Kate Moore, Ken Morris, Laura Morris, Heidi Nast, John Outterbridge, Anna Rainer, Jerzy Rozenberg, Robert Rydell, Joel Sanders, Jacob Segal, Carla Shedd, Neil Schwartz, Marjorie Schwarzer, Mitchell Schwarzer, Steve Slaughter, Peter Stampfer, John Stuart, Peter Tolkin, Michele Washington, and William Williams. Paul Kariouk and Sandra Vivanco have my sincerest thanks for their unwavering support through the years.

And finally I want to thank my aunts, uncles, and cousins whose reminiscences about the Outterbridges, Wilsons, Northerns, and Fullers have

inspired my passion for telling the stories of our shared past; my wonderful brothers—Dion Wilson, Frankie Wilson, and Byron Wilson—for believing that their little sister had something worthwhile inside that forehead they made so much fun of as kids; and my exceptional parents, Frank and Ivery Wilson, who began this journey with me but who, now in spirit, know all they made possible and more.

Introduction

In 1991 an advisory committee of the Smithsonian Institution, the United States' national museum, released a report proposing that a new entity—the National African American Museum—be established on a prominent site on the National Mall in Washington, D.C. This bid to establish a national museum of black history and culture was not the first time one had been proposed for the nation's capital; there had been other previous but failed attempts.[1] The report's findings suggested that the new museum be housed in the historic Arts and Industries Building that sat between the high-modernist Hirshhorn Museum and the neo-Romanesque Smithsonian Castle. Composed of leading scholars, curators, and museum experts, the committee cited three main reasons for starting this new institution. First, the purpose of the museum would be to promote the display, collection, preservation, and study of the historical and cultural legacy of black Americans. Second, the museum would provide a stable and constant presence of black heritage within the United States' largest museum and research complex. And third, by attracting visitors from around the country and the world the museum would change adverse perceptions of black Americans by dispelling long-standing racist beliefs and stereotypes.[2] Supporters and congressional representatives used the report's recommendations to request federal funding to create the new museum.

At public hearings and in newspapers, a debate ensued about the merits of the proposed institution. Boosters praised the significance of a na-

tional museum that would raise the public's understanding of black history as American history. It would be a long overdue gesture of inclusion after decades of neglect by the nation's premiere museum. However, not everyone agreed that the establishment of a national black museum was necessary or desirable, and resistance to the project emerged from many camps.[3] Some black citizens did not want the national black museum to be located in the Arts and Industries Building—the second-oldest of the Smithsonian's museums—that was over one hundred years old. This group lobbied for increased funding to construct a new edifice. Taking a different stance, representatives of other black museums from around the country expressed valid concerns that a national entity might siphon funds, visitors, and artifacts from their smaller institutions. However, it was Senator Jesse Helms, a white Republican from North Carolina, who successfully delayed the passage of the bill in a Senate committee in 1994, thereby derailing the endeavor. The archconservative and racist politician stated as the rationale for his obstruction that if government gave blacks their museum, then we would have to do the same for other groups. He gave special emphasis to how the Smithsonian would address "requests by other groups—e.g. the Nation of Islam, or the 'black separatist' groups that might want to use the museum space?"[4] Senator Helms's angst-ridden desire to exclude any representation of black nationalism from the museum highlights a critical question for the national institution: who would control curatorial content and use of the museum's space?

Today in cities and small towns around the United States, tourists and locals can visit museums exclusively devoted to the collection, conservation, and display of black history and culture. These new museums have been built in cities that had long violent histories of racial segregation. Birmingham hosts a stately brick edifice—the Civil Rights Institute—that commemorates the Alabama steel town's bloody skirmishes between protestors and racist factions in the 1960s. Elsewhere, Memphis's National Civil Rights Museum occupies the renovated Lorraine Motel, where exhibits and programs memorialize the site where an assassin's bullet took the life of civil rights leader Rev. Martin Luther King Jr. in 1968.[5] Two of the first public museums—Detroit's Charles H. Wright Museum of African American History and Chicago's DuSable Museum of African American History—occupy new and renovated buildings in the civic centers of their respective cities. These institutions comprise a small cross section of the hundreds of museums, memorials, interpretive centers, and historic sites that have been established over the past fifty years since the

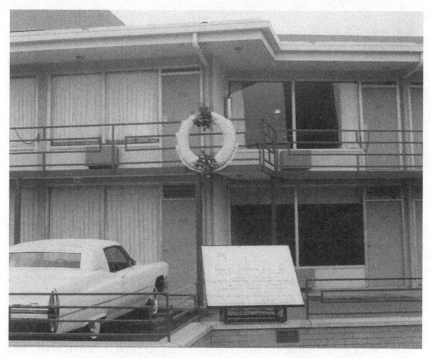

FIGURE 1. Rev. Martin Luther King Jr. Memorial, National Civil Rights Museum, Memphis, 1998. Author's photograph.

first grassroots museums opened in Chicago, Boston, and Detroit in the 1960s.[6] And there are soon to be new additions to the growing list. Non-profit organizations led by determined citizen groups allied with cultural commissions and local municipalities are busily raising monies and planning new museums in various regions around the United States. The most significant endeavor on the boards will be the Smithsonian's new National Museum of African American History and Culture (NMAAHC). After decades of racist elected officials rejecting citizen-led initiatives and debates about the efficacy of a national institution, the new 300,000-square-foot museum and research facility will finally rise on the last remaining unbuilt site along the National Mall across from the Washington Monument. Taking stock of these laudable advances, what does it mean for black Americans to claim a physical space in the nation's symbolic cultural landscape and a symbolic space in the nation's historical consciousness, two spheres in which their presence and contributions have been calculatingly rendered invisible and abject for over two centuries?

A FAIR WORLD

For architectural and curatorial precedents to these contemporary black museums of history and culture, we must look back over one hundred years beginning in the period after Reconstruction to explore the great world's fairs' Negro Buildings that were first erected in 1895 (with the last appearing in 1936), and we must survey the forgotten Emancipation expositions that began after 1910 and continued through the 1960s. For several decades, black Americans actively participated in mainstream world's fairs in the United States and abroad, but only after demanding inclusion, which often necessitated protesting to white organizing boards and politicians. To understand this public sphere of engagement, we will tour the fairgrounds of the large international expositions staged in the cities of Philadelphia, New Orleans, Chicago, Atlanta, Buffalo, Charleston, Jamestown, Dallas, and Paris, France. We will also roam the aisles of the expositions organized by black Americans to commemorate their hard-fought struggle to gain freedom from enslavement. These Emancipation expositions happened in cities with growing black populations—Philadelphia, Atlantic City, New York City, Richmond, Chicago, and Detroit. Through a unique curatorial ethic that governed the content of these mainstream and segregated events, black men and women created and circulated public narratives of who they were and wanted to become—ideologies of history and progress that transformed over time in relation to changing economic, social, and political forces.

At these spectacular events, black Americans joined what historian Robert Rydell has called the "world of fairs."[7] World's fair mania commenced in 1851 with the staging of London's immensely popular Great Exhibition of the Works of Industry of All Nations. Countries vied to surpass architect Joseph Paxton and his ethereal Crystal Palace's rousing success as a brilliant architectural and engineering feat. The extraordinary glass and iron pavilion proved to be a great booster of the British Empire's industrial and imperial prowess. As these events grew in popularity, countries jockeyed to host these grand international expositions that pit region against region and nation against nation. European and American governments not only staged these extravagant competitions to ascertain whose economy was the most industrious, but the contests also gauged whose society was the most culturally refined, racially evolved, and hence civilized.

The U.S. world's fairs were founded on the mutually beneficial tethering of the mythos of democratic republicanism to the liberalism of the

market economy.[8] To initiate these *grandes fêtes,* the elites of a particular city or region—railroad titans, industrialists, newspaper publishers, and scions of privileged families—proposed to local and national governments to host expositions around themes of international trade and national commemoration. These massive undertakings were financed through the incorporation of private exposition companies that lobbied for state monies and raised additional funds through stock offerings. These companies established organizing boards that managed finances, invited participants, and planned various events, including the opening-day ceremonies. The organizing board also selected architects, engineers, and landscape architects to plan the grounds and pavilions. These events also necessitated the mobilization of a large local labor force to clear the land, erect the expansive temporary halls and exhibits, and provide services during the period of operation. At the completion of the fair's run, the administrative bodies prepared reports that outlined the planning process and featured highlights of the exposition. For their part, local governments would devote open areas within the city limits to host the fairs, which could last from six months to a year. With entry priced modestly and profitability as one goal, these events attracted thousands of fairgoers from the region and in some instances millions of visitors from all over the world. Likewise the Emancipation expositions' fair builders, who came from the black elites, also formed private exposition companies and solicited funding from federal and state governments. These smaller events, often lasting a week to two months, were held in parks or inside expansive public armories and privately owned exhibition halls built to host events catering to large urban crowds.

The ideological agenda of the U.S. world's fairs endeavored a twofold mission: as public platforms to promote the promise of industrialization and American manufactures; and as international public spheres to advance American cultural hegemony by demonstrating its superiority and its historical legitimacy. With this mandate in hand, exposition masterminds presented to the promenading crowds stunning displays of American progress. The grand halls, magnificent exhibits, and elaborate performances at these exhilarating events, however, veiled inequalities absent from the sanguine pronouncements of a prosperous future for all. Rydell's critical analysis of the political economy of the great expositions elaborates on these Janus-faced circumstances when he reminds us that, "at a time when the American economy was becoming increasingly consolidated and when the wealth generated by the country's economic expansion was concentrated in fewer and fewer hands,

the exposition builders promised that continued growth would result in eventual utopia."[9] The fanciful presentations of cultural advancement and displays of material abundance on parade inside the fairgrounds masked the uneven distribution of power and wealth outside the fair's grand gates.

The fair organizers enlisted the great architectural talents of the time—Frederick Law Olmsted, Daniel Burnham, Louis Sullivan, Paul Cret, Raymond Hood, and others like the lesser known Bradford Gilbert, Vertner Tandy, and William Pittman—to build the phantasmal dream worlds that appeared for several months in metropolitan centers around the country. These men, and on occasion women, planned everything: the fairgrounds, the pavilions, and the layouts of the exhibits. The resulting temporary landscapes compartmentalized wares and peoples according to a strict system of classification formulated by experts in the social sciences, such as French sociologist Frédéric Le Play's methodical arrangement for Paris's Exposition Universelle in 1900. With the industrialization of Europe and America presented as the logical outcome and inevitability of civilization's advance, class difference could be rationalized and naturalized through a visual taxonomy of humans, plants, animals, products, and machines. An enraptured audience of future workers, managers, and owners marveled at the colorfully festooned halls and toured the impressive pavilion structures. Amid the wide-open sunlit interiors filled with machines and manufactures that turned raw materials into products before their very eyes, visitors witnessed a stunning visual teleology and geopolitical atlas about how past and future innovations (industrial capitalism) could transform their lives and the fortunes of the nation to lead the world.

At a time when the U.S. government was testing its imperial ambitions in the Caribbean, the Philippines, and eventually World Wars I and II, the great world's fairs also served as a means to define and boost national identity through commemorative events, as with Philadelphia's 1876 centennial and 1926 sesquicentennial of the nation's founding and Chicago's 1893 celebration of the European discovery of the continent at the World's Columbian Exposition. The fairs paraded the nation's history as the natural outcome of an exceptional people destined to be great. Those powerful white politicians, manufacturers, and transportation titans who set the ideological tone for the expositions (and who also funded the great museums) put the world—from primitive to civilized—on display so that the common sense of nation, race, and class could be known by those privileged to witness the spectacles. Within this comparative

framework, what and who was shown (or excluded) reinforced beliefs that historically nonwhite peoples belonged in the lower ranks of civilization and the nation's advance. As a consequence of this racialized as well as spatialized sociocultural hierarchy, certain groups, especially Asians, Native Americans, Africans, and American Negroes, were deemed exploitable for their resources and labor. In particular, this confirmed that black peoples were incapable of reason and judgment and therefore were unworthy of basic human and democratic rights. Beyond the fairgrounds, it was collectively determined that, given their natural limitations, black Americans should be by law and custom excluded from the mainstream public sphere, segregated into their own areas of the city, and by extension set apart in their own corner of the fairgrounds. This validated, as activist Ida B. Wells protested at the World's Columbian Exposition, the rise of Jim Crow *de jure* racial segregation and the structural dominance of white supremacy for decades to come.[10]

Because the expositions were in fact public spheres, they were open, if unintentionally, to alternative representations of American industry, culture, and national identity. When confronted with these powerful and persuasive narratives of civilization, black Americans used the fairs to vigorously respond to how they were being portrayed and positioned. Wells, Booker T. Washington, W. E. B. Du Bois, Mary Church Terrell, Kelly Miller, Meta Vaux Warrick Fuller, Carter G. Woodson, Alain Locke, Claude Barnett, Horace Cayton, Margaret Burroughs, and a host of other fair builders (primarily from the black elite and intelligentsia) sought to disprove the bleak forecasts augured by their fellow white citizens by taking measure of their own advancement. Inside the ideologically charged atmospheres of the mainstream fairs' Negro Buildings in Atlanta and Charleston and of the Emancipation expositions in New York and Chicago, the spacious wood and stone halls offered prospects where black citizens could witness their own progress as a race and a nation. Groups of black citizens formulated bold counternarratives to American progress. They created public spaces where disenfranchised blacks from across the African diaspora could imagine a world free from Euro-American subjugation. At the expositions and eventually in the early grassroots museums of the 1960s, they offered a range of strategies—from acquiescence (accommodation), to dissent (civil rights), to self-determination (black nationalism), to alternative national belonging (Pan-Africanism)—about how to elevate their collective fortunes against the rising tide of antiblack racism in the United States and around the world. This book tells the story of their visionary responses and daring propositions.

THE BLACK COUNTERPUBLIC SPHERE

The extensive scholarship on the U.S. world's fairs identifies black presence as one of many positions vying for recognition within the larger mainstream expositions.[11] If we expand our scope to study a series of events and institutions, rather than focus on one or two, then we can discern in greater detail how black Americans utilized the fairs as public forums both within mainstream and segregated social spheres. By inserting the early grassroots museums, such as Detroit's International Afro-American Museum (IAM) and Chicago's Ebony Museum of Negro History and Art, into this historical trajectory, we can also trace a different genealogy that emerges from the urbanization of black populations. I am keenly aware that there were hundreds of fairs and several museums—particularly those within black educational institutions—that existed during the period this book studies; thus all of them cannot be reviewed in this single volume (I will leave that task to other scholars). However, by examining the particular set of fairs and museums this book presents, as extensions of what is called the black counterpublic sphere, we can begin to understand them as places where different agendas for social advancement, cultural identity, and national belonging could be presented, seen, and debated publicly. Conceptually, the most productive methodology to study this subject matter is to examine the social spaces of the expositions and museums, along with their exhibitionary culture, built environments, and urban contexts, as the intersection of cultural and urban history and visual cultural analysis. Undertaking an interdisciplinary approach allows us to assess the social and spatial dynamics of race, nation, and class that shaped these complex cultural landscapes.

First and foremost, antiblack racism limited access to the key areas of American society that the mainstream world's fairs celebrated: the ability to exercise full rights of citizenship in a democratic republic and the right to earn wages as laborers in the market economy. This marginalization proved to be a double blow to blacks because, one, it curtailed their ability to operate within the mainstream public sphere to change social relations as well as within state structures in order that they might continue to make gains through legislative victories. And two, it eliminated the leverage that can be exerted through the private acquisition of wealth and property in an economy rapidly expanding under industrial capitalism. The rise of Jim Crow segregation after Reconstruction incrementally ratcheted back the public rights and private opportunities gained by former slaves after Emancipation. These racist practices and customs

grew out the antebellum southern Black Codes that regulated the activities of slaves and freedman. By the 1880s these customs were revived to limit the movement and activities of black citizens in cities and towns around the South. By the 1890s these practices were inscribed into Jim Crow laws that forbid blacks from public waiting rooms, trolleys, and railcars and disenfranchised black males from voting.[12] The core mission of why black Americans organized and participated in the fairs was, therefore, to regain these rights and privileges. But their fight was not without, as we shall see, the imperative to launch critical counterattacks on the latent inequalities embedded in the American ethos of democracy, freedom, and the market economy and to offer more just alternatives.

Since they were barred from participation in government and mainstream civic associations, black citizens formed their own "counterpublic sphere" that operated at the margins of the dominant American bourgeois public sphere and civil society.[13] While a lengthy presentation of public sphere discourse cannot be made here, it is important to mention key ideas that inform the arguments this book undertakes.[14] Through the writings of Jürgen Habermas, in particular *The Structural Transformation of the Public Sphere: An Inquiry into a Category of Bourgeois Society,* the concept of the public sphere has been defined as the universal realm wherein a society freely debates and discusses its collective affairs—outside of influence of the state and economy. A productive formulation of sociopolitical negotiations within nation-states, Habermas's theories have been critiqued and expanded by a host of scholars and theorists, most notably Nancy Fraser and Rosalyn Deutsche. Fraser argues that historically the nineteenth-century bourgeois public sphere of France, the subject of Habermas's analysis, was never outside of the economy or the state. Nonbourgeois concerns had fractured France's ideal public sphere "into a mass of competing interest groups."[15] Against the grain of this universalism, Fraser posits the emergence of "subaltern counterpublics . . . where members of subordinated social groups invent and circulate counterdiscourses, so as to formulate oppositional interpretations of their identities, interests, and needs."[16] Counterpublics allowed groups to recalibrate their methods and tactics to assure effective influence on what I call the mainstream public sphere.[17] As Fraser illustrates, the concept of a universal and transparent public sphere, particularly in the United States, falsely assumes it speaks for everyone. This evocation of a cohesive polity conjures an enduring image, unaltered by time or place. This polity consists of subjects who as citizens ideally approach and occupy this realm as equals, free to participate fully in the politics of de-

mocratic rule. However, as Deutsche suggests, drawing upon Fraser, this powerful timeless image of the democratic public sphere conceals social inequities, especially those informed by racial, class, and gender difference, that limit full participation. This image of universality renders the public utopic and ahistorical, thus veiling those power relations at play. Deutsche's cultural and spatial analysis, drawing upon the theories of the social production of space from sociologist Henri Lefebvre, also makes important links between social actions within the public sphere and how they are lived within urban space. Her review of the redevelopment of areas around New York City in the 1980s focuses on discourses deployed to legitimate the removal of homeless people from public places. According to Deutsche, claiming a space to be public, a universal social sphere supposedly open it to all, cultivated a powerful image of the public that excluded rather than included those not so easily accommodated within its neat social strata. Given how social inequalities operate to produce categories of difference, not all citizens therefore appeared equally within the public sphere and its physical analogue, public space. Thus by legislating who, what, and how public space should be used, dominant groups foreclosed the possibility of public space ever becoming political—open to contestation and difference. Deutsche's analysis of the city argues that urban space operates as a public sphere in which forces of production and the reproduction of social relations coalesce in conflicting ways to form political subjects.[18]

We will examine the world's fairs, Emancipation expositions, and grassroots black museums as extensions of the black counterpublic spheres within various cities around the United States. However it is important to note that within America's public spheres (both mainstream and counter) black participation was not always welcomed or allowed.[19] As scholar Michael Dawson observes, "The system of stratification in the United States based on race and its ideological components served to exclude African Americans both formally and informally from participation within the American bourgeois public sphere." But he notes as well that "this system also encouraged exclusion of African Americans from subaltern counterpublics such as those associated with the labor, populist and women's movements of the late-nineteenth century."[20] Thus the way that race and racism, in particular Jim Crow segregation, structured this domain of social engagement enabled the disempowerment and economic marginalization of black Americans. Because segregation through custom and law kept black citizens out of public and private amenities, stripped them of political rights, and kept them at the bottom of the wage

structure, it rendered them invisible—behind the veil in Du Bois's terms—within the dominant public sphere. The fairs and museums offered social spaces through which black Americans made their presence known to their fellow white citizens as well to their own counterpublic sphere (which was fraught with its own class and intraracial exclusions) within segregated black neighborhoods.

Late nineteenth- and twentieth-century religious, educational, and social associations—the cornerstones of black civic life—contributed to the wellspring of materials placed on view in the expositions and museums. These institutions and associations cultivated the careers of race leaders and the black intelligentsia, the men and women of the educated elite, who formed the organizing committees for the fairs and museums.[21] These people conceived of their curatorial ethics based on their desire of what the future might portend and how their relationship to their past should be understood. These future ambitions were constantly recalibrated when confronted with the sobering reminders of present circumstances within an increasingly racist and hostile society. In particular, fair organizers became aware of their diminished power when they negotiated with white exposition directors, who often unfairly meted out exposition resources. Undeterred, black fair builders crafted their own ideological frameworks and representations of black progress, like those on view at the segregated Negro Buildings and the unique black-organized expositions that commemorated Emancipation and whose displays both echoed and contradicted the dominant narratives of American progress and civilization. Regardless of whether their tone was contentious or conciliatory, the many statements lauding great strides that emanated from the elite circles failed, in part, to diffuse the unrelenting pressures of racial hostility that burdened the daily lives of black domestics, farmers, and laborers: antiblack racism blocked most avenues to wage labor and the right to vote, two critical spheres of power that would have more quickly "uplifted the race."

Undeterred by these impediments, black fair and museum organizers made strategic use of these public forums to address mainstream and black audiences and to introduce a range of strategies for black progress. Two of the fundamental questions for charting the race's forward march in the twentieth century were posed at the fairs: One, what would be the role of black labor in the nation's burgeoning industrial economy? And two, how and when would blacks citizens achieve social equality? Acutely aware of the economic and political hurdles to achieve these goals, fair organizers commissioned displays of mechanical devices, so-

ciological data, dioramas, historical artifacts, artworks, industrial arts, pageants, performances, government propaganda, and other artifacts. Race leaders and the black intelligentsia debated important aspects of these approaches at congresses devoted to the topics of religion, agriculture, business, industry, education, sociology, the black press, the African continent, the military, and women's issues. "Racial uplift," with its emphasis on respectability and self-help—ideals resonant within American liberalism—would be a dominant message heard and seen at many of the early southern fairs' Negro Buildings. As antiblack racism grew more strident and deadly in the early years of the twentieth century, others sought more direct forms confrontation; a rallying call for civil rights to gain social equality trumped patient servitude to white interests. From the perspective of civil rights activists, the problem was not the race's supposedly inherent traits of moral and intellectual inferiority but rather the way that the newly imposed shackles of Jim Crowism stalled any real social or economic advancement. The Great Migration brought large numbers of blacks into the factories and neighborhoods of northern industrial centers. The exploitive conditions within Fordist manufacturing required a different set of tactics to improve the working conditions and life outside of the shop floor. The rise of a vanguard of creative talent, a radical Left inspired by socialism and communism, brought new representations and ideas to the exposition forum. During the New Deal era, these progressive fair participants saw their civil rights battles within the international arena of the struggles for human rights against authoritarian regimes such as Nazism. The rise of the grassroots movement of citizens who founded museums in northern ghettos of Chicago and Detroit (already in the midst of post-Fordist deindustrialization) recast racial progress in terms of black pride and self-determination, themes central to the civil rights movement and black nationalism of the 1960s.

Equally important at the fairs and the later museums were the more dissonant narratives presented to the public that questioned integration into the United States' racially fraught social order. Intonations of Pan-Africanism that promoted unity throughout the black diaspora and African continent as a means of leveraging power against Euro-American imperial ambitions could be heard and seen in exposition speeches, exhibits, and performances. Black nationalism, which fostered social, cultural, and economic solidarity and autonomy to counter racist exclusion from the nation's institutions and industries, could also be perceived amid the critical voices and displays deriding America's failed promise of inclusion.

In total, however, we must recognize that the debates around these strategies for advancing the race did not fracture into mutually exclusive factions. Instead, camps allied and shifted relative to the racial climate at the time. While black elites may have set the tone for these strategies of uplift and advancement, the twentieth century's growing black working- and middle-class populations developed their own associations, social spaces, and cultural forms that were not necessarily in lockstep with the elites' overarching bourgeois ambitions, which at times reinscribed class hierarchies along intraracial color lines.[22]

In practice, this constant measurement of black progress also prompted an appraisal of black history. After all, charting advancement required that a group take stock of their past to measure how far they had traveled on the racialized scale of civilization. In their Independence and Emancipation Day celebration speeches, black orators recounted the history of struggle and freedom as a means of accentuating those rights of citizenship that had yet to be fully recognized. Historian Geneviève Fabre identifies in these narratives an ethos that ran counter to America's national memory. Fabre contends that black commemorative celebrations were oriented toward both a past *and* future, suggesting that "its mood was subjunctive, the ought and should prevailed over the was: with a feeling of urgency, of great importance, at the renewed delay, African Americans invented a future no one dared consider and forced its image upon black and white mind and spirits."[23] We can see this in the manner that the early black fair builders collected stories of struggle and perseverance from former slaves as a means of gathering evidence of black Americans' laudable accomplishments. From this collective memory, the black organizers carefully crafted exhibits and performances around historical narratives of enslavement and Emancipation that educated and fostered race pride in black audiences. In his various expositions forays, Du Bois, an organizer and contributor to several fairs, saw history as a pedagogical tool for civil rights education, especially since Negro history had been deliberately excluded from the national canon and African contributions had been expunged from world history. Woodson formed the Association for the Study of Negro Life and History (ASNLH) while participating in Chicago's semicentennial Emancipation exposition in 1915. The founders of the early museums, many of them ASNLH members, bolstered black pride by placing African and black American history on view for local residents, especially school-age children, so that black audiences understood their militancy as part of a historical worldwide fight for human dignity in places like the newly formed postcolonial nation

states of the African continent. "This is an important and dramatic event in World history," stated Dr. Charles H. Wright and the founders of Detroit's IAM in 1965 about the historical relevance of current civil rights conflicts. So that people remembered and learned about earlier efforts to achieve social equality, "we, therefore, propose to create a permanent, international monument to symbolize this struggle."[24] A historical consciousness that comprehended what and where black Americans had been guided the path toward who they were to become in the United States and elsewhere.

THE BLACK METROPOLIS

In order to thoroughly probe the transitory world of the Negro Buildings, fairgrounds, convention halls, and makeshift galleries of the early black museums, we must also study the segregated urban landscapes in which they resided. What do we gain from examining the city as well as the fair? Certainly, the world of fairs has become a sustained topic of research for many scholars. Much of this scholarship, while critically insightful, however, confines its research to the domain of the fairgrounds. By broadening our context to consider the spaces of fairs to be lived, conceived, and perceived, to borrow Lefebvre's theorization, we can examine the social production of these spaces as extensions of the urban realms where they took place. In other words, we can examine the social spaces of the fair by also studying how the forces of industrialization and antiblack racism rapidly transformed social structures and the material conditions of life in the American city.[25]

At these mainstream and black-organized events, progress as a narrative of civilization and the nation's forward advance was, as previously noted, implicitly racialized. In speeches, exhibits, and performances, black Americans strategically wielded an essentialized discourse of black progress as a "racial project" to deflect and eradicate antiblack racism. Sociologists Michael Omi and Howard Winant define a racial project as being "simultaneously an interpretation, representation, or explanation of racial dynamics, and an effort to reorganize and redistribute along particular racial lines."[26] They argue that racial projects operate within a "racial formation" of "sociohistorical process[es] by which racial categories are created, inhabited, transformed, and destroyed."[27] As a process that changes over time, a racial formation forges linkages between cultural representations and social structures so that "racial projects do the ideological 'work' of making these links."[28] Considering the fairs and mu-

seums as dynamic racial formations that change over time allows them to be situated within a constellation of processes that produces their institutional social spaces and those of the segregated city.

The urbanization of black populations occurred simultaneously with expansion of the United States' industrial base shortly after the end of the costly Civil War—a process influencing southern cities like Atlanta, whose powerful oligarchs hosted one of the first world's fair to invite black participation, the Negro Building at the Atlanta Cotton States and International Exposition. These urban communities became home to groups with a myriad of motivations for organizing, contributing, and visiting the fairs. Neighborhoods in the North, some already home to old settlers, grew exponentially as black migrants drawn by alluring prospects of well-paying industrial jobs (that never materialized) moved to cities to escape the harsh and exploitive sharecropping system. Eventually their growing numbers formed a "Black Metropolis," the name given to Chicago's Black Belt, but nonetheless applicable to other black urban communities, by sociologists St. Clair Drake and Horace Cayton, both contributors to the city's American Negro Exposition in 1940.[29] Once settled, these migrants entered into an urban milieu that included a cadre of elites who became the representative race leaders. Alongside them was a small bourgeoisie that included educated professionals and growing ranks of working-class families. Collectively, the middle strata embraced ideals of respectability and social uplift as markers of class status. And then there were the urban poor, what many derogatorily labeled as the "black masses," who struggled to survive living in substandard housing and toiled in underpaid unskilled jobs. Historian Christopher Reed's term *social grades* proves useful in characterizing early black urban social development. Borrowed from R. R. Wright Jr., a sociologist who organized the Emancipation exposition in Philadelphia in 1913, and more fully developed later by Drake, the concept argues that this nascent social structure did not stratify into the Black Metropolis's unique classed hierarchy until the 1930s.[30] (It should be noted that Du Bois, Wright's mentor, had earlier used the term *social grades* in his groundbreaking study *The Philadelphia Negro*.) Reed cogently argues that at the turn of the twentieth century the power structures of a classed social order had not yet been put into place in black urban communities—especially since the majority of blacks labored as lumpenproletariat.

Outside the domain of the Black Metropolis, power bases of colluding white political leaders and businessmen lorded over key resources. They herded black residents onto undesirable land—prone to floods and

other adversities—and into overcrowded neighborhoods with high rents and dilapidated buildings. Knowing they were eager to find employment of any kind, white factory owners hired black workers as strikebreakers. Accepting these jobs, however, pitted the replacements against hostile white and immigrant workers. Even with the concerted efforts to hinder black access to economic and political power, white Americans still relied on black labor in the South, and political parties depended on blacks' votes in cities throughout the North. For shrewd and enterprising black leaders this economic and political dependency opened channels of negotiation to leverage many things. This included participation in mainstream world's fairs and financial support for black-organized expositions and museums.

Positioning the expositions as an extension of dynamic urban space allows us to discern how the fairs drew together various groups of blacks and whites, immigrant populations and foreign participants, in the roles of organizers who assembled intellectual and financial capital. These groups provided the workers who produced and staffed the spaces of display and who rallied the fairgoers who witnessed the cavalcade of exhibits, performances, amusements, and speeches. Workers and fairgoers came from all classes, races, and ethnicities. Mirroring the segregated social sphere of city outside the fairground gates, black visitors, however, often encountered prohibitions and endured poor treatment as they toured the halls and midways. Additionally, in exchange for access, white businessmen in charge of fairs and municipal leaders who controlled the exposition halls could earn lucrative profits by charging black fair organizers inflated fees for concession services and high rates for white unionized labor. Because expositions could last between several days to several months, they nevertheless offered an accessible albeit temporary public forum. Black fair builders could tactically utilize these centrally located urban sites even though segregation limited black occupation to a short period of time. The early museum builders of Detroit adopted this strategy in their Mobile Museum whose exhibit on African and African American cultural history traversed the streets of the Motor City. The eventual construction of permanent museum buildings in civic districts like Detroit and Chicago in the 1980s marked a significant shift in the power of black populations to claim space in U.S. cities, although the black counterpublic sphere, an outcome of segregation and critical to the formation of the fairs and early museums, had fragmented by the 1970s.[31]

This book, *Negro Building*, begins its historical narrative with Philadelphia's centennial fair in 1876 because it encapsulates the problem of

why black Americans fought for inclusion (but failed to gain access) to the United States' first world's fair that commemorated national history and celebrated the country's industrial potential. Chapter 1 offers an in-depth study of Atlanta to examine how urbanization in the South fostered the formation of a black counterpublic that contributed to the first Negro Building dedicated to black progress at a mainstream world's fair. As we shall see, its strategy of social uplift centering on industrial education and the ideology of accommodation as conceived by Washington offered one strategy to negotiate the emerging segregated landscape of the Jim Crow South. However, as chapter 2 explores, other tactics for racial advancement soon emerged from Atlantans and those living elsewhere in the United States at the turn of the twentieth century. One such alternative viewpoint can be seen in Du Bois's research on the Georgia Negro included in the "American Negro" exhibit that debuted at Paris' Exposition Universelle in 1900 before it traveled to two other fairs in Buffalo and Charleston. Here in the public forums of the exhibits and Negro Buildings we discover the emergence of a new ethos of civil rights put forth by those race leaders willing to advocate for social equality. The black-organized northern semicentennial Emancipation expositions and the mainstream fairs that chapter 3 reviews provided platforms to formulate and represent black contributions to U.S., Pan-African, and world histories. These commemorative events introduced new modes for the presentation of black history, such as pageants and objects of mass culture that were geared toward the tastes of urban audiences. As this chapter narrates, Jim Crow segregation took new forms of antiblack racism in the North and the fair organizers conceived of new strategies of protest that challenged these obstacles to advancement. Chapter 4 explores two Emancipation expositions held in the Black Metropolises of Detroit and Chicago in 1940. In response to the growing presence of black middle and working classes in large urban centers, the agenda of the black elites could no longer rely solely on Washington's message of racial progress and uplift. Instead race leaders collaborated with a new Left vanguard of black cultural workers, part of the Popular Front, to provide fair content that drew upon southern vernacular and popular culture that resonated with urbanites. Their charge was to improve the conditions of work and life and end antiblack racism in the segregated northern city. Their radical spirit of protest and tactics of institution building led to the formation of the first black museums in Chicago in 1961 and Detroit in 1965. Chapter 5 provides a detailed study of the establishment of Detroit's International Afro-American Museum as it navigates the tur-

bulent era of civil rights, black nationalism, and virulent racism of a northern industrial city. As an effort mounted by ordinary citizens who were not trained museum experts, this early museum initiated a program to educate black Americans about their history so that they could self-determine the future of their community and its institutions. The conclusion takes us through the post–civil rights era to understand how the rise of globalization and neoliberalism has affected the cities, institutions, and groups this book reviews.

While today we no longer convene world's fairs, erect Negro Buildings, or host Emancipation expositions, visitors can roam the interpretive history galleries and gather in the spacious lobbies of the glass, stone, and steel structures of the nation's black history and culture museums in Cincinnati, Baltimore, San Francisco, and elsewhere. The Smithsonian's future NMAAHC, for example, will be housed in an architecturally ambitious new building centrally located on the National Mall. Standing amid the white marble archives of national patrimony, Lonnie Bunch the director of the NMAAHC proudly proclaims that its mission will be "to help all Americans remember, and by remembering, this institution will stimulate a dialogue about race and help to foster a spirit of reconciliation and healing."[32] In the long term this unique social space for critical historical reflection will in turn project a vision of the collective future for *all* American citizens. The chapters that follow show that we have much to learn from how groups of citizens negotiated changing racial and intraracial ideologies and navigated segregated public spaces in order to create a realm to show and view their own multivalent interpretations of race and nation, progress and history.

Prologue

Awash in subtle sepia tones, an albumen print that was taken around 1875 captures a panoramic view of the Lincoln Institute. The three-story brick schoolhouse was built in Jefferson City, Missouri's capital. Standing on a hillside in front their four-year-old building, seventy-five men, women, and children, all black Americans, proudly posed in their woolen suits and Sunday best. Their building was crafted in the fashionable Second Empire style, crowned with a mansard roof and topped with a stately bell tower. The new schoolhouse was a vast improvement from their former accommodations in an old barn where teachers had schooled newly emancipated slaves of all ages. Perhaps made at a gathering of the school's founders, students, teachers, benefactors, and leaders (they are not identified), the photograph celebrated a benchmark in the ten-year history of the fledging preparatory and normal school. To remember the occasion, they enlisted the evolving technology of photography, taking advantage of its ability to capture a moment in time for posterity. The large group portrait communicates the numerous ways that these citizens wished to be seen by their fellow Missourians, by people from around the country and world, and perhaps, by those in the future, like us, who would eventually view their picture. From one perspective, their confident pose and attire exuded an air of respectability and bourgeois propriety. Their manner of dress conveyed newly important signifiers of social status for many of these former slaves. As full-fledged Americans, they had finally achieved (at least for the moment) the rights and responsibilities of citizenship.

But also in their vocations as laborers, draymen, farmers, and domestics, many earned wages that gave them a toehold in the burgeoning industrial economy—albeit at the bottom. There were, nonetheless, new opportunities afforded by education and hard work. From another viewpoint, their assembly highlighted the fact that they now had the individual and collective freedom to pursue an education, along with their religious beliefs, work, commercial trade, political office, military service, and family life. Since the Lincoln Institute was initially funded by pledges donated by Union soldiers of the U.S. Sixty-Second Colored Infantry, the school and its new building stood as a testament to their entrepreneurial spirit and commitment to education as the foundation of social advancement.[1]

The record of this auspicious gathering of men and women would provide irrefutable evidence as to whether institutions like the Lincoln Institute, with their curriculum of industrial education, could transition former slaves into new lives as paid craftsmen and teachers. Lincoln's student body was guided through a sensible regimen of "combine[d] study and labor," the school's proponents wrote, "so that old habits of those who always labored, but never studied, shall not be thereby changed and that the emancipated slaves who have neither capital to spend nor time to lose may obtain an education."[2] Alongside their mission to elevate the fortunes of former slaves through industrial training, their stalwart brick schoolhouse demonstrated that as citizens they had the right to erect and inhabit schools, along with private homes, stores, and churches in cities, small towns, and rural villages. Their schoolhouse stood amid a thriving black civic sphere. As Americans they had claimed a place upon the nation's land and in the nation's historical narrative. This fading and tattered photograph bore witness to that event.

When taken as a measure of "progress," a popular term of the day derived from the potential of industrial capitalism to improve the well-being of social groups, the photograph provided proof as to how far these former slaves had advanced themselves since Emancipation. It displayed the enormous potential of black Americans as a workforce and citizenry, ideals that would be encapsulated in the educational philosophy of industrial training championed by race leader Booker T. Washington, who was also a major fair booster. When we consider it as a historical record, the photograph afforded a moment of reflection on the extraordinary accomplishments of those pictured, while also distancing them from their own and America's painful history and brutal legacy of enslavement. In spite of being laudable, these advancements were becoming more difficult to maintain and surpass, since racial prejudice had not ceased to exist

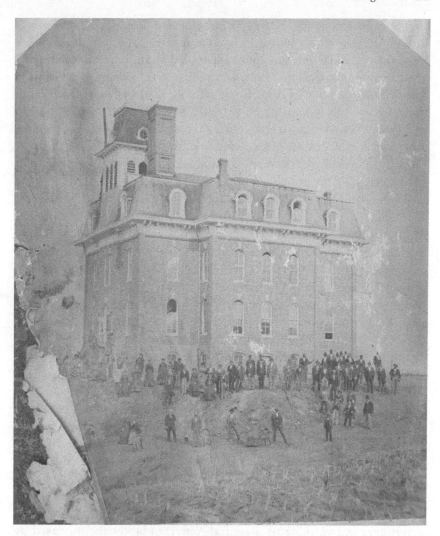

FIGURE 2. Lincoln Institute, Jefferson City, Mo., 1876. From *Lincoln Institute—Centennial Exhibit 1876* (Jefferson City, Mo: Lincoln Institute, 1876). Courtesy of Manuscript, Archives, and Rare Book Library, Emory University, Atlanta.

when slavery was ruled unconstitutional. On the contrary, antiblack racism had been recalibrated into new practices of discrimination, which by 1876 had begun to restrict access to public space, curtail male voting rights, and impede access to elected office. Despite the rising incidents of bigotry and violence, this group of proud black Americans in front of the schoolhouse that they had built had much to show the world.

The photograph of the Lincoln Institute and its educational community appeared as the frontispiece in a handwritten account of the founding, mission, and curriculum of the school, with the caption "embracing photographic view, historic sketch and classroom." Commissioned by the State of Missouri for its educational exhibit, the *Lincoln Institute* book was displayed in Philadelphia at the grand Centennial Exhibition held in 1876.[3] The five-hundred-page narrative condensed the school's unique story and included pages of student work in geology, algebra, mental philosophy, map drawing, penmanship, and other courses in a leather-bound volume suitable for public review.

The Lincoln Institute's earnest catalogue of progress may have represented one facet of black America's vision of itself, but other representations circulating around the fairgrounds revealed the way that others, particularly white Americans, viewed their fellow black citizens. These representations varied from a noble statue, *The Freed Slave,* that was part of the Austrian exhibit displayed in Memorial Hall to a disparaging spectacle of black men and women donning plantation attire who were hired to service a popular white-owned restaurant concession. None of these depictions perhaps reached a wider audience than the cover of *Frank Leslie's Illustrated Weekly,* a popular magazine that brought pictures of the most recent political, cultural, and world events to a national readership.[4]

Emblazoned on the front of the 1876 Centennial Exhibition souvenir issue of *Leslie's Weekly,* a colorful engraving illustrated a mythic gathering of the world's races. The scene depicts a very different kind of visual narrative of racial progress than the one photographed in front of Lincoln's brick schoolhouse. This fictional assembly of the family of man stands atop a grassy vista with each member adorned in costumes emblematic of her/his cultural (read racial) heritage. Together the five characters gaze outward across a fecund American landscape traversed by rivers and railroads, the conveyors of raw materials and finished products. Beyond this threshold appears the skyline of Philadelphia and the U.S. Capitol, both symbols of a civilized society and nation. In the distance, with its mass reminiscent of jagged mountain peaks, rises the exposition's impressive Main Building. The massive pavilion denotes a symbolic horizon of material and spiritual prosperity, with its expansive footprint validating the domestication of the American wilderness, a conquest of Native Americans and their land that proclaimed the might of the U.S. imperial project. In front of a globe stands the muse America. Standing broad shouldered and full bosomed in star-spangled dress, she

gestures westward to Europe. Another muse, Europe, is draped in imperial purple robes and grasps a shield encrusted with the crests of the two figures' shared paternal heritage. To the left of these paragons of white feminine virtue, and as a symbolic threshold to the west, kneels the Noble Savage, the only male figure of the quintet. In buckskin and feather headdress, he gazes upward to America. The Noble Savage yields to her wisdom and seeks guidance from those who will show him and his people the path toward civilized society. To Europe's right, and toward the east, bows the timid Asia, adorned in a simple green cotton tunic whose color blends with the grass below her feet. Lastly, next to the figure Asia and leaning back on her knees in a pose conveying deference and reticence, appears the ebony-skinned Africa. Clothed in pants and wrapped in cloth, Africa is depicted as a half bare-chested primitive clutching a rudimentary quiver of arrows. Her dress and tools symbolize basic human needs that are satisfied by the manual labor conducted by the men and women of her race. By virtue of her racial bloodlines, she foretells the likely fortunes of black Americans. Her place, last among the family of man, occupies a space in the margins of the worlds fair's sweeping cultural narrative.

This beautifully rendered engraving of the five races weaves a geopolitical allegory of progress. Its story, like the realm of the expositions, pits one nation and race against another in the quest to lead the cultural advancement of civilization according to aptitude and invention. By using women to represent heritage, *Leslie's* detailed illustration posits the female body and her reproductive capacity as the arbiter of both race and nation.[5] A nation's potential was believed to be biologically predetermined by its people's racial constitution, whose purity was safeguarded by controlling female reproduction; hence, the exaltation of white (bourgeois) womanhood during this period. In this regard, the United States' ability to lead the cultural vanguard provided the perfect subject for encapsulation in the temporary spaces of the U.S. centennial world's fair. Equally significant to the parable of human progress illustrated on *Leslie's* cover, the exhibits, pavilions, and fairgrounds at the fair also framed a new way of looking at the world.[6] As a didactic visual experience, the displays at fairs, along with those at museums, enabled privileged viewers (not everyone, of course, had access) to perform scripted national identities, underwritten by gender, sexual, racial, and class difference. This made it possible for those in the privileged subject position *to see* and others as the object of their gaze *to be seen.*

Both the Lincoln Institute's handcrafted presentation of racial progress

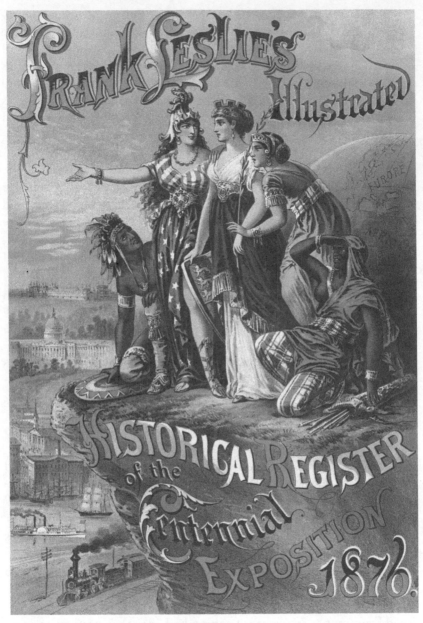

FIGURE 3. Cover of *Frank Leslie's Illustrated Weekly*, special Centennial Exhibition issue, 1876. Courtesy of Special Collections Research Center, California State University at Fresno.

within Missouri's educational exhibit and *Leslie's Weekly*'s mass-produced illustration of racialized evolutionary progress reveal the conflicting ways that expositions offered a space where notions of class, race, nation, and history could be presented and performed, viewed, and challenged. It is important, therefore, for us to consider how the fairgrounds like those built for the Centennial Exhibition and in the other events and institutions that this book discusses—particularly those organized by black Americans—constructed racialized social hierarchies. This social order was evident in exhibition content, in pavilion placement, and in plans of the fairgrounds themselves. It also influenced admission policies and who could move freely around the grounds and within the exhibition halls. Such organizational strategies, as we shall see, initiated new practices and reinforced emerging patterns of racial segregation in northern and southern cities where these grand events were staged and, likewise, the complex sphere inside the fairgrounds and halls was tethered to events and places outside of the exposition's gates.

Officially christened the International Exhibition of Arts, Manufactures and Products of the Soil and Mine, the U.S. Centennial Exhibition proudly put the history of the country's first one hundred years on view. It was a prodigious undertaking for a nation recently reunited after four devastating years of civil conflict. The exposition's splendid bounty also displayed to the world, implied by the fair's classification system, the ability of the nation's workers, managers, and owners to transform the rich raw materials of "soil and mine" into magnificent "arts, manufactures, and products."[7] The 1876 world's fair sought to prove that after one hundred years the United States was a top contender with its older European rivals. When seen in relation to the offerings of other nations at the Philadelphia exposition, the ambitious displays of natural history, national patrimony, and industrial ingenuity demonstrated how the United States represented the pinnacle of Western and white civilization's advance. Along with celebrating the nation's birthday, the centennial world's fair also served an additional purpose: undertaken as a nationwide endeavor with participants from all parts of the country, the international fair was a bid to mend the rift the Civil War had wrought in America's social fabric and an effort to lift the country out of a crippling economic depression. Organizers staged the exposition, as one magazine reported, to "inaugurate an era of good feeling" and "to remove the bitterness and ill-feeling engendered by war."[8] The former Union general and now president Ulysses S. Grant launched the opening-day festivities.

Philadelphia's sprawling fairgrounds overlooked the Schuylkill River. At the time of the nation's founding in 1776, the city's strategic location along this waterway and the Delaware River had made the major port a center of mercantile capitalism—bringing great prosperity to the United States' "First City." A living repository of American patrimony as the country's first capital, Philadelphia was an appropriate site for its first world's fair. Beyond its status as an industrial mecca and port, the city hosted several institutions, academies, societies, and museums dedicated to preserving the nation's history.[9] Around 1830 Philadelphia had shifted its economic base to industrial manufacturing. By the era of the fair, smokestacks emitting the effluents of the major industries of textiles, garments, machines, foundries, and publishing punctuated the city's former colonial skyline of steeples. After it annexed several nearby municipalities, Philadelphia by 1870 had reclaimed its stature as the second-largest city in the United States. Its neighborhoods swelled with the arrival of immigrants from Germany and Ireland and the migration of former slaves from the South after Emancipation.

In total, the Centennial Exhibition's fairgrounds stretched across 450 acres of Fairmont Park, making it the largest world's fair to date. A major attraction was the exposition's Main Building that covered nearly forty acres, or the size of a small city neighborhood. Cavernous and several stories tall, the great hall contained more than twenty miles of passages. An adjacent and slightly smaller structure, the Machine Hall housed the mammoth Corliss Steam Engine, whose machinery, equivalent to the power of 1,400 horses, symbolized America's untapped industrial potential as it piped energy to exhibits throughout the expansive fairgrounds. Moreover, to mark the occasion of national unity and as a didactic exercise to demonstrate how it could work in tandem with industry to build the wealth of the nation, the U.S. government financed an immense government pavilion to hold various exhibits from its Departments of War, Interior, Treasury, Post Office, and Arts and Science.[10] The largest area and budget was allocated to the Smithsonian Institution, the new national museum whose displays on research, ethnology, and natural history, as world's fair historian Rydell has observed, "provided the cement for integrating ideas of progress and race into a coherent ideological whole."[11] Assembled for the Centennial Exhibition, the Smithsonian's treasures would eventually form the core collection of the capital's U.S. National Museum, which opened to the public in the new Arts and Industries Building in 1881. The acquisition of exposition exhibits by a national institution indicates the extent to which permanent archives and

collections relied on the temporary fairs to gather the nation's historic and scientific treasures.

Veiled by the celebratory orations that extolled the Centennial Exhibition as exemplary of America's great promise as a nation bursting with resources and opportunities was the reality that not all Americans were conferred representation at the fairgrounds. Residing among Philadelphia's bustling port and industries was the largest black settlement outside of the southern states, a community that included families who had made the city their home for over two centuries.

Despite of the abysmal living conditions in the city's wards and the lack of employment opportunities in its factories—both a consequence of antiblack racism—Philadelphia's black residents formed a lively urban community. Its nascent class structure would attract the young sociologist W. E. B. Du Bois, who would study the community in detail twenty years later in his sociological opus *The Philadelphia Negro*.[12] With limited opportunity to hold elected office and participate in government, Philadelphia's black counterpublic sphere of civic associations had expanded considerably since Emancipation. Its church buildings, association halls, and meeting rooms anchored the bustling streets of the city's black neighborhoods. Proud of their accomplishments, Philadelphians would lead the effort for black representation at the Centennial Exhibition. For black Americans around the country, especially the small cadre of elites who comprised the echelons of leadership and drew their influence and stature from their positions as church, business, educational, and civic leaders, the world's fair represented a unique national forum where they could publicize and praise their own contributions to the founding of the nation. Additionally, black leaders desired recognition as American citizens and as bourgeois subjects who had a place in this new world of industrial production and commodities at the officially sanctioned commemorative event. Whether they could participate as social equals with whites was quickly thrown into question. Fair administrators thwarted their efforts at every turn, as would happen with many of the subsequent U.S. world's fairs.[13] This stinging rebuff would also serve as a solemn reminder to black Americans that, ten years after loosing the shackles of enslavement, the freedoms and privileges guaranteed with citizenship were still inaccessible. Their concerted attempts at inclusion in the national celebration would be made even more difficult by a devastating compromise after the election of 1876 in which northern Republican politicians conceded control of the South to Democrats in order to elect their candidate, Rutherford B. Hayes, to the office of president. This

betrayal by the "Party of Lincoln" ended Reconstruction and inaugurated the era of Jim Crow segregation. Black citizens would suffer greatly from the ascendance of state-supported white supremacy and violence throughout the South, where the majority of black Americans still resided, as well as in urban industrial centers, where many would eventually migrate. As a more ominous sign, the deliberate exclusion from the nation's grand celebration by white fair-builders forecasted greater efforts at prohibiting black citizens from participating in the public sphere that were yet to come.

Although the absence at the centennial world's fair of a collective exhibit of black progress signaled the rise of a post-Reconstruction backlash against their advancement, blacks were not completely absent from the fair. Representations of their achievements could be found scattered around various pavilions on the sprawling Fairmont Park grounds. In addition to the Missouri State educational exhibit featuring the volume on the history of the Lincoln Institute, there were other exhibits and events where blacks had been invited to participate. The American section of the fine arts exhibit, for example, displayed artist (and part Native American) Edmonia Lewis's stunning neoclassical marble statue *The Death of Cleopatra* along with other sculptures and paintings.[14] For the same exhibit, judges awarded Edward Bannister's rustic painting *Under the Oaks* a medal, an accolade they almost withdrew once they discovered he was a Negro.[15] And the great abolitionist Frederick Douglass sat on the platform among other dignitaries at the opening-day ceremonies, although police had initially barred his admittance even after the famous orator produced his ticket.[16] A few black workers found employment on the fairgrounds, although black businesses were not as fortunate in obtaining access to the fair's revenues. As previously noted, dressing in "coon attire" to entertain the crowds was required in some concessions, but some black workers also found jobs at white-run concessions or menial work as laborers on the grounds. While these proved to be somewhat stealth and random appearances, and were certainly not the grand showing black citizens envisioned, their small presence nonetheless indicated that they could successfully find avenues of participation in these mainstream public spheres.

Since it was the nation's first international fair, Philadelphia's Centennial Exhibition offers an excellent entrée into the conflicts of interest that arose and the various constituencies that populated the expositions and museums this book studies. As we shall explore at the subsequent mainstream world's fairs over the next fifty years in Atlanta, Paris, Buf-

falo, Charleston, Jamestown, and Philadelphia, and at the black-organized expositions celebrating Emancipation in Richmond, Philadelphia, Atlantic City, New York City, Chicago, and Detroit between 1913 and 1963, as well as at the first independent black museums in Chicago and Detroit beginning in the mid-twentieth century, black Americans constructed unique but at times challenging exhibits (like the Lincoln Institute's catalogue) in which they envisioned the race's future and remembered its past. The process of organizing these events required negotiation with white business and civic leaders who had their own racist, exploitive, and sympathetic reasons for black exclusion or inclusion. The representation of racial progress at mainstream events and at black-organized expositions required agreement among black Americans on what constituted advancement. This proved a difficult consensus to build, as the following chapters explore, given that many possessed diverse opinions and promoted different strategies for advancing the race, tackling trenchant antiblack racism, and imagining their own criteria for national belonging. In these carefully crafted exhibition spaces, the public—elite-, middle-, and working-class blacks along with people from around the world—witnessed displays, heard stirring speeches, and saw elaborate performances that conveyed diverse interpretations of what a fair and just world would look and be like.

CHAPTER I

Progress of a Race

The Black Side's Contribution
to Atlanta's World's Fair

Gentlemen of the Exposition, as we present to you our
humble effort at an exhibition of progress, you must not
expect overmuch. Starting thirty years ago with ownership
here and there in a few quilts and pumpkins and chickens
(gathered from miscellaneous sources), remember the path
that has led from these to the inventions and production of
agricultural implements, buggies, steam-engines, newspapers,
books, statuary, carving, paintings, the management of
drugstores and banks has not been without contact with
thorns and thistles.

—Booker T. Washington, opening-day speech, Atlanta Cotton States
and International Exposition

The Paris exposition had its Eiffel tower, the world's fair had
its Ferris wheel, but Atlanta had its negro building *[sic]*.

—H. R. Butler, *Atlanta Constitution*

A successful journalist, editor, educator, and businessman in the small
central Virginia town of Lynchburg, Irvine Garland Penn traveled south
in mid-January of 1895 to the bustling mercantile crossroads of At-
lanta.[1] The young, capable, and determined Penn came for two days of
meetings at Clark University. He attended a unique gathering of men
who like himself had made great strides in public life during the post-
Reconstruction era. Appointed to the positions of "Negro commission-
ers," this group convened to begin the laborious process of organizing

and gathering exhibits to fill the "Negro Building," an exhibition pavilion at the Atlanta Cotton States and International Exposition slated to open in the next nine months. The previous fall, the Atlanta Cotton States Exposition's Committee on the Colored Exhibit—a group of powerful white business and political leaders who also sat on the fair's board of directors—had selected prominent black southerners from several states to organize a landmark exhibit highlighting the progress of the Negro race in the thirty years since their emancipation from enslavement.[2] This would not be the first such effort, as an exhibit of Negro work had been included in the New Orleans World's Industrial and Cotton Centennial Exposition ten years earlier. Moreover, industrial expositions in which black citizens displayed their skills in mechanical and agricultural arts had been popular yearly events in several states. And some black leaders had even planned, but failed to fund, a national colored exposition for Atlanta in 1888. No white-run exposition had been willing to provide black Americans with their own exhibition hall in the prominent sphere of a world's fair until the Atlanta exposition.[3] This chapter explores in detail how Atlanta's unusual experiment, the Negro Building, came into being amid the boosterism of a New South and what the building and its contents represented for the future and current circumstances of black Americans in the Jim Crow era of economic and political disenfranchisement.

AN UNPRECEDENTED GESTURE

In their civic role as religious leaders, educators, newspaper publishers, and businessmen, the commissioners would soon adopt the mantle of "New Negroes"—a novel term for individuals whom blacks and whites alike perceived to have advanced their status to respectable, useful positions in a modern industrialized society.[4] They were educated in the expanding network of black colleges and normal schools: Fisk, Howard, and Atlanta Universities and Hampton and Tuskegee Institutes. All in the group were men. Mirroring white social norms, black men served as the chosen leaders and agents of public discourse. They represented the patriarchal bourgeois family as the cornerstone of respectability, a position that marginalized women from public prominence except as part of designated women's causes, although many black women would find a public voice in club activities such as rallying for women's suffrage, supporting the cause of better schools, and pressing for increased aid for the indigent and orphaned. Resolute activists such as Ida B. Wells, however,

would assert a public presence on par with their male counterparts in the world of fairs. The New Negroes were committed to self-improvement and promoted solidarity within their class of elites, which they believed were morally charged with advancing the future of the race.

A model of New Negro success, Penn was chosen to represent the State of Virginia. Bishop Wesley J. Gaines, a respected pastor of Atlanta's African Methodist Episcopal Church, and William H. Crogman, professor of Latin and Greek at Clark University, represented Georgia. Booker T. Washington, the head of the Tuskegee Institute and staunch advocate of industrial education, was selected to represent Alabama.[5] Several of the commissioners had been politicians. All were members of the Republican Party who had lost their public offices when white southerners disenfranchised black men from their right to vote by law and intimidation. Most of the commissioners held a moderate view of race relations and chose to work with white Democrats in power. In some instances, even though these men could not run for political office, they sought government appointments as agents and registrars. Commissioner Isaiah T. Montgomery, founder of the all-black town Mound Bayou in Mississippi, for example, believed that black citizens would have to sacrifice, albeit temporarily, political rights in exchange for financial support for education and economic advancement. The fight for social equality would have to be deferred in order to first cultivate better relations between the races.[6]

The influential and widely read *Atlanta Constitution* covered the meeting's deliberations. Many of the men stood out for their professional successes, but Washington cut the most striking figure. In comments that echoed reigning beliefs in the physical manifestations of racial difference as a determination of character, and hence cultural advancement, the white reporter tallied the college president's attributes: "His color is dark brown, but his face is the shrewd type." He next noted that "this head is not massive, but it is well shaped and on that would create a fine impression on a phrenologist. His features are rather large and his lips are strong and thoughtful."[7] The article allowed white Atlantans who would never have attended such a meeting to closely scrutinize the gathering and the participants' enterprising ambitions.

This extraordinary occasion to present the race's accomplishments in a dedicated pavilion both intrigued and excited the Negro commissioners. A similar opportunity had recently been denied black citizens at the great World's Columbian Exposition held in Chicago in 1893, where the ornate central Court of Honor, known as the White City, had captured

the imagination of 27.5 million visitors. The debate about whether to attend or participate in the Chicago fair included many of those now involved in planning the Atlanta event. Penn, for example, had contributed an essay to Wells's pamphlet that protested black exclusion from the exposition, *The Reason Why the Colored American Is Not in the World's Columbian Exposition.*[8] Crogman's Atlanta University had sent an exhibit of the school's work for display in the Liberal Arts Building. And Washington had traveled to the fairgrounds to deliver a speech at the exposition's Labor Congress, which had been convened to address unemployment and the national depression.[9] Introduced to the audience by Frederick Douglass, Washington in his speech praised the promise of black labor but also criticized the domineering sharecropping system that had indebted black farmers. He emphasized the need for black farmers through industrial education to transform their attitudes toward work, thrift, and morality.[10]

Yet in spite of the rosy prospects of inclusion in Atlanta, a similar set of reservations about racial discrimination was already brewing among the commissioners. Some in attendance harbored legitimate concerns about the nature of the white organizers' intentions, along with apprehensions about the long-term impact on race relations if they agreed to the terms of participation. On one side of the debate were those who reasoned that, because whites had favored the separate exhibit, it provided blacks with a rare opportunity to present a cohesive, thoughtfully crafted statement about the accomplishments of their race since Emancipation. Those who supported an exclusive pavilion dedicated to agriculture, mechanical and domestic arts, and education wanted to convey a strong sense of racial pride and solidarity. They therefore chose to gloss over the implicit racist intent of the white administrators to keep black displays out of the main pavilions: their effort to show unity among the Negro race would be thwarted, they rationalized, by having displays scattered throughout several buildings on the fairgrounds. On the other side of this thorny question were those who intensely spurned the notion of a completely separate building. This group contended that there was no inherent distinction between what either race produced. Therefore, why separate the exhibits? Would not the building be a debilitating step backward in the fight for social equality? For these commissioners, this unease was a valid concern given the evidence of segregated, second-class accommodations and transportation being offered to black travelers planning to visit the fairgrounds. Black-owned newspapers like the *Washington Bee,* for example, had already begun to advertise excursion packages

offered by the Southern Railway from northern destinations and around the South that connected directly to the fairgrounds.[11] But what the railroads failed to disclose in their advertisements was that once the train journeyed below the Mason-Dixon Line, and depending on various state laws, black passengers seated in first class could be forced to move to segregated second-class cars—an outcome of the patchwork of Jim Crow laws and customs blanketing the southern states. Further confirmation of the pervasiveness of segregation meant that black visitors to the fairgrounds could not stay in the numerous white-owned hotels in downtown Atlanta. Therefore, the committee was also entrusted with the task of arranging separate lodgings.

Unable to fully resolve the issue of separate pavilions, the commissioners did agree that demeaning treatment awaited black patrons planning to visit the fairgrounds. Writing in a report on their deliberations, which was published in a lengthy article titled "Progress of a Race" in the Atlanta Constitution, the commissioners tactfully expressed their dismay to the exposition's governing board, stating, "We earnestly recommend that the management of the exposition use all the influence in their power to obtain improved and more just facilities for colored passengers traveling to and from the exposition. We cannot too strongly urge this for the reason that we know a large portion of the colored race will not travel on the railroads with the present unequal accommodations, except when they are compelled to do so on matters of business."[12] In response, the fair's general governing executive committee (many of whom were influential railroad owners, former mayors, and state legislators) sheepishly claimed they were powerless to intercede in the manner in which states handled the privately owned railroads. Although they intended black southerners to finance the exhibits, the executive committee granted $4,000 to the Negro commissioners for travel expenses in their quest to acquire exhibits to fill the large hall—a gesture perhaps intended to compensate for the unpleasant segregated railcar issue.[13]

The opportunity to present their advances since Emancipation at the forthcoming international forum was an unprecedented one for southern blacks, in particular those living in Atlanta and in Georgia, which had the largest population of black residents in the region. But how would a separate building in the symbolic sphere of the fairgrounds be interpreted by black and white visitors, especially since it would reinscribe the everyday boundaries of segregation that now divided according to racial difference not only the South's railcars and waiting rooms but also its cities and towns? Furthermore, could the organizers ensure that the

contents of the Negro Building would be the principal story of the Negro's future prospects in the New South, or were there other equally compelling narratives that charted a different course for black progress and that challenged the degrading depictions of racial inferiority that appeared in all corners of the fairgrounds? Would the "accommodationist" cultural representation of the black citizen as industrious and self-supporting—ideals resonant with the New South's economic liberalism that underwrote the fair's agenda—ultimately signify a retreat from the fight for civil rights and social and economic equality? The fair and its planning process did offer, as we shall see, a temporary public sphere in which black and white southerners negotiated their individual and collective needs and aspirations.

After Emancipation, Atlanta's black residents had established a growing but separate enclave of businesses, religious institutions, voluntary associations, and educational institutions—a black counterpublic sphere that would contribute a rich selection of material on display at the Atlanta Cotton States Exposition and other subsequent fairs. But life in an increasingly segregated city, where its black citizens had neither political nor economic clout, posed challenges for not only the elite but also for the emerging ranks of middle- and working-class Atlantans and the majority of poor who labored in unskilled jobs and lived in abject poverty. If the fair, as a social space of spectacle, power, and control, created a pseudourban sphere—a miniature city in which the latest accomplishments in industry, science, and culture were displayed and witnessed—in what ways did the Atlanta Cotton States and International Exposition cultivate how black and white Americans would see this "New Negro" born of the post-Reconstruction era, and how would this New Negro fit into the future New South's industrial economy and racialized social hierarchy? To capture a panoramic view before we visit the Atlanta Cotton States Exposition's fairgrounds, we begin by examining life in Atlanta.

ATLANTA'S BLACK SIDE

With its hilly terrain sectioned into thirds by the sinewy lines of railroads, Atlanta's downtown in the last decade of the nineteenth century supported a dynamic economy and hosted a populace that made the city a wily down-home little cousin of its thriving kin up north—big daddy Chicago.[14] Atlanta's economic fortunes had been on the rise since Reconstruction, as a Yankee "can-do" ethos translated into what became known as "New South" boosterism. The city's mercantile and growing indus-

trial prosperity eclipsed the older doyens of the plantation economy—
Charleston, Savannah, and Mobile.[15] Atlanta's many train routes stretched
eastward to seaports, southward to the Gulf cities, westward to new ter-
ritories, and northward to the major industries and markets of New York
and Chicago. These rail lines stitched together a quilt of abutting terri-
tories that loosely partitioned the city's segregated neighborhoods. Its
urban environs, a hodgepodge of train depots, churches, stores, hotels,
saloons, shantytowns, and fine houses, were home to a diverse, some-
times contentious array of social groups characterized by class and racial
difference. Longtime white urban elites, who proudly paraded their dis-
dain for the once powerful but now dwindling planter class, allied with
an emerging class of ruthless southern entrepreneurs. Together, their greed
and ambition controlled Atlanta's political and economic base and their
powerful oligarchy lorded over its urban domain. Atlanta was home to
the remnants of a community of postbellum northern carpetbaggers and
sects of well-intentioned northern social reformers working in poor white
and black neighborhoods. The city's oligarchs envied these interlopers'
connections to wealthy northern industrialists, which made the north-
erners quite useful for business and trade. Atlanta's elites also found the
northerners' charitable assistance helpful in rebuilding the city but rejected
their divergent viewpoints on race relations. Atlanta's burgeoning indus-
trial economy also lured poor whites—many of them former farmers—
who sought employment in the cotton factories and mercantile estab-
lishments. And into the patchwork of the rapidly expanding urban fabric
was woven the area proudly called, by some, the Black Side.

In the period following the bestowal of emancipation and the passage
of constitutional amendments guaranteeing equal protection for all blacks
and the right to vote for black men, many freed men, women, and chil-
dren fled the brutal plantation life of toil and oppression to seek better
opportunities and greater freedoms in southern cities.[16] Once they mi-
grated to cities like Atlanta, black men and women discovered that racial
prejudice severely limited where they could live and work. Comprising
nearly half of Atlanta's population, black residents lived in all of the city's
wards, but most were concentrated in undesirable basins prone to flood-
ing and thus outbreaks of disease. "Darktown," "Buttermilk Bottom,"
"Shermantown," and "Black Bottom" were characteristic racist monikers
attached to these neighborhoods, labels that indicated both the area's low
position within the city's topographic contours and its low position within
social contours demarcated by race and class. On the eastside near Wheat
Street, and on higher ground on the westside near the campus of Atlanta

University, one could find the houses of the fledgling black elite. Many black neighborhoods had a mix of classes, and therefore one could find stately houses adjacent to the smaller homes of laborers, whose side vegetable gardens denoted their residents' rural roots.[17]

Once settled in postbellum Atlanta, the majority of black residents labored in poorly paid and unskilled, often dangerous jobs. Men worked on street crews as laborers and as rail-yard workers, where they took the jobs that white workers did not want. Women found jobs as laundresses, seamstresses, and domestics. Overall, employment in the region's growing manufacturing sector had been rendered inaccessible by the antiblack racist practices of white factory owners, managers, and workers. However, with invaluable expertise adapted from their plantation occupations, a few black men did secure work in skilled positions as draymen, livery workers, barbers, plasterers, carpenters, and blacksmiths.[18] Though not without challenges at work and home, urban life offered prospects not found in rural economies. Initially, enterprising merchants, grocers, clergy, and doctors achieved some financial gain, which they invested in property ownership. Many identified as "colored" and benefited financially and educationally from their often hidden ties to white families. This group formed the beginnings of Atlanta's black elite and intelligentsia.

A few outspoken and successful black men took advantage of rights granted with their freedom by running for political office during the era of Radical Reconstruction. Access to the vote, as black citizens knew all too well, provided access to power. At first, northern legislators sanctioned the right of black men to cast ballots, guaranteed by the Fifteenth Amendment during Radical Reconstruction and enforced by a military presence in southern cities and towns.[19] In the Compromise of 1877 that resolved a dispute about which candidate won the close 1876 presidential election, the Republican Party regained the presidency by conceding control of the South to the Democratic Party. This compromise prompted the immediate withdrawal of federal troops. Trusted northern white politicians had callously betrayed loyal black Republican voters for their own political gain. Elated by their newly won autonomy and the gain of a solid political block that controlled state and federal offices, southern white Democrats would incrementally strip black citizens of many of their rights and expel them from the mainstream public sphere over the next twenty-five years.

Atlanta's boundaries crept outward into Cobb County as its population grew. As a result of this expansion and as segregation became more pervasive, the city's black residents found themselves confined to an even

smaller area of the city. White authorities implemented by custom and legislation more stringent controls over what they perceived as a growing tide of black presence and power.[20] Black Codes, postbellum dictates similar to those laws under enslavement devised to control the mobility and activity of black residents, formed the foundation for Jim Crow legislation in the last three decades of the nineteenth century.[21] In 1871, Georgia was the first state, for example, to pass a statute segregating streetcars, followed by the legal segregation of all public spaces of the city, including schools, transportation, businesses, hotels, and entertainment venues.[22]

Despite losing economic and political ground and living under the harrowing consequences of antiblack racism and Jim Crow segregation, a social and cultural milieu nonetheless prospered. A black counterpublic sphere formed in Atlanta's black community. Rev. E. R. Carter praised Atlanta's Black Side, in a survey of the same name published in 1894, as a flourishing urban enclave. "Atlanta, for the Black Side, is the classic city," wrote Carter, the minister to the large congregation that attended Friendship Baptist Church.[23] In a textual mélange of Judeo-Christian and social Darwinist terminologies, Carter exalted the Black Side's many fine commercial, religious, and institutional buildings as glorious feats of a people progressing toward greatness. *The Black Side*, an illustrated book of engravings and photographs, catalogued Atlanta's growing black middle class, showcasing its businesses, luminaries, social institutions, schools, churches, and benevolent associations. The picture book also depicted families settled into comfortable middle-class houses and embraced bourgeois cultural values: thrift, respectability, and moral uplift. The adoption of the tropes and trappings of respectability distinguished them from their poorer black neighbors.

The Black Side represented the positive successes of black progress after enslavement, but there was also an urgent need to address the widespread social inequalities. Staking a claim for black self-sufficiency, Bishop Henry McNeal Turner wrote in the introduction of Carter's *The Black Side*, "The time is right for the Negro to fight his own battles, seek his own fame, achieve his own greatness and immortalize his own name."[24] Along with being a former officer of the Freedman's Bureau and a Republican member of the Georgia state legislature, Turner was also a stalwart Black Nationalist who publicly advocated for the repatriation of black Americans to Africa.[25] Turner positioned the Black Side as a political counterpublic sphere that would "fight [its] own battles" against the rising tide of racial prejudice flooding all regions of the South and drown-

ing hopes of advancement. Turner's passionate nationalistic appeal to rally for rights and autonomy, however, was not necessarily shared by all of his peers, as the later sections of this chapter examine.

With Atlanta's black population just over 40 percent of the city's residents, and as an indication of the growing wealth of the black community, Carter's review of the Black Side's nascent class structure proudly referenced the number of brick and stone buildings being erected by its institutions and businesses.[26] Shut out of political participation, and given the statewide hostility to labor unions, it was the black churches, voluntary associations, and benevolent societies that nurtured the counter-public sphere of the black community. Atlanta's black newspapers, the *Southern Christian Recorder* and the *Weekly Defiance,* along with the widely read *Savannah Tribune,* passed on to a growing literate population the latest local and national news about recent upsurges in lynchings and new segregation laws. One of the most significant factors contributing to the success of Atlanta's burgeoning black community was the growing number of residents who had been educated in the Negro colleges and in normal and industrial schools now open across the South. In 1870, less than 10 percent of blacks in Georgia could read and write. Twenty years later, that number had grown to a third of the black population.[27] Atlanta, with its numerous institutions of learning, had become the center of black education.

Carter's profile chronicled Atlanta's emergence as a progressive haven and educational center for blacks. Many institutions of Atlanta's Black Side promoted bourgeois ideals of social improvement in their missions and activities. During this period, historian Kevin Gaines observes that "racial uplift ideals were offered as a form of cultural politics, in the hope that unsympathetic whites would relent and recognize the humanity of middle-class African Americans, and their potential for the citizenship rights black men had possessed during Reconstruction."[28] Many in the bourgeois public sphere endorsed the notions of family, patriarchy, and feminine propriety that underwrote racial and national identity. Class advancement could be successfully achieved through an adherence to certain ideals of appropriate behavior. Therefore, notions of uplift were also meant to displace disempowering ideals of racial inferiority. These ideals supplanted biological notions of racial difference by suggesting instead that cultural differences explained the lower social status. But whether the adaptation of the ideologies of class difference—coded by cultural attributes of respectability, uplift, masculinity, self-improvement, and thrift—could boost the status of the entire race would be hotly debated and chal-

lenged at expositions over the next fifty years. The larger and more pressing question of whether black citizens could escape the damaging effects that antiblack racism had on everyday life—especially in respect to gaining access to wage labor that could provide food and housing—would weigh heavily upon everyone living within Atlanta's urban limits, regardless of whether he or she dug ditches, ran a barbershop, taught school, or led a congregation.

Post-Emancipation black Americans, especially those moving into the cities, believed that education was key to their advancement. The Freedman's Bureau, which started Howard University in Washington, D.C. in 1869, paid white northern missionary societies to come to the region and set up schools; these missionary organizations took over the primary funding of education after the bureau was phased out by 1876.[29] Creating a model for future Negro schools, the American Missionary Association founded Hampton Institute on a bluff in a rural part of Virginia in 1868. General Samuel Chapman Armstrong, a northerner who took over as head of Hampton, believed that good Puritan values of hard work and thrift would counteract what he believed was the natural tendency of Negroes to be lackadaisical, shifty, and backward.[30] Raised up from the disparaging depths of illiteracy and poverty through manual labor, newly minted black laborers would be prepared to assist in either the North's manufacturing economy or the South's industrializing agricultural economy.

Fulfilling Carter's portrait of Atlanta as an educational mecca, the city quickly became home to several schools. In tandem with the opening of normal schools around the South, the American Missionary Association, in a radical move, also started several colleges, including Fisk University in Nashville in 1866 and Atlanta University a year later. Soon thereafter, the freedmen's aid associations of other religious groups, such as the Methodist Episcopal Church, founded Rust University in Holly Springs, Mississippi, and Clark College in Atlanta, which in 1877 became Clark University.[31] As funding from northern philanthropists increased, the city's black schools like Atlanta University built large halls and campuses that became centers of the Black Side's civic pride.[32] By 1895, the year of the Atlanta Cotton States Exposition, numerous schools offered education from primary- to college-level courses.[33]

Although black educational institutions flourished in Atlanta, the most influential school for black students in America was located about 120 miles southwest of the city, in Tuskegee, Alabama. A former slave educated at Hampton Institute, Booker T. Washington would utilize his ad-

vocacy of industrial education to become the nation's most powerful Negro leader by the turn of the twentieth century. Born a slave and freed by Emancipation only to be enslaved again into a brutal existence mining for coal in a dreary West Virginia town, Washington's hard-won education afforded him an understanding of "what it meant to live a life of unselfishness, my first knowledge of the fact that the happiest individuals are those who do the most to make others useful and happy."[34] In 1881, General Armstrong dispatched Washington to Tuskegee to head a normal school for blacks in the Black Belt region of Alabama. Washington began his auspicious academic career by holding classes in a dilapidated shack and an old church. Lacking the funds to build a proper campus, he ingeniously mobilized the physical assets of his students, whom he put to work constructing their own classrooms and dormitories. Tuskegee students not only erected the buildings by making the bricks, they learned the art of building furniture, making mattresses, sewing cloth, and fashioning the brooms used around their campus. A didactic exercise in diligence, the students acquired valuable manual skills and in the process made their school both livable and financially viable. Under Armstrong's tutelage, Washington traveled to all parts of country to raise money from wealthy patrons. Deferential but persuasive in address, Washington solicited large donations from the likes of steel baron Andrew Carnegie and railroad tycoon Collis P. Huntington. The educator galvanized support from both sides of the color line: from northern white benefactors and southern white political and industrial leaders on one side, to black educators, religious leaders, benevolent societies, and the black press on the other.

Armed with the financial backing of powerful whites from around the country, Washington would fund the construction of an impressive campus outside of the small town of Tuskegee. Toiling against a rough native terrain of ridges and gullies on part of the former acreage of a defunct cotton plantation, whose soil made it barely suitable for cultivation, hardworking students erected the various halls of the campus. The workshops, barns, dormitories, and halls faced away from the main road, thus turning their backs on the town. Scholar Ian Grandison's probing spatial analysis suggests that, while the school's distance from town could be interpreted in one sense as imposed segregation that emphasized the marginal status of the school, in other ways it could be understood as desired autonomy from white scrutiny and control.[35] Far from the urban squalor and dusty commotion of Atlanta's Black Side, Tuskegee's solid edifices and orderly campus—referred to as the Farm, with its cattle graz-

ing and freely roaming the gullies—spatially demonstrated and visually represented the pastoral ideal of Washington's agenda for black progress.

The Black Side emerged as a bustling center of Atlanta's black counterpublic sphere. But now let us examine the white side, the one that ruled the city but depended on the city's black residents to achieve its ambitions of raising a New South. This objective would bring the two spheres together on the fairgrounds of the Atlanta Cotton States and International Exposition.

COTTON AND COLORED EXPOSITIONS

In the last decade of the nineteenth century, Atlanta's segregated social and urban sphere illustrated how the city transitioned from the "Old" South's agricultural economy of slavery to the "New" South's classed (although still racialized) economy of industrial capitalism. After the Civil War, a small vanguard of industrialists and investors championed the formation of new values that became known as New South boosterism. In his important chronicle *Origins of the New South, 1877–1913,* C. Vann Woodward documented that, contrary to the belief that the postwar South emerged as a continuation of the old plantation culture, the development of a new progressive class of businessmen signaled a break with that way of life—a shift toward principles and practices of industrialization that had been immensely successful in the wealthier North. At its core, Woodward's historical narrative of the South turned on the deeds of brash young white entrepreneurs who proved willing to break with antebellum traditions to implement their bold ideas at any cost. The results created a new but fledgling industrialized economic order that utilized local raw materials of cotton and lumber. This emerging sector of manufacturing and marketing benefited wealthy whites at the top by exploiting the labor of poor whites and blacks at the bottom. While economically innovative, the new social order nevertheless absorbed the racial hierarchies from the plantation economy more or less intact.[36] Studies of the post–Civil War South by historians Barbara J. Fields, Howard Rabinowitz, James M. Russell, and others have challenged Woodward's polemic of a discontinuity between the old and new southern orders.[37] Instead of the war fostering a complete metamorphosis of the region's economic order, they contend, the New South's economy thrived through a mutually supportive relationship between the disappearing planter caste and the emerging class of industrialists. The implementation of a sharecropping system that forced freed slaves into peonage merely redirected what had been

coerced labor under enslavement into coerced labor under the guise of industrialized agriculture. Likewise, the highly profitable state-run convict lease system provided a constant stream of able-bodied black workers whose labor was unpaid as it was under slavery. Prisoners (many falsely accused) were ruthlessly exploited to extract raw materials through logging and coal mining, to extract turpentine, to produce bricks, and to build the region's infrastructure of railroads, roads, and bridges.

Renowned white orators such as Atlanta's Henry W. Grady proved invaluable for proselytizing New South ideology—which dovetailed with American liberalism's free-market ethos—around the region and country. But it was the network of white-owned banks and railroads, along with migrating workers between the country and cities, that truly facilitated the region's economic expansion. In his famous speech to northerners about the region's promise and progress, Grady, editor of the influential *Atlanta Constitution,* captured the unwavering faith his class placed in industrial capitalism as the impetus for creating a new southern society. He noted how "the Old South rested everything on slavery and agriculture, unconscious that these could neither give nor maintain healthy growth." In contrast, "the New South presents a perfect democracy, [with] the oligarchs," like himself, "leading in the popular movement; a social system compact and closely knitted, less splendid on the surface, but stronger at the core; a hundred farms for every plantation, fifty homes for every palace; and a diversified industry that meets the complex needs of this complex age."[38] For national figures like Grady, who exercised a commanding influence over the civic and economic climate of their respective cities, one means for initiating a popular movement— a transformation in the social and economic order—was the regional and international exposition. These festive events that drew massive crowds served as ideal venues for elites to propagandize the interests of the New South and Atlanta's economic and social agenda: the subservience of the middle class, the subjugation of the working class, and the suppression of Negro advancement.

In 1881 Grady, whose wealth and power had ensconced him and his family in a comfortable Victorian mansion on Atlanta's fashionable Peachtree Street, seized on a brilliant idea first proposed to him by a Boston gentleman to hold a regional fair showcasing the farming and manufacturing techniques of Georgia's king crop: cotton.[39] Financially backed by a roster of enthusiastic merchants and businessmen, the first International Cotton Exposition opened in the fall of 1881 at Oglethorpe Park located in a wooded area northwest of downtown. The lively fair

drew crowds from all parts of the South, joined by a few curious visitors from the northern states to see the Phoenix—once burned to the ground by Union troops—"rise from the ashes."[40] Among the many events, the organizers hosted a Freedman's Day during which black visitors could view the exhibits and hear speeches made by the city's black leaders.[41] The enormous turnout of visitors from the region, along with the collaborative efforts of the planters with the cotton mill owners in contributing to the exhibits, made the fair a great success in its goal of promoting local products and industry.[42]

Six years later, a group of these same Atlantans—socially elevated by their thriving economic prosperity—decided to form a Gentlemen's Driving Park Association, a private club for family entertainment and "gentlemanly pursuits" (a euphemism for horse races).[43] The shrewd Grady, conceiving of a more strategic and financially lucrative use for the extensive acreage the club members had purchased, proposed to his fellow members that they incorporate a fairgrounds as part of their plans—a proposition to which they all heartily agreed. Opening its gates in October 1887 at what was now called Piedmont Park, a second regional fair, the Piedmont Exposition, presented numerous displays of local manufacturers in several expansive exhibition halls laid out over ten verdant acres of the Driving Club. The Piedmont Exposition displayed a myriad of local and regional goods, thereby promoting to an attentive audience of consumers and workers the products and factories through which the club members had amassed their great wealth. In a successful merger of commerce and leisure, the exposition solidified the power base of Atlanta's white oligarchs.

In the midst of the Piedmont Exposition's planning, Philip Joseph of Mobile, Alabama, and William A. Pledger of nearby Athens, Georgia, approached the Driving Club with a proposal for a fair dedicated to Negro progress that they had christened the National Colored Exposition.[44] It was proposed to open in the fall of 1888. Prominent race leaders and staunch supporters the Republican Party, Pledger and Joseph both served as editors of black newspapers. A controversial figure in Georgia after the ascendance of white Democrats to power, Pledger had until recently been a city customs surveyor for Atlanta and the leading black member in the state's Republican Party. Illustrative of his influential status among the state's black population, members of the Driving Club had previously invited the popular Pledger to deliver an address at the fair's Freedman's Day set aside for black visitors at the first International Cotton Exposition.[45] Joseph, who was director general of the proposed exposition, ex-

plained to the Driving Club members that despite offers to host the fair from northern cities, from Chicago for instance, Atlanta was centrally located, and the exposition would draw a significant audience of blacks to witness displays gathered from around the region and from as far away as Africa. Joseph sold the fair in educational terms as "an object lesson to the colored people, to show them what their comrades had done in industry, agriculture, and the arts and thereby encourage them to similar efforts and results."[46] Persuaded by the proposal, the club agreed to rent the two-hundred-acre fairgrounds and buildings at no charge.

Neither Pledger nor Joseph was new to the planning of expositions. Each had served as the respective Georgia and Alabama commissioners for the Colored Department at the New Orleans World's Industrial and Cotton Centennial Exposition held in 1884–85, which had celebrated one hundred years since the first exportation of cotton from New Orleans.[47] Since blacks provided the main source of agricultural labor in the cultivation of cotton, the managing board invited blacks to share their accomplishments.[48] White organizers placed former Republican senator Blanche K. Bruce, an influential black landowner and a registrar for the U.S. Department of the Treasury, in charge of organizing the Colored Department for the fair. Allocated four thousand square feet in the main exhibition hall, the exhibit presented artifacts from agricultural machinery to manufactured products. As a confirmation of the Negro's excellent artistic capabilities in the fine arts, Bruce had praised the paintings of a young artist, Henry O. Tanner, and the other notable artworks on display. Elevating the event's goodwill, Bruce publicly lauded the perceived lack of discrimination at the New Orleans fairgrounds as a hallmark of cooperative race relations.[49] In his speech at the opening ceremonies of the Colored Department, Bishop Turner commended white organizers for their willingness to welcome the Negro to the fair and fairgrounds, in spite of the recent Supreme Court rulings legitimating segregation.[50] New Orleans's Colored Department signaled a small gesture of recognition, but as Pledger and Joseph were willing to test in Atlanta, would white southerners support a large and autonomous exposition dedicated to the display of Negro progress?

Successful in their bid to gain use of the Atlanta fairgrounds, Pledger and Joseph chartered an exposition company to raise funds and created an executive committee of interested men and women from the city's various wards.[51] They assembled a local management committee composed of well-respected black Atlantans that included Reverend Gaines; Henry A. Rucker, a former barber turned successful businessman and ed-

ucator, Smith W. Easley, a political activist; and C. C. Wimbush, a customs surveyor.[52] With a site selected and an organizational structure in place, Pledger and Joseph's next major undertaking was to solicit an estimated $400,000 from the U.S. Congress to add to funds already raised. The large amount resulted from the need to construct separate facilities such as new hotels (to accommodate black fairgoers, so as not to "force that issue on the occasion of an exposition which was intended to harmonize the races," Joseph respectfully explained to the Driving Club members).[53] Backed by Grady and other influential members of the Driving Club, the Atlanta Chamber of Commerce, and the majority of Georgia's delegation to Congress, a group consisting of Joseph and two other representatives appeared in March 1888 before the House Committee on Appropriations in Washington, D.C. But as the fall months approached, neither the House nor the Senate had approved funding. For the next two years Joseph continued to rally support for the event. Well-attended meetings in the city's major churches indicated that interest among black Atlantans remained strong. However, in spite of efforts to underscore how the National Colored Exposition would stimulate the productivity of black workers, southern congressmen believed that the fair would have an opposite effect—it would instead demoralize their valuable labor force.[54] Under the emerging class structure of the New South, white leaders wanted to make sure that the "black masses," which from their perspective included the black elites, knew their place—that is, serving the interests of their white bosses and mistresses. Defeated, Joseph abandoned his efforts by 1890.

The National Colored Exposition never convened at the Piedmont fairgrounds. However, the success and popularity of the two white-organized expositions laid the groundwork for a much grander international event and the participation of Atlanta's black leaders and residents in the mainstream fair.[55]

In 1889 Grady suffered a premature death, but the persuasive and powerful editorial voice of the *Constitution* would continue to be a major advocate for the planning of a world's fair in Atlanta. The *Constitution's* editorials in the winter of 1893 envisioned an "industrial jubilee" of "magnificent exhibits and thousands of visitors." Prompted by a suggestion from the business manager of the *Constitution,* former Confederate Major Colonel William A. Hemphill, Atlanta's oligarchs decided to host a third exposition celebrating the city's role as a "gateway" for international trade.[56] Deeply motivated by their faith in the New South doc-

trine, fair boosters immediately began to organize and fund-raise for a grand world's fair—the Atlanta Cotton States and International Exposition to open in the fall of 1895.

Billing itself as an international affair, the Atlanta exposition would follow a long roster of such events beginning with London's Great Exhibition of the Works of Industry of All Nations staged at the magnificent iron and glass Crystal Palace in 1851. Enthusiastically promoted by daily editorials and reports in the pages of the *Constitution,* Atlanta's fair boosters wanted to accomplish two of the objectives not realized due to the lack of participation by the southern states at the immensely successful World's Columbian Exposition, which had closed three months prior to Hemphill's December editorials.[57] First, the fair organizers wanted to demonstrate how the South's industries situated near abundant local resources of cotton, lumber, tobacco, and coal could be competitive with their prosperous northern counterparts. Second, they wanted to show how the New South was prepared to contribute to the national and international economic fortunes of the United States in the forthcoming new century.[58] A more immediate rationale for staging the fair was to address a recent nationwide economic depression, which had already resulted in the failure of several local banks, the collapse of a handful of railroad companies, and the drop of cotton prices to an all time low.[59] While the region's leaders had heavily promoted the South's industrialization, in reality it had been painfully slow and often derailed by poor planning and lack of support from local municipalities. Stoking excitement among the city's main business establishment about the forthcoming festivities was therefore a tactic to raise confidence in the local markets as well as to increase sales of the region's staple product—cotton.[60]

Circulating a preliminary prospectus issued in 1894 intended to solicit investment in their endeavor, the collective of determined oligarchs touted "Atlanta's position as the great natural gateway of trade between the United States and the Central, South, and Latin American Countries."[61] Exposition board member, Grady protégé, and the *Constitution's* editor, Clark Howell observed in an essay written for the February 1895 issue of the *American Monthly Review of Reviews* that, although the United States functioned as Latin America's primary exporter, American businesses had been unsuccessful in gaining market access. Atlanta, the South's most prominent industrialized city, jockeyed into position to lead the nation in conquering the profitable markets of the Southern Hemisphere. Furthermore, considering the possibility of a cultural communion with places like Brazil, Howell imagined that contact between the two

regions might prove beneficial. He suggested that if "[racially] mixed populations are to be governed," then, "the statesmen of the Southern Republics must naturally look to the cotton states of America for precedents and suggestions for the solution of this difficult problem."[62] The fair, in the mind of its supporters, would set the stage for a rewarding economic and distinctive cultural exchange. In so doing, Atlanta would shine as an international model for forging harmonious relations between the races.

The carefully crafted prospectus circulated to exhibitors and investors bragged about the modern amenities and welcoming populace of their fair city. Atlanta, the prospectus touted, was well prepared to host a world-class exposition. The prospectus also boasted of Atlanta as a modern city whose population was nearing one hundred thousand, with refined citizens who were of "mainly Anglo Saxon descent . . . [with] a large admixture of leading races of Europe."[63] This whitewashed statistic failed to illuminate that black residents comprised close to half of the city and a third of the region's population. As a result of the sustained dependence on their black neighbors, the organizers felt compelled by necessity to consider the request of local black leaders to include their participation and representation at the forthcoming fair.

In January 1894, Bishop Gaines and Rucker, two organizers of the failed National Colored Exposition, approached Samuel Inman, the head of the Atlanta Cotton States Exposition's finance committee and a wealthy cotton merchant, about the prospects of hosting representative examples of the progress of the Negro race in an exhibition hall to be paid for by black southerners. In the editorial pages of the *Constitution,* Bishop Turner compared the prospect of what was being called the Negro Building to the New Orleans fair's Colored Department. Turner strongly advocated for the pavilion, noting that as "Americans from Africa" blacks deserved the opportunity to showcase their progress as had other Americans in previous fairs.[64] In the early stages of planning, the *Constitution* supported their effort by noting the financial benefits of inclusion: "our colored friends have good interest in the exposition" (a reference to the wealth of the emerging black middle class). Mindful of other possible financial gains, the editors speculated that black participation would "draw the aid of their wealthy friends in New England and probably other lands."[65] A group of black leaders met with the exposition's board of directors in the spring of 1894. Upon careful consideration, Inman "thought the Exposition offered a favorable opportunity to stimulate the race by an exhibition of its progress, at the same time giving substantial evidence of the good will of

the white people."[66] The board of directors reviewed the request for the Negro Building and, as the fair's illustrated history book recounts, it was cordially agreed on by all.[67]

This was a unique and never before seen gesture of inclusion that came with an offer to pay for the building. The majority of southern whites, even those heading up the fair, however, held steadfast to their belief in the social inferiority of their fellow black citizens. For the former plantation class and the ruling oligarchs, the lowliness of the Negro and the natural supremacy of the white race was obvious. Nevertheless they needed black labor to build and maintain their cities and towns, to work their farms and households, and to cater to the daily needs of their families. Economic reliance was clearly one significant reason for the tenor of interracial relations. But there were also the unspoken bonds that had been fostered through centuries of imposed sexual relations between white masters and black female slaves. Unacknowledged, though not invisible, interfamilial ties also proved a factor in continued interdependence.[68] On the eve of Atlanta's great fair, these white power bases had craftily deployed social customs and legal means to isolate many black residents in impoverished living conditions. When these unfair measures proved inadequate, white supremacists used forceful intimidation and violence to keep blacks obediently in their place. The *Constitution*, through its inflammatory reporting, published on a daily basis lurid stories about Negro thieves, murderers, and rapists plaguing the city and terrorizing the countryside. One editorial published during the exposition's planning heartily endorsed "separate but equal privileges and accommodations in all public places, schools, cars and all buildings and conveyances" in both the South and the North. Based on this division—one that evolved naturally from the superior human nature of the white race—the editors reasoned, "It is impossible to see how any self respecting colored man can be against it. The separate system is just as fair to the one race as it is to the other. Justice is its very essence."[69] Thus, the display of the Negro's laudable but meager accomplishments would symbolize blacks' rightful place in the New South's social order, far behind the rest of the races. And the exposition board of directors echoed these sentiments in their preliminary prospectus. They would accept the offer of Gaines, Turner, and others "for a full display in a building of their own" to display "evidences as they can present of educational and intellectual progress." But the board concluded with these stinging sentiments: that "the few and inadequate presentations they [blacks] have made have fitted them to enter at this time into a larger more complete exposition of their own work."[70]

"Inadequate presentations" reaffirmed the perception of Atlanta's white leaders about the lowly status of the Negro as naturally inferior.

For all black residents in Atlanta, urban life in the thirty years since Emancipation had offered an array of opportunities and obstacles from which to imagine and shape their own desires and representations of their future in the New South and in the United States. Contrary to what southern whites may have intended for the Negro at the fair, blacks had their own reasons for desiring and contesting participation in the Atlanta Cotton States and International Exposition.

Exclusion of black Americans from the White City in the World's Columbian Exposition had prompted vehement protest led by activist and journalist Wells. She was atypical of many black middle-class women in that she was willing to transgress the boundaries of the bourgeois household to become an outspoken activist publicly fighting for social justice. She utilized the educational network and the black press to become a formidable voice against the rising wave of white racism oppressing black citizens in the North and South. Incensed by the race leader's growing support in the United States and abroad, cultivated by her muckraking newspaper articles and impassioned speeches, the editors of the *Constitution* regularly attacked Wells for her aggressive campaigns against lynching. They labeled absurd her allegations of white overzealousness. The paper justified the brutality of lynching as "cruel and speedy vengeance," a natural characteristic of the "Anglo Saxon Race."[71]

In 1893 Wells published and circulated a collection of fiery protest essays in *The Reason Why the Colored American Is Not in the World's Columbian Exposition*. She and other activists, including Frederick Douglass, wrote stinging rebuttals against racist fair propaganda and segregation at the Chicago fairgrounds. They urged potential black visitors to boycott the fair. If they planned to attend the event, Wells advised them to stay away from the offensive displays that exploited racist stereotypes.[72] One of the debates within the black community about the World's Columbian Exposition was whether black citizens deserved their own separate pavilion, like the one planned by white women, or whether they should be included in all pavilions at the fairgrounds. This question reflected the growing unease about the rise of racial segregation, especially since no black workers were employed on the fairgrounds and because many visitors would have to travel to the fair in segregated railcars. In her two contributions to *The Reason Why*, Wells penned a scathing indictment of state-sanctioned white-supremacist violence. She dissected the unconstitutionality and inhumanity of the convict lease sys-

tem and she attacked the legal establishment of segregated railcars and growing prevalence of lynchings throughout the South. But not all was protest. Wells also enlisted Penn, a fellow Rust University graduate and journalist who had recently authored *The Afro-American Press and Its Editors*. To counter the perception of the Negro as lazy and uncivilized, Penn meticulously outlined the various achievements of the Negro race in the categories of education, professional achievement, patents, journalism, religious institutions, art, literature, and music. Penn's thoroughness and encyclopedic knowledge would lead to his selection to head Atlanta's Negro Building. By linking racial violence, economic exploitation, and political disempowerment to the symbolic public sphere of the fair, Wells could argue that the corrosive hatred underlying the recent spate of lynchings and the institutionalization of Jim Crow laws was the "reason why blacks" had been excluded from participating. The fair, she rightly inveighed, celebrated both the founding of the Americas and the nation's continued prosperity—events in which black citizens had been and would continue to be key participants.

Black Americans, as historian Christopher Reed has duly noted, were not fully absent from Chicago's grand exposition. Despite these obstacles, many did choose to participate and visit the fairgrounds. Douglass attended the fair as a representative of Haiti, which as the world's third nation-state erected a pavilion on the fairgrounds. Wells praised the Haitian pavilion as "the only acceptable representation enjoyed by us at the Fair."[73] Washington delivered a speech at a labor conference. A magnificent painting by Tanner, whose work had been praised in the Paris salons, was featured as part of the French exhibit. Feminist activists Fannie Barrier Williams joined Anna Julia Cooper to speak at various congresses. White organizers convened the Congress on Africa that brought together black Americans with representatives from Africa and the Caribbean to discuss interracial cooperation in the future of the North American continent. At the Dahomey Village concession, men, women, and children from a Fon tribe in Africa had been imported to display primitive habits and habitats, but they instead revealed a rich culture of skilled artisans and farmers.[74] Acutely aware of the value of expositions as an international forum for the presentation of progress, black Americans participated in the Chicago fair, even though they were prevented from having their own exhibit on Negro progress. They joined blacks from Africa and the Caribbean to present their own cultural advances in various venues around the fairgrounds.

Keenly aware of the Chicago fair's shortcomings, Rucker, Wimbush,

and Easley approached Washington in February 1894 to enlist his participation as a commissioner from Alabama for the proposed Negro Building at the Atlanta Cotton States and International Exposition.[75] At the meeting of black leaders with the board of directors of the exposition in March 1894, Bishop Gaines and Reverend Carter spoke on behalf of the Negro Building. And it had been a letter from Washington extolling how wise the board would be in "setting apart a separate building for the exhibits of the colored people" that persuaded Inman to endorse the proposal. Respectful of the board's influence, Washington also suggested that the board consider hiring a Massachusetts Institute of Technology–trained black architect currently teaching at Tuskegee, Robert Robinson Taylor, to design what Washington called the "Colored People's Building."[76]

Later in the spring of 1894, a contingent of white leaders from around the South invited Washington to join them to testify before the U.S. House Committee on Appropriations in a bid to request federal monies for staging the fair. Gathering in the District of Columbia, Washington joined Bishop Gaines and Bishop Abraham Grant of Texas as the spokesmen for Negro participation. Following speeches by exposition president Charles Collier, Howell, and Inman, Washington was the last to address the congressional committee. In a thoughtful, courteous presentation, the educator conveyed to Congress that "the Atlanta Exposition would present an opportunity for both races to show what advance they had made since freedom, and would at the same time afford encouragement to them to make still greater progress."[77] Representative George W. Murray, a black congressman from South Carolina, was in favor of granting their request, stating to his fellow legislators that the American Negro had progressed far more on the American continent than anywhere else in the world. Murray assured them that supporting this unique joint effort between white and black citizens would foster better race relations in the South and around the nation. Once put to a vote after several months in committee deliberation, Congress passed the bill to fund $200,000 for government exhibits.[78] Credited in part to the success of Washington's eloquent entreaty, the Atlantans received their funding. In return for solid black support, the exposition board of directors restated their commitment that a freestanding building would showcase the accomplishments of the Negro race—a new benchmark for representation at a world's fair.

It would take two years after Chicago's World's Columbian Exposition for black groups to successfully have an exhibition of their own at a world's fair. Southern black elites, some quite reluctantly, accepted the

board of directors' offer of a separate pavilion at the Atlanta Cotton States and International Exposition. They utilized what was to be called the Negro Building to publicize their own (at times controversial) portrayals of industriousness, moral uplift, bourgeois respectability, patriotism, and racial progress.

THE NEGRO EXHIBIT OR THE EXHIBIT OF THE NEGRO

Claiming his demanding duties at Tuskegee as a pretext for refusal, Washington declined the offer from exposition president Collier to head the Negro Building. In his place, Washington recommended the highly competent Negro commissioner from Virginia, Penn, to undertake the immense task of gathering and organizing the pavilion's content. At the January 1895 meeting of the Negro commissioners at Clark University, the group enthusiastically approved Penn's selection. Despite having protested participation in the Chicago fair, Penn did not view the separate Negro Building as a compromise to his earlier stance that building racial solidarity could be a practical bulwark against antiblack racism in America. Eager to get to work, he moved his family from Lynchburg to Atlanta in early March.[79]

Penn immediately solicited participation from all areas of the South. He tasked each commissioner with gathering specimens from their respective states. They were to assemble as much evidence as possible of the progress of the Negro race to fill every corner of the immense exhibition hall by the time the fair opened in September. The commissioners enlisted the assistance of county representatives, who contacted local colleges, schools, benevolent associations, churches, and newspapers to publicize the event and solicit contributions. The *Savannah Tribune,* in a gesture to promote competition between states, reported on the extensive activities of the Florida commissioner, M. M. Lewey, writing that "the best element of our race in the state [Florida] is wide awake to the importance of making a good display in the Negro Building."[80] As commissioner for the state of Alabama, Washington wanted to illustrate the "progress of the colored people of this country" and proposed that exhibits come from various schools from around the state.[81] To drum up enthusiasm among Atlantans, Crogman, Georgia's commissioner, wrote in his alma mater's newspaper, the *Atlanta University Bulletin,* that the Negro Building afforded black southerners the chance to see "a creditable collection of their own hand-work and brain-work, the divinity within them may be stirred, and they may go away thinking."[82] For Crogman,

a member of the emerging black intelligentsia, progress would be measured by acumen and aptitude in addition to industriousness. In his role as chief booster, Penn reported in the same issue of the *Atlanta University Bulletin* on the progress of assembling exhibition materials. The U.S. Patent Office had agreed to send models of patents submitted by black inventors. In addition, black-owned banks would be on-site to offer financial advice to interested business owners and farmers. Penn announced that several days of congresses had been organized around the themes of education, religion, agriculture and mechanics, the colored militia, and business.[83] The influential Josephine Bruce, wife of former senator Bruce, was busily arranging a women's congress to discuss issues of suffrage, temperance, education, and religion. Several local women, among them the spouses of Bishop Turner and Crogman, took on the task of assembling a photographic display of residences and churches to showcase black women's success at maintaining respectable households and leading upstanding civic lives.[84]

Despite Penn's prodigious efforts to rally support for a magnificent showing at the forthcoming fair, the head of the Negro Building still encountered resistance from those keenly aware of what accepting a separate pavilion at the fairgrounds would signal to whites. In spring of 1895 during one of the weekly meetings at Bethel African Methodist Church (Big Bethel) on Auburn Avenue, disgruntled attendees posed objections to the "lack of space for the colored exhibit, jim crow [sic] cars and of convict labor at the ground." Reporting on this meeting, the white reporter from the *Constitution* characterized the civil atmosphere and attendance as a meeting of "the most intelligent class of citizens. Speeches, not of a wild, rabid kind, but conservative clear, forceful arguments were made." Clearly one faction of this "most intelligent class of citizens" was perceptive enough to recognize that participation in the Negro Building could be a viable means to address larger concerns about racial injustices. To quell protest, those eager to have an exhibition, regardless of compromises, argued for the practical need and long-term promise of making a statement on Negro progress. One advocate for participation dismissed the objections to grievous treatment, suggesting instead that those who were critical of the Jim Crow railcars should have stated their displeasure prior to the commissioners' trip to Washington, D.C., a year ago. He also countered that there was little relation between the segregated railroads and the exposition. Others in attendance offered a different rationale, stating "we should take advantage of this opportunity

and go into this work with our whole souls. We should show them what a separate people can do." Anxious to move forward with his plans, Penn launched into a stirring speech that made a case for patience and accommodation concerning the current conditions at the fair and by extension the region as a whole. According to the newspaper, Penn reminded all in attendance that "the time, place and everything else showed that this was the greatest chance the colored man had ever had to show just what was in him."[85] In all parts of the South over the course of the steamy summer months of 1895, associations and schools assembled and crated exhibits and then shipped the cargo via rail and road to be installed in the twenty-five thousand square feet of exhibition space in the Cotton States' fairgrounds splendid new Negro Building.

The white ruling-class Atlantans financing the city's Cotton States Exposition yearned to rival the grandeur of Chicago's White City in the layout and design of the pavilions. This ambition was soon dampened by the immense cost of staging such a grand event. After much debate, fair organizers selected the Driving Club's Piedmont Exposition fairgrounds to host another fair.[86] Hemphill consulted Frederick Law Olmsted, landscape architect of Manhattan's Central Park and of the World's Columbian Exposition's 630 magnificent acres of Jackson Park, as a possible designer for the Atlanta fairgrounds. Visiting the city in the spring of 1894, Olmsted met with Hemphill to consult on the board of director's intentions. Perhaps as a cost-saving measure, the board eventually selected a local builder, Grant Wilkins, to plan the layout of the grounds.[87] Next, to design ten of the fifteen main pavilions, the board hired Bradford L. Gilbert, a white New York architect of train stations, hotels, and purportedly the first steel-frame skyscraper in the United States, the Tower Building in lower Manhattan. Gilbert had erected Atlanta's first modern office building, completed in 1891, and therefore he was familiar with the region. A competent architect, Gilbert never achieved the stature of his peers Henry Hobson Richardson, Louis Sullivan, William LeBaron Jenney, or Daniel Burnham, the latter of whose firm, along with Olmsted, led the design, planning, and construction of the grounds of the White City. In numerous commissions, including the design of the New York Central Railroad Exhibition Building at the Chicago world's fair, Gilbert had demonstrated his facility at adapting new technologies of construction to build monumental edifices to satisfy the ambitions and needs of his industrialist and robber baron patrons such as the Vanderbilt family.[88]

The fair buildings Gilbert envisioned for the Cotton States Exposition

possessed a uniform aesthetic. The sketches of the proposed pavilions were rendered in a spare neo-Romanesque style, which Gilbert described as "a truly American type of architecture—broad, natural, generous, and appropriate, free from the usual restraints of fixed rules and regulations, all based on actual requirements and the necessity of location and consideration of available material and labor."[89] To express the regional character of the Atlanta exposition and highlight one of the state's prime natural resources, Gilbert proposed that all of the buildings be erected of Georgia pine.[90] This was an ingenious cost-saving measure, given that most of the buildings would be demolished at the close of the fair or shortly thereafter. The expense of building Chicago's neoclassical White City had been enormously high due to the use of staff, an off-white plasterlike material that could be sculpted to look like stone or any masonry material—very expensive even though only one-tenth the cost of stone. Staff had liberally draped the World's Columbian Exposition's ostentatious neoclassical facades, conferring on the fairgrounds its signature radiant "whiteness." For Atlanta, however, Gilbert rejected staff as excessive and deceptive; he the preferred neo-Romanesque's "graceful outlines" and "bold construction."[91]

The use of wood-frame construction also meant that local workers could expeditiously erect the fair's pavilions.[92] By November 1894, work crews had completed much of the extensive grading of the site. This involved leveling several hills into gentle terraces and digging out a large basin for a lake. Fulton County provided the laborers from the highly exploitive convict lease system: 250 black and 50 white inmates, many of whom ranged in age from ten to seventeen years of age.[93] This was one unacceptable aspect of the fair that naysayers of the Negro Building pointed out as indicative of the mistreatment of black workers.[94]

Completed by the summer, the pavilions had large airy interiors with wide structural spans that maximized the area for exhibitions. All of the buildings sat on sturdy masonry foundations. Work crews stained the facades with creosote to produce a gray sheen, and they stained the roofs moss green. This subdued color palette gave the whole ensemble, as the architect boasted, the appearance of solid masonry reinforcing the massive volume that is the signature of the neo-Romanesque style.[95] The final aesthetic of the pavilions reflected the dual nature of the New South's ideological agenda. In some respects the large clapboard halls with spare classical detailing of columns and trim echoed the vernacular architecture of plantation homes that had long defined the economic and cultural character the region. But in other ways, the great spans of the in-

FIGURE 4. Bird's-eye view of Atlanta Cotton States and International Exposition, 1895. From *Souvenir Album of the Cotton States and International Exposition, Atlanta, Ga., 1895* (Portland, Maine: Leighton and Frey Souvenir View Co., 1895). Courtesy of Manuscript, Archives, and Rare Book Library, Emory University, Atlanta.

teriors, capable of housing entire train engines, captured the immense scale of the factory spaces that New South boosters hoped would symbolize the region's future prosperity.

When people visited the opening-day festivities on September 18, they entered a dramatic transformation of the Piedmont fairgrounds. Wilkins laid out the pavilions and amenities to take advantage of a natural depression in the site. The center of the gracefully terraced site had been hollowed out to accommodate an artificial lake fed by water drained from the nearby Chattahoochee River. The Clara Meer, as the lake was christened, had been fitted with an electric fountain—a feat meant to rival the magnificent water displays at the White City—and gondolas and electric launches ferried visitors across its clear waters. The main pavilions were situated on higher ground encircling the Clara Meer. Wide avenues planted with lush local flora—trees, shrubs, and flowers, including blossoming cotton bushes—linked various areas of the grounds. Granite stone stairways from the upper circuit of walkways cascaded down to a main pedestrian pathway skirting the lake. Incandescent and arc lights were erected, sponsored by their respective manufacturers, to illuminate all of

the buildings and to lend a magical luminosity to the finely manicured grounds at night.

Visitors came to the fair from all parts of the South. Upon arrival they entered on the western edge of the Piedmont Park fairgrounds through an elaborate Tudor gateway near the original Driving Club clubhouse; fairgoers could also come into the park on the southern edge by a secondary entrance or by an on-site train station that linked to the Richmond and Danville Railroad. The great halls dedicated to manufactures and raw materials of the southern economy—Agricultural, Mineral and Forestry, Machinery, Electricity, Transportation, and Manufactures—towered around the Clara Meer. Sandwiched between the main halls stood smaller state and federal pavilions. In the center of the ensemble, near the Japanese village, nestled the "diamond among jewels," the Women's Building, a special feature of the exposition modeled on a similar building at the World's Columbian Exposition. The organizers were proud of their effort to highlight the achievements of southern women in art and industry; the building was "a monument to woman's genius and ability," they proclaimed.[96] The neoclassical pavilion layered with staff ornamentation and designed by architect Elise Mercur of Pittsburgh, Pennsylvania, proved to be a popular destination. Its furnished rooms and exhibits provided white women with a comfortable haven from the hot teeming fairgrounds. The central position of the finely ornamented women's building was indicative of the exaltation of white feminine virtue.

Designed by a federal architect and placed at a high point on the northern edge of the fairground's green hills, the turreted U.S. Government Building housed in its gigantic fifty-eight-thousand-square-foot hall offerings from the federal Departments of the Treasury, Agriculture, Fish and Fisheries, War, Navy, Interior, Post Office, Justice, and State and from the Smithsonian Institution. Located in a corner of the U.S. Government Building, the Smithsonian's exhibit vividly illustrated for its viewers "the methods by which Science controls, classifies, and studies great accumulations of material objects, and uses these as a means for the discovery of truth."[97] A statue of Osceola, the great Seminole chief born near the local Chattahoochee River in 1804, greeted visitors entering into the "Types of Mankind" exhibit. Here, fully costumed plaster-cast figures of various racial types stood arranged in an ascending cultural hierarchy, beginning with "black types," "brown-red types," "yellow types," and finally ending with "white types." Competitive on an international level, exhibits like "Types of Mankind" and the fair in general advanced powerful concepts

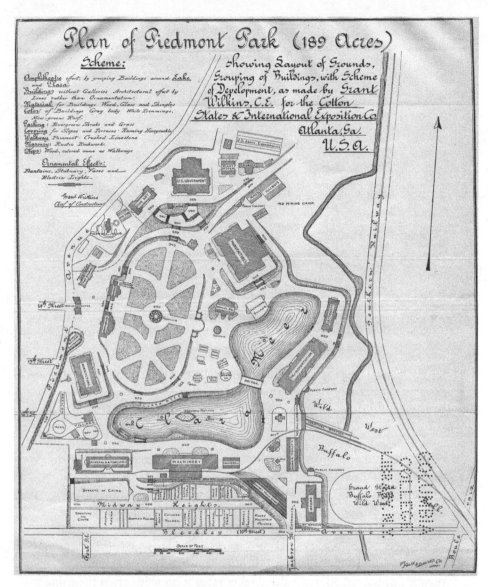

FIGURE 5. Map, Atlanta Cotton States and International Exposition, 1895. From *The Official Catalogue of the Cotton States and International Exposition, Atlanta Georgia, U.S.A. September 18 to December 31, 1895* (Atlanta: Clafin Mellichamp Publishers, 1895).

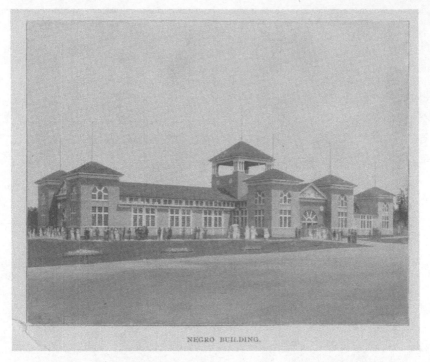

NEGRO BUILDING.

FIGURE 6. Negro Building, Atlanta Cotton States and International Exposition, 1895. From Walter G. Cooper, *The Cotton States and International Exposition and South, Illustrated* (Atlanta: The Illustrator Company, 1896). Courtesy of Manuscript, Archives, and Rare Book Library, Emory University, Atlanta.

of American civilization, whereby those at the vanguard of the nation's future would be the learned and hence progressive races.[98]

Fairgrounds like Atlanta visually and spatially orchestrated ideologies that would center the symbolic heteropatriarchal family as the juncture of national identity, racial purity, economic superiority, and cultural advancement. White Western nations, based on the evidence of their accomplishments that filled the exhibition halls, would leave behind the culturally impoverished, typically darker races who were often the subject of scientific displays like the Smithsonian's. These hierarchies of race, class, and nation were neatly displayed in row upon row of vitrines and impressively spatialized in the layout of the Piedmont Park fairgrounds. Rydell notes in his assessment of the southern fairs that "these hierarchical displays of race and culture furnished a scientific scaffolding for the emerging ideology of the New South. Seemingly backward 'types' of humanity, including blacks, could legitimately be treated as the wards

of the factory and field until an indeterminate evolutionary period rendered them civilized or extinct."[99] The degree of progress shown by the representative inferior types, in particular those who symbolized the South's ever-present "Negro problem," appeared in an exhibition hall just inside the Jackson Street entrance. Here in the southeast corner of the grounds, sandwiched between the bawdy Midway Heights and the raucous grandstand of Buffalo Bill's Wild West show, stood the other special feature of Atlanta's Cotton States and International Exposition—the Negro Building.

In celebration of the auspicious occasion of fair, the *Constitution* applauded one of the event's most unique symbols by proclaiming that "the Paris exposition had its Eiffel tower, the world's fair had its Ferris wheel, but Atlanta had its negro building *[sic]*."[100] Amusement to some and monument to others, the Negro Building blended with the neo-Romanesque style of the other buildings. Gilbert employed the same general palette as he did on the other buildings, but the details, the articulation of the facades, and the lines of the overall form were more spare, making this aesthetic gesture a nod to the humbler status of black southerners. The footprint of the building measured 112 feet wide by 260 feet long, making it one of the smaller pavilions of the fair. It cost approximately $10,000 to build.[101] One notable success of the construction process, often mentioned in the press, was that the Negro Building had been built solely by black labor under the management of white supervisors. Two black builders, John Thomas King of LaGrange, Georgia, and J. W. Smith of Atlanta, served as the primary contractors for construction.[102] The Negro Building's construction, as well as its content, would demonstrate to white capitalists the immense potential of black wage labor. This display of the viability of the New South's burgeoning industrial and agricultural economy was undermined by the highly profitable use of convict labor to build much of the fairgrounds (although it is not clear if these crews were used to erect the Negro Building) and by the presence of goods like cotton, which in reality was being cultivated by underpaid and exploited sharecroppers.

When it opened its doors to the public in mid-September, the only building ever dedicated "to the first national panorama of negro *[sic]* progress," as Penn declared, had a large, impressive central tower rising seventy feet in the middle of the space, with smaller towers on each of the four corners and two more flanking the entrance.[103] Inside the pavilion's central tower, visitors could climb the stairwell to partake of the expansive views of the rolling fairgrounds. The interior was laid out in

a symmetrical fashion, with exhibits flanking either side of the two aisles to form a continuous circuit through the displays. Along with the extensive exhibits and booths, various amenities catered to visitors, such as a black-owned restaurant that demonstrated culinary skills and business aptitude.[104] Similar to the other pavilions, clerestory windows provided ample natural light and cross-ventilation to relieve the scorching heat of the early fall. During the day these open transoms must have also allowed the clamor of the nearby Midway and Buffalo Bill's Wild West show to resonate through the hall.

When fairgoers strolled by the pavilion or entered through the large doorway, they were welcomed by a large, stately pediment molded out of staff positioned high above the front entrance. The ornate pediment featured a tableau narrating the progress of the Negro. On one side of the pediment appeared symbols indicating the lowly status of the race in 1865: a "slave mammie" adjacent to a log cabin, a basket, and rake. Upon close inspection, the figure of the rotund maternal mammy represented the reproduction of the plantation owner's livelihood; the farm implements stood for the production of the plantation class's livelihood; and the humble cabin signified the meager condition of slave life along with the natural closeness of the Negro to the land. Carved on the other side of the pediment were symbols auguring the future of the race in the form of a likeness of Douglass, a church, and the emblems of literature, art, and science. The noble profile of the famous patriarch Douglass, a former slave and courageous spokesman of the race who had died in 1895, invoked the theme of racial uplift in all of its masculinist and patriarchal glory. The sturdy stone church, in comparison to the decrepit wooden cabin, symbolized both the influence of European cultural practices as well as the use of Christianity as a means of moral improvement and discipline. "Representative of the new negro [sic] in 1895," said Penn of the pediment, this side of the scene also hinted that this level of cultural advancement had yet to be attained by the so-called black masses. Visitors gazing at the pediment's storied figures saw between these two depictions a plow and a mule. The center emblems of agriculture and manual labor suggested contemporary self-sustaining black industriousness. This underscored the value of the products of industrial training on display behind the pavilion's facade. The placement of this symbolic allegory at the threshold of the Negro Building represented Penn's statement of the evolution of Negro progress: "for the colored man to-day plows his field, while thirty years ago he, without almost an exception, plowed for another."[105] The building's pediment visualized a persuasive commentary,

aligned with then-current beliefs in social Darwinism, that blacks had surely advanced beyond enslavement but had not yet through their own wherewithal elevated their status above a life of physical labor. Excluding black elites and intelligentsia, who had surely advanced culturally, the black masses, the lumpenproletariat, remained first and foremost handworkers, farmers, and craftsmen, who had yet to ascend into the ranks of mindworkers. And as a result of these blacks location at the bottom of the social hierarchy, full political participation and the achievement of equal rights and social parity would have to wait until some unspecified date in the future: a time that, if social Darwinists and displays like the "Types of Mankind" were correct about natural aptitude, would never arrive.

Adopting in his curatorial ethic the tone of a "Bookerite" (the moniker for a follower of Washington's advocacy of industrial training), Penn chose to focus the key message of the exhibition on the establishment and successful outcome of industrial education programs, stating in the *Constitution* shortly after the fair opened that "the exhibit in the building is very extensively educational from a literary point of view, manufacturing and industrial as it relates to carpentry work, cabinet and furniture making of every description, brick work, carriage and wagon building, every phase of wheelwrighting, harness making, tin work, tailoring, millinery, dressmaking, printing, etc."[106] The sum total of the exhibits strongly emphasized facility in handwork—a skill most practical for working in an agricultural economy. Overall, Penn's position reflected a common set of views held by many white Americans. In her review of the fair, *The Negro and the Atlanta Exposition,* Alice Bacon (a white teacher at the Hampton Institute) enthusiastically promoted the success and promise of industrial training to raise the status of blacks. Bacon observed that after Emancipation the Negro race was naïve to seek immediate equality with whites through the vehicle of political enfranchisement.[107] Advancement, she argued, was predicated on cultural inheritance underwritten by biological aptitude, not achieved through acquisition. Her assessment corroborated Washington's plan. She commented that Tuskegee's industrial school program established the solid foundations upon which the Negro civilization must build. It is "the common school, the farm, and the skilled hand" that "must be the widest influences in the development of his [the Negro] race."[108] Taken together, Penn's summary, Bacon's commentary, and the Negro Building's pediment reinforced the notion that the appropriate home for the Negro was on the farm, away from urban life, and with no intellectual aspirations whatsoever. A small

contingent of exhibits also showcased accomplishments in the arts, commerce, law, and other areas not related to rural life, even though the majority of the displays boasted of a capable black worker highly trained for jobs in the field and workshop. But despite these dissonant voices in the Negro Building, the resounding tale told to the Atlanta Cotton States Exposition's white and black visitors was one in which the manual trades of the dutiful maid, seamstress, mason, and wheelwright best suited the current abilities, and possibly the future ones, of blacks in America.

Inside the vast hall of the Negro Building, fairgoers were greeted by a large portrait of Penn, flanked by two American flags and patriotically draped with bunting. The building's generous aisles allowed groups and individuals to comfortably move from one exhibit to the next. The displays, in part due to the stipulation of a separate exhibit, represented a microcosm of the fair's pavilions, showing work in agriculture, manufactures, machinery, transportation, women's affairs, fine arts, and foreign lands. Loosely organized by state, material from the Negro schools dominated the hall. Toward the right of the entrance, visitors viewed a presentation of the Presbyterian Board of Missions describing their schools for the training of colored youth. Adjacent to this display appeared various exhibits contributed by citizen groups from various Florida towns. The next area featured an array of exhibits from Penn's home state of Virginia. Most notable in the Virginian presentation was an extensive display of the Hampton Institute's bounty of craft and agricultural products. The school spared no expense in shipping furniture and ironwork from their workshops, along with mechanical drawings of houses built by apprentices and writings and other literary work penned by students. Hampton arranged its exhibition, as captured in a souvenir stereoscope card from the fair, in an orderly fashion, with well-dressed hosts milling about awaiting the inquiries of visitors. Next to Hampton's inspirational showing was an exhibit by the state's first colored savings bank located in Richmond. Placed among the other items on display in the twelve hundred square feet allotted to Virginia were a large wooden boat handcrafted by W. H. Grant, the head cook in a Lynchburg hotel, and a handmade bicycle assembled by a hard-working young farm boy, who had set up a workshop in an out building on a Virginia farm.[109]

Like the other states, the North Carolina State exhibit showcased submissions from numerous schools, among them the Agricultural and Mechanical School in Greensboro. Some of the displays featured articles for sale, including reading materials on various subject matter related to black

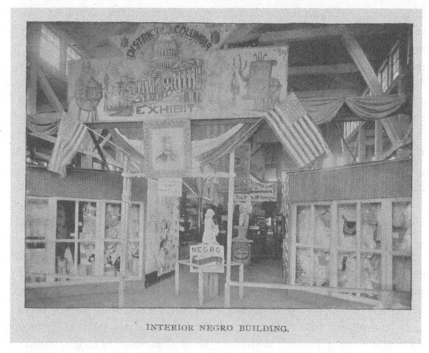

INTERIOR NEGRO BUILDING.

FIGURE 7. Interior of Negro Building entrance hall, Atlanta Cotton States and Inter
national Exposition, 1895. From Walter G. Cooper, *The Cotton States and International
Exposition and South, Illustrated* (Atlanta: The Illustrator Company, 1896). Courtesy of
Manuscript, Archives, and Rare Book Library, Emory University, Atlanta.

residents of the state. From the Alamance County exhibit, for instance,
interested parties could purchase a small pamphlet that told about the
character of this region of North Carolina and its people—a county of
15,000 white and 5,000 black residents. George Mabry, a school prin-
cipal and commissioner from the area wrote *A Sketch of Alamance County*,
a prospectus for interested investors and transplants. As Mabry narrated,
many white residents in Alamance County had abandoned their farms
to work in the county's twenty steam and cotton mills. Because antiblack
racism excluded most black residents from "technical work in the facto-
ries" except as woodcutters, laborers, or stevedores, they instead chose to
farm. Over time, blacks bought the land put up for sale by white farmers
and saw this as an opportunity to "get the right foothold so as to wield
a beneficial and appreciative influence in the New Southland."[110] Outlin-
ing the various educational opportunities, boosters portrayed Alamance
County as a prosperous region, free from the "personal violence," lynch-

ings and intimidation found elsewhere in the South. This rosy picture Alamance County was not without its challenges, as its economy still relied on the sharecropper system: even if black farmers owned their own parcels, they were still forced into buying seed and selling their crop to markets controlled by greedy white businessmen.

In the southeastern corner of the Negro Building, visitors found exhibits from Florida, South Carolina, and Arkansas industrial schools. Also in this section people could see the displays sent from Tennessee. Nashville's Meharry Medical College, the first college dedicated to training black physicians, put on an informative display of medical tools and equipment. And an enormous twenty-foot-long painting of the original Fisk Jubilee Singers, "who sung into existence the great Jubilee Hall of Fisk University by the ever-popular and melodious plantation melodies," graced the Tennessee exhibit.[111]

Rounding the corner, fairgoers encountered Georgia's sprawling state exhibit that occupied two sides of the aisle in the north corner of the pavilion. A large, fully operative engine built by young men in Athens demonstrated the technical skills of local youth. In his review, Penn boastfully commented that the "students in the Atlanta institutions are making buggies, wagons, etc., which are as good as those in large manufactures in the land."[112] The local schools Morris Brown College, Spelman Seminary, Atlanta Baptist Seminary, Clark University, Georgia State Industrial College, and Gammon Theological Seminary placed on view examples of their industrial training curriculum. Highlighting its normal school's industrial training program, Atlanta University, for example, displayed samples of woodworking and iron forging. A workbook of sewing techniques demonstrated an array of stitching methods, and a nearby dressmaking display featured a child's outfit and baseball uniform. There were also samples showing the productivity and aptitude of the school's printing studio. The industrial program was well represented, but Atlanta University, as Crogman had announced, also wanted to promote its extensive college curriculum. On bookshelves in the center of the university's impressive exhibit visitors could leaf through several volumes of philosophical methods, Greek, Latin, physics, trigonometry, and political economy.[113] The inclusion of the university's college curriculum—with its emphasis on intellectual enlightenment—in a pavilion whose emphasis was on manual training suggested that not everyone believed that fieldwork and handwork would be the sole vocations to elevate the fortunes of southern blacks. This debate would take on greater dimensions at other fairs in the first decades of the twentieth century.

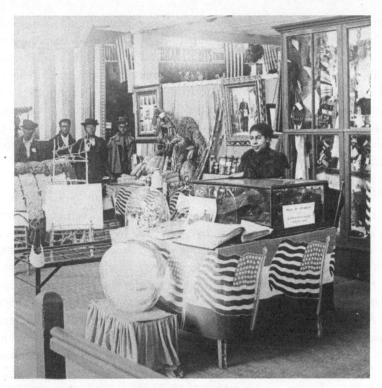

FIGURE 8. Alcorn Agricultural and Mechanical College exhibit (foreground) and "Uncivilized Africa" exhibit (background), Negro Building, Atlanta Cotton States and International Exposition, 1895. Courtesy of Hulton Archive, Archive Photos, Getty Images.

Following the Georgia effort, fairgoers could visit exhibits from Texas and Mississippi that displayed farming implements and various artifacts of mechanical training, including a large two-horse wagon. Visitors to the nearby Alabama exhibit witnessed a sizeable display assembled by Washington and his dedicated assistants. Naturally, Tuskegee's effort as the model of all industrial schools proved nothing less than astounding, as one visitor remarked. Illustrating the school's immense success at training woodworkers, a large filigreed wooden archway crafted in the school's woodshop welcomed visitors as they entered.[114] Inside, every facet of the nation's leading industrial training program was on display. In wooden cases hung samples of dressmaking, sewing, tailoring, and millinery crafted by dexterous women students. The furniture department

placed examples of tables, chairs, and desks on view to highlight the skills of Tuskegee trained craftsmen. On loan from the school's carriage shop, vehicles ranging from a phaeton to a farm wagon sat side by side on the exhibition floor. A fully operable steam engine manufactured by inventive students of the school's iron department filled the center of the space. Displays of tools, farm products, vegetables, and fruits showcased the range of trades that Tuskegee's students learned. Tangible material examples educated visitors about what black labor—when given the training and the opportunity—was capable of producing.[115] This was the New South's future workforce.

Walking back toward the entrance and completing the full circuit of the exhibits, visitors saw the presentation from the District of Columbia. Attached to a crossbeam just behind Penn's portrait hung a large sign that depicted the capital building along with various symbols of the arts— a painting palette, camera, musical score, and drafting triangle. Departing from Penn's theme of manual labor, artistic and intellectual accomplishment stood at the forefront of the district's submissions. Portraits by the Amateur Art Club of leaders Douglass, Senator Bruce, and Commissioner Jesse Lawson hung in a prominent location along with other paintings depicting popular nineteenth-century genres of still life, portraiture, and landscape. Sculptures by artist W. C. Hill, a bust of Frederick Douglass, an allegorical painting titled *The Obstinate Shoe,* and a life-size statue, *The Negro with Chains Broken but Not Off,* dominated the district's exhibition space. From the U.S. Patent Office, visitors could study the patents of colored inventors that included a truss design and a ventilator used in Pullman railroad cars. Howard University's handsome exhibit showed educational advances being made in the city. The district's exhibit put forth the message that its black residents engaged in a diverse range of intellectual and aesthetic pursuits in their work and home lives, posing a counterpoint to the larger theme of industrial education. Seemingly disappointed at the absence of schoolwork, Penn in his *Constitution* commentary remarked that a district school superintendent had deliberately withheld exhibits from colored schools.[116] But in total, the overarching message conveyed in the Negro Building was as Penn had conceived and implemented, emphasizing the manual skills and not the artistic and scholarly accomplishments of his fellow black Americans.

Undeterred by the offensive and unjust racist policies of the railroads, black citizens intrigued by the presence of the Negro Building and the concurrent congresses attended the Atlanta Cotton States Exposition in large numbers. Since the common practice of not renting rooms to black tourists

FIGURE 9. Washington, D.C., exhibit, foreground sculpture by W. C. Hill, Negro Building, Atlanta Cotton States and International Exposition, 1895. Fred L. Howe photographer. Courtesy of Kenan Research Center at the Atlanta History Center. VIS 145.47.01. 7 × 9 silver gelatin print.

in downtown's white-run hotels had limited access to decent accommodations, Penn and Atlanta's black community built a new hotel and organized homes where visitors could stay while touring the fair and attending its many events. The Negro Building hosted its opening celebrations on Monday, October 21. Black luminaries throughout the South, including Penn, Washington, Bishop Gaines, Pledger, and Reverend Carter, participated in the auspicious day of songs, beginning with the patriotic anthem "My Country, 'Tis of Thee," followed by speeches and prayers. The opening festivities for the Negro Building attracted an audience of about 1,500 black and 500 white visitors. Other popular events included Negro Day. Held on a windy December 26 at the end of the fair's run, it was obviously convened when white visitorship was waning. Events that day included a parade from downtown Atlanta to the fairgrounds as well as an afternoon of uplifting speeches and stirring music at the fairgrounds' Auditorium Building. The esteemed Major R. R. Wright Sr., the head of the Georgia State Industrial College in Savannah, spoke on the history of

education in Georgia, suggesting that through education black citizens would eventually stand on equal ground with others of the American union but that the South must continue along its patient march toward that desired end.[117] The Negro Building hosted many events, but it was Washington who presented the pavilion to the world.

"CAST DOWN YOUR BUCKETS"

The great Tuskegean trumpeted the Negro Building's ideological message in a speech delivered at the fair's official opening day on a hot September afternoon. Detailed in the correspondence between Penn and Washington, exposition president Collier was in favor of having Washington speak at the opening-day festivities of the Negro Building but was unwilling to extend an invitation for him to speak at the main exposition opening. On Penn's behalf, a New York representative from the Committee on Ceremonies pressured Collier to include a Negro speaker. Eventually, Collier relented. In an editorial on August 23, the *Constitution* announced that the invitation to a colored orator "would be a public proof that the relationship between the races in the south was friendly."[118] Penn suggested to Washington that his opening-day speech should praise the mutual cooperation it took to create the Negro Building, especially complimenting Collier and the Committee on the Colored Exhibit for their most generous assistance. Penn also requested that Washington not speak of the exhibits in specific terms but that he instead mention the wonderful "Negro inventions" on display. Penn also requested an appeal for fair treatment of black visitors at the fairgrounds in order to avoid any disruptive racial friction.[119]

At the opening-day ceremonies on September 18, a military procession of dignitaries (among them a contingent of black citizens) marched from central Atlanta along Peachtree Street to the fairgrounds. The parade lumbered for over three hours through the hot and sunny fall afternoon.[120] The *Constitution* reported that twenty-five thousand people streamed into the newly completed fairgrounds to hear the program of speeches. Gilbert's Auditorium Building on the west side of the fairgrounds filled with eager attendees waiting in the stifling heat for the events of the day to commence. Speakers for the ceremonies included Republican ex-governor and member of the Committee on the Colored Exhibit, Rufus T. Bullock, who served as the master of ceremonies. The opening invocation was followed by various orations and songs, including speeches by Collier and Mrs. Joseph Thompson, president of the Woman's Board. Bullock

introduced Washington to the mostly white audience, although a few black attendees listened in the back of the room. A group of twelve black physicians, who would form the National Medical Association, and pockets of black visitors packed into the fringes of the fairgrounds.[121]

Delivered amid boisterous inaugural fanfare, Washington's famous "Atlanta Compromise" speech eloquently reasoned that the future of southern prosperity for whites depended on black cooperation. Washington began by stating, "We have with us today a representative of the Negro enterprise and the Negro civilization."[122] Washington's steady cadence entranced his audience; with his "dusky hand raised high above his head," Washington implored white southerners to be just and obliging and in return asked their black neighbors to accept their subservient role.[123] His straightforward metaphor of separate fingers representing a separate social order, but mutually dependent races, both validated the rise of a segregationist mentality and acknowledged the Negro's place as a handworker in the New South's economic order. "Our greatest danger," he implored, "is that in that great leap from slavery to freedom we may overlook the fact that the masses of us are to live by the productions of our hands." He stated that "no race can prosper till it learns that there is as much dignity in tilling a field as in writing a poem." In his estimation, "It is at the bottom of life we must begin, and not at the top." Endeavors of the mind should not be the preoccupation of the Negro. He cautioned that instead blacks should be earnest in their "tilling" of the field as well as in "agriculture, mechanics, in commerce, in domestic service, and in the professions." Handwork would elevate the race's moral character. As proof of Negro progress in these fields of manual labor, Washington offered the Negro Building's impressive collection of "agricultural implements, buggies, steam-engines, newspapers, books, statuary, carving, paintings, the management of drug-stores and banks."[124] Respectful of his audience, he reminded them that the Negro Building's display had been possible with the generous assistance of southern and northern whites. The evidence of progress presented in the pavilion's exhibits should not be mistaken for a statement of social equality with whites. Such aspirations, in Washington's estimation, proved an egregious folly. On the contrary, what the Negro Building best conveyed was the result of the constant struggle of the Negro to lift himself up; as such, Washington cautioned visitors not to "expect overmuch." Furthermore, the machines, vehicles, and clothing crafted by the facile hands of southern black workers were far more familiar to whites than those of foreign immigrant European laborers who were slowly migrating to the region from

the North. These familiar black hands that had worked their plantations and nursed their children, he suggested, were all too eager to work in the South's emerging manufacturing and agricultural industries. He shrewdly reasoned to the capitalists in the audience that black labor was cheaper and hence more profitable. Washington suggested that blacks' inclusion in the enterprise to build a New South would be more valuable to Negro advancement than the misspent aspirations of writing poetry or practicing law. Washington's learned assessment suggested that this opportunity would prove more useful to his fellow Negroes than the privileges of citizenship prematurely granted to most of his race. The orator reminded people that the history of the American Negro began after Emancipation. As a consequence, this brief thirty years of advancement had not yet brought the black masses into equal standing with white citizens.

The Negro college president's speech echoed across the nation's telegraph lines, waiting to be reported in the next day's newspapers, such as the *Chicago Times-Herald, New York World, Boston Globe,* and *Baltimore Sun*.[125] In the months following the opening festivities, magazines, reviews, and weeklies widely circulated Washington's stirring entreaty. Its orator, along with his ideas, became immensely popular. In days after his speech, Washington received congratulations from numerous black luminaries, including Edward W. Blyden, Bishop Benjamin T. Tanner, and educator W. E. B. Du Bois. An article published in the *New York World* glowed with the word of "a negro Moses [who] stood before a great audience of white people and delivered an oration that marks a new epoch. . . . The whole city is thrilling to-night with a realization of the extraordinary significance of these two unprecedented events" (the other event was President Grover Cleveland's ceremonious act of switching on the electricity to start the fair from a remote location). Writing in the *Constitution's* editorial pages, exposition president Howell interpreted this unique speech delivered to an audience of southern white men and women as "the beginning of a moral revolution in America."[126] President Cleveland also extended his congratulations to the now nationally famous orator. The nation proclaimed Washington to be America's exemplary New Negro. As one article reported, "The speech of Washington has awakened the white men of the South to the realization that there has been a change. The negro building *[sic]*, with its exhibits of the work of negroes, offers its testimony to the truth of Booker T. Washington's teachings."[127] From the mainstream newspapers' perspective, the Negro Building aptly presented the emergence of a new social order and a viable solution to the race problem.

The great educator's noble oratory did not, however, persuade all black Americans in the South and elsewhere around the country toward his position. Disapproval and critiques circulated within the black press. The *Washington Bee,* a progressive urban newspaper, charged that Washington had offered nothing more than an apology for past wrongs by the "negro haters of the South." In their stinging rebuttal of Washington's speech, the *Bee*'s editors cited a recent law passed by the South Carolina legislature to remove all black officials from elected public office. Highly critical of industrial education because it placated white desires by sequestering black citizens away from the rest of society, the *Bee* editors inveighed that, instead of the plow and machine shop, "we need lawyers, doctors, scientists, and all kinds of professional men."[128] Moreover, there were those deeply offended by the intimation in Washington's tone that positioned black people as inferior to the white race. Many expressed disappointment that he conceded the fight for civil rights and social equality in exchange for the opportunity to continue to labor for the benefit of whites. In particular, at the fairgrounds, all eating establishments barred black patrons from entering, thus forcing them to dine exclusively in the restaurant located in the Negro Building. During the meeting of the National Afro-American Press Association at the fair, Penn made a concerted effort to dispel all rumors about ill treatment, although in one instance he could not dispute the allegation that black visitors had been refused entrance to the Midway's German Village and the Chutes amusements.[129] Washington's wildly popular appeal made obvious that the exposition had brought the Negro into close proximity but not into social equivalence with southern whites (evident in the marginal placement of the Negro Building away from other main pavilions). Amanda Gray, organizer of Howard University's exhibit, perceptively relayed in her report to the audience attending the Bethel Literary and Historical Association that at Washington's speech his friends "were compelled to sit in a 'curtain Negro Section.' "[130] As an archive of the industrious accomplishments of southern black workers and farmers, the Negro Building represented a visual narrative and spatial logic that buttressed Washington's accommodationist sentiments on race relations. Thus, the Negro Building location within the fairgrounds symbolized, but more importantly spatialized, the position of the Negro in society and in the city as separate and at some comfortable distance from whites.

Nationally and locally, other perspectives besides Washington's monocular vision of the New Negro circulated among black Americans. Even within the Negro Building, for example, black and white visitors found

an array of positions that departed from the overarching agenda of industrial education. Atlanta University's presentation of its college curriculum was one instance, and the District of Columbia's art exhibit offered another. Near the District of Columbia show stood an exquisite marble bust of radical Republican Charles Sumner carved by noted artist Edmonia Lewis, who at the time of the fair lived and worked in Italy. Lewis's sculptures, which were adopted by many white female abolitionists as symbols for their cause, often portrayed themes of the brutality of black female enslavement and vulnerability to sexual attack.[131] Noted in the official history as part of the Hampton Institute's exhibit and mentioned in brief by Penn in his review were three paintings by Tanner, the respected nineteenth-century genre painter. An expatriate living in Paris, Tanner was also the son of religious leader Bishop Tanner. Even though the organizers of the Fine Arts Building refused to show his paintings, Tanner's contribution included his canvas *The Bagpipe Lesson,* which had also been exhibited at the World's Columbian Exposition. In one sense, the themes of Tanner's realist paintings, often depicting images of rural life and black self-help shown in the prestigious Paris salons, harmonized with the tone set for the Negro Building.[132] In other ways, however, even though he was a friend of Washington and was praised by the Tuskegee leader as an ideal figure embodying the tenets of racial uplift, Tanner's illustrious artistic career in the European salons, along with that of Lewis, exemplified the possibility of a cosmopolitan existence beyond the toil of rural life.[133] Elsewhere in the Negro Building, in a section of the Georgia display, Bishop Turner curated an exhibit titled "Uncivilized Africa," with artifacts collected from his several trips to various parts of the African continent. Here, Turner showed a collection of swords and spears, woods, oils, leather, and cloth crafted by various groups living in Liberia on the western coast. The beauty of these impressive African tools and crafts illustrated Turner's belief that, if one examined black history, tracing it back to Africa, one would discover that blacks had always been industrious, especially as skilled slaves who built plantation homes, furniture, ironwork, and woodwork.[134] Turner's Black Nationalist stance—one that stressed political, economic, and cultural independence and recognized a vital historical legacy before Emancipation and before enslavement—struck a dissonant radical chord amid the accommodationist tone of Penn's Bookerite display.[135]

Mirroring the wider event structure of the Cotton States Exposition, Penn had also planned several days of congresses to bring together top black and white representatives to discuss a diverse range of strategies

for Negro advancement. As a counterpublic sphere where the topics of education, medical care, law, religion, business, women's issues, and the press could be debated and discussed, the Negro Building's meeting hall and the various churches around Atlanta served as critical forums for race leaders, educators, and women's clubs to meet with white philanthropists and missionaries. For example, well versed in the history of the black press, Penn organized a meeting of the National Afro-American Press Association. Convening in late November, the event brought together leading publishers such as T. Thomas Fortune of the *New York Age,* Pledger, Emmett J. Scott (a young Texas publisher and future personal secretary to Washington), and John C. Dancy Sr. (a North Carolina editor and customs collector).[136] Critical to the counterpublic sphere, the black press—its many newspapers, weeklies, and magazines—provided an indispensable conduit for circulating Bookerite messages of racial uplift, especially the virtues of industrial education. However, the pages of the black press also provided a platform to air the positions of those who vehemently disagreed.

To open an international forum, the Negro Building hosted a congress on Africa organized by J. W. E. Bowen, a professor of theology at Atlanta's Gammon Theological Seminary. Unlike the congress held two years prior at the World's Columbian Exposition, this forum was arranged by black leaders, although whites participated.[137] The *Savannah Tribune* extended a cordial invitation to all "interested in the civilization and redemption of the Dark Continent," a theme that highlighted the numerous missions dispatched to proselytize Christianity in parts of Africa. The congress showcased research and missionary work in Africa. Adopting the dominant position of imperialism, this forum afforded some black American elites an opportunity to compare their own progress against Africa's primitives. Their advances provided proof that the African could be civilized. But the congress also offered a means to foster greater solidarity with their brethren on the continent. His expertise cemented by his experience as an Episcopal minister, former missionary to Liberia, abolitionist, and early Pan-Africanist, Alexander Crummell spoke about "the Absolute need of an Indigenous Missionary Agency for the Evangelization of Africa."[138] In favor of African emigration, Bishop Turner, also a Pan-Africanist, boldly asserted in his paper that "the Negro has nothing to expect without social equality with the whites, and that the whites will never grant it." Directly criticizing Washington and his appeal two months earlier, Turner decried "the colored man who will stand up and in one breath say, that the Negroid race does not want social equality

and in the next predict a great future in the face of all the proscription of which the colored man is the victim is either an ignoramus, or is an advocate of the perpetual servility and degradation of his race variety."[139] The role of the Negro, and for some like Turner the role of the Negro nation as it harnessed the institutional power of the church, the press, and the university to appeal for the soul (and the resources) of Africa, could be debated at the Negro Building.[140]

Toward the end of the exposition, Penn planned several days dedicated to what he christened the "New Negro Woman." Since elite black women had been deliberately excluded from participation in the highly publicized Women's Congress at the World's Columbian Exposition (an event that promoted an educated, politically aware "New Woman"), the first ever Congress of Colored Women was convened at Atlanta. The Atlanta Women's Auxiliary, working with women's clubs in Washington. D.C., and led by Josephine Bruce, called together prominent educated middle-class women—clubwomen—from all parts of the country. Influential leaders Margaret Washington, wife of Booker T. Washington, and Josephine P. Ruffin had allied their interests and used the Atlanta congress to press for a national organization dedicated to the needs and moral elevation of women. The congress also invited Fannie Barrier Williams, an educator and social activist from Chicago who had been an advocate for black representation at the White City's Women's Building, to speak on the opportunities and possibilities for Negro women. Along with the many speeches delivered at the congress, the women addressed pressing social and political issues. They promoted temperance and condemned segregation laws, lynch laws, and lynching; they would work to establish asylums for orphans, the aged, and wayward youth; they requested that the southern newspapers refer to them as "Mrs." or "Miss" and to capitalize "Negro;" they scolded the black press for the failure to employ "higher class" diction in their pages; and as promoters of social improvement, they condemned the "one room" cabin, a common means of shelter in the South's Black Belt, as an undesirable home for black women to raise their families. The range of issues discussed at the congress reflected conservative ideas of femininity and propriety—beliefs that positioned the domestic sphere of the middle-class household, where moral values could be imparted and policed, outside of the public domain (at least in appearance). To be sure, while many of these ideals mirrored those of their white peers, black women also firmly advocated the progressive movements of civil rights and suffrage, thereby asserting themselves, like Williams, into positions of race leadership and into the

black counterpublic sphere. Six months after the Colored Women's Congress, the women would combine several organizations into the powerful and influential National Association of Colored Women (NACW).[141]

If the Negro Building's exhibits and congresses showed to the world the extraordinary achievements of the race, then how was it publicly received? In general, black response conveyed a high level of satisfaction. The black press, like the *Savannah Tribune,* supported participation and wrote favorably of the completed exhibition, although it also acknowledged that the exhibits failed to illustrate the full capabilities of Negroes in the South. Echoing this, Gray, the pharmacist and activist in charge of Howard University's exhibit, noted in *Women's Era* that, while people and the press had shown unanimous approval, the exhibition did not show the best work of the race, nor did it have the full support of one-third of the most influential people.[142] In her presentation to Washington, D.C.'s Bethel Literary and Historical Association (a group dedicated to Negro enlightenment), Gray outlined her report about the Howard University exhibit and general atmosphere of the exposition by recounting some of the "unpleasant discrimination that the colored people were forced to encounter even though they were invited guests at the Fair."[143] Some expressed disappointment at the failure to display the best evidence of Negro advancement, namely those who abhorred the racist conditions fostered by the segregation of transportation, hotels, and amenities at the fair. Displeased, they chose to stay away.

Reaction to the Negro exhibits by white fairgoers also varied. The volume of exhibits impressed many whites, but others lobbed harsh criticisms at the quality of the work in comparison to other fair pavilions. Baffled by the superior display and unable to believe the pavilion's contents had been crafted by black hands, one white visitor remarked to his companion upon exiting the Negro Building, "And now let's go to that nigger building. I want to see what the niggers have to show."[144] This visitor was unaware that he had already seen the "nigger building." One white reporter derisively characterized the exhibit for the Carrie Steel Orphan Home, part of the Georgia State displays, as "practical and pathetic."[145] And a judge from New Orleans was quoted in the *Daily Picayune* as being astonished but also doubtful that the work was the product of the "true negro, but invariably can be traced to the mixed-blooded black."[146] One *Constitution* editorial on the opening of the Negro Building boasted that "a great many people, especially at the north, seem to forget that the negroes of the south have, for more than two hundred years, been in close and familiar contact with the most refined and highly

civilized people to be found in the world."[147] Regardless of visitor response, all of the events at the fair reinforced the message of mutual interdependence of the races, with culturally superior white southerners comfortably in charge.

Whether assimilationist or nationalist in intent, the presentations inside the Negro Building were not the only interpretations of the past and future Negro put on view. Just west of the hall, fairgoers could be entertained by stereotypical depictions indicative of the low esteem in which some white southerners held their black neighbors. Adventurous visitors could partake in the boisterous festivities of Midway Heights, which was partially hidden behind the pavilions overlooking the southern edge of the Clara Meer. The hodgepodge of concessions proved to be more diverting than educational, and they were profitable enough to reduce the expenses of staging the fair.[148] Many of these concessions paraded animal acts and bawdy side shows of dancing ladies, but others featured unflattering parodies of foreign cultures, including a taxonomy of racist stereotypes in the Chinese Village, Indian Village, the Streets of Cairo, and the Dahomey Village. The latter was a makeshift African village populated, as the placard boasted, with real live "savages." Two large signs reading "40 Canibals [sic] and 15 Amazon Warriors" and "African Amazon Warriors Livingston and Stanley's Explorations" enticed the curious to step inside. Once admitted through a crude wooden gate, visitors discovered an "authentic" reincarnation of an African village complete with reed huts surrounding an open area where "savage" women carrying babies cooked over an open fire and "Dahomey darkies" pounded "on tomtoms."[149] Deeply offended, Bishop Turner questioned the display's authenticity, alleging that these were not wild cannibals at all but "lazy, good for nothing" Negroes from New York or elsewhere who have been taught by whites to "jump about like monkeys and yell like hyenas."[150] It is not known if these were indeed tribal peoples from regions of Africa, like the Fon on view at the White City. A few steps away people could visit another mythical caricature of black culture, the Old Plantation concession. In a review of Midway diversions in *Harper's Weekly*, Maude Adams described this Old Plantation, which had an old aunty "ringin the bell fo the cakewalk" who greeted visitors. With her head wrapped and wearing a tattered dress, the old woman announced in dialect, "Dis here am sho' 'nough 'possum-eatin' black nigger in here; 'tain't no black-faced trash. Come erlong an'see di nigger at de corn'shukkin' in di reg'lar ole plantation." To her sharp social Darwinist eye, Adams pronounced these "darkies" far more civilized than those found in the nearby Dahomey

FIGURE 10. Dahomey Village concession on the Midway, Atlanta Cotton States and International Exposition, 1895. Fred L. Howe photographer. Courtesy of Kenan Research Center at the Atlanta History Center. VIS 145.61.01. 7 × 9 silver gelatin print.

Village.[151] In addition to the savage and plantation personas, fairgoers were also entertained by a resuscitation of an antebellum stereotype in the service of product promotion—Aunt Jemima, a popular figure at the White City. Two food concessions featured black women dressed in mammy attire hawking tasty pancakes "jus oft 'da griddul" to hungry fairgoers.

Outside of lowbrow Midway Heights, other versions of these stereotypes could be found behind the gray facades of the various exhibition halls. The Women's Building, for example, offered an exhibit on the evolution of textiles. Its first tableau featured "an old plantation room," replete with a Negro woman carding, weaving, and spinning cotton, followed by an Indian squaw weaving baskets, next then to a "dark eyed Mexican maid" crafting linen, and ending with a Dutch women plaiting fine lace.[152] The racialized scale of civilization appeared even in this small craft exhibit. This time it was calibrated to rank aesthetics and aptitude. The appearance of these racist representations at the fair illustrated how

THE OLD PLANTATION.—MIDWAY.

FIGURE II. Old Plantation concession on the Midway, Atlanta Cotton States and International Exposition, 1895. From Walter G. Cooper, *The Cotton States and International Exposition and South, Illustrated* (Atlanta: The Illustrator Company, 1896). Courtesy of Manuscript, Archives, and Rare Book Library, Emory University, Atlanta.

the New South ideology resuscitated and mythologized Old South values, while also turning a handsome profit.

Scientifically validated racial hierarchies in the dioramas of primitive Zulus and Papuans in the Smithsonian exhibit and the resurrection of denigrating plantation imagery paraded on the Midway were also reinforced by technologies of viewing that endured beyond the end of the fair. The official photographer of the exposition, Fred L. Howe, produced photographs that showed staged depictions of black southerners that had no relation to any concession or exhibit. In these photographs black youth engaged in fisticuffs above the caption "Who's a Nigger," and a group threw dice above the caption "Crap at Coonville 'Seben come Eleben.' "[153] These pictures, which may have been taken for reproduction as postcards, characterized southern black males as violent, immoral, infantile, and

FIGURE 12. "Who's a Nigger?" photograph picturing black American youth at an unidentified location, Atlanta Cotton States and International Exposition, 1895. Fred L. Howe photographer. Courtesy of Kenan Research Center at the Atlanta History Center. VIS 145.70.01. 7 × 9 silver gelatin print.

slothful. Black women fared no better in official souvenir imagery. A stereoscope showed a nursery, (presumably the day nursery in the Women's Building), where five black women, "mammies," sat on a bench, and a fair-skinned woman sat in a chair, caring for their young white charges. A popular visual device, stereoscopes created an illusionary three-dimensional perspective from a two-dimensional image printed on an inexpensive small rectangular card. The apparatus brought the viewing subject's body in direct relation to the object viewed.[154] This closeness of the image of blackness to the white body in the private sphere of the home stood in contrast to the ways in which custom, law, and coercion spatially separated black bodies from white ones in the public fairgrounds and in the city.

For one hundred days, the neo-Romanesque pavilions that blended into the rolling hills of the Piedmont Park fairgrounds offered visitors two representations of modern urban life: the organized city and the racialized social hierarchy of the New South. In contrast to the dense avenues at the World's Columbian Exposition—an extension of Chicago's city

grid—the Atlanta Cotton States' fairgrounds echoed the rustic atmosphere and low density of the city's urban character. The Atlanta Cotton States and International Exposition, founded on the theme of new markets of trade and industry, presented a solution to the Negro problem by finding a place for blacks in the new city and new economy. Executing the fair organizers' intentions, the separate pavilion for Negro progress validated the segregation of black residents living in southern cities. In other buildings around the fair, there had allegedly been seen signs warning "dogs and negroes not admitted."[155] Rude treatment and exclusion from many of areas of the fair were common offenses directed at black visitors, despite Penn's efforts to paint a more hospitable picture of the fair's environment. The criticisms leveled by many blacks about a separate Negro Building and Washington's accommodationist speech indicated that the material benefits of true social equality were desirable. Those who had been troubled by the failure to directly address the spread of segregation, particularly at the fairgrounds, proved prescient in their concerns. Indeed, five months after the exposition closed, those equal rights guaranteed to black citizens under the Fourteenth Amendment would be rescinded by the Supreme Court's decision in *Plessy v. Ferguson* to uphold a state's right to segregate public facilities.

The large grey hall, the first ever Negro Building dedicated to the exhibition of black culture in America, with others soon to follow, provided a valuable counterpublic sphere for an emerging class of bourgeois blacks to display their progress at improving their own lives, along with those achievements of the majority poor living in urban and rural areas. The black elites' curatorial ethic was a way of envisioning themselves, shaped in part by discourses of class and race as the New Negro and as part of the forward advance of the New South, if not quite of the larger nation-state, given the apolitical tone of most displays. As a precursor to the Emancipation expositions that began with the Great Migration and the black museums of the mid-twentieth century, the Negro Building presented a panorama of accomplishment. It showed visitors the promise of black life in the South as primarily rooted in conservative ideals of moral uplift, manual labor, and a rural existence. With the illiteracy rate still more than half of the black population in Georgia and the South, the displays of craft, machinery, mechanical arts, agricultural products, and cultural artifacts visually encapsulated to the masses Washington's ideology of patient accommodation to current circumstances. Whether this one-time experience of the Negro Building's displays—reinforced by similar exhibits at yearly state fairs and regional industrial expositions—

would foster a lasting ethos of commitment to rural life and manual labor would be left to other factors. The success of Washington's plan, in the end, would be determined by the capacity of the New South's economy to industrialize, eventually incorporating black sharecroppers into the ranks of factory workers, and by the ability of blacks to establish their own businesses and increase their ownership of farmland. All of this was measured against their willingness to endure the constant threat of white racist violence and daily humiliation under Jim Crow's stringent regulation of urban and rural life.

In his "Atlanta Compromise" speech, Washington had deliberately placed the birth of the Negro, with no mention of African origins or centuries of enslavement, as "starting thirty years ago with ownership here and there."[156] In this truncated genealogy, black America began when its members first acquired official names, locations, and racial designations in the U.S. census of 1870. And from the modest social gains of Reconstruction, the New Negro was born as the modern persona and future identity of the race. At the fairgrounds, these modest representations of dutiful New Negroes, indicative of the humble light in which blacks wished to be seen by others, were overshadowed by the introduction of evidence of their inferiority in the main pavilions and on the Midway, cultural tropes that hampered their ability to achieve full rights of citizenship. Like the conflicting official and unofficial representations of black identity that conveyed industriousness and servitude circulating around the Piedmont Park fairgrounds, alternative, more radical ideas about black history and progress, the willingness to confront the growing antiblack racism and segregation, also circulated around the Negro Building and Atlanta, as the next chapter explores. Events at the fair gave a platform to a diverse range of public positions on the future of members of the black race as citizens, wage earners, and cultural producers. The visibility of black leaders and thinkers like Washington, Penn, Turner, and Wells, and the residents of black urban communities like Atlanta's Black Side (whose members visited the exhibition to see their own progress), serve as an indication of what the significant transformations in the material conditions of black life would be over the next sixty years.

CHAPTER 2

Exhibiting the American Negro

We have thus, it may be seen, an honest, straightforward
exhibit of a small nation of people, picturing their life and
development without apology or gloss, and above all made
by themselves.

—W. E. B. Du Bois, "The American Negro at Paris"

It is but natural that our achievements in agricultural
and mechanical branches should show the most favorable
advantage in the South. That section is our fatherland.
There is where the Negro is found in the greatest number,
and where exists the best opportunities to see the race as it is.

—*Colored American*

For France's grand Exposition Universelle in 1900, the U.S. government
proposed an ambitious plan to showcase a collection of unique exhibits
that would position the burgeoning industrial nation at the forefront of
social reform in the new century. Paris's magnificent world's fair also af-
forded black Americans an international stage to present their progress
in self-improvement. Thomas Junius "T. J." Calloway, a Fisk University
graduate who had achieved a comfortable middle-class livelihood in
Washington, D.C., heard of the United States' plans to participate in the
international fair. A former War Department clerk, the bright and ver-
satile Calloway had also served as a northern agent for Tuskegee Insti-
tute and as president of Alcorn Agricultural and Mechanical College in
Alabama. During the period that Calloway directed Alcorn A & M Col-
lege, he also served as a state commissioner for the Atlanta Cotton States
and International Exposition's Negro Building, which included an ex-
hibit of the college's industrial education curriculum.[1] At the time he

learned about the Paris fair, Calloway was managing editor at the *Colored American*, a weekly newspaper that advocated the tenets of racial uplift and black self-help in its articles and editorials. With close to eighty-seven thousand black residents living in its four quadrants, a third of the city's population, the District of Columbia was home to the nation's largest urban black community. A group of educated elites led the city's ·emerging class structure, a result of the ability of New Negroes like Calloway to secure positions in government agencies, although many had been forced out of elected office. These men and women had created an active public sphere in neighborhoods that hosted the offices of several newspapers, schools, and colleges, along with religious institutions and cultural organizations; some had presented their achievements and wares at Atlanta's Negro Building. Keen on showing the race's remarkable accomplishments to the world, Calloway was determined that an exhibit on the Negro—one that detailed and lauded the progress black Americans had achieved in education, business, and other arenas—should be a highlight of the U.S. endeavor in Paris.

Like residents in Washington, D.C.'s thriving black counterpublic sphere, many in Atlanta's Black Side also continued to prosper, despite persistent threat of intimidation and lynching and Jim Crow segregation sectioning off parts of the busy mercantile city. Less than two years after the close of the New South's great venture, the Atlanta Cotton States and International Exposition, a young scholar, William Edward Burghardt Du Bois, settled in the city's Black Side to teach at Atlanta University. A spirited intellectual and committed activist for civil rights, Du Bois would offer a progressive vision of black life in the twentieth century that challenged Booker T. Washington's popular agenda of acquiescence to white supremacy and the dominance of industrial training in education. Although the two race leaders would engage in heated public disagreements and ideological clashes in the two decades following the Atlanta fair, both men nonetheless believed that raising the moral and social conditions of the black masses was vital to spurring racial progress. Both subscribed to economic and social advancement underwritten by industrial capitalism's new social order, and both were invested in boosting solidarity among the class they chose to lead the race forward: the black elite.

Du Bois accepted the invitation from his old college friend Calloway to join the preparations for the Paris exposition. Together they planned an ambitious exhibit that encapsulated the prospects of the New Negro, which they rechristened in this international context as the "American Negro." The first section of this chapter examines the creation and display

of their "American Negro" exhibit at the Exposition Universelle. Under Calloway and Du Bois's stewardship, the exhibition (which also included contributions from Washington and the Tuskegee Institute) was filled with examples of what American blacks could accomplish as farmers and industrial workers but also as teachers, writers, artists, and thinkers. In the November 1900 issue of the *American Monthly Review of Reviews,* Du Bois summarized the exhibition's content and put forth the radical proposition that the emergence of an American Negro literature was indeed emblematic of the development of Negro thought. Were these not the achievements of a modern people, Calloway and Du Bois posed, if tolerance could supplant racial hatred and tyranny? They directed this message not only to American audiences at home and abroad but also took aim at European audiences whose imperial ambitions—driven by an appetite for manufactured goods—sought to dominate the African continent and its valuable resources. While the exhibit was on view in Paris, its organizers also forged alliances with other black peoples from the Caribbean, Africa, and the Americas at the fair and at a unique conference in London on the innovative doctrine of Pan-Africanism, which envisioned black unity as a counteroffensive against antiblack racism and imperialism. For Du Bois, Calloway, and those blacks viewing the American Negro exhibit, would this transnational linkage of rights and freedom from exploitation prompt them to reflect on the growing lack of rights and economic access in the nation-state to which they pledged allegiance?

As the rest of the chapter explores, Paris would not be the sole venue for the "American Negro" exhibit. Over the next two years it would travel to other world's fairs around the United States. A dedicated group of clubwomen would bring the "American Negro" to Buffalo's Pan-American Exposition in 1901. And the following year, the "American Negro" would be displayed at the Charleston world's fair's Negro Building, where the powerful voice and vision of Washington dominated the hall's curatorial message. The prominent black leaders and intelligentsia, who had assisted with the exhibits and congresses at Atlanta's Negro Building and contributed to the "American Negro," continued to imagine the future of the race at two important southern fairs. For the Negro Buildings at world's fairs in Charleston and also at Jamestown in 1907, they produced displays on industrial education, economic advancement, agriculture, women's rights, and self-help. If the curatorial ethic employed at these events promoted social advancement primarily through Washington's theme of accommodation, how would black organizers and visitors contend with the antiblack racism that tainted all aspects of the fair

FIGURE 13. W. E. B. Du Bois, Paris, 1900. Courtesy of Special Collections and University Archives, University of Massachusetts at Amherst Libraries.

experience—from insidious caricatures featured in official publications and portrayed on the Midway, to poor treatment and bigotry that greeted black visitors throughout the grounds; from the segregation of the fair's public facilities and transportation, to the deliberate exclusion from jobs and profit on the fairgrounds? The response of black patrons, as we shall learn, was to insist on equal treatment and access, to demand their civil rights. And when whites in power failed to heed these modest requests, the black visitors' tactics turned to protest and boycott.

At these events, this new generation of black citizens, many born after Emancipation, would reevaluate the efficacy of being an American against the continued denial of rights and within a wider sphere that included other emerging nationalist ideologies such as Pan-Africanism and black nationalism, which set a very different course forward than Washington's tactic of patient servitude.

A SHOW OF BLUER VEINS AND FAIRER SKINS

At the turn of the century, Washington's success at utilizing the Atlanta exposition and its Negro Building as a platform to promote the virtues of accommodation, and as a means to raise his stature as a national leader, proved that world's fairs could be useful public spheres where black Americans could intersect with influential white political and civic leaders and the business elite. As the widely regarded spokesman of his race, Washington was a powerful presence who controlled the editorial content of several newspapers. He had a say in the selection of political appointees, he influenced the missions of several associations and educational institutions, and he cultivated personal relationships with a succession of U.S. presidents. Thus, as many blacks keenly observed, the Negro Building's success in Atlanta served as a model for how to improve race relations with white southerners, while in the process boosting intraracial solidarity.

Two years after Atlanta's fair, Nashville, for example, hosted the Tennessee Centennial Exposition. To create their symbolic "White City of the South," the fair organizers built large neoclassical exposition halls, including a full-scale replica of the Greek Parthenon. Mindful of the success of Atlanta's Negro Building and desirous of competing with their commercial rival 250 miles to the southeast, the organizers thought it would be wise to also erect one at their event. Like in Atlanta, black labor erected the pavilion, and management paid for the hall's construction and the transport fees for the exhibits. Nashville's Negro Building, this time decorated with Moorish flourishes, exhibited black handicraft from the old plantation to the present. Prominent black schools and colleges from around the South once again loaned exhibits that received fifty-eight medals from the fair's judges. In their opening day speeches, Nashville's black dignitaries surrendered the same conciliatory gesture to their white neighbors, suggesting, just as Washington had, that black labor was far more dependable than the rabble of European immigrants streaming into northern industrial centers.[2] As the featured speaker at the commemorative Emancipation Day celebration at the fair, Washington delivered an updated version of his appeal for black cooperation.[3] Not far from where the great Tuskegean lectured on patience in all matters of race relations, the fair's organizers had replicated the same coarse reminders of where black southerners really belonged that had been seen in Atlanta. On the Midway Plaisance, the Ole Plantation trotted out a pantheon of racist stereotypes to amuse and entertain the roving groups of adults and children.[4]

Recognizing the usefulness of these two previous fairs, Calloway began to rally national support for a Negro exhibit in Paris that would outshine all others. In October 1899, he contacted his friend and former employer, Washington, along with one hundred other prominent blacks.[5] Calloway, who had been involved in organizing Alabama's state exhibits for the Atlanta Cotton States and International Exposition, made the argument in a letter to Commissioner-General Ferdinand Peck, the head of the U.S. Exposition Board, that in light of the success of Negro exhibits at Atlanta and Nashville it was imperative to convince not just southerners but people all over the world of the potential of the Negro. In particular, Calloway intended to dispel the misperceptions circulating in the press that black men were, as many an editorial had alleged, a "mass of rapists."[6] A Bookerite in certain aspects of his philosophy—an outcome of his ties to the Tuskegee machine—Calloway wanted the thousands who would visit the international fair to witness the Negro's advancement in religion, education, agriculture, the professions, and home life.[7] Departing from his stalwart mentor's belief in the inevitability of the Negro's humble status, Calloway, however, also yearned to show that blacks were the cultural equals of whites—in taste, habits, and even patriotism. Boasting amusingly in the pages of the *Colored American,* he wished to "furnish a crop of Afro Americans at that Paris Exposition with bluer veins and fairer skins than some of the pure whites on this side."[8] Calloway believed that his peers, those of the black bourgeoisie settled in places like the District of Columbia and Atlanta, had elevated their status to a level of cultural equivalence, if not social and economic parity, with white Americans—even though these were the same uppity ambitions that Washington had cautioned against in his "Atlanta Compromise" speech. Calloway saw Paris as an ideal world stage to verify such claims by offering sociological analysis, photographic documentation, and whatever else would be necessary to incontrovertibly prove this point.

Persuaded by his former employee's enthusiastic letter, Washington promptly dispatched a letter to President William McKinley, which he followed up with a personal visit to the president. Washington strongly recommended that a Negro exhibit be a part of the Education and Social Economy exhibit and that the dependable Calloway, who was fluent in French, be placed in charge of producing the exhibit.[9] Given his expertise in industrial education, Washington had already been invited by National Education Association (NEA) to join its planning committee for the fair. This group of educators from around the country agreed that

the U.S. exhibits should be assembled from a national point of view to illustrate how "Americans were applying the results of scientific training in every field of manufacturing industry and accomplishing wonderful feats of engineering in all parts of the world."[10] Calloway's proposal would make an ideal exhibit on the advances being made in Negro education.

Triumphant in his request, Calloway received an appointment one month later, in November 1899, as a special agent in the U.S. Department of Education and Social Economy.[11] Accepting the assistance of the last remaining black congressional representative, George H. White from North Carolina, who was soon to lose his seat due to segregationist redistricting to prevent blacks from holding political office, Calloway secured $15,000 in federal support to finance what would be called the "American Negro" exhibit. With the exposition opening in five short months and materials needing to be completed and packed for shipment by the improbable date of January 1, Calloway set up an office on F Street in northwest Washington, D.C., hired two capable stenographers, and quickly set about soliciting assistance and organizing materials.[12]

The overall response to participation in the fair proved favorable, but as with the Atlanta exposition concern was voiced by those wary of a separate exhibit being interpreted as a tacit acceptance of segregation. The newspaper *Africo American Presbyterian,* for example, thought it unwise to have a "distinctively Negro exhibit."[13] Aware of the reticence in some circles, Calloway, backed by the assurances of other fair supporters, promised that the Paris exposition provided another extraordinary opportunity for blacks to show how far they had advanced in America since slavery.[14] To fortify his argument, Calloway reminded doubters that the relevance of showcasing Negro self-improvement had already been proven as a means to advance the economic and social standing of the race. As an example he noted that "the success of the negro exhibits [at] the Nashville and Atlanta Expositions has opened up several factories for negro labor and crystallized strong sentiment in many parts favoring him as an operative."[15]

Calloway's bold vision for the Social Economy pavilion's "American Negro" exhibit would feature contributions on history, education, employment, property, literary advances, mechanical achievements, business and industrial development, and religious involvement. This rich array of subject matter would be supplemented by a sociological study of the conditions of black life in America.[16] Three main objectives lay behind Calloway's ambitions: One, the exhibit would defuse pernicious myths

of inferiority by highlighting the Negro's moral, intellectual, and material successes. Two, it would show that any group can prosper in the United States. Three, the United States could exemplify how equal treatment regardless of race can promote beneficial productive relations among all parties in a colonizing Europe, which was bound to cultivate its own "Negro problem" as it conquered African territories and their peoples.[17] This final ambition clearly expressed an even greater international role for the presentation of black advancement than had been conceived at the Atlanta fair. It also indicated a growing desire for more dialogue across the emerging modern black world in the Americas, the Caribbean, and Africa. Overall, Calloway embraced the nation's ethos of liberal democracy and planned an exhibition that would debut to the world a New American Negro.

For a month in late 1899, Calloway traveled through the southern states contacting universities, schools, businesses, churches, and institutions for material. His career as an educator and a journalist meant that he had access to the mainstream and black press in order to solicit financing and participation. In February 1900, he dispatched Andrew F. Hilyer, a Washington, D.C., inventor, lawyer, and accountant, joined by photographer Harry Shepard, to document life in the Black Belt and elsewhere in the South. Shepard and Hilyer gathered a wealth of information on the industrial progress of farmers and workers.[18] Experienced with planning fairs, Hilyer had also been a member of the Washington, D.C., commission, organizing displays sent to the Negro Building in Atlanta; and he had spoken at the Bethel Literary and Historical Association, reporting on the "results of the Exposition to the Negro."[19] To round out his crack team, Calloway engaged the talents of Daniel P. Murray, a brilliant assistant librarian at the Library of Congress. He entrusted Murray with the task of assembling an extensive collection of books, newspapers, and sheet music for display. Calloway must have been acutely aware of the implications of this choice, since the Library of Congress's authority would offer irrefutable proof of black literary achievement. With one last task to assign, the important cornerstone of the exhibit— an in-depth review of Negro life in America—Calloway contacted his old Fisk University chum, Du Bois, an esteemed professor and scholar, then living and teaching in Atlanta. In late December 1899, Du Bois accepted his friend's request to undertake a study of Georgia, home to the largest black population in the United States. Fortuitously, Du Bois was awarded a $2,500 stipend to hire twelve Atlanta University students to

commence the documentation and preparation of his award-winning *Georgia Negro* study.

The Tuskegee Institute's popular model of industrial education, black self-help, and racial uplift fulfilled one the aims of southern and northern whites—to keep the races far apart in distinct social spheres and in separate spaces. In response, black schools around the South built separate halls where their white visitors, patrons, and trustees could socialize comfortably away from blacks.[20] Atlanta University, however, would not submit to this interference. As a result the administration rarely entertained white trustees on campus, and white supporters rarely attended the school's graduation ceremonies. Under the leadership of white Yale graduate Horace Bumstead, who assumed the presidency in 1888, Atlanta University deemed that a college-level education was an appropriate ambition for black students. Bumstead, a staunch New England egalitarian, insisted on the highest academic standards founded on a belief in the democratic equality of the educational process.[21] Atlanta University's stubborn refusal to segregate its westside Atlanta campus meant that the State of Georgia suspended funding in 1887, forcing the school to seek alternative sources to finance its radical educational mission.[22]

In the midst of this tumultuous post-Reconstruction period, Bumstead followed the advice of trustee George Bradford and instituted a series of conferences to study, publicize, and educate people on the condition of Negro life in the country's quickly expanding urban centers.[23] To guarantee a national audience and to take advantage of the exuberant spirit of Atlanta's Negro Building, the first conference was planned as one of the Atlanta fair's congresses in the fall of 1895, but it was delayed until the following May. At that time, the Hampton and Tuskegee Institutes had already begun similar discussions that brought together leading proponents and practitioners of industrial education to deliberate the field's latest advances and to acquaint northerners and southerners with the current status and needs of rural blacks. At these gatherings, Washington's allies extolled the virtues of manual training over college education as the viable solution to the social and economic problems black southerners faced. Because many thought that the vices and moral distractions of city life stymied the race's advancement, consideration of urban black life was absent from the Tuskegee and Hampton discussions. Capitalizing on this oversight, Atlanta University found itself in an ideal position to undertake valuable sociological research on urban life. Honing in on its mission, Atlanta University recognized that it drew many of its students from

cities and large towns and that students would most likely return to those places upon graduation. Astutely aware of the symbiotic relationship between rural and urban economies, Bumstead speculated that "the improvement of Negro life in the cities will make itself felt in the improvement of Negro plantation life."[24] Therefore, a thorough study of urban conditions, Bumstead concluded, would not only be appropriate but also prove immensely beneficial to cities like Atlanta.[25]

The administration convened the conferences on Atlanta University's campus. Bumstead's initial vision called for careful statistical measurement of the living conditions of black residents in places like Atlanta. The first conference, held in 1896, was titled "Mortality of Negroes in Cities" and the second convened the following year under the banner of "Social and Physical Conditions of Negroes in Cities." Lacking the rigor of full-fledged scientific studies, the conclusions drawn by the scholars, religious leaders, and social activists at these inaugural conferences asserted that moral failing and inherent racial inferiority (the same moralizing terms that white supremacists employed) contributed to the high rates of black illiteracy, poor housing, unhealthiness, and criminality. Conceptually, the first two conferences failed to reveal how antiblack racism had fostered the adverse conditions under which urban blacks toiled.

It was in the summer of 1895 that Bradford became aware of a young talented sociologist, Du Bois, who was researching black life in the slums of Philadelphia. Bradford recommended to Bumstead that the school make every effort to hire this promising scholar.[26] Du Bois accepted Bumstead's offer of a professorship and arrived in Atlanta in late 1897 after completing his research in Philadelphia. Du Bois's biographer David Levering Lewis has detailed much of this rich formative period of Du Bois's life, but it is important to identify his educational history and previous research before discussing his impact on the Atlanta University conferences and his contribution to the "American Negro" exhibit in Paris. Du Bois was raised in the North, the son of free parents, and educated in the South at Fisk University. He then attended Harvard University and eventually traveled to Germany for two years to complete his studies in history and economics. Upon his return from Europe, Du Bois accepted a position at Wilberforce University in Ohio, a black college begun by the Methodist Episcopal Church in 1856. He had corresponded with Washington about securing a teaching position at Tuskegee, but the great Negro spokesman, as would happen on more than one occasion over the next ten years, failed to offer an appropriate appointment. Dissatisfied

with the educational climate of Wilberforce, Du Bois accepted a position as an assistant in sociology at the University of Pennsylvania.

In Philadelphia, home to the North's largest concentration of black Americans, Du Bois undertook an extensive sociological study of the city's impoverished Seventh Ward. Published in 1899, *The Philadelphia Negro* crafted the first comprehensive scientific view of black life in an American city. The young researcher's agenda encompassed a review of the "geographical distribution of this race, their occupations and daily life, their homes, their organizations, and, above all, their relation to their million white fellow-citizens."[27] For fifteen months, Du Bois lived in the Seventh Ward, walking the streets and visiting families residing in the two-story row houses of the neighborhood. He interviewed hundreds of residents. He collected a wealth of data on living conditions, family life, employment, health, crime, alcoholism, pauperism, suffrage, environment, amusements, religious life, social reform, and social associations. As an exhaustive compilation of statistics on the aforementioned research topics, Du Bois's thorough analysis showed antiblack racism's impact by rendering visible its withering effects on home life, social status, political influence, and economic opportunities. In particular, his research demonstrated how racism embedded within capitalism's mechanisms of exploitation harshly suppressed the wages of the city's black workforce. Much of what Du Bois investigated in Philadelphia's black community exposed how conditions of impoverishment, spurred by discrimination, had entrapped black residents, thus prohibiting their advancement. Amid these dire conditions, he also documented the formation of "social grades" and the creation of a small but influential class of elites—the 11.5 percent of the Seventh Ward who lived in well-appointed homes and rarely mingled with what they considered less-refined middle- and working-class blacks. Du Bois reminded them that, as a group, many of whom were "mulattoes" and therefore most likely to assimilate into American culture, they had an obligation to "serve the lowest class," which included the "submerged tenth" of "criminals prostitutes, and loafers." Even with his progressive examination of the caustic effects of capitalism, patriarchal and moralizing notions of racial uplift still colored the tone Du Bois's analysis and conclusions.[28] Nevertheless, as a remarkable study of the intricacies of social relations, *The Philadelphia Negro* captured the changing conditions of black urban life. Like the Seventh Ward, Atlanta's Black Side would offer the young researcher another thriving urban milieu from which to profile racism's impact on black advancement.

Acknowledging his new hire's exceptional research abilities, Bumstead

assigned Du Bois the task of completing the organization of the third Atlanta conference upon the scholar's arrival on campus with his wife Nina and infant son Burghardt. This third conference, "Some Efforts of American Negroes for Their Own Betterment," focused on the formation of benevolent associations and businesses in black communities. Du Bois shaped the agenda of the fourth conference on his own terms. For the "The Negro in Business" held in 1899, he launched a thorough inquiry into the status of black commerce in the South.[29] He drafted well-educated black men and women, long resident in their communities, to canvas the selected cities. Armed with prewritten surveys, these researchers set about their task of gathering data for the study on black employment. When examined in total, the data classified and traced the evolution of various occupations from the plantation to the city—house servant class, field hand class, plantation mechanic class, traders, capitalists, and manufacturers.[30] Keen on publicizing the data and circulating the study's invaluable content, Du Bois mailed the book along with the three previous ones to various federal and educational organizations around the country.[31]

The new professor was determined to make the Atlanta University conferences a serial study of black life that would influence the field of sociology, commenting that the study of "the American Negro would have contributed to the development of social science in this country an unforgettable body of work."[32] Weighing the impact of this prescient research, he believed the studies would provide invaluable information to those who had the resources and power to enact social policies.[33] When his fellow Fisk alumnus Calloway invited him to present his sociological research as part of the "American Negro" exhibit at Paris's Exposition Universelle, Du Bois eagerly grasped the opportunity to share this unique body of ongoing research on black life in American cities with international audiences.

THE NEGRO SPIRIT OF A PAN-NEGRO NATION

The Exposition Universelle was one of many world's fairs the French government planned at the city's fairgrounds along the river Seine. The iron-latticed Eiffel Tower, an icon from the 1889 fête, soared over the ornate art nouveau pavilions designed for the fair that opened its gates between April and November. Distinct from the American fairs, whose planners would typically choose a park outside of the host city's limits for the fairgrounds, the Parisians staged their events at the center of their lively cap-

ital. The juxtaposition between the exposition and the city meant that the fair's phantasmal realm of merriment and spectacle of invention could be experienced as integral to the modern metropolis. For France, the Exposition Universelle, which welcomed the new century, was expected to confirm the country's superiority in manufactures and culture over the other competing nations. For the United States, the nation's elaborate plans were meant to rival, indeed surpass, the efforts of its gracious host nation. Aware of the economic significance of this opportunity, an early report stated that "never has there been a better opportunity to show it [America's preeminence] to the world than is presented by the Universal Exposition of 1900. The proof of our superiority means not only the markets of France for our products, but those of all Europe, and of Central and South America."[34] In his final report on U.S. participation, Commissioner-General Peck, a scion from one of Chicago's first families, proclaimed that the U.S. cultural presentations had risen above their European rivals. The nation, wrote Peck, was "rapidly developing a highly perfected as well as soundly organized civilization" and was poised to solve the vexing problem that "so long annoyed Europe and the world and all ages, viz., the practical and satisfying combination of the artistic with the utilitarian, the aesthetic with the enduring, the beautiful and graceful with the progressive and strong."[35] According to his formulation of progress, the expansion of U.S. industries—strong, enduring, and mindful—would press onward hand in hand with the country's unique cultural spirit—artistic, graceful, and measured against the highest aesthetic standards. Peck's sanguine pronouncement coupled industry and culture as the driving force behind the nation's rapid rise to international prominence (the military at the time was battling Filipino revolutionaries under the pretext of "benevolent assimilation.") By the time of the fair's opening ceremonies, the U.S. victory in the Spanish-American War over the once formidable colonizer Spain inaugurated the United States' position as an international power. The exposition afforded the United States a forum to display the spoils of its newly minted imperial might.

The Exposition Universelle brought together the expertise of various white leaders who had been involved in the planning of other world's fairs. Even though many states submitted proposals for separate pavilions, Peck, a former vice president at the World's Columbian Exposition, made it clear to all that this would be a national undertaking, with all the exhibits representing one overall subject—the United States. Peck organized the following departments: Education and Social Economy; Fine Arts; Liberal Arts and Chemical Industries; Machinery and Electricity;

Transportation, Military, and Naval; Agriculture, Horticulture, and Foods; Forestry and Fisheries; Mining and Metallurgy; Textile Industries; and Furniture and Various Industries.[36] In the summer of 1898, the U.S. Congress appropriated $1.3 million to fund the American effort. The monies financed exhibits for a total area of 338,987 square feet, divided between several buildings at the Paris fairgrounds.[37] Although this final amount was considerably less area than anticipated, organizers designed exhibitions to efficiently utilize the allotted space.

In any international competition, the location, size, and visibility of fair exhibits reflected a nation's prominence in the march of civilization. Initially the French allocated a fairly small area for all of the U.S. exhibitions—just under 148,000 square feet, which was considerably less than what had been assigned to the French for their Manufactures Building at the World's Columbian Exposition. French organizers also informed Commissioner-General Peck that there was no longer room for a U.S. Pavilion among the prestigious row of national pavilion sites along the Seine. Perturbed by the snub, but not dismayed, Peck and the U.S. ambassador to France lobbied for a greater presence on the fairgrounds. Successful in their appeals, the United States received more space. Even more fortuitous, French authorities assigned the United States a total share of exhibition space equal to that of the Germans and British, thus giving American businesses access to expanding European markets.[38] By compacting the space between the other national pavilions, the French also granted the United States a prime space along the Rue des Nations.[39]

To mark the occasion of the country's recently acquired international stature, architects designed the U.S. Pavilion as an ornate rococo temple dedicated to American ideals. To distinguish it from the more restrained geometric profiles of its Turkish and Italian neighbors, the frothy confection was encrusted with eagles and other patriotic symbols and constructed of white staff to recall the opulence of the World's Columbian Exposition. This bid to astound and dazzle, however, failed to impress the cosmopolitan crowds, prompting one critic to quip, "It possessed no other quality than one of pure, unadulterated ugliness."[40] In its highly visible location on the Rue des Nations along the Seine and across from the Champs-Elysées, the U.S. Pavilion's gaudy imperial embellishments contrasted with the modern lyrical art nouveau of the French pavilions at the fair.[41] Alongside the lavish halls, festive balls, and other patriotic events celebrating America's greatness, the fair also offered other representations of the nation's cultural progress. The informative exhibits at the Social Economy Pavilion would showcase how America was utiliz-

ing a civilized intelligent means—the social sciences—to better the lives of those on the lower rungs of the social evolutionary ladder.

Frédéric Le Play, an influential commissioner of the Parisian expositions in 1855 and 1867, had devised the intricate classification system upon which the entire Exposition Universelle had been organized. A brilliant social scientist, Le Play also conceived of a pavilion dedicated to the progressive field of social economy, an "exhibit of articles having for their purpose the improvement of the physical and moral condition of the people."[42] Whereas most fair pavilions showcased natural specimens or man-made objects, the exhibits in the Social Economy Pavilion would educate visitors through "information," a means of visually presenting ideas without the material object as a reference. Mediums such as maps, diagrams, models, and photographs would be the appropriate way to describe how modern governments and social organizations administered their programs of education, colonization, and socioeconomics.[43] That the organization and management of modern society could be carried out through empirical study, meticulous statistical analysis, long-range planning, and implementation of social policy would legitimate the emerging field of sociology. In this regard, the Social Economy Pavilion represented new branches of knowledge introduced to the viewing public by modern techniques of communication.

The Social Economy Pavilion, in comparison to many of the fairgrounds' lavish halls, was a simple white neoclassical building erected along the Seine, opposite the Rue des Nations. Part exhibition space on the lower floors and part congress hall on the upper floors, the pavilion was where U.S. public charities and social-reform organizations, settlement houses, cooperatives, trade unions, tenement improvement associations, health organizations, and Negro self-improvement associations set up their exhibits. These organizations displayed their successes at disciplining and improving the welfare of America's less-capable charges—its children, workers, infirmed citizens, and Negroes. Inside the pavilion, the United States was allotted a modest three thousand square feet, posing a challenge for installation because of the large number of exhibits that had been planned.[44] The limited space, along with the need to present pamphlets, statistical charts, diagrams, maps, photographs, lantern slides, and models, meant that American organizers had to conceive of an ingenious design to display the multiple formats of information. Tackling the problem, the New Jersey School and Church Furniture Company designed a unique system of wing frames and wall cabinets to accommodate the many exhibits in the cramped space. Solid oak cabinets could

be utilized for shelving and model display. Shallow swinging frames provided a clever addition to maximize display area. Positioned at eye height and hung off of the wall, these frames could present information on both sides. Once installation was complete, the uniformity of the display units, appropriate to the theme of social control and reform, lent an overall cohesiveness to the appearance of the U.S. show.

More than one thousand displays in the twelve classes of the Social Economy exhibit filled the pavilion when the doors opened to the public in mid-April. The goal of the exhibits under "class 110," "Public or Private Movements for the Welfare of the People," elaborated on the United States' quest to modernize its society, with specific emphasis on the planning and management of urban populations. The exhibit presented a commentary on governmental, private, and business initiatives to manage the nation's new class structure. The American exhibit was sandwiched between the national exhibits from Germany and Holland in a small twenty-foot by thirty-foot space. As visitors entered, they saw in a corner to the left a display titled "Industries and Resources of the Country." Aligned in content with the underlying ambition of the U.S. presence at the exposition to support the expansion of American markets, and as evidence of private industry's effort to support social progress, the first section of the American exhibit described how the nation regulated its resources and industries. Perusing the various charts and graphs on the walls and in books, visitors were informed of America's new class structure, an outcome of the nation's successful effort to industrialize its economy. Differing from displays elsewhere on the fairgrounds that featured actual machinery and products, this exhibit focused on the statistical documentation of working conditions. In truth, however, what the curators presented as the "excellent" condition of the American workplace contrasted drastically with the allegations of inhumane treatment repeatedly leveled at companies by striking workers. Photographs documented the latest advancements in manufacturing by capturing disciplined workers manning the tidy factory floors of the Singer Sewing Machine, Remington Typewriter, McCormick Reaper, and Illinois Steel companies.[45] Neatly hung rows of charts and maps outlined the growth patterns and locations of various industries; nearby, in an area designated as a library, shelves housed trade papers, directories, and detailed studies and monographs about industry written expressly for the exposition by the U.S. commission for the fair. Reports from various state and federal bureaus of labor and statistics outlined efforts at social management. Displays that hung in the rear of the American exhibit educated

visitors on the charitable efforts at social betterment by the League for Social Service. Elsewhere in the exhibit, photographs placed into the wing frames sampled the social work of missions, lodgings, and slum stations run by the Salvation Army and the Young Men's Christian Association (YMCA) of North America.[46] Large models of tenement houses dominated the middle of the exhibit, giving visitors a highlight of the problems and advances U.S. cities had made in housing the poor and immigrant populations.

Significantly different in character from the large symbolic pediment announcing the Negro Building in Atlanta, a small sign in gold letters identified the "American Negro Exhibit." Organizers positioned the exhibit in a prominent front corner of the larger exhibition space, just to the right of the entrance. The exhibit was laid out in an L-shaped configuration and fitted out with the same wooden shelving and display system utilized throughout the United States' Social Economy exhibit.[47] It was a much smaller endeavor than the Negro Building in Atlanta, but the exhibit's extensive documentation of photographs, books, newspapers, and artworks, as well as industrial artifacts such as patents and products, illustrated a complex panorama of contemporary black life in America. Departing from the Atlanta exposition, where southern fair builders had clearly segregated the Negro Building from the other main pavilions, marginalizing it near the entertainment venues, white curators presented "American Negro" as an integral part of the whole U.S. endeavor.[48]

The first artifact seen by visitors to "American Negro" was a small bronze statuette of abolitionist Frederick Douglass, a reproduction of a larger statue sited in a square in Rochester, New York. The three-foot-tall likeness, sculpted by artist Sidney W. Edwards, symbolized the history of enslavement and celebrated the current civic life and public space of America's black citizens, a subject matter absent from Atlanta's Negro Building.[49] Stipulated by the organizers' classification criteria, the "American Negro" exhibit emphasized advances in education. Like the Atlanta Negro Building, industrial training was the primary focus. On the wall hung fifteen hinged wing frames displaying charts and photographs. In case number one appeared photographs documenting daily life at several schools: Fisk University, Howard University, Roger Williams University, Agricultural and Mechanical College in Greensboro, Berea College, Tuskegee Institute, and Claflin University.[50] The prints highlighting occupational training showed, for example, neatly dressed young women participating in a class on domestic work at Alcorn A & M College. Another captured a group of well-groomed men and women learning the

Aisle of Palace

1. American Library Association
2. Equitable Life Assurance Society
3. League for Social Service
4. Maps Class 103 (?)
5. League for Social Service
6. Models of Tenement Houses
7. Dark Room
8. Industries and Resources of Country
9. Bookcase
10. Negro Exhibit
11. Prudential Life Insurance Company
12. Prudential Life Insurance Company
13. Negro Exhibit
14. Negro Exhibit

FIGURE 14. Plan of the American exhibit, including the "American Negro" exhibit, Social Economy Pavilion, Exposition Universelle, Paris, 1900. From *Report of the Commissioner-General for the United States to the International Universal Exposition, Paris, 1900*, vol. 2 (Washington, D.C.: Government Printing Office, 1901). Drawn by Jacob Segal.

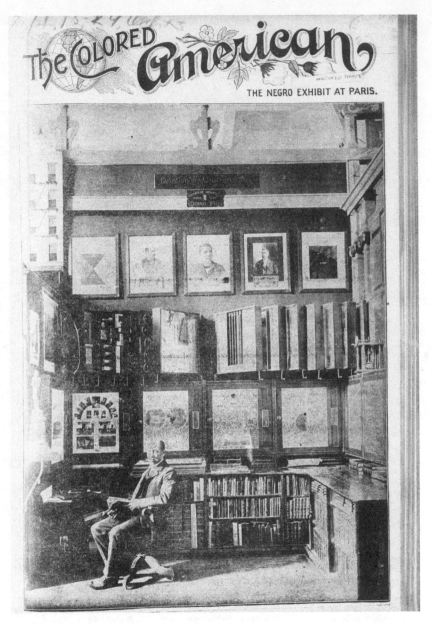

FIGURE 15. *Colored American* cover, picturing T. J. Calloway at "American Negro" exhibit, Exposition Universelle, Paris, 1900. Courtesy of Library of Congress. LC-USZ62–35751.

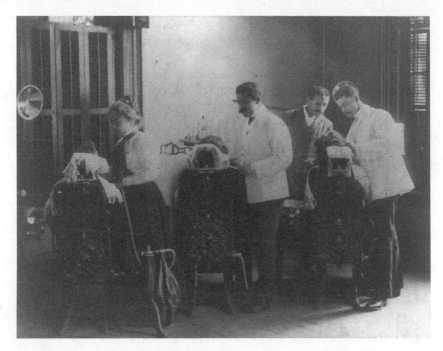

FIGURE 16 Photo of dentistry at Howard University, "American Negro" exhibit, Exposition Universelle, Paris, 1900. Courtesy of Library of Congress, Prints and Photographs Division. LC-USZ62–35751.

skills of dentistry at Howard University. On display above this case were sheets of four hundred patents by black inventors. In nearby case number four, the Hampton Institute's contribution showed photographs of the school by white photographer Frances B. Johnston. These plates had originally been taken for an article titled "Learning by Doin' at Hampton" published in the *American Monthly Review of Reviews*. Johnston's photographs of educational life at the school reflected both how the school wanted to present itself—uplifting blacks from ignorance and squalor—and what white benefactors perceived black education to produce, a subservient, dutiful black working and farmer class.[51] Elsewhere, visitors could examine photographs of other industrial schools and leaf through wing frames containing sewing and dressmaking samples.

In keeping with the mandate of industrial education for the Negro, seventeen hinged vitrines, positioned at eye height and placed on the central wall of the exhibition area, contained workshop and agricultural samples from the Tuskegee Institute. The school also contributed a series of large photomontages of the campus buildings, fields of crops, and stu-

dents in industrial training classes. One photograph depicted women till-
ing the fields around the school's extensive acreage. Another photograph
showed male students learning trades in the school's numerous workshops.
Similar to the didactic exercise at Atlanta's Negro Building—educating
the nation about the moral virtues of industrial education—the Tuskegee
exhibit presented Washington's increasingly popular doctrine to an in-
ternational audience. "When I speak of education as a solution for the
race problem," Washington wrote in an article on the value of industrial
training for social betterment, published during the period of the fair, "I
do not mean education in the narrow sense, but education which begins
in the home and includes training in industry and in habits of thrift, as
well as mental, moral, and religious discipline, and broader education
which come from contact with the public sentiment of the community in
which one lives."[52] Just above the Tuskegee display, in a central location
of the overall exhibit, were hung the photographic portraits of three black
leaders, New Negroes who had risen to national prominence. Two were
of national registrars of the U.S. Treasury, whose signatures appeared on
U.S. bank notes: former U.S. senator Blanche K. Bruce and Judson W.
Lyons, the current registrar. Third was of Booker T. Washington.[53]

Adjacent to this core section that emphasized how industrial educa-
tion bettered the fortunes of the nation's black masses appeared the out-
comes of those efforts: entrance into the small but growing middle class.
Photographs in case number two captured well-appointed single-family
homes whose residents adorned the exteriors with modest Victorian and
Queen Anne detailing. Atlanta's Bishops Henry McNeal Turner and Wes-
ley J. Gaines, along with well-known Washingtonians Francis J. Grimké
and Daniel P. Murray, owned the houses on view. These households ex-
emplified that bourgeois black families maintained a stable home life
founded on practices of thrift and adherence to strict and high moral stan-
dards. In the vestibule outside of the "American Negro" exhibit, a long
glass case showcased several models crafted by a teacher in the District
of Columbia's public schools. These nine tableaux chronicled the history
of Negro education. The scenes traced the evolution of an illiterate and
newly emancipated slave family whose future generation would become
the cadets and young ladies attending the "large commodious building
of the Washington Colored High School."[54] Generally, this comparative
display of schools and homes accomplished Calloway's curatorial in-
tention that "by contrasting views of mud chimney cabins with well ap-
pointed homes, crude log schoolhouses with commodious school build-
ings, etc., the past and present conditions of the race will be shown in a

FIGURE 17. Tuskegee Institute and its industries, photo montage by Harry Shepard, "American Negro" exhibit, Exposition Universelle, Paris, 1900. Courtesy of Library of Congress, Prints and Photographs Division. LC-USZ62-131969.

way to remove all doubt of the rapid progress being made."[55] Under Calloway's direction, the "past and present conditions of the race" chronicled blacks' cultural evolution and showed the history of the Negro in America.

While education was paramount to improving the conditions of black life, the "American Negro" exhibit also delivered a persuasive statement on artistic and intellectual achievements. Making use of the immense stores of the Library of Congress and selecting works from a variety of sources, Murray assembled an impressive bibliography of twelve hundred books. He shipped over two hundred books to Paris. This cross section of reading material was arranged on the shelves below the vitrines. Among Murray's choices of history and commentary appeared George Washington Williams's *History of the Negro Race in America*. Visitors could find on the shelves copies of Washington's *The Future of the American Negro* and Du Bois's *The Philadelphia Negro* and *Suppression of the African Slave Trade*. Works of history, literature, theology, and poetry by Frederick Douglass, Phyllis Wheatley, Charles Chestnutt, Paul Lawrence Dunbar, David Walker, and Bishop Benjamin T. Tanner rounded out the impressive collection.[56] With musical scores, weeklies, newspapers, and periodicals available for the public's perusal, this section of

FIGURE 18. Photos of (top) the home of Bishop Wesley J. Gaines, Atlanta, Ga., and (bottom) homes of poorer classes, Chattanooga, Tenn., "American Negro" exhibit, Exposition Universelle, Paris, 1900. Courtesy of Library of Congress, Prints and Photographs Division. LC-USZ62–67892 and LC-USZ62–72447.

the exhibit presented America's blacks as creative, literate, and cultur-
ally sophisticated.

Although Washington's authoritarian hand loomed as a formidable
presence in the content of the "American Negro" exhibit, Du Bois's own
carefully crafted interpretation racial progress challenged the powerful
race leader's impressive reach. Below the vitrines exhibiting Tuskegee's
submission, fairgoers could examine the plates and review the data from
Du Bois's Georgia Negro study. The graphic survey of thirty-two charts
and graphs, five hundred photographs, and numerous maps and plans
was placed in a commanding position in the oak cabinets.[57] Rather than
show artifacts of rural life and products of manual training, as did the
contents of Atlanta's Negro Building and the nearby Tuskegee offering,
the Georgia Negro study presented a scientific analysis processed by the
agile minds of American blacks. Du Bois had completed this systematic
sociological analysis in the early months of 1900 with the assistance of
devoted Atlanta University student researchers and compilers. They il-
lustrated all of the plates in colored inks on heavy white stock and trans-
lated some of the captions into French. As much a historical survey as a
sociological inquiry, the Georgia Negro display's insightful and concise
presentation narrated black life in Georgia over the course of the thirty
years since Emancipation.

When read comprehensively, the graphic information in Du Bois's sci-
entific study documented the social transformation of a group of people
from the Middle Passage to the twentieth century. Here for all to see were
tallied the facts that meant the American Negro had to be considered be-
yond the confines of the South and, in a key polemical move by Du Bois,
as integral to the formation of modernity. Affirming his scientific method,
Du Bois declared, "We have statistics: The increase of the black popula-
tion from 30,000 to 860,000, the huddling in the Black Belt for self-pro-
tection since the war, and a comparison of the age distribution with France
showing the wonderful reproductive power of the blacks."[58] In one of
the first plates, Du Bois located Georgia within the routes between Africa
and the Americas during the African slave trade, indicating the vast ex-
tent of what we now identify as the African diaspora. This introductory
map drew a historical and spatial sphere, a transnational one, in which
black life in Georgia was situated. In spite of the efforts by whites to po-
sition blacks outside the march of social progress, this first plate confirmed
that peoples of African descent throughout the world, including those in
Georgia, had participated in and would continue to contribute to the for-
ward advance of civilization (and capitalism). As Du Bois wrote in his

review of the fair in the *American Monthly Review of Reviews,* "One can see the successive steps by which the 220,000 negroes of 1750 had increased to 7,500,000 in 1890" and document "their distribution through the different States." Deliberately international in its scope of evaluation, the study's statistical analysis showed that a "comparison of the size of the Negro population with European countries underscored the striking fact that there are nearly half as many Negroes in the United States as Spaniards in Spain."[59] Plates educated viewers on the growth of the black population in the U.S. distribution of city and rural populations alongside a historical account of slave/free populations and statistics regarding educational enrollment, distribution of wealth, landholding, miscegenation, marital status, number of Negro publications, and distribution of religious denominations.

Complementing the data shown in the charts and graphs, Du Bois presented visual documentation in an album titled *Negro Life in Georgia, U.S.A.* Photography offered him another modern means of documentation and analysis. As scholar Deborah Willis has noted about the photographs taken by Thomas E. Askew for Du Bois, the brilliant sociologist "exhibited [a] curatorial vision that can be seen as both aesthetic and political."[60] Photography's strategic use in the exhibit was meant to shatter the demeaning image held in the minds of whites that Negroes comprised an undifferentiated black mass. The pictures provided a compelling visual narrative of the everyday spaces—homes, workplaces, churches, and civic organizations—where Georgia blacks belonged and lived. Challenging the perception that all southern blacks came straight from plantations (as the Atlanta fair's Ole Plantation concession had posed), but also making a claim to new designations of class, *Negro Life in Georgia, U.S.A.* captured everyday existence in the Victorian interiors of upper-class homes, well-stocked retail establishments, business offices, and social gatherings attended by fashionably dressed men and women of the black bourgeoisie. These images also promoted the conservative claim that the small but growing community of elite blacks was socially comparable to whites in standards of decency and domestic propriety. Other photographs portrayed dilapidated shotgun houses, rural shacks, and back alleys inhabited by the uneducated poor, or as Du Bois had labeled them in *The Philadelphia Negro,* Grade 3 "persons not caring enough to keep them at all times above want . . . with no touch of gross immorality or crime."[61] This array of images captured the diverse urban panorama that characterized Atlanta's Black Side and other U.S. cities, showing blacks evolution from shacks to affluent residences.

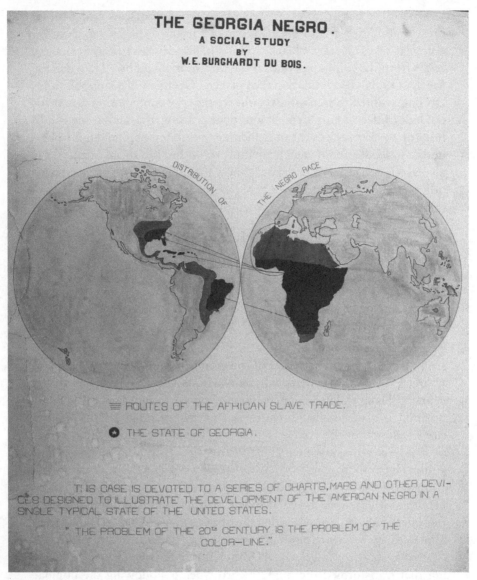

FIGURE 19. First plate of the Georgia Negro display, "American Negro" exhibit, Exposition Universelle, Paris, 1900. Courtesy of Library of Congress, Prints and Photographs Division.

Offering a historical counterpoint to the photographs and data on present conditions, Du Bois also included in his display a hand-copied compilation of Georgia's Black Codes. Collected by his researchers, these codes from the colonial period to the current moment listed in detail the forms of racial discrimination that plagued Georgia's black populations. Du Bois wanted to remind his audience that the contributing causes for the lack of decent employment and poor housing, the deplorable conditions of poverty seen in the documentary photographs, could not be limited to a debate about racial constitution within the social sciences. He also wanted visitors to understand how the unjust nature of racial prejudice had been ingrained over time, historically, in the country's laws—the very statutes that were supposed to sustain a fair and egalitarian society in the United States.

An additional three volumes of photographs titled *Types of American Negroes* revealed the scientific foundations of the Georgia Negro. These portraits included frontal and side portraits of men, women, boys, and girls taken in front of a dark backdrop. According to Du Bois, and later mentioned in a postexposition evaluation of the images, the subjects in many of these photographs had been "selected out of a school of about 300 young people between the ages of 12 and 20 years, 56 persons who seem to me to be fairly typical of the group of young Negroes . . . all of whom I have known personally for periods varying from one to ten years."[62] From statements made by Du Bois six years after the Paris exposition, it can be inferred that these students attended Atlanta University's high school and college. Du Bois collected these numerous profiles over several years, and he included early versions in the Georgia Negro study. These photographs would eventually become the core data for a comparative study of racial diversity that appeared as part of the Negro Health and Physique conference held at Atlanta University in 1906. In this later study, Du Bois classified the fifty-six images by racial types, each explained by a brief caption. These portraits documented the complex character of "Afro American types" in terms of the history of racial mixing that transformed the pure "Negro type."[63] Following the popular methodology of ethnography, Du Bois organized the racial types in a chromatic evolution of miscegenation from "Negro types," "Mulatto types," "Quadroon types," to "White types with Negro blood." From his careful assessment of these four types of American Negroes, any one of these types in his analysis could display desirable and undesirable physical and personal characteristics.[64] In relation to the latest anthropological tenets, the research contested the concept of the purity and superiority of one

FIGURE 20. Plates from *Types of American Negroes*, "American Negro" exhibit, Exposition Universelle, Paris, 1900. Courtesy of Library of Congress, Prints and Photographs Division. LC-USZ62–124639 and LC-USZ62–124640.

racial type, arguing that even comparative experiments of brain weight failed to discern the differences between black and white racial physiognomies. Du Bois questioned the inherent value of positing racial traits of face, hair, body type, and skin color as a measure of evolutionary advancement. In light of the flawed conclusions derived from the visual evidence of racial mixing as a determination of character, the sociologist reasoned that "in all these cases of physical and mental development and moral stamina, it is naturally very difficult to judge between the relative influence of heredity and environment—of the influence of Negro and mixed blood, and of the homes and schools and social atmosphere surrounding the colored people."[65] From this analysis of racial physiognomies, which was already manifest in the earlier Georgia Negro study, Du Bois concluded that it would be social conditions—subject to the influences of antiblack racism but also capable of being improved—that would determine the trajectory of any individual or racial group.[66]

As a comprehensive portrait of race and racism, the Georgia Negro study illustrates the progression of Du Bois's own theory of how black Americans would advance, which became based on an analysis and repudiation of theories of racial science and an evaluation of the impact of white supremacy in America. Du Bois's position on antiblack racism,

as the inclusion of the Black Codes and portraits of Negro life in the Paris exhibit support, saw class difference and national chauvinism as fundamental currents underlying the racial oppression blacks endured. We should note that Du Bois prepared the Georgia Negro study in the years between organizing the "The Negro Health and Physique" conference and writing the earlier essay "The Conservation of Races," presenting the latter to the American Negro Academy (ANA) in 1897. Part of the black counterpublic sphere, the ANA formed out of several literary groups in Washington, D.C., including the Bethel Literary and Historical Association. The ANA affirmed Du Bois's belief in the relevance of an intellectual vanguard and the importance of nurturing a black intelligentsia.[67] The select group of educators, artists, and scholars counted many fair boosters as members: Du Bois, Calloway, Henry O. Tanner, Major R. R. Wright, William H. Crogman, and Kelly Miller, a noted attorney and educator. Although clubwoman and educator Mary Church Terrell had been elected as president of the Bethel Literary and Historical Association and had therefore worked with many of the ANA's members, no women had been inducted into the organization. Collectively championing racial solidarity and advancement, the elite membership possessed a diverse range of positions, from ardent Pan-Africanists to industrial education advocates.[68] Proud of his association and at the time the academy President, Du Bois would include a list of the ANA's members in the "American Negro" exhibit.

At the inaugural meeting of the ANA in March 1897, Du Bois presented his essay "The Conservation of Races." Fundamentally essentialist in its affirmation of the biological basis of race, Du Bois discussed the tension and mutually constitutive relationship between racial and national identities.[69] In the measured prose of the social scientist, Du Bois reasoned that racial commonalities such as tribal associations had been the historical determinant of group affiliation. But as groups came together in cities, bonds of consanguinity lessened and peoples intermingled and became civilized. Subsequently, visible racial differences became secondary to newly cultivated social bonds and commonalities forged through economic necessity and spatial proximity. In this historical process, the physical distance between groups lessened as they established mutually dependent domestic and public spheres. Over time these social commonalities and practices, both spiritual and psychical, cemented collective bonds. Du Bois charted how cities evolved to become distinctly identified by their social differences—thus producing cities of husbandmen, merchants, or warriors. Cities eventually merged into "nations,"

surmounting once again physical distance. At this moment, according to Du Bois, ruling groups discovered that by foregrounding racial difference, this time as social differences recalibrated with new physiognomic evidence accorded by racial science, new national identities came into being. Following the logic of Du Bois's teleology of civilization, as nationalist ideologies drew together the phenotypic markers of race with the sociohistorical legacy of racial difference, transcendent ideals in the form of a "national character" and culture emerged. Du Bois posited that "spiritual messages," a theory derived from Hegel's material and spiritual dialectic, were expressed in national character: for England it was constitutional liberty and commercial freedom; for Germany it was science and philosophy.[70] As someone who had lived for two years in Germany and traveled widely, Du Bois was keenly aware of how the world's fairs functioned as international stages for the pageant of national character and spirit, where distinct cultural identities could be displayed, performed, and compared.[71] In this regard, why couldn't the Paris exhibition be the venue in which to represent the Negro's true "national character" and "spiritual message?"

With this sociocultural evolution mapped out, the transformation of the social and material conditions of urban life would be a requisite step in cultivating a Negro spirit *and* a Pan-Negro nation, hence Du Bois's continued research on black residents in cities like Atlanta and Philadelphia. Moreover, it was in the paradoxical conflict between the spiritual formation of the Negro as African (a cultural identity that formed "his" historical and social underpinnings) and the Negro as American (a national identity that devalued "his" potential) that produced the psychical split—a double consciousness in the American Negro. As Du Bois reflected in a passage from the "The Conservation of Races," which would become central to his seminal *Souls of Black Folks,* "What after all, am I? Am I an American or am I a Negro? Can I be both?"[72]

Toward the end of his essay, in a stance also taken in the Georgia Negro study, Du Bois argued that American blacks had to form their own nation that cultivated their own "race organizations: Negro colleges, Negro newspapers, Negro business organizations, a Negro school of literature and art, and an intellectual clearing house, for all these products of the Negro mind," like those found in the Black Side of Atlanta and Washington, D.C. He affirmed that "if in America it is to be proven for the first time in the modern world that Negroes . . . are a nation stored with wonderful possibilities of culture, then their destiny is not a servile imitation of Anglo-Saxon culture." This bold Black Nationalist statement

of independence and difference confirmed "a stalwart a originality which shall unswervingly follow Negro ideals."[73] For Du Bois, the Exposition Universelle provided an ideal international stage for the presentation of the Negro spirit and the Negro nation, which together he would later term Negro "culture." In this regard, with its visual compendium of blackness, albeit bourgeois, and its emphasis on the black counterpublic sphere and cultural achievement, the Georgia Negro display strategically challenged the desirability of America's national identity—especially given the nation's unfulfilled promises to black citizens.

The crowds in Paris lauded Calloway's well-crafted "American Negro" exhibit and Du Bois's ambitious sociological study. Calloway traveled with his wife, Anna, and their two children to Paris in March 1900 to oversee the installation of exhibits. Du Bois joined them later in the spring. Their curatorial efforts received wide praise from the exposition's juries, who awarded "American Negro" several prizes despite the fact that judges reviewed the work prior to its full installation. The judges conferred gold medals to the Georgia Negro display and its creator, Du Bois. They also honored the Tuskegee exhibit with a gold medal and distinguished Washington's *Monograph on the Education of the Negro* with a silver medal. But the real triumph occurred when the entire "American Negro" exhibit received the highly coveted Grand Prix. The mainstream press proudly reported these awards and wrote in detail about the exhibit and its organizers. Black publications like the *Colored American* and the *New York Age* featured extensive coverage of the exhibit and its accolades, along with detailed accounts about the exposition's many pavilions and highlights of the great sights of Paris.

During their tour of Paris and its splendid fairgrounds, Calloway and Du Bois, along with Hilyer, educator and activist Anna Julia Cooper, a young artist studying at the École des Beaux-Arts named Meta Vaux Warrick (later Fuller), and others attended a lavish banquet hosted at the U.S. Pavilion to celebrate the success of their endeavor.[74] These well-educated, successful blacks exemplified the new American Negro vanguard—what Du Bois would later christen the race's "Talented Tenth." This gathering of America's black elite stood in stark contrast to the caricatures of the subservient New World Negro and savage African depicted in some sections of the Paris fairgrounds. An American company, for example, imported a taste of southern culture and racist folklore by employing a black woman as a jovial Aunt Jemima to sell hot corn cakes in one of the pavilions. The global reach of European colonialism also transported to the fairgrounds other disparaging representations of black cultural identity.

For instance, the immensely popular Dahomey Village, one of the many colonial exhibits built by the French to re-create distant "exotic" colonies, imported peoples from that region of Africa. Regardless of how this group may have wanted to present their culture with pride and dignity to the European audiences, their presence at the fairgrounds afforded white visitors the opportunity to bear witness to their own cultural advancement beyond these "poor wretched savages."[75] Behind the illuminated façades of innocent delight, it was the violent acquisition of territory in Africa and other places, along with the imposition of colonial rule by European nations and the United States, that supplied the valuable raw materials that generated the great economic wealth on view at the magnificent Paris fairgrounds.

Following their grand banquet at the U.S. Pavilion, Du Bois and Calloway, accompanied by Cooper, traveled to London in the last week of July. Once in England, they joined a contingent of American representatives that included Bishop Turner and attended the first Pan-African Congress. Convened at Westminster Town Hall, the three-day convocation brought together over thirty black representatives. Men and women from Haiti, Jamaica, Barbados, Trinidad, Canada, Abyssinia, Liberia, Sierra Leone, South Africa, the colonial city of Lagos, and other parts of the world convened to deliberate how to improve the condition of the colored race.[76] Du Bois, as recounted by Lewis, was thrilled that London, "a metropolis of the modern world," as he called the city in his address to the Pan-African Congress, afforded him to be in the company of "racial equals for a change."[77] In his speech, which was adopted by the group and dispatched to leaders of the black world, Du Bois observed that modernization, a civilizing process, was in fact bringing black and brown people closer together. He reminded his audience that the opportunity for education and self-development would facilitate the emergence of a black "culture," what he had previously characterized as a "spiritual message," that would benefit all of human progress. This advancement would only be possible, however, if the problem of racial difference, what he called the "color line," did not curtail the progress of black peoples around the world.[78]

Du Bois's survey of Atlanta's and Georgia's blacks, whose introductory plate included the pronouncement that "the problem of the Twentieth Century is the problem of the color line," proved that blacks in America had elevated their status and would continue to advance their welfare despite toiling against the caustic effects of racial segregation and violence—a topic that Washington had evaded in his much lauded Atlanta presen-

tation five years before. For Du Bois, the "American Negro" exhibit offered a moment of reflection and appraisal concerning the path traveled thus far. It also represented an opportunity to present to the world the successes of the Negro race in "picturing their life and development without apology [a reference to Washington's Atlanta compromise] or gloss, and above all made by themselves."[79] Indeed, the Negro race, in Du Bois's estimation, had formed a Negro nation. Whether it could prosper within an American one or should ally itself in order to thrive with other Pan-African nations was not yet clear. But there would be other opportunities for black Americans to the see the thrilling exhibit and its multivalent message of black progress.

Hearing of the wonderful international reception of the "American Negro" exhibit, citizens in Buffalo, New York—in particular members of the Phyllis Wheatley Club of Colored Women, an affiliate of the newly established National Association of Colored Women (NACW)—contacted Calloway. They hoped to bring the award-winning exhibit from Paris to join their own exhibit on black progress at the Pan-American Exposition being planned for the city in 1901. At the turn of the century, Buffalo was home to a small but prosperous black enclave of 1,700 residents—less than 1 percent of the total population.[80] Buffalo's clubwomen and city leaders typified the black middle class taking root in cities around the country. The increasing number of schools and colleges cultivated a literate population who read black newspapers, weeklies, and magazines. Through these sources, they became keenly aware of the spread of Jim Crow segregation and the escalation of lynching and racial violence, along with what was being done to halt it. Black publications like the *Colored American, Colored American Magazine, Washington Bee, New York Age, Chicago Defender,* and *Richmond Planet* also provided venues to publicize and evaluate the various fairs in terms of how they would best present and improve the fortunes of the Negro. The reports on the award-winning Parisian exhibit and the success of the Negro Buildings in Atlanta and Nashville inspired other groups to want to display their accomplishments and local efforts at social advancement. Thus business, fraternal, benevolent, and protest organizations like the Phyllis Wheatley Club fostered a counterpublic sphere in which strategies of self-help and emerging civil rights activism vied for acceptance.

The members of the Phyllis Wheatley Club were adamant about having black representation at the forthcoming Buffalo exposition. Women like Ida B. Wells, who had intensified her activism against lynching since

her White City protest, and Mary Church Terrell, a suffragist, civil rights activist, and cofounder of the NACW, represented the growing number of progressive and educated black women. Like their white counterparts, the New Negro women believed steadfastly that all women should be given the same rights as men. Why shouldn't black women have a strong presence in organizing the fair's festivities and contribute to the content of exhibits and events argued the learned women of the Phyllis Wheatley Club, which included in its ranks Mary Burnett Talbert, a graduate of Oberlin College, and Mrs. Charles Banks, a graduate of the Hampton Institute.[81] Attorney, journalist, and politician James A. Ross joined Talbert to rally support at a meeting in November 1900. At the end of the gathering those assembled agreed to contact exposition officials to organize a Negro exhibit.[82] The determined coalition, inspired by Wells's activism at the World's Colombian Exposition, protested to the Pan-American Exposition board about the exclusion of black involvement. By the time Calloway arrived in Buffalo a month later to propose the exhibit, the governing board, some of whom had attended the Atlanta fair and witnessed the success of the Negro Building there, was willing to incorporate the "American Negro" exhibit, perhaps because of its many awards, into the displays at the Pan-American Exposition.[83]

A lakefront port and the eighth-largest city in the United States, Buffalo staged the fair to boost its chances to become one of the top industrial and trade centers for the Americas, a much sought after distinction in the wake of the recent imperial acquisitions of the Spanish-American War.[84] By excluding European involvement, the exhibits focused on promoting the markets and industry of the Americas. The architecture and fairgrounds of the Pan-American Exposition would express the United States' power to control its natural resources and would symbolize its dominance over the Americas.

Planners laid out the extensive fairgrounds on 350 acres of New York farmland. Energy generated from nearby Niagara Falls electrified the entire exposition. In keeping with the tradition of using the fairgrounds for experimentation in city planning, the exposition's layout enacted a symbolic and allegorical passage of human development and cultural evolution in which every race, along with every function, was given its appropriate place. This approach reflected the increasing use of social management and zoning to control immigrant populations pouring into northern industrial centers. In an aesthetic move to transcend the earlier Chicago exposition's monochromatic White City, whose whiteness symbolized an East-West axis of Euro-American cultural superiority, the Pan-

American planners chose to fully represent a polychromatic racial progression. To materialize the North-South American axis of the exposition's scope, the architects applied a range of hues on the exposition's Spanish Renaissance–styled pavilions. There in the muted light of the Great Lakes, transformed at night by millions of sparkling electric lights illuminated by hydroelectricity, visitors entering into the so-called Rainbow City's esplanade first witnessed cruder "barbarian" colors of reds, yellows, blues, and greens. After this primary color assortment, their view shifted to the middle ground pavilions whose refined color palette lightened to pale grey, blue, and buff hues. Finally, in the distance, their gazes lighted upon a crescendo of ivory and white hues enveloping the beacon of the Electric Tower, which at night beamed a great searchlight to illuminate the noble prospect beyond.[85] With hierarchies of race and nation as the framework, a narrative of civilization was carefully embedded in the visual and spatial order of the fairgrounds, as it had been at other fairs.

The vitrines, maps, and photographs of the "American Negro" exhibit filled a corner of the Social Economy section in the sprawling Liberal Arts Building. Under the stewardship of Ross (mentioned in one newspaper as "the assistant in charge of Negro Exhibits"), Calloway and Du Bois's entire exhibit was on hand, with additional material added to highlight local issues and people.[86] Black newspapers like the *Colored American* promoted the fair, praising the gracious reception extended by Buffalo's black community. The NACW convened its biennial national congress in Buffalo during the fair and Terrell, Margaret Washington, Talbert, and others brought the debate about black women's rights and suffrage to Pan-American audiences. Other more disparaging events also took place. President William McKinley's assassination while visiting the world's fair leveled another blow to the political aspirations of black leaders. While McKinley, a Republican, had failed to halt the disenfranchisement of blacks from participation in the political system, he nevertheless made appointments, with the counsel of Washington, of many former black politicians to federal positions. Moreover, despite the "American Negro" exhibit's exquisitely crafted message of progress, racist propaganda, as it had been at other fairs, could be seen all around Buffalo's Rainbow City. Buttressing the exposition's social Darwinist themes seen elsewhere on the fairgrounds, the Darkest Africa attraction, a village of ninety-eight "Africans" funded by the Buffalo Society of Natural Sciences, and across the way yet another Old Plantation concession, proved popular venues along the Pan-American's Midway.[87]

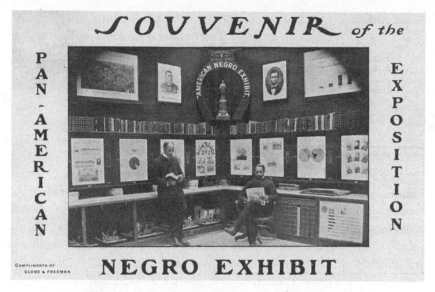

FIGURE 21. T. J. Calloway (left) and James A. Ross (right), "American Negro" exhibit, Pan-American Exposition, Buffalo, 1901. From *Souvenir of Negro Exhibit—Pan American Exposition* (Buffalo, N.Y.: Globe and Freeman, 1901). Courtesy of Buffalo and Erie County Public Library, Buffalo, N.Y.

When shown in the United States, the "American Negro" exhibit contested the racist ideological schema of the Buffalo fair by showing through scientific and material evidence that blacks were equivalent to whites in creative and intellectual ability. It showed that Buffalo's black population was striving to overcome what the Georgia Negro display's first plate had described as the color line imposed by the growing presence of racial segregation, even in the North.[88] The Phyllis Wheatley Club sponsored the exhibit to challenge the racist symbolism of the fair's layout and the degrading imagery of plantation and ethnographic concessions. The women astutely deployed the exhibit as a counterargument integral to their emerging demands for equal treatment of black women and men, showing a willingness to fight for fair representation.

When it concluded its presentation in Buffalo, "American Negro" would next be shipped south to the world's fair in Charleston, South Carolina. At two more southern expositions, Du Bois, Calloway, and Washington, along with Murray, Fuller, and others, would continue to debate and represent their divergent perspectives on the past, present, and future of black life in America. Many leaders in the South, where the large majority of black Americans still lived, deployed Washington's strategy

of accommodation and utilized major fairs planned for Charleston in 1902 and Jamestown in 1907 to foster white confidence in their industriousness and obedience; however, as the rest of this chapter questions, would the widespread segregation of facilities and poor treatment of black participants and visitors at these events eventually erode the viability of those aspirations?

"EXPOSITIONS AN INDEX TO PROGRESS"

In its assessment of the value of the Negro Buildings at southern expositions, the weekly Bookerite *Colored American* editorialized below the subheadline "Expositions an Index to Progress" that "it is but natural that our achievements in agricultural and mechanical branches should show to most favorable advantage in the South." The editors reminded their readers, "That section is our fatherland. There is where the Negro is found in the greatest number, and where exists the best opportunities to see the race as it is."[89] Keenly aware of the value of black participation at the New Orleans, Philadelphia, Chicago, Atlanta, Paris, Buffalo, and other fairs, Washington campaigned for Charleston's South Carolina Inter-State and West Indian Exposition to have its own Negro Building. Washington made his request to fair planners, even though the state and municipal legislatures of South Carolina had been the most aggressive in disenfranchising black male voters from their constitutional right to cast ballots and their right to be elected to political office.

In response to their exclusion from politics, an important source of power and influence, Washington conceived of a new philosophy of black economic self-help that was still in accordance with his overall strategy of racial uplift. To promote this new agenda, he organized the National Negro Business League (NNBL) in 1900, an organization that supported the growth of black business and encouraged entrepreneurship. His philosophy of self-help, derived from popular social Darwinist theories that had merged with liberal capitalist dogma, concluded that blacks would survive in the United States if a vanguard of businessmen made the race economically competitive.[90] Consequently, a well-considered and organized showing at the Charleston's fair dedicated to commerce would afford the perfect venue to test the feasibility of that prospect. If in Atlanta the Negro Building demonstrated that black workers had the skills to craft with their hands, then Charleston's Negro Building would show that black entrepreneurs possessed the acumen to profit by their industriousness. In the same way the board of directors at the Atlanta fair had addressed their

"Negro problem," the organizers of the Charleston event realized that in a city of sixty thousand, more than half of whom were black, a dedicated freestanding pavilion to Negro progress would, as Washington had advised, provide an "opportunity for the colored people of the United States." From Washington's perspective in the South, "so far as it concerns the treatment of the negro," he reasoned, perhaps too optimistically, the fair would take place in "one of the most liberal cities in the country."[91]

To avoid large crowds sauntering about the fairgrounds in Charleston's stifling summer heat and humidity, the fair builders planned to commence the Inter-State and West Indian Exposition in the temperate month of December 1901, opening its gates just one month after Buffalo's grand Pan-American Exposition closed. The Charleston fair mirrored the ambitions of its upland neighbor Atlanta, placing emphasis on commerce to provide the port city's merchants with the opportunity to foster new trading relations with other markets in the Caribbean and Central and Southern America nations. The city's standing as a major seaport had decreased significantly with the emergence of railroad hubs like Atlanta that were far more efficient in moving the South's raw materials to western and northern destinations. For many years Charleston's white business elites, whose infighting and absence of a solid plan for rebuilding after the Civil War had stunted the lowland's economic recovery, failed to maintain a critical rail link to the West. As a result, the once-bustling mercantile center, whose piers were now crumbling from disuse, had suffered from a series of economic depressions and natural disasters.[92]

Sited on 160 acres along Charleston's winding Ashley River, the fair erected its own "Ivory City," designed in a Spanish Renaissance and mission style by Bradford L. Gilbert, the architect of the Atlanta exposition. The Inter-State and West Indian Exposition raised pavilions dedicated to the South's great resources: Cotton and Commerce; Agricultures; Minerals; Forestry; Southern Women; the Arts; Transportation; Machinery; and the Negro.[93] Washington accepted the appointment as commissioner-in-chief for the Negro Building. He conceived of the pavilion's message of Negro progress, once again planning to exhibit numerous displays on industrial education and to showcase the diverse products of manual labor.[94] At the meeting of the Hampton Negro Conference convened the summer before the fair, it was resolved that the content of the Charleston exhibits would focus on the themes of education, religion, sanitation, and business while avoiding any subject matter that alluded to social and political protest.[95]

To implement his plans, Washington assembled a team from around

FIGURE 22. Negro Building, South Carolina Inter-State and West Indian Exposition, Charleston, 1902. From West Charleston Sertoma Club, *Charleston and the South Carolina Inter-State and West Indian Exposition: An Illustrated Souvenir of the Beautiful Exposition and the Historical Places and Prominent Features of the City* (Charleston, S.C.: Nelson's Southern Printing and Publishing, 1958). Courtesy of Special Collections Research Center, California State University at Fresno.

the South. Dr. William D. Crum—a highly respected physician and a politically ambitious former U.S. congressional representative who was forced out of office—assisted the Tuskegee leader with the preparations. With Washington's backing, Crum had recently been appointed to the controversial position of the collector of customs for the Port of Charleston.[96] Crum had also served as a Negro commissioner from South Carolina at the Atlanta Cotton States Exposition and therefore had experience planning fairs. With southern states eliminating black participation in all levels of government, fairs like Charleston's provided one of the few public venues where black men (some of whom harbored political aspirations, if not by election then by appointment), could become acquainted with those whites steering the reins of the region's power. With his leanings somewhere between Washington and Du Bois, Kelly Miller—a speaker at the Colored Women's Congress at the Negro Building in Atlanta, a respected professor of mathematics and sociology at Howard University, and a member of the ANA—was put in charge of the Bureau of Education for Charleston's Negro Building. Miller assembled a display that primarily showcased progress in the education of children, teachers, and manual laborers, but he also included a small section of work from black colleges.[97] Along with education, the organizers planned exhibits in agriculture, mechanics, and manufactures. Other important categories included morals and religions and social culture. Mrs. E. F. Sterrett, who was put in charge of the Negro Building's Women's Bureau, attended the NACW congress in Buffalo to solicit support for the Charleston exposition. Terrell, Margaret Washington, Josephine Bruce, and Anna Murray,

wife of Daniel P. Murray, assisted in organizing the woman's work displays, which would feature advances made in domestic arts, fine arts, and home economics. Calloway was briefly involved with the preparations for the Charleston event. His award-winning "American Negro" exhibit, including Du Bois's Georgia Negro study, was featured as one the Negro Building's main displays at the Inter-State and West Indian Exposition.

Except for the presence of Du Bois's finely honed sociological and historical analysis of the impact of antiblack racism and segregation on black life in Georgia, Charleston's Negro Building deliberately shunned any explicit protest of social inequalities or the question of suffrage. Led by Washington and his mandate of patient accommodation, black organizers seemed unwilling to antagonize their white patrons. Unfortunately, over the course of the preparations and the during the exposition, white organizers made several overt gestures to make sure that their fellow black Charlestonians and their guests stayed within their assigned places at the fairgrounds and in the segregated environs beyond the gates.

Gilbert and his planners sited Charleston's Negro Building between the Alaskan and Guatemalan Pavilions in a corner of the exposition grounds that was labeled the "natural section." Holding steadfast to Old South traditions rather than the upland's New South agenda, white organizers initially proposed that the Negro Building's aesthetic décor should recall that of the nearby antebellum cotton and rice plantations. In keeping with Old South nostalgia, they even planned to re-create a slave quarters surrounding this "homestead" to best showcase the development of the Negro race.[98] As designed by Gilbert and built by black work crews, a Spanish mission–style pavilion housed Charleston's collection representing Negro industriousness, which was fortunately displayed without the historical slave dependencies. The fifteen-thousand-square-foot Negro Building was laid out as a letter *H* that embraced two courtyards. Its size was half that of the Atlanta building and its open-trussed interior housed a moderate hall suitable for congress meetings and lectures. Tuskegee's contribution filled most of the south wing of the building. To welcome visitors to the hall and its many exhibits, students from an industrial training program erected a large brick archway. The building's contents put on a comprehensive display of the handicraft of black labor, but a final design gesture did unfortunately reinforce Old South perceptions. Recalling the antebellum landscaping of the grand plantation houses, the building had been situated so that a picturesque grove of live oaks ringed the pavilion as it overlooked the Ashley River—the main causeway that also flowed pass the major plantations of the region.

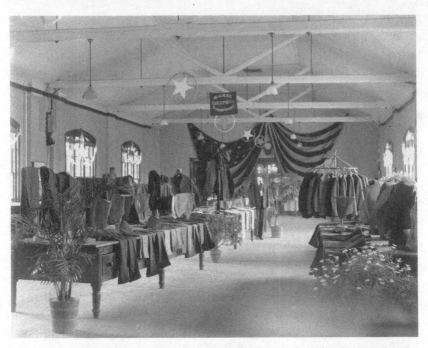

FIGURE 23. Hampton Institute exhibit, Negro Building, South Carolina Inter-State and West Indian Exposition, Charleston, 1902. Courtesy of Hampton University Archives.

The seamless representation of the cooperative, entrepreneurial southern Negro at the Charleston fair was shattered, however, by a divisive row over the installation of a large statue that paid homage to the region's plantation culture. In his role of chief architect, Gilbert envisioned for the front of the stately main Court of Palaces four statues depicting the original racial groups of the region: Huguenot (colonial whites), Aztec (Spanish settlers), Aborigine (Native American), and Negro. Keen on historical accuracy, Gilbert characterized his vision for the Negro group as follows: "I thought of suggesting with a central bale of cotton or Tobacco, the Cotton Gin, a figure on one side, of an old-time negro working in a cotton field." He then proposed placement of "a younger man lounging on a cotton bale, with a banjo, and a 'piccaninni' [sic] sitting below with a piece of watermelon, typical of plantation days." And to round out the Negro group, "possibly a figure of Booker Washington, as a representative negro [sic] of his race today, on the opposite side."[99] Gilbert went so far as to address this request directly to Washington, suggesting that his likeness be the model for the "well-formed" man steering the plough. The

chief architect diverged from his original scheme and proposed that the sixteen-foot-tall sculpture be placed in front of the Negro Building instead of the main court with the other statues.[100] In the final version of Gilbert's interpretation of Negro progress, artist George A. Lopez carved a stalwart Negress in full stride balancing a basket overflowing with cotton pickings on her head. She stood adjacent to a crouching blacksmith hammering away at an anvil, his well-worked sinews telling of a life dedicated to manual labor. Rounding out the trio sat a jovial banjo player, smiling and strumming away on his cherished instrument. This animated larger than life trio possessed distinctly African features, negating the historical reality that many blacks in the South, because of centuries of miscegenation, possessed decidedly Euro-American features. Lopez deliberately incorporated pronounced social Darwinist overtones in his piece, whose figures were more suggestive of a scientific diorama than a lyrical work of art. A likeness of Washington, however, had not been included in the final version. Absent the great race leader, the ensemble lacked a contemporary figure of comparable stature to Douglass as represented in the Atlanta Negro Building's pediment or the statuette at the entrance of Paris's "American Negro" exhibit; Lopez's statue lacked an acceptable representation of masculinity that black elites would sanction. The larger message the statue put forth was that this ahistorical portrait was the current state in which the Negro was seen by southern whites. For black citizens involved with the fair, the stone trio clearly posited there had been *no* racial progress.

This stereotypical representation, symbolically positioned by white organizers in front of black Charlestonians' temple to racial progress, deeply insulted blacks, especially the educated leadership. In contrast to the more industrialized cities of Atlanta and Nashville, race relations in Charleston and outlying rural areas sustained the paternalistic ties developed under the plantation economy. A caste system based on skin color had evolved from centuries of white owners raping their black women slaves. Black residents in the region still lived in close proximity to their white employers. And when it came to postbellum politics, the "colored" mulatto elites and middle class, when joined by the black working class and rural poor, formed a formidable alliance against the white minority. Ultimately white elites were able to maintain a tight grasp on the region's power and used that influence to prevent the black majority's voting bloc from seizing control.[101] From their perspective, white Charlestonians had donated the sculpture—what they considered as a tribute to idyllic southern plantation life—as a generous gift to adorn the front entry court of the

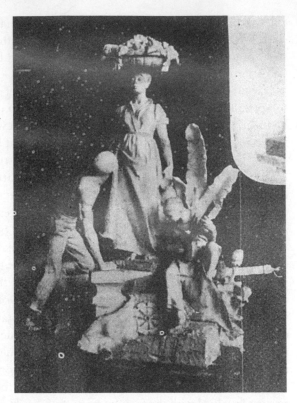

FIGURE 24. *Negro Group* by George Lopez, South Carolina Inter-State and West Indian Exposition, Charleston, 1902. From West Charleston Sertoma Club. *Charleston and the South Carolina Inter-State and West Indian Exposition: An Illustrated Souvenir of the Beautiful Exposition and the Historical Places and Prominent Features of the City* (Charleston, S.C.: Nelson's Southern Printing and Publishing, 1958). Courtesy of Special Collections Research Center, California State University at Fresno.

Negro Building. Inattentive to the racist slight, those in charge of the fair refused to acknowledge, as newspaper accounts conveyed, the rationale of the objections raised by some of the city's leading black citizens—some of whom themselves were alleged, as fairer-skinned mulattoes, to maintain their own color line between themselves and those darker-skinned blacks represented in the statue.

The impervious executive committee of the Negro Building responded to the requests to remove the ensemble by stating that the sculpture in fact presented a "striking fidelity to nature and its remarkable artistic merit. It represents the race as the artisan and the tiller of the soil. This is what the negro is." The committee went on to argue that "the Lopez statue represents 8,000,000 people, not a few thousand preachers, doctors, lawyers, waiters and Pullman car porters."[102] To the committee members, the statue was a faithful characterization of the black masses—their primary audience for their message of racial uplift. Objectors next channeled their complaints to Washington, who at first ignored their heated

protest, until they threatened to take the matter to the exposition's board of directors. A coalition of black associations led by Thomas J. Jackson, a key executive committee member, secretary, and field agent for the Negro Building's exhibits, joined by Rev. F. W. Richards, demanded that the distasteful statue be summarily removed. Eventually relenting, the apologetic Washington had the offensive sculpture carted away. But the white fair administrators, confident and proud of their homage to Negro progress, simply relocated their gift to a more prominent site on the fairgrounds before the commencement of the fair, which ran from December to May.[103] Seen by even more visitors in this new location, jurors awarded Lopez's depiction of the Negro race a silver medal in the sculpture category for fine arts.[104]

Insulted by the repositioning of the demeaning ensemble and the jury's award, black patrons—a significant portion of the fair's likely audience—boycotted the exposition. In spite of Washington and the other organizers' attempts to avoid confrontation, heightened racial bigotry had ruined their carefully planned showcase of Negro progress. Black citizens quickly discovered that protest proved an advantageous tactic of resistance. Along with the boycott, other misfortunes befell the Charleston event. Isolated from other major cities, underserved by major rail lines, absent a large local urban population, and pummeled by unseasonable cold weather, the Charleston fair failed to draw swarming crowds of fairgoers characteristic of previous expositions. For the ambitious white organizers, the Inter-State and West Indian Exposition was ruled, after the ticket receipts had been totaled, a financial fiasco.[105]

The public dissent at the Charleston fair indicated that not all blacks were content with the practice of separating Negro accomplishments from the main pavilions or with the racist treatment that awaited them at these southern events. Another series of particularly vehement and widely publicized protests were staged five years later at the Jamestown Exposition in Norfolk, Virginia, a fair that celebrated the three-hundredth anniversary of the founding of the Jamestown colonial settlement. Made confident by the federal support of Negro involvement at Atlanta, Paris, and Charleston, and endorsed by Washington's seven-year-old NNBL and other associations, the Negro Development and Exposition Company successfully lobbied Congress for $100,000 to host a national exhibition. The lead booster, Giles B. Jackson, had made his reputation as a skillful, cunning lobbyist and lawyer who had fought one of the early cases against railroad segregation with the support of Washington. A fiercely loyal former slave of Confederate general Fitzhugh Lee, who was now the pres-

ident of the Jamestown Exposition Company, the bombastic Jackson was made by his former master the director of the Negro Development and Exposition Company.

Jackson assembled an executive committee to oversee the three years of preparation for the event. Ambitious in desiring national participation, the director recruited experts for the executive committee who had assisted in planning previous fairs. He established an office in Washington, D.C., supervised by Ferdinand D. Lee, a prominent local attorney who also operated as field agent to New York and Pennsylvania. Jackson enlisted Calloway for his invaluable experience in organizing the "American Negro" exhibit, making him chairman of the executive committee. To tackle the immense task of soliciting and planning the exhibits and scheduling events, the resourceful Anna Calloway aided her husband. Andrew Hilyer, who had helped put together "American Negro," assisted his friend in the capacity of secretary treasurer and as supervisor in charge of collecting materials from around the country. As part of the Washington, D.C., bureau, Daniel P. Murray, along with his wife, Anna, once again gathered for display a library of over five hundred books and periodicals.[106] Agents fanned out across the Northeast, Southeast, and Midwest to review, collect, and ship materials. Altogether, 125 schools provided educational displays, making their 6,334 exhibits the largest group in the hall. Calloway and his team grouped these displays, along with over 3,000 other exhibits, in Jamestown's sprawling Negro Building by sections and types rather than by state affiliation.

The tercentenary fairgrounds could not be built at the original landing site of the Jamestown expedition. In light of this problem the planners sited the fairgrounds six miles from Norfolk at Sewells Point, which was located on the mouth of the James River and across from the Hampton Institute, home to the well-known Negro college. Organizers laid out the grounds in a formal grid pattern, with large colonial-styled main pavilions flanking an elaborate Court of Honor whose piers stretched out into the James River. Landscape architects once again separated the Negro Building from the other main pavilions on the picturesque grounds. At Jamestown workers erected the Negro Building on the western edge of the fairgrounds, obscured behind the "Warpath," the Midway's catchy nickname that demeaned the history of local Native Americans. A congressional allocation funded the construction of a large colonial-style hall. A Tuskegee-trained architect and professor, William S. Pittman, won the commission through a competition. Pittman, fortunate to be the son-in-law of Washington, designed the spacious two-story pavilion, which was

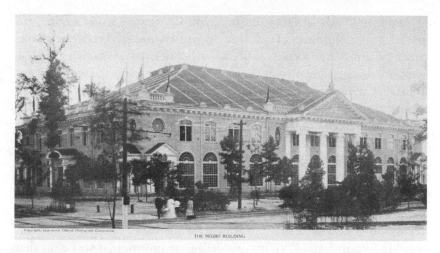

THE NEGRO BUILDING

FIGURE 25. Negro Building, Jamestown Exposition, 1907. From *The Official Blue Book of the Jamestown Tercentennial Exposition, A.D. 1907: The Only Authorized History of the Celebration* (1909), 674. Silvia Ros photographer. Courtesy of Mitchell Wolfson Jr. Collection, Wolfsonian–Florida International University, Miami Beach, XC1993.278.

built by black workers under the supervision of a black contractor, Boiling and Everett based in nearby Lynchburg.[107] The final grand hall accommodated over sixty thousand square feet of exhibition space, more than twice the size of Atlanta's pavilion. Its four stately white porticos erected on all sides of the pavilion allowed for multiple points of access to the several thousand exhibits inside.

The popular Negro Building (it was the only pavilion President Theodore Roosevelt visited while attending the fair) housed the now-standard template of content: numerous rows of educational and agricultural exhibits. The patents of inventions by black innovators did, however, fill a large display area. With Washington's NNBL involved in the planning, black-owned banks and businesses made demonstrations and gave presentations to interested fairgoers. In keeping with the popular doctrine of uplift by one's own abilities, curators gave exhibits that promoted moral and religious development prominent space on the exhibition floor. Displays of literature, art, and musical performances, including several concerts by members of the Fisk Jubilee Singers in the large auditorium space on the second floor, represented the race's cultural accomplishments. An awards jury that included Terrell, Crum, and several other prominent black southerners awarded over two hundred medals to displays and exhibitors.

Importantly, the Atlanta, Buffalo, and Charleston world's fairs promoted the establishment of new trading partners and markets as their overarching theme. The products of black handicraft had been included in these expositions, focusing on commercial enterprise through the economic rationale that blacks provided an accessible source of cheap labor. Encompassing a different ideological objective, the Jamestown Exposition—similar to Philadelphia's Centennial Exhibition (1876), the Chicago World's Columbian Exposition (1893), and the St. Louis Louisiana Purchase Exposition (1905)—honored a historic national event. At these previous national commemorative fairs, black representation in any cohesive form had been purposefully eliminated. As Wells had queried of the Chicago's White City, "Why are not the colored people . . . who have contributed so large a share to American greatness, more visible in this World's Exposition?"[108] With this deliberate omission, it was clear that whites in charge did not want their fellow black citizens to be part of the nation's parade of public history. Historian Benedict Anderson has posited that a nation forms its cultural memory (and national identity) through an "awareness of being imbedded in secular, serial time, with all of its implications of continuity, yet of 'forgetting' the experience of this opportunity—the product of the ruptures," which therefore "engenders the need for a narrative of identity."[109] Thus, black history (and presence at the various world's fairs) would prove to be a rupture in the continuity of the nation's narrative of freedom, liberty, and equality. Black citizens and heritage would be excised from the nation's collective memory until the Jamestown Exposition in 1907.

Some fair participants were indeed conscious of this momentous shift and made an effort to represent the rich contributions black citizens had made to the nation's history in their speeches, literature, and displays. Although the Jamestown Exposition officially opened its gates on April 26, the ceremonial opening of the Negro Building was held on July 4 to coincide with national Independence Day celebrations. Blacks had not yet experienced the rights of citizenship that the national holiday commemorated—an issue that was ignored by most of the fair's displays and events. Addressing this oversight, Kelly Miller, in his remarks to the opening-day crowds, recognized the significance of celebrating the simultaneous anniversary of the arrival of first colony of Europeans, the nation's founders, and the importation of the first enslaved Africans, the builders of the nation's fortunes. It was fitting, Kelly concluded in his speech, that "the Negro too, should commemorate this time and place, which is intended to show something of the part which he has played in the gen-

eral progress of the nation."[110] On Negro Day, August 3, Washington addressed some ten thousand visitors to the Norfolk fairgrounds. His speech applauded the great strides made through the opportunities the United States afforded the Negro. He delivered his oration from a box of honor, where black luminaries Major R. R. Wright, Francis Grimké, and others sat attentively. Washington spoke of the historical significance of the Jamestown site, saying that "here we entered enslavement" but that "[we] show the results of improvement both in slavery and in freedom."[111] In a similar vein, the commemorative souvenir book *The Industrial History of the Negro Race of the United States*, compiled by Jackson and D. Webster Davis to document the contents of Jamestown's Negro Building, began with a "history" of the Negro, chronicling the race's monogenetic biblical origins in Egypt and proceeding to narrate the arrival of Africans in Jamestown, Negro participation in American wars, Emancipation, and blacks' current educational, religious, and financial status. In strict Bookerite tones, *The Industrial History of the Negro Race of the United States* heralded the South as the rightful home of the Negro. Its pages praised Washington's historic words at Atlanta—"lay down our buckets where we are"—as the best way to uplift the race to become honest, self-respecting, productive, and frugal members of society.[112] More accessible to a wider audience than this written history, a series of historical tableaux was specially created for the pavilion by artist Meta Vaux Warrick Fuller. Fuller, who had studied under sculptor Auguste Rodin in Paris and had attended the Exposition Universelle, where she met Calloway and Du Bois, was commissioned in January 1907 by Calloway to create twenty scenes narrating the history of the Negro in America from Jamestown to the present time. With only a few months to prepare several large tableaux, Fuller wrote to Du Bois for assistance in determining which historical scenes would be appropriate for depiction.[113] Fuller must have witnessed the popular dioramas and panoramas at the Paris fair, whose enveloping and at times kinetic environments produced a new way of viewing for the spectator.[114] Fuller's almost life-size detailed environments presented a visual history of Negro life from the fields to the factories. These quarter-scaled scenes re-created Africans arriving with white settlers at Jamestown, life on a plantation, fugitive slaves escaping through the forest, a Civil War battle, Emancipation scenes, contemporary views of a college commencement, a church congregation, and the home of a "proper" Negro family. Three dimensional and vividly expressive, these gold-medal-winning panoramas, which covered more than fifteen hundred square feet of exhibition space, created a landscape of

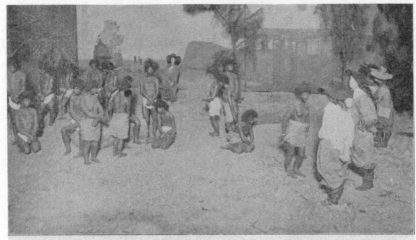

LANDING OF FIRST TWENTY SLAVES AT JAMESTOWN

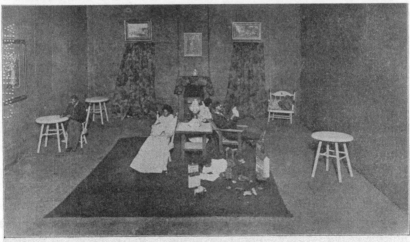

IMPROVED HOME LIFE

FIGURE 26. (top) "Landing of First Twenty Slaves at Jamestown" and (bottom) "Improved Home Life," tableaux by Meta Vaux Warrick Fuller, Negro Building, Jamestown Exposition, 1907. From Giles B. Jackson and D. Webster Davis, *The Industrial History of the Negro Race of the United States* (Richmond: The Virginia Press, 1908).

historical events and future prospects that prompted black spectators to recognize their place within the heritage of America and to envision their future place within the ranks of the respectable black middle class.[115]

Even with the aisles of the Negro Building—the largest of its kind—overflowing with wonderful exhibits and specimens of Negro progress that received praise from the mainstream and black press, black Americans from around the country refused to attend the fair due to the segregation of fair's public facilities. The Bookerite *Colored American Magazine* pleaded with its readers that Jamestown was not a "Jim Crow affair" any more than the Negro church, school, store, or progressive agency under Negro management. The magazine's earnest appeal, however, ran counter to the observations and experiences of potential participants and visitors.[116] Indeed, many were keenly aware that three years earlier the city of Richmond, just a few miles up the James River, had instituted public segregation of its streetcars and trolleys. Hearing of these new laws, black Bostonians had protested the $75,000 allocation for a Massachusetts State exhibit at the Jamestown Exposition. The Massachusetts Suffrage League demanded that funding be withdrawn unless there could be assurances that black visitors would not be discriminated against in Norfolk and while attending the fairgrounds.[117] The anti-Washington *Voice of the Negro*, based in Atlanta, urged that colored people go elsewhere for sightseeing or, better yet, stay at home to avoid what the publication had dubbed the "Jamestown Imposition," with its segregated railways and soda fountains.[118] Atlanta University, where Du Bois still held his appointment, refused to contribute exhibits out of protest against the segregation laws. Du Bois was personally incensed that the management had publicly stated that he was preparing an exhibit for the fair and declared such information to be "an impudent lie, and quite in keeping with this whole shameful and discredited enterprise."[119] These objections infuriated southern whites. The *Atlanta Constitution* parodied black protests by mocking "all of this fool negro hysteria" about separate coaches and hotels, saying that "the race line is drawn on social equality with the negro by Virginians."[120] Jackson and the Negro Development and Exposition Company attempted to assuage concerns about discrimination by stating that they too deplored the Jim Crow laws and that they would seek clean, accessible transportation to and from the fairgrounds.[121]

Throughout the process of planning the Negro Building and during the fair, critics repeatedly accused Jackson of mismanaging funds. The Negro press painted him as a deceitful swindler. Along with the likelihood of Jim Crow facilities, these felonious accusations kept many black

patrons from traveling to the Jamestown exposition. More and more, black Americans had become uneasy about the consequences of white-sponsored, separate Negro Buildings. Yes, it gave them a public platform to showcase their advancement, but the once-optimistic atmosphere inside the fairgrounds now mirrored the threatening landscape of racial subjugation and violence outside the gates. Agitated rather than accommodating, black citizens were increasingly willing to protest the racist policies and practices of white organizers and their powerful backers. Because the fairs were first and foremost economic undertakings, blacks astutely recognized that not spending the money on the admission ticket was a way to affect one of the exposition company's primary motives—profit. Ironically, it would be the lack of transportation to the fairgrounds for everyone, not just for black fairgoers, that would make the sparsely attended Jamestown Exposition an expensive disappointment.[122]

WASHINGTON AND THE LOST CAUSE

Two years after the Jamestown fair, Washington was still confident that expositions served as a practical means to demonstrate that blacks were making strides at self-improvement. In 1909, he began campaigning for a national Negro world's fair, an Emancipation Jubilee to celebrate fifty years of freedom. It should be convened in a southern city, he reasoned, because "the masses of the negro people are better off, in my opinion, in the southern states than in any other part of the world, and for that reason, if for no other, the masses of the people are going to remain in the south."[123] Over the course of that year, Washington rallied all of his political might. President William Howard Taft favored industrial education for black citizens, although he refused to appoint them to political office. With lukewarm support from white politicians, Washington's proposed event failed to garner federal funding. One year later he abandoned the idea for a national fair.[124] Regardless of Washington's misplaced trust that southern whites would embrace this exposition as a confirmation of their success in providing guidance and assistance to the darker races, many blacks knew that mere mention of an event celebrating Emancipation would stir up ill feelings and hostile judgments in light of the Confederacy's demoralizing defeat by the Union Army.[125] Washington's inability to secure funding indicated that his unparalleled influence was beginning to wane, that aspects of his ideology of accommodation were losing ground to a rise in a more vehement and visible strain of white supremacy, and that other, more radical black leaders like Du Bois and

the new Niagara Movement were gaining momentum with their activist agenda for full rights and social equality.

Where Washington failed at soliciting support for a grand southern fair to celebrate Emancipation, a few years later Jackson, the former head of the Jamestown Negro Development and Exposition Company, succeeded. Although Jackson had been labeled untrustworthy by the black press after allegations of financial mismanagement at the Jamestown fair, he proposed to hold another, this time a black-run exposition—the Negro Historical and Industrial Exposition—in Richmond, Virginia, in 1915.[126] Aware that northern states had funded similar events (as will be reviewed in the next chapter), Jackson called on his network of white supporters to raise capital for what he conceived of as a national Negro exposition. For twenty-two days in July 1915, the Negro Historical and Industrial Exposition took over part of the one-hundred-acre Virginia State Fair Grounds overlooking the Chesapeake, five miles outside of Richmond.[127] The effort by black Virginians was spirited in intent and, as one white visitor remarked, "hardly less than marvelous in [its] wide range and simplicity and usefulness."[128] Absent the offensive Old Plantation concessions, the modest Richmond Midway attractions entertained fairgoers with typical amusement fare, including Negro vaudeville acts, a troupe of white female divers, and a Wild West show from Oklahoma. Organizers set aside a "White Folks" Day to welcome white visitors to the fair. The fairgrounds' existing Administration Building housed an unimpressive selection from industrial training schools, associations, local manufacturers, and artisans, displays that lacked the sharper curatorial focus of previous fairs. Always a major presence at expositions, with a polished display of its students' handiwork, the Tuskegee Institute was conspicuously absent.[129] The fair's muted message indicated that it had been a rushed event with little time given for publicity, advertising, and the proper collection and presentation of materials. Many black participants and patrons stayed away because of Jackson's well-known troublesome reputation, which meant that at times white visitors outnumbered black fairgoers. Once again black leaders and the press leveled charges against Jackson's mismanagement of funds, with the *Chicago Defender* decrying the event as a shameful and "inadequate display of our progress."[130]

The disappointing fair closed its gates in late July. The great race leader Booker T. Washington died at Tuskegee the following November 1915. The Tuskegean had prescribed and promoted a policy of compliance and submission to white dominance as the salve to lessen the sting of Jim

Crow. Washington vigorously preached at these expositions that black citizens must first labor to elevate themselves out of their inferior economic and social status, so that they might more easily merge and assimilate into white American industries, institutions, and eventually culture— a viewpoint very much akin to then-popular notions of American individualism and liberalism. In his Negro Day speech at the Jamestown Exposition, Washington repeated his message of the value of education in promoting a life of high moral standards. He cited, for example, how the proper education of black women would provide southern households with intelligent, clean, and morally fit nurses to care for their "pure and innocent" white children. Events like the Jamestown fair, he went on to observe, ameliorated race relations by shifting the news about the South away from the unpleasantness of lynching to instead promote the Negro success in business, work, and homemaking. If white Americans would adhere to Christian notions of citizenship and abandon unwarranted fears of Negro political domination, then Washington guaranteed that "by patience, courage, and work we can overcome difficulties and secure and maintain our rightful place as useful citizens in our common country."[131] Change under these terms would be gradual and nonthreatening, confined within Negroes' homes and limited to rural communities. Under this scenario, blacks remained exiled from the mainstream public sphere of politics and the factory floors that fueled the nation's economic prosperity.

Complementing Washington's vision of the respectfully attired and deferential Negro, whites disseminated other images to keep black men and women obediently in their place. As the popularity of the "Coon Plantation" concessions, smiling mammies, banjo-strumming pickaninnies, and minstrel shows on the world's fair's Midways and Courts of Honor attest, many white southerners waxed nostalgic for old plantation society and the old enslaved Negro. Scholar Eric Lott and others have noted that the use of minstrelsy and plantation imagery provided working-class whites—many of them immigrants—with a means of allying their interests with the white middle and upper classes. White entrepreneurs exploited these popular representations, an ever-present reminder to blacks of their inferior status and origins, by featuring them on products and in advertising that circulated to a mass audience of consumers.[132] For example, while plans were being made to celebrate the fiftieth anniversary of Emancipation, white Texans initiated a movement in 1910 to erect a $1 million national monument in Washington, D.C., dedicated to black mammies. This monument would celebrate the endearing "house nigger"

as "an aristocrat, this Black Mammy," and introduce her to those who had not known the comfort of her "loving bosom." Yearning for the restoration of an imagined maternal spirit of sacrifice for her tiny innocent charges, white Americans conjured a mythic figure whose likeness once cast in stone would stir their and others' nostalgic hearts. Asexual and always ready to please, the drudgery, exploitation, and sacrifice of black female labor was sublimated into the reminiscences of a naturalized female body with her "ample breast" and gay "ebon face."[133] The mammy monument became so popular that the Texan initiative received a generous outpouring of money and hearty public support.[134] The mythic figure of the black mammy, associated with the "Lost Cause" of a failed uprising and the loss of a genteel plantation caste, proved a popular character in southern folklore and literature as well as an alluring advertising image to associate products with the values of being hardworking and loyal. It is no small wonder that the hearty figure of Aunt Jemima selling hotcakes appeared so frequently along the Midways. A few months after the national monument was proposed, an enterprising black principal in Athens, Georgia, announced that he was opening an industrial training school for cooks. S. F. Harris adopted the popular image of the black mammy as a surefire lure to attract attention and investment. Drawing upon her historical significance as a way of symbolizing the high quality of work offered by young black domestic workers, Harris named his industrial training school the Old Black Mammy Memorial Industrial Institute. Whites found the notion that students would be learning industrial and domestic arts in the spirit of old southern traditions immensely appealing.[135] An indictment of the inability of Washington's strategy of accommodation to improve the material circumstances of black life, the name and mission of Athens's new industrial school also exposed how difficult it was to change whites' perception of black identity from old stereotypes to the New American Negro.

Black citizens, who had incrementally developed active counterpublic spheres since Emancipation and many of whom were born well after that date of liberation, did not sit idly by and accept racist propaganda like the black mammy monument.[136] From the membership ranks of educational, religious, business, and cultural associations, new organizations dedicated to the fight for constitutional rights were forming. An urban-based organization, the National Association for the Advancement of Colored People (NAACP), whose very name championed the theme of racial progress, criticized Washington's policies and commanding influence. The organization formed in 1909 out of a merger between white

liberals, black activists like Ida B. Wells, Mary Church Terrell, Mary Burnett Talbert, and members of Du Bois's Niagara Movement.[137] At a meeting in 1905, the Niagara Movement's agenda, as Du Bois articulated, was "to press the matter of stopping the curtailment of civil rights."[138] Other means, such as legal challenges and boycotts like those at the Charleston and Jamestown fairs, had to be mobilized to end the tyranny of segregation and the barbarity of lynchings.

In researching the early urbanization of black populations, Du Bois comprehended the impact of the growing movement of black southerners to northern urban centers, which had by the time of Washington's death in 1915 become the historic Great Migration. The large-scale Taylorized factories in Chicago, Detroit, Philadelphia, New York City, and elsewhere needed a large workforce to keep their production lines moving. Du Bois's point in the *American Monthly Review of Reviews* article on the exhibit at the Paris fair—a salvo addressed to a white audience of readers but also meant to challenge prevailing notions of black progress—was that the American Negro was laboring with "deft hands, quick eyes and ears," just as Washington had vociferously promoted. But as Du Bois concluded, the American Negro was also becoming a "broader, deeper, higher culture of gifted minds," able to create a vision, as the contents of the "American Negro" exhibit represented, of what black life in the United States or outside of it could be.[139] A Pan-African alliance offered a robust counterallegiance to American nationalism, which had yet to fully incorporate the black citizenry into the body politic. Continuing with this quest of intellectual uplift and joined by a growing black intelligentsia, these black Americans would stage their own commemorative Emancipation expositions in rapidly growing northern urban centers, as the next chapter will explore. These events imagined black progress beyond acquiescence to call for more forceful means of acquiring political power and civil rights along with access to wage labor and decent housing. And in order to validate these new strategies and situate them within prevailing discourses of nation and race, black Americans took measure of notable black cultural achievements and contributions to national and even world history.

CHAPTER 3

Remembering Emancipation
Up North

Hear ye, hear ye! Men of all the Americas, and listen to
the tale of the eldest and strongest of the races of mankind,
whose faces be black. Hear ye, hear ye, of the gifts of the
black men to this world.

—W. E. B. Du Bois, *The Star of Ethiopia*

The American Negro must remake his past in order to make
his future.

—Arthur A. Schomburg, "The Negro Digs Up His Past," *The New
Negro*

It was the winter of 1912 and W. E. B. Du Bois, whose reputation as an
activist since the Paris fair had made him an important figure in the emerg-
ing black protest movement, was preparing a statement to deliver in front
of the U.S. Senate Committee on the Industrial Fairs. He had been ap-
proached by his fellow American Negro Academy (ANA) member, the
charismatic Major R. R. Wright, and asked to contribute to Wright's plans
for a national exposition to commemorate the fifty-year anniversary of
Emancipation.[1] The major, then head of the Georgia State Industrial Col-
lege in Savannah, had contributed to events at the Negro Buildings in At-
lanta and Jamestown. Wright had began circulating his proposal for a
national commemorative fair at the same time as the more widely known
Booker T. Washington was doing the same, but he held a more expan-
sive view of who and what a semicentennial celebration of liberation and
progress should encompass.[2] Wright wanted to incorporate contributions
from all over the world, gathering for display a diverse array of products
manufactured in the Caribbean and Africa. He believed that a "Pan

African congress consisting of representatives from all parts of the world" would make a splendid main event.[3] Undaunted by the great Tuskegean's unsuccessful bid a year before, Wright had formed the American Semi-centennial Emancipation Exposition Company in 1910 to raise funds for a national exposition to be held in Savannah. Blacks made up almost half that city's population, making the community the second-largest black enclave in Georgia after Atlanta's Black Side.[4] Du Bois, intrigued by the international scope of his colleague's endeavor—especially the prospect of convening the Second Pan-African Congress—met the major in the nation's capital to present their request for $250,000 in funding from the Senate committee. Joining the two prestigious educators were other fair boosters, among them the major's son, Richard Jr. The younger Wright was a reverend in the African Methodist Episcopal Church (AME Church) and a respected sociologist who had worked with Du Bois on a study of Alabama sharecroppers for the U.S. Department of Labor and had presented at several of Atlanta University's conferences on the city.[5] Young Wright and his peers shared his father and Du Bois's commitment to dispelling scientific and popular notions of the inferiority of black aptitude by utilizing the public forum of expositions.

Seated before the Senate committee, Du Bois eloquently recited his brief declaration. He began by outlining the numerous ways that an exposition of this scope would serve to educate both black and white Americans on "concrete and spiritual things," or, the material and cultural circumstances of the everyday lives of black people.[6] He informed the senators that European fairs and ethnographic museums regularly showed educational exhibits on the genius of African craftsmen. By contrast, he pointedly stated, U.S. fairs rarely included equivalent displays on American Negroes. Willing to break with the influential Washington's agenda for racial uplift, Du Bois proposed expanding the fair's educational purview beyond that of showcasing Negro handiwork. His pedagogical vision for the exposition embraced the progressive ideas of social improvement movements. Similar to the Georgia Negro presentation in Paris, but on a much grander scale, Du Bois imagined an extensively documented display of scientific charts that illustrated, for example, the migration of enslaved blacks from Africa to the Americas. He advocated for an ethnographic exhibit that characterized the physical attributes of the Negro. Informative graphs analyzing urban life, educational achievements at battling illiteracy, the work of religious organizations, business successes, cultural accomplishment, and evidence of social betterment created by health institutions and improved conditions in domestic life would

round out the sociological exhibit. This material, assembled by head curators, would form the core display, with various voluntary exhibits assembled around it. Congresses and juried awards would be high points over the course of the fair. Du Bois concluded his statement with a pioneering proposal: the commemorative event would provide a unique opportunity for a public parade of significant historical events and figures. In a spark of creative genius, he envisioned a spectacle drawing upon the history of African civilization: it would commence with the great Sudanese kingdoms and narrate the tale of the Middle Passage to the Americas, following the colonization and development of the United States and linking the experience of black Americans to major events in Pan-African and world history.[7] Du Bois's innovative exposition would offer a comprehensive educational display about American Negro life to capture the imaginations of newly emerging black urban audiences.

During a period of social and urban change between 1910 and 1926, black leaders like Du Bois and the Wrights conceived and presented, as this chapter explores, a series of commemorative Emancipation expositions in northern cities. Inspired by the themes explored in the Emancipation fairs, these individuals and their organizations would later participate in two important mainstream northern expositions in the 1920s. At these events, issues related to urban life in the North would supplant the ideological foundation of previous exhibition efforts, namely, the theme of progress since liberation presented through artifacts of manual labor and rural life in the southern states. In these northern contexts, organizers, participants, and viewers would still foreground black progress, but at the fairs they would also grapple with new political allegiances, new questions of ethnic assimilation and national belonging, new historical narratives of enslavement and their African origins, and new popular forms of mass entertainment that challenged the older established cultural forms that promoted bourgeois moral improvement.

Crucial to these developments was the incremental migration of southern blacks, first to cities like Atlanta as we have seen and eventually en masse to northern industrial centers beginning around 1910. This population shift fueled the formation of large urban enclaves. In these neighborhoods, southern migrants became part of an emerging racialized class structure of elites, workers, and the poor that was engendered by industrialization (and that accelerated in the era of Fordism beginning in the 1920s). Once arrived, many blacks joined a counterpublic sphere that saw the rise of progressive improvement and protest organizations like the National Association for the Advancement of Colored

People (NAACP) and the National League on Urban Conditions among Negroes begun in 1910, which eventually was renamed the National Urban League (NUL). Their growing activist base challenged white racist exploitation and injustices, such as the overcrowding of black neighborhoods due to segregated housing policies and widespread discrimination in hiring practices. As a black middle and working class emerged concurrent with the migration of large numbers of black residents into urban centers, these groups sought a new cultural milieu dedicated to leisure activities. An emerging popular culture of melodramatic race movies, raucous jazz performances, and ribald vaudeville shows differed greatly from the high cultural fare of the black elites who for years had promoted activities—especially at the fairs—that would nurture sensibilities of moral uplift, self-help, and respectability in the lower classes.[8] During this period, pageants—with their historical sweep, agenda of cultivating civic pride, and casts of hundreds—would become one popular vehicle for public edification in the world of fairs. As the result of changing sociocultural and material processes, these factors influenced the organization of several expositions celebrating the fiftieth anniversary of Emancipation and black contributions to world history staged in Philadelphia, New Jersey, New York, and Chicago. Yet, as poorly paid workers in an industrial economy that at times was as abusive as the sharecropping economy many southerners had fled, black visitors to the fairs encountered a perspective from which to gauge how they had progressed and if they had indeed been liberated from the racist exploitation of their labor. This point of view on social inequalities came into stark relief when groups of black fair boosters joined whites and immigrant groups at two mainstream fairs in New York and Philadelphia in the 1920s.

While the fairs offered black Americans a prospect from which to look forward, the events also compelled them to look back. For those living in 1913, emancipation from enslavement had occurred almost two generations earlier. For many it had become a historical event rather than a shared collective memory. When considered in relation to new scholarly inquiries into black history—especially the increased publication of written histories and the formation of popular associations dedicated to its study—the displays and cultural programs at these northern expositions drew together narratives of black history from the rich patchwork of memories and oral histories of Africa, the Middle Passage, slavery, and life since Emancipation. The curatorial stance of southern fairs may have proffered Washington's tactic of deferential accommodation in the face of the cleaving blows of Jim Crow segregation, but these northern fairs

became pedagogical events that educated black audiences about their own history and achievements in order that they might fend off the devastating impact of antiblack racism. And when black citizens participated in mainstream events such as New York City's America's Making Exposition and Philadelphia's Sesquicentennial Exposition, they would reconsider the efficacy of their American identity and citizenship, especially in relation to racial politics of immigration and eugenics in the 1920s. Remembering the fifty years since Emancipation, as we shall discover, fostered racial pride that in turn nurtured an understanding of past injustices and a vision of a future unfettered by current ones.

FIFTY YEARS OF EMANCIPATION

The U.S. Senate deliberated the American Semi-centennial Emancipation Exposition Company's request for funding two months following Wright's and Du Bois's presentations. On one side of the aisle, the senator from New York argued the merits of the exposition, stating that in light of the separation of the races in all affairs of life a fair of this sort would encourage Negroes to be law-abiding citizens. On the other side of the aisle, racist southern senators backed by like-minded colleagues from Nebraska and Kansas impeded passage of the bill by claiming that the two races could not live together without one being subservient to the other.[9] These objections notwithstanding, the Senate managed to approve $250,000 in federal funds, with a caveat that the Exposition Company fund-raise an additional $50,000. When the bill reached the House of Representatives in January 1913, the Industrial Expositions Committee (headed by a representative from Alabama who no doubt shared the sympathies of his fellow southerners in the upper house) refused to send the bill to the floor for a vote, thereby abruptly ending the black fair boosters' concerted effort.[10] Laced with the rhetoric of white supremacy that had already been conveyed to Washington, these blistering refusals made it clear to Wright and Du Bois that southern whites were resolutely unwilling to celebrate or remember the day their former slaves had been manumitted. Emancipation was a minor historical setback for southern whites it seemed, in comparison to their major defeat in the battle for secession, which had been mythologized throughout the region in Confederate monuments, reunions, and commemorations of their "Lost Cause."

Regardless of the numerous impositions that some white Americans may have put in place to impede the celebration of the anniversary of Emancipation, black civic groups, churches, and leaders of the resilient

black counterpublic sphere nevertheless commemorated their hard-won struggles and liberation from enslavement.[11] For fifty years, Emancipation celebrations (which typically coincided with New Year's Day but could also happen on June 19 and July 4) had served as days of collective remembrance. Men, women, and children would dress in their finest to cheer the parades of black social and religious associations, military groups, and school bands. Community picnics and local fairs often followed these joyful processions. Gathered together in the segregated public spaces of their neighborhoods, in halls or nearby parks, black residents listened to prominent ministers, race leaders, and educators deliver inspirational speeches, often in the form of passionate jeremiads appealing for justice and delivery from exile. Particularly in urban areas, these assemblies brought together the black bourgeoisie with the working class, each donning the trappings of their respective group and embracing those notions commensurate with their status.

As the examples of special Negro Day events at previous world's fairs have shown us, black leaders used Emancipation commemorations to remind their audience of black workers, farmers, shopkeepers, and professionals how far they had come since the era of enslavement, but they also emphasized how far their fortunes had yet to progress. Considering this celebratory spirit, historian Geneviève Fabre characterizes its mode of reflection "as a *political gestus* which contributed to the development of the collective memory." She cogently puts forth that this represented "not just a memory of past events, but a *memory of the future,* the anticipation of action to come—and of the historical consciousness of a people who are often perceived as victims rather than as historical agents."[12] Subsequently, as blacks migrated northward and westward, Emancipation Day commemorations became a way of forging communal ties between newcomers and locals. The celebrations reconnected northern blacks back to the South where liberation from enslavement had occurred. As the years progressed and those who had directly experienced Emancipation and slavery passed away, the celebratory events served to remind the next generation of their legacy in the United States— a mournful recollection of forced servitude that at times some wished to forget. This politicized recollection of the race's forward advance from slavery was carefully weighed against (or perhaps weighed down by) the present's untenable conditions of diminished political rights and access to wage labor.

Contrary to the vehement resistance of racist southern politicians to federally finance a national celebration of the fiftieth anniversary of

Emancipation, four northern state legislatures in Pennsylvania, New Jersey, New York, and Illinois demonstrated a willingness to fund separate expositions in their respective states. Regardless of the growth in urban populations, black elites had to depend on the paternal generosity of white politicians and business leaders for inclusion in major fairs and for funds to hold their own events. But since those in power in the North had rendered poll restrictions less stringent—allowing a greater number of black men to cast votes for the elections of state legislators, governors, and mayors—this access to the ballot box meant that white politicians leveraged allocations for the expositions as a means of swaying the black vote, especially the Democrats, toward their party's interests.

Over the next two years, from 1913 to 1915, thousands of Emancipation semicentennial fairs and ceremonies were hosted in small towns and large cities around the country, but the ones receiving the largest grants were planned for major northern cities: Philadelphia, Atlantic City, New York City, and Chicago. Though in 1913 the *New York Age* tallied the total black population of any one of these cities' four states as no greater than that of Washington, D.C., in five years the number of blacks living in New York City would surpass that of the District of Columbia.[13] Washington was accurate in his prediction that after Emancipation blacks would stay in the South; in 1910 90 percent still resided in the fourteen southern states.[14] But this concentration would shift drastically as the Great Migration—the great exodus of blacks moving to industrial centers like Chicago and New York City—commenced around the same time. With their industries flailing, southern cities, who had made manufacturing the cornerstone of the New South doctrine, had never achieved the success of their rival northern industrial behemoths, due in part to a lack of capital investment but also stymied by the influx of goods from the North that were cheaper than those products manufactured in the South. Poorly financed and undercut, factory output and work began to dwindle. As a result, unemployed white workers gravitated to those jobs held by black laborers that they had at one time shunned. Many black southerners who initially migrated north were therefore semiskilled workers who had been displaced from their jobs in cities like Atlanta. Over time, rural blacks followed as a means of escaping the impoverishment caused by the destruction of their crops by the voracious boll weevil and the degradation of the sharecropping system. The opposite was happening in the North. There were more jobs than workers to fill them. Two factors began to stem the flow of immigrant workers that had channeled more than eight million new residents into U.S. cities and towns

since the turn of the century: the start of World War I in 1914 and the paranoia surrounding the infiltration of "genetically unfit" immigrants into white American society and cities. Desperate to keep the furnaces blazing and large-scale production lines moving along as the flow of foreign labor became more restricted during wartime, manufacturers hired labor agents to lure black workers from the South to replace the millions of workers no longer immigrating. Between 1914 and 1920, an estimated six hundred thousand southern blacks journeyed northward to cities.[15]

The industrial northern city provided a different spatial landscape of racial, social, and economic negotiation for black urbanites. The development of fairgrounds like Chicago's White City had established a set of urban design principles—the City Beautiful movement—to manage the flow of new urban masses through orderly arrangements of civic, commercial, industrial, and residential districts. A hierarchy of transportation systems knitted together the metropolitan center with satellite cities and suburbs rimming the boundaries of the central hub. Drawn from Ebenezer Howard's garden city ideas and Frederick Law Olmsted's theories of landscape, the tenets of the City Beautiful movement created a dignified civic identity symbolized by neoclassical architecture sited in urban parkscapes representative of an American idyll of nature. Most extraordinary, this image of the modern American city aspired to unify, ideologically and visually, an urban polity that in reality was splintered by class, race, and ethnicity. The new discipline of urban planning focused on decongesting land by moving poor residents into tenements and other planned housing and by establishing efficient modes of transportation to link neighborhoods to civic, commercial, and industrial zones. The implementation of zoning laws facilitated municipal control of land use, thereby allowing cities to manage land's value. Deeply imbued with racial prejudices against certain groups, these new rules affected both when and where municipalities could build housing. Scrupulously regulated by banks, land values became a primary rationale in the minds of white homeowners to legally and physically keep black residents from moving into their neighborhoods.[16]

In their respective cities, planning committees staged the Emancipation expositions in new civic structures. In comparison to the southern fairs where Negro Buildings had been designed to separate blacks from the rest of the pavilions, northern municipalities and private companies built large public halls in the central business and civic districts, making them accessible to black exposition companies willing to pay for their use. These big exhibition and convention halls were a new and modern

building type—one specifically created to accommodate year-round the large crowds and displays of conventions, congresses, and fairs. Backed by growing wealth in urban communities, black residents appropriated large armories whose vast interior spans provided an indoor parade ground for guard units, thus making them ideal for arrangements of booths and displays and for theater performances and pageants.

The northern semicentennial Emancipation expositions were much smaller and of a shorter duration than the grand international world's fairs. To share publicity and boost momentum, the northeast planning committees scheduled the fairs in succession in the fall of 1913: Pennsylvania in August, New Jersey in September, and New York in October (Chicago's fair would be held in July 1915). And to ensure that the events would be enjoyable celebrations as well as public forums to promote strategies of social advancement, members on the state committees enlisted the talents of three important figures within the growing black intelligentsia: Rev. R. R. Wright Jr. for Philadelphia; a young Howard University professor, Alain Leroy Locke, for Atlantic City; and Du Bois for New York City. Following Du Bois's success with the widely seen "American Negro" exhibit, sociologists like Wright Jr. and Locke would become key contributors to the Emancipation expositions and other fairs during the Progressive era. Social scientists in this period began to study and document the problems of poverty, immigration, crime, employment, health, education, and family within black and immigrant communities in cities as well as in rural areas. Black-organized expositions provided an opportunity to collectively assess the current social welfare of the race as it related directly to core themes of racial progress and efforts of social betterment. The format of the fairs also meant that sociological studies could be presented in exhibits and their results deliberated in congresses convened during the events. In addition to the important role that sociologists played at the fairs, historians also responded to the commemorative ethos of the Emancipation expositions. Using the events as public platforms, members of the black intelligentsia—educators, scholars, and artists—sought to counter racially motivated efforts to eliminate black contributions from the nation's official canon. They wished to dispel the myth that black Americans had no historical roots or connections to their African origins. The increase in the number of credentialed sociologists and historians was made possible by the success of the black educational system at providing strong academic foundations for students. Additionally, the willingness of some white administrators to admit black students to graduate schools meant that new educational

opportunities were available. Of equal significance was the courage of black men and women who endured scathing attacks by white classmates and teachers while integrating major universities such as Harvard, Columbia, Chicago, and Pennsylvania. These graduates led an influential cadre of trained professionals who would steward new urban organizations like the NUL and NAACP.[17]

Receiving the sum of $20,000 from the State of Pennsylvania, secured in part by the work of Harry Bass—the state's only black representative from Philadelphia—the Emancipation Proclamation Exposition opened for one week in late September. The organizing committee hired a black architect to plan eight buildings in a small park in the southern part of the city, prompting one newspaper to boast of the largest contract ever awarded to colored builders up North.[18] The organizing committee placed the AME religious leader Wright Jr., who had graduated with a doctorate in sociology from the University of Pennsylvania, in charge of gathering the many exhibits for the fair.[19] Wright planned a special sociological congress to address the question of Negro progress, with an emphasis on the race's moral, physical, educational, and industrial advancement. On the day of the sociological congress, great throngs of visitors filled the auditorium, including a stellar roster of men and women who were educators, activists, and race leaders. A young Rhodes scholar with a doctorate from Harvard University, Locke delivered a paper titled the "Basis of Racial Adjustment." Wright also enlisted Kelly Miller, Atlanta University's William Crogman, and respected Tuskegee Institute sociologist Monroe N. Work to present scholarly papers. In an afternoon session, Du Bois gave a speech that asked his audience, "What Is Race Prejudice?" This rich provocation prompted responses by progressive activist Nannie Burroughs and future Harlem Renaissance writer Jessie Fauset.[20] However successful the congress, the fair's larger outcomes were less than stellar. In their review of the overall quality of the exhibits and atmosphere, the widely read Bookerite newspaper the *New York Age* proclaimed the event a "dismal failure" (although the congresses were spared the *Age*'s pointed commentary).[21]

Two weeks later, organizers staged New Jersey's Golden Jubilee—a much smaller weeklong event at the Exposition Hall by the beach in Atlantic City, a location pitched in advertisements as "The World's Greatest Seashore Resort."[22] The Golden Jubilee's brochures touted Atlantic City's eight miles of boardwalk, amusements, and sea bathing—new types of leisure activities that gave city dwellers a respite from crowded urban confines. While these new forms of entertainment were becoming more preva-

lent at fairs, the expositions' main objective was still educating the public on the black race's advancement. A Philadelphia native who lived for a while in nearby Camden, Locke assisted in the Atlantic City preparations. He and his fellow organizers depended on New Jersey's black counter-public sphere of associations, schools, churches, and businesses to provide evidence of the state's black achievements.[23] The central committee—in responding to the requests of thirty-seven local leagues, whose sheer numbers and conflicting agendas prohibited cohering to a singular over-arching theme—parceled together an eclectic seven-day celebration.[24] Exhibits, booths, and performances could be found throughout the large hall. One display, for example, documented the evolution of the black household. Told in the familiar Bookerite refrain, it posited the origins of racial uplift in the home. Its illustrations began with a log cabin attended by a mammy preparing hoecakes, followed by a small white-washed shanty, and concluding with a well-appointed house with windows adorned by lace curtains and electric push buttons that provided access to the latest domestic conveniences.[25] In total, the seaside fair lacked a cohesive message about the status of the race. Even with their collective efforts to a stage memorable event, the New Jersey celebration, like its Philadelphia predecessor, failed to garner sustained national interest or accolades in the critical forum of the Negro press. New Yorkers (and two years later Chicagoans), however, would pursue in their semicentennial Emancipation expositions a more ambitious agenda concerning the future progress of black politics, history, and economics than Philadelphia's or Atlantic City's planning committees could muster.

A PAGEANT OF BLACK HISTORY

In the fall of 1912 Robert N. Wood, with the support of a group of non-partisan citizens, approached New York's Democratic governor, William Sulzer, about holding a fair to celebrate the fiftieth anniversary of Emancipation. Wood also persuaded the Democratic Organization of New York to pressure the legislature to pass a bill funding the fair.[26] Wood, a powerful black party member and owner of a printing business, headed the political association United Colored Democracy. Finally, in May 1913, the New York state legislature awarded $25,000 for a semicentennial fair. Governor Sulzer created an Exposition Commission managed by his fellow Tammany supporter, Wood.[27] The commemorative booklet published for New York's Emancipation exposition praised the state's Democratic Party: "In the changing conditions of fifty years, New York Democracy

has, because of political expediency, reversed positions with New York Republicanism."[28] In particular, the politically slanted booklet featured a large photograph of a deferential Wood standing behind the chair of Charles V. Murphy, saloon owner and powerful political boss of Tammany Hall. In an acerbic editorial, the *New York Age* characterized Wood's position as one of a "Friday" or "office boy." The *Age* went so far as to suggest that, if this picture was supposed to be indicative of racial progress, then witnessing that absurdity was worth the price of purchasing the booklet.[29] To be sure, the photograph of Wood and Murphy could be interpreted as emblematic of northern racism—Democrats needed black citizens for their labor and votes, yet blacks were not permitted to have equal standing or, in this instance, a comparable seat with white power bases at the negotiating table.

Right away Wood needed assistance with the many preparations required for planning an exposition of this size and scope. Wood, whose business printed the *Crisis*—the magazine published by the newly formed NAACP—asked its editor, Du Bois, to join what was being billed as the National Emancipation Exposition.[30] Three years earlier, Du Bois had departed Atlanta for New York City where he edited the *Crisis*. By the time the activist and educator arrived in Manhattan in 1910, 91,000 blacks lived there, less than 2 percent of the city's total population; Atlanta's black residents numbered only 52,000, but in that case they accounted for almost a third of the southern city's total population. New York City had been home to enslaved and freed-black residents since the time of the first Dutch settlement in the seventeenth century. Manhattan's black enclaves, such as Seneca Village in what is now Central Park, had been steadily displaced as white neighborhoods crept northward from the southern tip of the island.[31] By 1913 most black Manhattanites (including Du Bois for his first few years) lived in an area around W. Fifty-Eighth Street and Tenth Avenue known as San Juan Hill. Harlem, the next destination for the migration of the city's black settlement up the island, was being advertised in the widely read *Age* as a possible place to settle, especially for those new residents arriving from the South as well as from parts of the Caribbean.[32] Over the next decade, the Great Migration would nearly double New York City's black population. This rapidly growing diverse urban community formed an ideal audience for the Emancipation fair's message of racial progress.

Aware of his success with the Paris fair, Wood offered Du Bois the chairmanship of the most critical committee, the exhibitions committee. Du Bois was joined in his efforts by editors of the city's black newspa-

pers, including the *Amsterdam News* and the *Brooklyn Eye* but not the widely read *New York Age*.[33] Four months before his appointment to the exposition, Du Bois had presented his plan for a national Negro fair to the U.S. Senate. Fascinated by the idea of a Jubilee of Freedom, Du Bois in other writings had conceived of the fair in the form of a small and mobile exhibit—one that could travel around the country displaying a scientific and artistic study of the advances of the Negro over the past fifty years.[34] Unfortunately, political sniping among black leaders and the press severely hampered Du Bois's arrangements for New York's National Emancipation Exposition, which included the importation of artifacts from Africa for display and the convocation of an international sociological congress.[35] The *Age*'s Fred Moore, a loyal Bookerite who had purchased the paper from its founder T. Thomas Fortune several years earlier, became a vehement and constant critic. Moore and the *Age* took every opportunity to criticize the event to its national audience of readers.[36] In a front-page cartoon, Moore lampooned Du Bois for bringing in exhibits from around the United States and overseas from Africa instead of focusing on the progress of New York's Negroes. Although new to New York City, Du Bois in his position as the editor of a national publication was able to draw upon an extensive network of newspapers and magazines for support. To quiet the rancor of his critics, Du Bois used the pages of Baltimore's *Afro-American,* a competitor of the *Age,* to praise the New York state legislature for putting the Exposition Commission firmly in the hands of capable black citizens. In a rather acerbic passage, he derided the *Age*'s editor, Moore, as "a Negro newspaper scribbler who failed to secure a place on the commission in order to create discord from within."[37]

Held for a week in October at the Twelfth Regiment Armory on Ninth Avenue near the San Juan Hill neighborhood, New York City's elaborate National Emancipation Exposition attracted over thirty thousand visitors.[38] In a few short months, Du Bois had assembled an array of exhibits from around the country on agriculture and manufacturing, health and sanitation, and art and culture—he classified the bounty of exhibits under fifteen divisions, and the fair sponsored several festive days of musical events, artistic displays, and a sociological congress.

His ambitious and efficient effort did not sway everyone. A disapproving review letter to the *New York Times* observed that the fair lacked the displays of farm equipment and livestock typical of the southern fairs. The *Age* chimed in with its Bookerite position, criticizing that organizers showed very few practical exhibits.[39] Contrary to these biased assess-

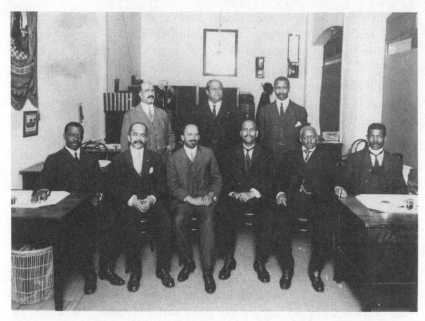

FIGURE 27. National Emancipation Exposition organizers, New York City, 1913. Standing, left to right: James Carr, assistant exposition corporation counsel; Robert N. Wood, exposition chairman and president of United Colored Democracy; Dr. John R. Hillery, physician. Sitting, left to right: Rev. W. A. Byrd, director of the religious congress; James Anderson, managing editor of *Amsterdam News;* W. E. B. Du Bois, editor of the *Crisis;* Rev. G. H. Sims, pastor of Union Baptist Church; G. B. Clayton, real estate and employment agent; Rev. J. Henry Taylor, editor of the *Pilot.* Courtesy of Special Collections and University Archives, University of Massachusetts at Amherst Libraries.

ments, in fact professional dressmaking and millinery, a four-cylinder auto engine, and working models of a cotton mill, oil mill, and turpentine still could be found among the exhibits. Du Bois and his committee curated agricultural exhibits that highlighted black innovations in modernized farming techniques and agricultural machinery. These material displays of ingenuity appeared between informative charts on sanitary conditions and health and graphs on mortality rates, whose data measured the transformation in blacks' quality of life from slaves to modern citizens in fifty short years. Du Bois organized this educational exhibit with the assistance of his sociology colleague Monroe N. Work, an associate in the Niagara Movement. In 1912 Work also had begun publishing a yearly compendium of Negro progress, *The Negro Year Book,* and had contributed to several of the Atlanta University conferences. Like at the urban-themed conferences, at New York's Emancipation fair Du Bois

		SPECIAL DAYS	AFTERNOONS	EVENINGS
		PROGRAM OF THE		
		National Emancipation Exposition		
		OCTOBER 22 to 31, 1913		
		12th Regiment Armory		New York City
Oct. 22	Wednesday	Albany Saratoga Troy	Fraternal Orders	Opening Exercises
Oct. 23	Thursday	New Rochelle	Masons and Odd Fellows	Pageant
Oct. 24	Friday	Governor's Day Syracuse	Stenographers and Artisans	Music School Settlement Concert
Oct. 25	Saturday	Mount Vernon White Plains	All Southern Day Pageant	Athletic Meet
Oct. 26	Sunday	Douglass Day Rochester	Inter-church Chorus RELIGIOUS	Will Marion Cook and Double Quartette CONGRESS
Oct. 27	Monday	Lincoln, Ill., Day, Yonkers SOCIOLOGICAL	Professional Men CONGRESS	Banquet
Oct. 28	Tuesday	Baltimore Buffalo WOMAN'S	Children's Day DAY	Pageant
Oct. 29	Wednesday	Boston, Binghamton, Elmira, Ithaca, Auburn	Business Men	Clef Club Concert
Oct. 30	Thursday	Washington, D. C., Kingston, Newburgh, Ossining, Poughkeepsie	West Indians	Pageant
Oct. 31	Friday	Greater New York	Native New Yorkers	Exposition Band Concert and Costume Ball

FIGURE 28. Program of National Emancipation Exposition, New York City, 1913. From *Crisis*, November 1913.

foregrounded issues pertaining to life in the nation's cities. He held fast to his promise that the exposition would represent "every phase of life connected with the negro race," adding that "in many cities . . . the colored man has erected and is controlling vast manufacturing establishments or controlling big business. In one of our booths we propose to display by models the largest buildings and the greatest industrial plants now controlled by the negro."[40] Exemplifying these points, exhibits about Alabama's Dixie Industrial Company and Texas's and Indiana's Mill City Cotton Mills demonstrated progress in the black ownership of factories. Elsewhere, an exhibit on the health and physical attributes of the Negro showed photographs of well-known athletes and women who represented ideals of beauty and womanhood.[41] (Exhibits such as these linking good health with a physically fit and aesthetically pleasing albeit racialized body indicated the prevalence of eugenicist attitudes during this period, even among black Americans.)[42]

To enhance the fair's cultural offerings, as well as to provide critical evidence of the robust and striving black nation that he had envisioned in the "American Negro" exhibit, Du Bois drew on the expertise of colleagues from previous expositions. He extended an invitation to the Library of Congress's Daniel P. Murray to once again use his vast knowledge and resources to assemble a commanding collection of books on Negro history and life. As one newspaper duly noted fifteen years after Paris's "American Negro" exhibit, Murray's selection was now large enough to fill a good-sized library.[43] Du Bois also wanted the New York fair to have a symbolic artistic statement of cultural advancement. He commissioned his friend artist Meta Vaux Warrick Fuller to envision a sculptural centerpiece for the hall. To create the eight-foot-tall expressionist sculpture *Humanity Freeing the Slave* (also known as *Emancipation*), Fuller's skilled hand captured the figures of a man, woman, and child in rough-hewn bronze. Less didactic than her historical Jamestown tableaux, her allegorical trio finds shelter under a tree whose looming branches wait to seize the group's precious freedom.[44] With their broad shoulders and stern brows, the main male and female figures' ideal physiques exude a robust countenance, their dignified pose a far cry from Charleston's racist plantation trio. To the fair's crowds, the family represented both the origins and future generations of the Negro race.

Du Bois placed the symbolically charged *Humanity Freeing the Slave* in the exposition's Court of Freedom and near a large Egyptian styled structure, the Temple of Beauty. He commissioned local black architects William Foster and Vertner Tandy—the latter a protégé of William Pittman

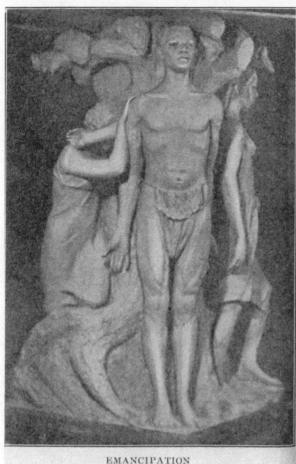

EMANCIPATION
By
META WARRICK FULLER

FIGURE 29.
Humanity Freeing the Slave (also known as *Emancipation*) by Meta Vaux Warwick Fuller, National Emancipation Exposition, New York City, 1913. From Robert T. Sims, *Negro Poets and their Poems* (Washington, D.C.: Associated Publishers, 1923).

and the architect of Jamestown's Negro Building—to design the small pavilion. The Temple of Beauty's interior displayed a cache of artworks highlighting important events in black history. On one wall hung Juan Hernandez's sprawling canvas depicting the black soldiers of the Twenty-Fifth Infantry Regiment's charge at the Battle of El Caney in the Spanish-American War.[45] Silhouettes of Egyptian deities and monarchs adorned the exterior facades. Further enhancing the mood of a desert oasis, tall potted palm plants were placed at each corner. Four twenty-foot-tall obelisks painted with hieroglyphics surrounded the temple and at its rear a large sphinx guarded the south entrance of the hall. In total, the

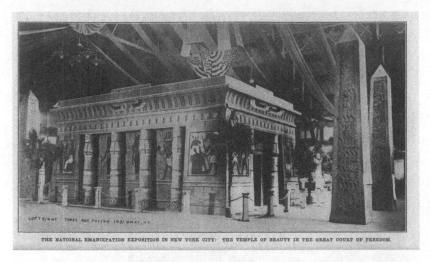

THE NATIONAL EMANCIPATION EXPOSITION IN NEW YORK CITY: THE TEMPLE OF BEAUTY IN THE GREAT COURT OF FREEDOM.

FIGURE 30. Temple of Beauty, National Emancipation Exposition, New York City, 1913. From *Crisis,* December 1913.

deliberate choice of African decor stood in stark contrast to the southern Negro Buildings, whose organizers had adapted a European aesthetic to visually cohere, in a manner appropriate for the race, with the other buildings at the fairgrounds. Not everyone, as it turned out, was delighted with this homage to the Negro's African origins. Relentless in their efforts to rebuke Du Bois and the exposition, the *Age* characterized the decorations as more representative of an African past than of the "New York Negro" since Emancipation.[46]

The Egyptian-styled theme served as a backdrop for Du Bois's lavish three-hour pageant, *The Star of Ethiopia,* a centerpiece of the fair. First written in 1911, the expanded six-part performance told the story of the formation of human civilization on the African continent and highlighted black people's contributions to the world. For the cast of over three hundred, such an immense undertaking required exceptional organizational skills. Composer Charles Young penned the music for the pageant. And Du Bois's friend and former Wilberforce student, Charles Burroughs, directed the large cast, with Daisy Tapley assisting with the music and Dora Cole Norman in charge of choreography.[47] Under the guidance of this group of seasoned theater professionals, *The Star of Ethiopia* was a pageant chronicling the advance of black civilization the likes of which had never been staged or witnessed in the United States.

Staged to nurture civic pride, pageants gained in popularity around

the turn of the twentieth century when groups began to present histori-
cal pageants—founded in mythologies of folk culture—in small towns
and major cities around the United States. In wider practice, and as the
next section explores with the America's Making Exposition, white Amer-
icans and immigrant groups (they typically excluded blacks from par-
ticipating in mainstream performances) put on historical pageants to cul-
tivate communal identities rooted in myth, history, and place. The
recently constructed public parks, stadia, amphitheaters, and the Beaux-
Arts civic architecture of the City Beautiful movement provided symbolic
backdrops for these popular performances. Allegorical in their content,
pageants mined America's history to yield for their audiences a wellspring
of cultural enlightenment and moral grounding. Often involving casts of
thousands, pageants enlisted local residents who guided the larger com-
munity through a mythological narrative of building their collective fu-
ture through cooperation, hard work, and good citizenship. Historian
David Glassberg posits that pageants formed an important means of en-
acting public collective memory, observing that, "although the prevail-
ing concerns of powerful local interests who organized the ceremonies
had the greatest influence upon which version of the past was designated
as public history, the desire to appeal to a mass audience also affected
public history's content and form." Particularly relevant for Du Bois's
interest in pageantry was that, as Glassberg observes, "the celebrations
furnished arenas for the ritual construction of a public history, the
meanings of which were shaped by popular expectations as well as civic
official's political agenda and power."[48] The symbolic performances es-
poused progressive notions of social evolution and promoted participa-
tion in the formation of a shared historical consciousness of the United
States.

Keenly aware of its immense pedagogical potential, Du Bois adopted
the pageant form to present a story of black history beginning in Africa
(hence the Egyptian-styled decor) and culminating in the present-day city
of New York. Du Bois's embrace of "Ethiopianism" links him to a long
lineage of black nationalists such as Henry Highland Garnet and Alexan-
der Crummell, who believed, based on a passage from Psalms, that Africa
and her children would experience a cultural, economic, and political re-
naissance.[49] A utopian and mystical Ethiopia provided popular symbol-
ism among Masonic associations, secret societies, and Greek organiza-
tions popular with many middle-class blacks.[50] To claim an African origin
meant that the race had cultivated a distinct refined culture, similar to how
other groups in previous fairs had invoked their origins. This kind of pub-

lic performance allowed various immigrant groups, such as Italian or Greek Americans, to claim racialized cultural affiliations to their homeland. On one hand, Ethiopianism provided a means to cultivate Pan-African solidarity, recognizing commonalities across the city's already diverse black community. (New York City, we should note, was not only a destination for southern blacks but also for people migrating from the Caribbean and parts of Africa, who joined old settler black communities in Manhattan and Brooklyn, home to black residents since the city was a Dutch colony.) On the other hand, Ethiopianism also hinted at racial assimilation into the American melting pot—a goal implicit in American pageantry. Progressive-era pageants often drew upon Judeo-Christian and folk themes that helped to calm the ethnic, racial, and class conflict churned by technological progress.[51] That Ethiopianism offered black Americans such a panacea in the face of social upheaval suggests that Du Bois staged his populist pageant to reconcile the two nationalisms: Negro and American.

The title *The Star of Ethiopia* alluded to the medal of honor given by King of Kings Menelik II, who had defeated Italian colonialists to form the powerful African Abyssinian Kingdom in 1896. Du Bois had conferred with Emperor Menelik's attaché at London's inaugural Pan-African Congress in 1900. In his 1915 history, *The Negro,* whose narrative parallels that of the pageant, Du Bois ended the chapter on Egypt and the battle for the independence of Ethiopia with this poetic elegy:

> That starr'd Ethiop Queen that strove
> To set her beauty's praise above
> The sea nymphs[52]

Du Bois's representation of a spiritual and nationalistic Africa differed greatly from the staged savage natives witnessed by audiences who visited ethnographic displays at world's fairs and who viewed the anthropological and zoological displays at New York City's American Museum of Natural History, Chicago's Field Museum, and the Smithsonian Institution.[53] The Egyptian-styled Temple of Beauty proclaimed the mythic past and promising future of the Negro, a public history and collective memory called forth in Du Bois's inspired staging of *The Star of Ethiopia.*[54] Like the Emancipation Day speeches, the pageant's spirited message was crafted to provide consolation in the face of unrelenting racial distress.

Performed in the Court of Freedom, Du Bois's prelude to *The Star of Ethiopia* commenced with a trumpeted call to witness: "Hear ye, hear ye! Men of all the Americas, and listen to the tale of the eldest and strongest

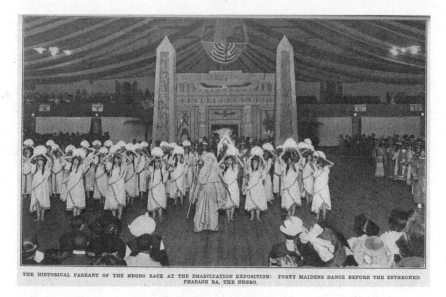

THE HISTORICAL PAGEANT OF THE NEGRO RACE AT THE EMANCIPATION EXPOSITION: FORTY MAIDENS DANCE BEFORE THE ENTHRONED PHARAOH RA, THE NEGRO.

FIGURE 31. *The Star of Ethiopia*, National Emancipation Exposition, New York City, 1913. From *Crisis*, December 1913.

of the races of mankind, whose faces be black. Hear ye, hear ye, of the gifts of the black men to this world."[55] The allegorical story unfolded in six episodes presented through oratory, music, and dance. A "Negro and mulatto" cast of 350 performers portrayed the historical figures of the Queen of Sheba, Mohammed, Crispus Attucks, Toussaint-Louverture, Nat Turner, Frederick Douglass, and Sojourner Truth. The dramatic staging of the creation of Islam, the Middle Passage, the Haitian Revolution, and Emancipation vivified black history for the rapt exposition audience. Eclipsing Fuller's static historical Jamestown tableaux, the full-scale live performance presented the audience with a spectacular visual history of Africans and the Negro in the Americas that rivaled any Western narrative of civilization. In dynamic scene after scene, black peoples gave the world the supreme "gifts" of original human settlements, religion, democracy, and culture, to name only a few.

Enthralled by the sheer scale of the animated production and the encompassing mise-en-scène, the predominantly black urban audience witnessed Pan-African history as both a commemoration of Emancipation and as a significant and enduring contribution to world history. The temple, which served as the background for the six scenes, did not reference the architecture of Anglo-America but instead symbolized a mythic black

spirituality in its African form and decor. Conceptually, as a commemorative event of Emancipation, the black progress represented in the pageant was defined not only in terms of physical labor, as Washington had emphasized, but also as a historical process that tied the American Negro to Africa. A reporter considered the purpose of the pageantry of *The Star of Ethiopia* "to stimulate the pride of the colored people in the historical progress of their race."[56] In other words, the pageant's underlying goal was to promote in its audience a comprehension of the Negro's past in order to foster agency in the fight against current forms of racial oppression and as a means to reclaim foreclosed rights of U.S. citizenship.

Other regions besides major East Coast cities planned weeklong publicly financed Emancipation expositions. Once home to the Great Emancipator, Lincoln, Illinois was the appropriate host for a semicentennial event to celebrate its native son. In July 1913, Democratic governor Edward Dunne named an interracial committee to plan the fair. Bishop Archibald F. Carey, a black Republican and graduate of Atlanta University, was selected to head the National Negro Semi-centennial Exposition Association. Bishop Samuel Fellows, a white Republican alderman and Episcopal bishop, joined Carey in running the association. Other black committee members included fraternal member Major R. R. Jackson, clubwoman and physician Dr. Mary Fitzbutler-Waring, and journalist and attorney Thomas W. Swann. Supported by black professional associations, white philanthropists, and politicians, they secured enough state and (eventually, after southern senators had blocked the initial appropriation) federal funds to host the Lincoln Jubilee Exposition in Chicago.[57] Staged in the summer of 1915, the exposition was convened, according to the prospectus, "to allay race prejudice, growing out of a widespread unfamiliarity with the Negro's general social progress."[58] The commission condemned the degrading portrayals of blacks in the press and endeavored to "set forth the negro as he really is."[59] The fair's organizing committee wrote in their prospectus the requisite statement of social advancement. But by including the following quote from Du Bois (and not Washington, an indication of the shift in power by 1913), they delivered a bold statement about broader human rights and justice: "[Negroes] are today girding themselves to fight in the van of progress, not simply for their own rights as men but for the ideals of the greater world in which they live; the emancipation of women, universal peace, democratic government, the socialization of wealth and brotherhood."[60]

Ten years into the twentieth century, Chicago was home to forty thou-

sand black residents, 2 percent out of a total city population of two million. Black Chicago had already developed a social infrastructure of associations, business, and newspapers, with black residents primarily settled in a region south of the Loop (the central business district), east of the stockyards, and centered on the southern stretch of Michigan Avenue. The area was called the Black Belt, referencing its residents' rural roots in the swathe of dark soil originally stretching from Alabama and Mississippi. Because racist practices on the part of landlords and realtors had corralled black residents and businesses into this area, it was more diverse in terms of class than other areas of the city. Elites, most often those who were college educated, filled the ranks of doctors, lawyers, business owners, bankers, and clergy. Barbers, waiters, porters, artisans, and teachers, many of whom had attended high schools and normal schools, sought a level of middle-class respectability in their choice of home and activities. Working-class blacks found work as railroad and stockyard workers, laundresses, domestic workers, and laborers but were excluded from skilled industrial work mostly apportioned to whites. Chicago's working-class blacks were also limited to service work within their own community, as whites over time employed fewer blacks as barbers and caterers.[61] This emerging class and social structure in Chicago's Black Belt centered around prevailing ideals—reinforced by cultural practices—of family, work, and religion that ran counter to the perception by many white Chicagoans that their black neighbors were an undifferentiated community of mostly illiterate, lazy, and unmannered residents. Indeed the black community was stratified into elites and the poor: "old settlers" and "new settlers," the northerners and southerners whose allegiances split along the lines of what constituted respectability, cultural tastes, political affiliation, and even what newspaper was preferred reading.[62]

This stratification of social life could be found in the different storefronts and institutional edifices lining the streets of the Black Belt. Working with white progressives, educated black leaders and activists founded local branches of the NAACP, NUL, Young Men's Christian Association (YMCA), and the National Negro Business League (NNBL). Chapters of the Oddfellows, Knights of Pythias, and the Elks joined with other voluntary and social associations in the city's black counterpublic sphere. The city maintained four black newspapers, including the *Chicago Defender*, which began publication in 1908. The *Defender* was started by Robert Sengstacke Abbott, a Hampton Institute graduate and reporter on the latest national and local news. Within its pages, blacks could read the latest reportage on sporting events, theater and recitals, and the emerg-

ing mass culture of movies and vaudeville. Its content kept Chicagoans abreast of the black world, while it also acquired a national audience, especially among southern readers. The *Chicago Defender,* along with the *New York Age,* advertised jobs and editorialized about the alluring prospects in northern factories for downtrodden southern blacks in search of a new start.[63] Historian Davarian Baldwin, in his astute study *Chicago's New Negroes,* suggests that "the North may have offered images of cultural freedom, but it was southern dollars and desires that made Chicago's black consumer culture so viable."[64] As Baldwin argues, the new settlers brought with them a different set of imperatives than those of the older, more established elites. Work was central to sustaining a viable urban livelihood. New forms of industrial labor also opened avenues for social mobility as well as providing free time from work obligations. The activities engaged in during this new found leisure time often occurred in venues purveying affordable amusements, such as vaudeville theaters, ballrooms, nightclubs, moving-picture halls, and gambling dens. These new spaces of leisure also provided income for those entrepreneurs who established these businesses along the Black Belt's famous Stroll and whose success eventually drew the ire of many respectable blacks who disdained the vice and immoral behavior that followed such establishments.[65] Many facets of this black Chicago came together for the Lincoln Jubilee Exposition that took place from August 22 to September 16, 1915.

While the organizing committee originally proposed for its venue the Eighth Regiment Armory located in the heart of the Black Belt, the mammoth Chicago Coliseum south of the Loop and the site of several important political conventions (including a Republican Party convention three years earlier) was their final choice to host the Lincoln Jubilee Exposition. The Lincoln Jubilee directly followed the close of Richmond's ill-fated Negro Historical and Industrial Exposition, and many of its exhibits traveled to Chicago, along with material from more than twenty states. Rather than draw from the northeastern and southern black communities, Lincoln Jubilee organizers sought contributions primarily from the midwestern and western states: Arizona, Colorado, Iowa, Kansas, Kentucky, Louisiana, Michigan, Minnesota, Oklahoma, Ohio, Oregon, New Mexico, Pennsylvania, Texas, West Virginia, Wisconsin, and Wyoming.[66] The exhibition committee divided the exposition into six general departments: Religion, Education, Military Affairs, Industry, and Social Progress, also adding a Miscellaneous department. The opening-day festivities drew a crowd of over 12,000 spectators who filled every seat

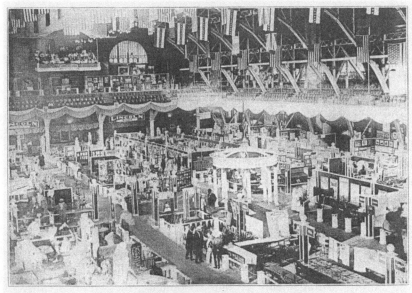

GENERAL VIEW LOOKING NORTH.

FIGURE 32. Interior view looking north, Lincoln Jubilee, Chicago Coliseum, 1915.
From *Lincoln Jubilee Album: 50th Anniversary of Our Emancipation; Held in Chicago,
August 22nd to September 16th, 1915* (Chicago: National Half-Century Exposition,
1915). Courtesy of Chicago History Museum.

and packed the aisles.[67] Over 135,000 visitors (some estimates put the
number at almost 800,000) attended the Lincoln Jubilee's three-week run,
prompting the local and national press to hail it as a great success.[68]

The planners emphasized black Chicago's allegiance to the nation's
democratic values. Patriotism, combined with the Black Belt's entrepre-
neurial potential, was made visible amid the many booths, performances,
and displays. In efforts to underscore the commemorative exposition's
national significance, the organizers had red, white, and blue bunting and
flags draped from the coliseum's soaring rafters. Upon entering the vast
hall, fairgoers were greeted by a full-size statue of President Lincoln. A
circular temple composed of eight Greek columns towering at least twelve
feet surrounded the likeness of the martyred emancipator, whose figure
stood in a wide stance with one foot ahead of the other, suggesting a confi-
dent forward advance. Near the heroic statue, curious visitors could pe-
ruse relics of Lincoln's presidency, highlighted by a commemorative dis-
play of his deathbed and bloodstained garments.[69] Amid the patriotic
atmosphere, the fair's organizers aimed to show "an actual optical dem-

onstration" of how Chicago provided a unique context, a "melting pot" they called it, that was a catalyst for black advancement. But in looking forward to future prospects, especially the potential that Chicago offered the race, they intended "to contribute towards the larger education of the great masses of Americans, and to demonstrate the possibility and promise of the future of this people."[70]

Seeking to portray a diverse range of what blacks had accomplished, organizers chose a wealth of material from various black communities, from the local to the regional and the international. Chicago's neighbors from Michigan, for example, assembled one of the largest exhibitions, whose state funding was successfully secured with the assistance of Swann. One popular booth featured recent inventions—a self-lubricating cylinder for steam engines, for example—from Detroit's Elijah McCoy that drew crowds of curious fairgoers.[71] Michigan's art gallery offered visitors fine paintings of important luminaries such as Sojourner Truth and Abraham Lincoln, along with genre paintings of landscapes and still-life arrangements. A sign announcing the women's cause of "Equal Suffrage"—probably promoted by Mary E. McCoy, a chief organizer and head of the Michigan Association of Colored Women's club— was hung on one of the banisters at the front of Michigan's exhibit.[72] In seeking the presence of African nations, Swann invited a white University of Chicago anthropology professor, Frederick W. Starr, to curate an exhibit of books, tribal artifacts, and raw materials from Liberia similar to an earlier display he had assembled for Buffalo's Pan-American Exposition. Bearing an official title bestowed by Liberia's president, Starr solicited two young black American military officers in West Africa who were engaged in military offensives to gather material and ship it to Chicago. Upon the close of the fair, the two officers requested that the material be donated to Wilberforce University to become part of the institution's teaching archive.[73] All of these exhibits from the region and world captured the interest of fairgoers. But it was the manufacturing and commercial exhibits that took center stage in Chicago's parade of black accomplishments.

In comparison to the East Coast expositions, with their focus on education, industrial arts, and high cultural achievement, the Chicago event featured exhibits that were primarily entrepreneurial in scope.[74] The organizers extended an invitation to the now legendary but ailing Washington (a financial supporter of the fair) to speak at the meeting of the National Negro Authors Association. Personal care companies, for example, set up prominent and popular booths. These companies would

MICHIGAN EXHIBIT, INVENTOR McCOY AND HIS DEVICES, LUBRICATING OIL CUPS.

FIGURE 33. Elijah McCoy and his inventions, Michigan State exhibit, Lincoln Jubilee, Chicago Coliseum, 1915. From *Lincoln Jubilee Album: 50th Anniversary of Our Emancipation; Held in Chicago, August 22nd to September 16th, 1915* (Chicago: National Half-Century Exposition, 1915). Courtesy of Chicago History Museum.

influence new urban populations' sense of style while amassing great personal fortunes for their owners. Hair care specialists from Annie M. Malone's Poro College in St. Louis ran a booth featuring hair products and styling demonstrations for women visitors. Through the innovation and selling of black hygiene and beauty products, Malone, a dedicated clubwoman, maintained her position as overseer of black domestic respectability, selling items that enhanced female beauty while simultaneously carving a niche for herself in the world of business and entrepreneurship. With her emphasis on Pan-African origins of black beauty—*poro* referred to a western African community—she gave her saleswomen a means of securing a modicum of financial independence. This was self-help under the mantle of the advancement of black womanhood. Poro College proved a supremely lucrative business venture for the enterprising Malone, and she would eventually erect a large manufacturing complex and educational facility in the heart of the Black Belt.[75] But according to a reporter from the *Defender*, the "biggest and most attractive" exhibit showcased the soaps, powders, and perfumes locally manufactured by

the popular Overton Hygienic Company, whose future headquarters would become an important landmark in black Chicago. Its ambitious founder, Anthony Overton, also published the conservative journal *Half Century* and would eventually launch the *Defender*'s competitor, the *Chicago Bee,* in 1926. Overton manned the booth with his three daughters and four young saleswomen. During the first few days, the company did a brisk business by selling their "high brown powder" along with dozens of powders, soaps, perfumes, and toiletries.[76]

In the large and cavernous hall, the many musical performances and the wealth of literature and artworks showcased black cultural advancement, including the requisite prized paintings by artist Henry O. Tanner, which hung in a prominent position in a display of fine art.[77] The organizers assembled an impressive Grand Jubilee Chorus of Five Hundred Voices. On three nights during the first and third weeks of the exposition, this group performed the *Historical Tableau and Pageant of Negro History.* The performance of song and dance mimicked *The Star of Ethiopia,* with its narrative also beginning in Egypt, but it ended in the modern Negro home. The final scene, "Ethiopia and the Ten Graces," celebrated peace as the agent of progress. Enhancing the atmosphere of each act, slides were projected in the hall that displayed, for example, the siege of Fort Sumter, an extract from the Emancipation Proclamation, the Supreme Court's opinions on segregation, and Matthew Henson at the North Pole.[78] Elsewhere, joining the illustrious canvases of Tanner, were other works of art geared toward more-popular tastes. The *Chicago Defender* reported on artist Byrone E. Fontaine, whose canvases had been inspired by the features of the South's castes of "mulattos and octoroons," especially those with Aryan features of blonde hair and blues eyes. Fontaine was one of several contemporary black artists creating a new form of popular art that appealed more to sentiment than the mastery of modern techniques perfected by Tanner and his peer Robert S. Duncanson.[79] In one of the allegorical canvases on view, Fontaine portrayed a family scene of a dark-skinned, rotund mother surrounded by her five children, whose skin hues lightened from medium brown to fair as the children grew younger in age. Suggestive of a diorama charting the history of miscegenation, Fontaine arranged these progeny—far more sexualized and desirable than their asexual "mammy"—in front of their moss-covered cabin. Completing the parable of the southern social landscape, cotton fields spanned the middle ground, and a glint of mellow sunlight illuminated the big house in the distance.[80] While the South

served as the painting's context, Fontaine migrated the logics of intra-racial differentiation to a northern context, where women could purchase products like Overton's "high brown powder" to achieve the more desirable fair skin. Mass-produced pictures of racial pride that might not be considered fine art, but that were visually appealing to the crowds of fairgoers, could be purchased for a reasonable sum elsewhere on the exposition floor. Two ambitious entrepreneurs, Claude A. Barnett, a Tuskegee Institute graduate, and J. T. Simms marketed their Douglas Specialties Company as a retailer of "high grade Negro pictures for Negro homes." The businessmen sold portraits of black women posed in various historical phases of Negro life alongside images of historic figures like Frederick Douglass and Sojourner Truth to fair visitors keen on decorating their flats or houses with tasteful emblems of black cultural pride.[81]

The southern fairs had emphasized the importance of manual labor, education, business, thrift, and moral uplift. But the New York and Chicago Emancipation semicentennial fairs began to publicize a cultural history of the Negro that was both a collective memory drawn from enslavement and a Pan-African history that tied its audience to black peoples from the African continent and the Caribbean. These expositions promoted a public history in the form of pageants, panoramas, pictures of black luminaries, and written histories. Organizers displayed cultural productions to captivate and educate the throngs of fairgoers. Once engaged, black urbanites found mass-culture versions of these artifacts available for purchase to furnish their homes and workplaces with symbols of racial pride and respectability. At various booths, people could buy books by Du Bois, Washington, and other authors on Negro history in order to learn more about their past struggles and achievements. One such vender at Chicago's Lincoln Jubilee was Carter G. Woodson, who had traveled from Washington, D.C. Expanding his stock beyond books, Woodson's booth, like that of the Douglas Specialties Company, also sold small portraits of Douglass and Truth, poet Paul Laurence Dunbar, and other luminaries.[82]

A scholar as well as a teacher, Woodson was educated at Berea College, the University of Chicago, and Harvard University, the second black student after Du Bois to receive a doctorate from the latter. One year prior to attending the fair, Woodson published *The Education of the Negro Prior to 1861*. In part because of popular notions of cultural advancement, he was convinced that "the achievements of the Negro properly set forth will crown him as a factor in early human progress and a maker of modern civilization."[83] Together with many of his peers, he ad-

vocated the tenets of racial uplift, such as self-help. But Woodson was also an anti-Bookerite who had become weary of the single-leader allegiance model that the press and pulpit popularized—particularly when those who assumed the mantle of leading the race had been chosen by powerful whites. Woodson envisioned a more participatory effort that started among the people. And thus he put forward the innovative idea that shared knowledge of the past and collective service would be key to cultivating cultural and racial solidarity.[84]

Visiting Chicago for several months, Woodson was invited to a conference organized by University of Chicago sociologist Robert E. Park, whose agenda was to counter the racist depictions of southern blacks in *The Birth of a Nation* film that had been released that winter.[85] A spectacle screened to sold-out crowds in major cities, *The Birth of a Nation* offered a cinematic panorama of the Civil War and Reconstruction that derived its story from Thomas Dixon's overtly racist novels, which brimmed with mythic Judeo-Christian symbolism. D. W. Griffith's technically innovative three-hour moving picture vivified the southern mythology of the origins of white supremacy. Depicted as progressing little beyond their lowly plight of enslavement, black characters on a South Carolina plantation (reminiscent of George Lopez's controversial Charleston statue) were drawn from the stereotypes of the pickaninny, the rastus (a subservient black male, typically a servant, waiter, or porter), and the mammy—with the latter performed in grotesque manner by a white male actor blackened up with cork. The movie reminded its audience that even more dangerous than the black masses were those politically ambitious college-educated blacks, especially those of mixed race. The mulattoes, played in the saga by white actors in blackface, had to be feared for their insatiable sexual appetites (a consequence of their Negro blood) and their cunning wiles in seeking power and influence (a result of the white bloodline). With black politicians shown as infesting the legislative floor of the State House, the film fully endorsed barring blacks from political office and voting. The visual drama of the film validated the rise of the Ku Klux Klan and its invisible, violent quest to maintain a racialized social hierarchy by keeping the white bloodline "untainted."[86] Griffith pieced together a historical roster of racialized stereotypes into a visual narrative through the new technologies of cinema in a way that live pageants, static displays, and sculptural tableaux at the expositions could never achieve.[87] Unlike the fairs, which proved expensive singular events to stage, the movie house proliferated new year-round spaces for viewing mass culture. Park's response was one of many protests. With

its membership over six thousand, the NAACP attempted to halt show-
ings of *The Birth of a Nation,* alleging that its inflammatory subject mat-
ter incited racial tensions wherever it was screened.[88]

Woodson declined the invitation to the conference but informed the
influential Park that he was planning to form an organization to circu-
late useful historical and sociological information that would counter per-
nicious depictions in vehicles like *The Birth of a Nation.*[89] The literary
societies that led to the formation of the ANA—such as Washington,
D.C.'s Bethel Literary and Historical Society, Philadelphia's American Ne-
gro Historical Society started in 1897, and the Negro Society for His-
torical Research founded in 1911 by John E. Bruce and ANA member
Arturo Alfonso Schomburg—preceded Woodson's historical organiza-
tion, the Association for the Study of Negro Life and History (ASNLH),
formed in 1915. Educated elites, however, had dominated the member-
ship of these organizations. Woodson, therefore, conceived of a more pop-
ulist organization especially geared toward black populations moving to
cities.[90] Historian Rayford Logan, in recalling the probable influences on
Woodson's philosophy, speculates that the racist climate that had fo-
mented *The Birth of a Nation* had also made Washington, D.C., the na-
tion's capital, a completely segregated place where its black residents lived
in a "secret city." The nation needed, Woodson surmised, a new organi-
zation to lift the veil of secrecy.[91]

Over the course of his Chicago visit, Woodson roomed at the Wabash
Avenue YMCA (an important civic institution whose building was
funded by philanthropist Julius Rosenwald). There he met fellow resi-
dent visitors Monroe Work and William Hartgrove, a teacher from Wash-
ington, D.C., along with Chicagoans James E. Stamps, a Yale graduate
student in economics, physician George Cleveland Hall, and others.[92] He
discussed with the group the need for an organization to tell the history
of the Negro people untainted by the distortions and vitriol of white his-
torians. While Du Bois posited the pageant as an effective vehicle for pub-
lic enlightenment, Woodson took a different approach. He imagined that
a historical association with an affordable membership fee and a widely
circulated journal could be another viable means of educating blacks
about their history. From those initial meetings, Woodson founded the
ASNLH. When he returned to Washington, D.C., Woodson had the as-
sociation incorporated and immediately started publishing the *Journal
of Negro History.*[93] Sold for twenty-five cents, each of the four issues of
the first volume published essays by Woodson on black migration to
Cincinnati, by Monroe N. Work on African traditions, by Howard's Kelly

Miller on black physicians, and by Jessie Fauset and Mary Church Terrell reviewing books about black history. With its local chapter structure, the ASNLH foresaw its mission as cultivating historical knowledge among all black Americans.

The formation of the ASNLH represented growing interest among black Americans in participating in organizations specifically dedicated to the study and dissemination of black history. The rise in scholarship on the Americas and the African continent that filled the pages of the *Journal of Negro History* in part derived from the emergence of a professional class of experts who had been educated to study subjects like history and the social sciences. In February 1926, Woodson successfully launched Negro History Week as an annual event to recall the historical legacy of blacks in America. Civic holidays, begun in the nineteenth century, had been one means to establish a ritual around the remembrance of important national events. Thus, the formal establishment of a week of pageants, lectures, and performances, accompanied by informative literature, would further educate black citizens on their own history. Newspapers like the *Defender,* the *Pittsburgh Courier,* and hundreds of smaller papers published articles about historical figures and important events, cartoons for younger readers, and announcements of the organizations hosting Negro History Week events. Collective commemoration—now codified into a black history—became an effective vehicle for personal edification and the continued social advancement of the race.

Revealingly, the content of the expositions celebrating the fiftieth anniversary of Emancipation indicated that the old agenda of educational and agricultural advancement as signifiers of progress was being supplanted by historical representations and cultural expressions. These events also illustrated the various ways that fair builders experimented with innovative modes of presenting black life and heritage in new formats like pageantry. The semicentennial expositions were primarily intraracial affairs that catered to growing black urban audiences. Although the black press covered the expositions in great detail, the white public knew very little about the fairs—these events were drawn from and sited within the black counterpublic spheres of northern cities. In light of these social and cultural transformations as a consequence of urbanization, these new representations and ideals of black progress, history, and national belonging would also be presented in mainstream white-organized expositions. Two expositions in the 1920s, the regional America's Making Exposition in New York City and the international Sesquicentennial Exposition in Philadelphia, provided black leaders an opportunity to test

the reception of white audiences to these notions that linked the success of black progress to civil rights, cultural nationalism, and Pan-Africanism.

AMERICANIZE, AFRICANIZE, OR RADICALIZE

While we often reference Du Bois's stirring *Souls of Black Folks* and other literary histories like *The Negro* to praise his contribution to the black intellectual legacy, it is also important to understand how and why Du Bois also adopted the appealing spectacle of pageantry as a means to publicize and popularize black history. He wrote in an editorial for the *Crisis* in the fall of 1915 that the exposition as a productive public forum had been exhausted. Its replacement, the pageant, seemed to be a more suitable vehicle for urban audiences because it mobilized "all the devices of modern theatrical presentation and with the added touch of reality given by numbers, space and fidelity to historical truth."[94] Because pageants were mass spectacles and staged in large open spaces, they offered blacks an opportunity to perform their history in a shared public domain. An effective tool of rallying civic participation, the pageant's theatrical format also cast the host city's population in the roles of both performers and spectators, which in the context of northern black communities could bring together in large crowds old settlers and newcomers. Du Bois, however, was frustrated that, despite its promise as a means to present black history, only one grand pageant staged by blacks had been attempted and that had been at New York City's National Emancipation Exposition (although this claim ignored performances such as the *Historical Tableau and Pageant of Negro History* at Chicago's Lincoln Jubilee). To bridge this creative chasm, Du Bois proposed that the NAACP form the Horizon Guild to develop the Negro dramatic arts. The guild's first undertaking was to stage a grander version of *The Star of Ethiopia* in Washington, D.C., as part of that city's Emancipation commemorations. Performed in October 1915 at the National Catholic Park and at the American League Ballpark, this version featured over one thousand performers and attracted thousands of spectators. The vast open area of the ball field facilitated free movement of the choreographed groups of performers. Far more extravagant and spacious than the New York version, the sheer scale of the performance amplified the pageant's realism. One viewer declared that *The Star of Ethiopia*'s colorful-costumed episodes "were sufficient to give a vivid impression of the savage hordes swarming into Egypt or the Union armies sweeping into the south and liberating the slaves."[95] *The Star of Ethiopia* would be performed in Phila-

delphia in 1916 and again in Los Angeles in 1925. Du Bois and his collaborators deployed the pageant as a means to characterize racial progress as a historical process recuperated through folk culture—reconnecting the New American Negro back to the African continent.

Another opportunity for Du Bois to stage a panorama of black history, this time to a broad audience that included white fairgoers, emerged when he received an invitation to show black progress at an exposition sponsored by the New York City and State Boards of Education in the fall of 1921. Franklin K. Lane, a former U.S. secretary of the interior, named the fair America's Making: A Festival and Exhibit of Three Centuries of Immigrant Contributions to Our National Life. Staged at the Seventy-First Regiment Armory on Manhattan's East Side, the fair offered each immigrant group (or, as the organizers characterized them, "different racial groups") an opportunity to show what "gifts" they had given to build America's stature. The invited representatives would come from the Dutch descendants of the first New York settlers and from immigrant groups recently arrived from "Russo-Carpathia or Czechoslovakia." Since it was an urban event, there would be no fairgrounds with pavilions. Neither would there be a system of categorization nor invited federal or foreign government participants. A modest undertaking, the America's Making Exposition would host exhibits and stage pageants that highlighted foreign cultural heritage within a U.S. context.

State organizers modeled the fair's format and intentions on previous state expositions celebrating folk culture in Buffalo and Albany. These fairs had displayed the arts and crafts of immigrant groups as a means of acknowledging their contributions to the nation, thereby furthering their adoption of American values and practices, a process that became known as Americanization.[96] One underlying rationale for these immigrant expositions was to prove that, by acknowledging and elevating cherished "gifts" of folk culture crafted by immigrants, those same hands, when put to work in factories, could be effectively mobilized toward increasing economic productivity and hence prosperity of the United States. Using the previous fairs as precedent and backed by a host of civic and municipal organizations, including the progressive People's Institute and Peoples of America Society, the America's Making Exposition was promoted as having two goals: to recognize the diversity of cultural contributions since the founding of the nation and to acknowledge immigrant participation in making America great.[97]

For many cities, immigrant assimilation in this period of U.S. history was a contentious process. It was believed and "verified" through the

racist discourse of eugenics in which particular groups, especially eastern and southern Europeans, along with Chinese and Africans, carried traits of feeblemindedness and the seeds of degenerate and immoral behavior. Along with the high birth rate among these groups, these innate undesirable characteristics fueled special concern and prompted drastic measures to stem such immigrants' increasing numbers in the nation's urban centers. In practice, these paranoid efforts at "racial containment" stirred urban conflict. Such antagonism and pressures sparked a series of strikes and anarchist bombings by targeted immigrant groups and black residents. Compounding anti-immigrant sentiments and racism, rampant unemployment directly following World War I ignited the simmering resentments of mistreated immigrants and black Americans who had fought for the United States against the imperial powers of Europe. The May Day Riot in Cleveland, Ohio, which began as socialists marching in support of the unemployed, was one such consequence that compounded native white anxiety about "Communist" foreigners. Stoked racial tensions between white and black residents also erupted in the bloody urban skirmishes of the Red Summer of 1919 in Baltimore, Chicago, Charleston, Omaha, New Orleans, New York City, Philadelphia, Texarkana, Washington, D.C., and other cities and towns. These volatile reactions further exacerbated tensions with white ruling elites.

The passage of the Emergency Quota Act in the spring of 1921 began to circumscribe what constituted acceptable countries from which to admit immigrants. That the arrival of dysgenic waves of lesser races had diluted the purer American stocks drawn from Nordic and Alpine groups already settled on American shores was a notion that grew in popularity among established Euro-American natives. This popular perception fomented an environment of hostility toward immigrants, especially after the United States had solidified its imperial presence after World War I. "With a domestic protectionist mood taking hold in the postwar era," as scholar Daylanne K. English observes of this period, "an urgent question emerged: how to sustain this new American power, along with a more vigorous and distinctive Americanness."[98] Fundamentally, eugenics intensified this anxiety. While it had been debunked as a science, certain aspects nonetheless gained a foothold in the popular imagination. Madison Grant's great lament, *The Passing of the Great Race,* warned progressives that the "continuity of inheritance has a most important bearing on the theory of democracy and still more upon that of socialism, and those, engaged in social uplift and in revolutionary movements are consequently usually very intolerant of the limitations imposed by hered-

ity."[99] In other words, the work of Irvine Garland Penn, T. J. Calloway, Du Bois, Washington, Terrell, and all those engaged in social advancement at the expositions and elsewhere had ignored the inherent traits of the Negro race that severely limited any realistic possibility of advancing beyond blacks' current meager circumstances. Along with a cadre of influential white racists, the powerful Grant formed the American Eugenics Society that counted among its members Lothrop Stoddard, Charles Grant, and Henry Fairfield Osborn, the powerful head of the American Museum of Natural History (who also served on the advisory committee for the America's Making fair). In the fall of 1921, the American Museum of Natural History hosted the weeklong Second International Congress on Eugenics, just prior to the opening of America's Making. The congress assembled an extensive public exhibition of eugenic materials where visitors could peruse booths on heredity and family and on race and migration and could learn applications of eugenic practices.[100] This eugenics exhibit ran for a month concurrent with, although not connected to, the America's Making Exposition.

In part, America's Making sought to relieve the tensions between natives and foreigners. Its progressive organizers—which also included the Russell Sage Foundation and Andrew Carnegie Corporation, organizations that either directly or indirectly funded eugenic studies—subtly deployed some of the language and logics of racial differentiation. Immigrants were organized, for instance, under a rubric of "racial groups" that superceded national, regional, and cultural origins. In an early version of the exposition's poster, organizers listed descendant participants in a racial phenotypic hierarchy from the most white, and hence native and American, to the most "colored," and hence foreign and non-American. This placed "Africans" at the bottom of the last column. In the final version of the posters, in response to the requests of black leaders, "Africans" became "Negroes," and they were listed alphabetically in the middle column between Lithuanian and Norwegian groups.[101]

To represent the accomplishments of the African, John Daniels, the exposition's white general director, contacted Du Bois through the NAACP. Daniels, a protégé of sociologist Park, had worked with many progressive organizations in Boston's slums. His research, *In Freedom's Birthplace,* studied Boston's black neighborhoods, one of the first such studies by a white sociologist, and concluded that the Negro had evolved since his importation during enslavement and had much to offer America.[102] Daniels's more recent research on immigrants argued that it would be the neighborhood, often settled by a singular race, that would offer the

best prospects for Americanization, thus presaging Park's later research on black and immigrant assimilation.[103] Daniels believed in the progressive notion that civic identity, whether for the immigrant or native born, was a process undergoing constant change. Therefore, those ideals and practices that constituted being an American were being always transformed. For the general director, therefore, the evolving status of the Negro in American society and the race's unacknowledged contributions to the nation fell within the purview of the America's Making Exposition.

Du Bois, busy with other events, which included organizing the Second Pan-African Congress in Europe, passed the opportunity to organize participation in the America's Making fair to James Weldon Johnson, writer, poet, composer, and executive secretary of the NAACP. Having written a travelogue of the World's Columbian Exposition for his university's newspaper, the *Atlanta University Bulletin,* Johnson was intrigued by the prospect of a public presentation of black history to such a broad audience.[104] He thought the fair would be an impressive and instructive experience for black New Yorkers who had now settled in Harlem, a neighborhood experiencing accelerated growth from the waves of migrants coming from the South and the Caribbean. Johnson agreed to join the effort but noted in his response to Daniels's initial invitation that, upon reviewing the list of invited racial groups (the early version), he recommended that "Africa be placed somewhere other than at the end of the immigrant groups" precisely because "there are so many groups which the African group antedates that it seems to me logical that it should come somewhere up in the first half dozen."[105] Seeking collaborators, Johnson contacted his friend Eugene Kinckle Jones, executive secretary of the NUL. Jones took on the responsibilities of the chairman of the executive committee of what was being now called the Negro Group, with Johnson serving as chairman. To aid in the Negro effort in the role of secretary Johnson invited his friend Victor R. Daly, who had been managing the *Messenger,* a radical paper with Marxist leanings founded by activist and socialist A. Philip Randolph. A host of others lent their talents to the various committees, including Du Bois; Johnson's brother and noted composer, J. Rosamund Johnson; bibliophile Schomburg; singer and composer Harry T. Burleigh; and the *Crisis*'s literary editor, Jessie Fauset. Singer Daisy Tapley and choreographer Dora Cole Norman, original collaborators on *The Star of Ethiopia,* served with Du Bois on the executive committee. For the task of what to do about a pageant and exhibition celebrating the Negro contribution to the United States, Du Bois conceptualized the

core artistic vision and the other members of the black intelligentsia assumed the responsibilities for its execution.

With its imposing neo-Romanesque turreted edifice and enclosed parade ground, the vast Seventy-First Regiment Armory was capable of holding eleven thousand visitors. Once redecorated and converted into an interior fairgrounds, the central floor of the armory provided an ideal stage for the two weeks of pageants that were part of the America's Making fair. Workers arranged seats around the floor, christened "The Commons," to create a performance space for the participating groups and visitors. Here, pageants, panoramas, singing contests, and folk dances were staged in the mornings for school groups and in the afternoons and evenings for the general public. Booths exhibiting immigrant contributions to craft, architecture, art, folklore, literature, drama, music, and education ringed the outer areas of the armory. Recognizing that their target audience might have neither the time nor money to attend, the fair's planners dispatched experts on the respective racial groups to schools, settlement houses, and civic associations in various New York City neighborhoods to lecture on their cultural contributions. For example, black educators gave lectures titled "The Indian and Negro in American Music and Poetry" and "The African in America" to audiences of adults and school children.[106]

The organizers placed the Negro exhibit in a far corner between the Irish exhibit and an office. For the exhibition space, Du Bois envisioned the African's contribution to architecture. He proposed a large pyramid in bas-relief rising in the booth with two sphinxes of Giza flanking either side. That unique gift to America, music, would drift through the space as songs played on a large phonograph. In addition to the pyramid, Jones announced additional features for the exhibit space. To tie the Negro's legacy in America to the fertile land of the nation, the exhibit would also display paintings depicting scenes of farmers tilling the rice, cotton, tobacco, and sugar fields of the South, with representative agricultural products nearby.[107] Additionally, Du Bois wanted an emblem of black history to welcome visitors to the exhibit. In his description he vividly imagined the figure of Ethiopia, "whose dark face shines forth from massed drapery of a white Sudanese *bernouse* [dress] which flows down in folds to the ground and has perhaps a single splash of crimson color."[108] In her right hand Ethiopia, would cradle a globe emblazoned with "Music" and whose interior would contain a dancing figure; and in her left hand she would clutch a globe labeled "Labor," with a bale of cotton, a sugar cask, and bundles of tobacco and rice inside. From the

hand of work would dangle a broken chain whose last link would be painted red. To create this noble symbol of cultural and racial advancement, Du Bois once again called upon the talents of Fuller. Inspired by her friend's description, Fuller created *Ethiopia,* a simple five-foot-tall figure absent the globes and other elements.[109] As no photographic documentation exists of the finished booth except for a version of Fuller's statue, we must assume, as per Du Bois's notes and Jones's descriptions in the biweekly *America's Making News,* that the final exhibit resembled Du Bois's original plans.

The exhibit, with its pyramid centerpiece, shared knowledge of black cultural contributions with fairgoers who daily visited the booth. On one night of the fair, however, it would be the pageant that trumpeted the key themes of black progress. This time the Negro's gift to America would be recognized as on par with other racial groups who had made the industrial, political, and cultural fortunes of the nation. Du Bois conceived the core script of the pageant. Jesse A. Shipp, who had produced shows for actors Bert Williams and George Walker, directed the show. The pageant's seven scenes mirrored the masonry layers that formed the Negro exhibit's pyramid: "Exploration," "Giants of Labor," "Hand Maidens of the Lord," "Emancipation of Democracy," "Defense," "Books," and "Music." Each scene received a musical accompaniment ranging from slave songs to classical and popular music penned by black musicians. When one epoch unfolded to the next, the number of performers on stage doubled, beginning with 1 actor and ending with more than 350. On the brisk November evening of the Negro pageant's performance, attendees, among them Du Bois and his wife, Nina, were treated to the thrilling presentation of what was billed as *The Seven Gifts of Ethiopia.*

The pageant's first scene, "Exploration," followed the exploits of Estavanico de Dorantes, a Spaniard of Moorish decent who had explored the southwestern United States. By opening the pageant with the heroic figure of Estavanico, Du Bois placed the discovery of America in the capable hands and keen mind of a black male and provided proof of the race's contribution to the nation's early history. Upon Estavanico's death, dancers entombed him amid four large cornerstones. The erection of the pyramid that concluded each scene signified the importance of enslaved and emancipated labor in building the nation's material wealth. Next, Ethiopia, who had been costumed to resemble Fuller's sculpture, energetically pirouetted across the floor. Her gestures honored the self-reliant black woman who provided for her family through work and personal sacrifice. Equally important, by working as domestics, seamstresses, and

AMERICANS OF NEGRO LINEAGE

"Ethiopia" A Symbolic Statue of the EMANCIPATION of the NEGRO RACE.

From the Exhibit

By Mrs. Mete Warrick Fuller a Negro Sculptor

I N the making of America, the part played by the African group is of tremendous importance. His great contributions have been labor, personal service and music.

Negro labor in slavery and freedom, cleared the forests and swamps for the great agricultural regions of the South. It entered America one year before the Puritans and only twelve years after the Cavaliers. From the early 17th Century to the present day, Negro labor has been indispensable in the fundamental industries of the South. On its work depend the great crops of cotton, sugar, tobacco and rice. Negroes are also engaged in the operation of coal mines, fisheries and transportation. It has furnished faithful personal and domestic service and recently has succeeded in the skilled trades.

In 53 years of freedom the Negro has increased his homes owned from 12,000 to 600,000; farms operated from 20,000 to 1,000,000; business enterprises from 2,100 to 50,000. He has increased in literacy sixty per cent. and the number of his teachers from 600 to 38,000. The sum spent from his own pocket for his own education has increased from 80,000 to 1,700,000 dollars; his church property from 1,500,000 dollars to 85,900,000 dollars, and his general wealth from 20,000,000 dollars to 1,100,000,000 dollars.

Churches, colleges and great social agencies have been organized by the Negro. This race has produced orators, writers, and educators. It has given to this country the only distinctively "American" music; the "Sorrow Songs" or Jubilee Music and the syncopated instrumental and vocal rhythms.

The Negro-exhibit is designed to symbolize the origin of the race in Africa and its progress in America. Wall decorations will show their industrial contribution to the nation and the educational work among those of their own race. The industrial school will be depicted. Their Musical festival typifies their wonderful contribution to this branch of art.

FIGURE 34. *Ethiopia* by Meta Vaux Warrick Fuller, the Negro contribution to America's Making Exposition, New York City, 1921. From *Book of America's Making Exposition, 71st Regiment Armory New York, October 29 to November 12, 1921* (New York: City and State Departments of Education, 1921).

field hands, these black women had also labored for others and in doing so had contributed to the nation's economic prosperity. Her body was also laid to rest inside the pyramid. During the scene "Emancipation of Democracy," actors costumed as Booker T. Washington, Sojourner Truth, Benjamin Banneker, and other historic figures carried stones that bore inscriptions identifying contemporary national and international political struggles: "The Right to Vote," "Africa for the Africans," and "The Emancipation of Women." The "Defense" scene reminded the audience of the sacrifice of black soldiers from the revolutionary acts of Attucks to the battlefields of World War I. For the scene celebrating black contributions to literature and the arts, children toted large books, including Du Bois's own *Souls of Black Folks,* to complete the top course of the pyramid. And lastly, in the finale honoring the gift of black music, the majestic pyramid, now completed, became a shining beacon. Emerging from its inner chambers to the uplifting tune of Johnson's march, *Walk Together Children,* Estavanico and Ethiopia came forth, trailed by bands of Egyptians and Ethiopians and surrounded by their dancing sprightly progeny.

The final scene of *The Seven Gifts of Ethiopia* bolstered a fundamental conservative premise of racial uplift that the preservation of the patriarchal bourgeois family was still critical, as it had been in the post-Reconstruction era, to raising the Negro out of social exile. With that stance, Du Bois in part reinforced eugenic beliefs that a fit family ensured a robust continuation of the race. Commenting on Du Bois's book *The Gift of Black Folks,* published in 1924 to counter similar perceptions of racial and immigrant bigotry as had the earlier pageant, Du Bois's biographer, Lewis, astutely surmises that Du Bois's "emphatic thesis cut both ways across the plane of racial typologies, an argument that could be construed to have exactly the opposite meanings."[110] In this regard, along with affirming the racist implications of class and patriarchy that oppressed the race, the pageant also challenged some of the core themes of the America's Making fair's agenda. Where the earlier *Star of Ethiopia* ended with the Negro in America, *The Seven Gifts* returned Americans to Africa. This embrace of origins, "Pan-Africanization," signified a different register of what history might portend for the Negro and proposed a bold alternative national solidarity to the exposition's objective of Americanization and integration.

The Seven Gifts of Ethiopia was one of many pageants performed at the America's Making Exposition. The fair's organizing committee pro-

duced two pageants to commence and end the event. The exposition opened with a lavish pageant, *Foundation Laid,* that showcased a march of all thirty-two racial groups. The *New York Times* described the "stirring visualization" as follows: "the immigrant groups all the way from the discoverers to the latest comers, and many of them in costumes of their ancestral lands, rushed with outstretched hands toward the flag held by a tall, fair Saxon youth and sang, in voices that had memories of their languages, 'The Star Spangled Banner.' "[111] A white youth, with striking Nordic features, had been deliberately chosen to underscore the attributes of the racial status quo.[112] On the exposition's closing evening, the pageant *E Pluribus Unum* was staged. It narrated the story of young America, who grew hardy from the material gifts given to him by the various racial groups. On his journey he received guidance and wisdom from a radiant angel who was joined by her handmaidens, Liberty and Justice; together they symbolized the virtues of whiteness and womanhood. When the pageant reached its finale, the trio of angels rose to the lofty heights of the armory hall and they inscribed in light, "They shall be thy people" along with "E Pluribus Unum."[113] At the pageant's culminating moment, the races, this time grouped as nuclear families, entered the hall. Outfitted in work uniforms sans the folk attire, the families proudly marched forward carrying the symbol of their newfound allegiance—the American flag. As witnessed by all in attendance, out of many diverse racial groups emerged one America. The "naturalized families" had claimed their rightful place as productive Americans. These bookend pageants framed an allegory of race and nation in which the handworker from abroad could progress to become a dutiful citizen and dedicated factory worker, with the prospect of those nobler races (read Nordic or Alpine) achieving the status of mindworkers—political leaders and captains of industry.[114]

Of course not everyone could rise to the top of the armory's rafters or the nation's racialized social hierarchy. As per America's Making's taxonomy, black New Yorkers—many of whom had migrated to the city from the South, the Caribbean, and the African continent—were grouped with all immigrants, even though many black Americans could also be classified as both native born and original settlers. From the logic of the exposition's ideological mission to *make Americans,* blacks were not yet citizens—a status that many whites believed to be a natural outcome blacks' weaker aptitudes and abilities. Refuting these claims, black Americans believed their circumstances resulted directly from the stranglehold that racism imposed on their rights and livelihoods; for decades

Jim Crow had stalked their every advance. In a bold counterproposition, Du Bois and his collaborators emphasized the deep and vast black contributions to the nation and to the world. In his pageants, Du Bois staged two visions of Negro citizenship: one American and one African. Both narratives culled a historical consciousness from the collective memory of enslavement in the New World while also promoting Pan-African solidarity, or, an understanding of the past that was necessary for the difficult civil rights struggles that lie ahead.

Even though participants in the America's Making Exposition could claim foreign lineages, the fair's context and content made it a local and regional event. World's fairs continued to be held in the United States, but these expositions now seemed more requisite than unique. The international expositions had lost the luster of the earlier grand affairs. In June 1925, Swann, an organizer of the Lincoln Jubilee who was now practicing law in Philadelphia, contacted Du Bois about holding the next Pan-African Congress in that city. Backed by several of Du Bois's friends, Swann, a goodwill liaison officer between the United States and Liberia, believed the congress would be an impressive international event for the forthcoming Sesquicentennial Exposition in 1926, which would celebrate 150 years since the signing of the Declaration of Independence. Swann also inquired about the possibility of Du Bois developing and staging new pageantry for the fair. In response to Swann's proposal, Du Bois was wholeheartedly in favor of holding the Fourth Pan-African Congress in Philadelphia, especially since his recent efforts to arrange for a summit in the Caribbean—a complicated negotiation influenced by political jockeying by hosts and organizers—had failed. A few years earlier Du Bois, in a bid to influence the future of African colonies at the Versailles peace conference that ended World War I, had convened the first (of this series) Pan-African Congress in Paris. Held in 1919 and attended by educated middle-class and privileged elite representatives from the Americas, Africa, Europe, and the Caribbean, the event drafted a slate of final resolutions demanding self-determination and rights for the millions of colonized African peoples.[115] Subsequent congresses followed in London, Paris, and Brussels (constituting the second congress, in 1921) and in London and Lisbon (the third congress, in 1923), but two years had elapsed since the last meeting. Du Bois relayed to Swann that he thought the conference could be hosted for less than $5,000, making it a reasonable undertaking by the Sesquicentennial Exposition's board. He was less optimistic, however, about staging the popular although extremely expensive

Star of Ethiopia, particularly in light of past difficulties in raising sufficient monies to present a performance of that scale.[116]

In February 1925 Philadelphia's Republican mayor, L. Freeland Kendrick, formed an executive committee to assist in putting together an exhibit about the advancement of the Negro in America since "Crispus Attucks fell in the Boston Commons" for the city's Sesquicentennial Exposition.[117] With the initial sum of $100,000 promised for the exhibit, the mayor selected John C. Asbury, a black attorney, member of the Pennsylvania state legislature, and a fellow Republican to be director and chairman of the Committee on Negro Activities. As a publisher and banker, Asbury had avidly supported Washington for many years and the great race leader had even invited him to deliver Tuskegee's commencement address in 1909. Asbury's views reflected those of the primarily conservative long-established black elite of Philadelphia, a group Du Bois had studied at the turn of the century. This community, many of whom were highly respected lawyers, physicians, bank owners, businessmen, and religious leaders, had moved out of the black wards of Center City, where migrants from the South now settled, to the northern fringes of Germantown and North Philadelphia, thus prompting white residents to flee the Negro invasion of these areas to outer suburbs.[118]

Two months before the opening of the fair in May 1926, the plans for the Negro exhibit were proceeding at a glacial pace.[119] In an effort to expedite the process, Asbury enlisted the exposition expertise of T. J. Calloway, who at that time was the secretary of the Maryland Interracial Commission and head of the Lincoln Land Development Company, which had built an enclave of black middle-class residences in suburban Prince Georges County. With little time for preparation, Calloway traveled to New York to meet his "American Negro" exhibit collaborator, Du Bois. He and his old friend discussed the curatorial direction for the Negro exhibit, whose presentation Calloway thought should unfold somewhat akin to a pageant of black accomplishment. The white fair organizers had allotted the exhibit twelve thousand square feet in the vast Liberal Arts Building on Broad Street, opposite the new Sesquicentennial Stadium. Du Bois suggested to Calloway that he gather exhibits to examine the Negro from a scientific point of view, which, like the Georgia Negro study shown in Paris, would be illustrated by maps, diagrams, graphs, and mechanical devices. Calloway and Du Bois envisioned as their crowning contribution the publication of the *Moon—Shining Daily for the Darker World,* a daily newspaper to be circulated at the exposition grounds and distributed all over the eastern half of the United States.[120]

The daily paper's content would include pictures, general national news, special cultural features, and Pan-African news, the latter providing a forum to further the ideas of solidarity and Pan-African sovereignty. Du Bois's suggestions thrilled his old Fisk classmate. To commence with constructing the booth for the Negro exhibit, Calloway hired local artist Laura Wheeler Waring, a talented painter who would later create a portrait of Du Bois for the Harmon Foundation.[121]

For a conference in May called by the Committee on Negro Activities, which was attended by business and educational leaders assisting with the exposition, Du Bois prepared a proposal for the Fourth Pan-African Congress. In it he outlined the need to send invitations to representatives in the United States, the West Indies, England, France, and Africa; to the colonial offices of powers that controlled protectorates; to organizations promoting education and social uplift; and to commercial interests. Conscious of how environment heightened experience—exemplified in his plan for Egyptian-styled decoration that regaled the armory at New York's Emancipation exposition and the large pyramid at the America's Making fair—Du Bois requested that for the fourth congress a large hall be secured and decorated with colorful flags of independent nations and colonial powers. Du Bois imagined that more than two hundred delegates would travel to Philadelphia. Participants from all parts of the world would crowd the hall eager to hear and discuss "what is today the most interesting and fateful continent in the world." Raising the specter of urgency and the promise of a Pan-African agenda, he also reminded the sesquicentennial's Committee on Negro Activities that "America has a peculiar interest in Africa; a historical connection through the slave trade; a philanthropic interest in the abolition of the slave trade and the founding of Liberia; a great and growing economic interest through investments in the Belgian Congo and more recently Liberia."[122] This important Pan-African meeting would bring black Americans into dialogue with contemporary Africans to formulate a strategy to counter Euro-American imperialism.

When the sesquicentennial's general board failed to furnish the promised funds, Asbury and Calloway's endeavor to assemble the best exhibits and arrange for the many performances and congresses was quickly derailed, making it all the more difficult to acquire the displays by the fair's opening date and to host Du Bois's Pan-African conference.[123] This delay meant that exhibition materials were still arriving four months after the fairgrounds opened to the public. Compounding these difficulties, some exposition officials sanctioned, much to the dismay of the city's

black leaders, attempts by the Ku Klux Klan to stage a march from historic Center City to the fairgrounds and to hold a national meeting as a premiere event of the fair.[124] The Klan, whose membership numbered several thousand statewide, appealed to racist, anti-Semitic, anti-Catholic, and anticommunist workers in the industrial regions around Philadelphia. By adopting racist attitudes toward black workers, their direct competitors for industrial jobs, immigrants could claim their "whiteness" and some modicum of power. In the midst of this rising racial turmoil, Calloway tried to form an interracial committee to ease tensions, but such efforts failed due to white apathy and lack of funding.[125] In May, the mayor placed a prominent black surgeon, Dr. John P. Turner, the president of the black National Medical Association, on the exposition's board of directors.[126] By the fall of 1926, three months after the exposition had opened, E. L. Austin, director of Domestic Participation and Special Events, would dismiss Calloway, despite his efforts to assemble a noteworthy Negro display in such a short period of time. Du Bois also withdrew from participation, perhaps incensed by the how the fair's management dealt with Klan's request.[127]

The unmemorable Sesquicentennial Exposition, an overall poorly planned and executed event when compared with previous world's fairs, ran for six financially dismal months, most of them rainy, from May 31 to December 1, 1926.[128] White organizers divided the Negro exhibit—not the version planned by Calloway and Du Bois—between several sites in different buildings on the fairgrounds. Initially the exhibit had been allotted space in the Liberal Arts Building, but by the time the fair opened the main part of the display (which focused on urban social associations), had been moved to the Palace of Agriculture, reinforcing associations between Negro aptitudes, handiwork, and farm labor.[129] The Tuskegee Institute, Howard University, and several other educational institutions displayed their materials in the Hall of Social Economy and Education. A cultural display of the work of Augusta Savage, a young artist living in Harlem, represented one of the few artistic presentations in the Negro exhibit.[130] Complementing the exhibits, the Committee on Negro Activities scheduled a calendar of concerts and pageants. Du Bois was invited to appear as himself in a presentation of the pageant *Loyalty's Gift* conceived by his former collaborator and choreographer, Dora Cole Norman. Du Bois, however, gracefully declined to join the spectacle.[131] When performed, *Loyalty's Gift* drew one of the largest audiences of the entire exposition.[132] Yet, Philadelphia's Negro exhibit and events lacked the cohesive message of racial uplift and progress that curatorial

efforts by Washington and Penn, Calloway and Du Bois had demonstrated at other fairs.

Amid the turmoil around the sesquicentennial's staging, black organizers demanded representation at the opening-day ceremonies of the exposition. Several days before the opening of the fair and after rejecting Asbury's initial request, Mayor Kendrick made an unusual move: he contacted A. Philip Randolph, founder of the new union, the Brotherhood of Sleeping Car Porters, to deliver one of the three opening-day speeches. Secretary of State Frank B. Kellogg and Secretary of Commerce Herbert Hoover joined Randolph on the dais at the opening ceremonies on May 31, 1926.[133] This choice of a New Negro voice may have been, on one hand, an effort to appease Asbury and others by having a black speaker on the program. But the choice of the radical Randolph might have also meant that his unorthodox and antagonistic socialist views, especially for the conservative black Philadelphian elite, would not resonate across the press as Washington's famous speech in Atlanta had done. Randolph was keen on the opportunity and accepted Kendrick's intriguing invitation in spite of its last minute extension.

Even though he was not listed on the official program, the thirty-six-year-old Randolph gave one of the longest orations of the day. He spoke uninterrupted, despite a note to Kendrick from Klan representatives to cut off his speech. An impassioned socialist, Randolph celebrated black contributions to building the backbone of democracy that had made America a steadfast twentieth-century nation.[134] In his eloquent opening statements, Randolph justified his presence at the fair and every black American's right to commemorate the signing of the Declaration of Independence. Black people, he furthered, were woven into the fabric of the nation's traditions, industries, and beliefs. Randolph believed that through blacks' suffering and achievements the Negro was the most American of all Americans, boldly stating, "He is the incarnation of American, his every pore breathing his vital spirit, without absorbing it's cross [sic] materialism." Drawing on the metaphor of the "gift," similar to Du Bois's references in his two pageants, Randolph divided his speech into sections characterizing what the Negro has given to America. Citing the work of historian and linguist Leo Wiener and the popular interest in Ethiopia as the origins of humankind, Randolph told how seafaring Africans had journeyed to the Americas to trade with pre-Columbian societies well before the arrival of European colonists. Africans brought with them tobacco, cotton, sweet potatoes, and peanuts and introduced these crops to Native peoples. Describing the condition of enslavement as labor

within a system of mercantile capitalism, so it could be comprehended in terms of material and ideological forces, the union leader told his audience that slaves were America's original workforce. Through their unrewarded sweat and toil, these "workers" had changed the unruly character of the American wilderness into a bountiful landscape, and in so doing they spurred the economic development of the new nation. Linking the prosperity of New England's cotton mills to the yields of Negro laborers tilling the fields in the South and the Caribbean, he proclaimed that "the early material foundations of America's greatness rests upon a labor force which costs Africa nearly one hundred million souls." Randolph referred to the mass migration of black southerners as a vital labor reservoir for the North and as an answer to the call of America's industry. And he reminded his audience that black Americans were neither lazy nor ignorant: in many parts of the country black citizens, as brilliant and facile mechanical laborers and engineers, like Elijah McCoy, had contributed significant inventions to the nation. Expanding his list of "gifts," Randolph mentioned the Negro contributions in defending American shores in various conflicts. He spoke of how the insistent cry for freedom by the Negro reminded white Americans that democracy's promise of equal rights had remained unfulfilled for some of its citizens. He exalted slave songs as the only true American music. The poetry of Wheatley and Dunbar, along with the writings of "Du Bois, Washington, James Weldon Johnson, Kelly Miller, Chestnutt, the Grimkés, Braithwaite, Carter G. Woodson, Brawley, and the ever developing newer school of Negro writers," represented the "highest reaches of literary genius and talent."[135] He lauded government intervention in monitoring the unchecked economic power of robber barons and corporate monopolies in order to protect the rights of "plain people" who worked for a living.

In his most emboldened pronouncement, a departure from civil religious jeremiads of previous black fair presenters, Randolph predicted that the next "gift" the Negro would bestow upon America would be what he termed "economic democracy." The inspired leftist envisioned that black workers would lead the heroic fight to bargain with employers on behalf of improving the conditions for all workers (an astute observation in light of the increase in the scale of production and the size of the workforce under Fordism). Black workers would form the vanguard in labor organizing and ally with fellow white workers to receive "equality of reward, for equality of service." Randolph's brilliant oratory, to a mostly white crowd of sixty thousand, proposed that economic democracy would foster political and social democracy as well: "in politics, the

Negro demands political equality, the right to be voted for as well as to vote, a place in the responsible agencies of the nation." Blasting Washington's willingness to defer to the will and wisdom of southern whites, Randolph audaciously demanded that it should be America that changed to meet needs of the Negro, stating that "the Negro today, would have his suffrage be the means of securing the adoption of social legislation." He listed the impact of political rights in "better schools, better housing, improved community sanitation, larger modern recreational opportunities and facilities for the children of the community in which they live as well as more pronounced even-handed justice before the courts."[136] Standing on a dais thirty years after the great Tuskegean, Randolph challenged the race leader's earlier accommodationist stance by affirming that in the interdependent modern world no people could stay separate. But as Mayor Kendrick may have intended, the avowed socialist's radical rally to action was ignored by both the mainstream press and the majority of the Negro press, except the *Pittsburgh Courier*, which published Randolph's entire speech.

The black-organized expositions, pageants, and exhibits created during this period presented a popular version of black history, filled with nationalistic ideals of racial solidarity and cultural distinctiveness, to urban and increasingly middle- and working-class audiences.[137] No longer would fairs primarily exhibit the manual products of southern educational institutions: as public spheres to promote strategies of advancement, the exhibits at northern expositions in Chicago, Philadelphia, and New York proudly featured the cultural production of a new cadre of individuals and institutions.[138] The mechanization of manufacturing in the production of food, automotive, steel, and a host of other items required large labor pools. And blacks moved into cities in the North to seek work in this expanding economic milieu. The content of the fairs began to reflect the new consumer culture, as in the displays at Chicago's Lincoln Jubilee, and to address the needs of the new worker, as did Randolph's speech.

The failed Negro exhibit at Philadelphia's Sesquicentennial Exposition, however, was indicative of the degree to which segregation and visible support of racist organizations like the Klan hindered a progressive and critical expression of black life in mainstream events. Although Du Bois valued pageantry's pedagogical capacity to popularize black history to a wider public, his efforts were continually challenged by the refusal of white authorities—except on rare occasions such as the America's Mak-

ing Exposition—to include black content and enable black participation. In a humorous fictional story, "The Black Man Brings His Gifts," published in *Survey Graphic* in 1925, Du Bois wrote a scathing satire that revealed the deeply ingrained racism of groups like the white-run American Pageant Association, which refused to recognize black cultural productions or include blacks in the organization.[139] By the 1920s, the pageant had begun to wane as a popular means of interpellating civic identity, especially as a tool to Americanize immigrants.[140] One goal of performances at the America's Making fair was to show a nascent labor force rising from immigrant populations, thus representing in a future-oriented glance what all Americans together could make. Progress in this respect could be mediated through performing the evolution from foreigner to native within the civil-religious framework of the pageant. As Glassberg astutely asserts about the pageant format, "Disparities evident between past and present values were healed by the evolutionary doctrine of progress."[141] If pageants imagined a set of social relations that were best crafted within the small scale of local communities and grounded in the religious and oratory traditions of the country fair, then such performances proved, as Du Bois realized, a fruitful medium for black communities of New York City and elsewhere, who, because of segregation, formed a small town within a large city. However, the postwar era presented a new scale of urbanization that the pageant format could not arbitrate. Rapidly growing cities, New York City and Chicago were beset with problems of class abrasion, unemployment, and racial tensions. Mass spectacles could now be experienced through the more widely available visual technology of cinema and in the movie palace. The complexities and dynamism of urban life amid the fast-moving elevated and subterranean rail lines, the ephemeral glow of brightly lit entertainment districts, and the cacophony of screeching cars mixed with the sounds of a myriad of dialects cultivated what sociologist Georg Simmel has observed as the blasé attitude of metropolitan populations.[142] As the Chicago Emancipation exposition had already hinted, new forms of cultural production such as moving pictures appealed to the tastes of urban audiences no longer captivated by folk tales and homespun costumes or by the high cultural tastes of ruling elites.

In Randolph's speech, as with Du Bois's pageants and Woodson's history association, public history served as a vital springboard from which to educate blacks about how their rich American and Pan-African heritage would assist them in charting their future. Radical in its ambition, Du Bois's Temple of Beauty at the New York Emancipation fair offered

not just a stylistic alternative to the Euro-American architecture of the mainstream fairs; its aesthetic choice signaled another origin for *world* culture that was Egyptian—hence, black—in opposition to the dominant Greco-Roman origin theory of Western art history. Revolutionary for an exposition speech, Randolph's statements at the Philadelphia Sesquicentennial laid new ground by emphasizing how black labor had to be understood in historical terms as having built the great material and spiritual wealth of American industrial capitalism.

The union leader's tone and entreaty for civil rights suggested that a new generation was willing to agitate for economic and social justice. At the world's fairs, protests erupted and petitions circulated to end segregation at the fairgrounds. A week before the union leader's speech, for example, Boston's *Guardian* newspaper, led by fiery publisher Monroe Trotter, a member of Du Bois's Niagara Movement cadre, printed a "Petition against Segregation." Addressed to President Calvin Coolidge and sponsored by the National Equal Rights League, the petition demanded that the U.S. government "abolish by Executive Order the present segregation of Colored federal employees in Executive Departments." "A subjection of one racial element to the racial prejudice," the petition put forth, was "therefore a denial of equality of citizenship to the race signaled out from all others for such subjection."[143] The fight for civil rights would be waged in the black counterpublic sphere by diverse associations who held a spectrum of positions from conservative to radical, such as the NUL, the NAACP, and labor unions like the Brotherhood of Sleeping Car Porters. Civil rights would be debated in the editorial columns and reports in the *Baltimore Afro American, Pittsburgh Courier,* and *Chicago Defender.* And the value of American rights, in general, would be challenged by emerging radical groups like the Communist Party of the United States of America (CPUSA) that sought alternatives to government-sanctioned economic exploitation. At this critical juncture, two generations after Emancipation, many black Americans were no longer willing to be patient. Randolph's words and those of others aimed to radicalize them.[144]

The Klan's brazen and almost successful bid to march in the Sesquicentennial Exposition's public festivities indicated that white elites and middle and working classes feared the "New Negro" militancy emerging from the activist circles that advocated joining the labor movement and progressive associations. In the years immediately following World War I, racial tensions between black soldiers (who felt they deserved the rights they had risked their lives to defend) and angry white crowds (who believed that these newly entitled blacks were a danger to the balance of

power) exploded in violent confrontations in East St. Louis, Philadelphia, Chicago, Washington, D.C., and several other cities. Blacks were becoming more aware of their rights, history, and culture. The quest for social equality could not be halted by sporadic attacks by unruly white mobs or by the coercive racial oppression that impeded access to decent work, housing, and education. Through the 1930s and 1940s, blacks organized expositions as vital public forums to link the historical granting of civil rights to the current fight to regain those same constitutional privileges.

CHAPTER 4

Look Back, March Forward

This is a community of stark contrasts, the facets of its life
as varied as the colors of its people's skins. The tiny churches
in deserted and dilapidated stores, with illiterately scrawled
announcements on their painted windows, are marked off
sharply from the fine edifices on the boulevards with stained-
glass windows and electric bulletin boards. The rickety frame
dwellings, sprawled along the railroad tracks, bespeak a way
of life at an opposite pole from that of the quiet and well-
groomed orderliness of middle class neighborhoods. And
many of the still stately appearing old mansions, long since
abandoned by Chicago's wealthy whites, conceal interiors
that are foul and decayed.

—St. Clair Drake and Horace R. Cayton, *Black Metropolis*

To win a people's peace America must end the semi-free
status of her Negro population. Freedom for the Negro
means full freedom for America.

A militant history is the heritage of the Negro and
democratic whites, America which yet struggles to make
America.

—*National Negro Museum and Historical Foundation* pamphlet

Published in 1945, *Black Metropolis* charts the lives of Chicagoans toil-
ing and striving in the city's famous Black Belt. The lyrical passages scat-
tered throughout the study read more like an excerpt from native son
Richard Wright's novels than a probing sociological analysis about the
impact of antiblack racism on urban life (the widely praised and con-
troversial Wright did, in fact, contribute the introduction to the book of

his friends Horace Cayton and St. Clair Drake). *Black Metropolis*'s pivotal chapter, "Bronzeville" (a race-proud name for the Black Belt that recast the old moniker's pejorative connotations), surveys the area's black counterpublic sphere. Its cadence directly addresses the reader and its rich mosaic of descriptions and observations encircle us within a slowly turning panorama that captures the rhythms of black Chicago. Scrutinizing the kinetic throngs, Cayton and Drake's (and our) astute gaze assesses the variegated complexions of the populace, noting that in the streetscape "swirls a continuous eddy of faces—black, brown, olive, yellow, and white."[1] The authors take us on a tour of the Black Belt's locales, through the front parlors, the backrooms, and the streets that enlivened Chicago's sprawling black enclave. We enter the drugstores and funeral parlors that sit between bustling newspaper offices and busy employment offices. We are taken inside the theaters that premiere homegrown talent and welcome out of town performers in raucous vaudeville reviews and first-rate melodramas. In the *Black Metropolis,* glamorous movie stars, sports figures, and big band musicians stream in and out of the swank lobbies of black-run hotels. Race-proud merchants and department stores compete against older white establishments. Picket lines spring up to protest unfair labor practices wherever they occur. Beggars guard their turf on street corners, while race leaders dine elbow to elbow with their constituencies in local eateries. "Reefer dens" and "call houses" along the infamous Stroll provide illicit amusements for both black and white patrons. Inside the densely populated confines of Bronzeville's domain, black Chicagoans have erected important community institutions, reputable hallmarks of racial progress: Provident Hospital, George Cleveland Hall Library, the Young Women's Christian Association (YWCA), Hotel Grand, Parkway Community House, and the Michigan Boulevard Garden housing for middle-income residents. Verdant Washington Park, which was laid out by Frederick Law Olmsted in the 1870s and connected to a string of parks that formed the Midway of the World's Columbian Exposition's White City, hosts popular sporting events and public rallies. And churches of various denominations throughout the area number more than five hundred.[2]

The inhabitants in this miniature world engaged in a range of commercial, religious, labor, leisure, educational, and civic activities all contained within the racially demarcated borders of Chicago's Black Belt. Cayton and Drake characterized the Black Metropolis as a "world within a world" or, as they wrote elsewhere in the sociological study, eight square miles

growing within the womb of the white.[3] They used the more general "Black Metropolis" interchangeably with "Chicago" to suggest that, while the collective ethos within the Black Belt may have been unique to their city, the conditions they analyzed were prevalent in black neighborhoods in cities around the United States—Detroit's and Philadelphia's Black Bottoms and New York City's Harlem, to name a few. Although the black community's institutions—families, hospitals, churches, theaters, businesses, offices, and hotels—appeared on the surface to be similar to those found in white neighborhoods, Cayton and Drake argued that black institutions had developed in an appreciably different manner due to of their isolation from mainstream culture and the obstruction of economic and political gains caused by racial prejudice. Despite the Black Belt's segregation from mainstream social spheres, it was nonetheless tethered to a black national cultural network and counterpublic sphere—the Negro nation W. E. B. Du Bois had imagined that maintained, in the words of Drake and Cayton, its own unique "bonds of kinship, associational and church membership, and common minority status."[4] It was both black residents' marginalization within the white metropolis and their ties to other black communities around the country that nurtured a collective cultural identity that would be on display at the fairs of the 1930s and 1940s.

Blacks may have been forced to live inside the Black Metropolis, but they also worked outside in the city's industries, businesses, and private homes. They were, as Drake and Cayton perceptively asserted, "a separate social community life resting upon a continually broadening economic base in the larger society."[5] With money in their pockets, black urbanites fed the growing wealth of the Black Metropolis along with those white store owners who had set up their businesses there. Once the black community became essential to the economic engine of the city, black residents, as the sociologists effectively emphasized in several chapters, mobilized their labor and purchasing power to shift the color line.[6] With contrasting and conflicting attitudes drawn from the latest strategies for social advancement among the black elite, with economic struggles for fair wages and equal treatment by the working class, with emerging mass cultural tastes, and with the spirited agenda of the cultural left that linked the struggle for civil rights to the fight for human rights, this urban identity would be presented at two large Emancipation expositions in the midwestern industrial centers of Detroit and Chicago during 1940.

THE IDEOLOGICAL FACETS OF BLACK PROGRESS

Detroit's fair, called Seventy-Five Years of Negro Progress, and Chicago's American Negro Exposition followed in the tradition of the latter city's Lincoln Jubilee of 1915. As per the script of all Emancipation expositions, these two fairs sought to publicize and promote the advancement of the race since the Civil War. By 1940, the circumstances of the Negro as presented in the displays at these events were, as this chapter considers, vastly different from those presented at the earlier commemorative events and in the southern Negro Buildings. Religious and educational institutions still provided major support; there were booths dedicated to agricultural advancement, even in northern industrial cities, but mostly at the behest of governmental agencies; and the well-established, predominately male black elite of businessmen, politicians, and clergy, still controlled the governing boards that organized the events. However, the political, economic, and cultural contexts in which these events were staged had significantly transformed, especially for those not part of the race's elite cadre. Critically, the economic depression and capitalist reshuffling of Fordism in the 1930s had devastated black workers, especially those who had been servants (white families reduced household expenses) and factory workers (blacks were the last hired and the first fired).[7] This proved to be a major setback in the progress of the race.

The Depression spawned New Deal programs that in less than ten years changed black America's relationship to the government. Blacks were often at the bottom rung for receiving benefits from New Deal programs, despite the fact that unemployment devastated black neighborhoods the worst. However, black citizens were able to use their votes (when they were allowed to cast them) to pressure federal, state, and local municipalities to provide assistance in jobs and housing and to pressure lawmakers to fight discrimination. To court the black vote, New Deal agencies set up booths at the expositions to proselytize their Keynesian economic gospel. And vote-seeking politicians used the commemorative expositions as forums to directly solicit black support.

Labor, as A. Philip Randolph had predicted in his Philadelphia Sesquicentennial Exposition speech in 1926, had become an important rallying point for urban blacks. As new and old settlers found work in industrial centers—often in menial or extremely hazardous jobs—labor unions sought their membership, in particular the Congress of Industrial Organizations (CIO), as did other Left and radical groups, particularly the Communist Party of the United States of America (CPUSA). By rad-

ically integrating their ranks of workers while also luring black intellectuals and cultural workers to their cause through a platform of anti-lynching and support for racial equality, these organizations provided another avenue of protest outside of the traditional race leadership circles and moderate organizations such as the National Association for the Advancement of Colored People (NAACP) and National Urban League (NUL).[8] By the 1930s, middle-class organizations like the NAACP, along with educational institutions like the still-influential Tuskegee Institute, tempered their tactics as some moderates gained access to government positions. For some among the elite, this ascension into government ironically implicated them as part of the racist state power wielded against poor blacks.[9] Both radical and moderate groups, especially the CIO, sponsored booths and exhibits at the 1940 fairs.

Along with transformations in the political and economic spheres, the cultural realm of black America had also changed. Replacing those high cultural genres—which possessed moral platitudes that promoted racial uplift—popular race films, vaudeville shows, and recording and night-club acts provided new genres of entertainment and mass culture that offered pleasant diversions for urban populations. But it was the cultural wing of the Left's Popular Front, the Cultural Front, especially in Chicago, that merged a radical agenda of racial equality, workers rights, and human rights and led to a blossoming of literary and visual arts. The brilliant artistic influence of these "cultural workers" would shape the cultural agenda for both expositions, but the Chicago fair would benefit the most from their inspired vision. The public could experience the work of this cultural vanguard in the extensive collection of art on view, the public readings of literature and poetry, and the elaborate stage productions of theater and dance.[10]

Organizers billed these expositions as commemorative events that celebrated the seventy-five years since Emancipation. However, those who had directly experienced liberation from enslavement, particularly as adults, were now deceased. The firsthand collective memory of enslavement had faded considerably. The previous Emancipation expositions had focused primarily on black progress. Most of the fairs looked toward the future rather than backward in a mode of historical reflection. At the 1940s fairs, chapters of the Association for the Study of Negro Life and History (ASNLH), black newspapers, and other local heritage groups sponsored events to inaugurate a critical role for black collective memory and public history as a political cause, in the spirit of Du Bois's curatorial ethic. In this recalibrated role for the past, what did the promise

of Emancipation—a history now presented in books and artifacts show-cased in the exposition hall—mean to urbanized black populations some seventy-five years later? When people heard the drumbeats to advance the race, the mantra of black progress that had been central to exhi-bition discourse for over fifty years, what was the prospect of gazing forward when the ideological lens had been subdivided into many dif-ferent facets—racial uplift, economic liberalism, black nationalism, Pan-Africanism, civil rights, socialism, and communism? With problems of housing, labor, growing class stratification, and trenchant antiblack racism bearing on all aspects of daily life in the Black Metropolis (and at the fairs held at white-owned venues, which posed a myriad of obstacles), Chicago's and Detroit's black-organized expositions in 1940 had to craft a radically different agenda from that of earlier events or risk, as we shall see, failure.

In the twenty-five years since the semicentennial celebrations, black southerners continued to migrate out of the region. Following a lull in the exodus during the Great Depression, more than 1.1 million black Americans moved around the country between 1935 and 1940. The rural belts in Georgia, Alabama, and South Carolina witnessed the biggest out-migrations, with the cities New York, Cleveland, Detroit, and Chicago the main destinations.[11] Since 1910, when 90 percent of blacks still resided in the South, the Great Migration had increased Chicago's black population sixfold and Detroit's black population an astounding twenty-five-fold.[12]

Black Americans streamed into urban centers via railroads and high-ways. Once arrived, they headed directly to established settlements like Chicago's Black Belt and Detroit's Black Bottom. Within Detroit, for in-stance, black residents crowded primarily into a region of the city sand-wiched between the downtown business center and the factory complexes on the Eastside. In 1936, Detroiters reimagined what had been called Black Bottom as Paradise Valley in a show of racial pride spurred by an effort to shake off southern connections and the negative connotations of "blackness" as the lowest position of the racial hierarchy. Gratiot, Hast-ings, Brush, and Vernor Streets marked the initial boundaries of this bustling residential and commercial district, which expanded as more res-idents settled in the area. White Detroiters were proud of their ethnic heritage, a mixture that Thomas Sugrue describes as "a veritable United Nations of ethnic names." However despite having diverse ethnic back-grounds, white residents could claim political and economic power

through their whiteness, a position boosted by their antipathy for less deserving inferior Negroes.[13] As a result of the animosity emanating from those neighborhoods where whites lived, along with the racist practices by landlords and realtors preventing blacks from obtaining housing elsewhere in the city, black Detroiters crowded into dilapidated nineteenth-century hotels, run-down row houses, and rooming houses that owners had subdivided into rabbit warrens of apartments and rooms. Over two hundred thousand people packed into sixty dangerous and unsanitary blocks, with half of the dwellings unsafe for habitation, compared to less than one-fifth in white areas.[14] The housing shortage grew increasingly dire as more individuals and families arrived in the city. The limited choice forced people to double and even triple up in already substandard housing stock. With nowhere for black Detroiters to move, unscrupulous landlords, who charged inflated rents for shabby apartments and outbuildings, gouged renters.

The widespread practice of placing restrictive covenants on who could own houses prevented black, Jewish, and other residents deemed "undesirable" from owning homes in other parts of the city. Abetted by the real estate industry, neighborhood groups orchestrated the spatial division of the city according to race, and local governments by fiat legally sanctioned the segregation of cities like Detroit and Chicago.[15] The housing shortage became so acute that black residents eventually had no choice but to find homes in working- and middle-class white neighborhoods. These efforts to escape the congested slums only exacerbated racial tensions already inflamed by the practice of factory owners hiring black workers as strikebreakers. For example, when a black doctor, Ossian Sweet, and his family moved into a white Eastside Detroit neighborhood in 1925, irate white neighbors reacted with death threats, and protests by unruly gangs erupted in front of the Sweets' new home. Aided by well-armed friends, a defiant Dr. Sweet retaliated against the incursions and the resulting gun battle between the mob and Sweet left one white man dead and one injured.[16] While the tragic events of the Sweet case made national headlines, what little was being done to alleviate the housing crisis in the Black Metropolis often met with intractable resistance owing to entrenched antiblack racism on the part of city governments, white neighborhood groups, and the banking and real estate industries.

Governmental and social organizations did assist southern black migrants in making the transition to urban life. Under New Deal social policies and programs instituted by Democratic president Franklin Delano Roosevelt in the 1930s, new federal agencies like the Works Progress Ad-

ministration (WPA) provided jobs in a variety of occupations, from construction to cultural work. The formation of the U.S. Housing Authority in 1937 provided funds for eliminating slums and constructing new public housing. Federal monies made possible various cultural institutions that had previously relied on private philanthropy, like libraries and community and arts centers. Social associations and self-help groups, along with black churches, made valiant efforts to provide assistance, especially during the Depression, when the more vulnerable black workers swelled the ranks of the unemployed. The NUL established chapters in both Detroit, beginning in 1916, and in Chicago a year later. League members often greeted newly arrived travelers at train stations to help them find lodgings or locate a family member. League offices operated as employment centers to aid men and women with finding jobs. They also functioned as brokers between workers and businesses. To fight against the types of racial prejudice encountered in northern cities—the segregation of public facilities, employment discrimination, restrictive covenants in housing, and police brutality—Chicagoans also founded a chapter of the NAACP in 1910, and the Detroit chapter followed a year later.

By the early 1940s, the local chapters of these national organizations, along with publishers of black-owned newspapers and recently elected black representatives to the Illinois and Michigan state legislatures—core institutions of the black counterpublic sphere—nurtured the talents of the Black Metropolis's race leaders, more typically known as "race men." This cadre, who were all staunchly positioned in the ruling black elites, became the key organizers of Detroit's and Chicago's expositions celebrating seventy-five years of progress since Emancipation.[17] The race men who ran the fairs brokered relationships with state organizations and private industry on the exposition floors and outside in the Black Metropolis. Their success at business, politics, and as leaders orchestrating the "uplift of the race" trumpeted the promise of American liberalism or, as Drake and Cayton described it, "the ultimate triumph of individual initiative."[18]

To rally support, the ASNLH's monthly *Negro History Bulletin* recalled the success of the Negro Buildings at Atlanta and Jamestown and of Chicago's Jubilee Exposition, encouraging black cooperation and participation in Detroit's and Chicago's forthcoming Emancipation expositions. Championing the cause of black progress as their predecessors in the black press had done, the *Negro History Bulletin* reminded its readers that the two commemorative expositions provided a rare public opportunity to dispel racist perceptions by showing Negro accomplishment.[19] Let us now examine these two events where race men joined forces

with cultural workers to craft a kaleidoscopic array of black progress in the modern city.

SEVENTY-FIVE YEARS OF NEGRO PROGRESS

To stir public curiosity and draw greater participation in Detroit's Seventy-Five Years of Negro Progress Exposition, a celebration to be convened in May 1940, black organizers circulated promotional literature that illustrated the historic act of liberation from enslavement. Sent to churches, social and volunteer associations, businesses, and individuals across the country, their colorful poster depicted a resolute Lincoln standing astride a podium. His towering figure radiated the themes of "wisdom," "freedom," "tolerance," "enlightenment," and "inter-racial understanding" to an appreciative group of former slaves, including one who had yet to cast off his broken shackles. In place of the ubiquitous rows of cotton fields that symbolized the rural landscape of the South, in this scene of joyous liberation the newly freed Negroes assembled in front of the lofty skyscrapers populating the modern metropolis. The picture's symbolic and historical narrative of Emancipation was framed by the twentieth-century prospects of urban life introduced by the Great Migration. Detroit represented one such promising destination for advancement.

The city near the southern border of Michigan had been home to a small black community well before the rapid expansion of its population began in 1910. In the mid-nineteenth century, Detroit had served as a way station on the Underground Railroad where sympathetic white abolitionists and brave black residents harbored former slaves seeking refuge before they crossed the Canadian border to freedom.[20] The itinerants of the Great Migration, who joined a large flood of European immigrants seeking work in the auto and manufacturing industries, radically transformed the landscape of this northern city whose shipping piers hugged the banks of the Detroit River that flowed into Lake Erie. The exposition's colorful poster beautifully encapsulated the commemorative theme—that seventy-five years ago blacks had been liberated from enslavement—however, hidden behind the lofty words and inspiring images was the fact that black Detroiters had yet to cast off the shackles of racial discrimination, a dire situation evidenced by their inability to secure decent housing, employment, education, and medical care in the booming metropolis on the lake.

All fitting the profile of race men, a committee of local leaders organized what they initially billed as the "First Negro World's Fair"—the

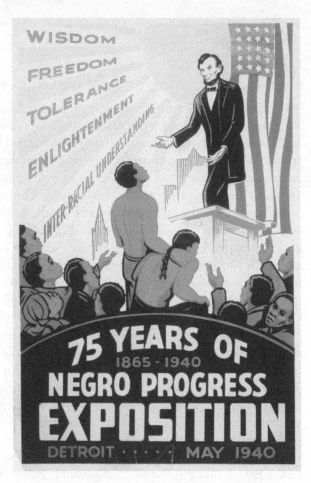

FIGURE 35. Poster, Seventy-Five Years of Negro Progress Exposition, Detroit, 1940. Courtesy of Collections of the Henry Ford, Benson Ford Research Center, Dearborn, Mich.

Seventy-Five Years of Negro Progress Exposition. Joining the committee was State Senator Charles Diggs Sr., a prominent local funeral director in Detroit. The longtime director of the Detroit Urban League (DUL), John C. Dancy Jr., served on the committee. Snow Grigsby, a postal worker who formed the Civil Rights Committee (CRC) that fought racial discrimination in Detroit's city government, also held a key position on the exposition's organizing committee. Louis E. Martin, publisher of the *Michigan Chronicle,* the Detroit bureau of the *Defender,* provided contacts to the extensive black newspaper network. Dr. George Baber, an African Methodist Episcopal (AME) minister served as general chairman of the exposition. Louis C. Blount and Moses L. Walker, heads of the black-owned Great Lakes Mutual Life Insurance Company, and Eddie Tolan,

executive director of the exposition and an admired Olympic athlete who headed the state's Negro Youth Administration, rounded out the committee. This group represented the leaders of Detroit's black counterpublic sphere, its black-owned businesses, churches, political parties, newspapers, cultural institutions, and volunteer associations.[21]

These influential race men often disagreed with each other about how to lead black Detroit forward, particularly in terms of what strategies would alleviate the racism rampant on the factory shop floors, in government agencies, and within the housing system. These men had to contend with a legion of problems affecting the lives of poor and working-class Detroiters. Although these were pressing causes, the ameliorative strategies to ease them (which required direct confrontation with the white elites in charge of the auto industry and government) would not end up being the focus of the exposition. Most within this group of race men, perhaps excluding Grigsby, would never call for more radical tactics of protest: a call for worker solidarity or collective efforts to alleviate poverty would not constitute the primary aims of the exposition committee. On the whole, the majority on the committee proselytized Bookerite self-help and racial uplift as the means for advancing black Detroit. As such, the public display of over a half century of accomplishments would be one way of galvanizing public support around the exposition's concepts of "wisdom, freedom, tolerance, enlightenment," and "inter-racial understanding." This commemorative fair would promote ideals but not direct action.

Although Detroit's black women contributed to the fair, they were less prominent in its organization. During this period, middle-class organizations such as the DUL and many labor unions emphasized "manhood rights" that placed the needs of women workers secondary to those of their male counterparts. The collaborative spirit of early social uplift was supplanted by efforts to raise the stature of black men in order, some believed, to keep "mothers" safely at home and away from treacherous white male employers. Women, however, formed auxiliaries and associated organizations to aid their striking fathers, husbands, and brothers. Whenever possible, they demanded that New Deal agencies also allocate resources to support their needs.[22] In practice this attitude greatly marginalized those women who did work, especially by discounting the value of the legions of domestic workers. When it came to more radical organizations, in particular those that focused on cultural production, women did take key leadership roles and served on the front lines of the long march toward equal rights.[23]

Over two hundred organizations sponsored exhibits and events at Detroit's ten-day Seventy-Five Years of Negro Progress Exposition. The Emancipation exposition's fair builders proudly boasted that prominent black figures from all over the world composed its international advisory committee. Among the lengthy roster appeared the names of several previous fair participants: Major R. R. Wright, Bishop R. R. Wright Jr., and Monroe N. Work, along with Mary McLeod Bethune, prominent educator, and Walter White, executive secretary of the NAACP. Senator Diggs assisted in the acquisition of monies from the state legislature, which in the end gave the paltry sum of $7,500 for expenses. Private donations provided the rest of the funding, including a generous amount from the AME Church, which planned its national convention in Detroit concurrent with the exposition. With the failure to secure funding from the lucrative financial networks of white businesses and government, the lack of monies forced Dancy, Grigsby, and Tolan to be inventive and practical with the allocation of resources, meaning the fair could only be staged for a total of ten days.

The occupations of Dancy, Tolan, and Grigsby represented the range of jobs now available to middle-class black men; they directed social organizations like the DUL or worked for federal and municipal agencies like the National Youth Administration (NYA) and the U.S. Postal Service. Under Dancy's tenure the DUL became the chief supplier of black workers to various businesses and industries. He brokered deals with Dodge, Ford, and Packard to hire black workers for their auto assembly plants, mostly in low-paying nonunion positions, a practice that the rest of the auto industry subsequently adopted.[24] Antagonistic to labor unions until the mid-1940s, when he finally agreed to work with leaders of the CIO's United Auto Workers (UAW) union in their fight for better pay and working conditions, Dancy had for many years steered DUL policy away from directly confronting the auto industry's policies of discrimination and antiunionism, a position contrary to the NUL's, under Eugene Kinckle Jones, strong support of unionization.[25] Along with being the executive director of the DUL, Dancy was a commissioner of the city's House of Corrections, making him one of the few blacks in city government and an influential liaison with city and white business leaders. Coming from a family of government officials in the South, Dancy was also a powerful force in local politics through his efforts to organize black votes for the Republican Party. His father, John C. Dancy Sr., began as a custom's collector in Wilmington, North Carolina, and rose to national prominence as a government agent in Washington, D.C. His fa-

ther had also been a close confidant of Booker T. Washington and an aux-
iliary commissioner for Atlanta's Negro Building. Like many of his peers,
Dancy Jr. also dedicated time to various associations, devoting many
hours to the local chapter of the ASNLH.[26] And yet even with his ties,
white elites turned a deaf ear when the Emancipation exposition com-
mittee made appeals for support. This old model of race leadership had,
however, challengers.

In terms of progressive political beliefs and activism, Snow Grigsby's
views were far more radical than those of the moderate Eddie Tolan, the
all-star athlete whose popularity also began to eclipse the visibility of the
traditional race leaders. An outspoken civil rights advocate and a migrant
from South Carolina, Grigsby formed Detroit's Civil Rights Committee
in 1933 to directly challenge racial discrimination in municipal jobs. In
many instances, the CRC was far more aggressive in pursuing unfair prac-
tices in the city's post office, electrical plants, and school system than the
local chapter of the NAACP, to which Grigsby also belonged.[27] By con-
trast Tolan was less vocal about his political views. His inclusion as a
figurehead in the exposition leadership signaled the rise in national pop-
ularity of sports figures and entertainers who achieved their prominence
from the new mediums of newsreels, movies, and radio broadcasts and
the proliferation of print media, mass media that had not existed at the
time of the earlier expositions. Dancy met Tolan as a promising athlete
through the DUL-sponsored sports teams for youth, and he assisted the
young man in advancing his athletic career. Once called "the fastest hu-
man," Tolan had been a former University of Michigan football hero who
had won two gold medals in sprinting in the 1932 Olympic Games, and he
had a brief career in vaudeville. The former athlete was hired in July 1939
after several delays in planning the Detroit fair, the idea being that his
celebrity would bring visibility to the exposition's agenda.[28]

The Seventy-Five Years of Negro Progress Exposition opened on Fri-
day, May 10, 1940. Joined by mayors of the black towns of Boley, Okla-
homa, and Mound Bayou, Mississippi, the white mayor of Detroit, Ed-
ward J. Jeffries, cut the large ribbon to open the fair to the public.[29] The
event showcased 250 exhibits in sixty-eight thousand square feet of space
at the cavernous downtown Detroit's Convention Hall. Visitors paid
twenty-five cents to enter the fair. Sections of the exposition represented
advances in industry, art, medicine, law, agriculture, religion, government,
citizenship, athletics, business, science, patriotism, home building, engi-
neering, and architecture. Following Bookerite tenets promoting racial
advancement through self-help, many of the exhibits and events focused

on business, education, and religion. Detroit's Booker T. Washington Trade Association, the largest chapter of the National Negro Business League (NNBL), sponsored the exposition's Business Day to showcase Negro entrepreneurial successes. On that same day, Poro College treated women fairgoers to an elaborate hair care show, in which representatives offered styling demonstrations. On the following day, Women's Day festivities featured Poro College's founder, Annie Malone, to honor her success in business.

Like the previous Negro fairs, this one also showcased black educational achievement in exhibits from the Tuskegee Institute, Wilberforce University, and nineteen other colleges. One of the most highly anticipated exhibits of the fair was a working reproduction of the scientific laboratory of Tuskegee's Dr. George Washington Carver. The Carver-Tuskegee enterprise reinforced Negro success in both education and business, thereby boosting the exposition's message of moral uplift and black economic self-reliance. This feature exhibit demonstrated black advancement in the fields of technology and science—a theme widely promoted in the popular mainstream Century of Progress fairs of this era. Due to Carver's illness and much to the disappointment of exposition crowds, an assistant of the great scientist intermittently tended the laboratory. The exhibit placed Carver's scientific instruments on view, but his innovations in the adaptation of peanuts, sweet potatoes, and other products were left out due to poor planning.[30]

Although their representation was small in comparison to the exhibits of business and industry, labor unions—a new presence at the Emancipation fairs—also contributed displays that advanced the cause of the black worker. The CIO, founded in 1935, hosted a booth providing fairgoers with information on how union membership had improved the wages, working conditions, and hours of black industrial workers, especially those in the UAW. The CIO made a concerted effort to increase membership of black workers by directly addressing their concerns and placing them on key committees. In the fight against discrimination on and off the factory floor, the union federation took a stand against segregated workplaces. Recognizing the need to attack problems facing members outside of the factory door, the CIO supported the creation of better housing for black workers to alleviate untenable overcrowding. Large portraits of leading black trade unionists hung at the CIO's exhibit. Other material on view at the booth praised class solidarity. One important mission of the labor federation was its promotion of cooperation between white (a large percentage of whom were immigrant) and black workers—

an important message to the city's growing industrial workforce. Many white workers, who saw black hires as a direct threat to their livelihood, violently resisted this push for interracial solidarity. Nearby at the fair, the CIO's competitor, the more established American Federation of Labor (AFL), had also set up a booth; but, indicative of its larger policies and practices, the AFL made no appeal in its literature or imagery to black workers attending the fair.[31]

The fair proved a perfect venue to promote New Deal successes. Fifteen thousand square feet of city, state, and federal displays presented information about New Deal agencies and initiatives for new highways, unemployment, youth, and public works. In light of the need to court black voters in urban areas, both political parties took advantage of the exposition as an opportunity to win over their votes. As the black-owned *Detroit Tribune* editorialized, "All indications seem to point to a lively contest between two major political parties in Michigan during the approaching presidential election."[32] The Republican Party sent John Hamilton to address the exposition's crowds. Hamilton, who spoke on Business Day, commended the organizers on their hard work and remarked on the need for freedom and equal treatment for all Americans.[33] But it was the Democratic speaker the day before, James A. Farley, the chair of the National Democratic Committee, who attracted a huge audience of twenty thousand on Federal Employees' Day. An on-site radio booth broadcast his speech to listeners around the country. As postmaster general, Farley had authorized the first postage stamp featuring the likeness of a black American, Booker T. Washington, released to the public a month before. After an introduction by Democratic Senator Diggs, Farley praised Negro progress by telling the crowd, "There can be no true democracy unless all the people are considered and protected alike by government."[34] The growing popularity of the Democratic Party, promoted by a Tammany-like machine in Detroit and much to the chagrin of Dancy and other black Republicans, signaled the shift of the city's black vote toward the party that had been able to secure better-paying and skilled jobs for them in industry, an effort that the Republicans had refused to undertake. And later that year, Detroit's black citizenry, like that many other cities around the nation, voted to reelect President Roosevelt to a third term, along with his platform to address racial discrimination and establish social programs for employment and housing.[35]

The fair's organizers made a concerted effort to promote cultural heritage in the areas of music, popular entertainment, art, and history as part of the Emancipation exposition's public programming. Visitors to

the Convention Hall could find high cultural fare, such as the nightly performances of the Hampton Quartet, who entertained visitors with concerts of spirituals, classical arias, and popular songs. And fairgoers could also consume mass cultural fare that included appearances from sports and entertainment celebrities. For example, on the same day as Farley's popular speech, the tap dance genius and film actor Bill "Bojangles" Robinson greeted fairgoers.[36] At a well-attended Friday event, heavyweight champ and hometown hero Joe Louis, the famous Brown Bomber, received a medal for good sportsmanship from fellow star athlete Tolan. Importantly, the public visibility of these cultural figures signified new models of racial uplift. As presented within the themes of the exposition, these luminaries had succeeded through their tenacity and hard work to surmount racist efforts to subordinate their creative and athletic talents. The sartorial choices of these debonair men and glamorous women introduced new images of black success and racial pride. In many ways, their mass appeal challenged the high cultural programming traditionally featured at these expositions and favored by the bourgeois organizers that was meant to improve the tastes and chasten the behavior of the lower classes.

The fair's roster of artists took on the new role of cultural worker. Their works merged black cultural sensibilities—some drawn from southern folk culture—with modern aesthetics to craft new narratives of perseverance and creative resilience. Many of the fair's artists, writers, and performers had benefited from federal monies made available through various New Deal agencies, such as the WPA's Federal Art Project (FAP), and much of this work filled the exposition floor. Across the United States, the FAP paid artists to create murals, posters, sculptures, photographs, and paintings to beautify public places. As a promotional effort to encourage attendance, the fair sponsored a weekly radio program for four months prior to the opening. Poet Robert E. Hayden, a Detroit native who grew up in Black Bottom, worked for the WPA's Federal Writers Project, and participated in the cultural Left, organized one of the fair's radio programs. An in-studio choir performed Hayden's "Songs of Progress," composed of Negro spirituals and secular songs.[37] In another performance, the fair organizers brought to the exposition's theater the modern dance troupe from the Karamu House of Cleveland, a WPA-sponsored community and arts center. The troupe performed a dazzling series of modern works choreographed to African music, Negro spirituals, and popular tunes and delivered a provocative narrative charting the evolution of black music and dance to audiences that totaled ten

thousand.[38] These performances exemplify how this emerging cadre of radical artists utilized a folk and Pan-African ethos, rather than the high cultural aesthetics the elites promoted, to engage black urban audiences directly.

A commendable but small display of art and history could also be found on view. On the west side of the Convention Hall, an art exhibit displayed a range of painting and sculptures. Visitors could see artworks of New Yorker Richmond Barthe, whose work focused on racial themes and black history. Elsewhere in the exhibit, painter Eugene Grigsby, the son of fair organizer Grigsby, exhibited a portrait of his grandfather, a noted mail carrier and activist during Reconstruction.[39] The talented Augusta Savage, now an established artist since her contribution to the Philadelphia fair in 1926, contributed a compelling symbolic work displayed in a prominent location in the show. She lent a smaller cast of a larger sculpture commissioned for the New York world's fair, *The Harp: Lift Every Voice and Sing,* inspired by James Weldon Johnson's popular Negro anthem. In Savage's piece, a lyrical line of ascending robed choir members formed the body of a harp raising their voices in the resounding musical epiphany of social uplift. *The Harp* sat in front of the centerpiece of the exposition—an eighteen-foot-high plinth topped by a gilded hand holding a torch reminiscent of the Statue of Liberty, with towering likenesses of John Brown, Douglass, Truth, and Washington on the four sides of the plinth.[40]

Less artistically innovative than *The Harp,* the statue of the great black leaders created a symbolic gateway to the twenty-thousand-square-foot pavilion built inside the Convention Hall that housed the Negro Hall of Fame curated by Dancy and Grigsby. An ardent collector, Dancy owned one of the most extensive collections of books on black culture and history in the city; and his involvement in the ASNLH made him an ideal curator for the Negro Hall of Fame. Even though he clashed with the more reserved Dancy on many issues, Grigsby, also member of the local ASNLH, joined in planning the important exhibit. The Hall of Fame presented busts, pictures, relics, and personal belongings of famous Negroes and whites who had contributed to the progress of the black race. A statue of inventor Benjamin Banneker, a bust of explorer Matthew Henson, and other likenesses of abolitionists, writers, artists, and scientists comprised the ranks of the hall's parade of historical figures. The celebrated, many of them contemporary musicians and performers, included Carver, Bethune, Douglass, Carter G. Woodson, Marian Anderson, Joe Louis, C. C. Spaulding, Paul Laurence Dunbar, Paul Robeson, Ethel Waters, W. C.

Handy, Bishop Richard Allen, Duke Ellington, Daniel A. Payne, Elijah McCoy, Phyllis Wheatley, and Bill Robinson.[41] Visitors to the hall could also peruse an extensive collection of over four thousand historical documents and manuscripts. The nearby library exhibit borrowed materials from the Library of Congress, the Detroit Public Library (DPL), and Arthur Schomburg's extensive collection, which had been accessioned as part of the New York Public Library. In this section of the exhibit, visitors could read first hand accounts of the noble deeds of Douglass, the soldiers of the Civil War, and the local heroes who operated the Underground Railroad.[42]

As a commemorative memento and educational booklet, based in part on their contribution to the exposition, Dancy and Grigsby compiled *A Brief History of 75 Years of Negro Progress*. Dancy contributed a history of the Negro people in Michigan. Dean of Howard University, influential member of the ASNLH, and protégé of Woodson, Charles H. Wesley was invited to contribute an essay. More refined and detailed than Giles B. Jackson's early twentieth-century industrial history, the essay by the Harvard-trained Wesley characterized social progress as a modern force that affected economic, religious, educational, and cultural life. "Looking backward seventy-five years," Wesley observed, "the Negro population group has made progress in the mastery of the tools and techniques of Western Civilization."[43] Significantly, the representations and narratives of black history were no longer being derived from individual memories of Emancipation, as the generation of former slaves had now passed away. In their place, as Dancy's and Wesley's essays and the content of the cultural and historical displays revealed, collective memory had transitioned into public history. Codified into the narratives of heroes and great men, the past was now recalled through participation in ritualistic viewing of artifacts, documents, and monuments at the expositions. But this entombment of the past into static presentations also encouraged a passive visual consumption of history that disconnected its viewers from the current conditions of black life in America.

Over eighty-five thousand people visited Detroit's ten-day Emancipation exposition. The tools, techniques, and accomplishments being celebrated at the event were still primarily founded on Washington's conservative vision of industrial training, despite the fact that many of the cultural and historical displays affirmed other avenues of advancement. Many whites were still beholden to their belief in the social inferiority of blacks. Despite its noble intentions, the exposition had not dissuaded them from those views. One white U.S. congressman, in a speech to the

House of Representatives, described the exposition as a tribute to the success of the Bookerite ideals of self-help: "The Tuskegee idea itself is a heroic monument. . . . Booker T. Washington had an affirmity [sic] for the soil and he taught his people their need for it."[44] Seventy-five years after liberation from bondage, in the mind of many white Americans, Detroit's black middle and working classes had not progressed beyond their natural affinity for the tilling the land.

Not all black citizens were pleased with the fair's final outcome. They harshly criticized the shortcomings of Detroit's Emancipation exposition. Robert Crump, a reporter for the Associated Negro Press (ANP) Service, whose story on the exposition circulated in black newspapers around the country, complained that white businesses had been awarded contracts for all of the concessions, greatly profiting from most of the stands.[45] (There may have been underlying motives at play in Crump's pointed criticism, since, as we shall review next, the ANP's founder and owner, Claude Barnett, was a main organizer of the competing Chicago Emancipation exposition.) While ideals of thrift and self-help underwrote the successful black businesses that delighted fairgoers on the exposition floor, the reality of antiblack racism meant these same businesses did not partake in the very real profits accrued in the ticket booth behind the scenes.

Racial tensions in Detroit around access to fair employment and decent housing demonstrated the need to cultivate greater "inter-racial understanding," as the poster had promoted. The rapid growth of Detroit's black population along with an expansion of the city's white population—many poor and working-class whites left the South for similar reasons as their black neighbors—transported the same southern racial tensions to a northern context. Recent immigrants, in their efforts to Americanize and gain the "wages of whiteness," also adopted harsh antiblack racist beliefs that were leveled against those who they perceived as economic competitors. Amid such volatile antagonisms, the scheduled conference of religious leaders on the exposition's Race Relations Day did was not a serious deliberation on this issue because unionization, better housing, and fair political representation were not central to the discussion. White political leaders also attended the exposition and delivered speeches calling for racial equality, but once these same political leaders were comfortably ensconced in office—made possible in part by black voters—they were rarely willing to implement those necessary changes they had promised. As historian Harold Cruse observed of the politics of the period, "Every four years the great fiction of the assimilated American (white and/or Protestant) ideal is put aside to deal with the pluralistic reality of

the hyphenated-American vote, of which the largest is the Negro-American."[46] One important success was the inclusion at the exposition of booths hosted by trade unions. These organizations, along with their cultural agenda, provided one means to leverage change; but overall, fair organizers kept the festivities focused on comfortable bourgeois goals of educational and entrepreneurial advancement. Considering the harshness of Detroit's industrial landscape, Dancy's strategy of being a peaceful, accommodating intermediary would eventually yield to more forceful tactics of protest and intervention in the civil rights era of the 1950s and 1960s.

DETERMINATION

Inspired by the success of Chicago's Lincoln Jubilee twenty years before, James Washington began in 1935 to plan for a seventy-fifth anniversary Afra-Merican Emancipation Exposition to happen in five years.[47] A resident of black Chicago, Washington was a former farm extension agent and a real estate developer. He was joined in his effort by John Sengstacke, who headed the Abbott publishing company that printed the widely read *Chicago Defender* (founded by Sengstacke's uncle, Robert Sengstacke Abbott). Washington's and Sengstacke's entrepreneurial successes represented the growth of a Negro market—one fueled by the incomes of middle- and working-class clientele with limited ability to patronize white businesses outside of their black enclave. This Emancipation exposition would emerge out of a unique collaboration between Chicago's race leaders, who would use their political and economic networks to create a framework for the fair, and the radical cultural workers whose spirited vision of black life would create the fair's extraordinary cultural content. This alliance, observed Drake and Cayton, typified an "unplanned division of labor" in the Black Metropolis, "with the 'accepted leaders' negotiating and pleading for the Negroes, while the 'radicals' turn[ed] on the heat."[48]

Chicago's black population had grown considerably since the start of the Great Migration. Its expansion under the engines of industrialization led to the development of a diverse class structure that expanded the black district southward from the Loop until it hit, as Drake and Cayton characterized in the *Black Metropolis*, "the invisible barbed wire fence of restrictive covenants." Over a quarter million strong, Chicago's black enclave was no longer identified in some circles as the "Black Belt." To veil unflattering connotations of "blackness" and impoverishment that had

become associated with this moniker, the area had been rechristened the more fashionable "Bronzeville," whose robust cultural scene by the 1940s rivaled that of Harlem in the 1920s.[49] The concept of Bronzeville reflected an embrace of a racial identity that attempted to reimagine blackness beyond a monochromatic mass. This visual recalibration implicitly embraced the centuries of miscegenation in the polychromatic shimmer of golden/black/brown hues. Bronze, the gleaming sumptuous metal associated with the monumental, also solidified black Chicago's stature within the White City. This new Bronzeville moniker promoted by many of the city's black leadership and cultural elite also suggested the greater "integration" of blacks, a new term for older concepts of assimilation within American culture and society.[50] After the Great Depression, Bronzeville nurtured a range of cultural expressions of fine arts and literature, of blues and swing, all imbued with a distinctive racial pride that would give the Chicago exposition its unique artistic resonance.[51]

A primary destination for the migratory flow of blacks out of the South, Chicago had evolved a substantial cultural milieu that could readily contribute to a national fair, with a home audience eager to witness a celebration of black achievements since Emancipation. However, in spite of their growing numbers, as historians have noted of the city's Century of Progress world's fair, Chicago's blacks had been given little opportunity to plan, participate, or, perhaps most importantly, find employment in these kinds of fairs.[52] The organizers of Chicago's Century of Progress Exposition in 1933, for example, contracted an accommodations broker whose agents issued cards imprinted with "Certificate void if issued to any person not of the Caucasian race." In response to an inquiry from the head of Chicago's NAACP, the fair's bureaucracy reasoned, with vicious circular logic, that the prohibition made perfect sense "since the homes and apartments listed with this organization do not accept colored people."[53] In another incident, a Southside contingent joined forces with African Chicagoans to propose a joint ethnographic exhibit on Negro and African progress. Over the course of their negotiations, the group allied with a less than scrupulous company run by white businessmen who in the end usurped the idea, converting the exhibit of black progress into the "All African Exhibit" concession to be sited, as had been the pseudo-African villages at previous fairs, within the bawdy spectacles of the Midway promenade.[54] And once again, the exposition's Negro Day corralled black fairgoers into a special day of events and resulted in allegations that the fair's white-owned venues and union workers had deliberately overcharged black organizers of that day's events for their services.[55]

These injustices were not limited to Chicago. The planning and visitation of the Hall of Negro Life at the 1935 Texas Centennial Exposition was similarly fraught with impasses, including overt racism by the exposition board and segregation of the Dallas fairgrounds.[56] For that particular event, NUL head Eugene Kinckle Jones, who had organized the America's Making Exposition, served as chairman.[57] Given that Texas was the western front of the South, the white fair organizers revived the tradition of a separate Negro Building. In one vicious episode, the pavilion's white contractor, who by law and stringent financial penalties had been obligated to finish the project, decided to paint the building's exterior bright red and green. The racist contractor, resentful for having to erect a building for a black constituency, chose the garish colors because he thought "Negroes liked loud colors."[58] And although it sat between the popular General Motors Pavilion and the Fine Arts Building, tall shrubbery walled off the Hall of Negro Life from its neighbors, an attempt many believed to marginalize the pavilion. Elsewhere on the grounds, "For Whites Only" signs greeted visitors to lavatories. Several concessions refused service to black patrons. And drivers denied black visitors the privilege of riding buses that toured the fairgrounds.[59] In response to these racially motivated exclusions and offenses at mainstream events, black citizens launched their own efforts to celebrate the seventy-fifth anniversary of Emancipation around the country, but none were more ambitious than James Washington, who wanted Chicago to host the first Negro world's fair, christened the Afra-Merican Emancipation Exposition. Detroit's organizers may have attempted to achieve this honor, but their ten-day poorly funded exposition failed to crystallize as a full-fledged national event.

By January 1940, with the opening day for the Chicago fair sixth months away, little had progressed with the planning of the Afra-Merican Emancipation Exposition. The exposition board had leased the enormous Coliseum, site of the 1915 Lincoln Jubilee. Its one hundred thousand square feet gave organizers four times the space of Atlanta's Negro Building to fill with exhibits from around the country and world. Several months earlier, two members of the Illinois state legislature, with the support of Governor Henry Horner, had secured $75,000 in funding for the fair. Concerned about the delays, Governor Horner established a small governing board—the Diamond Jubilee Exposition Authority—to oversee what was now being billed as the American Negro Exposition. Claude A. Barnett, a former editor of the *Chicago Defender* who now directed the influential ANP, became a key booster and organizer for the event.

L. L. Ferguson, of V. P. Jackson Funeral System, and A. W. Williams, president of the United Mutual Life Insurance Company, joined forces with Barnett in organizing the exposition.[60] Truman K. Gibson Jr., a well-respected lawyer whose father had founded the Supreme Liberty Life Insurance Company, was named director of the exposition. As the sole white member on the board, Robert Bishop, assistant to Governor Horner, served as the group's liaison. This group of black men (like for the Detroit fair, women were absent from the upper echelons of planning) represented the heart of Chicago's elite and bourgeois circles. As race men—businessmen, publishers, and political aides—they wielded influence concerning pressing local and national issues. Their more conservative tactics in advocating for change, however, did not prevent them from hiring left-leaning activists, artists, and scholars to join in planning the ambitious American Negro Exposition.

It should be recalled that the Tuskegee graduate, Barnett, had sold photographs at the Lincoln Jubilee and had been an ardent supporter of Negro involvement in several fairs. A skillful promoter, he had also assembled an extensive exhibit on the Negro press for Dallas's Texas Centennial Exposition. In the twenty-five years since the 1915 fair, Barnett, possessing astute business acumen, had realized that the men and women of these growing urban communities had a desire for goods that catered to their emerging sense of style and beauty and that they yearned for information about what blacks were thinking and doing elsewhere in world. Early in his career, he had become an associate with the Kashmir Beauty Company, selling products that competed with Poro's and Overton's lines. Diversifying his activities after Kashmir closed in 1926, and taking advantage of his expertise at gauging the public's taste, Barnett had developed the first independent black news service, the Associated Negro Press. The ANP supplied news stories to hundreds of newspapers around the county, employing some of the most talented writers in the nation. Fascinated with advertising, Barnett had perceptively anticipated the black consumer market. "I Reach the Negro" topped the letterhead for his advertising, newspaper, and magazine company. For the 1940 Chicago Emancipation fair, Barnett exploited his network, which encompassed both the black and white worlds, to expeditiously cobble together additional funding, attract exhibitors from around the country, and launch an ambitious publicity campaign that included national contests to design the exposition poster and to enter the Miss Bronze America beauty pageant that would take place at the fair—all by the July opening date. Clearly possessing the encyclopedic sensibility required to control such

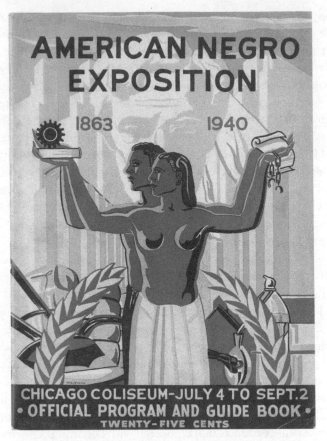

FIGURE 36. Program and guidebook, with image by Robert S.
Pious also used for the fair's poster, American Negro Exposition,
Chicago, 1940. From *American Negro Exposition, 1863–1940:
Chicago Coliseum—July 4 to September 2; Official Program and
Guide Book* (Chicago: Exposition Authority, 1940). Courtesy of
Manuscript, Archives, and Rare Book Library, Emory University,
Atlanta.

an extensive network of relationships, Barnett also carefully recorded his
fair-related activities and correspondence, akin to how the mainstream
fairs archived their activities, providing the only in-depth record of the
Emancipation fairs that this book studies.

Meticulously groomed and well-spoken race men like Barnett and Gib-
son represented the educated elite power base of black Chicago. But while
they exercised influence over Bronzeville, the white political machine still
wielded power over Chicago and the nation. And it was with these white

politicians and business leaders, who were either exploitive or support-
ive (depending on whether there were votes or money to be gained), that
the exposition organizers had to negotiate all aspects of planning the fair.
Barnett and Bishop traveled to Washington, D.C., in the spring of 1940
for a meeting with Secretary of Agriculture Henry A. Wallace to garner
more federal financing and exhibitions from agencies like the WPA, NYA,
and U.S. Department of Agriculture.[61] Wallace's strong progressive and
left-leaning affiliations ensured that federal support could be secured.
White politicians and business elites were willing to assist in the event,
especially if it meant that black patrons would be spending money on
their goods and services. Many whites in charge, however, perceived
Bronzeville as housing illiterate, unemployed black masses who were a
persistent danger to the social order of the city. Not limited to Chicagoans,
these beliefs reflected the sentiments of many white Americans. Ironically,
as Barnett and others sought federal and state funding, some white law-
makers envisioned that the fair would serve as a venue to lure urban
blacks back to rural regions of the South—thus solving the "Negro prob-
lem." Arthur W. Mitchell, the first black Democrat elected to Congress
and a Chicago native, stated in a letter of support to a House commit-
tee that because "the exposition in Chicago purports to emphasize the
agricultural opportunities offered to the Negro in the South, I think it is
destined to do much good in the way of halting the wholesale migration
of the Negro from the farm to the city."[62] To secure the funding, Mitchell
may have had to appeal to the misguided convictions of his white col-
leagues. Of course, the improvement of farm production and farm own-
ership for southern blacks mired in an exploitive peonage system was
an important national issue within the black counterpublic sphere, war-
ranting funding and publicity. But rather than laud these accomplish-
ments, the congressional report on the bill to fund the American Negro
Exposition stated another more important hoped for outcome of the ex-
position: "It is hoped that, showing the possibilities for advancement of
the Negro in returning to the land, an interest in such may help relieve
the unemployment situation, especially in the urban centers." That sen-
timents like "these Negroes, whom industry cannot absorb," should move
away from the city "back to rural life, to which they are best adapted,"
were voiced in the deliberations over funding for the exposition shows
that, despite the presence of accomplished blacks like Barnett and Mitchell,
bigoted white leaders still cast the black masses as social inferiors and
were intent on limiting access to industrial wage labor critical for social
advancement.[63]

With most of the funding finally in place at a very late stage of planning, three months before the fair opened, other obstacles and scandals plagued the organization and execution of the exposition—some of which boiled over into the newspapers and the pages of the *Crisis* after the lights of the fair had dimmed. A dispute over the use of nonunion Negro workers (who were barred from joining construction unions because of antiblack racism) hampered the completion of exhibits by the opening date. The Negro Musicians' Union launched into a dispute with the exposition authority over the employment of nonunion musicians at various musical programs and the use of recordings furnished by the Columbia Broadcasting System (CBS) that were played over the public address system for the duration of the fair.[64] At the core of much of the event's acrimony simmered disagreements between the original organizers of the Afra-Merican Emancipation Company led by James Washington and the newly appointed Diamond Jubilee Exposition Authority led by Gibson. Meetings devolved into bickering and name calling at several junctures, thus further encumbering the planning process.[65] Overcoming some of these obstacles, while keeping others at bay that would only resurface at a later date (particularly financial shortfalls and overspending), the American Negro Exposition managed to open on time in July 1940 to a crowd of twenty thousand excited visitors from around the country.

The organizing committee selected Independence Day to open the fair to the public. By commencing on the Fourth of July, organizers were choosing to remind visitors that the rights of citizenship associated with the founding of the United States had yet to be realized for the American Negro. The main exposition floor in the Coliseum was divided into wide aisles where visitors could stroll past booths and displays grouped under the themes of education, business, industry and science, religion, federal agencies, public health, and agriculture. In the center of the space, organizers placed the event's conceptual core, which was a meticulously crafted commemorative and historical display. They stationed stages for literary readings and performance along the walls, with a large art gallery occupying the South Hall and a theater located in the North Hall. President Roosevelt, seeking reelection in the forthcoming November contest, inaugurated the event by flipping a switch from his home in Hyde Park, New York. On the warm and sunny afternoon, Mayor Edward Kelly, Senator Slattery, James Washington, Gibson, and Bishop James Bray made the requisite opening-day speeches praising the fair. They applauded Negro accomplishment and remembered the events that had led to Emancipation.[66]

Over the next two months, visitors—who paid twenty-five cents for

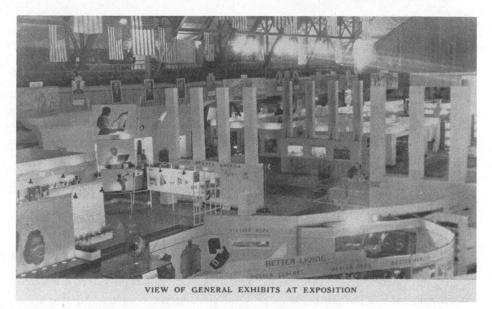

VIEW OF GENERAL EXHIBITS AT EXPOSITION

FIGURE 37. Interior view, American Negro Exposition, Chicago Coliscum, 1940. From *American Negro Exposition: Report by Diamond Jubilee Exposition Authority to Afra-Merican Emancipation Commissions of the State of Illinois and of the Federal Government* (Chicago, 1940). Courtesy of Special Collections Research Center, University of Chicago.

admission—could view an array of displays and performances. Inside the sprawling Coliseum, fifty-two thousand square feet were dedicated to 120 main exhibits. As intended by its astute fair planners, the event served as a critical public space, albeit temporary, that linked the black counterpublic sphere to the mainstream public sphere. The education exhibit featured a history of the Tuskegee Institute illustrated by maps and models of important buildings on its now sprawling campus. Fisk University, the Hampton Institute, Atlanta University, Wilberforce University, and several other colleges made contributions to the fair, although education exhibits no longer dominated the exposition as they had at the southern fairs forty years earlier. Promoting the Negro in business, the executive committee's sphere of interest, branches of the NNBL and the National Negro Insurance Association also set up displays. The Federal Works Agency (FWA), a New Deal agency, was placed near the center of the hall and had a large modernist-designed triptych of photographs that showed the importance of education, health, and recreation to being a good citizen. The NYA booth located along the east wall provided models of important events in each state and convened a youth chorus that performed dur-

ing the fair.[67] Acknowledging black contributions to the history of the city, and promoting the city government's efforts to ameliorate the problems of overcrowding and to provide other services, the City of Chicago's booth displayed a replica of Jean Baptiste Pointe DuSable's cabin—the first house built in the city—as well as a model of the federally funded Ida B. Wells Homes housing project, which opened in 1938, and Bronzeville's George Cleveland Hall Library, which was named after the activist and cofounder of the ASNLH.[68]

Throughout the two-month-long exposition, white political figures from both parties descended on the Coliseum seeking votes. Even though Chicago was a Democratic stronghold, the Republican candidate for vice president, Wendell Willkie, made an appearance. Also putting in an appearance was Secretary Wallace, who was running for vice president on Roosevelt's reelection ticket. Wallace spoke to a packed audience of over five thousand fairgoers, with another two thousand eager listeners spilling out onto the sidewalk. In his speech, which was reported to a national audience in major newspapers and circulated across the ANP wires to black newspapers, Wallace assured the crowd that America could win its international fight against fascism and Nazism abroad if it could do away with unemployment, the abuses of tenant farming, and race and class discrimination at home in order to unite the nation against a foreign threat. He reassured blacks that they would not remain a "scapegoat" for the nation's problems.[69] Indicative of his progressive views, Wallace shared the platform with Paul Robeson, the famous actor and singer, who was an outspoken member of several local leftist organizations fighting against racial discrimination and for the rights of workers. Echoing the promises made in the speeches at the Detroit exposition two months earlier, representatives of both parties offered assurances for the eventual elimination of segregation and the establishment of equal opportunity, all in an effort to secure the critical black vote in the forthcoming national election.

For evidence of what the American Negro Exposition's promotional literature championed as the twin themes of commemoration and progress, the executive committee of conservative race men drew from the Black Metropolis's rich creative milieu of artists, writers, and scholars. These leftists among the fair's planners, many of whom were directly engaged with trade unions, represented an unparalleled cast of creative talent: sociologist Horace Cayton; writers Arna Bontemps and Franklin Marshall Davis; and artists William Edouard Scott, Charles C. Dawson, and Margaret Taylor Goss Burroughs. Bontemps, a well-respected poet,

writer, and historian who had been a key contributor to Harlem's cultural renaissance, was made director of research and planning. Barnett's close friend Cayton, a writer and sociologist who trained under Robert E. Park, served as assistant to Director Gibson. Dawson and Scott, gifted painters, muralists, and illustrators, were put in charge of the general layout of the expansive exposition floor. Davis, a poet, writer, and executive editor of the ANP, arranged publicity. A young painter, poet, teacher, and writer for the ANP, Margaret Burroughs assisted with planning an ambitious exhibit of black art. This group of cultural workers crafted the fair's exhibits and programming to show, as the advertising promised, both the degree of integration into American life that Negroes had achieved and the history of cultural contribution that Negroes had made to world civilization.

Different in character from the executive committee, this group of cultural workers formed an integral part of Chicago's Cultural Front.[70] They adapted strategies from the Left's Popular Front to form progressive institutions, such as the Southside Community Art Center and various federally funded art and writer programs, which fostered interracial cooperation in the creation of a New Negro culture.[71] Central to the counterpublic sphere of this period, the press, cultural centers and monies from federal agencies helped nurture a radical revision of black culture. These cultural producers allied with labor unions that fought across racial lines to unite workers in the fight for fair wages and better working conditions—a crucial mission since blacks had suffered greatly under the Fordist recalibrations caused by the Great Depression. Their artistic vision addressed a working-class audience and drew upon urban life and rural roots to inspire art, song, poetry, and literature. They merged high cultural forms with mass cultural mediums to produce dynamic hybrid works that were accessible to a broad audience. Collectively, as artists, writers, and scholars, some wearing more than one hat, they initiated the Chicago Renaissance, a crescendo of black cultural production—"a proletarian realism"—that rivaled in ambition its predecessor in Harlem. More importantly, as passionate activists, Communists, and Black Nationalists, they supported implementing a radical agenda of social rights. Many of these Chicago artists aggressively fought racist segregation, risking arrest to integrate various arts organizations. The rumblings of the war against fascism in Europe and Japan would be equated a year later in 1941 with a fight for democratic rights at home. For them, protest was but one form of creative practice. Nationally, they joined with radical Jewish, Asian, Chicano, and white artists who shared their activist be-

liefs, and among the spirited group discussions centered on achieving economic and social parity. These men and women engaged in art making, writing, and performance as cultural work equal to other forms of labor that sustained an urban existence. Overcoming the labor stratification of Taylorism and Fordism, their mental labor—intellectual capital—was reconnected with those who physically labored on the shop floor. Locally, these radicals built institutions and skillfully channeled the support of federal agencies into educational programs, community and art centers, and publications.[72] They also used locally based news outlets such as the *Defender* and the ANP to voice their platform of social justice to a national readership. This extraordinary politically charged cultural outpouring flowed into the planning of the American Negro Exposition, making it a pivotal event that led to the formation of the black museum movement twenty years later. The exposition often figures as a minor footnote in institutional histories, but when the American Negro Exposition is placed in a genealogy of fairs that from time to time drew together this institutional network, we can understand how these events served as a crucible in which an array of positions—radical and conservative—on black life could be publicly presented and debated.

Black Chicago attracted a number of intellectuals and scholars who studied and wrote about its inhabitants and the city they had made. Cayton had arrived in 1931 for his training under sociologist Park at the University of Chicago.[73] By 1939, he had written *Black Workers and the New Unions* and would soon publish, with St. Clair Drake, *Black Metropolis,* the most significant and definitive study of black urban life since Du Bois's *Philadelphia Negro.* Both Drake and Cayton worked within the WPA, utilizing the fieldwork of WPA workers as their base data. Drake also assisted Cayton with organizing the exposition's social science exhibits. Having spent several years in Harlem before moving to Chicago in 1935, Bontemps joined the thriving Illinois Writers' Project funded by the WPA. Cayton and Bontemps became immersed in the city's active black literary scene in which their close friend writer Richard Wright, a former Chicagoan, was prominent. Wright's moving introduction to *Black Metropolis* captured the mood of the kinetic imagined and real Chicago, a city that was simultaneously alluring and alienating.[74] Wright outlined the book's themes that exposed the hidden relationships between blacks and whites, revealing the separate world where Negroes lived, which, if understood together with the hidden black-white relationships, affected the institutions and people of black Chicago.[75] Wright, Cayton, as well as other black sociologists such as E. Franklin Frazier, who would

also contribute to the Chicago fair, adopted Park's observations about the social and urban transformations of immigrant groups and blacks. Park and his followers argued that, to break down the intimacy and isolation of ethnic and racial enclaves, there must be increased mobility in poorer immigrant and racial colonies spurred through employment opportunities and education. These means of social assimilation guaranteed that individuals would establish outside social relationships. Integration, a theme the American Negro Exposition advocated, successfully occurred when racial and ethnic groups cast off isolating irrational sentiments and beliefs to become indoctrinated into the mainstream social, economic, cultural, and spatial sphere of the city.[76]

Under the curatorial genius of Barnett, Bontemps, and Cayton, the exhibits emphasized the history of the Negro in America, the Negro's present position, and the race's future integration into American life made possible by improvements in the status of the New Negro.[77] The focus on music, art, history, and literature—the cultural products of urban life in Chicago—differed profoundly from the presentations of handiwork, craft, and mechanical arts offered by the displays of southern educational and agricultural institutions at the earlier Negro Buildings. This New Negro was still shaped by the same forces of modernization as when the term first appeared in 1895, but by the 1940s cultural forces also exerted a significant influence. Alain Locke, who was one of the organizers of Atlantic City's Golden Jubilee held in 1913, was invited to assist with an ambitious and extensive exhibition on black art. By now a noted and widely praised scholar, Locke had published the anthology *The New Negro* in 1925, which included essays by Du Bois, Frazier, and Kelly Miller; poetry by James Weldon Johnson, Bontemps, and Langston Hughes; drama by Jessie Fauset; and illustrations by Aaron Douglas and of African artworks. This incarnation of the New Negro was markedly different from Booker T. Washington's ideal hardworking industrious entrepreneur. Locke's New Negro was versed in African history and culture and inclined toward Du Bois's stance on racial politics, civil rights, and Pan-African culture and history. The essays, poetry, and art in *The New Negro*—a portable cultural exposition—heralded a new spirit and era.[78] Inflected by cultural advancement, Locke's version of racial progress would, however, prove challenging for most black workers and laborers in their everyday lives, especially since many dwelled in deplorable slums and experienced rampant antiblack racism in the workplace, leaving them unable to improve their most rudimentary living conditions.

Keenly aware of the mass cultural influences of new forms of specta-

cle like cinema, the American Negro Exposition organizers created an encompassing environment whose focus was to entertain, as well as educate, its audience on black cultural progress and history. This captivating visual and spatial narrative of racial progress began in the symbolic space of the exposition's entry, carried through the aisles of the exhibits, and culminated with murals draped on the outer walls of the main floor. Artist and builder Joseph P. Evans was the supervisor in charge of the construction on the exposition floor.[79] Entering the gateway into the main floor of the exposition hall, visitors first arrived at the Court of Dioramas, designed in a spare Egyptian-influenced art deco style. This visual essay in black history provided an entrée into the historical events, figures, and circumstances of black advancement since the age of the pharaohs. A magnificent fifteen-foot-tall replica of Abraham Lincoln's tomb (the original was in nearby Springfield, Illinois) dominated the center of the space. Directly behind Lincoln's monument and positioned on a pillar at the back of the space appeared a life-size statue of a young black male titled *Determination,* by Italian artist Edgardo Simone. A sculptural statement embodying "manhood rights," the robust figure's muscular arm clutched a document of great importance, perhaps the Constitution or Bill of Rights. His broad shoulders and workman's attire indicated a man of modern industry. Head turned, with his gaze steady toward the future, this symbolic figure of black masculinity represented the exposition's iteration of the New American Negro. In contrast to the singular heroic figure of Lincoln that had greeted visitors to the Lincoln Jubilee twenty-five years earlier, the commemorative tomb and the sanguine *Determination* bracketed the ideological underpinnings of the new Chicago fair. At one end, Lincoln recalled the vestiges of white paternal generosity, signaled by the mnemonic device of the tomb. And on the other end, *Determination* offered the promise of the industrial future navigated by the brains and brawn of the independent black male (although during wartime a large number of women would fill the ranks of industrial workers). Forty-five years prior, the pediment of Atlanta's Negro Building had presented fairgoers with a narrative of progress that posited rural life as the vehicle for advancement, with religion fostering social and cultural connections, whereas at the symbolic entry of the American Negro Exposition, the industrial worker (still steeped in bourgeois ideals of masculinity and the patriarchal family) now symbolized the race's agent of progress.

Invention, protest, and heroic deeds now distinguished the recollection of the black historical legacy in the United States. Twenty dioramas depicting important historical events radiated out from an impres-

FIGURE 38.
Determination by
Edgardo Simone,
Court of Dioramas,
American Negro
Exposition, Chicago,
1940. From *American
Negro Exposition,
1863–1940: Chicago
Coliseum—July 4 to
September 2; Official
Program and Guide
Book* (Chicago:
Exposition Authority,
1940). Courtesy of
Manuscript, Archives,
and Rare Book
Library, Emory
University, Atlanta.

sive memorial display. Embedded in six-foot-tall pillars were vitrines containing dioramas. The top of the pillars had originally been planned as pedestals for small statuettes of black luminaries that together would form a hall of fame. Bontemps and Dawson supplied the historical material for the introductory display. One scene, for example, re-created white American painter Eastman Johnson's *Negro Life at the South,* depicting prewar life behind a large house in Washington, D.C. Strategically placed lighting heightened the drama of the historical settings that began with the formation of human civilization in Africa and ended with the bravery of American soldiers in World War I. Organizers dedicated

separate dioramas to the American revolutionary Crispus Attucks, the innovative genius of Banneker, and sports notables such as jockey Isaac Burns Murphy. Unlike Meta Vaux Warrick Fuller's tableau at Jamestown, none of the main displays recognized the immense contributions of black women.[80] Evans and Erik Lundgren, a white artist, supervised a staff of over seventy craftsmen and artists who built the scenes and assembled the cases. Lundgren, who had designed dioramas for the world's fairs in San Francisco and New York, had been recommended by Governor Horner to ensure—in a statement once again affirming that whites believed the Negro to be their inferior in all things—that the display would "surpass any similar venture ever attempted by Negroes."[81]

Another major artistic endeavor undertook the creation of several highly visible murals that hung, along with large photos, on the upper-floor balconies lining the outer edges of the exposition's main floor. These murals expanded the scope of the historical narrative of the dioramas, showing events in United States as well as Haiti and Ethiopia to place the Negro in an African diaspora. Scott supervised the painting of murals portraying the likenesses of Booker T. Washington, Du Bois, Sojourner Truth, Dunbar, Toussaint-Louverture, Bethune, and Wheatley, along with contemporary entertainment and sports heroes such as Paul Robeson, Jesse Owens, Duke Ellington, and Marian Anderson.[82] Scott, who studied art under the tutelage of Henry O. Tanner, had a successful career as a painter and muralist. The WPA's Illinois Art Project had commissioned Scott to paint the mural *Mind, Body, and Spirit* at Chicago's Wabash Young Men's Christian Association (YMCA), celebrating the twentieth anniversary of the ASNLH that had been founded there. The Chicagoan artist Charles White, who would receive several awards from the exposition's fine arts jury, painted two large murals for the ANP's National Negro Press booth depicting the vital role of the press in furthering civil rights. Artist Aaron Douglas also created five murals—enlargements of his illustrations for James Weldon Johnson's book *God's Trombones*—for display in the exhibit on the black church located along the west wall of the expansive hall.[83] White's and Douglas's stirring murals indicated the historical and contemporary importance of these key civic associations to the vitality of the black counterpublic sphere. Every booth, display, and presentation encountered on the hall's floor by visitors could be read against a backdrop of black history. In many of these artistic presentations, the radical creative workforce underscored workers' rights, protests for civil rights, and racial solidarity.

Literature, dance, performance, and music figured centrally into the

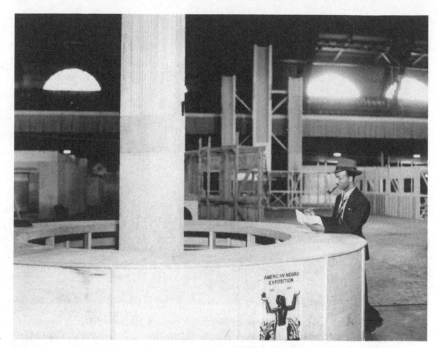

FIGURE 39. Joseph P. Evans, supervisor of construction on exposition floor, American Negro Exposition, Chicago, 1940. Courtesy of Barbara Shepherd Photo Collection, Vivian G. Harsh Research Collection, Carter G. Woodson Branch, Chicago Public Library.

scheduling of events. At specific events in the Hall of Literature, for instance, Wright and poet Langston Hughes, along with Cayton and Bontemps, recited passages and discussed their works with interested fairgoers.[84] The Schomburg Collection and Moorland Foundation loaned rare manuscripts for the literature section. The Illinois Writers' Project, a group that employed Bontemps, published the *Cavalcade of the American Negro* expressly for sale at the fair as a commemorative memento of the exposition. The popular booklet recounted a history of the Negro and appraised the current condition of race relations. Its narrative directed the racial pride of Bronzeville toward collective action against economic hardship and political disenfranchisement.

For a section of the educational exhibit on the social sciences, Cayton wanted to showcase important work on the social conditions of Negro life. The exhibit was divided into three parts: one, a figure to represent the blending of races and cultures, or, the miscegenation and integration that produced the American Negro; two, a historical analysis of black

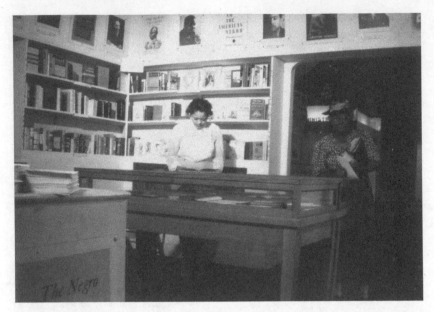

FIGURE 40. Hall of Literature, American Negro Exposition, Chicago, 1940. Courtesy of Barbara Shepherd Photo Collection, Vivian G. Harsh Research Collection, Carter G. Woodson Branch, Chicago Public Library.

contribution to the social sciences; three, a series of dioramas illustrating Negro sociological research. To get names of possible contributors and ideas for a sociological exhibit, Cayton contacted the patriarch of black sociologists, Du Bois, who was in his seventies and had returned to Atlanta University to teach and edit the journal *Phylon*. Perhaps all too familiar with the immense energy required to research and assemble an exhibit of this scope, and citing his involvement in the Paris world's fair and New York's Emancipation exposition as his impeccable qualifications, Du Bois declined participation, due in part to the absence of an offer of compensation for his contribution.[85] In need of a sociological exhibit, Cayton then turned to his friend Frazier to organize a display.

For the exhibit, Frazier proposed a review of the categories of racial types, the Negro family, economic information on southern farmers and northern workers, labor relations, lynching, sharecropping, peonage, and race riots.[86] Drawing from his recently published book, *The Negro Family in United States,* translating it into a mode of visual representation suitable for lay audiences, Frazier created five dioramas showing the social evolution of America's blacks. Grounded in narratives predicated on sustaining the patriarchal structure of the family unit, the five tableaux

began with a scene showing the disenfranchised family of enslavement. This was followed by the *House of the Mother*, depicting a family of eight ruled by the black female and crowded into a one-room cabin; the *House of the Father*, displaying the black male whose productivity and ability to acquire wealth was stifled by the broken promise of post-Emancipation federal land grants; the *City of Destruction*, where the vices and crimes of the urban life failed to better the fortunes of the Negro family; and the *City of Rebirth*, where wholesome community and civic life nurtured an environment in which the Negro family could productively and reproductively flourish. Understood in a larger context, Frazier's dioramas reiterated popular discourses, often seen at expositions, that promoted traditional concepts of the family and home life, especially in cities with large immigrant populations.[87] However, by the 1930s, eugenic discourse had overshadowed the gentler form of Americanization espoused at expositions like America's Making.[88] Seen at local fairs, these exhibits equated environment as a natural condition for advancement without fully distinguishing how human and historically influenced social forces affected the lives of Americans.[89] Perhaps not intending to overtly promote eugenic practices, Frazier's visual presentation on the Negro family did reinforce classic notions of respectability and propriety wherein men worked and women maintained the family and household. At its core, this vision presented a familial narrative of racial progress that had framed the beliefs and practices of the black bourgeoisie since Emancipation.

Complementing traditional techniques of display, the American Negro Exposition also incorporated new modes of presentation drawn from mass culture—popular musical and dance performances and motion pictures. These aimed to entertain more than uplift but were nonetheless financially lucrative for those who produced them. Bronzeville was home to an array of theaters, nightclubs, and movie houses, where the latest race movies and top chitlin circuit acts entertained middle- and working-class audiences as a means of easing the stresses of urban life. Culturally astute Chicago organizers were keen on incorporating these popular and profitable genres into the cultural fare of the exposition. For example, merging the spectacle of pageantry, discourses of race betterment, and the promotion of national pride into a parade of the most ideal features of femininity, organizers planned a spectacular beauty pageant, Miss Bronze America. Black newspapers from around the country sponsored contestants. On the day of the popular pageant, the swinging jazz sounds of Duke Ellington and his orchestra accompanied the blockbuster event. In addition to the pageant, fairgoers were dazzled by the *Chimes of Nor-*

mandy, a swing version of a French opera performed by members of the WPA's Illinois Music Project in the North Hall.[90] For an exposition exclusive, Bontemps and Langston Hughes penned their own floor show, *Tropics after Dark,* that was meant to showcase talents like Pork Chops Patterson, a tap dancer popular on the black nightclub circuit; but funding to launch the show failed to materialize.[91] Theatrical performances had always been a part of previous expositions—pageants like *The Star of Ethiopia* and *The Seven Gifts of Ethiopia* had explicitly promoted an agenda of racial pride, respectability, and progress. But the performances in Chicago showcased a national pool of black talent who entertained working- and middle-class audiences visiting the fair. By the 1940s, motion pictures also provided a new genre for the cultural programming for fairs. During the last three weeks of the American Negro Exposition, the theater showed free films that focused on black life, including *One Tenth of Our Nation,* a documentary on education produced exclusively for the event.[92] These popular genres also brought wealth and status— once reserved for prominent educators, religious figures, and business leaders—to black entertainers such as Ellington and Robeson, who made personal appearances at the exposition. These endeavors indicate how cultural workers deployed mass culture forms and themes to transmit their message of how to change the material conditions of the workplace and everyday life.

One of the most cohesive statements at the fair came from an exhibition of Negro and African art that filled the entire South Hall of the Coliseum. Named after the great painter Henry O. Tanner and funded by the Harmon Foundation and the WPA's Federal Art Project, the Tanner Galleries exhibited paintings, sculpture, and drawings. Not only did the galleries display the works of now-famous nineteenth-century artists like Tanner and Edmonia Lewis, but the exhibit also displayed new works of art that captured the proletarian realism of contemporary black life. Because of the exclusionary practices by bigoted gallery owners, curators, and museum directors that kept black artists out of mainstream venues, the Negro Buildings and earlier Emancipation expositions had provided black artists with one of the few public places where they could show their work.[93] Under the stewardship of Barnett, the American Negro Exposition sponsored an exceptional exhibition of historical and contemporary artworks, curated by Howard University's Alonzo J. Aden. Burroughs, Rosalie Dorsey, and Catherine Davis from the Southside Community Art Center Association, a planning group for a new WPA-sponsored arts center, assisted Aden in the task of gathering artworks from around the country.[94] Locke

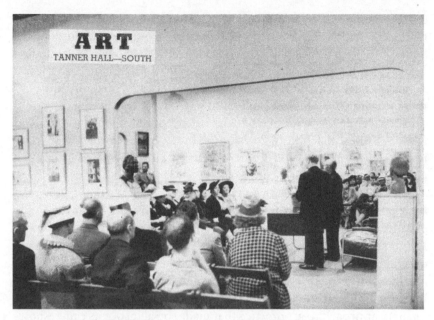

ART
TANNER HALL—SOUTH

FIGURE 41. Tanner Galleries, American Negro Exposition, Chicago, 1940. Courtesy of Special Collections Research Center, University of Chicago.

headed the jury charged with awarding prizes and he contributed several essays on the content and aesthetic philosophy of the exhibit.[95]

Several universities and museums, along with individual artists and collectors loaned works for the comprehensive show. The curators assembled over three hundred paintings, sculptures, pieces of graphic art, and ceramic works for the exhibition, dividing them between several rooms to replicate the atmosphere of a fine art gallery. One section, the "Memorial Exhibition," displayed works from Tanner, Lewis, Robert S. Duncanson, and Fuller, many of which had been shown in earlier expositions. Many of these works, as noted previously, presented mythic Judeo-Christian themes and images of self-help that were allied with the dominant ideology espoused by the race leadership. The inclusion of these artworks provided a historical foundation upon which to understand the offerings of contemporary artists.

Capturing a range of aesthetic sensibility, some of the contemporary paintings and sculptures conveyed a palatable realism that characterized the alienation and allure of life in black America and in the Black Metropolis, while others poignantly depicted the challenges—the failed harvests, the harshness of sharecropping, impoverishment—faced by black farm-

ers who remained in the South. The "Contemporary Negro Art" exhibit featured a wide range of mediums by artists from around the country. Some of these artists had also been exhibited at previous fairs, including works from Barthe, Savage, Laura Wheeler Waring, and Eugene Grigsby. A stellar roster contributed an extraordinary array of mediums and genres, including watercolors, oil paintings, sculpture, lithographs, and drawings. Hale Woodruff, Elizabeth Catlett, Sargent Johnson, Archibald Motley, Robert Blackburn, Beauford Delaney, James Porter, Jacob Lawrence, Horace Pippin, and Romare Bearden all participated in this unparalleled exhibition of Negro art.

Chicago's Cultural Front was well represented in the exhibit. Artworks by exposition organizers Burroughs and Dawson were displayed in the galleries. Award-winning Chicagoan painters White, William S. Carter, and Eldzier Corter were also present, and they also joined with Burroughs and others in various local organizations such as the Arts Craft Guild, the FAP, and the soon-to-open Southside Community Art Center. Through exhibits, lectures, and educational initiatives, this group crafted a radical documentary approach to art practice that made social justice its cause, showing in their works black life as it really was. For example, White's award-winning drawing *There Were No Crops This Year*, which appeared on the cover of the exhibition catalogue, depicted the hardships—emotional fatigue, spiritual impoverishment, and physical exhaustion—faced by a black farmer and his wife whose land had become barren. White's sketch illustrated how encroaching pressures of poverty and race stifled social and economic advancement for many rural black families. As a counterpoint to these representations of anguish and hopelessness, visitors to the Chicago fair could also see works such as White's mural for the Negro press booth that depicted heroes of black history and sought to cultivate collective pride through working-class solidarity. These murals and other historical depictions narrated the valiant struggle to overcome oppression, as also found in Jacob Lawrence's epic series *The Life of Toussaint L'Ouverture*, which took second place in the watercolor category. History, therefore, could offer lessons for how collective action would overcome racism to establish a vital national spirit.

The Field Museum of Chicago, the Schomburg Collection, and the Emery Ross Collection of Photographs also loaned artifacts from various regions of Africa for display in the third section of the exhibition. African art was not only incorporated into the show for its beauty and originality but also to imbue the exhibition, as Locke characterized the curatorial intentions, with the Pan-African collective spirit that perme-

ated "the work of our people." First and foremost, Locke envisioned a larger mission for the works on display. He wanted viewers to "notice in their canvases the sober realism which goes beneath the jazzy superficial show of things or the more picturesqueness of the Negro to the deeper truths of life, even the social problems of religion, labor, housing, lynching, unemployment, and the likes."[96] Locke emphatically stated that the black and white artist shared common ground in their documentation of American life and experience. Overall, the broad cultural reach and historical trajectory of the exhibition indicated an emerging consideration of art practices and cultural influences within a modernist aesthetic to which black artists had made significant contributions. But the exhibit also promoted how art might begin to illuminate "the deeper truths of life, even the social problems."

Lasting for two months during the hot Chicago summer, the American Negro Exposition was attended by well over a quarter of a million fairgoers. While these numbers were impressive, they still fell far short of the original goal, making the fair a disappointing financial endeavor. The executive committee and cultural workers delivered on their promise of an awe-inspiring cultural and historical cavalcade, but the event failed to achieve its ambition as a national Negro world's fair. The late date at which planning for the fair had commenced had caused a great deal of trouble. In the words of a testy letter from Cayton to Barnett concerning reimbursement, "This has the appearance of very sloppy business practice, however you know as well as I the state of confusion that existed at the time [of planning the fair]."[97] Compounding the problem of time, the white owners that controlled the Coliseum and its in-house workforce made sure they and their workers received a hefty cut of state and federal monies up front. And the high price of Coliseum's unionized carpenters, in the words of Barnett, had "bilked them for $34,000," far exceeding the $10,000 budgeted for construction.[98] These and many other similar incidents quickly drained the fair commission's coffers. By the close of the fair, unplanned costs made it difficult to pay for the many shipping bills, damaged and lost articles replacement requests, travel expenses, and even for the prizes awarded in the various competitions. In the end, the power of race leaders was still stunted in part by the anti-black racism of those in charge of the Coliseum even as fair organizers sought, as James Washington had done, to mitigate the racist treatment's impact on the black majority. The aggressive actions of white businesses served as a reminder that the Black Metropolis was a vulnerable black world within a predatory white one. And the American Negro Exposi-

tion's failure to achieve national status, as scholar Adam Green suggests, was a consequence of the failure to cultivate a collective imaginary for group identity, a cohesive black nationalist spirit—a shortcoming exemplified in the varied tonalities of black ideology represented in the creative cavalcade produced by the fair's cultural workers.[99]

However, there were some notable changes in how racial progress had been conceived and represented. The most significant inclusion in the exposition (not featured at the previous fairs, except as the core figure in the Randolph's radical speech in Philadelphia) were exhibits and events dedicated to the black worker and the working class of Bronzeville. Distinct from both the farmer in Booker T. Washington's vision of the southern Negro, the intellectual vanguard Du Bois imagined as the New American Negro, and the businessman vaunted at the Lincoln Jubilee or the recent Seventy-Five Years of Progress Exposition, the worker formed the most prevalent new identity of the modern industrial city. Labor unions and their meeting halls joined the churches, offices, and halls of cultural institutions and social organizations to comprise the public spaces of Chicago's and Detroit's segregated neighborhoods. *Cavalcade of the American Negro,* the exposition's commemorative literary booklet, cited a history of the American worker in which Negro slaves "took a hand in every phase of the nation's early construction." The booklet also saluted the work of free blacks who facilitated northern industrialism and participated in westward expansion and recognized the validation of Negro labor present in industrial training institutes like Tuskegee.[100]

The exposition's ambitious cultural agenda also renewed the collective memory of freedom from enslavement, representing black history as public history. In a strategic repositioning, Emancipation was cast as the promise of freedom from exploitation for all black workers—industrial or agricultural. For instance, the U.S. Agriculture Department's "The Negro on the Land" exhibit showed the historical advancement of the black farmer. The largest exhibit of the fair, it recast what had been "thought of as drudgery" as "an essential, dignified, productive industry" woven into the future economic fortunes of the nation's blacks.[101] The *Cavalcade,* along with recounting the rich history of workers and unionization, alerted its readers to the challenges faced by the contemporary black worker—low wages, the ban of black workers from unions, and discrimination in layoffs and rehiring.[102] These observations about the historical and contemporary condition of the worker in cities like Chicago and Detroit made a plea for political action and activism. Unionism, therefore, defined the next important phase in the black worker's march for-

ward. The concluding sections of the *Cavalcade* advocated advancement "Toward Democracy."

The American Negro Exposition aimed to cultivate a social consciousness and solidarity beyond racialized nationalism wherein blacks of all classes would recognize their economic and social circumstances in relation to minorities elsewhere in the world who also suffered oppression. To comprehend the nature of a solution, as the *Cavalcade* put forth, required cooperation and collective action with other socially minded Americans. Until then, it stated, racial consciousness must suffice as a means for political activity, and the Negro would develop "political mindedness, cohesion, and management" when suffrage was granted and civil rights conferred the full privileges of American citizenship. The exposition's utopian vision of equality and integration, driven by collective determination, would be one way to achieve the full realization of American democracy.[103] The next thirty tumultuous years of civil rights protest would test that noble vision.

THE NEGRO MUSEUM

The American Negro Exposition took place amid a flourishing network of social and cultural institutions in Chicago. It nurtured a cadre of radical writers, artists, and intellectuals who would influence the local and national cultural scenes over the next three decades. Several organizers of the exposition's cultural programs—Burroughs, White, and Dawson, along with other cultural activists—had spent more than two years fundraising and devising an ambitious agenda for the WPA-sponsored Southside Community Art Center. Three months after the exposition closed, the art center officially opened in a former mansion on S. Michigan Avenue in the heart of Bronzeville. The institution served as a lively hub for the Southside's leftist, radical, and Communist black writers and artists.[104] A vital contributor to this cultural scene of salons, associations, newspapers, and schools, the multitalented Burroughs was the pivotal figure that connected the expositions of the 1940s to the black museum movement of the 1960s. Arriving in Chicago with her working-class parents who had migrated from southern Louisiana in the early 1920s, Burroughs was a child of the Great Migration.[105] She attended local schools and began to display her watercolors and paintings in the mid-1930s. Among her many activities as a cultural worker, she taught art classes at DuSable High School and frequently contributed to the *Defender, Chicago Bee,* and the ANP, where the young writer penned social com-

mentary and reports on various issues—many exclusively about black women's issues.

Desirous of promoting a more populist knowledge of black history (somewhat similar to Woodson's vision), Burroughs became affiliated with the National Negro Museum and Historical Foundation (NNMHF), founded by a group of Chicagoans in early 1940s. The NNMHF was comprised of representatives from various religious, labor, and cultural organizations, including Bishop James Bray, a leader within the Colored Methodist Episcopal Church, and leftist artist Franklin Marshall Davis.[106] Others participating in the organization were Samuel Stratton, a DuSable High School colleague, and John Gray, an assistant to Robeson. The NNMHF was one of several associations formed in the Southside, like the local chapter of the ASNLH and the DuSable History Club Committee, dedicated to raising awareness of Negro history. The NNMHF was the only one, however, committed to establishing a public museum dedicated to the collection and display of documents and artifacts representative of Negro achievement. Most major mainstream museums in northern cities at this time did not openly discriminate in their admissions policies. Black patrons could visit many of Chicago's museums, and the Art Institute of Chicago, for example, also loaned exhibits to the Southside Community Art Center). Most southern museums, however, did discriminate, refusing to admit black patrons unless they were school groups invited by the institution.[107] Art museums in particular rarely exhibited the work of black artists, which is why the expositions provided a crucial venue for exposure. Natural history museums still promoted racist imagery and ideas associated with theories of human progress in exhibits such as the Chicago Field Museum's "Races of Mankind" show, first unveiled to the public for permanent display in 1933. "Races of Mankind" displayed 101 bronze figures, crafted by sculptor Malvina Hoffman, representing racial types from around the world.[108] This exhibit joined the new dioramas of African zoology and anthropology at both Chicago's and New York's natural history museums.[109] In this segregated cultural landscape, the Negro museum would therefore have many functions: as an educational institution for classes on black history, an exhibition space for the display of art and history, and an institution within the black counterpublic sphere that joined the battle against antiblack racism in the United States and abroad. The NNMHF's long-term goal was to raise enough monies to build a museum on an empty lot adjacent to the George Cleveland Hall Library on S. Michigan Avenue.[110] Within a few blocks, the Southside Community Art Center, the Hall Li-

brary, and the proposed museum would form the cultural epicenter of Bronzeville.

Chicago's NNMHF was not the first effort undertaken, however, to establish a national Negro museum. Several earlier attempts had failed. In 1915, shortly after Woodson incorporated the ASNLH, another group of determined black citizens in Washington, D.C., believed that it was time for a national monument in the city—one that commemorated the black soldiers who had courageously fought in all of America's conflicts. Calling themselves the National Memorial Association (NMA) and led by Ferdinand D. Lee, an attorney and organizer of the Jamestown Exposition, the group urged various branches of the War Department and federal government to recognize the contribution that Negro soldiers and sailors had made to the nation since the Revolutionary period.[111] Its charge became more urgent as the military drafted thousands of black men to serve in World War I. The NMA championed these fallen soldiers, saying they deserved recognition for their sacrifices—a small gesture of respect considering that many surviving soldiers returned to a hostile country that refused to grant them the constitutional rights they had so valiantly defended. To underscore the black soldier's relevance to the nation's collective memory, the association's members joined military burial processions marching through the streets of Washington, D.C. These acts explicitly linked the commemoration of the black soldiers to the historic architectural icons in the nation's capital that honored American democracy.

After a decade of lobbying for recognition and funding, the House Committee on Public Buildings and Grounds finally granted the NMA a hearing in 1929.[112] By then the group had expanded the scope of the proposed memorial to black soldiers to include a large museum, designed by black architect Edward R. Williams. The neoclassical Beaux-Arts temple would be located along the lawn of the National Mall, which had been redesigned along the principles of the City Beautiful movement as laid out in the McMillan plan of 1901.[113] At the hearing, Lee informed the committee that the building would house a hall of fame, art and music rooms, a library, an auditorium, and a museum, with room for exhibits on the Negro's contribution to military service, art, literature, invention, science, and industry.[114] Seating five-thousand, the auditorium would be able to host events such as school graduations, which, because of antiblack racism, had limited access to larger public venues elsewhere in the capital. Members of the National Association of Colored Women (NACW) Julia West Hamilton, Mary Church Terrell, and Bethune sup-

ported the NMA, and Hamilton and Terrell appeared at the hearing to read statements backing funding for the group's proposal.[115] Representative William R. Wood, a white Republican from Indiana who had introduced the resolution, reminded his colleagues that blacks had no public art gallery or museum. Wood had been impressed with what he had seen at the Negro Building in Atlanta and at the Lincoln Jubilee in Chicago, and he believed the NMA's request was reasonable.[116] In spite of the vocal objections of bigoted southern politicians, both the House and Senate approved bills for the museum in 1929. President Calvin Coolidge, a Republican, signed the bill into law and formed a National Memorial Commission of twelve presidential appointees to oversee the creation of a memorial museum. Later, in November 1929, newly elected President Herbert Hoover, also a Republican, nominated an official committee that included Lee, Terrell, and Bethune; other commissioners and advisors were drawn from a broad sweep of the black elite, including Anthony Overton, Annie Malone, A. Philip Randolph, businesswoman A'Lelia Walker, banker Jesse Binga, and Tuskegee president Robert Moton.[117] The monies, however, came with stipulations that greatly hindered the success of the project. The federal funding of $50,000 would only be awarded after the NMA had raised a staggering half-million dollars, a caveat added due to the fierce opposition by southern representatives. The Great Depression doomed the creation of the national memorial museum by the mid-1930s.[118]

There were other proposals for a national Negro museum. Enthused by the many semicentennial Emancipation celebrations and drawing upon their momentum, Kelly Miller, who had participated in several expositions, proposed in 1915 that Howard University form a new library of Negro Americana. The university would form the institution around its already significant collection of books and documents, including the collection of Jesse E. Moorland, Howard alumnus and cofounder with Woodson of the ASNLH.[119] While the idea received support from a wide range of scholars, the university's administration chose not to pursue the proposal. In 1938, Miller revived the concept. Writing an article for New York's *Amsterdam News,* Miller proposed that the museum gather together "literary, historical sociological, statistical, scientific and artistic material growing out of the contact of the American with the European on the Western continent during the past four hundred years."[120] Despite having obtained the written and verbal support of many scholars and leaders, both black and white, Miller's second proposal would never be built. Therefore, Chicago's NNMHF became the next effort at creating

a national museum dedicated to the collection and display of black history and culture.

Following the pedagogical objectives of the sociological studies that had appeared at the fairs, the NNMHF's message advanced a radical deployment of historical knowledge to change current policies and laws. The group argued that the fight for lasting social change was a fundamental element of both Negro and American history, as Randolph had emphasized in his Philadelphia speech; indeed this fight was the Negro's legacy in the United States. The NNMHF linked knowledge of history directly to contemporary struggles for social and economic parity. The group compared the manner in which Douglass and Lincoln had united blacks after the Civil War to how the CIO and unions were uniting all industrial workers in the fight for decent wages and to make capitalism accountable to its workforce. The determined alliance of radical educators, activists, and artists claimed that militancy was deeply ingrained in the American ethos: "To win a people's peace America must end the semi free status of her Negro population," NNMHF members wrote in their mission statement. "A militant history is the heritage of Negro and democratic whites," but the country is an "America which yet struggles to make America."[121] The NNMHF firmly maintained that the struggle for peace in the United States could only be secured by adopting a progressive platform that included the establishment of the Fair Employment Practices Committee (FEPC), the abolition of poll taxes, a minimum wage of seventy-five cents per hour, an antilynching law, a bill supporting full employment, an extension of Social Security benefits for the unemployed and elderly, and adequate housing.[122] The group's stance was no longer patient accommodation but direct political action founded on a historical legacy of militancy.

In her position as the NNMHF's executive secretary, Burroughs organized the foundation's public events, including those planned for Negro History Week. The NNMHF annexed local associations for its temporary exhibition spaces; for example, the hall of the United Packinghouse Workers (a CIO union) on 49th and Wabash served as one venue for black history exhibits as well as foundation meetings.[123] The NNMHF sponsored a Negro History Week program in 1945 at the nearby DuSable High School. For that year's events, Burroughs and Gray organized what they advertised as a "mass meeting" to hear a keynote speech by Frazier. Publisher of the recently started *Negro Digest,* John H. Johnson, along with representatives from the Chicago Federation of Labor and the United Electrical Radio and Machine Workers of America, also delivered speeches.

Dancers and choral groups performed pieces celebrating African culture and liberation from enslavement.[124] The foundation's agenda of historical awareness initiated a grassroots movement drawing together publishers, unions, and artists to challenge racial discrimination in business, work, and housing.

For Negro History Week in 1946, the NNMHF planned a large interracial event at one of the large hotels in the Loop and dedicated its program to two causes—Negro contributions to World War II and the union of white and black workers in a common goal to obtain a living wage. Speakers were to include Stratton, a distinguished war veteran, and representatives from the Chicago Civil Liberties Committee (CLC) and the Southside Council of the Communist Party. The packinghouse union cosponsored the event, which was intended as more rally than lecture. At this Negro History Week event, the NNMHF had planned to inaugurate a national protest against the filibuster of the FEPC then underway in the U.S. Senate. In the midst of planning, however, Stratton, Gray, and Burroughs discovered that the city's Congress, Stevens, and Sherman Hotels refused to host the event, claiming that "we prefer not to have the business." Incensed by the racially motivated denial of service akin to the Jim Crow practices usually encountered in the South, the NNMHF immediately called a mass meeting of the packinghouse union members. The foundation also contacted the CLC to launch a legal action and an investigation. The CLC soon learned, after a series of test cases (that involved sending racially mixed groups to the hotels' restaurants), that the various hotel managements would always "discover" that they had lost the reservations of predominately black integrated groups. The CLC filed a letter and affidavit with the governor requesting prosecution of the LaSalle Hotel in particular for violating civil rights law.[125]

Committed to activism and protest, the NNMHF fought against segregation in a more robust manner than had occurred at any of the expositions to date. The NNMHF disbanded in the late 1940s without achieving its long-term goal of establishing a museum. In part due to the more conservative postwar atmosphere that fomented the McCarthy-era anti-Communist hearings, the NNMHF lost its momentum. Bishop Bray died in 1944. Davis moved to Hawaii in 1948. And the foundation's other members directed their efforts toward other organizations. Even though the Federal Bureau of Investigation had been keeping a file on her activities since the 1930s, Burroughs—an important impetus in bringing together artists and writers from around the world—remained politically active. In the fall of 1950 Burroughs and her former husband, Bernard

Goss, for example, proposed to establish a Chicago chapter of the Harlem-based Committee on the Negro in the Arts, a leftwing interracial organization committed to challenging stereotypes of blacks in the arts and to promoting greater integration.[126] Much to Burroughs's disappointment, the Southside Community Art Center shifted its agenda from progressive causes to more conservative ones, and in the mid-1950s her membership was rescinded.[127]

Up to the formation of the NNMHF, black-organized expositions and black participation in world's fairs had explicitly shaped exhibits and events around the theme of racial progress and social advancement, also drawing upon the central theme of commemorating Emancipation. That the curatorial ethic of the two major Emancipation expositions in 1940 also held fast to these tenets, to varying degrees, is not surprising in light of the role of Chicago's and Detroit's black elites in sponsoring the events. As this chapter has shown, popular and radical visions of black advancement supplied by cultural workers did appear in these fairs' cultural agendas and on the exposition floors. The range of positions presented about the future of the race suggests that there was no singular vision concerning how black America would advance its fortunes or how to challenge the racial prejudice that had created dire conditions in both urban and rural communities. While white Americans may have seen their fellow black citizens as an undifferentiated mass, black Americans clearly saw themselves in a myriad of identities shaped by centuries of being central to the nation's development—an awareness of black history made possible in part by the orations, performances, artworks, and exhibits experienced at the fairs. The collaboration of race leaders and cultural workers produced works that were witnessed in person and reviewed in newspapers by a national audience. This critical moment bears the origins of the long civil rights era, witnessing as it did, in the words of scholar Nikhil Pal Singh, "the development of institutional information networks that linked black intellectuals and activists with geopolitically dispersed populations who could be mobilized—with unpredictable consequences for the nation as a whole."[128]

As we have learned from the Detroit and Chicago expositions, black organizers of the celebrations to commemorate seventy-five years since Emancipation promoted lofty goals. Detroit's fair aspired toward "interracial understanding." Chicago's desired "to hold the first real Negro world's fair." Yet neither fair realized these aspirations. While the racial harmony on the floor of the Detroit exposition was represented in well-

crafted displays and discussed in forums by white and black leaders, the ability of white concession owners to profit from the fair's events to the exclusion of black businesses proved that black organizing committees exerted limited control over the very mechanisms of capital that financed and profited from their own exposition—this was the uneven distribution of wealth and power that leftist radicals sought to recalibrate. The national scope of Chicago's American Negro Exposition did position the event as the first Negro world's fair. Participants, contributors and visitors came from all parts of the United States and the black world. Gibson, Barnett, Cayton, and others drew upon a robust network of associations and institutions that did not exist some forty years earlier, when Irvine Garland Penn, Booker T. Washington, and others gathered materials for the southern Negro Buildings. Indeed, Chicago was linked, as Drake and Cayton suggested, to a black nation. However this Negro nation, defined by its strong cultural affinities and shared history, was still situated within a white nation. Cosmopolitan, bustling Bronzeville, along with Detroit's Paradise Valley, sat squarely within hostile urban environs controlled by long-established white power bases with their own need for black support and agenda for domination. Therefore, in traveling outside the limits of the urban black belts, black citizens faced the prospect of encountering a racist epithet on any street or discrimination in any store. Violence became a tactic mobilized by some resentful whites when black residents, overwhelmed by crowded conditions and rundown housing, began to settle in housing built by federal funds that had been erected to alleviate shortages or when they tried to purchase homes in white neighborhoods, an option made possible by middle-class wages. Against such hostilities, the fairs offered a temporary space of refuge. Inspired by the art and sculptures, the Negro halls of fame, the booths and floor shows, the creativity, imagination, and promise as cultivated in the phantasmagorical realm of these two emancipation fairs, black urbanites could envision what the future might hold. The cultural workers crafted hybridized popular culture representations, using known vernacular forms to interject their radical message of forward advance. But potent and persuasive images of what black life ought to be in the Black Metropolis became something else when that vision encountered the hard asphalt that paved the streets of the White City.

Moreover, individuals who had shaped the displays and agendas of the various temporary Negro Buildings and Emancipation expositions— Lee, Miller, and Burroughs—fought to build a long-term institution dedicated to black history and culture. Whether a national museum should

be erected within the symbolic space of American democratic institutions on the National Mall, within the civic sphere of Negro America at Howard University, or in the cultural core of Bronzeville tested the limits of black national belonging. Regardless of the desire to appear within the symbolic space of the nation, the symbolic space of black American collective memory and public history remained consigned to segregated enclaves in Harlem, Chicago, Atlanta, Detroit, the District of Columbia, and elsewhere in the United States. Yet despite these setbacks, by the 1940s popular interpretation of historical events and celebration of race leaders filled the editorials, articles, and cartoons of widely read black newspapers. Negro History Week programs sponsored by the ASNLH and other local organizations like the NNMHF promoted a greater understanding of history, which also expanded to include a Pan-African perspective. Far more detailed than the history of the race inscribed on the pediment at Atlanta's Negro Building, this emergent historical consciousness, with its New Negro, Cultural Front, and racial uplift strains, would become the backbone of a more nationalistic black pride in places like Detroit and Chicago by the 1960s. Within this context, the activities of the NNMHF emphasized the relevance of nurturing a political agency among black Americans, as the pedagogical project of Du Bois's *Star of Ethiopia* had promised. The foundation's battle against racism, as its willingness to file charges against racist management of the Chicago hotels reveals, connected the fight for civil rights to basic tenets of American Democracy that Emancipation should have bestowed. An active remembrance of past events was an important prelude to political action. As historian James E. Young has written, "collected memory," a constellation of meanings, should be used to vivify the past in the present.[129] Unlike the expositions that had represented the past to validate a vision of the future, new black museums in the 1960s—such as Chicago's Ebony Museum of Negro History and Art and Detroit's International Afro-American Museum, which are reviewed in the next chapter—called on black history in order to transform the material conditions of life in the present.

To Make a Black Museum

To give an accurate sense of identity and worth regarding America's Negroes, by demonstrating the quality and depth of their contribution to world culture and particularly to the New World.

—Mission statement, International Afro-American Museum, Detroit, 1965

I think one of the stumbling blocks is that the nature of the black experience in this country does indicate something about the total American history which frightens Americans.

—James Baldwin, House hearing on proposed Commission on Afro-American History and Culture, March 1968

In the summer of 1963, Chicago hosted the Century of Negro Progress Exposition celebrating one hundred years since Emancipation. Held in the latter half of August at the newly opened high-modernist McCormick Place Convention Center, the fair's exhibits filled three hundred thousand square feet of floor area.[1] Organized by James E. Stamps, cofounder with Carter G. Woodson of the Association for the Study of Negro Life and History (ASNLH) and an organizer of the social security exhibits at Chicago's American Negro Exposition, and Alton A. Davis, the centennial exposition featured eighteen days of events, performances, and tributes. Assuming their long-standing role as fair contributors, black businesses and civic associations organized many of the displays and booths. Joining them on the exposition floor, new sponsors—companies such as AT&T and Pepsi Cola—funded exhibits on Negro history. The presence of these major corporations verified Claude Barnett's prescient observation that the purchasing power of the black consumer class was grow-

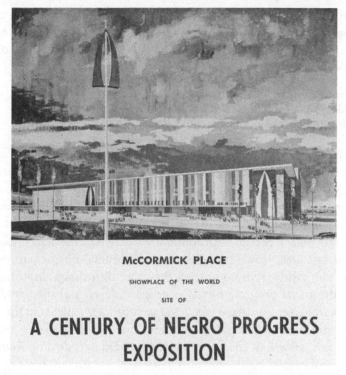

McCORMICK PLACE

SHOWPLACE OF THE WORLD

SITE OF

A CENTURY OF NEGRO PROGRESS EXPOSITION

FIGURE 42. Artist's rendering, Century of Negro Progress Exposition, McCormick Place Convention Center, Chicago, 1963. From American Negro Emancipation Centennial Authority, *A Century of Negro Progress Exposition: McCormick Place, Chicago, Ill., August 16th— September 2nd, 1963* (Chicago: American Negro Emancipation Centennial Commission, 1963). Courtesy of Special Collections Research Center, University of Chicago.

ing. The presence of these large international companies also demonstrated how the Cultural Front's techniques of cultural production and representation through mass culture had been absorbed into corporate structures.[2]

Band leader Duke Ellington made a return engagement to a Chicago Emancipation fair, scoring and directing the stage show *My People,* which included performers from the Alvin Ailey modern dance troupe. One week prior to his participation in the March on Washington for Jobs and Freedom on August 28 (an idea conceived in the 1940s by A. Philip Randolph), Rev. Martin Luther King Jr., civil rights activist and advocate for nonviolent change, toured the exposition's displays.[3] During his visit, King stopped by a rehearsal of Ellington's stage show and orchestra leader Billy

Strayhorn performed *My People*'s tribute to King, part of the closing section celebrating great black Americans. Titled "King Fit the Battle," the song dramatized the story of recent violent encounters with southern white supremacists:

> King fit the battle of Alabam—Birmingham
> And the bull got nasty—ghastly—nasty
> Bull turned the hoses on church people[4]

With its theme of "gifts," the stage show's narration of black cultural achievement echoed *The Star of Ethiopia*—a performance Ellington had seen as a youth. In comparison with W. E. B. Du Bois's earlier pageant, the overall score of *My People* conveyed a more subtle political message, one that some argued was out of step with the rising militant stance against antiblack racism.[5] Although his creative genius had inspired Ellington, Du Bois, would not attend this centennial Emancipation exposition. The visionary who shaped the groundbreaking curatorial ethic about the racial progress of the American Negro and the Pan-African world had become a citizen of Ghana in voluntary exile from the United States after being investigated and persecuted for his socialist and communist affiliations. At the age of ninety-five, Du Bois died on August 27, 1963, in Accra.

When the Chicago fair closed, the era of the great Emancipation expositions also ended. The fair's program still held fast to exhibiting "the progression of civilization." Its organizers proclaimed that "the elements of justice, equality and liberty, within the chemistry of Democracy, acts as a catalyst upon its principal component—FREEDOM—and forces out of it those impurities such as prejudice, hate and fear."[6] The Century of Negro Progress Exposition failed to draw the projected crowds of 800,000. Instead, by one estimate it attracted a disappointing 18,000 fairgoers.[7] Giving a reason for the poor attendance, one fair promoter commented, "The Negro community is in no mood for retrospection, and the current racial stance is one of militancy, for the present and ferment for the future."[8] The exposition was no longer a constructive public forum for early twentieth-century race men like Stamps to disseminate rhetoric and strategies for "uplifting the race." By the 1960s, black Americans were seeking modes of direct action that would forge advances in social justice and equality rather than high-minded and well-worn platitudes on racial progress.

For the exposition's Negro History Day festivities, the organizing committee honored Margaret Burroughs (who also exhibited her art-

works at the fair) for founding the two-year-old Ebony Museum of Negro History and Art. It was from Ishmael Flory (an outspoken Communist and labor activist who in the mid-1950s started a historical association called the Afro-American Heritage Foundation) and Bishop James Bray that the outspoken Burroughs inherited the idea to start a museum dedicated to black history and culture in Chicago.[9] Through her many contacts and travels with artists and activists, she had assembled by the 1960s an impressive collection of artifacts and artworks, turning her home—a carriage house behind a large three-story mansion on S. Michigan Avenue—into a gallery. The old twenty-room Gold Coast mansion, with its imposing facade, was a few doors up from the Southside Community Arts Center and had been for many years a social club for black railroad workers. The private Quincy Club Bar, which served food and drinks, was a popular place frequented by black luminaries like Du Bois, A. Philip Randolph, and Paul Robeson for social and educational events of Chicago's black Cultural Front.[10] When the Quincy Club decided to sell the property in the early 1960s, they offered it to Burroughs for the purpose of starting a museum. During Negro History Week in 1961, Burroughs and with several other dedicated history supporters, including her friend Samuel Stratton, who had been part of the National Negro Museum and Historical Foundation (NNMHF), Gerard N. Lew, Eugene Feldman, and her husband, Charles Burroughs, drew up a charter for the Ebony Museum of Negro History and Art—an idea hatched two months earlier. The museum officially opened three rooms of exhibits in October.[11] Since it had secured a space to display artwork and other material, the Ebony Museum actively sought artifacts, papers, letters, costumes, relics, and other items to add to its growing collection. The year of the museum's opening, 1961, was the same year that the Freedom Riders left Washington, D.C., to travel to Burroughs's birthplace of southern Louisiana, only to be attacked during their journey by violent white mobs in Birmingham and Montgomery, Alabama. Continuing their long-standing engagement in national and international activism centered on cultural production, the Burroughs wove these current events into the public programming of the new museum. For example, during the celebrations for 1963's Negro History Week, Margaret Burroughs and the new museum joined Flory's Afro-American Heritage Foundation and invited Pan-Africanist Dr. John Henrik Clarke to deliver talks titled "Africa and the Freedom Rides" and "New Opportunities and Responsibilities of the Afro-American Writer."[12]

The civil rights era would have a profound impact on blacks in both

FIGURE 43. DuSable Museum (formerly Ebony Museum), S. Michigan Avenue, Chicago, early 1970s. From Eugene Feldman, *The Birth and the Building of the DuSable Museum* (Chicago: DuSable Museum Press, 1981). Courtesy of DuSable Museum of African American History.

the South and North and it would inspire the creation of new museums dedicated to promoting black history and culture. Although private citizens, historical societies, and black colleges and universities had formed collections of artworks and artifacts, these new institutions would be the first public museums in the United States exclusively dedicated to the research, promotion, and permanent display of black history and culture.[13] Because the world's fairs and their fairgrounds were by design temporary, after the events ended mainstream museums collected the most valuable artifacts and artworks (excluding the contents of the Negro Buildings) and placed them on permanent public view.[14] For the black-organized expositions, the message of racial progress was more valuable than the material content of the exhibits, although some artifacts and artworks found their way into the collections of black colleges and universities. The establishment of new black museums allowed for the long-term presenta-

tion of ideas of black pride and self-improvement and for the collection of artifacts of black heritage. The new museums forged ties within the social networks and institutions of the black counterpublic sphere, which facilitated the institutions' missions. Importantly, since the founders established these new museums in buildings that blacks owned, there was no longer the issue of white-controlled exhibition halls and their inflated fees or restrictions on time allotted for use. Liberated from these constraints, new public institutions developed exhibits and programming—a hybrid of 1940s radicalism and 1960s black cultural nationalism—that were calibrated to respond to the fast-changing civil rights era and to reach the broad constituency that lived and worked in the black neighborhoods where the museums were located.

Following Burroughs's lead a group of Detroit citizens would also soon launch their own museum. On the evening of March 10, 1965, Dr. Charles Wright, a black gynecologist practicing in the city, drove to the campus of Wayne State University (WSU) for a meeting with local residents. That evening the group founded a new institution: the International Afro-American Museum (IAM). This black history museum would be the third one founded after the Ebony Museum and Boston's American Negro History Museum, established in Beacon Hill in 1963.[15] Tired, but enthusiastic and motivated about this new project, Wright had returned earlier that day from a two-day sojourn to administer medical assistance at one of the most momentous and bloodiest protests of the civil rights era—the march across the Edmund Pettus Bridge in Selma, Alabama. With his activist experiences underpinning the strategies for creating the new museum, Wright, like Burroughs and her fellow Chicago artists, harbored a fervent desire to dispel the myths about the legacy of black peoples in America. This could be best accomplished by showing historical evidence that blacks had been vital contributors to the nation's prosperity and that the black struggle embodied fundamental democratic ideals of freedom. One means of documentation would be to detail the legacy of forced servitude during enslavement and the untenable costs of racial oppression within a segregated society.

Wright began the meeting by telling the group assembled of his experiences fighting against antiblack racism in Detroit's medical system and his recent trip to provide medical aid to the besieged marchers in Selma. These experiences had shaped his belief that now was the time for a museum "devoted to the past and present fight for freedom of the American Negro." Wright's opening comments passionately advocated for change. He wanted to change the Negro's "opinion of himself" to re-

dress how whites had misrepresented the Negro in history. Further, to underscore the immense potential and importance of his proposition, Wright told of a wonderful museum dedicated to the resistance against Nazism that he had visited in Copenhagen, and that contacts there and in other cities in the United States had expressed interest in supporting a new black museum. He conveyed that, even if Detroiters would be the originators of this unique monument to the local and national struggle against racial oppression, the museum should solicit worldwide participation. In the end, he championed the creation of an international museum of black history and culture—what he called an "Afro-American Freedom Museum."[16]

This chapter considers how several important urban and cultural developments in Detroit in the 1960s influenced Dr. Wright and the founders' plans for their new museum. How the institutional framework of a new museum—what I call grassroots black museums, because these were not created by museum experts—came into being offers a compelling case study. To understand the ideologies of black consciousness raising that underlay the creation of these new museums, it is important to consider what resulted from competing, although not mutually exclusive, strategies of civil rights activism and black cultural nationalism and the legacy of black radicalism of the 1940s. In what ways did "Negroes" in the 1960s reframe their "black" identity around themes steeped in their own cultural nationalism drawn from African rather than American identities? How did this Pan-African identity form out of sentiments of solidarity cohering around the postcolonial uprisings in Africa, the Caribbean, and America that led many to question white European and U.S. cultural domination? Significantly, how would the Detroit museum's presentation of this iteration of black cultural nationalism (one that had strong ties to the left radicalism of the 1940s and disagreements with the revolutionary black nationalism of the 1960s) serve as the impetus for popular ideals of self- and social improvement? In an important ideological shift, these beliefs were, however, no longer derived from the nineteenth-century discourse of progress that had been underwritten by Euro-American concepts of civilization. As Detroit's new museum would promote, possessing a "black consciousness" professed an awareness of all black peoples' contribution to the history of the United States and the world. But as this chapter considers, the constitution of a diasporic understanding among Detroiters, while universal in intent, had to nonetheless contend with fundamental cultural differences of class, gender, and race as lived in the gritty industrial metropolis. Furthermore, it is equally

important to explore the ways that the unorthodox museum, with its unique exhibition strategies and curatorial ethics that evolved from the Negro Buildings and Emancipation expositions, navigated the shifts in the city's sociocultural, political, economic, and urban landscape.

IAM DETROIT

Detroit was a critical incubator for this unique form of museum. With the continued exponential growth of black urban populations between 1940 and 1960, the institutions comprising the black counterpublic sphere gained momentum in pressuring local, state, and federal governments to desegregate public facilities and integrate public and private workforces. In the midst of this historic social upheaval, Detroit's industries and economy also underwent two important transformations that greatly influenced its urban structure. First, Detroit's sprawling industrial complexes and its population of workers, managers, and owners had benefited immensely from America's postwar boom in manufacturing—particularly automotive production. However, by the time of the Detroit museum's founding in the mid-1960s, the city's position as an industrial mecca and city manufacturers' centralized approach to production, as historian Thomas Sugrue has cogently analyzed, were already being scaled back incrementally. The effects of the intentional dismantling of Detroit's industrial base expedited the catastrophic departure of businesses, white residents, and the middle class to nearby outlying communities.[17] Second, after World War II, black Americans continued to leave the racially segregated South in large numbers to seek what they perceived to be coveted employment opportunities on the assembly lines of Detroit's car manufacturers. Once arrived, these newcomers made a new life in the city that, whether at work or at home, involved a constant struggle against the limitations posed by pervasive racial prejudice.[18] Over time, the unjust conditions of segregated workplaces, coupled with the lack of adequate housing and unrelenting police harassment, turned Detroit into a tinderbox of civil unrest—one that eventually exploded in several days of violence and destruction in July 1967.

Along with the expansion of its manufacturing base and population growth in the immediate postwar era, Detroit had also become a vital cultural center for black art, jazz, rhythm and blues, literature, and theater. Even though antiblack racism made the creation, circulation, experience, and control of black cultural production a challenge in the city, creativity flourished. As the Seventy-Five Years of Negro Progress Expo-

sition had shown, the increasing visibility of black culture—both popular and high—greatly facilitated public interest in black history. By the 1960s, the grooving sounds of Detroit's own Motown, whose dazzling performers and acts could be seen on the new medium of television, brought black popular music and its unique style to mainstream audiences. In the wake of these cultural renaissances, new cultural movements embracing black heritage also prospered. African forms and references had become a visible influence in dance, poetry, literature, theater, and fine art of the city's flourishing Black Arts movement. The new museum drew upon and contributed to this rich urban and cultural milieu.

Neither a museum expert nor a scholar like Du Bois or Woodson, Wright had nevertheless gained knowledge through personal and collective action against racial prejudice and injustice in both the North and South. To discuss the formation of Detroit's first black history museum, he gathered together an interracial group of educators, museum directors, and concerned citizens. The group of thirty-three convened at the School of Nursing's Richard Cohn Building on the campus of WSU, located directly behind the city's prestigious cultural center that housed the Detroit Institute of Arts (DIA), the main branch of the Detroit Public Library (DPL), and the Detroit Historical Museum (DHM). One person in attendance who shared Wright's passion for history was Dr. Audrey Smedley, a young professor teaching anthropology and history at WSU. In the early 1960s, Smedley had conducted fieldwork in northern Nigeria, and her activism was inspired by both her postcolonial African experiences and the recent momentous events of the civil rights era. Unlike the early NNMHF, which was organized solely by black Chicagoans, this new museum initiative (like the Ebony Museum) welcomed participation by interested white Detroiters. Joining the racially integrated group was Dean Katherine Faville, head of WSU's School of Nursing and an early supporter of Wright's new museum project. A "great white liberal," Faville befriended Wright through her involvement in efforts to desegregate Detroit's hospitals in the 1950s and 1960s.[19] To test the reception of mainstream institutions and their all-white administration and boards, Wright also invited three directors from those institutions: Dr. Henry Brown of the DHM, Willis Woods of the DIA, and James Babcock of the DPL's Burton Historical Collection. WSU faculty in anthropology, sociology, and medicine, along with local teachers, nurses, and several close friends of Wright, also attended this inaugural meeting.[20]

After his opening statement, Wright's intriguing proposal for an Afro-American Freedom Museum was opened to debate. Attendees, especially

FIGURE 44. International Afro-American Museum (IAM), inaugural meeting, Detroit, 1965. Seated third from left: Audrey Smedley. Seated on right: Dr. Charles H. Wright. Courtesy of Charles H. Wright Museum of African American History. PH106–01.

those associated with the city's mainstream museums, raised pertinent logistical questions about how the new institution would be developed, funded, and managed. For example, would it be affiliated with other institutions like a university that could also assist in funding the project? Dr. Brown of the DHM inquired whether the funding would be public or private. Woods, from the DIA, inquired about the source of the museum's exhibitions. Where would the artifacts for exhibitions come from? Some voiced concerns that as a national museum it would gather artifacts from all around the country, thereby stripping communities and towns of their irreplaceable local history. Furthermore, if it became an international museum, some argued, would not it be better located in New York City or Washington, D.C.? To which others countered that, in light of interest from Canadian black history groups, Detroit in fact would be more centrally located for an international museum, which might even include participation from groups in Latin America. Would the core exhibition speak more broadly about what "freedom" meant to all Americans or would it be specifically dedicated to Negro culture? Would the museum send exhibits to other museums around the country, or would the institution function as an archive? To the proposal of an archive, black Detroiters at the meeting responded that its contents and location were less important than what they loosely identified as the "psychological effect"—

how the institution's ideological message would be received by its visitors. The acquisition of old books and dusty artifacts was less urgent, they believed, than the critical need for exhibits that could instill in a black audience an understanding of history and culture that was inspiring and revolutionary. Because of the difficulty of displaying artifacts connected with the painful legacy of enslavement, and because of material culture and images associated with racial violence and stigmas, creating a collection was secondary to presenting images and narratives to cultivate the audience's sense of dignity and respect. The museum's primary mission would be to encourage and inspire by praising black accomplishments instead of following a conventional program of collection and research. The agenda to celebrate black achievement drew directly from the expositions, although by the mid-1960s the rhetoric of progress was absent from the conversation.[21]

Wright and his fellow organizers placed selecting a name for the new museum on the agenda of the first meeting. International in ambition, the museum's primary goals would be to serve as a monument to the struggle against racism and to promote racial pride not just in Detroit but also to worldwide audiences. To gain a sense of self-pride and historical agency, it was crucial, the organizers determined, for Negroes to overcome the detrimental effects of over 350 years of "brainwashing" by whites. Inspired by the philosophy espoused by Du Bois and popularized by Woodson, the museum founders insisted that the goal of the museum would be to eliminate the degrading ideas and images black Americans had been taught, especially the notion that they had not made important historical contributions to humankind. First and foremost, the cultivation of a new cultural spirit of self-awareness—a "black consciousness," which the founders hoped would call forth a new "black or afro" identity out of the Negro—would be a primary focus of the museum's self-presentation. Even though America's New Negro had been imagined and represented in different ways by Irvine Garland Penn, Booker T. Washington, T. J. Calloway, Du Bois, Mary Church Terrell, Meta Vaux Warrick Fuller, Alain Locke, Randolph, Horace Cayton, and others, the concept was, regardless of interpretation, a product of the modernizing forces of industrial capitalism that reconfigured the racial formations of the antebellum slave society. In a more negative vein, Jim Crow segregation had produced new discourses of social progress that disseminated representations of racialized imagery that at times skillfully reconstituted older stereotypes of the "mammie" and "Tom." Cultural critic Kobena Mercer has perceptively characterized this "subjective re-

construction of black consciousness and black identity" as "the process of 'coming to voice' that transformed objects of racist ideology to subjects empowered by their own sense of agency." Mercer then adds this critical observation of the 1960s: "This transformation was inscribed in the dialectical flux of slogans such as Black is Beautiful and Black Power, signs that were characterized by their radically polyvocal and multi-accentual quality."[22] "Blackness" was now to be understood and seen as desirable and beautiful rather than abject and invisible. It was lived instead of being objectified. But in other more detrimental ways in a late-capitalist society, this visual and vocal enunciation of blackness, experienced by the many men and women who donned African-inspired dress and hairstyles, was also subject to commodification and the dilution of its social impact by the voracious turnover of consumer tastes. Nonetheless, inspired by these new beliefs and cultural trends, the Detroit museum's founders chose to name the institution the International Afro-American Museum, its acronym proudly spelled IAM.[23]

At this first meeting, Wright also made it clear to the room of scholars and museum experts, some of whom were white, that he believed it was vital for the success of the institution that "the ordinary Negro" build the museum. IAM in this respect began as a local grassroots endeavor that united middle- and working-class blacks. Wright reminded everyone that, as a consequence of having everything given to them by whites, including the National Association for the Advancement of Colored People (NAACP), black citizens needed to be the initiators of their own institutions. The granting of civil rights alone, he warned, would not accomplish the important task of boosting racial pride. Wright thought the museum should not only collect artifacts but, more importantly, should inspire black citizens to action. He wanted Afro-Americans to make their own history. Empowered by their accomplishments, they would each proudly exclaim, echoing the civil rights activist King's call for self-respect, "I am."

After the initial meeting, Smedley drafted the museum's mission statement. She circulated the final document, which detailed the importance of the philosophical underpinnings of the museum's name, IAM, to potential supporters. She outlined the institution's goals: to present the African and New World roots of the Afro-American, to utilize scientific methods in gathering material and displays, and to be an inspirational social statement providing a celebratory presentation of Negroes in all of the Americas. Referencing postcolonial transformations in Africa, Smedley cast IAM as a symbol of the revolutionary human struggle for

freedom and equality around the world. Its mission was to "correct" the impact of three hundred years of brutal oppression. The museum would recognize the effects of the denial of black history, said the mission statement, noting that in "the face of relentless humiliation and degradation, it is little wonder that the image which the Negro has of himself is one of painful dehumanization." To combat this detrimental legacy, the statement concluded by affirming, "We protest the distortions of our history, and of our Self, and propose to change this image."[24] This last statement illustrates that one primary purpose of IAM would be to make black history an accessible and visible means of disarming the detrimental impact of prejudicial images that had permeated the nation's popular imagination by way of advertisement, film, and now television.[25]

At the next meeting, in mid-June 1965 again held at WSU's Cohn Building, Smedley introduced the revised mission statement. Only a few of the previous attendees returned. Most of the WSU faculty and museum experts Woods, Babcock, and Brown did not come back, although Brown and the DHM remained supporters and would provide invaluable assistance to the new museum. Once the meeting commenced, debate ensued about the various facets of the proposed mission statement. Smedley, in concurrence with Wright, was emphatic that the assistance of white supporters would be welcomed but that only black members of the institution should manage the museum. Otherwise, she warned, the museum would be another charitable gesture that would fail to improve blacks' self-image and consciousness. Even though it would strive for international stature, the fledgling museum would stress local community participation as vital to its success. It was collectively agreed that grassroots participation in organizing IAM was desirable in order to avoid the perceived failure of efforts like the federally sponsored poverty programs— mandates of President Lyndon Johnson's Great Society initiative—whose agencies administrated from the top downward. Adhering to this point of view, Wright distrusted the state because of its historical support of racist institutions and laws, especially in its failure to uphold the full rights of all Americans or in passing legislation that would eradicate terrorist acts like lynching. Wright, as we will examine in the second half of this chapter, would campaign vigorously against a federally sponsored national Negro museum. He aimed to ensure that any new black museum would emerge from a grassroots movement initiated by the "common people" who would make it a reflection of their own struggles and history.

These initial meetings revealed the diverse identities and histories of

IAM's founders. Born in Dothan, Alabama, Wright typified the origins of many middle-class blacks in Detroit who had grown up in rural and working-class families in the South—Alabama, Tennessee, Mississippi, and Kentucky. His father had been a brakeman on the railroad and his mother, a former domestic, had started a small grocery, guaranteeing Wright a black middle-class upbringing. Through his schoolteacher, a graduate of the Tuskegee Institute, he encountered ideals of Bookerite self-help and uplift.[26] Wright attended the Meharry Medical College. He followed the trajectory of Penn, Calloway, Wells, Barnett, and Woodson, all of whom had been educated in the network of southern black colleges and had migrated to northern urban centers to pursue solid black middle-class professions in medicine, law, education, publishing, and the church. While interning at the white-run Harlem Hospital, Wright helped campaign for the city council bid of Adam Clayton Powell Jr., who had pushed for greater integration of the hospital's staff and services.[27] A committed activist, in March 1965 Wright traveled to Selma to attend to wounded civil rights protesters who had been viciously attacked by club-wielding white police as they attempted to cross the Edmund Pettus Bridge. Later, he recalled of his encounter with the courageous activists that the "siege of Selma was temporarily relieved, but not lifted," indicating that after the protesters departed Selma the segregation remained.[28] On another trip Wright journeyed through the combat zone of Bogalusa, accompanied by the well armed black militant group Deacons for Defense and Justice, to offer medical aid to protesters whose injuries resulted from demonstrations against the Jim Crowism rampant in that Alabama town.[29] As an active member of the Detroit Medical Society (DMS), a branch of the National Medical Association, Wright and his colleagues battled the city, hospital administrators, and white doctors and nurses for two decades to desegregate Detroit's public and private hospitals.[30] He also helped organized medical workers to eradicate antiblack racism in medical education and patient treatment. For Wright, because it was deeply embedded within institutional structures, antiblack racism had proven stubborn to uproot.

Wright saw these local struggles within the larger context of the international fight for black self-rule. In 1964 Wright was invited to participate in a survey to fund improvements of hospitals in Liberia, Sierra Leone, and Nigeria under the auspices of the Public Health Division of U.S. Agency for International Development (USAID), a new foreign-assistance program for developing countries established under the Kennedy administration. While traveling with his fellow doctors through West Africa,

Wright observed the legacy of white colonial rule and the harsh conditions suffered by his African colleagues burdened by ill-equipped hospitals and clinics.[31] An amateur historian, he was also curious about local traditions that continued in concert with modernization. Wright visited several village museums to view displays of local art and culture. He carried a tape recorder that he used to capture villagers' folktales, personal narratives, and local histories. On his way back to the States, Wright and a few colleagues made a detour to Denmark to solicit the participation of Scandinavian doctors in USAID; then they went on to London and San Francisco. While in Copenhagen, Wright befriended Dr. Eigel Moerk, a former resistance fighter during the Nazi occupation in the 1940s. Moerk took the group on a tour of the new Freedom Museum that was dedicated to the four-year battle of the Danish Underground against their Nazi oppressors. Moved and inspired by the display, Wright asked himself, if Danes could build a museum after four years of occupation, what could blacks do to tell their story after 350 years of oppression?[32]

Twelve years younger than Wright, Audrey Smedley had an upbringing like that of Burroughs, reflecting the milieu of urban working- and middle-class blacks in the North who had been aided by the successes of early civil rights struggles that integrated labor unions, factories, public services, and educational institutions. Migrating from Alabama, her father had been a United Auto Workers (UAW) member and had worked on the assembly line of the Detroit Ford plant.[33] The early civil rights successes in northern cities opened a myriad of new opportunities for the black middle class, making it more common for their children to pursue careers outside of traditional fields, such as in fine arts or anthropology. Dissatisfied with the contentious racial climate that had defined her college experience at the University of Michigan, Smedley spent her third year studying in Paris, where she befriended Senegalese and Nigerian students who introduced her to ideas of Pan-Africanism and Négritude. In 1951, the cosmopolitan capital was made lively with American expatriates and blacks from French colonies in the Caribbean and Africa. Paris was, at least upon first encounter, starkly different than the racially divided industrial city where Smedley had grown up. Immersing herself in its cultural milieu, she attended several salons at the home of writer Richard Wright, who had been estranged from the United States since 1947. He considered political action far more relevant than the cultural approach of the proponents of Négritude, which he believed was less important to American Negroes given their loss of African cultural traditions during

the Middle Passage.[34] Unlike the older expatriate author, whose attitudes were shaped by his experiences in the Jim Crow South, the next generation of black cultural workers, especially young women like Smedley, had grown up in northern working- and middle-class communities where black culture—music, poetry, theater, and art—was becoming a vehicle for political agency. This whirlwind of experiences while studying in Paris and traveling around Europe and northern Africa, piqued Smedley's interest in the diverse histories of African nations. Upon returning to the States, she switched her major to anthropology with the intent on returning to some region of Africa for fieldwork. Troubled by the racist theories and practices that pervaded American anthropology, Smedley continued her graduate and doctoral studies at the University of Manchester in the United Kingdom. Before completing her degree in social anthropology, Smedley spent two years in northern Nigeria conducting field research.[35]

Once she returned to Detroit to teach at WSU, Smedley engaged in various activist causes. She joined, for example, Dr. King and two hundred thousand other demonstrators in the Walk to Freedom March organized in June 1963. The march commemorated the twentieth anniversary of Detroit's 1943 deadly racial unrest and protested the continuation of the same social injustices and underlying tensions that had led to the tragic event. King's speech drew upon the tradition of Emancipation orations by situating the current travails of the Negro as the legacy of a promise long deferred. He reminded the audience that one hundred years ago the Emancipation Proclamation had freed the Negro from enslavement but that one hundred years later the Negro was still not free. Drawing upon a narrative of progress, he spoke of how Negroes discovered a new sense of self-respect as they moved from plantations to rural life and then on to urban and industrial life where education and unionization improved their circumstances. "All of these forces conjoined to cause the Negro to take a new look at himself," King declared. "Negro masses all over began to re-evaluate themselves, and the Negro came to feel that he was somebody."[36] This desire for America's black citizens to feel as if they were "somebody" epitomized the mission that brought Smedley's interests, experiences, and activism together with those of Wright and the other founders in March 1965 to establish the new museum dedicated to the history of the struggles and achievements of black America.

From the personal trajectories of Wright and Smedley, we discover that two at-times coincident ideologies and social practices influenced their

work and activism: one of racial uplift, adhering to traditional ideals of respectability and racial pride; and the other of radicalism, actively seeking to break down barriers of racial discrimination and advocating for greater self-determination. Harold Cruse, an activist and Marxist intellectual, would note that this period merely echoed the longer political struggle of the American Negro since Emancipation, with tendencies that ebbed between "two difficult sets of facts." Cruse reminded readers that these facts were what Du Bois referred to as "integrationism (civil rights, racial equality, freedom) versus nationalism (separatism, accommodationist self-segregation, economic nationalism, group solidarity and self-help)."[37] But as the example of the museum founders demonstrates, Cruse's black-and-white ideological formulation for radical change often played itself out in shades of gray as black Americans deployed a range of tactics on the ground to dismantle Jim Crow racism's social, economic, and political structures.

The civil rights movement stirring middle-class suburbs and the Black Nationalist movement agitating the downtown ghettos of Detroit would profoundly affect the fledgling museum in its early years. The black bourgeoisie, for example, had grown substantially since the early part of the century, as had the class structure that included working-class and poor blacks and a small cadre of elites. The social pages of Detroit's *Michigan Chronicle* showcased the social activities of the city's successful black professional class. The weekly newspaper featured full-page photo spreads of the elaborate balls, convocations, and conventions hosted by the Detroit chapters of sororities and fraternities and an array of local social clubs and organizations. At the time, the sociologist E. Franklin Frazier criticized these associations, which he believed mirrored white society, as a black "society without status." Indeed, Frazier's *Black Bourgeoisie* charged that the black middle class lived in a world of make-believe, even lambasting one of Wright's fellow Detroit physicians for a frivolous installation of a Hammond organ on his sizeable yacht.[38] But Wright, while he belonged to social and professional organizations, never desired to climb the black elite's social hierarchy. Instead, he utilized this network as a means of raising monies for various social causes like IAM and the African Medical Education Fund that awarded academic scholarships to educate young African doctors in the United States. Wright sharply criticized the ambitions of some of his peers. These successful professionals believed they had escaped the realm of what Wright described in an unpublished essay as "the pit"—a metaphor, following popular social science rhetoric, for the abyss of Detroit's ghettos and segregated neigh-

borhoods.[39] Many middle- and upper-class blacks had moved away from the Black Bottom and Westside neighborhoods to the city's suburban fringe. In Wright's view, their urban flight offered the black bourgeoisie the illusion that they had escaped racism. But in reality their new subdivisions of ranch homes and split-levels were just as stridently segregated from white residents. They were still mired in the dispiriting world of "the pit." More importantly for Wright, these bourgeois blacks were also derelict in their responsibility to use their resources to aid poorer blacks and challenge the deeply ingrained political, social, and economic forces behind racial oppression. Believing that they were equal to their white peers, this group of elites sought integration and assimilation into white standards at the expense of their own black heritage. They belonged to organizations like the Detroit Urban League (DUL) and to local chapters of the NAACP and benefited from those who worked within the white power structure rather than undertake the necessary antagonistic actions necessary to transform it. Wright had experienced their apathy firsthand. In its early phases of garnering support, IAM had contacted the local branches and national headquarters of organizations like the NAACP and DUL but had failed to gain any interest. IAM did, however, receive encouraging responses from various Black Nationalist groups, such as the publisher of the Nation of Islam's *Muhammad Speaks*.[40]

In the second year of IAM, 1966, the nation's airwaves reverberated with the rallying cry of "Black Power." Counter to the nonviolent tactics of civil rights advocates like King, this new iteration of black nationalism would radicalize many poor and working-class blacks in Detroit and around the United States to directly and forcefully challenge racist institutions and those who governed them. Shortly after the passage of the Civil Rights Act in July 1964 and the Voting Rights Act in August 1965, civil rights actions began to seem to some in the movement as an inadequate means to realize effective political change and social equality, especially in northern cities where nonviolent tactics proved ineffective at dislodging entrenched and structural antiblack racism. In June 1966, black Americans heard the cry for Black Power from Stokely Carmichael, head of the Student Nonviolent Coordinating Committee (SNCC), a key civil rights group that had staged acts of civil disobedience around the South.[41] Assessing the entrenched conditions of social and economic inequalities produced by centuries of white racism, Carmichael proposed Black Power as an ideological framework for action. It could serve as a potent impetus for how black Americans might begin to politically organize to seize control—if not of the government, then of their own com-

munities. Detroit's local chapters of SNCC and the Congress for Racial Equality (CORE) remained vocal against racial injustice in the industrial city. Several nationalist groups—including the Freedom Now Party, UHURU, that was started by WSU students, and the Revolutionary Action Movement (RAM)—formed in the wake of civil rights victories to rally for black economic autonomy and political power in their own communities.[42] RAM, in particular, addressed concerns facing the Detroit's black autoworkers, a group that regularly encountered unfair segregation and dangerous working conditions on the shop floors of auto plants. They also deeply resented the lack of black representation in key management positions in both the union and the auto companies. Eventually, some members of these groups would splinter off to form the League of Revolutionary Black Workers, a radical nationalist group that bypassed the traditional protocols of the union to directly recruit black workers for its cause. Unlike the earlier radicalism of the Communist Party of the United States of America (CPUSA) and the Popular Front, revolutionary nationalism posited black solidarity—"a re-Africanization of Americans"—not class position as the most effective means to overthrow domestic and global imperialism.[43] The goal was to reorganize capitalist production and forge a radical economic agenda toward the needs of black workers and away from the wealth of white owners, the ineffective unions, or integrationist black leaders, thus putting Carmichael's Black Power into action.[44]

Adopting a slightly different strategy, black cultural nationalists of the 1960s, such as those in the Black Arts movement, like their predecessors celebrated African heritage as a means of casting off Euro-American influences and cultivating distinctive black cultural practices akin to what Du Bois and Locke had posited. Far more radical than earlier black cultural nationalists in calling for structural change, these adherents professed that fostering cultural enlightenment and racial solidarity served as important precursors to the guns and grenade phase of revolutionary action.[45] In radical publications like *Anthology of Our Black Selves* and eventually in mainstream magazines like *Negro Digest* (later renamed *Black World*) and *Ebony* (both owned by the Chicago-based Johnson Publishing), blacks around the country were introduced to this new form of racial consciousness. Even though it retained the patriarchal social organization of older groups—manhood rights still served as a flashpoint—the Black Power movement no longer invested in the rhetoric of racial progress and social advancement that had been founded on bourgeois notions of propriety and adaptation of white norms. In 1965, the same

year that Wright and others founded IAM, Detroiters empowered by these fresh black nationalist attitudes of self-determination and cultural solidarity established other important cultural institutions, such as Vaughn's Bookstore on the city's black Westside that specialized in black literature and history. Detroiter Dudley Randall set up Broadside Press to publish works by black authors and poets. Both the bookstore and the press became catalysts for the Black Arts movement in Detroit. These forums drew upon the radical legacy that emerged from the Left institutions of the 1940s and mobilized activism around a flourishing literary and arts milieu influenced by black nationalist ideals. And, stating that American slavery had destroyed ties between black Americans and Africa, black students at WSU petitioned the university to offer a course in Afro-American and African history. Proud to share her research on race, culture, and the African diaspora, Audrey Smedley taught one of WSU's early courses on black history.[46]

Awakened by the sights, poetic riffs, and sounds of the burgeoning Black Arts movement, many race-conscious blacks adopted styles, especially among the youth, that reflected a newly discovered connection to their African heritage. This new state of mind exclaimed that black—no longer miscegenated bronze or tan—was indeed beautiful. For example, Burroughs, whose institution's name—the Ebony Museum—also reflected this burgeoning black pride, had adopted an African-inspired sartorial preference in the 1950s. Incorporating black popular cultural sensibilities, magazines and boutiques in the 1960s made Afro-style in hair and dress visible to a wide audience. The style's instant popularity showed that blacks desired to cast off white standards of beauty and fashion.[47] Bold in their expression of racial pride, "brothers" and "sisters" donned the "natural look" in hairstyles, abandoning caustic chemical treatments that had tamed "naps" and straightened hair for decades.[48] A December 1967 cover of *Ebony* magazine featured, for instance, headshots of black actors and athletes above the caption "Natural Hair—New Symbol of Race Pride."[49] And yet, Afrocentric style became quickly commodified within the culture industry.[50] Its instant popularity muted its political message and impact. "Once commercialized in the marketplace," as Mercer observes of the period, "the Afro lost its specific signification as a black cultural-political statement. Cut off from its original political context, it became just another fashion: with an Afro wig anyone could wear the style."[51]

IAM's mission statement captured very succinctly the "revolutionary movement for freedom" that not only reflected the passage of the Civil

Rights Act but also echoed the stance of emerging black nationalist groups and the emerging culture of black pride. The message of Black Power resonated with many blacks regardless of class, context, or region—although groups had varying stakes in its political efficacy. Magazines such as *Ebony* published several issues dedicated to the Black Power debate, including the poignant excerpt from an Omaha barber venting pent-up anger to the Kerner Commission, convened to review the recent spate of "race riots." He explained, "We would have to fight the police, because they, with Congress are the greatest perpetrators of crime in this country." He then questioned if "We Shall Overcome" was an effective way to fight the police.[52] In his 1967 book *The Crisis of the Negro Intellectual*, Cruse scathingly criticized middle-class blacks who professed to know what was best for poor blacks because of the nationalist rhetoric of their cultural activities. Cruse chastised many Black Power proponents for failing to recognize that cultural freedom could not be achieved because it was still greatly hindered by economic and class barriers.[53] For Cruse, the control of black culture, politics, and economics were all necessary and vital to a successful nationalist project. The constellation of relationships through which IAM had formed, however, challenged Cruse's critique. Even though Wright, Smedley, and the museum founders were ensconced within Detroit's black middle class by way of their professional rank, financial status, and activism, they were nevertheless keenly aware of the damage that antiblack racism had wrought on the psyche and material conditions of all black Americans through their own working-class histories. IAM's founders wanted to exercise their right to form an institution by themselves—for and about black history and culture. In that regard they embraced self-determination. But the founders cannot be labeled revolutionary nationalists in the sense that they did not completely shun white involvement; nor did they wish to radically transform the social order through complete autonomy as a separate black nation. But neither can they be classified as true integrationists who yearned to mirror white cultural norms. As an alternative strategy, IAM's founders forged structural changes through their encounters with mainstream institutions. They utilized the museum as a means to change the cultural foundations upon which black Americans based their collective identity. In doing so they were indebted to the collaborative spirit of the exposition organizers of years past, who had crafted diverse and contested discourses of racial progress circulating within the black counterpublic sphere. IAM builders wanted to represent, more or less free from white interpretation, their own conception of the past, present, and fu-

ture state of black America.[54] Distinct from the exposition organizers, however, IAM's founders refused to accept the temporary spaces of the fairgrounds and assembly hall—domains, in the end, controlled by white authorities—as the primary sphere in which to proclaim their cultural identity. Instead, they sought a permanent place in the city, a public museum where they could collect and represent their own history of struggle and achievement on their own terms. IAM's mission embodied, therefore, a tempered version of the black cultural nationalism of the period. The museum's curatorial mission was to create an inspiring array of exhibitions, artworks, and performances about African and Afro-American cultural identity and to show the compelling history of black's quest for freedom. In tandem with raising black consciousness, the new museum's organizers endeavored to alter the economic and political conditions of Detroit's black residents through community activities and cultural programs.

WESTSIDE STORY

Detroit's politics of urban space and culture was the dynamic backdrop for the formation of the new museum. To resolve the issue of where to begin IAM, Dr. Wright offered space in the basement of his former home and office at 1549 W. Grand Boulevard, a few miles west of the WSU campus. Like Burroughs's Ebony Museum in Chicago, which had opened the doors of its converted mansion five years earlier, IAM also started in a small brick house—a more modest residence than the Chicago museum—situated in the heart of the Detroit's black Westside. Through the hard work of a core of dedicated founders, IAM set up its offices in January 1966. Tenants lived on the building's first and second floors, while the basement provided ample room for three small offices from which IAM members could begin the task of implementing the museum's ambitious agenda.

Like much of the city, the Westside was built of one- and two-story brick houses sited close to adjacent homes, as Wright's was, to maximize coverage of the lot. Punctuated by the soaring pinnacles of downtown office buildings, church steeples, and smokestacks; interrupted by the acreage of industrial complexes; and bisected by the stripes of old boulevards and the sinuous threads of new freeways, an aerial view of Detroit at this time revealed a vast carpet of little brick boxes spreading from the fringe of the river across the city. The population of the Westside had changed over time from its beginnings as a predominantly immigrant

FIGURE 45. IAM, 1549 W. Grand Boulevard, Detroit, n.d. Courtesy of Charles H. Wright Museum of African American History. PH104–07.

community of autoworkers to become an increasingly black settlement by the 1950s, as white residents moved to suburbs outside of Detroit. Much has been written about the racial and urban politics of postwar Detroit, and I will not recount that rich and lengthy history here.[55] However, it is important to mention that as black residents poured into the city, drawn by the war economy of the 1940s, access to housing became a festering crisis that seized the physical and social infrastructure of the Motor City. Detroit at the time was the fourth-largest city in the United States, and its neighborhoods of bungalows and low-rise apartment buildings were far more spread out than in most major cities. As a result of this dispersal, Detroit maintained half the population density of New York City and two-thirds that of Chicago.[56] Jammed with Packards, Fords, Dodges, and Chryslers, Detroit's roadways—the long, wide spokes of Woodward, Grand River, Gratiot, and Michigan Avenues—functioned as the primary conduits for white suburbanites traveling from the outer hamlets of Dearborn, Ferndale, and Grosse Pointe into the city's downtown. Detroit's white population grew between 1940 and 1950. Even with the increase in number of white residents, however, their percentage of the city's total population was getting smaller as its black population over the same period doubled.[57]

The need for single-family housing led to a chess-board-like expansion of black neighborhoods, with black homeowners leaping over white enclaves into areas previously off-limits but now opened to them by "block-busting" realtors.[58] To stop this detrimental and underhanded practice, the city's elected governance board, the Common Council, passed a Fair Neighborhood Practices Ordinance making it unlawful to refer to race in the advertisement of property. By 1966, the failure to halt discriminatory practices led to a public hearing. Keen on engaging the mainstream political sphere, IAM publicly supported both the addition of an amendment that would make it a misdemeanor to refuse to show or sell a property to someone because of race or nationality and an open housing policy that would prevent, in most cases, discrimination in rental properties. But the open housing policy did not square with the metro area's white residents. The new open housing ordinance resulted in a racist backlash by white homeowner associations. Leaflets threatening, "To the colored people—you stay put in your homes—no one will hurt you," mysteriously found their way into black neighborhoods.[59]

By the 1960s, slums like Detroit's Paradise Valley (formerly Black Bottom) had received a new designation, "ghetto," to signify their condition of spatial and social isolation. Countless exposés, books, documentaries, and sociological studies probed and dissected the problems of ghetto areas—crime, illegitimacy, social welfare, juvenile delinquency, and drug use.[60] To excise the squalor in these areas, the City Plan Commission prepared one of the first master plans in the country, the Detroit Plan, to clear slums and build freeways. A lucrative partnership between the city and development companies championed the cause of "urban renewal." The city slated for demolition ghetto areas to west of downtown, such as Corktown, and poor neighborhoods to east, such as Paradise Valley. Detroit was still ranked as the fifth-largest city in the United States, notwithstanding a loss of two hundred thousand residents by 1960, and the city administration proceeded optimistically with new modernist additions to the cultural district's DIA and DPL buildings. Even with the newly built gleaming office towers and spacious public plazas graced with abstract modern sculptures, businesses still left downtown, preferring to set up headquarters in municipalities that lured them with the prospect of lower taxes and access to a white workforce that had already migrated out to suburbs. To connect white suburbanites to the remodeled downtown, civic, and cultural districts, urban renewal projects constructed major expressways close to downtown that eviscerated poor black neighborhoods. The newly erected concrete spaghetti of the north-south Chrysler Freeway and

the east-west Edsel Ford Freeway formed a mammoth interchange at the heart of what was formerly Paradise Valley. In the 1950s, the black areas of the Westside bore the negative externalities of new canyons where the north-south Jeffries Freeway bisected the western spur for the Ford Freeway, one block north of Wright's home on W. Grand Boulevard.[61]

Detroit's ambitious plan to eradicate urban blight achieved national visibility. The city was tapped as a potential recipient of Model Cities monies from the so-named federally funded urban renewal program that was a key component of Johnson's War on Poverty.[62] Along with commendations for Detroit's physical improvements, the national news also praised the city for how well, as a major city, it had handled its racial tensions by electing black officials to all levels of municipal, state, and federal political office. Detroit was further lauded for the success of its black middle and working classes, whose level of economic achievement—particularly in homeownership—was far ahead of the national average. But on the ground in black neighborhoods, Detroit's acclaimed urban development projects exacerbated the housing crisis and heightened racial tensions, as not all of the units that had been ceremoniously bulldozed in the name of urban regeneration had been replaced. One estimate is that by 1962 urban renewal had affected at least a third of the city's black population.[63] One major outcome from the construction of new freeways was that the squalor and overcrowding of displaced Paradise Valley migrated with its population to the neighborhoods of the Westside. As these urban renewal policies cleared slums, racial tensions did not, however, subside. Instead, the resulting displacements only antagonized long-standing tensions between the racialized patches that made up Detroit's urban fabric. Detrimental urban planning and housing politics legislated by a succession of mayors prompted residents to organize and self-determine the fate of their own neighborhoods—a strategy of organizing that had proven key for the unionization and integration of the auto industry.[64] Local branches of national groups such as the moderate DUL and NAACP, along with nationalist groups like SNCC, CORE, local associations, and community-liaison commissions, launched a flurry of protests, conventions, and marches to pressure Detroit's government to relieve explosive racial tensions and ameliorate unjust social conditions in the city.[65]

Fearful of the spread of the dissent unleashed by the Los Angeles Watts rebellion in July 1965, Detroit's local government, state and federal agencies, and black leaders desperately sought to defuse the city's racial tensions. Even before Watts exploded, one *Michigan Chronicle* article de-

scribed the local climate as tense: "Here in Detroit the spasmodic outbreaks involving 'splinter groups' who have expressed impatience with accepted civil rights organizations are expected to increase."[66] Over the course of the summers of 1965 and 1966, the city's busy streets and neighborhoods teetered on edge of unrest, as the possibility of racially motivated violence posed a constant threat. Some local leaders believed, a perception buoyed by the years they had dedicated to easing racial tensions through community-liaison committees, that Detroit's model of race relations would undoubtedly be the exception to this trend of urban discord. The DUL's black leadership made a sanguine pronouncement that revealed their confidence: "We are witnessing the best climate in Detroit in many years, and Detroit has the best core of community leaders devoting their time, effort and counsel to community problems."[67] After the passage of the Civil Rights Act, black Detroiters had become, in the subsequent three years, more aggressive in calling for the integration of workplaces, public areas, and neighborhoods. In reaction to this new sense of entitlement, many working-class whites recoiled at the prospect of integration, sometimes resorting to violence. As a consequence, Detroit witnessed several skirmishes between black and white groups as each made incursions into the preserve of the other throughout the 1960s.[68]

Amid this volatile climate, Black Nationalist groups assailed the city government for not responding more forcefully to the needs of those disenfranchised by urban renewal and to the scores of racially motivated incidents at the hands of angry white citizens and a bullying police force. Inciting animosity with his call for racial justice against aggressive police action, the charismatic Rev. Albert Cleage Jr. was among the local black militants who attacked the NAACP, DUL, and other organizations that he believed failed to act in the interests of *all* blacks, instead catering to their middle-class cronies. Stokely Carmichael paid a visit to Detroit on several occasions, as did other black militants such as H. Rap Brown, to preach a message of Black Power to those who had become impatient with Mayor Jerome Cavanagh and his integrationist cadre's gradual plan to halt racism, housing segregation, and police brutality. It would be the latter—a police invasion of an illegal club akin to a speakeasy, a "blind pig"—that would spark a three-day uprising. By its conclusion, the violence had left forty-three dead (thirty-three blacks, with thirty killed by law enforcement), over 7,000 arrests, 1,100 injured, and an estimated $12 million in property damage.[69] It would take President Johnson's dispatching the National Guard to quell the arson, sniping, and looting.

The impact of race on Detroit's urban transformations has been well documented in a plethora of publications in the fields of sociology, urban studies, and history. Many of these studies, however overlook the cultural vitality of Detroit's black community in the postwar years and how cultural production contributed to its residents' political and social activism, as the early years of IAM illustrate. In spite of the harsh living conditions of Paradise Valley, St. Antoine Street, the area's cultural corridor, offered top entertainment venues, hotels, and dining.[70] Beginning in 1936, the *Michigan Chronicle* (an offshoot of John Sengstacke's *Chicago Defender*) opened its newspaper offices on St. Antoine. It and the older *Detroit Tribune* reported on many of the social and political happenings in Paradise Valley and the Westside. In their heyday in the 1940s and 1950s, these areas were a favorite stomping ground for national figures such as Joe Louis and Bill "Bojangles" Robinson, both headliners at Detroit's 1940 Emancipation exposition. Visitors to Detroit, like those attending the fair, stayed in the areas' hotels and dined in their many restaurants, cafés, and lunch counters. In between the rows of residences lining St. Antoine, there were black-owned business, association halls, churches, nightclubs, restaurants, poolrooms, and blind pigs. The ornate neoclassical Paradise Theater on Woodward—the city's first symphony hall—was sold to a black owner and converted in 1941 into a top entertainment and movie house. Along with several ballrooms, blues clubs, and music halls, the theater hosted the hottest stars of the jazz circuit, including Cab Calloway and his band, Billie Holiday, Count Basie, John Lee Hooker, Jimmie Lunceford's band, and Duke Ellington's orchestra. Around the corner from the Paradise Theater, the elegant nine-story, black-owned Gotham Hotel opened in 1942. Because racist practices barred them from the city's white-run hotels, black visitors stayed at the Gotham, which built a reputation as the finest black-owned hotel in the country. When patrons dined at the Gotham's swank Ebony Room restaurant, locals could mix with nationally known politicians, novelists, entertainers, and sports figures.[71] Detroit's many black social groups staged their extravagant cotillions, dances, and banquets at these clubs and ballrooms, making St. Antoine traffic on Friday and Saturday nights a continuous stream of gleaming Cadillacs and Packards. Undeterred by local protest, the grand schemes of the Detroit Plan began razing this lively cultural center in the 1950s.

Wiped out by redevelopment, many of Paradise Valley's clubs and businesses closed. A few of them migrated over to the Westside's Twelfth Street, which became the new but far less spectacular black cultural cor-

ridor. In the late 1950s, the Motown sound emerged out of the middle- and working-class Westside. Many of the label's earliest performers and musicians, including its ingenious founder Berry Gordy Jr., had been employed in the auto industry. Yet the Motown sound and glamorous style rose above its working-class roots to present middle-class personas that comfortably meshed with mainstream tastes. Gordy set up his recording studio, called Hitsville U.S.A., in his home on W. Grand Boulevard, several blocks east of Wright's former residence. The success of the Motown phenomenon and other cultural institutions during the civil rights era illustrated the ways that culture became a means for many black residents to assert their needs in Detroit's political arena.[72] Additionally, Detroit hosted the Black Arts conventions in 1966 and 1967, sponsored by Broadside Press, the local publisher that supported the work of Black Arts movement poets, playwrights, and novelists and was located in its founder Randall's home on the Westside. The publisher provided a home for the work of Detroit writers Woodie King and Ron Milner, along with writers Margaret Danner, Gwendolyn Brooks, Haki R. Madhubuti, Nikki Giovanni, and Audre Lorde. In 1967, Randall, in collaboration with the Burroughs, edited a collection titled *For Malcolm: Poems on the Life and Death of Malcolm X*. The Black Arts conventions gathered together activists, artists, and militants from among older Left radicals and newer black nationalists. Carmichael, H. Rap Brown, and Betty H. Shabazz were invited as keynote speakers. Aware of the deep-seated resentment and open hostility displayed by many whites in the area, the conventions called for black solidarity under the themes of "unity, self-help, and liberation."[73] But as mainstream venues of publishing, film, music, and television opened to include black artists, older venues such as the nation's hundreds of black newspapers—major boosters of the expositions and its race leaders—ceased production.[74]

The range of cultural activities and organizations in Detroit during this period, from the 1950s to the mid-1960s, included associations whose membership promoted public interest in black history. As evidenced by their members' involvement in the Seventy-Five Years of Negro Progress Exposition, the Detroit branch of the ASNLH had a large and active membership in the 1940s; but like the national organization the branch's activities decreased by the mid-1950s. Later in that decade, under the leadership of Arthur Coar, members revived the Detroit chapter.[75] The association sponsored many public lectures, including one-day courses called "The History and Heritage of the Negro" taught at local high schools.[76] The local chapter hosted the three-day national convention of

ASNLH in 1962. One of the papers presented at the national convocation was "Colonial Regime Attitudes toward American Negroes in Africa" by Dr. Charles Wright, whose subject matter he culled from his recent travels in Africa for USAID. Driven by his passion for black history, Wright served as a member of the local chapter's executive committee.

Seeking acceptance in mainstream institutions, Coar, as head of Detroit's chapter of the ASNLH, cultivated relationships with various local museums.[77] As Detroit's black population grew in number and influence, the DIA on occasion presented exhibitions featuring work by black artists, including an exhibition of the work of artist Jacob Lawrence during Negro History Week in February 1950. In general, however, curators typically excluded black artists from the DIA's major exhibitions.[78] In the early 1960s, Coar successfully persuaded the DIA to move forward with a plan to erect a wing dedicated to African art. Funded in part by wealthy automotive scion Edsel Ford and his wife, Eleanor, the museum's $4 million expansion had been slated for development in the City Plan Commission's master plan. The ASNLH spearheaded a fund-raising drive to raise $50,000 for the new collection and wing. The African Art Gallery Committee, some of whom Wright would call on to assist IAM, included Mayor Cavanagh; Dr. Charles Wesley, national president of the ASNLH; John C. Dancy Jr., former executive director of the DUL and organizer of Detroit's 1940 Emancipation exposition; artist Jacob Lawrence; Brown of the DHM; Babcock of the DPL; U.S. Representative Charles Diggs Jr., the son of State Senator Diggs who had helped fund and organize the 1940 Emancipation exposition; along with judges, corporate heads, and diplomats. In many ways this association, as the mainstream expositions had done, afforded an avenue for Detroit's black power base to connect with the city's white elites.[79]

In June 1966, the DIA opened its modern steel-and-glass addition. The museum planned a lavish opening gala for its new galleries, inviting wealthy patrons from Bloomfield Hills and Grosse Pointe while barring the ASNLH from participating in the opening ceremonies. Ignoring the ASNLH's fundraising success, the museum did not invite Coar to speak at the event, nor did any museum representative mention or thank the association for its efforts and contributions. Wright was incensed by the racist snub. The day following the opening of the new wing, Wright and a small group of artists and activists led a rowdy picket line in front of the museum's austere entrance on Woodward Avenue. The group paraded with large placards asking, "Why Mix Politics with African Art?" Wright had launched the protest against the DIA without Coar's knowledge and

much to the latter's ire. As part of his efforts to obtain artifacts for the DIA, Coar had brokered the acquisition of former governor G. Mennen Williams's African art collection, which Williams had assembled while he was undersecretary of state for African affairs. But on opening night, the collection was nowhere to be seen. Wright alleged that the failure to display Williams's donation was a political ploy by the museum to appease the powerful Republican Mayor Cavanagh, who was engaged in a fierce battle for a U.S. Senate seat with Williams, a Democrat. The small band of vocal protestors on his museum's doorstep caught DIA director Woods unawares. Compounding the DIA's embarrassment, a major board meeting took place on the day of the protest. Scheduled to be in attendance were several wealthy and powerful white art patrons and members of key historical and art commissions around the city and state. Wright fearlessly made his demands known: black Detroiters would no longer tolerate exclusion but instead would establish their own institutions. The act of insubordination infuriated Coar. Wright never returned to another meeting of Detroit's ASNLH.[80]

This incident proved that mainstream cultural institutions—an arena of power for the city's political and economic elites—were rife with antiblack racism that prevented black participation in exhibits and stewardship. Wright was determined for black Detroiters to build their own institutions so that they could control their content. The DIA's offensive actions made his mission to establish a public museum of black history and culture more urgent in the fight against local and global racial oppression.

THE MOBILE MUSEUM

IAM's mission statement outlined the museum's primary goals: first, to cultivate in black Americans a sense of pride in their contributions to the nation and world; second, to achieve this level of self-recognition by refuting the distortions and lies perpetuated in the annals of American history; third, to collect and preserve materials and artifacts of the social, political, and cultural life of black Americans.[81] The core of the mission still strove to cultivate a sense of dignity and understanding in its audience through the presentation of accomplishment. But no longer would displays be created and shown as an indication of racial progress. One hundred years after Emancipation, the new museum no longer sought to represent, as prior expositions had done, what blacks "could do" in America. Blacks were in fact fully absorbed into the wage labor market, albeit

primarily in the lowest ranks. Finally, the argument that blacks ought to be American, in the full sense of rights and representation, had been legislated by the Civil Rights Act in 1964 and the Voting Rights Act in 1965. Thus black politicians were beginning to be elected to office at all levels. The need to make the case in displays of social equality and through racialized notions of progress was therefore becoming less obligatory, although the white supremacy that limited economic and political advancement had not disappeared. Racial pride as an American nationalist discourse had transformed into Black Power, with an array of models for self-determination. The aesthetics of black pride—as manifested in dress, hairstyles, and rhetoric that advanced Pan-African solidarity—had supplanted American cultural norms. As a museum dedicated to preserving the past, IAM's mission would be to show to the world what blacks "had done" and to correct the history that marginalized their immense contributions—their "gifts," as Du Bois and Randolph had described, to the world.

With IAM's ambitions directed toward cultivating an international audience, the initial efforts to plan the museum's financing and public programming took root at the local level. The founders composed a roster of officers, made up of local supporters (some of whom had attended the first meeting and half of whom were women), to steward the new museum. Wright assumed the post of president. Other officers included Cornelius Pitts and Patmon Young, two young attorneys, and Oretta Todd, an ob-gyn nurse and a teacher at WSU who had joined with Wright and others to desegregate Detroit's hospitals.

The first order of business was to implement the mission of IAM. Organizers divided into committees to address fund-raising, exhibitions, oral history, research, and art. The group immediately initiated a national membership drive that offered yearly memberships for two dollars, with a fifty-cent discount for student members. For its first fund-raiser, held a month after the organizers first met, IAM sponsored performances of *Were You There?*, a popular play written by Charles Wright that translated the Easter story to a contemporary setting. Next, the group solicited guidance and advice in initiating an oral history project.[82] To build the collection, members distributed flyers around Detroit asking residents to help start the museum by taking "a good look" in their attics or basements for maps, letters, and pictures that would "unravel the mysteries of the American Negro." Possible donors received instructions to call or write to IAM. Then, a member of the research committee would come

to their homes to examine the articles. After reading about the unique new museum in the *Detroit Free Press,* Mildred Barnes from Kalamazoo, Michigan, generously donated a family heirloom, an 1896 edition of *A School History of the Negro Race in America, from 1619 to 1890.* Trained by members Blanche Foster and Andrew Travers, the museum's oral history committee acquired many valuable artifacts during their visits and interviews with elderly citizens. By the end of the first year, the committee had collected several tapes for the museum's new oral history library, and IAM's first public exhibit showcased its oral history project at the National Conference of Educators Racism in Education meeting held in the fall of 1966 at the University of Detroit.[83]

IAM also launched several outreach projects to both inform and educate Detroit-area residents. An important mechanism of the black counterpublic sphere for the organizers of past expositions, the black press would prove an invaluable platform for the museum's organizers. The *Michigan Chronicle* published several informative articles highlighting the museum's early activities, and Wright often wrote editorials for the newspaper on various efforts to desegregate public facilities and on his civil rights activities. Gaining national publicity, IAM was profiled in a 1966 issue of *Negro Digest* in the magazine's "On the Civil Rights Front" section, just above a report on Carmichael's rise to the leadership of SNCC. Another vehicle for circulating IAM's message of historical consciousness was the member newsletter. The front page of the large-format broadsheet detailed IAM's mission, solicited memberships, and published short essays by laypeople and experts on new topics in black history. For example, Smedley contributed an article titled "Meaning of Racial Differences" to the first issue. She drew upon her expertise as an anthropologist, emphasizing how social differences—created by human intervention rather than naturalized racial differences—influenced current economic and social disparities. In another article, a museum volunteer and local teacher, Obie Newman, wrote about the value of historical consciousness, citing the work of Melville Herskovitz and studies by Dr. Kenneth Clark on the psychological consequences of blacks being denied their history. Rev. Robert C. Chapman, a white Episcopalian minister who served as chaplain for the museum's organizers, gave examples of how histories of religion in the United States had mocked, subordinated, and excluded the contributions of the black church. Printed on the newsletter's back page, a bibliography of over fifty books also offered select readings for youth. The museum recommended to its audi-

ence Herskovitz's *The Myth of the Negro Past,* Du Bois's *The World in Africa* and *Black Reconstruction in America,* Basil Davidson's *The African Past,* and Arna Bontemps's *100 Years of Negro Freedom.* The museum inaugurated a weekly radio program on WJLB that began as a twenty-minute show and expanded to a half hour broadcast at 7:30 P.M. on Saturdays. Hosted by Obie Newman, the program featured discussions on black history topics. As another component of its public educational mission, IAM offered a class, "The History of African People" taught by Dr. Kenneth C. Wylie from the History Department at Michigan State University beginning in January 1967. The black-owned Great Lakes Mutual Life Insurance Company generously agreed to host the class in the lobby of its office building. Taught over several weeks, Wylie's syllabus followed the same historical framework as the museum's proposed first exhibition (discussed in the next section), beginning with the geographical and cultural background of the African continent and following developments up to the emergence of Pan-Africanism and the founding of Africa's modern nation-states.[84] Through these activities, IAM built relations with institutions of the city's black counterpublic sphere and launched an ambitious multipronged effort to educate Detroiters on local and world black history.

Wright's former residence on W. Grand Boulevard sufficed for museum offices, solving one problem of the fledgling institution. But the museum needed more space for exhibitions. International in ambition, the founders wanted to reach a larger audience beyond the Westside and Detroit. Similar to Du Bois's concept for a traveling Emancipation semicentennial exposition, Wright devised a clever plan to utilize trailers to show IAM's exhibits. While the museum's long-term goal was to renovate an existing space and eventually build a new museum building, a mobile exhibition space would be a useful short-term solution. Several rationales validated the adoption of such an unusual mode of display. In light of the fact that black people now lived in all regions of the United States, the museum's strategy to send a fleet of these trailers to cities, small towns, and rural areas paralleled the peripatetic history of black Americans. Since the Mobile Museum would be built from trailers, interior compartments could provide a sleeping area for a researcher and an audio and photographic studio for recording interviews. IAM representatives on these tours would gather oral histories and artifacts from black elders. Wright envisioned IAM's fleet of trailers journeying throughout the United States, Canada, and South America, bringing the museum's message directly to all peoples of African descent.[85] Expanding on the visual displays, symbolic ar-

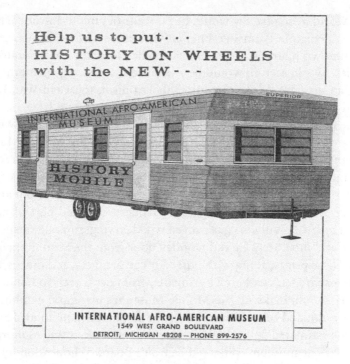

FIGURE 46. Proposed IAM Mobile Museum, 1967. Courtesy of Charles H. Wright Museum of African American History.

chitecture, and pageants at the Negro Buildings and Emancipation expositions, IAM's unique curatorial proposition would directly engage the black public in the making of its own historical narrative.

The proposed content of the trailers—a Pan-African exhibition curated by Smedley—would present two legacies of American blacks. The first collection of trailers would display exhibits exploring African cultural and historical heritage. Their exhibits would chart a historical time line similar to that in Du Bois's history, *The Negro*. Each section would trace the early origins of humankind to the development of agriculture, societies, permanent settlements, and civilizations in parts of the African continent, leading up to contact with colonizing Europeans. This period would be followed by displays showing the rise of the transatlantic slave trade and colonialism and then their decline. It would conclude with the emergence of contemporary African nations. A second group of trailers would tell the story of Africans in the Americas. These exhibits would chronicle the technological and cultural contribution of Africans in the

New World. Also on view would be portraits of famous historical figures such as Benjamin Banneker, Phyllis Wheatley, and Crispus Attucks and lesser-known figures such as Estavanico de Dorantes. Incorporated into the New World section would be a detailed history of its plantation systems, an account of slave revolts, abolitionism, the Civil War, Reconstruction, and the civil rights movement.

The first task IAM faced in implementing this ambitious new undertaking was to draw up plans for the first trailer in the Mobile Museum. With these plans, museum organizers could then seek artifacts for display and solicit funding. After the public protest in June 1966 over the manner in which the DIA had treated Governor Williams's donation of African art, Williams (upon Wright's request) donated part of his collection to IAM. Williams gave seven woodcarvings, among them an exquisite and intricately carved wooden door from the Senoufo people of Mali. These pieces, along with other African artifacts, audiotapes, slides, and transparencies gathered by Smedley from her travels to London and Nigeria, would make up the Mobile Museum's inaugural exhibit.

The estimated cost of constructing the first mobile unit totaled $9,000, with the estimated operating costs for the year amounting to more than $15,000. The museum contacted Detroit's Board of Education for assistance; but, while interested in the idea, the board was unwilling to provide funding. In need of monies, IAM next applied for a $5,000 matching grant from the newly funded Michigan Council for the Arts to help pay for half of the cost of the Mobile Museum. Due to a stipulation that the arts council could not fund building projects—which is what they determined the Mobile Museum to be—the review panel summarily rejected IAM's request. Wright had been appointed to the museum committee for the arts council, one of only three black reviewers on its several grant review panels. Only one of the two projects put forward by black institutions received funding, with that selection labeled a "special case." Because almost none of the funds had been allocated to any project that directly engaged black audiences, Wright alleged that racial prejudice on the part of the arts council had influenced its duty to fairly dispense public monies. Unwilling to accept the racially motivated denial, he and others in IAM began writing letters to galvanize support from other black organizations, community leaders, and politicians to challenge the arts council's decision. A pointed letter to Republican Governor George Romney yielded no response or action. In two follow-up meetings, a coalition of black state representatives and organizations presented to the arts council evidence of discrimination in its appointments and

appropriations. The coalition persuasively demanded that black groups receive their fair share of monies. They insisted that black citizens be represented on all levels of the council and that all future council programs be integrated (even though the arts council claimed that it had rejected funding of the Mobile Museum because it would be "for Negroes only"). Contrite and apologetic, the Michigan Council for the Arts agreed to these demands, granting monies for the Mobile Museum by the summer of 1966.[86] Wright and others saw this success as another small fight in the larger battle against antiblack racism embedded in governmental structures. As institution builders, they became keenly aware that other similar fights needed to happen in all instances in which federal and state monies were disbursed to cultural organizations.[87]

In the fall of 1966, Obie Newman began contacting manufacturers to purchase a trailer for the Mobile Museum. By June of the following year, the museum had acquired a thirty-five-foot long by eight-foot-wide trailer for less than $3,000. Construction on the interior commenced immediately. Inquiries were made to hire, at a modest stipend, someone to assist Smedley, chair of the IAM's research committee, with assembling the exhibit. An Africanist on the faculty at Indiana University's Art History Department recommended Rosalyn Walker, a young black graduate student in art history, who volunteered to work on the project. Eager to get started, Walker arrived in mid-June to join Smedley and a group of museum volunteers, electricians, and carpenters. Along with the exceptional pieces acquired from Governor Williams and her own donated pieces, Smedley had been successful in obtaining artifacts on loan through various associates at museums and universities, including the British Museum in London. Through his alliance with Henry Brown, Wright negotiated with the Detroit Historical Commission to utilize the DHM's storage facility and laboratory at Historic Fort Wayne for the construction of the trailer and assembly of its exhibits. Over the course of Detroit's steamy summer, the project proceeded at a swift pace.[88] Smedley, who oversaw the construction, would teach at WSU in the morning and spend the rest of the day building the exhibitions, working well into the late hours of the evening with her two young children in tow.[89] In late July 1967, as time drew close to completing the project for its premiere at the Michigan State Fair, Detroit exploded in the worse urban rebellion in recent history.

The Twelfth Street area—a former Jewish neighborhood in the 1930s where the dispute began—was overcrowded with black families living in dilapidated houses. As examined earlier in this chapter, middle-class

FIGURE 47. Interior of IAM Mobile Museum under construction, Detroit, 1967. Courtesy of Charles H. Wright Museum of African American History. PH104–13.

blacks had moved into Westside neighborhoods in the 1920s. However, forty years later many of those families had moved north and west to suburban areas such as Inkster that were now open to blacks. At the time of the rebellion, the houses and apartments around Twelfth Street were filled to capacity by people who had migrated westward out of the Paradise Valley area as an outcome of the tabula rasa practices of urban renewal. The concentration of people in the Westside approached 21,376 per square mile. This overcrowding created twice the density of other parts of the city. Many of the business owners had followed white residents to the suburbs, and efforts by black businesses to improve their premises were impeded by a lack of financing, an outcome of the discriminatory practices of banks. As a further consequence of these actions, the Twelfth Street commercial district quickly became populated with pool halls, bars, pawnshops, and blind pigs, along with the problems of prostitution, number runners, pimps, and general rowdiness these busi-

nesses attracted.[90] Along with constant harassment, arrests, beatings, and killings by bigoted white police officers, these untenable conditions fed the anger, resentment, and, ultimately, the rebellion.

IAM was just north of the worst violence, but it was still close enough to feel it. The museum's offices did not sustain any damage and, in a stroke of good fortune, the new Mobile Museum was still parked at the DHM's storage facility, awaiting finishing touches. Saddened by the devastating violence but also inspired to intervene, the museum's organizers felt their mission to be even more relevant after the tragic events. Once Smedley and her assistants completed work in early August, they parked the new trailer in front of the museum offices on W. Grand Boulevard. With many in the neighborhood suffering from postriot trauma, the museum opened the doors of its mobile unit in hopes of reawakening their sense of optimism. In its first outing, more than one thousand residents toured the new Mobile Museum's "African Art and History" exhibit.[91]

The first visitors saw a visually compelling five-part presentation of African art and history compressed into the confines of the trailer. The first section displayed colorful maps, captions, and images that pinpointed the origins of humankind two million years ago on the African continent. The exhibit informed visitors about the establishment of farming communities in the Sahara and Sudan regions. The next section mounted on the wall told the story of the formation of ancient civilizations in the Nile valley and of the creation of important trading centers. Following this section, visitors viewed the histories of the great empires of the western Sudan, which included photographs of the region and a model of a Sudanese dwelling created by artist Leroy Foster. Next, visitors walked into a small area that featured exhibits of Ashanti, Yoruban, and Congolese sculptures. Along with these stunning artifacts, text panels outlined the emergence of the transatlantic slave trade. Several Benin bronze statues and the intricately carved Senoufo wood door donated by Williams were also prominently displayed nearby. The final section of the exhibit showed color transparencies of contemporary African nations whose citizens heroically fought to be free from colonial rule. Before leaving the mobile unit, visitors could purchase greeting cards and artworks with black themes from a gift shop. Limited to less than three hundred square feet and with a level of craft not achieving that of the well-financed exhibits of mainstream institutions, the impressive exhibit nevertheless combined the disciplines of art history, anthropology and political science. The compact show gave visitors a rarely seen history of the African continent that solidly refuted, as its promotional literature proudly announced, the "myth of Africa as

a land of jungles and savagery and no history."[92] No longer represented as primitive or mythical, African culture was portrayed as historically connected by the Middle Passage and contemporary struggles against colonialism to the cultures of the African diaspora in the Americas.

Directly linking IAM to the legacy of black Americans, who had utilized the fairs in Atlanta, Paris, Charleston, Jamestown, New York, and Chicago as accessible venues for the display of racial progress, the first official appearance for the Mobile Museum was at the Michigan State Fair at the end of August 1967. It should be noted that, in adhering to the European model of research and education, mainstream American museums like the DIA functioned as permanent and symbolic institutions erected by the ruling elites to signify their control of urban space and public history. In contrast, the alternative displays at the expositions and at museums like IAM allowed blacks to tactically claim space, albeit a temporary one, for the public display of their accomplishments and history. In this tradition, the Mobile Museum's light-blue trailer, freshly painted with a new sign, was stationed in front of a picnic grove and next to the fair's poultry building. Like the proud students who had staffed the displays at the Negro Building in Atlanta, Smedley and other volunteers conducted tours on a regular basis, explaining in great detail the key parts of the exhibit. People marveled at the artworks. They read intently the captions and the extensive maps. Recognizing that many blacks were adopting Afrocentric decoration and dress as a mode of expressing racial pride and solidarity, the exhibit provided a detailed history of clothing, hairstyles, and artifacts. Over the course of the ten-day event, at least sixteen hundred fairgoers visited the unit, with the museum raising over $1,000 in donations.[93] An exemplary grassroots undertaking, the Mobile Museum's "African Art and History" exhibit proved immensely successful in reaching a broad audience in ways that the DIA's new African wing could never achieve.

As a result of the Mobile Museum's visibility at the state fair and extensive coverage in the press, queries on the traveling exhibit's availability came from organizations around the Detroit metropolitan area. The following fall, IAM received an invitation to bring the mobile unit to the Black Arts Festival sponsored by the Ann Arbor chapter of CORE. A request also followed from the Detroit Board of Education (youth being Wright's most desired audience), booking the Mobile Museum to tour area high schools in the winter and spring of 1968. As part of the Detroit Public Cultural Enrichment Project, the Mobile Museum visited twenty-one schools. The tour was federally funded from Title 1—the

Elementary and Secondary Education Act, part of Johnson's War on Poverty—which gave monies to poor and educationally deprived children. A museum volunteer drove the Mobile Museum to each high school and parked it on-site for several days. Museum volunteers also served as docents. Over the course of these tours, thousands of black and white students passed through the exhibit, including groups from nearby junior high and elementary schools. Local residents who had heard about the wonderful display of African culture from their excited children would also drop in to view the exhibit. For some, seeing the artifacts from Africa offered a novel experience, prompting them to ask many probing questions. But for others, including some teachers, the exhibit displayed nothing of educational value or appeal.[94] IAM knew it had a difficult task ahead, but the Mobile Museum was one promising vehicle, in a literal sense, to spread its message of self-knowledge and black consciousness.

The Mobile Museum turned out to be an ideal exhibition venue to tour a city whose residents had moved away from its center. Diverse organizations across the city booked the traveling museum for public events. During Negro History Week in February 1968, for example, the trailer was sited in an empty lot just off Woodward Avenue and across the street from the J. L. Hudson Company, the region's largest department store. This location made the exhibit accessible to many Detroiters who worked downtown. With the migration of the city's population to outer suburbs, the Hudson Company had developed four successful shopping centers to cater to these new areas.[95] In July 1968, the Mobile Museum traveled to three of the Hudson Company's shopping centers—Westland, Northland, and Eastland Shopping Centers—spending one week at each location. In its first year, the "African Art and History" exhibit visited eighteen churches around Detroit, but the museum was disappointed that black ministers did not do more to support the new institution. IAM also stationed the trailer at the Detroit Historical Museum for a week in August before returning to the Michigan State Fair a second time. The next year the Mobile Museum would continue to be a popular draw. The portability of the exhibit made IAM visible to a larger portion of the city's black population; it also made IAM more accessible to white Detroiters in ways that, given the racial partitioning of the city, a museum building in a black neighborhood would not have allowed.[96]

By the spring of 1968, the membership of IAM had grown to over one thousand. Due to the success of the Mobile Museum, the revenue for 1967 topped $15,000. IAM also expanded its activities, including making a popular educational film, *You Can be a Doctor,* and considering the pos-

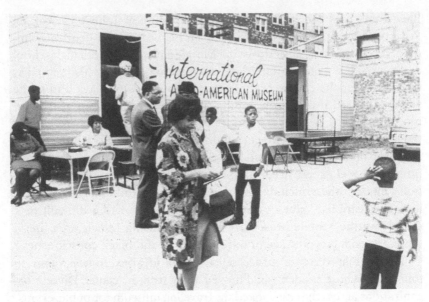

FIGURE 48. IAM Mobile Museum stationed on Twelfth Street, Detroit, 1967. Courtesy of Charles H. Wright Museum of African American History. PH104–12.

sibility of a sister project called the Careermobile.[97] The museum sponsored an evening public lecture series, "Afro-American in American Life," which covered a range of topics from history, politics, science, economics, and anthropology. In August IAM hosted the Afro-American Festival at the Northwestern Recreation Center, located a few blocks from the W. Grand Boulevard museum. IAM launched a summer educational program for youth aged seven to eighteen, scheduled for July and August. Taking into consideration the number of requests for the Mobile Museum and the coordination of informational material and events, the workload necessitated that the museum hire a full-time executive director and secretary. In order to accommodate the new staff, the museum expanded into the first and second floors of the W. Grand location. This move, funded by member donations, allowed for the creation of an exhibition space on the first floor and the opening of a gift shop to sell artwork, books, pamphlets, cards, and jewelry in the rear of the house.[98] Efforts were made to encourage the Detroit Board of Education to cosponsor projects, but the board remained resistant, even after the success of the Mobile Museum. IAM struggled to overcome these financial obstacles while it flourished as a functioning grassroots black history and cultural museum in Detroit. But it had yet to achieve national stature.

"IF NEGROES DON'T HELP TO BUILD
THEIR OWN FREEDOM MONUMENT . . . "

IAM's intention was to be a national museum with an international presence. To get it underway, however, the founding committee had first applied for a charter from the State of Michigan, a move that would not preclude the museum from pursuing a national charter at a later date.[99] IAM's ambitions of being the first national museum of Afro-American history were immediately challenged. Six months after IAM's founding, U.S. Representative James H. Scheuer, a Democrat representing the Bronx, New York, introduced a bill to give Woodson's Negro History Week official federal authorization. In an addendum, the bill also proposed to establish a national museum of Negro history and culture. Under this plan, a federal commission of experts on black history would be selected to study the viability of the institution and report their findings directly to President Johnson. Upon hearing of this congressional plan, Wright immediately investigated the matter to ascertain who had initiated this new proposal. He believed that the bill represented a white liberal's effort to contribute to the historic changes occurring in 1965 with the passage of civil rights legislation. Wanting to know more, Wright traveled to Washington, D.C., and with the help of black Representative John Conyers of Michigan met with an aide from Scheuer's office. At this meeting, the aide proudly showed letters backing the national venture from various important black leaders. Some of these letters came from the same organizations that IAM had contacted for support but that had either not written back or had responded by discouraging IAM from pursuing its mission. Concerned about these new developments, Wright convened several meetings in the fall of 1965 to address this pressing matter. The vote on the national Negro museum bill, however, was postponed due to the end of the congressional calendar.[100]

Critical of the white representative's proposal, Wright thought that the creation of a national black museum should be an endeavor initiated by the people, not the state. Initially, IAM emerged as the lone dissenter against the federal government's effort to establish a national museum. Representative Powell, a vocal civil rights champion and representative from Harlem (for whom Wright had campaigned), also believed that black Americans should be the ones to initiate plans for a national museum.[101] In a press release, Powell declared that "a race that denies its past has no future," and he urged organizations like the ASNLH to organize a national drive and come to a conference in support of that aim

in Washington D.C.[102] Likewise for Wright, state initiation of this proposition provoked cause for concern, especially in light of the fact that the U.S. government could not be trusted to offer black citizens an accurate and inspirational account of their history. Scheuer and another white congressional representatives' failure to consult with any black groups about their plan deeply offended Wright, who interpreted from their actions that there would be no room for "the common people to play a role in building it [the national museum]." A *Michigan Chronicle* article argued that "if Negroes don't help to build their own freedom monument, an Afro-American museum," then according to Wright, " 'We're going to have it handed to us on a silver platter.' "[103] If black Americans did not assume responsibility in building a national museum, he charged, then they certainly would not have any say as to who would be represented in the institution; controversial and radical figures such as Du Bois, Robeson, Marcus Garvey, and Malcolm X would likely be excluded to placate the government's need to represent only those willing to accommodate a white agenda.[104] Wright cited the challenges that Harlem's Schomburg Collection had confronted when it was being accessioned by the city as proof that government could not effectively and respectfully manage black cultural institutions and heritage.[105] Moreover, critical of the latest attempts to profit from the marketing of black history, Wright assailed companies like Pepsi Cola, Coca-Cola, and Old Taylor Bourbon that reaped profits by selling albums and ad content featuring black history—even though most blacks were unable to benefit from knowing their own history. To instill self-pride and a positive self-image, it was vital that blacks conceive and make the institution themselves, since no amount of monies for an archive, history books, and a museum would accomplish this. An agent of racial oppression like the U.S. Congress could not be trusted to objectively right previous wrongs; nor could local and state governments. From Wright's perspective, the two congressmen proposing the national black museum bill would politically benefit, as had happened in the past, from saving poor Negroes and their history from disappearing. In the end this would ordain "two more great-white-fathers," Wright cynically thought, "a commodity that is already in over supply."[106] In spite of Wright's considered objections, however, Scheuer's proposal had apparently received enormous support from the black establishment.

In response to the growing prominence of Black Nationalist organizations such as the Black Panther Party and fearful of another hot summer of racial unrest (Detroit still smoldered), Scheuer sought to resur-

rect his bill in the fall of 1967. The congressman enlisted Hugh Scott, a white Republican senator from Pennsylvania, to put forth a similar bill in the Senate. To publicize the proposal, Scheuer organized a one-day conference cosponsored with the ASNLH, whose executive director, Wesley, was an enthusiastic booster of the bill. Hosted in Washington, D.C., this conference convened during February's Negro History Week. It served as a highly visible national platform to tout Scheuer's integrationist project, the Commission on Negro History, which at a cost of $500,000 would nominate eleven experts to "study all aspects of the problem of preserving, collecting, and ultimately integrating evidence of the Negro past into the mainstream of American history."[107] This version of the bill did not explicitly state that a museum should be formed, but one likely outcome of the commission would be the proposal for such an institution. Historians C. Eric Lincoln and C. Vann Woodward and writer Ralph Ellison participated in two panels on the themes of collecting and disseminating materials. Members from both the New York and Washington, D.C., branches of the National Urban League (NUL) presented at the event. Wright was unable to participate in the conference but had been corresponding and meeting with various representatives to persuade them that this effort to build a black museum must instead be a grassroots effort initiated by black citizens.

As a counterproposal to Scheuer's commission, Wright put forward his program to prepare one hundred federally funded mobile exhibits (modeled on IAM's Mobile Museum) that would travel throughout the country. These mobile exhibits would set up a network of nationwide oral history committees that would record the stories of elderly blacks and collect important artifacts and documents. Federal monies would thus seed the formation of grassroots institutions across the nation. For excellent models of the fledgling black museum movement, Wright pointed to the examples of Burroughs's African American Museum (formerly the Ebony Museum) and the American Negro History Museum in Boston's Beacon Hill neighborhood.[108]

As part of the congressional review process, the House Select Subcommittee on Labor sponsored a daylong public hearing in lower Manhattan on March 18, 1968. Scheuer, black Representative Gus Hawkins from California, and white Representative Bill Hathaway of Maine comprised the panel that heard from representative black leaders from around the country. In attendance were the heads of social organizations and historical associations: John W. Davis of the NAACP Legal Defense and Education Fund; Roy Innis, the head of CORE; and Wesley, repre-

senting ASNLH. Cultural representatives invited to testify included
Jackie Robinson, sports hero and special assistant to New York gover-
nor Nelson Rockefeller; noted novelist James Baldwin, accompanied by
Betty Shabazz; and ABC television correspondent Malvin Goode. Also
invited as representatives of black cultural institutions were Dr. John A.
Davis of the American Society of African Culture in New York and Wright
from IAM.

At the hearing, the subcommittee heard positions that ranged from en-
thusiastically supportive to distrustfully resistant. Several of the presen-
ters noted how black history, especially any mention of events prior to
enslavement, was glaringly absent from school textbooks read by Amer-
ican children. The official public record shamefully omitted the deeds and
accomplishments of historical figures such as Banneker and Attucks.[109]
From the perspective of a *New York Times* reporter, the tone of many of
the testimonials bordered on dispassionate, a reflection of an intention
on the part of presenters to objectively state the facts. At times, however,
the presentations became emotional. Some even conveyed a simmering
bitter anger.[110] Regardless of their position on the bill, all agreed that the
deliberate neglect of black history had been a tool to maintain the per-
ception of the Negro as a buffoon and minstrel. All testified that the care-
ful collection of materials on a national scale would be an important en-
deavor to correct these beliefs. Even though history was the focus of the
day, most of the presenters also frankly discussed the current role of politi-
cians and the media in sustaining denigrating representations of blacks
and maintaining discriminatory practices that denied blacks access to
prominent roles in these two important arenas of power. Enthusiastic
about the alliance between the ASNLH and Scheuer, Wesley offered the
strongest support in favor of the commission. He declared, "We do it be-
cause for too long a period the history of black people has been neglected
and enough has been said to indicate that what we should be doing is
collecting information, documents especially; documents are fundamen-
tal in the way of history."[111] Departing from the eloquent testimonials
of the historians and politicians, Robinson delivered his perspective in
an earnest, straightforward manner. He told the audience and subcom-
mittee that black children knew more about the poetry of Longfellow
than the verses of Wheatley and Dunbar. Robinson empathized with the
militant black youth whose frustrations had been stoked by Congress's
failure to pass a fair housing bill and to open more job opportunities,
but he concurred with Scheuer that a federal effort such as this would
help defuse some of the anger that had exploded in all of the recent "ri-

oting." Robinson suggested that perhaps Scheuer might want to get "some of these black power guys who are on the fence" involved. In response to this idea, Representative Hathaway betrayed his fear that people like Carmichael might take over the black leadership.[112]

The next group of speakers did not offer conciliatory remarks. Candid in his response to the subcommittee, Baldwin rendered a nuanced assessment of the interrelation between black history and American history, positing that one could not be taught without the other: "I think one of the stumbling blocks is that the nature of the black experience in this country does indicate something about the total American history which frightens Americans."[113] Speaking of the need for the commission to function with some modicum of autonomy, he expressed a profound distrust of white liberals like Scheuer, whom he characterized as "missionaries" who needed to take care of their own communities rather than tell blacks what was wrong in theirs. Following Baldwin's statement, activist Shabazz offered support for the bill and emphasized the importance of teaching black history in schools. Next, a defiant Innis, who proudly introduced his Black Nationalist credentials, stated that a positive first step in this process would be to remove *Negro* from the name of the commission and replace it with *black* or *African American*. Further, Innis was adamant that in spite of the commission's description as a "presidential committee," its membership should be chosen by black citizens and composed of black citizens. He reminded the panel that if "we are dealing with the problems of black people in America in any way, we should keep in mind the need for the creation of indigenous institutions, black institutions, institutions of our own."[114]

The last speaker scheduled that afternoon was Wright, who was joined by Charles Burroughs, a cofounder of Chicago's African American Museum. The absence of Margaret Burroughs, who perhaps did not present to the committee given her radical past, meant that the panel of presenters was mostly male and thus ignored the important contributions black women like her and Smedley were making to the black museum movement. At the start of his presentation, Wright proudly recited the accomplishments of IAM and its members. He was the most vocal critic of Scheuer's bill, claiming that an effort of this magnitude must come from the black public, not from outside of it. Although Wright acknowledged that the current bill did not propose a museum, he still believed that the bill should reflect the will of the people. The government should provide them with an opportunity to participate in deliberations, thus determining in what manner their interests would be best served, whether by a com-

mission, museum, or whatever they deemed appropriate. Resolute in his presentation, Wright asked the subcommittee to recognize and respect the growing desire for self-determination emerging in black communities. The bill, in Wright's estimation, duplicated on-the-ground efforts already being made by museums like IAM. Wright argued that the national commission, funded by the federal government, would undermine such local institutions' important efforts. These local endeavors represented the will of black people in making their own history. Yet, these institutions had not received support from the federal government or the stature associated with such support. And from experience with trying to gain publicity and support for IAM, Wright stated bitterly, "We can't do anything unless we get white leadership, which I object to."[115]

Eclipsing Innis's proclamation of his nationalist stance that day, Wright was the only one who objected outright to state control of the collection of black heritage and the exhibition of black history. In a testy exchange with Representative Hawkins, Wright perceptively rejoined, "Is the Federal Government able to deal objectively with any matters dealing with Afro-Americans?" Reflecting on his activist experiences fighting racism in his profession, Wright informed Scheuer, "I would have to revise my whole attitude with the Federal Government and my relationship with it in terms of being a Negro." He added, "There is nothing in my experience that would allow me at this moment to say that the [desired] results would accrue from a responsive commission about which I had nothing to say."[116] What Wright stated that day—yet what no one else would acknowledge—was the extent to which the problem of antiblack racism originated in the means by which the state sponsored and sustained laws, institutions, and social practices. From his experiences in places like Detroit and Selma, Wright knew all too well that city, state, and federal agencies would not be able to satisfactorily address matters that concerned black Americans, especially given the recent failures of civil rights and housing commissions created by the President Johnson's War on Poverty. As a glaring example of this failure, the nation's museum, the Smithsonian Institution, in Wright's opinion, "has been more concerned with reptiles and birds than with Black Americans."[117] Wright disparaged the fact that Scheuer's proposed commission would receive a half-million-dollar allocation when the federal government had failed to award $50,000 to restore the great abolitionist Frederick Douglass's home in the nation's own capital. The goal of the commission should be to instill a sense of pride and positive self-image, Wright contended, which was more important than archives, books, and a museum building. But if that were

to happen, Wright argued passionately, then the people must be involved in every stage of the project.[118]

In a vigorous campaign against the bill, Wright contacted political representatives and black leaders. In response to the tragic assassination of King on April 4, 1968, however, Robinson was hurriedly named as the head of the commission that same day.[119] Astonishingly, the bill to establish the renamed Commission on *Afro-American* History and Culture passed the House by a vote of 263 to 45 in September 1968. An identical bill in the Senate failed due to a rush to adjourn. After five tumultuous years of Johnson's civil rights and Great Society initiatives, the following November the majority of voters elected the conservative Republican Richard Nixon to the office of president. Like so many of the bills to fund expositions and the previous National Negro Museum proposal, Scheuer's proposal was not reintroduced again. The commission was never formed, and the proposal for a national black museum languished for almost two decades.

Even more keenly aware of the importance of collective action in the fight for black representation, rights, and power, IAM formed a national association of black museums to maintain control of the right to represent black history. Many more small museums had made themselves known during the national museum controversy. And more significantly, new institutions were being created out of the shared desire to bolster black pride in the wake of the civil rights movement and King's assassination. This new museum coalition would possess enough national clout to ensure that the development of black museums would remain in the hands of their communities around the country. In particular, the need for such an organization was made even more imperative with the firestorm that erupted around the exhibition "Harlem on My Mind," curated by Allon Schoener, which opened at the Metropolitan Museum of Art in the winter of 1969. Issues around white sponsorship, curatorial direction, and display of the exhibition were main flashpoints for protest. While the organizers may have been well intentioned, activists from all strata of black New York City contested the exhibit's overall depoliticized ethnographic approach as well as the exclusion of black artists from the Met and other city art institutions.[120]

In the fall of 1969, Chicago's DuSable Museum of African American History (formerly the African American Museum, née Ebony Museum) co-hosted with IAM the first National Black History Museums Conference in Detroit. Renewing their commitment to sustain and foster new black museums, Wright and Margaret Burroughs asked participants from all over

the country and Canada to join the conference. Representatives from a variety of museums—from larger institutionally funded museums like the Anacostia Neighborhood Museum in Washington, D.C. (newly affiliated with the Smithsonian), to smaller local efforts like the Josiah Henson Museum in Ontario, Canada—were invited. Wright persuaded black congressional representatives to support the event. Even though he and Wright had been on opposing sides of the national museum issue, Wesley, through the invitation of Representative Conyers, agreed to join the discussion.[121] The daylong program hosted a series of speakers who covered the topics of legislative action, resources, education and acquisition of black material culture. Burroughs, Conyers, Diggs Jr., and Wright, along with faculty from WSU and the University of Michigan, made presentations to the conference audience. Richard Austin, Detroit's first black candidate for mayor, discussed the impact of black history museums on the city. The new black museum association recognized that "many of the problems that we face are the by product of the distortions and deletions of black history, [and] we can solve them only by correcting the distortions and replacing the deletions." The ideological project of instilling pride through black heritage would be one facet of the project to rebuild solidarity and agency among black citizens. It was clear that this association, which would come to be known as the African American Museums Association (AAMA) and which operated within the national black counterpublic sphere, wanted its representative museums to strive to link education and political activism with the business of collecting and presenting black history.[122]

To expand its office and museum space, in 1972 IAM moved into the two adjacent residences on W. Grand Boulevard. Doorways cut through the party walls between the houses and opened new spaces for more galleries. Simultaneous with the expansion, the museum's activities also continued to develop IAM's community-based agenda. IAM maintained its Mobile Museum project. According to a 1978 estimate, over fifty thousand people a year visited the trailer, many of them school children. Although plans for several other vehicles never materialized, the museum sponsored numerous art and history exhibitions, alongside its oral history project.[123] At their expanded W. Grand address, IAM launched, for example, an exhibition on the Montgomery bus boycott, which also honored Detroit resident Rosa Parks. The museum also initiated several events celebrating the accomplishments of Robeson, whom IAM considered an important figure in the history of labor organizing and black radicalism in Detroit. Germane to its heavily unionized audience, in 1971

FIGURE 49. IAM exhibition at 1549 W. Grand Boulevard, Detroit, n.d. Courtesy of Charles H. Wright Museum of African American History. PH136-01.

IAM opened "The Life and Times of Paul Robeson," offering an overview of the great actor's achievements and attempting to resuscitate his contributions after black nationalists like Cruse had dismissed his positions and impact. In 1975, Wright published *Robeson: Labor's Forgotten Champion,* which examined Robeson's trade union activities in detail.[124] Two years later, the museum exhibited "The Making of a Militant," which explored in detail Robeson's political activities. And in 1978, in celebration of the late activist's eightieth birthday, the museum launched an extensive yearlong series of conferences, television and radio programs, and exhibitions, along with making an honorary medallion and two record releases.[125] Additionally, the museum's volunteers continued to collect oral histories. The public could listen to these invaluable tapes at the museum's Westside location. A 1980 inventory showed that IAM had amassed an extensive library of recordings from all over the country. Among its collection were rare interviews with noted artists Elizabeth Catlett and Romare Bearden.[126]

Although it called itself a museum, IAM also offered a variety of

community-based activities. These were often cosponsored with other organizations, much in the spirit of Chicago's Southside Community Arts Center. The museum provided lectures on black history to schools, churches, and social associations. In 1976 the museum established the Paul Robeson Scholarship, which was given to an outstanding scholar or athlete. In collaboration with the Detroit Board of Education, the museum sponsored the In School Youth Work Experience Program for fifty high school students. Finally, IAM cosponsored public service conferences with Mercy College on citizen consciousness and black involvement in public policy and on the political climate of South Africa.

IAM successfully utilized various media outlets to disseminate its message. Its radio show, *Spotlight on Black People,* during which hosts interviewed a range of public figures, continued to be popular. Communist and historian C. L. R. James, who had in the 1940s and 1950s allied with local trade union radicals James Boggs and Grace Lee Boggs, was one such invited guest. The museum also sponsored radio programming that complemented its exhibitions on Parks, Robeson, and the Voting Rights Act of 1965. As television stations and the mainstream press became more amenable to covering black culture after decades of neglect, IAM successfully produced several specials on black history for the local public television station, including a performance of Charles Wright's play, *Were You There?*[127] Also during these years, the museum published two books: *Blacks in the Age of the American Revolution,* by Colin Palmer; and the Robeson biography by Wright. These two publications and other programming affirmed the museum's commitment to present the history of black response to injustice so that Detroiters could comprehend their contemporary political activities within a larger historical legacy of protest and militancy.

A BLACK MUSEUM BUILDING

In the fall of 1975, IAM, rooted in local engagement, adopted a new name, the Afro-American Museum of Detroit (AAMD). Even though scarce funding prompted the museum to seek grants from a variety of sources, the sixteen-member board, museum members, and staff rallied to continue the AAMD's activist mission.[128] Over the years, the museum cultivated productive alliances with unions, religious institutions, other museums, educational institutions, and other grassroots organizations. The ascendancy of black politicians in Detroit's city government with the 1974 mayoral election of Coleman Young (a progressive activist in the 1940s

FIGURE 50. Margaret Burroughs and Dr. Charles H. Wright at book signing of Wright's *Robeson: Labor's Forgotten Champion*, n.d. Courtesy of Charles H. Wright Museum of African American History. PH103-01.

and 1950s) influenced the success of these associations and assisted in the challenges faced by the AAMD.

From the beginning, Wright and the founders had planned for the museum to have its own building. They had moved into the W. Grand Boulevard location in 1966 as a temporary solution. Once Young was elected, Wright sent the new mayor—an ally of the museum in its fight against the Michigan Arts Council—a letter requesting assistance for the museum's expansion plans. He reminded Young that the museum functioned as a vital community organization that promoted positive messages and images in an effort to combat the many social problems plaguing Detroiters.[129] Like his predecessors, Young focused on downtown redevelopment, adding a new arena and riverfront properties, such as the cylindrical towers of the Renaissance Center in 1977.[130] While these additions presented a modern downtown skyline when viewed from the suburbs, the reality on the streets of downtown Detroit was that businesses continued to shutter their storefronts, thus robbing the city of vital tax rev-

enue and other income. For the AAMD, the need for a first-class facility dedicated to the display of black history and culture was made more urgent in 1976 when the DIA turned down the groundbreaking touring exhibition curated by art historian Richard Powell, "Two Centuries of Black American Art." After considerable lobbying, the city agreed in 1978 to lease property to the AAMD in the Cultural Center—ironically, a parcel located near the city's cultural jewel, the DIA. To design a new twenty-thousand-square-foot museum facility, the AAMD hired the architectural firm Sims Varner Associates, whose partner, Howard Sims, had advised the museum for the past ten years. Over the course of its fundraising drive, the AAMD successfully raised a substantial amount of monies through small and large donations. Even with those donations, the museum still needed financing to meet the $5 million required to construct the new facility.[131] A deft political tactician, Young pieced together $2.3 million from federal Housing and Urban Development block grants to pay for construction. Groundbreaking for the new museum, which was renamed the Museum of African American History (MAAH), took place on March 10, 1985. The event occurred exactly twenty years after the museum's founding—a resounding triumph for Wright and the museum volunteers' prodigious efforts.[132]

Two years later, on May 7, 1987, Dr. Wright and Mayor Young together cut the ribbon to open the MAAH's new two-floor, twenty-eight-thousand-square-foot building. The exterior of the new museum was a large gray trapezoid clad in cast concrete panels. The playful postmodern silhouette of African domed roofs—shaped from bent steel and painted red—enlivened the building's blank facade and created an entry court for the new museum. Unlike previous exhibitions, which had been assembled by a committee of museum volunteers, the MAAH's new core exhibit, "An Epic of Heroism: The Underground Railroad in Michigan, 1837–1870," was a professional curatorial undertaking that merged national history with local events and places.[133] The architects designed the new building to accommodate traditional museum functions, with space provided for exhibition preparation and fabrication, storage, conservation, a gift shop, conference rooms, and multipurpose rooms for special events. To manage its new institutional framework, the museum hired the requisite staff. Wright and the museum volunteers' grassroots strategy to build a community museum had succeeded. They had persevered and moved into a new building just two blocks away from the site of their first meeting in March 1965.

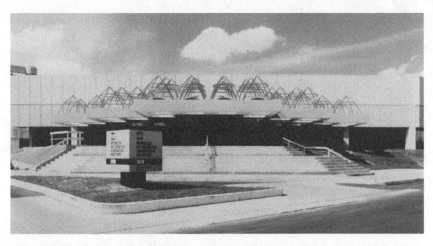

FIGURE 51. Museum of African American History, Detroit, 1987. Courtesy of Charles H. Wright Museum of African American History. PH104–08.

While we have learned how the activism of Wright, Smedley, Burroughs, and the museum advocates, in their fight for access to decent work, education, health care, and housing during the 1940s and 1950s, underpinned their mission to form the first black museums in the 1960s, we must remember that none of the founders were trained museum experts. They instead worked from the bottom up through grassroots methods of organizing. Their inspiration and knowledge came from their experiences in their places of work and their efforts within organizations in the black counterpublic sphere that were dedicated to challenging and eliminating racial prejudice. As Wright protested in his fight against a national Negro museum, it was important for blacks to claim their radical history by comprehending the activities and philosophies of the likes of Garvey, Du Bois, Malcolm X, Wells, and Robeson, along with a host of other historical figures and events. Thinking in broad terms, as its initial statement of purpose advocated, Detroit's museum would be allied with all movements around the world to defeat oppression: "The Struggle of Black peoples for political and social equality is broadening the whole concept of freedom by releasing mankind from the bond of racism."[134] While the education of youths and adults about their history informed the museum's primary agenda, IAM's founders and supporters, under the leadership of Wright, recognized that in tandem with that mission was the need to confront racist state and institutional structures. They believed this would guarantee self-determination concerning how black America's histori-

cal legacy would be represented and preserved. Their goals were quite different from the early agendas of Penn, Washington, and Calloway, whose curatorial ethic presented black audiences with ideals promoting respectability—represented in dress, work, domestic habits, and religion—that mirrored white social norms. By contrast, the black cultural nationalism represented by IAM and other museums focused on a distinct "black" culture whose legacy was not that of white America but rather originated from a Pan-African perspective that drew historical ties back to Africa. To be sure, this connection was no longer conveyed by references to the mystical Ethiopia that had been conjured by Du Bois. Anthropological and historical research verified this genealogy through a presentation of Africa's contemporary political changes—for example, like those illustrated in the materials on display at the Mobile Museum. No longer invisible or denied, and echoing Du Bois in their original statement of purpose—that no longer would the "material and spiritual contributions made by Black Men to culture and civilization" go "unacknowledged"—the founders of IAM were proud to make, present, and witness their own black history.

Wright, Smedley, and the museum's promotion of black culture, along with Wright and Smedley's resistance to white collaboration in forming and managing the institution, paralleled black cultural nationalist philosophies (although IAM's founders did not embrace the revolutionary aftermath). IAM survived what scholars Howard Winant and Michael Omi in their excellent analysis of racism and social structures define as "a willful neglect of key political determinants of race—the racial state, class conflict, the politics of alliance and coalitions—that ultimately doomed many cultural nationalist projects to irrelevance as U.S. racial formation processes overtook their models."[135] IAM's longevity was due to Wright and his collaborators' recognition of the political and economic ways in which antiblack racism functioned to limit black access to power. Gaining wisdom through his activist experiences, Wright recognized the state as an agent of racialized structures—hospitals, grant agencies, museums, municipal governments—that had to be consistently challenged not simply by withdrawing from those structures but instead through the formation of and participation in organizations of the black counterpublic sphere that could tactically contest the mainstream institutional framework.

Epilogue

In the late 1970s through the 1990s cities around the United States witnessed the establishment of a number of new public museums dedicated to the black American legacy, along with the expansion of those institutions founded in the 1960s. These institutions presented black history to an increasingly large and racially diverse audience. These promising developments would also lead to the successful proposal to build a national black history museum in Washington, D.C., in 2002. But we should keep in mind that this growth in the number of public institutions occurred within social, cultural, economic, and political spheres that were radically different from the world's fairs of the post-Reconstruction period, the Emancipation expositions of the Jim Crow era, or the grassroots museum movement of the civil rights era. Fundamental to these differences was the emergence of new technologies and forums of public viewing that transformed how black history and culture would be represented, seen, and understood. For example, inspired by the immense success of author Alex Haley's book *Roots* and its television adaptation, the Afro-American Museum of Detroit sponsored its own local heritage exhibition in May 1977 titled "Detroit's Black Roots." In a newsletter article that contemplated the influence of the landmark television series, Charles Wright asked, was the *Roots* frenzy "a passing fancy or will it help to advance the cause of democracy in the United States?"[1] To be sure, the medium of television engaged a different mode of viewing than the expositions or early museums had cultivated. Within the vast halls of the expositions,

groups of men, women, and children had gazed into cabinets and dioramas showcasing racial progress; had witnessed the roar of engines that would fire the nation's industrial future; and, at the mainstream fairgrounds, had gawked at "natives," allegedly imported from Africa, who went about their scripted daily activities in their sideshow cage of the obligatory Dahomey Villages. The fairgrounds and armories had extended the reach of the city's public sphere of social engagement by crafting a miniature phantasmal city within the larger metropolitan limits. Inside these carefully crafted domains, visitors had also experienced new ways of viewing, a "mobile virtual gaze" facilitated by new technological apparatuses of their day that were the forerunners of cinema. Still collective in its broadcasting sweep, television nevertheless provided a more intimate and individuated viewing experience. Flattened onto the surface of a cathode-ray tube, scenes on television were also gathered from around the world and from different historical epochs, as the fairs had done. But television transported these scenes into the private realm of the home.[2]

How did the new visual culture of television programs like *Roots,* a historical narrative of black enslavement and liberation, depart from prior modes of representation, display, and viewing deployed in the expositions and the early grassroots museums? Did earlier notions of racial progress, uplift, and social advancement—key topics of debate within the black counterpublic sphere—persist, disappear, or transform after the 1970s? These conditions and ideologies all changed in relation to the emergence of new racial projects, namely those of the New Right and neoliberalism, and the recalibrations that late capitalism and globalization wrought upon work and wages in the United States. This occurred in concert with the deindustrialization (post-Fordism) and subsequent redevelopment of urban centers where black leaders were now in control of city governments. In this new post–civil rights context, therefore, how did the growing number of museums of black history and culture envision their role, particularly in light of the revived proposal for a national black museum? As Wright justly queried, how would they continue to "advance the cause of democracy in the United States?"

A visual epic of black history mass marketed to mainstream audiences, *Roots* proved a blockbuster cultural phenomenon in the mid-1970s. Filmed for the small screen and broadcast in color, the show divulged the brutality and degradation of slavery. Its camera angles captured the beads of sweat flowing into the bloody lacerations inflicted on an en-

slaved African, whom viewers came to know as Kunta Kinte, the main protagonist of Alex Haley's semiautobiographical family saga. The spectacle of *Roots* exposed an unseen American history, one that shocked and enthralled the nation's viewers for eight consecutive nights. This story of the Middle Passage and the brutality of slavery had not been part of the mocking performances in the Dahomey Villages, the noble myths of the Pan-African pageant, or the ethnographic displays of African and black American culture in the small mobile gallery in Detroit. *Roots*'s particular account of slavery, one that was grafted onto the American ethos of liberalism, reached a national audience of millions in the space of one week.

Aired on prime-time television in January 1977, six months after the nation commemorated the bicentennial of the signing of the Declaration of Independence, the twelve-hour epic of one "black man's family" prompted newspapers articles and editorials, magazine covers and feature stories to glow with praise about the "monumental impact" of the series and its provocation of national self-reflection brought to the country by the purveyors of mass culture—the television industry and Madison Avenue.[3] At the time of its broadcast, the miniseries reigned as the most watched program ever televised. Shown over eight nights it reached over thirty-six million households and averaged eighty million viewers per episode, a distinction that beat out a broadcast of Hollywood's Technicolor ode to the Civil War, *Gone with the Wind,* shown the previous November. By comparison, one of the most successful American world's fairs—the World's Columbian Exposition—ran for six months and had attracted twenty-seven million visitors to Chicago.[4]

For captivated American audiences, the lure of the series's historical sweep was also reflective of a "postmodern" turn away from discourses of progress and toward the experience of the past and the celebration of "American heritage." As cultural theorists Andreas Huyssen and Michael Kammen have both observed, the postwar era began to abandon modernity's absolute faith in society's forward advance and cast a backward gaze toward reassuring representations of history as experienced through film, television, museums, and new venues of heritage culture.[5] In other words, the project of heritage shifted the ideologies of race and nation from the future-oriented ideologies of progress toward realignment with the past. The New Right's promotion of enduring national traditions and an essential American identity was bolstered by the emerging heritage industry. As scholar Kevin Walsh notes, "The heritage display with its denial of process, and its emphasis on the synchronous spectacle, removes

any idea of change through time. The spectacle represents the isolated event; we are removed from history."[6] Some who were familiar with the book Roots, for instance, felt the television adaptation shortchanged the grittiness of Haley's narrative in favor of a more palatable story for white viewers. Historical inaccuracies abounded. The production designers, for example, portrayed Kunta Kinte's African home as a bucolic village surrounded by a neatly manicured lawn—one more appropriate for a golf course than a subtropical settlement in Gambia. These aesthetic adjustments followed the tendency of heritage projects to transform and trivialize historical context for the sake of visual appeal.[7]

Roots's ratings success also demonstrated that people of all races and ethnicities would watch subject matter related to black American history. This could only happen, however, if Haley's book was transformed from a history of state-sanctioned violent economic exploitation of black men and women into a mainstream narrative that propped up popular myths of American exceptionalism. The message and mythos resonating throughout the broadcast version of the story trumpeted an ethnic immigrant's tale of arrival and assimilation. Similar to what the grand pageants of the America's Making Exposition had intended, the presentation of black history in Roots morphed into an ethnic history that was identifiable and accessible to all viewers. Hollywood repackaged Haley's story as that of a man and his family who rose above their meager circumstances, thus celebrating how the values of freedom and liberty facilitated upward mobility, individualism, and entrepreneurship. Here we can locate the influence of conservative ideas that muted structural inequities and racism's impact on black social structures of exchange and forms of kinship. By the 1980s, this neoliberal rhetoric would find its voice in the Reagan era's demonization of the "welfare queen" and castigation of the undeserving poor as wards of the state rather than productive wage laborers who accrued their wealth through the ownership of private property. These notions of liberalism were validated in the last episode of Roots, which concluded with Tom Moore—the grandson of Kunta Kinte and the son produced from the rape of Kunta Kinte's daughter, Kizzy, by her white master—escaping a life of sharecropping in Virginia. With his wife and children in tow, Tom migrated westward to farm their newly purchased plot of land in Tennessee. The core values imparted by Roots centered on the importance of the nuclear family, a patriarchal ideal that freed slaves were finally able to pursue after being emancipated and incorporated into the nation's body politic. Sociologist Herman Gray assesses the success of Roots as a consequence of it being "anchored by familiar

commitments to economic mobility, family cohesion, private property, and the notion of America as a land of immigrants held together by shared struggles of hardships and ultimate triumph."[8] Confirming this intent, Roots's producer, David L. Wolper, characterized his $6 million epic as being squarely aimed at middle-class audiences.[9] Thus, fundamental to its widespread appeal was how Roots embodied ideals of class mobility and the American dream of success.

While the interest in popularizing black history had been championed earlier on by Carter G. Woodson and the Association for the Study of Negro Life and History (ASNLH), the mid-1970s success of Roots can be seen as heralding black America's entry into the mainstream heritage market.[10] For black viewers, Roots presented a pageant of black history in the spirit of W. E. B. Du Bois's The Star of Ethiopia, one that reached a national and international black audience. After decades of protest over the demeaning stereotypes in popular media, the most successful television sitcoms of the day—Good Times and Sanford and Son—still portrayed black Americans as struggling and ghettoized, mostly working class, but just making it in the black enclaves of big cities. Filling that void, Roots collated various tropes of "blackness" that reinvigorated the sentiments of cultural nationalism made popular in the 1960s—but absent the radical political agenda.

Significantly, Haley's project of tracing his roots also sparked a national passion for discovering family heritage. This was especially so among the expanding black middle class, many of whom had grown up in the North but now desired to learn and experience their southern "roots." The program's success prompted a rise in the popularity of family reunions, research groups, seminars, and agencies providing services to assist in tracing family lineage.[11] However, the quest to discover authentic African roots circumvented European ties and connections to other parts of the African diaspora, such as the Caribbean and Latin America, which were also part of the family lineage of many American blacks. These searches also unearthed discoveries of the effects that political disenfranchisement, violence, rape, and exploitation had on black social life. Those modes of reconnection, often steeped in celebration and commemoration, overlooked the difficult social conditions that had produced these truncated, lost, and grafted family trees. Overall, Roots's impact was widespread within what remained of the black counterpublic sphere.

Presaging the popularity of Roots by two years, the second Black Museums Association conference convened in Detroit in 1975, titled "Black

History Museums: A Reflection of African Heritage." The event brought together local cultural activists such as poet Dudley Randall with a national roster of museum organizers and historians—including Charles Wright and Margaret Burroughs. Following a series of meetings led by artist E. Barry Gaither of Boston's Museum of the National Center for Afro-American History, founded in 1963 and financed in part by the National Museum Act administered by the Smithsonian, the national black museums group merged with other cultural organizations and museums to officially form the African American Museums Association (AAMA).[12] The AAMA held annual meetings to advise new institutions on collecting, programming, fund-raising, and management. The organization helped shepherd the growth of these nascent museums.[13] These new public institutions would integrate various activities into their missions: restoration of historical sites; and creation of art museums, archeology museums, and local, state, and regional historical agencies. After the first museums in Chicago, Boston, and Detroit in the early to mid-1960s, along with Harlem's Studio Museum in 1968, a second generation of black history and culture museums opened in other major cities around the country, notably Dallas's African American Museum in 1974, the Afro-American Historical and Cultural Museum in Philadelphia in 1976, and the California Afro-American Museum in Los Angeles in 1979.[14] These were followed by a third generation of commemorative museums in the 1980s and 1990s that focused on the history of specific events and sites in Memphis, Birmingham, and elsewhere.

The devastating fiscal crises of the 1970s crippled the municipal governments of many of the aforementioned cities, especially those with large black populations and under the stewardship of the first generation of black mayors such as Cleveland's Carl Stokes, Newark's Kenneth Gibson, and Los Angeles's Tom Bradley. As the example of Detroit's urban history has revealed, suburbanization fueled by the movement of capital investment to outlying areas and the abandonment of urban factory complexes and workforces greatly reduced the tax base of many cities. The devaluation of urban land, both residential and commercial, by way of "uneven development" in the 1960s and 1970s was followed in the 1980s by reinvestment in urban areas through redevelopment and gentrification.[15] This trend of redevelopment fostered the creation of cultural districts that opened art galleries, museums, artist lofts, and cafés that attracted white urban professionals. As rents halted their downward trend and began to ratchet upward, these newly "discovered" neighborhoods, like Manhattan's East Village, lured private and state capital in-

vestment back to the city, in the process displacing poor and working-class residents, and businesses in these areas.[16]

Like many large urban centers facing instability in the 1970s, Detroit's urban and economic character continued to weaken. The movement of its hallmark industries to areas with lower taxes and the migration of its population to suburban communities (a process that began in the 1940s) accelerated during the 1970s.[17] We can attribute the phenomenon of "white flight" to the economic shift to service sector work and a social climate aggravated by unrelenting racial tensions that had been instigated by block-busting practices of the real estate industry and that went undeterred by government intervention. As Thomas Sugrue's research about Detroit persuasively uncovers, the movement of white residents and deindustrialization began in the 1940s, contrary to the popular perception that the city's decline began after Mayor Young's election.[18] Detroit's eroding tax base—caused by years of departing tax revenue, a problem white mayors like Jerome Cavanagh had failed to stem—led the city toward a fiscal crisis by 1972, two years before Young's arrival in office. Even though Young and the emerging black power base announced a "new era" for the city, they were faced with an extremely difficult task, particularly in light of the city's history of fiscal problems. These were exacerbated by the rising homicide rate, itself a consequence of the lack of jobs, housing, and social services to address these long-term and by then widespread problems.

Young proved a master at deploying redevelopment as a means of consolidating his political base and battling the economic decline of Detroit.[19] Having focused much of his energies on downtown, industrial areas, and neighborhoods, the mayor turned next to the Cultural Center. He conceived of a redevelopment scheme that would create new buildings, including for the Museum of African American History (MAAH), less than three years after that museum's new facility had opened. Under this scheme, MAAH would move one block south to a newer building, again designed by Sims Varner Associates, on an empty lot adjacent to the Science Center. (The Center for Creative Studies, an art school adjacent to MAAH, would move into the museum's readapted facility.) Wright and the museum activists did not anticipate that their vision for the museum was not shared by Young. Because of stipulations in the measure that funded the construction of the new museum building, the mayor controlled the board and, hence, controlled the museum. The museum's director and board put in place by Young pressured Wright to step down under the pretext that it was time for the next generation of leadership.

Infuriated and powerless to fight the mayor's machinations, Wright was even more incensed that the new museum's agenda veered away from the tradition of community activism, evident in the museum's move to no longer publish its newsletter or provide educational programming for youth.[20] By 1990, Wright relinquished his position as chairman of the board of trustees. He would no longer be directly involved in the museum he had helped to create.

For over twenty years, the MAAH's community-based agenda of black cultural enlightenment fought to stem the detrimental social impact of the problems of unemployment, poor schools, crime, and drug abuse brought on by the continued decline of Detroit's economic base. Shortly after the new larger museum opened in April 1997, a longtime board member lamented, "There are no longer people on the board who speak for those outside the gate," adding that "the nationalist community is outside the loop now. And so are the poor people and those folks who have historically been political activists."[21] In his assertion of authority, the imperious Young failed to honor the grassroots activism at the heart of the institution. He appropriated the museum as a symbol of his and black Detroit's rise to power—an emblem of black Detroit's legacy within the civic space of the city. However, it would be a bittersweet ascendancy for Young. Seven months after the opening of the $33.5 million building, Young, who left office in 1994, died at age seventy-nine from heart and respiratory failure.[22] The body of the four-term former mayor lay in state under the vast glass dome of the museum's dramatic rotunda. And in March 1998 the museum changed its name for the fourth time to become the Charles H. Wright Museum of African American History.[23]

Amid this whirlwind of change, MAAH failed to stay focused on local activism and its unique role as a community cultural center. To do otherwise proved challenging, as black museums in the 1980s were pressured to financially sustain themselves and become more like conventional institutions—bastions of high culture with wealthy trustees, new buildings, and exhibitions that appealed to mainstream audiences.[24] A move into a new building, while providing better visibility and facilities, often took black museums outside of those communities they had traditionally served. Additionally challenging was the fact that black urban enclaves—where forced segregation had given rise to Atlanta's Black Side, Chicago's Bronzeville, and Detroit's Paradise Valley—were devastated by the shift of manufacturing to outlying suburban areas and cheaper labor markets. These neighborhoods suffered the loss of their diverse class structures

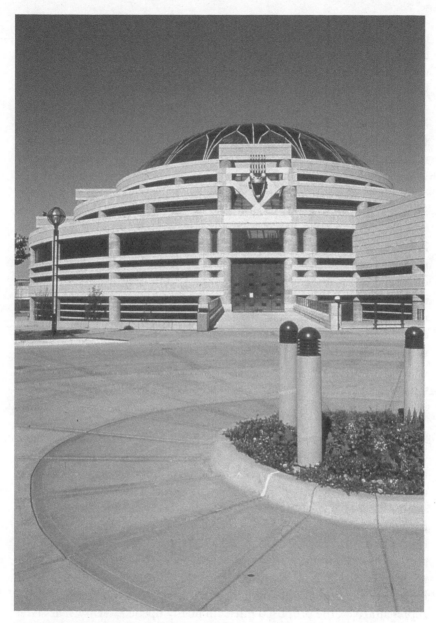

FIGURE 52. Charles H. Wright Museum of African American History, Detroit, 2001. Author's photograph.

and their black counterpublic spheres that maintained a range of commercial, educational, social, and civic institutions (although some church congregations stayed intact).[25] Local black museums faced, like all museums, competition from other modes of viewing such as television, which by its very nature could bring history-themed programming like *Roots* to national audiences. The sense of "one small nation of people" as described by Du Bois, embodying a black nation within a none-too-welcoming white one, once again raised a set of paradoxical imperatives for these institutions. On the one hand, black museums sought to foster wider acceptance of their mission to heighten the understanding of black contributions to national and world history by seeking alliances with municipal, state, and federal institutions. This was an avenue that Charles Wright and MAAH had pursued, much to the detriment of their original grassroots mission. On the other hand, despite wider acceptance, these museums still suffered from unequal distribution of resources, a consequence of structural antiblack racism that profoundly affected their ability to mount exhibitions and offer public programming.[26] Additionally up for debate (particularly with the expansion of older museums and the establishment of a new generation of institutions) was whether black history would continue to be represented as a distinct legacy, underscored by Black Nationalist and Pan-African ideologies, or would instead be absorbed into the mainstream of American values and ideals.

The terms under which black history might be integrated into the United States' mainstream museums and the nation's historical canon was again tested by the efforts to establish a national black museum in Washington, D.C., in the early 1990s (a descendent of both the project that Ferdinand Lee had proposed in 1915 and the effort that Wright had fought against in the 1960s). In April 1968, while Congress debated the bill to form the Commission on Afro-American History and Culture, an Ohio representative put forth another bill to establish a federally financed Negro history and culture museum to be located in Wilberforce, Ohio, home to the historic black schools of Wilberforce University and Central State University.[27] Through the indefatigable support of black congressional representatives, the proposed museum finally opened twenty years later as the National Afro-American Museum and Cultural Center. Some five hundred miles away from Washington, D.C., the new museum was, however, nowhere in the vicinity of the nation's capital; the new museum was "national" in name only. In 1984, supporters excited by the interest in black heritage generated by *Roots* and the growth in the number of lo-

cal black museums, which by 1988 numbered over two hundred—revived the idea for a national museum in the heart of the United States' symbolic landscape.[28] A campaign was launched to establish a national African American museum to be located in Washington, D.C.

A committee composed of several highly respected black historians and museum experts prepared an extensive report that outlined recommendations for the new museum.[29] The committee proposed that given the importance of the institution and its mission—one that had been excluded from the symbolic space of the nation's capital—the new museum should be located on the National Mall. In a twist of fate, the committee recommended that the Arts and Industries Building of the Smithsonian Institution, the original home of the U.S. National Museum that had housed the relics of Philadelphia's Centennial Exposition of 1876, be transformed to accommodate the new institution.[30] While the site was not an ideal structure for a contemporary museum's functions, the committee's proposal to place a museum dedicated to black history in the building that had housed the first national museum must be interpreted as a radical gesture to reposition the formerly marginalized history of blacks in America on the foundations of the nation's museological traditions. Around the same time, in 1992, artist Fred Wilson, in his groundbreaking exhibition "Mining the Museum," plumbed the depths of the Maryland Historical Society's collection to expose the "museum's denial" of its black history.[31] Spencer Crew, who would become the director of the National Museum of American History in 1994, curated the Smithsonian's landmark exhibit "From Field to Factory," an exhibit on the Great Migration that opened in 1987. From the mid-1980s onward, mainstream museums were being challenged to be more expansive and inclusive in their curatorial policies and philosophies.

In 1991 the Smithsonian Institution's trustees, who had long opposed the plan of a separate institution for black history, finally agreed to support the new national museum. Some observers complained, however, that the new institution would be half the size of the other Smithsonian museums on the mall. Representative Gus Savage of Illinois criticized that black American heritage would be once again stuck with "an old dilapidated building."[32] This group preferred that the proposed museum be granted monies for a new building. Others, including Burroughs from the DuSable Museum, opposed the Smithsonian's control of the project on the basis of the institution's legacy of excluding black history. Overall, these objections proved sufficient to prevent the bill from being passed in the House of Representatives. In the following congressional session

a similar version of the bill was introduced in the U.S. Senate. This time, southern conservative Senator Jesse Helms of North Carolina, who had already launched his attack on the immoral and un-American exhibitions funded by National Endowment for the Arts, blocked the bill on procedural grounds from making it to the Senate floor for a vote. A bigoted southern Democrat-turned-Republican during the civil rights era, who was already incensed that funding had been granted for the National Museum of the American Indian, Helms claimed the extensive report presented by the new African American museum's committee lacked a budget and plan for implementing the institution. Acutely aware of timing, Helms was able to delay a vote on the bill. The next election brought a stinging Republican victory, a return of racist Dixiecrats born again as the Christian Right. Their control of both houses of Congress hindered the museum bill's passage for several years. Fath Ruffins, a historian at the Smithsonian during this period, has linked Helms's obstruction to the way in which a national black museum would have challenged the regional mythos of the "Lost Cause."[33] This collective memory of the Confederacy defeat carried great currency for many decades, as Booker T. Washington and Major R. R. Wright discovered, when southern congressional representatives rejected proposals to fund national expositions celebrating the fiftieth anniversary of Emancipation.

Would the successful establishment of the proposed new museum hinge on abandoning the activist spirit that had been critical to black Americans' organization of prior fairs and grassroots museums (a possibility Wright had warned against) in order to make the national museum's content more palatable to mainstream audiences? Ruffins poses the question this way: "Is the story of black separation, isolation, and achievement against the odds of the primary narrative of meaning?" She goes on to posit that, "in most African American museums, some version of this narrative is absolutely central; it fulfills African American needs for a validating and distinctive history." But she also warns us that, "for other Americans troubled by the history of segregation, the great narrative of African American life has much more to do with integration into and acceptance by the mainstream of American life."[34] The tenor of this debate echoes the one that occurred a century earlier between the Black Side's fair organizers over whether they should accept the offer of a separate Negro Building at the Atlanta fairgrounds. In that case, factions had split into those who believed they could better control what they showed and how they were seen by having their own building, and those who thought they should fight for integration into the main spaces of the exhibition. A cen-

tury later this dilemma continued to be central to the national black museum debate, but in a different cultural, political, and economic context.

If we widen our sphere of analysis beyond the physical site, as we have done in the examples in the previous chapters, we can see that the symbolic space of the National Mall is also embedded within the urban space of the District of Columbia. With this in mind, it is important to acknowledge that, at the time of these debates in the 1990s about the viability of a national black museum, black Washingtonians made up well over half of the district's residents—although they were politically disenfranchised because they lacked elected representation in the U.S. Congress. Moreover, the district's local economy depended heavily on the federal government for employment, especially since its agencies and branches had taken the first steps to integrate their workforces in the 1940s and 1950s. The determination of the Republican Congress of the early 1990s to reduce the size of government—touted in the their "Contract with America"—meant the elimination of a source of employment that had provided upward mobility for many black residents living in the district and its outlying suburbs. Along with this Republican agenda emerged a new conservative racial project that circulated ideas and representations of black Americans and other minority groups as undeserving, dependent on the state, and dangerous, all of which justified the need to increase law enforcement. As these beliefs, first posited in the Reagan era, gained wider acceptance, they were linked to structural economic efforts that pushed black citizens and other minorities to rely less on state support and more on the supposedly robust private sector for jobs and services. Under the guise of fostering greater personal accountability, conservatives deprived black workers of those gains made through the labor movement, civil rights struggles, and the affirmative action programs that had been instituted to undo structural inequities brought about by centuries of racism.[35] If the proposed national museum in the 1990s was to carry on the legacy cultivated in the fairs and the grassroots museums of promoting black history as an activist practice in favor of civil rights and against prejudice and social injustice—an unlikely prospect given the proposed museum's stewardship by the Smithsonian—it would have clashed with the expansion of the New Right's agenda.

The national museum project was once again resurrected in 2002. This time congressional funding was successfully approved a year later. With what is now being called the National Museum of African American History and Culture (NMAAHC) opening in 2015, on a site bordering the Washington Monument and on the symbolic green of the National Mall,

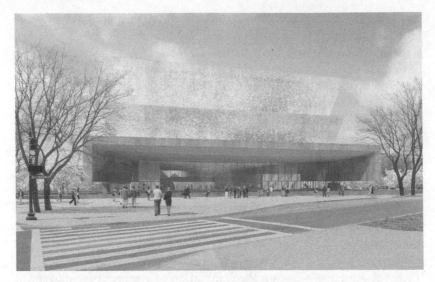

FIGURE 53. Design proposal by Freelon Adjaye Bond for the Smithsonian's National Museum of African American History and Culture, Washington, D.C., 2009. Courtesy of Smithsonian National Museum of African American History and Culture.

our efforts to understand the debates, activism, accomplishments, and failures of these earlier individuals and groups, events and institutions becomes even more timely.

Du Bois astutely predicted that over the course of the twentieth century the importance of cities would increase under the engine of industrial capitalism and that these urban centers in the United States would also be the places where blacks from the South and rural areas would migrate to live and work. Coincident with its allure, the Black Metropolis, as Horace Cayton and St. Clair Drake christened it, also tendered a host of social and economic challenges. These thriving black communities were settled by men and women—factory workers, preachers, doctors, laborers, beauticians, bankers, domestics, teachers, nurses, shopkeepers, singers, lawyers, hustlers, artists, writers, and newspapers publishers—who made the most of their professional and personal lives within the inequitable social spheres of the segregated American city. Through the emergence of a black counterpublic sphere and the cultural milieu of their neighborhoods, these enclaves provided their residents with opportunities for enrichment and advancement. The urban domains of Washington, D.C., for T. J. Calloway, Daniel P. Murray, and Mary Church Terrell; Atlanta

for Bishop Henry M. Turner, I. Garland Penn, and Du Bois; New York City for Du Bois, Alain Locke, and James Weldon Johnson; Philadelphia for Bishop R. R. Wright Jr. and John C. Asbury; Chicago for Ida B. Wells, Claude Barnett, Margaret Burroughs, and Horace Cayton; and Detroit for Snow Grigsby, John C. Dancy Jr., Charles Wright, and Audrey Smedley formed educational, political, religious, and cultural networks whose scope was national and international. These leaders' organizations, institutions, and associations contributed the exhibits, performances, and artworks that narrated the story of racial progress at the fairs; their organizations also helped finance and found the first black public museums. Regardless of racial prejudice's oppressive reach, the buildings, fairgrounds, converted houses, and neighborhoods that formed the social spaces of the fairs and museums also performed as public spaces in which black Americans could engage the imagination, cultivate new knowledge, and partake in reflection on their rich legacy in the United States and beyond. Regardless of whether they advocated accommodationism, civil rights, Pan-Africanism, socialism, communism, or black nationalism, these visionaries rethought and reimagined their national belonging and future roles in an emerging classed society. These leaders, scholars, activists, and artists created places where America's blacks were "shown to be studying, examining, and thinking of their own progress and prospects," as Du Bois had written about the "American Negro" exhibit in Paris.[36] A diverse black public comprised the audience, along with other racial groups, of these events and institutions. Black Americans' purpose was not to simply go to these events and visit these institutions—bearing witness to the symbolic pediments of the Negro Building, being entertained by the elaborate pageants, hearing the moving orations, or marveling and learning about the arts of Africa—but, as this book has shown, to see what they themselves had made. As Du Bois eloquently characterized the people who made up the "American Negro," they are "a small nation of people, picturing their life and development without apology or gloss, and above all *made by themselves*."[37]

Notes

INTRODUCTION

1. As chapters 4 and 5 examine in detail, the National Memorial Association proposed a national Negro memorial (and museum) in 1915. That same year, scholar Kelly Miller also conceived of a new national library of Negro Americana for Howard University's campus in Washington, D.C. In 1965 a white Democratic congressman from the Bronx, New York, James Scheuer, proposed a bill to form a committee to study the creation of a national Negro museum of history and culture.

2. Claudine Brown, *Final Report of the African American Institutional Study* (Washington, D.C.: Smithsonian Institution, 1991), 6–7.

3. Raoul Dennis, "Who Axed the African American Museum on the Mall?," *Crisis,* February–March 1998, 8–13.

4. Jacqueline Trescott, "Helms Stalls New Museum; Backers Still Hope to Free African American Project," *Washington Post,* September 29, 1994, D1.

5. Mabel O. Wilson, "Between Rooms 307," in *Sites of Memory: Perspectives on Architecture and Race,* ed. Craig Evan Barton (New York: Princeton Architectural Press, 2001), 13–26.

6. Chicago's DuSable Museum of African American History was founded as the Ebony Museum of Negro History and Art in 1961; Boston's Museum of the National Center for Afro-American Artists was founded in 1963 (it would later be called the Museum of the National Center for Afro-American History); and Detroit's Charles H. Wright Museum of African American History was established in 1965 as the International Afro-American Museum. An excellent overview of black history institution formation can be found in Fath Ruffins, "Mythos, Memory and History: African American Preservation Efforts, 1820–1990," in *Museums and Communities: The Politics of Public Culture,* edited by I. Karp and C. M. Kreamer (Washington, D.C.: Smithsonian Institution Press, 1992), 506–611.

7. See Robert Rydell, *All the World's a Fair* (Chicago: University of Chicago Press, 1984), and *World of Fairs* (Chicago: University of Chicago Press, 1993).

8. New York City held a world's fair, the Exhibition of the Industry of All Nations, in 1853–54. Philadelphia hosted a small regional fair in 1865, but it was the nation's first commemorative exposition held there, the 1876 Centennial Exhibition, that positioned the United States as an important international presence. Events in Boston and Louisville (1883), St. Louis (1884), New Orleans (1885), Buffalo (1889), Chicago (1893), and San Francisco (1894) followed. See Robert Muccigrosso, *Celebrating the New World: Chicago's Columbian Exposition of 1893,* The American Ways Series (Chicago: I. R. Dee, 1993); and Pieter van Wesemael, *Architecture of Instruction and Delight* (Amsterdam: 010 Publishers, 2001).

9. Rydell, *All the World's a Fair,* 4.

10. Ida B. Wells-Barnett and Robert W. Rydell, *The Reason Why the Colored American Is Not in the World's Columbian Exposition* (Urbana: University of Illinois Press, 1999).

11. Adam P. Green, *Selling the Race: Culture and Community in Black Chicago, 1940–1955* (Chicago: University of Chicago Press, 2006); Christopher Robert Reed, *All the World is Here! The Black Presence at White City,* Blacks in the Diaspora (Bloomington: Indiana University Press, 2000); Rydell, *All the World's a Fair;* Rydell, *World of Fairs;* Shawn Michelle Smith, *Photography on the Color Line: W. E. B. Du Bois, Race, and Visual Culture* (Durham, N.C.: Duke University Press, 2004); Deborah Willis, "The Sociologist's Eye: W. E. B. Du Bois and the Paris Exposition," in *A Small Nation of People: W. E. B. Du Bois and African American Portraits of Progress,* ed. the Library of Congress (New York: Amistad and Harper Collins, 2003), 51–76; Deborah Willis and Carla Williams, "The Black Female Body in Photographs from the World's Fairs and Expositions," *Exposure* 33, no. 1/2 (2000): 11–20; Theda Perdue, *Race and the Atlanta Cotton States Exposition of 1895,* Georgia Southern University Jack N. and Addie D. Averitt Lecture Series (Athens: University of Georgia Press, 2010).

12. The name Jim Crow was taken from a minstrel character. Typically performed by a white male in blackface, Jim Crow was first popular in the 1830s. See Eric Lott, *Love and Theft: Blackface Minstrelsy and the American Working Class,* Race and American Culture (New York: Oxford University Press, 1993); and Jan Nederveen Pieterse, *White on Black: Images of African and Blacks in Western Popular Culture* (New Haven, Conn.: Yale University Press, 1995).

13. Nancy Fraser, "Rethinking the Public Sphere: A Contribution to the Critique of Actually Existing Democracy," in *The Phantom Public Sphere,* ed. Bruce Robbins and Social Text Collective (Minneapolis: University of Minnesota Press, 1993), 1–32.

14. Jürgen Habermas, *The Structural Transformation of the Public Sphere: An Inquiry into a Category of Bourgeois Society,* Studies in Contemporary German Social Thought (Cambridge, Mass.: MIT Press, 1989); Bruce Robbins, ed., *The Phantom Public Sphere* (Minneapolis: University of Minnesota Press, 1993).

15. Fraser, "Rethinking the Public Sphere," 5.

16. Ibid., 14.

17. Ibid., 15.

18. Rosalyn Deutsche, *Evictions* (Cambridge, Mass.: MIT Press, 1996), "Questioning the Public Space," *Public* 6 (1992): 49–64, and "Art and Public Space: Questions of Democracy," *Social Text* 33 (1992): 34–52.

19. Arjun Appadurai et al., "The Black Public Sphere," *Public Culture* 7, no. 1 (1994): 11–14.

20. Michael C. Dawson, "A Black Counterpublic? Economic Earthquakes, Racial Agenda(s), and Black Politics," *Public Culture* 7 (1994): 199–200.

21. Reed, *All the World is Here!*

22. St. Clair Drake and Horace R. Cayton, *Black Metropolis: A Study of Negro Life in a Northern City* (New York: Harper and Row, 1945); Kevin Kelly Gaines, *Uplifting the Race: Black Leadership, Politics, and Culture in the Twentieth Century* (Chapel Hill: University of North Carolina Press, 1996); Reed, *All the World is Here!* Nikhil Pal Singh, *Black Is a Country: Race and the Unfinished Struggle for Democracy* (Cambridge, Mass.: Harvard University Press, 2004).

23. Geneviève Fabre, "African American Commemorative Celebrations in the Nineteenth Century," in *History and Memory in African American Culture*, ed. Geneviève Fabre and Robert O'Meally (New York: Oxford University Press, 1994), 73. Adam Green also notes the significance of this inflection in the black collective memory. See Adam P. Green, "Selling the Race: Cultural Production and Notions of Community in Black Chicago, 1940–1955" (Yale University, 1998).

24. "International Afro-American Museum (A Statement of Purpose)," n.d., Charles H. Wright Papers, Charles H. Wright Museum of African American History, Detroit.

25. In *The Production of Space,* Lefebvre identifies "social space" as a product of the relationships between people, making it indistinguishable from mental and physical space. Through its lived condition, social space supports the relations of production and reproduction of capitalism. Under capitalism (mercantile, industrial, and global), according to Lefebvre, the modern city presents itself not as an object but as a network of spaces and representations. Urban space ensures that the links are properly maintained between flows of energy, labor, commodities, and capital. See Henri Lefebvre, *The Production of Space,* trans. Donald Nicholson-Smith (Cambridge: Blackwell, 1991), 55. Also see Henri Lefebvre, *State, Space, World: Selected Essays,* trans. Gerald Moore, Neil Brenner, and Stuart Elden (Minneapolis: University of Minnesota Press, 2009).

26. Michael Omi and Howard Winant, *Racial Formation in the United States: From the 1960s to the 1980s,* Critical Social Thought (New York: Routledge and Kegan Paul, 1986), 56.

27. Ibid., 55. Racial formations include the paradigms of ethnicity, class, and nation, none of which alone can fully encompass "the specificity of race as an autonomous field of social conflict, political organization, and cultural/ideological meaning." Ibid., 48. Importantly, Omi and Winant link theories of cultural representation to structural issues of labor, class, and social phenomenon.

28. Ibid., 56.

29. Drake and Cayton, *Black Metropolis.*

30. Citing Chicago at the time of the World's Columbian Exposition in 1893, Reed notes that the elites "dominated black society in terms of status, but in absolute terms of their influence over all black society, their role was tenuous at

best." Reed, *All the World is Here!*, 83. Also see Davarian L. Baldwin, *Chicago's New Negroes: Modernity, the Great Migration, and Black Urban Life* (Chapel Hill: University of North Carolina Press, 2007).

31. Dawson, "A Black Counterpublic?," 197.

32. For the full mission statement by Lonnie Bunch, the NMAAHC's director, see Lonnie Bunch, "A Vision for the National Museum of African American Museum of History and Culture," n.d., http://nmaahc.si.edu/section/about_us.

PROLOGUE

1. *Lincoln Institute: Centennial Exhibit 1876* (Jefferson City, Mo.: Lincoln Institute, 1876).

2. Ibid., 8. The description of the Lincoln Institute's curriculum was written by Surgeon C. Allen, Captain Henry R. Parsons, Captain Harrison Du Bois, First Lieutenant A. M. Adamson, and First Lieutenant R. B. Foster.

3. Along with the former infantrymen who made the initial donations to start the school, other benefactors in the establishment of the Lincoln Institute were white philanthropists, including Rev. Charles Avery, Josiah King, and Thomas Howe. Ibid.

4. An illustrator by training, Frank Leslie served as an American commissioner to the Paris Exposition of 1867.

5. Anne McClintock, *Imperial Leather: Race, Gender, and Sexuality in the Colonial Conquest* (New York: Routledge, 1995), 357.

6. See Tony Bennett, *The Birth of the Museum* (London: Routledge, 1995), 193; and Timothy Mitchell, *Colonising Egypt* (Berkeley: University of California Press, 1991).

7. Senate, ed., *Message from the President of the United States, Transmitting an Exhibit of the Result of the United States Centennial Exhibition and Celebration of 1876* (Washington, D.C.: Government Printing Office, 1879), 10. Also see Robert Rydell, *World of Fairs* (Chicago: University of Chicago Press, 1993), 20–21.

8. "The Centennial Exhibition," *The Manufacturer and Building*, January 1876, 18, http://cdl.library.cornell.edu/cgi-bin/moa/moa-cgi?notisid=ABS1821-0008-51.

9. The Peale's Museum, founded in 1786 and named after its founder-artist Charles Wilson Peale, became the first museum to accession artifacts belonging to the United States' most prominent figures and significant national events. Philadelphia's other important institutions include the Library Company (1731), the American Philosophical Society (1743), the Philadelphia Academy of Natural Science (1812), the Athenaeum (1814), and the Historical Society of Pennsylvania (1824). See the excellent history of early museums in Philadelphia by Steven Conn, *Museums and American Intellectual Life, 1876–1926* (Chicago: University of Chicago Press, 1998), 34.

10. House of Representatives, Committee on Public Buildings and Grounds, ed. *Government Exhibits at the Centennial* (House of Representatives, 1877).

11. Rydell also adds, "The Smithsonian's exhibits, moreover, were at least as important in laying the groundwork for favorable reception of evolutionary

ideas about race in the United States as was the centennial visit to America of Thomas H. Huxley, popularizer of Darwin's theory of evolution." See Rydell, *World of Fairs*, 27.

12. W. E. B. Du Bois, *The Philadelphia Negro* (Philadelphia: University of Philadelphia Press, 1996).

13. For an excellent history of black American efforts to gain access to the Centennial Exhibition, see Philip S. Foner, "Black Participation in the Centennial of 1876," *Phylon* 39, no. 4 (1978): 283–96.

14. For a probing study of the historiography and creation of Lewis's *The Death of Cleopatra,* see Kirsten Pai Buick, *Child of the Fire: Mary Edmonia Lewis and the Problem of Art History's Black and Indian Subject* (Durham, N.C.: Duke University Press, 2010).

15. Foner, "Black Participation in the Centennial of 1876," 283.

16. Ibid.

CHAPTER I

1. For an extensive review of Penn's many activities prior to and following his involvement with the Atlanta Cotton States Exposition, see Joanne K. Harrison and Grant Harrison, *The Life and Times of Irvine Garland Penn* (Philadelphia: XLibris, 2000).

2. The Committee on the Colored Exhibit included former Republican governor Rufus Bullock, George W. Harrison, W. H. Venable, and J. G. Oglesby. See "Awakening of a Race," *Atlanta Constitution,* September 22, 1895, 24.

3. Kathleen Ann Clark, *Defining Moments: African American Commemoration and Political Culture in the South, 1863–1913* (Chapel Hill: University of North Carolina Press, 2005), 154–62.

4. The term *New Negro* has a history of usage long before its adoption by Alain Locke during the Harlem Renaissance. Scholar Henry Louis Gates notes that the *Cleveland Gazette* mentions the term regarding passage of the New York Civil Rights Law on June 29, 1895. See Henry Louis Gates, "The Face and the Voice of Blackness," in *Facing History: The Black Image in American Art, 1710–1940,* ed. Guy C. McElroy (San Francisco: Bedford Arts Publishers; Washington, D.C.: Corcoran Gallery of Art, 1990), 36.

5. The Negro commissioners were chosen on September 11, 1894. Walter G. Cooper, *The Cotton States and International Exposition and South, Illustrated* (Atlanta: The Illustrator Company, 1896), 57. The initial roster of Negro commissioners in January 1895 were Booker T. Washington, Alabama; A. E. P. Albert, Louisiana; Jesse Lawson, District of Columbia; M. M. Lewey, Florida; G. V. Clark, Tennessee; W. H. Crogman, Georgia; R. J. Perkins, West Virginia; Isaiah T. Montgomery, Mississippi; W. A. Hawkins, Maryland; J. B. Middleton, South Carolina; W. H. Stewart, Kentucky; W. C. Coleman, North Carolina; N. W. Cuney, Texas; and W. O. Emery, Arkansas. From *The Official Catalogue of the Cotton States and International Exposition, Atlanta Georgia, U.S.A. September 18 to December 31, 1895,* (Atlanta: Clafin Mellichamp, Publishers, 1895), 134.

6. August Meier, *Negro Thought in America, 1880–1915* (Ann Arbor: University of Michigan Press, 1988), 38.

7. "Progress of a Race," *Atlanta Constitution,* January 20, 1895, 17.

8. Ida B. Wells-Barnett and Robert W. Rydell, *The Reason Why the Colored American is Not in the World's Columbian Exposition* (Urbana: University of Illinois Press, 1999).

9. Christopher Robert Reed, *All the World is Here! The Black Presence at White City,* Blacks in the Diaspora (Bloomington: Indiana University Press, 2000).

10. Ibid., 129–30.

11. "Southern Railway for the Cotton States and International Exposition, Atlanta, Ga.," *Washington Bee,* September 14, 1895, 6.

12. "Progress of a Race," *Atlanta Constitution,* January 20, 1895, 17.

13. Cooper, *The Cotton States and International Exposition and South, Illustrated.,* 58. Also see *Atlanta Constitution,* January 20, 1895, 17.

14. For a thorough history of the white settlement of Atlanta, see Franklin M. Garrett, *Atlanta and Environs: A Chronicle of Its People and Events,* vol. 1 (Athens: University of Georgia Press, 1969), 225–28. Also see James Michael Russell, *Atlanta 1847–1890: City Building in the Old South and the New* (Baton Rouge: Louisiana State University Press, 1988), 267. For an excellent overview of the Georgia's transition from an agrarian economy to an industrial capitalist economy, see Joseph P. Reidy, *From Slavery to Agrarian Capitalism in the Cotton Plantation South: Central Georgia, 1800–1880,* Fred W. Morrison Series in Southern Studies (Chapel Hill: University of North Carolina Press, 1992).

15. David R. Goldfield and Blaine A. Brownell, *The City in Southern History: The Growth of Urban Civilization in the South* (Port Washington, N.Y.: Kennikat Press, 1977); Lawrence Harold Larsen, *The Rise of the Urban South* (Lexington, Ky.: University Press of Kentucky, 1985).

16. Among the original residents who settled Terminus, the original name of Atlanta, were a small group of blacks. During Atlanta's first twenty years, free blacks and slaves made up roughly 20 percent of Atlanta's population, see Howard N. Rabinowitz, *Race Relations in the Urban South, 1865–1890* (New York: Oxford University Press, 1978), 19; Campbell Gibson and Kay Jung, *Historical Census Statistics on Population Totals by Race, 1790 to 1990, and by Hispanic Origin, 1970 to 1990, for Large Cities and Other Urban Places in the United States* (Washington, D.C.: U.S. Census Bureau, Population Division, February 2005). Also see Claudia Dale Goldin, *Urban Slavery in the American South, 1820–1860: A Quantitative History* (Chicago: University of Chicago Press, 1976).

17. During the early phases of Reconstruction, black citizens, according to the 1870 census, made up 46 percent, or close to half, of Atlanta's 21,789 residents. Rabinowitz, *Race Relations in the Urban South, 1865–1890,* 19; Gibson and Jung, *Historical Census Statistics on Population Totals by Race, 1790 to 1990, and by Hispanic Origin, 1970 to 1990, for Large Cities and Other Urban Places in the United States.*

18. W. E. B. Du Bois, "The Negro in Business," in *Atlanta University Publications,* ed. Atlanta University and W. E. B. Du Bois (New York: Octagon Books, 1968), 8.

19. Darlene Clark Hine, *Speak Truth to Power: Black Professional Class in United States History* (Brooklyn, N.Y.: Carlson Pub., 1996), 39.

20. David R. Goldfield, "The Urban South: A Regional Framework," *The*

American Historical Review 85, no. 5 (1981): 1025–29; John Kellogg, "Negro Urban Clusters in the Postbellum South," *Geographical Review* 67, no. 3 (1977): 310–21; Rabinowitz, *Race Relations in the Urban South, 1865–1890,* 105–6.

21. Goldfield, *Race Relations in the Urban South, 1865–1890,* 34.

22. L. Donald Grant, *The Way It Was in the South: The Black Experience in Georgia* (Secaucus, N.J.: Carol Publishing Group, 1993), 215.

23. Rev. E. R. Carter, *The Black Side: A Partial History of the Business, Religious and Educational Side of the Negro in Atlanta, Ga.,* Black Heritage Library Collection (Freeport, N.Y.: Books for Libraries Press, 1971), 22.

24. Bishop Henry McNeal Turner, introduction to *The Black Side,* by Carter, 8.

25. Russell, *Atlanta, 1847–1890,* 179–81; Grant, *The Way It Was in the South,* 157, 278. Also see Kevin Kelly Gaines, *Uplifting the Race: Black Leadership, Politics, and Culture in the Twentieth Century* (Chapel Hill: University of North Carolina Press, 1996), 23.

26. By 1890, the Black Side of Atlanta comprised 42.9 percent of the city's population, down slightly from 43.7 percent in 1880 but still close to half of the city's residents. Ronald H. Bayor, *Race and the Shaping of Twentieth-Century Atlanta,* Fred W. Morrison Series in Southern Studies (Chapel Hill: University of North Carolina Press, 1996), 7; Gibson and Jung, *Historical Census Statistics on Population Totals by Race, 1790 to 1990, and by Hispanic Origin, 1970 to 1990, for Large Cities and Other Urban Places in the United States.*

27. Du Bois, "The Negro Common School," 16.

28. Gaines, *Uplifting the Race,* 4–5.

29. W. E. B. Du Bois, "The College Bred Negro," in *Atlanta University Publications,* ed. Atlanta University and W. E. B. Du Bois (New York: Octagon Books, 1968), 12–13; and "The Freedman's Bureau," *Atlantic Monthly,* March 1901.

30. Meier, *Negro Thought in America, 1880–1915,* 88.

31. In a few years, black church organizations were also able to start Morris Brown College in 1880, followed by Spelman Seminary in 1881. Carter, *The Black Side,* 28–35; Garrett, *Atlanta and Environs,* 1:823.

32. Garrett, *Atlanta and Environs,* 1:743–44.

33. See Carter, *The Black Side,* 20; and Garrett, *Atlanta and Environs,* 1:742.

34. Booker T. Washington, *Up from Slavery* (New York: Oxford University Press, 1995), 43.

35. Kenrick Ian Grandison, "The Black College Campus as a Cultural Record of Postbellum America," in *Sites of Memory: Perspectives on Architecture and Race,* ed. Craig Evan Barton (New York: Princeton Architectural Press, 2001), 73. For a lengthier exploration, see Kenrick Ian Grandison, "Negotiated Space: The Black College Campus as a Cultural Record of Postbellum America," *American Quarterly* 51, no. 3 (1999): 529–79.

36. An excellent detailed account of the post–Civil War transition from a slave-based agricultural economy to an equally exploitative land-lease system appears in Reidy, *From Slavery to Agrarian Capitalism in the Cotton Plantation South.*

37. In his urban history of nineteenth-century Atlanta, Russell analyzes economic data, maps, and population statistics to discern the absence of a complete rupture with previous economic structures. See Russell, *Atlanta, 1847–1890,* 147.

Also see the special issue of *Journal of Southern History* (November 2001): 4, 67. Barbara J. Fields and Harold D. Woodman write informative essays in that same issue. Also see Rabinowitz, *Race Relations in the Urban South, 1865–1890*. For further reading on the impact of Woodward's history, see John B. Boles and Bethany L. Johnson, *Origins of the New South Fifty Years Later: The Continuing Influence of a Historical Classic* (Baton Rouge: Louisiana State University Press, 2003).

38. Henry W. Grady, "The New South—A Speech Delivered at the Banquet of the New England Society, New York, December 21, 1886," in *The Complete Orations and Speeches of Henry W. Grady*, ed. Edwin DuBois Shurter (Norwood, Mass.: Norwood Press, 1910), 19. Also see Harold E. Davis, *Henry Grady's New South: Atlanta, a Brave and Beautiful City* (Tuscaloosa: University of Alabama Press, 1990).

39. Franklin M. Garrett, *Atlanta and Environs: A Chronicle of Its People and Events*, vol. 2 (Athens: University of Georgia Press, 1969), 29.

40. Fêting the rise of "the phoenix from the ashes" of the Civil War, Atlanta's oft-used metaphor of rebirth, the exposition would demonstrate how far Atlanta had progressed since the war. Even those who had been dispatched to vanquish the Confederate menace from the city attended the International Cotton Exposition. It was General Tecumseh Sherman, the Union leader who had torched the city to the ground, who remarked upon seeing the beautifully landscaped grounds, "I have come today to look upon these buildings where once we had battlefields." Ibid., 33.

41. "At the Exposition," *Atlanta Constitution*, December 29, 1881, 2.

42. Garrett, *Atlanta and Environs*, 2:34.

43. After much debate, the group purchased from the family of an original Terminus settler an old farmstead located a few miles north and outside of the city limits. Originally from the *Atlanta Constitution*, March 22, 1887; see Garrett, *Atlanta and Environs*, 2:137.

44. William A. Pledger, the son of a slaveowner, was a graduate of Atlanta University. He was a newspaper editor and lawyer and would eventually become president of the National Afro-American Press Association. See James Sullivan Clarkson to Booker T. Washington, February 25, 1896, Booker T. Washington Papers, www.historycooperative.org/btw. For a discussion of Philip Joseph's journalistic activities, see Henry Lewis Suggs, *The Black Press in the South, 1865–1979*, Contributions in Afro-American and African Studies No. 74 (Westport, Conn.: Greenwood Press, 1983), 26.

45. "At the Exposition," *Atlanta Constitution*, December 29, 1881, 5.

46. "Will It Come Here?" *Atlanta Constitution*, June 23, 1887, 5.

47. "Colored Commissioners to be Elected to World's Exposition," *Cleveland Gazette*, August 23, 1884, 2; "Through the City," *Atlanta Constitution*, September 1819, 84; Suggs, *The Black Press in the South, 1865–1979*, 27.

48. For an excellent history of New Orleans slave trade, see Walter Johnson, *Soul by Soul: Life Inside the Antebellum Slave Market* (Cambridge, Mass.: Harvard University Press, 1999). Also see "Lands and Labor South," *New York Times*, December 27, 1884, 5.

49. "Negro Exhibit at New Orleans," *Washington Post,* January 12, 1885, 1; "Register Bruce," *Chicago Daily Tribune,* December 13, 1884, 8.

50. Robert Rydell, *All the World's a Fair* (Chicago: University of Chicago Press, 1984), 80–81.

51. "The Colored Exposition," *Atlanta Constitution,* July 27, 1887, 8.

52. "Atlanta the Place," *Atlanta Constitution,* July 2, 1887, 7; "A Charter Asked For," *Atlanta Constitution,* July 17, 1887, 11.

53. "Will It Come Here?" *Atlanta Constitution,* June 23, 1887, 5.

54. "Did Not Come Up," *Atlanta Constitution,* August 1, 1888, 5.

55. Other southern international fairs were held in Louisville, Kentucky, in 1883 and New Orleans in 1885.

56. See "An Exposition Next Year," *Atlanta Constitution,* December 15, 1893, 4; and "Atlanta and Her Exposition" and "The Gateway-Atlanta Is the Center of a Vast and Important Region," *Atlanta Constitution,* December 24, 1893, 4.

57. See Cooper, *The Cotton States and International Exposition and South, Illustrated,* 5; and Garrett, *Atlanta and Environs,* 2:313.

58. Cooper, *The Cotton States and International Exposition and South, Illustrated,* 5.

59. Garrett, *Atlanta and Environs,* 2:285; Cooper, *The Cotton States and International Exposition and South, Illustrated.*

60. See Cooper, *The Cotton States and International Exposition and South, Illustrated,* 5; Garrett, *Atlanta and Environs,* 2:313.

61. Anonymous, *Preliminary Prospectus of the Cotton States and International Exposition Company* (Atlanta: Franklin Printing and Publishing, 1894), 1. The first page of an early brochure for the exposition featured a map of the Northern and Southern Hemispheres of the Americas. It pinpointed Atlanta as the center of a trade hub, with its spokes radiating outward to connect through Port au Prince to Caracas; through Tampa, Key West, Havana, Colon, Panama, on to Quito; through Montgomery, Mobile, New Orleans, to Mexico; and through Washington, Baltimore, Philadelphia, New York, to Boston. Ibid., 10.

62. Clark Howell, "The Cotton States and International Exposition," *American Monthly Review of Reviews,* January 1895, 165. Intent on flexing its imperial muscle, the U.S. government considered digging a channel across Nicaragua to open a sister canal to the one planned for Panama. This new trade route would shorten the distance between New Orleans and San Francisco and open numerous new markets for American goods.

63. Anonymous, *Prospectus of the Cotton States and International Exposition to be Held at Atlanta* (Atlanta: C. P. Byrd, 1895), 7.

64. Henry M. Turner, "Strong Negro Endorsements," *Atlanta Constitution,* January 7, 1894, 17. Rucker also expressed his indignation at being excluded from the World's Columbian Exposition.

65. "One Feature of Our Exposition," *Atlanta Constitution,* January 5, 1894, 4.

66. Cooper, *The Cotton States and International Exposition and South, Illustrated,* 8.

67. I. Garland Penn, "The Awakening of a Race," in *The Cotton States and International Exposition and South, Illustrated,* ed. Walter G. Cooper (Atlanta:

The Illustrator Company, 1896), 59. Penn's essay was first published in the *Atlanta Constitution,* September 22, 1895.

68. See Hortense Spillers, "Mama's Baby, Papa's Maybe: An American Grammar Book," *Diacritics* 17, no. 2 (Summer 1987): 64–81; Cheryl I. Harris, "Whiteness as Property," in *Critical Race Theory: The Key Writings that Formed the Movement,* ed. Kimberlé Crenshaw (New York: New Press, distributed by W. W. Norton, 1995), 357–83.

69. "The Ohio Color Line," *Atlanta Constitution,* February 10, 1894, 4.

70. Anonymous, *Preliminary Prospectus of the Cotton States and International Exposition Company,* 12.

71. See "The Ida Wells Crusade," editorial, *Atlanta Constitution,* August 2, 1894, 4. Other scathing attacks were launched against Wells in "A Northern Negro Outrage," *Atlanta Constitution,* June 30, 1894, 4; "The Ida Wells Crusade," editorial, *Atlanta Constitution,* July 29, 1894, 18; and "The English Anti-Lynchers," *Atlanta Constitution,* January 19, 1895, 4.

72. Wells-Barnett and Rydell, *The Reason Why the Colored American Is Not in the World's Columbian Exposition;* Elliot Rudwick and August Meier, "Black Man in the 'White City': Negroes and the Columbian Exposition 1893," *Phylon* 26, no. 4 (1965): 354–61.

73. Quoted in Reed, *All the World is Here!,* 174–75.

74. Ibid., 101.

75. Smith W. Easley, C. C. Wimbush, and H. A. Rucker to Booker T. Washington, February 9, 1894, Booker T. Washington Papers, www.historycooperative.org/btw.

76. "A Feature the Exposition Will Be the Colored People's Building," *Atlanta Constitution,* March 23, 1894, 5.

77. Washington, *Up from Slavery,* 121.

78. Cooper, *The Cotton States and International Exposition and South, Illustrated,* 27–28.

79. Washington, *Up from Slavery,* 122; E. H. Webster, "The Atlanta Exposition," *Bulletin of Atlanta University,* February 1895, 2. Also see Irving Garland Penn to Booker T. Washington, February 14, 1895, Booker T. Washington Papers, www.historycooperative.org/btw.

80. "The Negro in Atlanta," *Savannah Tribune,* July 20, 1895.

81. "To the Colored Citizens of Alabama from Booker T. Washington," February 28, 1895, Booker T. Washington Papers, www.historycooperative.org/btw.

82. William Crogman, "Negro Building at the Atlanta Exposition," *Atlanta University Bulletin,* February 1895, 3.

83. I. Garland Penn, "Negro Building at the Atlanta Exposition," *Bulletin of Atlanta University,* May 1895, 3.

84. "Penn on His Work," *Atlanta Constitution,* August 22, 1895, 9.

85. See *Atlanta Constitution,* April 3, 1894, 8.

86. The full terrain of Piedmont Park, home to the earlier Piedmont fair, provided a relatively flat site, with slight rolling hills typical of this region of Georgia. The park contained the clubhouse, grandstands, and a half-mile racetrack. An additional ninety acres of high ground overlooking the city was annexed for the fair. The site was situated advantageously two miles from Union Depot, the

city's main train station. And railroad tracks already connected directly from the site to the Richmond and Danville Railroad. See Anonymous, *Prospectus of the Cotton States and International Exposition to be Held at Atlanta*, 2. Three electric lines provided ample wattage for machinery and lighting. And streets were freshly paved with asphalt leading from downtown to the fairgrounds. See Anonymous, *Preliminary Prospectus of the Cotton States and International Exposition Company*, 11.

87. See *Atlanta Constitution*, March 18, 1894, 18.

88. For a review of Gilbert's involvement in the fair, see F. H. Boyd Coons, "The Cotton States and International Exposition in the New South—Architecture and Implications" (master's thesis, University of Virginia, 1988).

89. Bradford Gilbert, "The Architectural Features of the Atlanta Exposition," *Harpers Weekly*, September 1895, 892. Architects most often utilized the neo-Romanesque details characterized by massive volumes, simple lines, and large archways in the design of large utilitarian buildings such as hotels and rail terminals. Kathleen Curran, *The Romanesque Revival: Religion, Politics, and Transnational Exchange*, Buildings, Landscapes, and Societies Series 2 (University Park: Pennsylvania State University Press, 2003), 226, 242.

90. Don Harrison Doyle, *New Men, New Cities, New South: Atlanta, Nashville, Charleston, Mobile, 1860–1910*, Fred W. Morrison Series in Southern Studies (Chapel Hill: University of North Carolina Press, 1990), 48.

91. Gilbert, "The Architectural Features of the Atlanta Exposition," 892.

92. Ibid., 893.

93. *Savannah Tribune*, "Atlanta Exposition—Other Notes," April 13, 1895, 2.

94. *Atlanta Constitution*, "The Colored Exhibit," April 3, 1895, 8

95. Gilbert, "The Architectural Features of the Atlanta Exposition," 893.

96. *The Official Catalogue of the Cotton States and International Exposition Atlanta Georgia, U.S.A. September 18 to December 31, 1895.*

97. *Report of the Board of Management: United States Government Exhibit; Cotton States and International Exposition Atlanta, Ga., 1895.* (Washington, D.C., 1897), 134.

98. Rydell, *All the World's a Fair*, 19.

99. Ibid., 101.

100. H. R. Butler, "What Is the Negro Doing," *Atlanta Constitution*, October 13, 1895, 3.

101. Penn states the amount of the contract at $9,651. Penn, "Negro Building at the Atlanta Exposition." By comparison, the cost of the Women's Building (17,000 sq. ft.) was $30,000, the Georgia State Building (12,200 sq. ft.) was $8,000 and the U.S. Government Building (46,800 sq. ft.) was $49,760.57. *Report of the Board of Commissioners Representing the State of New York at the Cotton States and International Exposition held at Atlanta, Georgia 1895* (Albany, N.Y.: Wynkoop Hallenbeck Crawford Company, 1896), 34.

102. Penn, "Negro Building at the Atlanta Exposition"' *Savannah Tribune*, April 13, 1895, 2

103. Penn, "The Awakening of a Race," 63.

104. "Penn on His Work," *Atlanta Constitution*, August 22, 1895, 9.

105. Penn, "The Awakening of a Race," 60.

106. Ibid.

107. Miss Alice M. Bacon, *The Negro and the Atlanta Exposition*, Occasional Papers (Baltimore, Md.: Trustees of the John Slater Fund, 1896), 7.

108. Ibid.

109. Penn, "The Awakening of a Race," 60.

110. George S. Mabry, *A Sketch of Alamance County, N.C. for the Colored Exhibit to the Cotton States and International Exposition, Atlanta, Ga., U.S.A.* (1895).

111. Penn, "The Awakening of a Race," 61.

112. Ibid.

113. Webster, "The Atlanta Exposition."

114. Penn, "The Awakening of a Race," 60.

115. L. W. B., "Is He a New Negro?," *Chicago Inter Ocean*, September 28, 1895, 7.

116. Penn, "The Awakening of a Race," 60.

117. "The Negro Congress," *Atlanta Constitution*, December 27, 1895, 8.

118. "On the First Day. A Colored Orator Has Been Invited to Participate in the Opening," *Atlanta Constitution*, August 23, 1895, 9.

119. Irving Garland Penn to Booker T. Washington, August 12, 1895, Booker T. Washington Papers, www.historycooperative.org/btw.

120. Washington, *Up from Slavery*, 126.

121. See the history of the National Medical Association by Charles Wright, *The National Medical Association Demands Equal Opportunity: Nothing More, Nothing Less* (Southfield, Mich.: Charro Book Company, 1995).

122. Washington, *Up from Slavery*, 127.

123. James Creelman, "South's New Epoch; A Negro Moses Spoke for a Race; Creelman Story of the Great Day," *New York World*, September 19, 1895, Booker T. Washington Papers, 3–17, www.historycooperative.org/btw.

124. Washington, *Up from Slavery*, 128–30.

125. See "What They are Saying," *Atlanta Constitution*, September 21, 1895, 4; and "As Our Brothers See Us," *Atlanta Constitution*, September 22, 1895, 16.

126. James Creelman, "South's New Epoch; A Negro Moses Spoke for a Race; Creelman Story of the Great Day," *New York World*, September 19, 1895, Booker T. Washington Papers, 3–17, www.historycooperative.org/btw.

127. L. W. B., "Is He a New Negro?"

128. "Apologizing for Wrongs," *Washington Bee*, October 19, 1895, 4.

129. "Negro Editors Meet," *Atlanta Constitution*, November 22, 1895, 11.

130. Minutes, January 21, 1896, Bethel Literary and Historical Association, p. 39, Folder 6, Bethel Literary and Historical Association Papers, Manuscript Division, Moorland-Spingarn Research Center, Howard University, Washington, D.C.

131. See Sharon F. Patton, *African-American Art*, Oxford History of Art (Oxford: Oxford University Press, 1998), 97.

132. Penn, "The Awakening of a Race," 61.

133. An excellent comparison of Tanner and Edmonia Lewis can be found in Kirsten Pai Buick, *Child of the Fire: Mary Edmonia Lewis and the Problem of*

Art History's Black and Indian Subject (Durham, N.C.: Duke University Press, 2010). Also see Albert Boime, "Henry Ossawa Tanner's Subversion of Genre," *The Art Bulletin* 75, no. 3 (1993): 415–42; S. Patton, *African-American Art;* Guy C. McElroy, ed., *Facing History: The Black Image in American Art, 1710–1940* (San Francisco: Bedford Arts Publishers; Washington, D.C.: Corcoran Gallery of Art, 1990). According to historian Wilson J. Moses, Turner was the most articulate spokesman of African repatriation after Reconstruction. Wilson Jeremiah Moses, *The Golden Age of Black Nationalism, 1850–1925* (Hamden, Conn.: Archon Books, 1978), 200–201.

134. L. W. B., "Is He a New Negro?"

135. The *Constitution* reported on Turner's trip to Africa. See "Bishop Turner" and "Bishop Turner Back," *Atlanta Constitution,* June 27, 1894, and July 5, 1895, 4.

136. "Negro Editors Meet," *Atlanta Constitution,* November 22, 1895, 11.

137. Reed, *All the World is Here!*

138. "Congress on Africa," *Savannah Tribune,* December 7, 1895; "Negro Meetings," *Atlanta Constitution,* December 5, 1895, 16.

139. From an essay by Turner in J. W. E. Bowen, ed., *African and the American Negro: Addresses and Proceedings of the Congress on Africa* (Atlanta: Gammon Theological Seminary, 1876), 196.

140. Gaines, *Uplifting the Race,* 39.

141. See Erlene Stetson, "Black Feminism in Indiana, 1893–1933," *Phylon* 44, no. 4 (1983): 8–9. Also see " 'New' Negro Woman," *Atlanta Constitution,* December 22, 1895, 22; and "The Negro Congress," *Atlanta Constitution,* December 28, 1895, 8.

142. Bacon, *The Negro and the Atlanta Exposition,* 28.

143. Minutes, January 21, 1896, Bethel Literary and Historical Association, p. 39, Folder 6, Bethel Literary and Historical Association Papers, Manuscript Division, Moorland-Spingarn Research Center, Howard University, Washington, D.C.

144. Bacon, *The Negro and the Atlanta Exposition,* 25.

145. Remson Crawford, "The Atlanta Exposition," *Atlantic Monthly,* September 14, 1895, 873.

146. "See the Fair Judge Seymour's Comment on the Exposition," *Daily Picayune,* November 7, 1895, 3.

147. "Negro Day," *Atlanta Constitution,* October 20, 1895, 16.

148. On the south side of the Midway's lane were the Rocky Mountain Ponies, Monkey Paradise, Indian Village, Chinese Village, German Village, Animal Arena, Living Pictures, and Beauty Show. And on the north side of the lane fairgoers could visit the Exhibit Train Shed, Phoenix (Ferris) Wheel, Gold Mine, Little World, Moorish Palace, Café Theater, Streets of Cairo, and the Mythic Maze.

149. "The Atlanta International Exposition," *Leslie's Weekly,* October 24, 1895, 270.

150. L. W. B., "Is He a New Negro?"

151. Maude Adams, "The Midway at the Atlanta Exposition," *Harper's Weekly,* November 23, 1895, 1109.

152. "The Great Southern Exposition," *New York Observer,* June 27, 1895, 864.

153. Cooper, *The Cotton States and International Exposition and South, Illustrated.*

154. As art historian Jonathan Crary writes, stereoscopes operated "on the visual priority of the object closest to the viewer and on the absence of any mediation between eye and image." Jonathan Crary, *Techniques of the Observer: On Vision and Modernity in the Nineteenth Century* (Cambridge, Mass.: MIT Press, 1996), 127.

155. "Booker T. Washington Denounced," *Washington Bee,* October 26, 1895, 1.

156. Washington, *Up from Slavery,* 129.

CHAPTER 2

1. T. J. Calloway was born in Cleveland, Tennessee, in 1866 and was educated at Fisk University. See biographical information in Henry Davenport Northrop, Joseph R. Gay, and I. Garland Penn, *The College of Life or Practical Self-Educator: A Manual of Self-Improvement for African Americans* (Chicago: C. J. Harris, 1993), 64–67.

2. See Robert Rydell, *All the World's a Fair* (Chicago: University of Chicago Press, 1984). Also see "Gather for a Fete," *Chicago Tribune,* May 1, 1897, 9.

3. Ruth Winton, "Negro Participation in Southern Expositions, 1881–1915," *The Journal of Negro Education* 26, no. 1 (1947): 34–43.

4. "The Tennessee Exposition," *New York Times,* May 2, 1897, 1. Tennessee's Negro Building was designed by Fred Thompson, who later became known for his elaborate "exotic" structures at Luna Park on Coney Island. See Woody Register, *The Kid of Coney Island: Fred Thompson and the Rise of American Amusements* (New York: Oxford University Press, 2001), 52–53.

5. Even though it was published in Washington, D.C., the *Colored American,* of which Calloway was briefly managing editor, was at one time financially supported by the Tuskegee Institute and often published essays by Washington. August Meier, *Negro Thought in America, 1880–1915* (Ann Arbor: University of Michigan Press, 1988), 226.

6. Although Calloway's specific contribution to the Atlanta Cotton States and International Exposition is noted in David Levering Lewis's essay, "A Small Nation of People," the official history and other primary sources fail to note it. See David Levering Lewis, "A Small Nation of People," in *A Small Nation of People: W. E. B. Du Bois and African American Portraits of Progress,* ed. the Library of Congress (New York: Amistad and Harper Collins, 2003), 24.

7. Thomas Junius Calloway to Booker T. Washington, October 4, 1899, Booker T. Washington Papers, www.historycooperative.org/btw. Calloway also published a history of Tuskegee and Washington; see Thomas Junius Calloway, "Booker Washington and the Tuskegee Institute," *New England Magazine,* October 1897, 131–47.

8. *Colored American,* November 25, 1899, 3.

9. Booker T. Washington to William McKinley, October 24, 1899, Booker T.

Washington Papers, www.historycooperative.org/btw; "The American Negro Exhibit," *Colored American,* November 3, 1900, 2.

10. *Report of the Commissioner-General for the United States to the International Universal Exposition, Paris, 1900* (Washington, D.C.: Government Printing Office, 1901), 2:336. Desirous of an impressive showing, the head of the NEA committee, William T. Harris, the federal commissioner of education, thought it might be wise to pool the expertise of leading innovators in industrial education.

11. "Negro School Exhibit at Paris," *Washington Post,* November 3, 1899, 11.

12. Anonymous, "The Negro Exhibit," *Star,* December 14, 1899.

13. "Negro at Paris," *Colored American,* January 6, 1900, 8.

14. "Negro at Paris," *Colored American,* January 6, 1900, 8; "Negro Exhibit at Paris" *Colored American,* December 16, 1900, 1.

15. "The Negro Exhibit in Paris," *Washington Post,* December 13, 1899, 11.

16. Thomas Junius Calloway, "The Negro Exhibit," in *Report of the Commissioner-General for the United States to the International Universal Exposition, Paris, 1900* (Washington, D.C.: Government Printing Office, 1901), 2:463.

17. Editorial, *AME Church Review* 16, no. 3 (January 1900): 381, Box 102–5, Folder 144, Mary Church Terrell Papers, Moorland-Spingarn Research Center, Howard University, Washington, D.C.

18. Calloway would eventually dismiss Shepard in a dispute widely publicized in the press. Labeled an anarchist in the mainstream newspapers, Shepard held what were perceived to be inflammatory views on race relations by espousing that blacks should retaliate for violent treatment—namely lynching—at the hands of whites. Shepard allegedly spread his antisegregationist views while he traveled through the South as an agent for "American Negro" exhibit. See "Mr. Hilyer Off for the South," *Colored American,* February 10, 1900, 10; and "To Make Negro Traitors," *Washington Post,* March 1, 1900, 11.

19. Miss Alice M. Bacon, *The Negro and the Atlanta Exposition,* Occasional Papers (Baltimore: Trustees of the John Slater Fund, 1896), 19–21. And also see Minutes, January 21, 1896, Bethel Literary and Historical Association, p. 39, Folder 6, Bethel Literary and Historical Association Papers, Moorland-Spingarn Research Center, Howard University, Washington, D.C.

20. W. E. B. Du Bois, "The Cultural Missions of Atlanta University," *Phylon* 3, no. 2 (1942): 108.

21. Ibid. Also see George A. Towns, "Phylon Profile 16 Horace Bumstead, Atlanta University President," *Phylon* 9, no. 2 (1948): 109–14.

22. Ibid., 111–12.

23. David Levering Lewis, *W. E. B. Du Bois: Biography of a Race, 1868–1919* (New York: Henry Holt and Company, 1993), 217–18.

24. Atlanta University, "Mortality among Negroes in Cities," in *Atlanta University Publications,* ed. Atlanta University and W. E. B. Du Bois (New York: Octagon Books, 1968), 4–6.

25. Ibid., 3.

26. Lewis, *W. E. B. Du Bois: Biography of a Race, 1868–1919,* 217–18.

27. W. E. B. Du Bois, *The Philadelphia Negro* (Philadelphia: University of Philadelphia Press, 1996), 1.

28. For an excellent overview of *The Philadelphia Negro,* see the chapter "Urban Pathology and the Limits of Social Research" in Kevin Kelly Gaines, *Uplifting the Race: Black Leadership, Politics, and Culture in the Twentieth Century* (Chapel Hill: University of North Carolina Press, 1996). Also see Shane Vogel, *The Scene of Harlem Cabaret: Race, Sexuality, Performance* (Chicago: University of Chicago Press, 2009), 139–46.

29. Du Bois convened the conferences on an annual basis until 1913. They were divided into two series, with the second series updating the data and conclusions drawn from the first ten conferences. Along with the initial four meetings, the other conferences in the first series were "The College Bred Negro" (1900), "The Negro Common School" (1901), "The Negro Artisan" (1902), "The Negro Church" (1903), "Some Notes on Negro Crime" (1904), concluding with "A Select Bibliography of the Negro American" (1905). The second series of conferences were "The Health and Physique of the Negro American" (1906), "Economic Co-operation among Negro Americans" (1907), "The Negro American Family" (1908), "Efforts for Social Betterment among Negro Americans" (1909), "The College Bred Negro American" (1910), "The Common School and the Negro American" (1911), "The Negro American Artisan" (1912), and "Moral and Manners among Negro Americans" (1913).

30. W. E. B. Du Bois, "The Negro in Business," in *Atlanta University Publications,* ed. Atlanta University and W. E. B. Du Bois (New York: Octagon Books, 1968), 7–13.

31. The study was sent, for example, to the U.S. Bureau of Labor, the U.S. Census Office, Harvard University, Wellesley University, the Hampton Institute, and the Tuskegee Institute as well as to physicians, insurance companies, magazines, and newspapers.

32. W. E. B. Du Bois, "A Pagaent in Seven Decades," in *W. E. B. Du Bois Speaks,* ed. Philip S. Foner (New York: Pathfinder Books, 1991), 38.

33. In the speech "The Study of the Negro Problems," delivered in 1897 before the American Academy of Political and Social Science, he noted that "the new study of the American Negro must avoid such misapprehensions from the outset by insisting that historical and statistical research has but one object, the ascertainment of the facts as to the social forces and conditions of one-eighth of the inhabitants of the land. Only by such rigid adherence to the true object of the scholar, can statesmen and philanthropists of all shades of belief be put into possession of a reliable body of truth which may guide their efforts to best and largest success." W. E. B. Du Bois, "The Study of Negro Problems," in *W. E. B. Du Bois Speaks,* ed. Philip S. Foner (New York: Pathfinder Books, 1991), 117.

34. *Report of the Commissioner-General for the United States to the International Universal Exposition, Paris, 1900* (Washington, D.C.: Government Printing Office, 1901), 1:17.

35. Ibid., 69.

36. Ibid., 33.

37. *Catalogue of the Exhibitors in the United States Sections of the International Universal Exposition, Paris 1900* (Paris: Société Anonyme des Imprimeries Lemercier, 1900), 6; *Report of the Commissioner-General for the United States to the International Universal Exposition, Paris, 1900,* 1:15.

38. Robert Rydell, "Gateway to the 'American Century': The American Representation at the Paris Universal Exposition of 1900," in *Paris 1900,* ed. Diane P. Fischer (New Brunswick, N.J.: Rutgers University Press, 1999), 133.

39. *Report of the Commissioner-General for the United States to the International Universal Exposition, Paris, 1900,* 1:31.

40. F. Hopkinson Smith, "The Pictorial Side of the Exposition of 1900," *Outlook,* January 5, 1901, 67.

41. "The United States Government Building at the Paris Fair," *American Monthly Review of Reviews,* March 1900, 346–47.

42. *Report of the Commissioner-General for the United States to the International Universal Exposition, Paris, 1900,* 2:284.

43. Pieter van Wesemael, *Architecture of Instruction and Delight* (Amsterdam: 010 Publishers, 2001), 408; *Report of the Commissioner-General for the United States to the International Universal Exposition, Paris, 1900,* 2:284.

44. *Report of the Commissioner-General for the United States to the International Universal Exposition, Paris, 1900,* 1:54.

45. Ibid., 2:394.

46. Ibid., 2:407.

47. Shawn Michelle Smith addresses photography's role at the "American Negro" exhibit in representing the complex racial history of Black America. See Shawn Michelle Smith, *American Archives: Gender, Race, and Class in Visual Culture* (Princeton, N.J.: Princeton University Press, 1999). For a brief comparison of Washington's and Du Bois's exhibits in the "American Negro," see Rydell, "Gateway to the 'American Century,' " 138–44.

48. For a detailed description of the exhibit, refer to "The American Negro Exhibit" in *Colored American,* November 3, 1900; and Calloway, "The Negro Exhibit," 463–67.

49. In 1894 Douglass lobbied for the City of Rochester to erect a monument in memory of black soldiers and sailors who had died in the Civil War. Douglass died in 1895 and a group of local and national leaders, including publisher T. Thomas Fortune, raised funds to erect the monument. The dedication ceremony was held in September 1898 and included speeches by Fortune, Ida B. Wells, Susan B. Anthony, and John C. Dancy Sr. See "The Douglass Monument," *New York Age,* January 4, 1900, 1.

50. Harry Shepard, who had been hired by Calloway, took many of the photographs of schools. See Deborah Willis, "The Sociologist's Eye: W. E. B. Du Bois and the Paris Exposition," in *A Small Nation of People: W. E. B. Du Bois and African American Portraits of Progress,* ed. the Library of Congress (New York: Amistad and Harper Collins, 2003), 74.

51. Refer to S. Smith, *American Archives.* Also see Jeannene M. Pryzybylski, "American Visions at the Paris Exposition 1900: Another Look at Benjamin Johnston's Hampton Photographs," *Art Journal* 57, no. 3 (Autumn 1998): 60–68.

52. Booker T. Washington, "Education Will Solve the Race Problem. A Reply," *North American Review,* August 1900, 221.

53. Washington would eventually use his power to have Lyons removed from office for being sympathetic to Monroe Trotter's Boston Riot. Trotter would join

Du Bois in forming the Niagara Movement. See the introduction to vol. 8 in the Booker T. Washington Papers, www.historycooperative.org/btw.

54. Thomas J. Calloway, "The American Negro Exhibit," *Colored American,* November 3, 1900, 9.

55. "To Prove the Negro's Value," *Washington Post,* November 5, 1899, 5.

56. "Negroes as Authors," *Washington Post,* January 22, 1900, 9.

57. W. E. B. Du Bois, "The American Negro at Paris," *American Monthly Review of Reviews,* November 1900, 576.

58. Ibid., 577.

59. Ibid.

60. Willis, "The Sociologist's Eye," 64.

61. Du Bois, *The Philadelphia Negro,* 311.

62. W. E. B. Du Bois, "The Health and Physique of the Negro American," in *Atlanta University Publications* (New York: Arno Press and the New York Times, 1968), 20, 30–31.

63. Du Bois stated: "The types are only provisionally indicated here as the lines are by no means clear in my own mind. Still I think that some approximation of a workable division has been made, so far as that is possible without exact scientific measurements." Ibid., 31.

64. In one photograph, Du Bois described a fair-skinned young man in a suit as "light brown, curled hair, stocky build; good ability, erratic application; quick tempered. Grandson of a leading white southerner." He described the character of a darker-skinned young man in different terms, as "very dark brown, crisp closely curled hair, medium height and slim; slow but plodding and perfectly reliable." "White, very light golden hair, light blue eyes, tall and stately; ordinary ability, very reliable, quiet and kind" summed up the facial features and personality of a young woman. See ibid., 31–33.

65. Ibid., 37. Du Bois observed that since rural schools were underfunded, those blacks descended from "ignorant" field hands would be poorly educated. In contrast to darker blacks from rural areas, those mulattoes descended from "town bred" "house-servants" would benefit from the better educational systems found in cities.

66. Scholar Shawn Michelle Smith makes important connections between the photographers and Du Bois's students and Atlanta families. Smith asserts that the props and poses of the middle-class elite indicate that Du Bois held a "preoccupation with patriarchal authority as the sign of respectable class consolidation." See Shawn Michelle Smith, *Photography on the Color Line: W E. B. Du Bois, Race, and Visual Culture* (Durham, N.C.: Duke University Press, 2004), 104.

67. The first meeting of the ANA was held at the Lincoln Memorial Church. Washington, Bishop Tanner, and J. W. E. Bowen supported the group. See "To Promote Art and Letters," *Washington Post,* March 4, 1897, 12.

68. Wilson J. Moses argues that the elitist members of the ANA believed that "black people as a race in America required an indigenous missionary force, elite bearers of culture who would guide them in the creation of an Afro-American civilization." Wilson Jeremiah Moses, *The Golden Age of Black Nationalism, 1850–1925* (Hamden, Connecticut: Archon Books, 1978), 74. Also see Wilson Jeremiah Moses, "The Lost World of the Negro, 1895–1919: Literary and In-

tellectual Life before the Renaissance," *Black American Interest Forum* 21, no. 1/2 (1987), 61–83. For the connection between Crummell and Du Bois's notion of the "Talented Tenth," see Alfred A. Moss, *The American Negro Academy: Voice of the Talented Tenth* (Baton Rouge: Louisiana State University Press, 1981).

69. For a discussion of the conservatism and essentialism in Du Bois's assessment of race in "The Conservation of Races," see Tommy Lee Lott, *The Invention of Race: Black Culture and the Politics of Representation* (Malden, Mass.: Blackwell, 1999); Thomas C. Holt, "W. E. B. Du Bois's Archaeology or Race," in *W. E. B. Du Bois, Race, and the City,* ed. Michael B. Katz and Thomas Sugrue (Philadelphia: University of Pennsylvania Press, 1998), 61–76; and Anthony Appiah, "The Uncompleted Argument: Du Bois and the Illusion of Race" in *"Race," Writing, and Difference,* ed. Henry Louis Gates (Chicago: University of Chicago Press, 1986), 21–37.

70. W. E. B. Du Bois, "The Conservation of Races," in *W. E. B. Du Bois Speaks,* ed. Philip S. Foner (New York: Pathfinder Books, 1991), 78.

71. Ibid.; Holt, "W. E. B. Du Bois's Archaeology or Race," 67.

72. Du Bois, "The Conservation of Races," 79.

73. Ibid., 79–81. Also see Willis, "The Sociologist's Eye."

74. "Colored Americans Dine," *Colored American,* August 11, 1900, 3. Also see Lewis, "A Small Nation of People," 47.

75. Jeannene M. Pryzyblyski, "American Visions at the Paris Exposition 1900," 68.

76. S. E. Hamedoe, "The First Pan-African Conference of the World," *Colored American Magazine,* September 1900, 223.

77. Lewis, *W. E. B. Du Bois: Biography of a Race 1868–1919,* 249.

78. W. E. B. Du Bois, "Address to the Nations of the World," in *W. E. B. Du Bois Speaks,* edited by Philip S. Foner (New York: Pathfinder Books, 1991), 125; Pan-African Association, *Report of the Pan-African Conference: Held on the 23rd, 24th, and 25th of July 1900* (London, 1900), Reel 2, W. E. B. Du Bois Papers, 1877–1965 (microfilm), University of California at Berkeley and Columbia University, New York.

79. Du Bois, "The American Negro at Paris," 577.

80. Campbell Gibson and Kay Jung, *Historical Census Statistics on Population Totals by Race, 1790 to 1990, and by Hispanic Origin, 1970 to 1990, for Large Cities and Other Urban Places in the United States* (U.S. Census Bureau, Population Division, February 2005).

81. Talbert would later become the president of the NACW from 1916 through 1920. She campaigned to preserve the home of Frederick Douglass at Cedar Hill in Anacostia, Washington, D.C. See Joan Marie Johnson, " 'Ye Gave Them Stone': African American Women's Clubs, the Frederick Douglass Home, and the Black Mammy Monument," *Journal of Women's History* 17, no. 1 (Spring 2005): 66–67; and Fath Ruffins " 'Lifting as We Climb': Black Women and the Preservation of African American History and Culture," *Gender and History* 6, no. 3 (November 1994): 377.

82. "Negro Exhibit: Buffalo Negroes Think Their Race Should Be Recognized at the Pan-American Exposition," *Commercial Advertiser and Journal,* quoted in William H. Loos and Ami M. Savigny, *The Forgotten Negro Exhibit: Buffalo's*

Pan-American Exposition, 1901 (Buffalo, N.Y.: Buffalo and Erie Country Public Library, 2001), 11–12.

83. See "Africans, Darkies and Negroes: Black Faces at the Pan-American Exposition of 1901, Buffalo, New York," n.d., www.buffalonian.com/history/articles/1901–50/ucqueens/negro_exhibit_at_pan_am.htm.

84. Robert Gonzalez, *Designing Pan-America: U.S. Architectural Visions for the Western Hemisphere* (Austin: University of Texas Press, 2011).

85. Ernest Knaufft, "Artistic Effects of the Pan-American Exposition," *American Monthly Review of Reviews,* June 1901, 686–93; "Pan-American Color," *New York Times,* April 28, 1901, 7; "Visual Culture at the Pan-American Exposition," Illuminations Revisiting the Buffalo Pan-American Exposition, University of Buffalo, June 11, 2005, http://ublib.buffalo.edu/libraries/exhibits/panam/art/plan.html#civilization.

86. Columbus White, "The Pan-American Show," *Colored American,* June 15, 1901, 3.

87. An article in the *Colored American* announced that "fifty men, women, and children arrived in Buffalo last week from the Congo Free State, Africa. They have taken their quarters on the Midway known as 'Darkest Africa.' They worshipped their god Mohamed, Sunday on the Midway with great devotion, singing, and dancing." See "The Great Exposition," *Colored American,* June 29, 1901, 6.

88. "Colored Woman Will Speak," *Atlanta Constitution,* July 7, 1901, 18; Beverly Jones, "Mary Church Terrell and the National Association of Colored Women, 1896–1901," *Journal of Negro History* 67, no. 1 (1982): 20–33.

89. "Negro Achieving Results: Expositions an Index to Progress" and "New Negro at Charleston," *Colored American,* August 10, 1901, 3, 8.

90. "The Second Meeting of the National Negro Business League," *Colored American,* July 6, 1901. Also see Meier, *Negro Thought in America, 1880–1915,* 104.

91. "Negro Exhibition at Charleston," *Washington Post,* May 3, 1901, 4.

92. "Charleston Noise," *Savannah Tribune,* August 24, 1901. Also refer to Don Harrison Doyle, *New Men, New Cities, New South: Atlanta, Nashville, Charleston, Mobile, 1860–1910,* Fred W. Morrison Series in Southern Studies (Chapel Hill: University of North Carolina Press, 1990), 182–87.

93. "Opening of the Charleston Exposition," *Literary Digest 23,* December 14, 1901; "Charleston and Her 'West Indian Exposition,'" *American Monthly Review of Reviews,* January 25, 1902, 58–61.

94. Winton, "Negro Participation in Southern Expositions, 1881–1915," 40.

95. "Hampton Conference Ends," *New York Times,* July 20, 1901, 5.

96. Meier, *Negro Thought in America, 1880–1915,* 164.

97. "The Southern Carolina Interstate and West Indian Exposition," *Colored American Magazine,* September 1901, 331–36.

98. See *The Southern Carolina Interstate and West Indian Exposition* (Charleston: Lucas and Richardson, 1902), 6, South Carolina Historical Society, Charleston; and T. Cuyler Smith, "The Ivory City" *Frank Leslies's Popular Monthly* 53, no. 5 (March 1902): 503–4.

99. Bradford Gilbert to Edward McCrady, May 18, 1901, Research File, Col-

lege of Charleston, Avery Research Center for Afro-American History and Culture, Charleston, S.C.

100. Bradford Lee Gilbert to Booker T. Washington, June 4, 1901, Booker T. Washington Papers, www.historycooperative.org/btw.

101. D. Doyle, *New Men, New Cities, New South,* 302–5.

102. "Negroes Protest against Statue," *Atlanta Constitution,* November 2, 1901, 5. See also "Charleston and Its Exposition," *New York Times,* December 1, 1901, SM10; and "Negroes Dislike a Statue—Protest against the Work of Sculptor Lopez at South Carolina Exposition," *Washington Post,* November 17, 1901, 8.

103. See "Negroes Dislike a Statue—Protest against the Work of Sculptor Lopez at South Carolina Exposition," *Washington Post,* November 17, 1901, 8. Also see D. Doyle, *New Men, New Cities, New South,* 309–10.

104. *Exhibition of Fine Arts Catalogue: The South Carolina Interstate and West Indian Exposition* (Charleston, 1901–1902), 7, South Carolina Historical Society, Charleston.

105. William D. Crum, "The Negro at the Charleston Exposition," *Voice of the Negro,* August 1904, 331–35.

106. Winton, "Negro Participation in Southern Expositions, 1881–1915," 42; Helen A. Tucker, "The Negro Building and Exhibit at the Jamestown Exposition," *Charities and the Commons,* no. 18 (September 21, 1907); William Hayes Ward, "A Race Exhibition," *Independent,* November 14, 1907, 1168; "Negroes at Jamestown," *Washington Post,* April 12, 1905, 2; "Negro Architect's Skill," *New York Times,* November 24, 1906, 2; "Negro Exhibit at Expo," *Washington Post,* December 23, 1906, E1; "Cornerstone Laid," *Washington Post,* February 15, 1907, 13.

107. *Alexander's Magazine* 3, no. 4 (February 15, 1907): 177.

108. Ida B. Wells-Barnett and Robert W. Rydell, *The Reason Why the Colored American Is Not in the World's Columbian Exposition* (Urbana: University of Illinois Press, 1999), 4.

109. Benedict R. O'G Anderson, *Imagined Communities: Reflections on the Origin and Spread of Nationalism,* rev. ed. (London: Verso, 1991), 205.

110. Giles B. Jackson and D. Webster Davis, *The Industrial History of the Negro Race of the United States,* (Richmond: The Virginia Press, 1908), 199.

111. "The Negro's Gala Day," *Washington Bee,* August 1, 1907, 1.

112. Jackson and Davis, *The Industrial History of the Negro Race of the United States,* 60.

113. Meta Vaux Warrick to W. E. B. Du Bois, January 29, 1907, W. E. B. Du Bois Papers, 1877–1965 (microfilm), University of California at Berkeley and Columbia University, New York.

114. As Walter Benjamin would later observe, "in the panoramas the city dilates to become a landscape." Walter Benjamin, "Paris, Capital of the Nineteenth Century," in *Reflections,* ed. Peter Demetz (New York: Harcourt Brace Jovanovich, 1979), 150. Also see Jonathan Crary, *Techniques of the Observer: On Vision and Modernity in the Nineteenth Century* (Cambridge, Mass.: MIT Press, 1996), 112–13; and Anne Friedberg, *Window Shopping—Cinema and the Postmodern* (Berkeley: University of California, 1993).

115. "A Negro Sculptress," *Los Angeles Times,* April 14, 1907, V110; Jackson

and Davis, *The Industrial History of the Negro Race of the United States,* 204–5; W. Fitzhugh Brundage, "Meta Warrick's 1907 'Negro Tableaux' and (Re)Presenting African American Historical Memory," *Journal of American History* (March 2003): 1368–400.

116. R. W. Thompson, "The Negro Exhibit at Jamestown," *Colored American Magazine,* July 1907, 31.

117. "Wants Negroes Treated Fairly at Jamestown," *Washington Post,* March 16, 1906, 5.

118. "The Jamestown Imposition," *Voice of the Negro* 4, no. 10 (October 1907): 344–45.

119. Du Bois, March 29, 1907, W. E. B. Du Bois Papers, 1877–1965 (microfilm), University of California at Berkeley and Columbia University, New York.

120. "Boston Negroes and the Jamestown Exposition," *Atlanta Constitution,* April 14, 1906, 6.

121. *An Address to the American Negro by the Negro Development Company* (Richmond, Va., 1907); "No Race Discrimination," *Washington Post,* July 8, 1907, 4.

122. "Why Jamestown Was a Dismal Failure," *New York Times,* December 1, 1907, SM9.

123. "Booker T. Washington Urges Great Negro Exposition," *Atlanta Constitution,* October 31, 1909, B5.

124. "For Negro Exposition," *New York Times,* November 18, 1909, 18; Booker T. Washington to William Howard Taft, October 21, 1909, Booker T. Washington Papers, www.historycooperative.org/btw; " The Negro Exposition," *New York Times,* November 19, 1909, 10.

125. "Negro Exposition Fuss," *New York Times,* December 25, 1909, 18.

126. Henry P. Guzda, "Labor Department's First Program to Assist Black Workers," *Monthly Labor Review* 105, no. 6 (1982): 39–44.

127. "Great Exposition and Celebration," *Industrial Advocate,* October 31, 1914, Tuskegee Institute News Clippings File, Division of Behavioral Science Research, Tuskegee, Ala. (microfilm), University of California at Berkeley.

128. Plummer F. Jones, "The Negro Exposition at Richmond" in *American Monthly Review of Reviews,* no. 52, August 1915, 186. Also see Winton, "Negro Participation in Southern Expositions, 1881–1915," 43.

129. "Mayor Opens Big Negro Exposition," *Richmond Times Dispatch,* July 6, 1915, Tuskegee Institute News Clippings File, Division of Behavioral Science Research, Tuskegee, Ala. (microfilm), University of California at Berkeley.

130. R. W. Thompson, "Richmond, Va., 50th Anniversary Exposition a Failure," *Chicago Defender,* July 31, 1915, 1.

131. Booker T. Washington, extracts from an address at the Jamestown Tercentennial Exposition, August 3, 1907, the Booker T. Washington Papers, www .historycooperative.org/btw. Also see "The Negro's Gala Day," *Washington Bee,* August 10, 1907, 1.

132. Eric Lott, *Love and Theft: Blackface Minstrelsy and the American Working Class,* Race and American culture (New York: Oxford University Press, 1993).

133. "Honor 'Old Black Mammy,'" *Washington Post,* June 5, 1910, MS2. A

poem in the *New York Times* captured the white South's affection and fever for the monument to mammy:

> Her skin was black, her soul was white,
> Her many virtues justly claim
> The tribute of a sculptured stone
> To glorify the lowly name
> Of old black mammy.

Minna Irving, "Old Black Mammy," *New York Times,* June 26, 1910, SM5. For a critique of myth of the mammy and denigration of black womanhood, see Hortense Spillers, "Mama's Baby, Papa's Maybe: An American Grammar Book," *Diacritics* 17, no. 2 (Summer 1987): 64–81.

134. "Tribute to 'Black Mammy,'" *Washington Post,* April 28, 1910, 11; "It Is Up to the South," *Washington Post,* May 4, 1910, 6; Hollis W. Field, "To Build a Monument of 'Ol' Black Mammy,'" *Chicago Daily Tribune,* May 29, 1910, G3.

135. "To Erect Fitting Memorial to Black Mammy of South," *Atlanta Constitution,* July 6, 1910, 5; "The Old Black Mammy," *Atlanta Constitution,* July 25, 1910, 4; "Servant Problem Being Settled at Athens, Ga.," *Atlanta Constitution,* August 27, 1911, A6.

136. The Richmond fair featured a child's pageant titled *Answer to a Birth of a Nation,* with children pantomiming a history of Negro progress to show that blacks had become useful and intelligent members of society. "Increased Attendance at Negro Exposition," *Richmond Times Dispatch,* July 18, 1915, Tuskegee Institute News Clippings File, Division of Behavioral Science Research, Tuskegee, Ala. (microfilm), University of California at Berkeley. The proposal for the mammy monument persisted into the 1920s amid vehement protests from black groups, including the NACW. See J. M. Johnson, "'Ye Gave Them Stone,'" 69–79.

137. Meier, *Negro Thought in America, 1880–1915,* 78–84.

138. W. E. B. Du Bois, "The Niagara Movement," in *W. E. B. Du Bois Speaks,* ed. Philip S. Foner (New York: Pathfinder Books, 1991), 146.

139. W. E. B. Du Bois, "Strivings of the Negro People," *Atlantic Monthly,* August 1897, 197.

CHAPTER 3

1. Major Wright was a graduate from the inaugural class at Atlanta University and a well-known scholar and businessman. His accomplishments and high regard among the black elites made him a key participant in several expositions; he had spoken at Atlanta Cotton States' Negro Day festivities and joined the events at the Jamestown tercentenary. He also organized Georgia's yearly black state fair. For a review of Major Wright's early activities, see June O. Patton, "And the Truth Shall Make You Free: Richard Robert Wright Sr., Black Intellectual and Iconoclast, 1877–1897," *Journal of Negro History* 81 (1996): 17–30.

2. "Ten Thousand Dollars Secured for the Semi-Centennial Exposition to be Held by Afro-Americans," *Afro-American,* November 13, 1909, 1.

3. "Plan of Exposition," *Afro-American,* November 13, 1909, 6.

4. Campbell Gibson and Kay Jung, *Historical Census Statistics on Population Totals by Race, 1790 to 1990, and by Hispanic Origin, 1970 to 1990, for Large Cities and Other Urban Places in the United States* (Washington, D.C.: U.S. Census Bureau, Population Division, February 2005).

5. "Negro Exposition May Be Held in Savannah," *Atlanta Constitution,* February 3, 1912, 2.

6. W. E. B. Du Bois, "How to Celebrate the Semicentennial of the Emancipation Proclamation," in *W. E. B. Du Bois Speaks,* ed. Philip S. Foner (New York: Pathfinder Books, 1991), 227. Also see *Crisis,* May 1912, 8, 20.

7. Du Bois, "How to Celebrate the Semicentennial of the Emancipation Proclamation," 226–29.

8. An example of this can be found in the *The College of Life or Practical Self-Educator,* which was published by a white and black religious leader in 1895 just prior to the opening of the Negro Building in Atlanta. I. Garland Penn was one of the editors and contributed a piece on Atlanta's Negro Building. As a portable primer on racial uplift, the thick volume not only provided a history of notable institutions and race leaders in education and religion but also featured articles on "the proper conduct of life" in marriage, on business, on social ettiquette, and on health. See Henry Davenport Northrop, Joseph R. Gay, and I. Garland Penn, *The College of Life or Practical Self-Educator: A Manual of Self-Improvement for African Americans* (Chicago: C. J. Harris, 1993), 91–94.

9. "$250,000 Given for Negro Show," *Atlanta Constitution,* April 3, 1912, 1.

10. J. B. Clarke, *A Memento of the Emancipation Proclamation Exposition of the State of New York* (Emancipation Proclamation Exposition Commission, 1913), 15; "Negro Jubilee Bill Doomed to Defeat," *Atlanta Constitution,* January 18, 1913, 5.

11. For a history of Emancipation celebrations, see Mitchell A. Kachun, *Festivals of Freedom: Memory and Meaning in African American Emancipation Celebrations, 1808–1915* (Amherst: University of Massachusetts Press, 2003).

12. Geneviève Fabre, "African American Commemorative Celebrations in the Nineteenth Century," in *History and Memory in African American Culture,* ed. Geneviève Fabre and Robert O'Meally (New York: Oxford University Press, 1994), 73.

13. "Emancipation Celebration," *New York Age,* July 24, 1913.

14. Carole Marks, "Black Workers and the Great Migration," *Phylon* 46, no. 2 (1985): 148–61.

15. Howard N. Rabinowitz, *The First New South, 1865–1920* (Arlington Heights, Ill.: Harlan Davidson, 1992), 156.

16. Christine Boyer, *Dreaming the Rational City: The Myth of American City Planning* (Cambridge, Mass.: MIT Press, 1983).

17. James Edward Blackwell and Morris Janowitz, *Black Sociologists: Historical and Contemporary Perspectives,* the Heritage of Sociology (Chicago: University of Chicago Press, 1974); Joyce A. Ladner, *The Death of White Sociology* (New York: Vintage Books, 1973).

18. William J. Robinson, a black builder, and C. Henry Wilson, a black architect, completed the fair's pavilions. "Emancipation Expo to open Monday,

Sept. 15," *Afro-American,* September 6, 1913, 2; "Aftermath of Exposition," *Afro-American,* October 11, 1913, 7. Also see R. R. Wright Jr. to Alain Locke, Box 164–96, Folder 2, Alain Locke Papers, Moorland-Spingarn Research Center, Howard University, Washington, D.C.

19. "First Annual Meeting Held," *Christian Recorder,* February 2, 1913, Tuskegee Institute News Clippings File, Division of Behavioral Science Research, Tuskegee, Ala. (microfilm), University of California at Berkeley; "Emancipation Jubilee Opens in Quaker City," *New York Age,* September 25, 1913.

20. "Big Crowds at Exposition," *Afro-American,* September 20, 1913, 2.

21. "Show Progress Made by Colored Race" *New York Age,* October 20, 1913, Tuskegee Institute News Clippings File, Division of Behavioral Science Research, Tuskegee, Ala. (microfilm), University of California at Berkeley; "Exposition at 'Philly' was a Dismal Failure," *New York Age,* November 9, 1913, 1.

22. "The Emancipation Celebration," *New York Age,* July 24, 1913; "Emancipation Jubilee Opens in Quaker City," *New York Age,* September 25, 1913; "New Jersey Celebration Opening," *New York Age,* October 2, 1913, all in Tuskegee Institute News Clippings File, Division of Behavioral Science Research, Tuskegee, Ala. (microfilm), University of California at Berkeley.

23. *The Emancipation Celebration. State Organization. To the Colored People of New Jersey* (Trenton, N.J.: Emancipation Proclamation Commission, 1913), Box 164–178, Folder 21. Alain Locke Papers, Moorland-Spingarn Research Center, Howard University, Washington, D.C.

24. "Three Expositions" *Crisis,* October 1913, 298; *Golden Emancipation Jubilee New Jersey Semi-Centennial Exposition* pamphlet, Box 164–178, Folder 20, Alain Locke Papers, Moorland-Spingarn Research Center, Howard University, Washington, D.C.

25. *Philadelphia Ledger,* October 7, 1913, Box 164–178, Folder 20. Alain Locke Papers, Moorland-Spingarn Research Center, Howard University, Washington, D.C.

26. Clarke, *A Memento of the Emancipation Proclamation Exposition of the State of New York,* 15.

27. With the dominance of the Democratic Party in the South and its growing hold on northern politics after the presidential election of Woodrow Wilson in 1912, Wood believed that allying with Democrats would be the only way that blacks could regain the right to vote along with other civil rights, especially given the incremental abandonment by Republicans that had hastened the post-Reconstruction move toward segregation. However, by the time of the New York Emancipation exposition, Wilsonian policies had introduced a slew of segregation legislation that the NAACP vocally protested. See "Political," *Crisis,* August 1912, 166; and Nancy J. Weiss, "The Negro and the New Freedom: Fighting Wilsonian Segregation," *Political Science Quarterly* 84, no. 1 (March 1969): 61–79.

28. Clarke, *A Memento of the Emancipation Proclamation Exposition of the State of New York,* 16. To remember the fair and its memorial occasion, Emancipation, visitors could purchase a booklet titled *A Memento of the Emancipation Proclamation Exposition of the State of New York,* prepared by the fair's organizing committee and not under the supervision of Du Bois.

29. "An Interested Program," *New York Age,* October 30, 1913.

30. In later years Du Bois would recall that Wood assisted him in details of how to publish the *Crisis* and in securing a loan to finance its publication. See W. E. B. Du Bois, "Editing the *Crisis*," *Crisis,* March 1951, 148.

31. Leslie M. Alexander, "Community and Institution Building in Antebellum New York: The Story of Seneca Village, 1825–1857," in *"We Shall Independent Be": African American Place Making and the Struggle to Claim Space in the United States,* ed. Angel David Nieves and Leslie M. Alexander (Boulder: University Press of Colorado, 2008), 23–46.

32. Du Bois's exact address is unknown during his first years in New York City, however he did initially live somewhere in the San Juan Hill neighborhood. Du Bois eventually sent for his wife and daughter and together they settled into a home in the Bronx. See David Levering Lewis, *W. E. B. Du Bois: Biography of a Race, 1868–1919* (New York: Henry Holt and Company, 1993), 431, 38.

33. "Exposition to Show Advance," *Afro-American,* July 12, 1913, 2.

34. W. E. B. Du Bois, "The Jubilee of Freedom," 1913, W. E. B. Du Bois Papers, 1877–1965 (microfilm), University of California at Berkeley and Columbia University, New York.

35. "Commissioners at Loggerheads," *New York Age,* June 6, 1913; "The Emancipation Commission," *New York Age,* June 3, 1913; "Du Bois Sued for Libel," *New York Age,* June 10, 1913; "The Emancipation Celebration," *New York Age,* June 24, 1913; "Protests of Citizen Scare Commissioners," *New York Age,* July 31, 1913, 1; "Commission Now Faces Big Deficit," *New York Age,* September 25, 1913.

36. The highly influential T. Thomas Fortune, a staunch supporter of Booker T. Washington and cofounder with him of the National Negro Business League, founded the *New York Age* in 1887.

37. "Commission Says Carr Will Stay," *Afro-American,* July 19, 1913, 1. See also "Social Uplift," *Crisis,* August 1913, 163.

38. "The Exposition," *Crisis,* December 1913, 184.

39. Everett P. Martin, "Fifty Years of Freedom," *New York Times,* December 15, 1913, 8; "Charts Show Race Progress," *New York Age,* October 30, 1913, 1–2.

40. "Negroes to Hold a Big Exposition," *Amsterdam News,* October 10, 1913, Tuskegee Institute News Clippings File, Division of Behavioral Science Research, Tuskegee, Ala. (microfilm), University of California at Berkeley.

41. "Beautiful Jubilee Exhibition Has Been Success," *Newport News,* October 30, 1913, Tuskegee Institute News Clippings File, Division of Behavioral Science Research, Tuskegee, Ala. (microfilm), University of California at Berkeley; "Charts Show Race Progress," *New York Age,* October 30, 1913, 2.

42. Daylanne K. English, *Unnatural Selections: Eugenics in American Modernism and the Harlem Renaissance* (Chapel Hill: University of North Carolina Press, 2004); Susan Currell and Christina Cogdell, *Popular Eugenics: National Efficiency and American Mass culture in the 1930s* (Athens: Ohio University Press, 2006).

43. Everett P. Martin, letter to the editor, *New York Times,* December 15, 1913, 8.

44. W. Fitzhugh Brundage, "Meta Warrick's 1907 'Negro Tableaux' and

(Re)Presenting African American Historical Memory," *Journal of American History* (March 2003): 1398. Also see "Negro Exposition Opens," *New York Times,* October 23, 1913, 5; "Millions of Negroes Expected in New York on Oct. 22," *New York Times,* September 26, 1913, 4.

45. "Negro Exposition Opens," *New York Times,* October 23, 1913.

46. "Charts Show Race Progress," *New York Age,* October 30, 1913, 1; "Negro Exposition Opens," *New York Times,* October 23, 1913, 5.

47. "Three Expositions," *Crisis,* October 1913, 298.

48. David Glassberg, "History and the Public: Legacies of the Progressive Era," *Journal of American History* 73, no. 4 (1987): 958–59 (both quotes). Also see David Glassberg, *American Historical Pageantry: The Uses of Tradition in the Early Twentieth Century* (Chapel Hill: University of North Carolina Press, 1990).

49. In the Bible (King James version), the quote from Psalms 68:31 reads, "Princes shall come out of Egypt; Ethiopia shall soon stretch out her hands unto God." Wilson Jeremiah Moses, *The Golden Age of Black Nationalism, 1850–1925* (Hamden, Conn.: Archon Books, 1978), 157. Moses also examines the use of Ethiopia in several of Du Bois's works, including *The Souls of Black Folks* and *The Quest of the Silver Fleece.*

50. Moses, *The Golden Age of Black Nationalism, 1850–1925,* 167.

51. Glassberg, "History and the Public," 979.

52. W. E. B. Du Bois, *The Negro* (New York: Dover Publications, 2001), 26.

53. For an probing analysis of the relationships between collecting and conquest, in particular the emergence of zoological dioramas in the African halls of the 1930s, see Donna Haraway, "Teddy Bear Patriarchy," in *Primate Visions: Gender, Race, and Nature in the World of Modern Science* (New York: Routledge, 1989), 26–58.

54. "The Emancipation Exposition," *Outlook,* November 8, 1913, 514; Renee Ater, "Making History: Meta Warrick Fuller's 'Ethiopia,' " *American Art* 17, no. 3 (2003): 12–31.

55. W. E. B. Du Bois, "The National Emancipation Exposition (The Star of Ethiopia)," *Crisis,* November 1913, 339. "The Exposition," *Crisis,* December 1913, 84.

56. Frederic Haskins, "Advance of the Negro . . . ," *Pittsburgh Gazette,* October 1915, Tuskegee Institute News Clippings File, Division of Behavioral Science Research, Tuskegee, Ala. (microfilm), University of California at Berkeley. Also see *The Illinois (National) Half-Century Anniversary of Negro Freedom* (Chicago: Fraternal Press, 1915).

57. *History and Report of the Exhibition and Celebration to Commemorate the Fiftieth Anniversary of the Emancipation of the Negro: Held at the Coliseum, Chicago Illinois, August 22nd to September 16th, Nineteen Hundred and Fifteen* (Fraternal Press, 1916), 13.

58. *The Illinois (National) Half-Century Anniversary of Negro Freedom.* Chicago had been settled by a black trader, Jean Baptiste Pointe DuSable, and always had black residents among its population. In the summer of 1902 Chicago's blacks had organized a monthlong event called the Middle States and Mississippi Valley Negro Exposition at the First Regiment Army. See "Negro Exposition," *Washington Post,* August 15, 1902, 10; "The Negro Exhibit Is Open,"

Chicago Daily Tribune, August 15, 1902, 8; and "Record Breaking Crowd at the Negro Exposition," *Chicago Daily Tribune,* September 12, 1902, 7. Also see Allan H. Spear, *Black Chicago: The Making of a Negro Ghetto, 1890–1920* (Chicago: University of Chicago Press, 1967), 63.

59. *The Illinois (National) Half-Century Anniversary of Negro Freedom.*

60. Ibid. The Du Bois quote was originally published in an editorial, "Fifty Years of Freedom," *New York Times,* December 12, 1909, SMA4.

61. As a result of the loss of white patronage, black service workers and business owners relied more on other blacks as clients and customers. Du Bois observed this shift occurring in Philadelphia at the turn of the century. See W. E. B. Du Bois, *The Philadelphia Negro* (Philadelphia: University of Pennsylvania Press, 1996).

62. Davarian L. Baldwin, *Chicago's New Negroes: Modernity, the Great Migration, and Black Urban Life* (Chapel Hill: University of North Carolina Press, 2007).

63. Marks, "Black Workers and the Great Migration," 152–55. Also see "Negroes Deserting South for North," *New York Times,* November 12, 1916, X12.

64. Baldwin, *Chicago's New Negroes,* 39.

65. Ibid., 41.

66. *History and Report of the Exhibition and Celebration to Commemorate the Fiftieth Anniversary of the Emancipation of the Negro: Held at the Coliseum, Chicago Illinois, August 22nd to September 16th, Nineteen Hundred and Fifteen,* 53–55.

67. Francis H. Warren, *Michigan Manual of Freedmen's Progress* (Detroit, 1915), 362.

68. The organizing committee's final report estimates that local attendance was 490,000 and visitors from out of state numbered 272,000, for an estimated total attendance of 862,000 (although the committee's final number adds 100,000 more attendees than the 762,000 total from adding local and out of state). Other articles put the attendance significantly lower at 135,000. *History and Report of the Exhibition and Celebration to Commemorate the Fiftieth Anniversary of the Emancipation of the Negro: Held at the Coliseum, Chicago Illinois, August 22nd to September 16th, Nineteen Hundred and Fifteen,* 18; "Lincoln Exposition a Monster Success," *Chicago Defender,* September 18, 1915, 3.

69. According to the official exposition report, these artifacts were loaned by Chicagoan Charles Gunther. *History and Report of the Exhibition and Celebration to Commemorate the Fiftieth Anniversary of the Emancipation of the Negro: Held at the Coliseum, Chicago Illinois, August 22nd to September 16th, Nineteen Hundred and Fifteen,* 14.

70. "The Lincoln Jubilee and the World's Most Unique Exposition, Chicago Illinois, August 22 to September 16, 1915," Box 164–180, Folder 21, Alain Locke Papers, Moorland-Spingarn Research Center, Howard University, Washington, D.C.

71. *History and Report of the Exhibition and Celebration to Commemorate the Fiftieth Anniversary of the Emancipation of the Negro: Held at the Coliseum, Chicago Illinois, August 22nd to September 16th, Nineteen Hundred and Fifteen,* 13. .

72. See Warren, *Michigan Manual of Freedmen's Progress*.

73. See correspondence, Box 3, Folder 7, 9, and 10, Frederick Starr Papers, Special Collections Research Center, University of Chicago.

74. "Exposition of Negro Achievement," *Christian Science Monitor*, July 24, 1913, 20; "Twenty States Agree to Help Honor Lincoln's Work," *Christian Science Monitor*, September 26, 1914, 18; "Negro Advance in Half Century Is to Be Shown," *Christian Science Monitor*, August 14, 1915, 8; "Lincoln Relics at Negro Exposition," *Christian Science Monitor*, August 25, 1915, 5.

75. Baldwin, *Chicago's New Negroes*, 66.

76. "Lincoln Jubilee Shows Progress of Afro-Americans," *Chicago Defender*, August 28, 1915, 1.

77. William Chenery, "The Guide Post," *Chicago Herald*, August 1915, Tuskegee Institute News Clippings File, Division of Behavioral Science Research, Tuskegee, Ala. (microfilm), University of California at Berkeley.

78. *National Half Century Anniversary Exposition and the Lincoln Jubilee*, program, Research Center, Chicago History Museum.

79. Art historian James Porter places Fontaine within a cadre of "natural artists," folk artists who represent the world in terms of symbolism. See James A. Porter, *Modern Negro Art* (Washington, D.C.: Howard University Press, 1998), 136.

80. "Birth of a Nation," *Chicago Defender*, August 28, 1915, 1.

81. "Lincoln Exposition Monster Success," *Chicago Defender*, September 18, 1915, 3; "Race Shows Wonderful Progress in 50 Years," *Chicago Defender*, September 4, 1915, 3.

82. See James E. Stamps, "Fifty Years Later," *Negro History Bulletin* 29, no. 3 (1965): 31–32.

83. Quoted in Charles H. Wesley, "Our Fiftieth Year," *Negro History Bulletin* 28, no. 9 (1965): 173.

84. See August Meier, *Negro Thought in America, 1880–1915* (Ann Arbor: University of Michigan Press, 1988), 263; Kevin Kelly Gaines, *Uplifting the Race: Black Leadership, Politics, and Culture in the Twentieth Century* (Chapel Hill: University of North Carolina Press, 1996), 247.

85. Jacqueline Anne Goggin, *Carter G. Woodson: A Life in Black History*, Southern Biography Series (Baton Rouge: Louisiana State University Press, 1993), 33.

86. As the *Atlanta Constitution* observed at a screening in their fair city, crowds cheered the thrilling rescue by the Klan of the town beset by an excited, drunken Negro mob. See "Dash of Ku Klux Thrills Audience in Great Picture," *Atlanta Constitution*, April 24, 1918, 7. For a critique by a white critic, see "The Birth of a Nation," *Outlook*, April 14, 1915, 854.

87. World's fairs were sites for the development of precinematic technologies. See Anne Friedberg, *Window Shopping: Cinema and the Postmodern* (Berkeley: University of California, 1993).

88. William Monroe Trotter, the activist publisher of the *Guardian* who co-founded the Niagara Movement and the NAACP with Du Bois, attempted to ban the movie from Boston by pressuring local politicians and staging protests in front of the theater where it was screened. "Citizens Plead at State House for

Film Ban," *Christian Science Monitor,* April 19, 1915, 4; "Mass Meeting to Discuss How to Stop Film," *Christian Science Monitor,* May 1, 1915, 4; "Negroes Mob Photo Play," *New York Times,* April 18, 1915, 15. Attending the meeting of the Boston protest of *Birth of a Nation* were Du Bois's early supporters at Atlanta University, Horace Bumstead and George Bradford. See "Mass Meeting to Discuss How to Stop Film," *Christian Science Monitor,* May 1, 1915, 4.

89. Goggin, *Carter G. Woodson,* 33.

90. Fath Ruffins, "Mythos, Memory and History: African American Preservation Efforts, 1820–1990," in *Museums and Communities: The Politics of Public Culture,* ed. I. Karp and C. M. Kreamer (Washington, D.C.: Smithsonian Institution Press, 1992), 506–611.

91. Rayford Logan, "Carter G. Woodson: Mirror and Molder of His Time, 1875–1950," *Journal of Negro History* 58, no. 1 (1973): 12.

92. Goggin, *Carter G. Woodson,* 33.

93. For the ASNLH and the *Journal,* he solicited input and participation from a range of scholars and leaders, including Major R. R. Wright, Kelly Miller, W. E. B. Du Bois, and Robert E. Park. See Stamps, "Fifty Years Later"; and Goggin, *Carter G. Woodson.*

94. "Editorial," *Crisis,* September 1915, 230–31.

95. "The Star of Ethiopia," *Washington Bee,* October 16, 1915, Tuskegee Institute News Clippings File, Division of Behavioral Science Research, Tuskegee, Ala. (microfilm), University of California at Berkeley.

96. For an overview of the other immigrant exhibitions, which include Arts and Crafts fairs and the America's Making Exposition, see Allen Eaton, *Immigrant Gifts to American Life* (New York: Russell Sage Foundation, 1932).

97. "America's Making," *New York Times,* November 1, 1921, 12. Also see Ilana Abramovitch, "America's Making Exposition and Festival (New York, 1921): Immigrant Gifts on the Altar of America" (PhD dissertation, New York University, 1996), 31.

98. English, *Unnatural Selections,* 11.

99. Madison Grant, *The Passing of the Great Race; or, The Racial Basis of European History* (New York: C. Scribner, 1916), 1.

100. Robert Rydell, *World of Fairs* (Chicago: University of Chicago Press, 1993), 46–47.

101. "America's Making—A Festival and Exhibit," Social Subject Files, Part 11, Series A, Reel 1, Frame 381, Papers of the NAACP (microfilm), Schomburg Center for Research in Black Culture, New York Public Library.

102. Abramovitch, "America's Making Exposition and Festival (New York, 1921)" 34–35.

103. John Daniels, *America via the Neighborhood,* Americanization Studies (New York: Harper and Brothers, 1920).

104. Christopher Robert Reed, *All the World Is Here! The Black Presence at White City,* Blacks in the Diaspora (Bloomington: Indiana University Press, 2000), 8–9.

105. James Weldon Johnson to John Daniels, March 18, 1921, Social Subject Files, Part 11, Series A, Reel 1, Frame 321, Papers of the NAACP (microfilm), Schomburg Center for Research in Black Culture, New York Public Library.

106. "Lecture Bureau," America's Making Inc., New York Historical Society Library.

107. *America's Making News,* no. 6, October 1, 1921, 4, New York Historical Society Library.

108. "A Proposed Exhibition and Pageant Illustrating the Part Which the American Negro Has Played in the Making of America," Social Subject Files, Part 11, Series A, Reel 1, Frame 378, Papers of the NAACP (microfilm), Schomburg Center for Research in Black Culture, New York Public Library; also found in W. E. B. Du Bois Papers, 1877–1965 (microfilm), University of California at Berkeley and Columbia University, New York.

109. "Negro Sculptress Completing Symbolic Statue for Exhibit," *America's Making News,* no. 4, August 31, 1921, 1, New York Historical Society Library.

110. David Levering Lewis, W. E. B. *Du Bois: The Fight for Equality and the American Century, 1919–1963,* 1st ed. (New York: Henry Holt and Company, 2000), 95.

111. "America's Making," *New York Times,* November 1, 1921.

112. Abramovitch, "America's Making Exposition and Festival (New York, 1921)" 67.

113. Ibid., 72.

114. Laura Doyle, *Bordering on the Body: The Racial Matrix of Modern Fiction and Culture,* Race and American Culture (New York: Oxford University Press, 1994).

115. Lewis, W. E. B. *Du Bois: Biography of a Race, 1868–1919,* 576–78. For a history of the later congresses, see Lewis, W. E. B. *Du Bois: The Fight for Equality and the American Century, 1919–1963.*

116. Thomas Swann to W. E. B. Du Bois, June 18, 1925; Du Bois to Swann, July 16, 1925; and W. E. B. Du Bois, "Memorandum of the Pan-African Congress," 1925, all in W. E. B. Du Bois Papers, 1877–1965 (microfilm), University of California at Berkeley and Columbia University, New York. The organization, as reviewed in chapter 2, was formed in Paris in 1900 at a meeting of representatives from around the world, but it took almost twenty years before the next congress would convene. The first official Pan-African Congress was held in Paris in February of 1919. The second followed in 1921 and was convened in London, Brussels, and Paris. The third congress met in London and Lisbon in 1923. See Lewis, W. E. B. *Du Bois: The Fight for Equality and the American Century, 1919–1963.*

117. "$100,000 Race Exhibit for Philly Sesqui," *Afro-American,* February 28, 1925, Tuskegee Institute News Clippings File, Division of Behavioral Science Research, Tuskegee, Ala. (microfilm), University of California at Berkeley. Since Du Bois's *Philadelphia Negro* survey in 1896, the black population of Philadelphia, at the time the largest community of blacks in the North, had grown from 40,000 in 1900 to 135,000 twenty years later, although the swift growth of Harlem made New York City's black population the largest in the country. Gibson, Campbell, and Kay Jung, *Historical Census Statistics on Population Totals by Race, 1790 to 1990, and by Hispanic Origin, 1970 to 1990, for Large Cities and Other Urban Places in the United States* (Washington, D.C.: U.S. Census Bureau, Population Division, February 2005).

118. "$100,000 Race Exhibit for Philly Sesqui," *Afro-American,* February 28, 1925; "John C. Asbury Heads Sesqui-Centennial," *Pittsburgh Courier,* August 8, 1925, 11, both in Tuskegee Institute News Clippings File, Division of Behavioral Science Research, Tuskegee, Ala. (microfilm), University of California at Berkeley.

119. See W. E. B. Du Bois to John C. Asbury, September 8, 1925; Du Bois to D. C. Collier, October 26, 1925; D. C. Collier to Du Bois, October 29, 1925; Du Bois to Asbury, January 19, 1925; Asbury to Du Bois, February 26, 1926; and Du Bois to Governor Gifford Pinchot, May 7, 1926, all in W. E. B. Du Bois Papers, 1877–1965 (microfilm), University of California at Berkeley and Columbia University, New York.

120. Thomas J. Calloway to W. E. B. Du Bois, April 27, 1926, W. E. B. Du Bois Papers, 1877–1965 (microfilm), University of California at Berkeley and Columbia University, New York.

121. Thomas J. Calloway to W. E. B. Du Bois, May 4, 1926; Du Bois to Calloway, May 8, 1926, W. E. B. Du Bois Papers, 1877–1965 (microfilm), University of California at Berkeley and Columbia University, New York.

122. W. E. B. Du Bois, "Memorandum of the Pan-African Congress," May 8, 1926, W. E. B. Du Bois Papers, 1877–1965 (microfilm), University of California at Berkeley and Columbia University, New York.

123. See "Sesqui-Centennial Conference Held," *Amsterdam News,* May 12, 1926, 11; and "Exhibits Pouring into Sesqui," *Pittsburgh Courier,* October 9, 1926, 11.

124. "Klan Events Barred at Sesqui Exposition" *Washington Post,* June 23, 1926, 1; Rydell, *World of Fairs,* 159.

125. "Work of Inter-Race Commission Held Up, Funds Lacking," *Afro-American,* February 13, 1926, 20.

126. "Sesqui-Centennial Conference Held," *Amsterdam News,* May 12, 1926, 11.

127. "Hymn of Hate Turns to 'Frat Song' at Mammoth Dinner as Testimonial to Calloway," *Pittsburgh Courier,* September 25, 1925, 11. A lavish dinner celebrated Calloway's departure or, as the *Courier* termed it, his "retirement." Asbury, Turner, and Major R. R. Wright were also in attendance. Also see "Sesqui Releases T. J. Calloway," *Afro-American,* September 18, 1926, 14.

128. Steven Conn describes the lackluster event: "When it was over, the Sesquicentennial celebration vanished from public memory as quickly as its buildings were demolished. Neither did the Sesquicentennial produce a lasting symbol—no Corliss Engine, no gleaming colonnades—of the sort that helped fix other expositions firmly in the imagination of Americans." Steven Conn, *Museums and American Intellectual Life, 1876–1926* (Chicago: University of Chicago Press, 1998), 235.

129. "Exhibits Pouring into Sesqui," *Pittsburgh Courier,* October 9, 1926, 11.

130. Educated at the Cooper Union, Savage had been recently barred from attending an American-sponsored art school in Paris because of her race; the *Crisis,* under the stewardship of Du Bois, had taken up her cause. Lewis, *W. E. B. Du Bois: The Fight for Equality and the American Century, 1919–1963,* 94–95, 99.

131. Dora Cole Norman, *Loyalty's Gift—An Historical Pageant,* Box 102,

Folder 6, Mary Church Terrell Papers, Moorland-Spingarn Research Center, Howard University, Washington, D.C.

132. Another pageant *Ethiopia,* drawing on similar themes to Du Bois's well-known spectacle, was also staged at as part of the exposition's Department of Pageantry and, like *Loyalty's Gift,* drew crowds of thirty thousand or more spectators. "Loyalties Gift Is Wonderful Pageant," *Pittsburgh Courier,* July 17, 1926, 11; "1000 Voices Impress Big Sesqui Crowd," *Pittsburgh Courier,* September 4, 1926, 11; "30,000 People Expected to See Spectacular Musical Drama on Ethiopia, on Sept. 22," *Pittsburgh Courier,* September 13, 1926, 11. Also see Erastus Long Austin and Odell Hauser, *The Sesqui-centennial International Exposition: A Record Based on Official Data and Departmental Reports* (Philadelphia: Current Publications, 1929), 246–47.

133. Rydell, *World of Fairs,* 160; Kendrick to Randolph, *The Messenger* 8, no. 6 (June 1926): 190.

134. "Randolph Speech at Opening of Sesqui-Centennial," *Pittsburgh Courier,* June 12, 1926, 1.

135. Ibid.

136. Ibid. Also see Rydell's excellent analysis of Randolph's speech in Rydell, *World of Fairs,* 161–64.

137. "The Star of Ethiopia," *Washington Bee,* October 16, 1915.

138. As historian August Meier observes of the period, "Frequently history was held to be of value in instilling race pride, solidarity, and self-help, whether these might be directed toward economic co-operation, toward an all-Negro community, or even colonization." Meier, *Negro Thought in America, 1880–1915,* 261.

139. W. E. B. Du Bois, "The Black Man Brings His Gifts," *Survey Graphic,* 1925, 655–57.

140. It is important to recognize that pageants were ideological forums precisely because their imaginary dimensions and performative actions served the needs of the state in the subject formation of citizens. See Louis Althusser, "Ideology and Ideological State Apparatuses," in *Lenin and Philosophy and Other Essays* (New York: Monthly Review Press), 170–77.

141. Glassberg, "History and the Public," 979.

142. George Simmel, "The Metropolis and Mental Life," in *Rethinking Architecture,* ed. Neal Leach (New York: Routledge, 1997), 69–79.

143. "Petition against Segregation," *Guardian,* May 5, 1926, Tuskegee Institute News Clippings File, Division of Behavioral Science Research, Tuskegee, Ala. (microfilm), University of California at Berkeley.

144. As historian Kevin Gaines observes, "Randolph, Carter G. Woodson, Langston Hughes, Nella Larsen, and E. Franklin Frazier were all critical of accommodationist black leadership." Gaines, *Uplifting the Race,* 236.

CHAPTER 4

1. St. Clair Drake and Horace R. Cayton, *Black Metropolis: A Study of Negro Life in a Northern City* (New York: Harper and Row, 1945), 379.

2. Ibid., 380–81.

3. Ibid., 80. Also see Adam P. Green, *Selling the Race: Culture and Community in Black Chicago 1940–1955* (Chicago: University of Chicago Press, 2007).

4. Drake and Cayton, *Black Metropolis,* 396.

5. Ibid., 287.

6. Ibid., 287, 312.

7. Ibid., 84.

8. Ibid., 733–36; Nikhil Pal Singh, *Black Is a Country: Race and the Unfinished Struggle for Democracy* (Cambridge, Mass.: Harvard University Press, 2004). Also see the excellent study of the Popular Front in Michael Denning, *The Cultural Front: The Laboring of American Culture in the Twentieth Century* (London: Verso, 1996).

9. As historian Kevin Gaines observes, for instance, the NAACP failed to initially act in the Scottsboro case, in which nine young black men in Alabama were wrongly accused of attacking two white women. The Communist Party, through its International Legal Defense arm, came to their aid. See Kevin Kelly Gaines, *Uplifting the Race: Black Leadership, Politics, and Culture in the Twentieth Century* (Chapel Hill: University of North Carolina Press, 1996), 251.

10. Bill Mullen, *Popular Fronts: Chicago and African-American Cultural Politics, 1935–46* (Urbana: University of Illinois Press, 1999).

11. See Henry Louis Taylor and Walter Hill, *Historical Roots of the Urban Crisis: African Americans in the Industrial City, 1900–1950,* Crosscurrents in African American History (New York: Garland Pub., 2000); Daniel M. Johnson and Rex R. Campbell, *Black Migration in America: A Social Demographic History* (Durham, N.C.: Duke University Press, 1981), 95–96; and Campbell Gibson and Kay Jung, *Historical Census Statistics on Population Totals by Race, 1790 to 1990, and by Hispanic Origin, 1970 to 1990, for Large Cities and Other Urban Places in the United States* (Washington, D.C.: U.S. Census Bureau, Population Division, February 2005).

12. Since the days of the Lincoln Jubilee Exposition, Chicago's black population, for example, had grown from 44,103 to 277,731 by 1940, with the population doubling between 1920 and 1930. Likewise Detroit had experienced exponential growth in its black population, beginning with 5,741 in 1910 and expanding to 149,119 by 1940. Drake and Cayton, *Black Metropolis,* 8; Richard W. Thomas, *Life for Us Is What We Make It: Building Black Community in Detroit, 1915–1945* (Bloomington: Indiana University Press, 1992), 26; Gibson and Jung, *Historical Census Statistics on Population Totals by Race, 1790 to 1990, and by Hispanic Origin, 1970 to 1990, for Large Cities and Other Urban Places in the United States.*

13. See Thomas Sugrue, *The Origins of Urban Crisis: Race and Inequality in Postwar Detroit* (Princeton, N.J.: Princeton University Press, 1996), 211.

14. Johnson and Campbell, *Black Migration in America,* 110. An article in the NUL's *Opportunity Magazine* reported that in Detroit " 'landlords have no trouble getting $45.00 and $50.00 a month for four rooms without electric light and frequently without bath.' In Chicago practically no building is going on in the neighborhoods of Negro residence as newcomers continue to pour in." "Housing the Migrants," *Opportunity Magazine* (October 1923), in *Up South: Stories,*

Studies, and Letters of This Century's African-American Migrations, ed. Malaika Adero (New York: New Press, distributed by W. W. Norton, 1993), 48–49.

15. See Allan H. Spear, *Black Chicago: The Making of a Negro Ghetto, 1890–1920* (Chicago: University of Chicago Press, 1967); and Arnold R. Hirsch, *Making the Second Ghetto: Race and Housing in Chicago, 1940–1960* (Cambridge: Cambridge University Press, 1983).

16. Sugrue, *The Origins of Urban Crisis,* 24.

17. In Drake and Clayton's *Black Metropolis,* people described the ideal race leader as male, although they also talk of "race women." In Drake and Cayton, interviewees said that a race leader knows "the difficulties of the race and fights without a selfish reason; is a sincere person with some moral principle; is sincere and has a plan; has a constant, sincere interest in the race; is sincere and people know he is not after some hidden personal interest; has the interest and well-being of the Negro race uppermost in his life." Drake and Cayton, *Black Metropolis,* 393.

18. Ibid., 717.

19. "Two Negro Expositions," *Negro History Bulletin* 3, no. 6 (1940): 89.

20. David M. Katzman, *Before the Ghetto: Black Detroit in the Nineteenth Century,* Blacks in the New World (Urbana: University of Illinois Press, 1973).

21. See "Exposition Office to Open Jan. 1," *Michigan Chronicle,* December 30, 1939, 1; and Eddie Tolan to John C. Dancy, December 27, 1939, Reel 10, Frame 841, Detroit Urban League Papers, Michigan Historical Collections (microfilm), Bentley Historical Library, University of Michigan at Ann Arbor.

22. Victoria W. Wolcott, *Remaking Respectability: African American Women in Interwar Detroit* (Chapel Hill: University of North Carolina Press, 2001), 216.

23. See the chapter "Engendering the Cultural Front" in Mullen, *Popular Fronts.*

24. John C. Dancy, *Sand against the Wind: The Memoirs of John C. Dancy* (Detroit: Wayne State University Press, 1966), 64; R. Thomas, *Life for Us Is What We Make It* .

25. August Meier and Elliot Rudwick, *Black Detroit and the Rise of the UAW* (New York: Oxford University Press, 1979), 18, 56.

26. R. Thomas, *Life for Us Is What We Make It,* 160–2.

27. Ibid., 235–43.

28. "Tolan to Head Detroit Exposition," *Associated Negro Press,* July 26, 1939, Reel 19, Claude A. Barnett Papers (microfilm), Stanford University, Stanford, Calif.; "Eddie Tolan Is Appointed Director 1940 Exposition," *Michigan Chronicle,* July 15, 1939; "The 1940 Exposition" *Michigan Chronicle,* July 22, 1939.

29. Mound Bayou was established in 1887 in the Yazoo Delta. Its founder, Isaiah T. Montgomery, was one of the state commissioners for the Negro Building at the Atlanta Cotton States and International Exposition.

30. See "75 Years of Negro Progress—Exposition Newsletter," *Michigan Chronicle,* January 6, 1940, 7; "Seventy-Five Years of Progress Exposition Opens Here Next Friday," *Detroit Tribune,* May 4, 1940, Reel 10, Frame 890–1, Detroit Urban League Papers, Michigan Historical Collections (microfilm), Bentley

Historical Library, University of Michigan at Ann Arbor; and Robert Crump, "20,000 Exposition Hear Farley," *Chicago Defender,* May 25, 1940, 7.

31. "75 Years of Negro Progress Features Ten-Day Exposition in Detroit," *Daily Worker,* May 13, 1940, Tuskegee Institute News Clippings File, Division of Behavioral Science Research, Tuskegee, Ala. (microfilm), University of California at Berkeley. For an excellent review of the activities of the CIO in northern cities, see Mullen, *Popular Fronts;* and "The New Unions" in Drake and Cayton, *Black Metropolis,* 314.

32. "Michigan in the Limelight," *Detroit Tribune,* May 11, 1940.

33. "Hamilton Praises Progress of Negro Americans at Fair," *Globe,* May 17, 1940, Tuskegee Institute News Clippings File, Division of Behavioral Science Research, Tuskegee, Ala. (microfilm), University of California at Berkeley.

34. "Negroes' Liberalism Lauded by Farley," *Christian Science Monitor,* May 13, 1940, 7.

35. R. Thomas, *Life for Us Is What We Make It,* 258–63. Also see Robert D. Crump, "Detroit Politics Gain Impetus," *Associated Negro Press,* May 29, 1940, Reel 20, Claude A. Barnett Papers (microfilm), Stanford University, Stanford, Calif.

36. "Bojangles Studies Exposition Program," *Chicago Defender,* March 30, 1940, 12.

37. "Exposition to Present Broadcast," *Detroit Tribune,* February 17, 1940, 1.

38. "Karamu Dancers Make Hit before Large Audience at Exposition," *Detroit Tribune,* June 1, 1940, 1.

39. "Paints Portrait of Noted Sire to Hang in Negro Progress Exposition," *Detroit Tribune,* May 25, 1940.

40. See "Exposition to Honor Carver and Louis; Comes to Close on Sunday," *Detroit Tribune,* May 18, 1940.

41. "In the Negro Hall of Fame, Convention Hall," Reel 10, Frame 960; "Negro Hall of Fame," *Detroit Tribune,* April 6, 1940, Reel 10, Frame 890–1, both in Detroit Urban League Papers, Michigan Historical Collections (microfilm), Bentley Historical Library, University of Michigan at Ann Arbor.

42. "75 Years of Negro Progress Exposition, Educational Exhibition," Reel 10, Frame 953, Detroit Urban League Papers, Michigan Historical Collections (microfilm), Bentley Historical Library, University of Michigan at Ann Arbor; "Seventy-Five Years of Progress to Open Here Next Friday," *Detroit Tribune,* May 4, 1940, and "Negro Hall of Fame," Reel 10, Frame 890–1, Detroit Urban League Papers, Michigan Historical Collections (microfilm), Bentley Historical Library, University of Michigan at Ann Arbor.

43. Charles H. Wesley, "The Story of Negro Progress in the United States," in *A Brief History of 75 Years of Negro Progress,* ed. Charles H. Wesley and John C. Dancy (Detroit, 1940), 9.

44. "A White Man Tells What He Thinks of the American Negro's Progress," *Detroit Tribune,* May 18, 1940.

45. Robert Crump, "20,000 Exposition Hear Farley," *Chicago Defender,* May 25, 1940, 7.

46. Harold Cruse, *The Crisis of the Negro Intellectual* (1967; New York: William Morrow and Co., 1984).

47. Ted Poston, "One Man's Dream Comes True," *Pittsburgh Courier,* June 15, 1940, 18. Also see the chapters "Negro Business: Myth and Fact" and "Style of Living—Upper Class" in Drake and Cayton, *Black Metropolis.*

48. Drake and Cayton, *Black Metropolis,* 731.

49. According to Drake and Cayton, the Bronzeville name was first used in 1930 by an editor of the *Defender* who sponsored a contest to name the mayor of Bronzeville. Ibid., 383. Also see Hirsch, *Making the Second Ghetto.*

50. Harold Cruse notes that World War II ended Negro insularity and, "until 1940, the word integration had not appeared, even in the language of the NAACP; the war inspired the first series of articles in *Crisis,* NAACP's official publication, demanding the 'integration of the armed forces.' " Prior to that the NAACP's theme had been one of civil rights. Cruse, *The Crisis of the Negro Intellectual,* 208–9.

51. See Davarian L. Baldwin, *Chicago's New Negroes: Modernity, the Great Migration, and Black Urban Life* (Chapel Hill: University of North Carolina Press, 2007); Davarian L. Baldwin, " 'Chicago's New Negroes': Race, Class, and Respectability in the Midwestern Black Metropolis, 1915–1935" (PhD dissertation, New York University, 2002).

52. Robert Rydell, *World of Fairs* (Chicago: University of Chicago Press, 1993), 165–71; Green, *Selling the Race.*

53. A. C. MacNeal to Col. Robert Isham Randolph, and Frank McBride to Jay Tomlin, June 23, 1933, Series 1—General Correspondence, Box 339, Folder 1–10853, Century of Progress Collection, Daley Library Special Collections and University Archives, University of Illinois at Chicago. Correspondence confirms that a separate Visitors Service affiliated with the Southside Church Commission had been established to handle the accommodation requests of black visitors.

54. See correspondence in Series 1—General Correspondence, Box 7, Folder 1–190, 1–191, 1–192, Century of Progress Collection, Daley Library Special Collections and University Archives, University of Illinois at Chicago.

55. Christopher Robert Reed, "In the Shadow of Fort Dearborn," *Journal of Black Studies* 21, no. 4 (1991). Also see correspondence in Series 1—General Correspondence, Box 365, Folder 11707, 11708, and Box 369, Folder 11817, Century of Progress Collection, Daley Library Special Collections and University Archives, University of Illinois at Chicago.

56. Rydell, *World of Fairs,* 171–82.

57. Jones was assisted by Jessie O. Thomas, southern field secretary of the NUL, in the role of general manager. In planning the event they reviewed the mainstream Jamestown Exposition, Philadelphia Sesquicentennial Exposition, and Chicago Century of Progress fair. But, as Thomas writes in the official account of the Texas fair, they were unable to find any information on what Negroes had done, so they invented their own general scheme. Jessie O. Thomas, *Negro Participation in the Texas Centennial Exposition* (Boston: The Christopher Publishing House, 1938), 27.

58. Ibid., 21.

59. Ibid., 77–83.

60. See Truman K. Gibson, "Memorandum," n.d., Box 366, Folder 4, Claude A. Barnett Papers, Chicago History Museum.

61. Chicago's representative, Arthur W. Mitchell, the only black congressman in the country, proposed a bill in the House for an allocation of $75,000 in additional federal monies; Illinois senator James M. Slattery sponsored a similar bill in the Senate. Congress eventually passed the bill and President Roosevelt signed the funding measure a month before the exposition opened its doors. "American Negro Exposition," *Amsterdam News,* June 15, 1940, 10, Tuskegee Institute News Clippings File, Division of Behavioral Science Research, Tuskegee, Ala. (microfilm), University of California at Berkeley.

62. House Committee on the Library, *Report: American Negro Exposition,* 76th Cong., 3d sess., H.R. Rep. 1979 at 2 (1940).

63. Ibid., 2.

64. See Report, July 1940, Box 30, Claude A. Barnett Papers, Chicago History Museum; Frank Marshall Davis, "Official Answers Chicago Fair Critic," *Crisis,* February 1941, 49, 58; and Selma Gordon, "75 Years of Negro Progress," *Crisis,* January 1941, 10–11, 20.

65. American Negro Exposition, *American Negro Exposition: Report by Diamond Jubilee Exposition Authority to Afra-Merican Emancipation Commissions of the State of Illinois and of the Federal Government* (Chicago, 1940), 7–8.

66. A large chorus assembled for the exposition sang a celebratory program that included the "Negro National Anthem," the "Star Spangled Banner," and several Negro spirituals. "Roosevelt Pushes Button Opens Local Exposition," *Chicago Defender,* July 13, 1940, 1.

67. "Exposition at Chicago Opens on July 4th," *Chicago Defender,* June 29, 1940, 1; Workers of the Writers' Program of the Works Progress Administration in the State of Illinois, *Cavalcade of the American Negro* (Chicago: Diamond Jubilee Exposition, 1940), 91–95.

68. Workers of the Writers' Program of the Works Progress Administration in the State of Illinois, *Cavalcade of the American Negro,* 24; Drake and Cayton, *Black Metropolis,* 660.

69. "Jobless Threat to Democracy, Wallace Says," *Washington Post,* September 3, 1940, 3; "Wallace Attacks Scapegoat Idea," *New York Times,* September 3, 1940, 13.

70. Denning, *The Cultural Front.*

71. Mullen also mentions the American Negro Exposition as an effort to transform how black culture was perceived. See Mullen, *Popular Fronts,* 11.

72. James Edward Smethurst, *The Black Arts Movement: Literary Nationalism in the 1960s and 1970s,* the John Hope Franklin Series in African American History and Culture (Chapel Hill: University of North Carolina Press, 2005).

73. Robert Bone, "Richard Wright and the Chicago Renaissance," *Callaloo* 28 (Summer 1986): 446, 453.

74. Richard Wright, "Introduction," in *Black Metropolis: A Study of Negro Life in a Northern City,* ed. St. Clair Drake and Horace R. Cayton (New York: Harper and Row, 1945), 17.

75. Ibid., 19.

76. Park spent several years studying rural life in the Black Belt in Alabama as a close confidant of Booker T. Washington. As a result, he understood the rural roots of many of Chicago's migrants. When Park began teaching at the Univer-

sity of Chicago's School of Sociology in 1913, he also accepted the position as the president of the interracial board of the Chicago Urban League (CUL), thus providing him with the opportunity to observe firsthand the challenges facing blacks pouring into the city. Robert E. Park, Ernest W. Burgess, and Roderick D. McKenzie, *The City (1925)* (Chicago: University of Chicago Press, 1967), 1. Also see Davarian L. Baldwin, "Black Belts and Ivory Towers: The Place of Race in U.S. Social Thought, 1892," *Critical Sociology*, no. 30 (2004): 397–450; Andrew Ross, *The Gangster Theory of Life: Nature's Debt to Society* (London: Verso, 1994), 117–19; and Mabel O. Wilson, "Making a Civilization Paradigm: Robert Park, Race and Urban Ecology," (unpublished paper, New York University, 1996).

77. Claude Barnett to Jackson Davis, March 11, 1940, Box 336, Folder 4, Claude A. Barnett Papers, Chicago History Museum.

78. Locke stated optimistically that blacks migrating out of the South had cast off those degrading plantation stereotypes of "mammies," "Uncle Toms" and "sambos." He believed that out of the passionate cultural productions created by the urbanized New Negro a fresh conceptualization of black identity would emerge to form a "new American attitude." Alain Locke, ed. *The New Negro* (1925; New York: Atheneum, 1936), 10.

79. For more on Evans's work as an artist, see Kymberly Pinder, "Black Public Art and Religion in Chicago" (unpublished manuscript, April 2011), which is forthcoming as a published book.

80. "Hall of Fame Will Depict Important Events in the Life of Negro at Exposition," *Black Dispatch,* May 25, 1940; and "History of Negro Told in Dioramas," *Kansas City Call,* August 2, 1940, both in Tuskegee Institute News Clippings File, Division of Behavioral Science Research, Tuskegee, Ala. (microfilm), University of California at Berkeley.

81. "Director of Ill. World Fair Exhibits Supervising Work for Chi Exposition," *Pittsburgh Courier,* June 15, 1940, 18.

82. *American Negro Exposition: Report by Diamond Jubilee Exposition Authority to Afra-Merican Emancipation Commissions of the State of Illinois and of the Federal Government,* 17.

83. Workers of the Writers' Program of the Works Progress Administration in the State of Illinois, *Cavalcade of the American Negro,* 92.

84. "Chicago Negro 'World's Fair' Shows Race's Achievements," *Christian Science Monitor,* August 16, 1940, 3; *American Negro Exposition: Report by Diamond Jubilee Exposition Authority to Afra-Merican Emancipation Commissions of the State of Illinois and of the Federal Government,* 22.

85. Horace R. Cayton to W. E. B. Du Bois, April 29, 1940; Du Bois to Cayton, May 3, 1940; and Cayton to Du Bois, May 15, 1940, all in Reel 51, Frames 102–4, W. E. B. Du Bois Papers, 1877–1965 (microfilm), University of California at Berkeley and Columbia University, New York.

86. "America's Negro Problem to be Depicted in Social Science Exhibit at Chi Exposition," *Pittsburgh Courier,* June 27, 1940, 13.

87. For an assessment of Frazier's conservatism, see Singh, *Black Is a Country,* 77.

88. At state and country fairs across the country, for example, eugenics advocates advised audiences about how to adopt domestic habits and hygienic prac-

tices of the "typical family." Advocates promoted race-coded terms like *gene pools, hereditary stock,* and *fitter families.* Robert Rydell notes how the eugenics discourse of racial betterment received legitimation by its inclusion in mainstream museums such as Chicago's Field Museum and in presentations at the fairs, including the 1939–40 New York World's Fair. Rydell, *World of Fairs,* 49–58; Mary K. Coffey, "The American Adonis: A Natural History of the Average American," in *Popular Eugenics: National Efficiency and American Mass Culture in the 1930s,* ed. Susan Currell and Christina Cogdell (Athens: Ohio University Press, 2006), 185–216.

89. *American Negro Exposition: Report by Diamond Jubilee Exposition Authority to Afra-Merican Emancipation Commissions of the State of Illinois and of the Federal Government,* 24.

90. American Negro Exposition, *Exhibition of the Art of the American Negro, 1851–1940* (Chicago: Tanner Art Galleries and American Negro Exposition, 1940), 28, 35.

91. Hughes and Bontemps wrote the story and the music was penned by Zilner Randolph and Margaret Bonds. Performers included 270-pound tap dancer Pork Chops Patterson, ballroom dancers Johnson and Grider, dancer Sweetie Pie De-Hart, half-pint singer and comedian Dick Montgomery, with the local Horace Henderson band providing musical accompaniment. "Jam Opening of 'Tropics after Dark' at Exposition," *Chicago Defender,* July 20, 1940, 3.

92. Barnett promoted the idea for a film made expressly for the exposition. Along with Barnett, Charles S. Johnson and Channing Tobias provided content and the film was funded by a grant from the General Education Board. "Film on Negro Education Shown at Race Progress Exposition Here," *Chicago Defender,* September 7, 1940, 17. For a history of race movies of the period, see Donald Bogle, *Toms, Coons, Mulattoes, Mammies and Bucks: An Interpretive History of Blacks in American Films* (New York: Continuum, 1989).

93. See James A. Porter, *Modern Negro Art* (Washington, D.C.: Howard University Press, 1998), 76.

94. Carline Evone Williams Strong, "Margaret Taylor Goss Burroughs: Educator, Artist, Author, Founder, and Civic Leader" (UMI, 1994), 79.

95. Aden and Barnett assembled a jury of experts that included Dawson, Daniel C. Rich from the Art Institute of Chicago, and George Thore and Peter Pollak, both from the WPA's Illinois Art Project. Alain Locke, "The American Negro Exposition's Showing of the Works of Negro Artists," in *Exhibition of the Art of the American Negro, 1851–1940,* ed. American Negro Exposition (Chicago: Tanner Art Galleries and American Negro Exposition, 1940).

96. Alain Locke, "The American Negro Exposition's Showing of the Works of Negro Artists," Box 369, Folder 3, Claude A. Barnett Papers, Chicago History Museum.

97. Horace Cayton to Claude Barnett, October 16, 1940, Box 368, Folder 5, Claude A. Barnett Papers, Chicago History Museum.

98. Claude Barnett to G. James Flemming, July 31, 1940, and Claude Barnett to F. D. Patterson, Box 368, Folder 2, Claude A. Barnett Papers, Chicago History Museum.

99. Green, *Selling the Race,* 44.

100. Workers of the Writers' Program of the Works Progress Administration in the State of Illinois, *Cavalcade of the American Negro,* 54.

101. *American Negro Exposition: Report by Diamond Jubilee Exposition Authority to Afra-Merican Emancipation Commissions of the State of Illinois and of the Federal Government,* 16.

102. Workers of the Writers' Program of the Works Progress Administration in the State of Illinois, *Cavalcade of the American Negro,* 58.

103. Ibid., 90.

104. Green, *Selling the Race;* Mullen, *Popular Fronts.*

105. Eugene Feldman, *The Birth and the Building of the DuSable Museum* (DuSable Museum Press, 1981), 27–29; Margaret T. G. Burroughs, *Life with Margaret* (Chicago: In Time Publishing and Media Group, 2003), 41–44, 166–69.

106. There are very few records of the NNMHF. The group began in the early 1940s and its activities seemed to trail off by the latter part of the decade. Besides accounts in the *Defender* and *Chicago Bee,* the Madeline Stratton Morris Papers in the Vivian G. Harsh Collection at the Woodson Branch of the Chicago Public Library contain a rare bulletin of the organization's manifesto. Also see Feldman, *The Birth and the Building of the DuSable Museum,* 13.

107. Dorothy Williams, "Adult Education in Public Libraries and Museums," *Journal of Negro Education* 14, no. 3 (1945): 322–30.

108. Tracy Lang Teslow, "Reifying Race," in *The Politics of Display,* ed. Sharon MacDonald (London: Routledge, 1998), 53.

109. Donna Haraway, "Teddy Bear Patriarchy," in *Primate Visions: Gender, Race, and Nature in the World of Modern Science* (New York: Routledge, 1989), 26–58.

110. Construction of the library branch was funded by the Rosenwald Foundation in 1932, and Chicago Public Library's first black librarian, Vivian Harsh, established at the new branch an extensive "Special Negro Collection" of books on literature and history. "E. Franklin Frazier on Negro History Week," *Chicago Bee,* February 17, 1945; Drake and Cayton, *Black Metropolis,* 741.

111. "Shaft to Colored Soldiers," *Washington Post,* March 19, 1916, 3.

112. The NMA urged the formation of memorial associations in each state to lobby congressional members to support a bill funding the memorial to black soldiers. "Memorial to Negro Proposed in Bill," *Washington Post,* February 1, 1928, 24.

113. One proposal for the Negro museum suggested it be built perpendicular to the symbolic axis connecting the Capitol, the Washington Monument, and the recently completed Lincoln Memorial; other options proposed building it on government land near Howard University.

114. House of Representatives, Committee on Public Buildings and Grounds, *To Create a Commission to Secure Plans and Designs for and to Erect a Memorial Building for the National Memorial Association, Incorporated in the City of Washington, as a Tribute to the Negro's Contribution to the Achievements of America* (House of Representatives, February 1, 1928), 1.

115. W. E. B. Du Bois made several inquires to people associated with the NMA, including Hamilton and Terrell, about the trustworthiness of Lee and to find out more about the proposal for a possible *Crisis* article. See W. E. B. Du

Bois to Lizzie Bassett, May 2, 1928, Reel 26, Frame 1133; Du Bois to Mrs. A. N. Curtis, May 2, 1928, Reel 26; Du Bois to Julia West Hamilton, May 3, 1928, Reel 27, Frame 11; Julia West Hamilton to Du Bois, May 6, 1928, Reel 27, Frame 12; and Mary Church Terrell to Du Bois, May 3, 1928, Reel 27, Frame 861, all in W. E. B. Du Bois Papers, 1877–1965 (microfilm), University of California at Berkeley and Columbia University, New York. Also see Robert L. Wilkins, "The Forgotten Museum" (unpublished paper, 2002), 3; "Memorial to Negro Proposed in Bill," *Washington Post,* February 1, 1928, 24; and "$500,000 Memorial to Honor Achievements of Negro Race," *Washington Post,* March 10, 1929, 10.

116. House of Representatives, Committee on Public Buildings and Grounds, *To Create a Commission to Secure Plans and Designs for and to Erect a Memorial Building for the National Memorial Association, Incorporated in the City of Washington, as a Tribute to the Negro's Contribution to the Achievements of America,* 17.

117. "President Hoover to Meet with National Memorial Association," *Chicago Defender,* November 30, 1929, 2.

118. Wilkins, "The Forgotten Museum," 7; "Negroes to Mark Passage of Bill," *Washington Post,* April 21, 1929, 22.

119. In taking stock of other collections, Miller acknowledged the importance of Fisk University's holdings as well as the efforts of Woodson, Schomburg, Murray, and others, including blues musician W. C. Handy, in gathering historical documents and artifacts. "Negro Americana Begun at Howard University," Box 71-1, Folder 15; and Kelly Miller to President S. M. Newman, June 15, 1914, Box 71-1, Folder 29, both in Kelly Miller Papers, Moorland-Spingarn Research Center, Howard University, Washington, D.C.

120. "Dr. Kelly Miller Seeks National Negro Museum," *Amsterdam News,* August 6, 1938, A8, Box 71-2, Folder 92, Kelly Miller Papers, Moorland-Spingarn Research Center, Howard University, Washington, D.C.

121. *National Negro Museum and Historical Foundation, Inc.,* pamphlet, February 1946, Madeline Stratton Morris Papers, Vivian G. Harsh Research Collection, Carter G. Woodson Branch, Chicago Public Library. Much like the *Pittsburgh Courier*'s popular "Double V" campaign, which stood for victory abroad and at home, a slogan picked up by other outlets such as the *Defender,* the foundation argued that the struggle against fascist regimes could only be won if America rectified its own oppressive actions at home.

122. *National Negro Museum and Historical Foundation, Inc.,* pamphlet, February 1946, Madeline Stratton Morris Papers, Vivian G. Harsh Research Collection, Carter G. Woodson Branch, Chicago Public Library.

123. Burroughs, *Life with Margaret.*

124. "E. Franklin Frazier on Negro History Week," *Chicago Bee,* February 17, 1945; "Mass Meeting to End Week of Long Negro History Activities," *Chicago Bee,* February 11, 1945. The following year, the foundation honored those whose work improved race relations. Honorees included Frazier, Johnson, Robeson, Bethune, Representative Adam Clayton Powell Jr., Vice President Henry A. Wallace, author Howard Fast, and union president Mike Quill. See "Negro History Meet to Honor 17 Americans" *Chicago Bee,* February 18, 1946; and

"Negro History Week Mass Meeting at DuSable Sunday" *Chicago Bee,* February 10, 1946.

125. "Loop Hotels Ban Race History Fete" *Chicago Defender,* February 11, 1946, 12; "Chicago Hotels Set Quota on Negroes at Banquets," *Chicago Defender,* March 2, 1946, 12.

126. Bernard Goss and Margaret Burroughs to Friends, September 20, 1950, Box 1, Folder 44, Michel Fabre Archives of African American Arts and Letters, Manuscript, Archives, and Rare Book Library, Emory University, Atlanta. For a detailed account of the left-wing integrationists and black nationalists among the CNA, see Cruse, *The Crisis of the Negro Intellectual,* 212–20.

127. Burroughs, *Life with Margaret,* 75; Mullen, *Popular Fronts,* 192.

128. Singh, *Black Is a Country,* 69.

129. James E. Young, *The Texture of Memory: Holocaust Memorials and Meaning* (New Haven, Conn.: Yale University Press, 1993), 280.

CHAPTER 5

1. The lead architect for the new convention center, which opened in 1960, was Alfred Shaw of the Chicago firm Graham Anderson Probst and White; architect Edward Durell Stone designed the Arie Crown Theater that was part of the complex.

2. Scholar Michael Denning argues that the culture industry of leisure and entertainment benefited greatly from the creative capital that the Cultural Front expended. Michael Denning, *The Cultural Front: The Laboring of American Culture in the Twentieth Century* (London: Verso, 1996), 38–50.

3. "A Century of Negro Progress," *Chicago Defender,* January 6, 1962, 16; "Camera Visit to Century of Negro Progress Exposition," *Chicago Defender,* August 24, 1963, 14; "Exposition to Hold Negro History Day," *Chicago Tribune,* September 1, 1963, A5.

4. Harvey G. Cohen, *Duke Ellington's America* (Chicago: University of Chicago Press, 2010), 394.

5. Ibid., 392–98.

6. *A Century of Negro Progress,* program, Box 2, Charles Bishop Papers, Vivian G. Harsh Research Collection, Carter G. Woodson Branch, Chicago Public Library.

7. Del Shields, "Bad Timing to Blame for Exposition Shame," *Philadelphia Tribune,* September 17, 1963, 7.

8. Ibid.

9. Margaret Burroughs, interview with author, June 2005. Also see Margaret T. G. Burroughs, *Life with Margaret* (Chicago: In Time Publishing and Media Group, 2003), 100. Flory, a member of the CPUSA, was a fixture in the Black Belt's political scene and was involved in several unions. His leadership included becoming the head of the Chicago branch of the National Negro Congress. See Harold Preece, "Ishmael Flory Becomes Prominent Labor Leader," *Chicago Defender,* August 26, 1939, 13; and James Edward Smethurst, *The Black Arts Movement: Literary Nationalism in the 1960s and 1970s,* the John Hope Franklin Se-

ries in African American History and Culture (Chapel Hill: University of North Carolina Press, 2005), 194.

10. Burroughs, *Life with Margaret,* 100–101; Carline Evone Williams Strong, "Margaret Taylor Goss Burroughs: Educator, Artist, Author, Founder, and Civic Leader" (UMI, 1994), 187.

11. See Hal Barger, "Couple Inspire Museum," *Chicago Daily Tribune,* December 17, 1961, S1; and Eugene Feldman, *The Birth and the Building of the DuSable Museum* (DuSable Museum Press, 1981), 15–16.

12. "Windy City Notes Du Sable Week," *Daily Defender,* August 22, 1963, 6.

13. Historian and former director of the National History Museum in Washington, D.C., Spencer R. Crew traces the formation of black historiography, suggesting that it was the impetus for the development of black history museums. This scholarship was followed by the formation of literary and historical societies and eventually led to the founding of institutions dedicated to the research and display of black history. Spencer R. Crew, "African Americans, History and Museums: Preserving African American History in the Public Arena," in *Making Histories in Museum,* ed. Gaynor Kavanagh (London: Leicester University Press, 1996), 80–91; John E. Fleming, "African American Museums, History, and the American Ideal," *Journal of American History* 81, no. 3 (1994): 1020–26.

14. Studying the nineteenth-century origins of the modern museum, scholars Tony Bennett, Timothy Mitchell, Didier Maleuvre, and Steven Conn have argued that the museum's cultural function is a highly politicized one. See Tony Bennett, *The Birth of the Museum* (London: Routledge, 1995), 60–61; Timothy Mitchell, *Colonising Egypt* (Berkeley: University of California Press, 1991), 13; Didier Maleuvre, *Museum Memories: History, Technology, Art* (Stanford, Calif.: Stanford Unversity Press, 1999); and Steven Conn, *Museums and American Intellectual Life, 1876–1926* (Chicago: University of Chicago Press, 1998).

15. The Boston museum is a compelling story that is not included in detail in this book. However it is nonetheless an important institution in the triad of first black history museums and will no doubt be covered in future scholarship on the topic.

16. "Minutes of the Project: IAM Meeting," March 10, 1965, Charles H. Wright Papers, Charles H. Wright Museum of African American History, Detroit (hereafter CWMAAH).

17. See Thomas Sugrue, *The Origins of Urban Crisis: Race and Inequality in Postwar Detroit* (Princeton: Princeton University Press, 1996).

18. These former farmers, domestic workers, and day laborers settled in what they imagined to be an urban milieu that was considerably less racially stratified than what they had experienced back home. Once they arrived in the bustling industrial town, housing was scarce and, when found, it was often substandard and segregated in the less desirable parts of the city, which lacked basic amenities. Many autoworkers also faced the grim reality of having to regularly walk picket lines to demand that blacks be promoted to better assembly line positions and receive pay equal to that of their white colleagues. See ibid.; August Meier and Elliot Rudwick, *Black Detroit and the Rise of the UAW* (New York: Oxford University Press, 1979); and Richard W. Thomas, *Life for Us Is What We Make It:*

Building Black Community in Detroit, 1915–1945 (Bloomington: Indiana University Press, 1992).

19. Dr. Audrey Smedley, interview with the author, December 5, 2005. For a history of the Detroit Institute of Art's relationship with the International Afro-American Museum (later renamed the Charles H. Wright Museum of African American History), see Karen R. Miller, "Whose History, Whose Culture?: The Museum of African American History, the Detroit Institute of Arts, and Urban Politics at the End of the Twentieth Century," *Michigan Quarterly Review* 41, no.1 (Winter 2002): 136–54.

20. Wilbur C. Rich and Roberta Hughes Wright, *The Wright Man: A Biography of Charles Wright, M.D.* (Detroit: Charro Books, 1999), 147.

21. "Minutes of the Project: IAM Meeting," March 10, 1965, Charles H. Wright Papers, CWMAAH.

22. See Kobena Mercer, " '1968': Periodizing Politics and Identity," in *Cultural Studies,* ed. Lawrence Grossberg, Cary Nelson, and Paula A. Treichler (London: Routledge, 1992), 433. For an excellent collection of essays that examines the transformations of Pan-Africanism, also see Sidney J. Lemelle and Robin D. G. Kelley, *Imagining Home: Class, Culture, and Nationalism in the African Diaspora* (New York: Verso, 1994).

23. Meeting Minutes, "Minutes of the Project: IAM Meeting", March 10, 1965, Charles H. Wright Papers, CWMAAH.

24. "Proposal for the Creation of an International African American Museum," Charles H. Wright Papers, CWMAAH. To accomplish these goals the museum listed several objectives:

1. To give an accurate sense of identity and worth regarding America's Negroes, by demonstrating the quality and depth of their contribution to world culture and particularly to the New World.

2. To repair distortions of the Negro's place in history by documenting facts which have been hitherto unknown, unaccepted or ignored.

3. To provide a means of collecting and storing artifacts and other source materials suitable for research on the history of the New World Negro.

"International Afro-American Museum—Statement of Purpose," n.d., Charles H. Wright Papers, CWMAAH.

25. See Michele Wallace, "Modernism, Postmodernism and the Problem of the Visual in Afro-American Culture," in *Out There: Marginalization and Contemporary Cultures,* ed. Russell Ferguson et al. (Cambridge, Mass.: MIT Press, 1990), 39–50; and Jan Nederveen Pieterse, *White on Black: Images of African and Blacks in Western Popular Culture* (New Haven, Conn.: Yale University Press, 1995).

26. Rich and Wright, *The Wright Man,* 3–13.

27. Dr. Charles Wright, interview by George Myers and Ron Ames, Box 2, Folder 10–4, Kellogg African American Health Care Project, University of Michigan Medical School, Bentley Historical Library, University of Michigan at Ann Arbor.

28. Ibid.; Charles Wright "The Siege of Selma," unpublished report, March 1965, 6, Charles H. Wright Papers, CWMAAH; Rich and Wright, *The Wright Man,* 135–38.

29. The Deacons patrolled the area to protect civil rights activists in the Congress for Racial Equality (CORE) and local black workers from Klan attack. See Charles Wright, "Report to Medical Committee of Human Rights, Bogalusa, LA, July 17–24, 1965," Charles H. Wright Papers, CWMAAH; "A Trip through Hell—Local Doctor Tells of Trip to Bogalusa, La., and How He Was Aided by Deacons on Ride through Klan Territory," *Michigan Chronicle,* July 31, 1965, 1.

30. To protest the refusal of the American Medical Association (AMA) to fight against segregation of medical facilities and to admit more black doctors, Wright renounced his membership to the powerful and influential professional organization. See Wright's history of the National Medical Association, Charles Wright, *The National Medical Association Demands Equal Opportunity: Nothing More, Nothing Less* (Southfield, Mich.: Charro Book Company, 1995).

31. Charles Wright, "Report of Medical Facility Survey, Republic of Liberia," 1963, Charles H. Wright Papers, CWMAAH.

32. "Minutes of the Project: IAM Meeting," March 10, 1965, Charles H. Wright Papers, CWMAAH; Rich and Wright, *The Wright Man,* 115–19.

33. Dr. Audrey Smedley, interview with the author, December 5, 2005.

34. For an excellent discussion on the distinctions between Richard Wright's political philosophy and the Négritude of Léopold Senghor and others, see the chapter "Wright, Negritude, and African Writing" in Michel Fabre, *The World of Richard Wright,* Center for the Study of Southern Culture Series (Jackson: University of Press of Mississippi, 1985), 192–214.

35. Dr. Audrey Smedley, interview with the author, December 5, 2005.

36. For King's speech at Detroit's Walk to Freedom March, see www.mlkonline .net/detroit.html.

37. Harold Cruse, *The Crisis of the Negro Intellectual* (1967; New York: William Morrow, 1984), 564.

38. Edward Franklin Frazier, *Black Bourgeoisie: The Rise of a New Middle Class,* 1st Free Press Paperback ed. (New York: Free Press, 1965), 208; Rich and Wright, *The Wright Man,* 105.

39. See Charles Wright "The Negro in the Pit," unpublished essay, n.d., Charles H. Wright Papers, CWMAAH.

40. Charles Wright to Roy Wilkins, October 7, 1966; Charles Wright to Whitney Young, June 17, 1968; Richard Durham to Obie Newman, July 11 1966, all in Charles H. Wright Papers, CWMAAH.

41. The call for Black Power was first made by Adam Clayton Powell Jr., who mentioned the topic in two separate speeches in 1965 and 1966. See Cruse, *The Crisis of the Negro Intellectual,* 427. *Black Power* was also a 1954 book on new African nations by Richard Wright, who originated the term.

42. Robin D. G. Kelley, "Stormy Weather," in *Is It Nation Time?,* ed. Eddie S. Glaude (Chicago: University of Chicago Press, 2002), 75.

43. Ibid., 84.

44. For an excellent social history of the radical black nationalist movement in Detroit in the early 1970s, see Dan Georgakas, Marvin Surkin, and Manning Marable, *Detroit, I Do Mind Dying,* updated ed., South End Press Classics 2 (Cambridge, Mass.: South End Press, 1998).

45. In 1965, in response to the assassination of Malcolm X and the vicious-

ness of the Selma attacks, Amiri Baraka, then known as LeRoi Jones, founded the Black Arts Reparatory Theater/School (BART/S) in Harlem. See LeRoi Jones, "The Revolutionary Theater," *Liberator,* July 1965, 4–6. Also see Larry Neal, "The Black Arts Movement," *The Drama Review: TDR* 12, no.4 (Summer 1968): 33. For an excellent history of black cultural nationalism, see William Van Deburg, *The Black Power Movement and American Culture, 1965–1975* (Chicago: University of Chicago Press, 1992), 171.

46. "New Bookstore Specializes in Afro-Americans," *Michigan Chronicle,* January 2, 1965; "WSU Students Ask for Afro-History," *Michigan Chronicle,* October 16, 1965. For a thorough analysis of the context in which these cultural sites and institutions functioned, see Smethurst, *The Black Arts Movement,* 179–246.

47. See Margaret Burroughs, "Down the Straight and Narrow," *Urbanite,* May 1961.

48. Susannah Walker, "Black Is Profitable: The Commodification of the Afro, 1960–1975," *Enterprise and Society* 1, no. 3 (2000): 536–64. For local response to the new trend, see "The Natural Look Becomes More Than Just a Fad," *Michigan Chronicle,* September 24, 1966, 5.

49. Phyl Garland, "The Natural Look," *Ebony* 21, no. 8, June 1966, 146.

50. Michael Denning argues that the Cultural Front's embrace of mass cultural forms and meanings meant that these would eventually be absorbed into the professionalization of mental labor within the state-sponsored expansion of universities and industry. See Denning, *The Cultural Front.*

51. Kobena Mercer, *Welcome to the Jungle: New Positions in Black Cultural Studies* (New York: Routledge, 1994), 110.

52. "We Have Marched, We Have Cried, We Have Prayed," *Ebony* 23, no. 6 April 1968, 36. Also see "The Black Revolution," special issue, *Ebony* 24, no. 10, August 1969.

53. Tying the debate of the 1960s to the larger intellectual debate since the 1880s about the progress of the American Negro, Cruse demonstrated that throughout this period so-called leaders consistently failed to examine a total viewpoint of black life that linked cultural advancement to economic and social oppression. See Cruse, *The Crisis of the Negro Intellectual,* 38.

54. John H. Bracey, Elliott M. Rudwick, and August Meier, *Black Nationalism in America* (Indianapolis, Ind.: Bobbs-Merrill, 1970).

55. See Joe T. Darden, *Detroit, Race and Uneven Development,* Comparative American Cities (Philadelphia: Temple University Press, 1987); Sidney Fine, *Violence in the Model City: The Cavanagh Administration, Race Relations, and the Detroit Riot of 1967* (Ann Arbor: University of Michigan Press, 1989); Georgakas, Surkin, and Marable, *Detroit, I Do Mind Dying;* Sugrue, *The Origins of Urban Crisis;* and June Manning Thomas, *Redevelopment and Race: Planning a Finer City in Postwar Detroit,* Creating the North American Landscape (Baltimore, Md.: Johns Hopkins University Press, 1997).

56. See U.S. Bureau of the Census, "Population of the 100 Largest Urban Places: 1940," www.census.gov/population/documentation/twps0027/tab17.txt.

57. Campbell Gibson and Kay Jung, *Historical Census Statistics on Population Totals by Race, 1790 to 1990, and by Hispanic Origin, 1970 to 1990, for*

Large Cities and Other Urban Places in the United States (Washington, D.C.: U.S. Census Bureau, Population Division, February 2005); J. Thomas, *Redevelopment and Race,* 84; Sugrue, *The Origins of Urban Crisis,* 34.

58. Block-busting occurred when black homeowners moved into white areas and whites, fearful of falling property values, moved out to new suburban developments. Their departure placed more homes on the market for prospective black buyers, a lucrative scenario for greedy white realtors and banks that profited from selling homes to both groups. "Homeowners Seek Block-Busting Ban," *Michigan Chronicle,* January 16, 1965, 1.

59. One poll estimated that 80 percent of Michigan's white residents stood firmly against an open housing policy. Fine, *Violence in the Model City,* 59. Also see Nicholas Hood to Charles Wright, August 1, 1966, Charles H. Wright Papers, CWMAAH; and "White Backlash Growing, 80% reject Open Housing," *Michigan Chronicle,* October 8, 1966.

60. One perspective on the problems of the ghetto can be discerned from the work of noted psychologist Dr. Kenneth Clark, whose analysis diagnosed the social and physical pathologies lurking within the bounded black community. Kenneth Bancroft Clark, *Dark Ghetto: Dilemmas of Social Power,* 1st ed. (New York: Harper and Row, 1965), 22. One year after the passage of keystone civil rights legislation, Daniel P. Moynihan, a political scholar and former assistant secretary of labor, published his report *The Negro Family: The Case for National Action* (1965) for the U.S. Department of Labor. Also see Lee Rainwater and William L. Yancey, *The Moynihan Report and the Politics of Controversy; a Trans-action Social Science and Public Policy Report* (Cambridge, Mass.: MIT Press, 1967), 51.

61. See J. Thomas, *Redevelopment and Race.*

62. In 1966, with urban development well underway, the Municipal Civic League selected Detroit to receive the All-American City Award for its successes in community and race relations. Charles Monroe Haar, *Between the Idea and the Reality: A Study in the Origin, Fate, and Legacy of the Model Cities Program* (Boston: Little, Brown, 1975).

63. J. Thomas, *Redevelopment and Race,* 63.

64. See Meier and Rudwick, *Black Detroit and the Rise of the UAW.*

65. Although blacks achieved various municipal positions, white liberal coalitions in the city still kept the activists and reformists confined. James Jennings, *The Politics of Black Empowerment: The Transformation of Black Activism in Urban America,* African American Life Series (Detroit: Wayne State University Press, 1992), 120.

66. Albert Dunmore, "Summer of Discontent? Local and National Dangers Signals Plague Leaders," *Michigan Chronicle,* May 23, 1964, 1.

67. "Will Detroit Be a Watts? Local Leaders Say 'No,' " *Michigan Chronicle,* April 23, 1966, 1.

68. "Detroit Warned on a Potential Racial Outbreak," *Michigan Chronicle,* May 15, 1965, 1; "Stay Cool," and "Police, Officials Stay Alerted to Trouble Spots" *Michigan Chronicle,* August 21, 1965, 1.

69. Fine, *Violence in the Model City,* 298–99.

70. See Kermit Bailer's oral history in Elaine Latzman Moon, *Untold Tales,*

Unsung Heroes: An Oral History of Detroit's African American Community, 1918–1967, African American Life Series (Detroit: Wayne State University Press, 1994), 176.

71. See Vivian Baulch, "Paradise Valley and Black Bottom" *Detroit News,* August 7, 1996, http://apps.detnews.com/apps/history/index.php?id=174.

72. Suzanne Smith, *Dancing in the Street: Motown and the Cultural Politics of Detroit* (Cambridge, Mass.: Harvard University Press, 1999), 19.

73. For an excellent review of popular and radical cultural movements see ibid., 175–77, 191–92. Also see "Black Arts Convention has Self-Help Theme," *Michigan Chronicle,* July 1, 1967, 11; and Smethurst, *The Black Arts Movement.*

74. After forty-five years, Claude A. Barnett closed the Associated Negro Press in September 1964, and the *Detroit Tribune* ended publication after forty-four years. See Alfred Duckett, "A Man with a Flair," *Michigan Chronicle,* September 12, 1964.

75. Harvey C. Jackson Jr., "Summary History of the Detroit Branch of the Association for the Study of Negro Life and History," *Negro History Bulletin,* October 1962, 7.

76. Advertisement, *Michigan Chronicle,* March 21, 1964.

77. Coar worked on small projects with the DHM, which had presented a major exhibition, "Negro Life and Culture," in 1952. Together Coar and the DHM sponsored the erection of a historical marker to honor the meeting in Detroit of Frederick Douglass and John Brown. Henry D. Brown, "A Brief Survey of Holdings of Michigan Institutions . . . and Activities in the Field of Negro Life and History," *Negro History Bulletin,* October 1962, 6.

78. "Of Lawrence and Gwathmey," *Michigan Chronicle,* February 25, 1950.

79. See Arthur Coar, "Detroit Branch of Association for the Study of Negro Life and History Launches $50,000 African Art Drive," *Negro History Bulletin,* February 1964, 7; and "Detroit Museum Plans Gallery for African Art," *Chicago Daily Tribune,* February 15, 1963, I39.

80. David L. Good, "African Art Row Erupts Here in Picketing, Politics," *Detroit News,* June 29, 1966; Rich and Wright, *The Wright Man,* 149–52.

81. International Afro-American Museum, "Statement of Purpose," flyer, 1967, Charles H. Wright Papers, CWMAAH.

82. In the process of contacting organizations, Wright came across Julius Lester, a blues musician and director of the Newport Folk Foundation in New York City. The foundation over the years had made valuable field recordings around the South of little-known folk, blues, and bluegrass musicians. Lester, who also served as the cultural coordinator for SNCC, expressed interest in supporting the museum in anyway possible. See Julius Lester to Charles Wright, February 17, 1967, Charles H. Wright Papers, CWMAAH.

83. "Take a Good Look," flyer, n.d.; "The Oral History Committee of the International Afro-American Museum, Inc.," guidelines, December 12, 1967; "Exhibitions," note, n.d.; "Brief History of the Afro-American Museum of Detroit and the Afro-American Museum of Detroit Building Fund," report, 1979, all in Charles H. Wright Papers, CWMAAH.

84. *IAM Newsletter,* Fall 1966; "IAM Announces a Special Course in the His-

tory of African People," flyer, 1966; Louis Blunt to Charles Wright, November 30, 1966, all in Charles H. Wright Papers, CWMAAH.

85. "Proposal for the Establishment of Mobile Vans," 1967, Charles H. Wright Papers, CWMAAH.

86. See the following for descriptions of the event: "African Art Pieces to be Utilized—G. Mennen Williams Gift," *Michigan Chronicle,* January 14, 1967, 12. Also see *Help Us Put History on Wheels,* pamphlet, 1967; "Estimated Cost of Preparation of Mobile History Exhibit," memorandum, n.d.; Charles Wright to Gov. G. Mennen Williams, January 3, 1967; Jackie Vaughn III to Ray Scott, April 5, 1967; Ray Scott to Cornelius Pitts, August 2, 1967; Ray Scott to Charles Wright, November 18, 1967, all in Charles H. Wright Papers, CWMAAH. Also see "IAM Receives $4600 Grant to Support Mobile Exhibit," *Michigan Chronicle,* January 3, 1968; and Rich and Wright, *The Wright Man,* 155–56.

87. Wright's advice to other groups seeking to challenge arts councils was to "secure a list of all members of the Arts Council and the subcommittees in your state. Demand a list of the appropriation made by the Council during the past year." Charles Wright, "If You're Not There When They Slice Up the Pie, Shame on You," unpublished essay, n.d, Charles H. Wright Papers, CWMAAH.

88. The museum purchased a trailer for $2,600, most likely from Superior Motorhomes. Obie Newman to Pyramid Mobile Homes, November 11, 1966; Roy Seiber to Charles Wright, January 6, 1967; Rosalyn Walker to Charles Wright, January 6, March 8 and 16, and May 19, 1967, all in Charles H. Wright Papers, CWMAAH. Also see "African History Exhibit Plans Mobile Museum," *Michigan Chronicle,* May 6, 1967; and Rich and Wright, *The Wright Man,* 156.

89. Dr. Audrey Smedley, interview with the author, December 5, 2005.

90. J. Thomas, *Redevelopment and Race,* 130; Fine, *Violence in the Model City,* 4.

91. C. Elrie Chrite, Executive Director IAM, to membership, September 23, 1967, Charles H. Wright Papers, CWMAAH.

92. *African Art and History Exhibit,* pamphlet, n.d., Charles H. Wright Papers, CWMAAH.

93. "Afro-American Exhibit Is Free at State Fair," Dick Frederick Agency press release, 1967, Charles H. Wright Papers, CWMAAH; "Exhibit Traces African Culture," *Detroit Free Press,* August 31, 1967; "Mobile History Van Displays Glorious Heritage of Africa," *Michigan Chronicle,* September 2, 1967.

94. See "IAM Exhibits Lists High School Sites," *Michigan Chronicle,* December 16, 1967, 2; *Great Cities Program, Detroit Public Schools, International Afro-American Mobile Museum School Tour,* IAM report, 1967 and 1968; "Mobile History Unit," calendar, 1967; Neomi Hill, reports on Mobile History Unit, January, February, and March 1968, all in Charles H. Wright Papers, CWMAAH.

95. See "Mobile History Unit," calendar, 1967, Charles H. Wright Papers, CWMAAH; and Darden, *Detroit, Race and Uneven Development,* 24–25.

96. "Churches Mobile History Van Has Visited 1968," IAM note, 1968; "IAM New Bulletin and Meeting Announcement," newsletter, 1968; "IAM News Bulletin," newsletter, June 1968, all in Charles H. Wright Papers, CWMAAH.

97. Wright envisioned the Careermobile as a cousin of the Mobile Museum that would travel to schools, educating students on the myriad of career oppor-

tunities that were now open to black Americans. See Rich and Wright, *The Wright Man,* 166–67. Also see Dr. A. B. Britton to Dr. Wright, December 9, 1967; "You Can Be a Doctor," news release, September 1968; "IAM Film Donors," note, n.d., all in Charles H. Wright Papers, CWMAAH.

98. "IAM the Afro-American in American Life," flyer, 1968; "IAM Is Sponsoring Their First Annual Afro-American Festival," news release, 1968, both in Charles H. Wright Papers, CWMAAH.

99. "Minutes of the Project: IAM Meeting," September 29, 1965, Box 3, Charles H. Wright Papers, CWMAAH.

100. "Negro Museum Bill Introduced," *New York Times,* August 25, 1965, 22; Report by Charles Wright, "A Trip to Washington D.C. to Defeat the House Bill #10683," 1965; Meeting minutes, International Afro-American Museum, September 29, 1965, Charles H. Wright Papers, CWMAAH.

101. Lee Miller, "Black Museum Thrives," *Detroit News,* June 17, 1985, 1A.

102. Adam Clayton Powell Jr., chairman of the House Committee on Education and Labor, "Press Release: Chairman Powell Seeks the Resignation of U.S. Department of Interior Historian for Racial Views; Asks Negroes to Initiate Museum of Negro History," September 26, 1965, Dr. Audrey Smedley Personal Papers.

103. "Warn a Negro Museum May 'Be Just Handed to Us,' " *Michigan Chronicle,* October 1, 1966.

104. "A Trip to Washington D.C. to Defeat the House Bill #10683," 1965, Charles H. Wright Papers, CWMAAH; Nadine Brown, "Protest Museum Bill," *Detroit Journal,* July 27, 1967.

105. "Select Subcommittee of Education," March 12, 1968, Box 3, Folder Scheuer Correspondence, Charles H. Wright Papers, CWMAAH.

106. Charles Wright to Rep. Diggs, March 24, 1969; Charles Wright to Whitney Young, June 17, 1968, both in Charles H. Wright Papers, CWMAAH.

107. James H. Scheuer, member of Congress, to colleague, February 5, 1968, Charles H. Wright Papers, CWMAAH.

108. James H. Scheuer to Colleague, February 5, 1968; ASNLH conference program, February 15, 1968; Charles Wright to Carl Albert, June 17, 1968; Charles Wright to Whitney Young, June 17, 1968, all in Charles H. Wright Papers, CWMAAH.

109. This hearing led to several articles in mainstream newspapers informing the public of important figures in black history. While there was a consensus in these newspapers that black historical figures had been neglected in American history, a white *Wall Street Journal* writer, Arlen Large, argued that history was typically written about generals and business tycoons, noting these were "jobs that have been off limits to Negroes during America's past." Therefore a black man picking cotton and washing dishes at a lunch counter, Large wrote, "was no way to get your name in history books." Arlen Large, "Black History: Rehabilitating U.S. Negro Heroes Faces Danger of Puffery" *Wall Street Journal,* June 18, 1968, 16. Also see Tom Wicker, "In the Nation: Meet Benjamin Banneker," *New York Times,* March 26, 1968, 44.

110. Witness List, Hearings on H.R. 19262, Select Subcommittee on Labor, U.S. House of Representatives, March 18, 1968; Charles Wright to John Cordice, n.d., both in Charles H. Wright Papers, CWMAAH. Also see Kathleen Teltsch,

"Negroes Say U.S. History Slights their Heritage," *New York Times,* March 19, 1968, 21; Lucia Johnson, "Negro Museum? Legislation Sought for Commission on History, Culture of Black Race," *Christian Science Monitor,* April 15, 1968, 7.

111. Howard N. Meyer, *Integrating America's Heritage: A Congressional Hearing to Establish a National Commission on Negro History and Culture* (College Park, Md.: McGrath Publishing Company, 1970), 74.

112. Ibid., 65–67.

113. Ibid., 41.

114. Ibid., 23.

115. Ibid., 93.

116. Ibid., 96.

117. Howard N. Meyer, *Integrating America's Heritage: A Congressional Hearing to Establish a National Commission on Negro History and Culture* (College Park, Md.: McGrath Publishing Company, 1970), 79.

118. Oretta Todd, letter to editor, *Christian Science Monitor,* June 7, 1968, 22. Also see Charles Wright to Select Subcommittee on Education, March 12, 1968; and Charles Wright to Whitney Young, June 17, 1968, both in Charles H. Wright Papers, CWMAAH.

119. Lucia Johnson, "Negro Museum? Legislation Sought for Commission on History, Culture of Black Race," *Christian Science Monitor,* April 15, 1968, 7.

120. Allon Schoener, *Harlem on My Mind: Cultural Capital of Black America, 1900–1968* (New York: New Press, distributed by W. W. Norton, 1995); Bridget R. Cooks, "Black Artists and Activism: Harlem on My Mind (1969)," *American Studies* 48, no. 1 (2007): 5–39.

121. Other invited congressional representatives included Charles Diggs (Michigan), John Conyers (Illinois), Shirley Chisholm (New York), William Clay (Missouri), Gus Hawkins (California), Robert Nix (Pennsylvania), and Louis Stokes (Ohio). See *National Black History Museums Conference,* program, September 27, 1969; and Charles Wesley to Rep. John Conyers, September 9, 1969, both in Charles H. Wright Papers, CWMAAH.

122. *National Black History Museums Conference,* program, September 27, 1969, Charles H. Wright Papers, CWMAAH.

123. For its mobile unit, IAM had developed a new exhibition on black inventors that showed donated prototypes of the first traffic signals conceived by Garrett Morgan. In 1976 the Mobile Museum displayed "Blacks in the Age of the American Revolution" in celebration of the U.S. bicentennial.

124. Charles H. Wright, *Robeson: Labor's Forgotten Champion* (Detroit: Balamp Publisher, 1975).

125. Given the popularity and success of the "African Art and History," IAM also organized new exhibitions on African art and culture and was approached by the Smithsonian in 1968 to develop a more detailed exhibition for circulation about the origins of African culture. See *Brief History of the Afro-American Museum of Detroit and the Afro-American Museum of Detroit Building Fund,* AAMD report, 1980; "Joint Ventures between the Museum and Outside Agen-

cies," IAM statement, 1984; "Rosa Parks and the Montgomery Bus Boycott," IAM press release, February 1971; "Detroit's Black Roots," AAMD pamphlet, May 30, 1977; "Case Statement of Afro-American Museum of Detroit," report, October 1978; Robert Mason, Smithsonian, to Dr. Audrey Smedley, September 13, 1968, all in Charles H. Wright Papers, CWMAAH.

126. Later exhibits, including "Detroit's Black Roots," "Blacks in Michigan," on the Underground Railroad, and on the Ossian Sweet case of 1925, continued the museum's mission to chronicle and celebrate local history. See *Brief History of the Afro-American Museum of Detroit and the Afro-American Museum of Detroit Building Fund,* AAMD report, 1980; and "Facts About the Afro-American Museum," n.d., both in Charles H. Wright Papers, CWMAAH.

127. See "Joint Ventures between the Museum and Outside Agencies," IAM statement, 1984, Charles H. Wright Papers, CWMAAH.

128. Wright remained a key figure in the stewardship of the institution and others like Margaret Zarif and Robert Shannon assumed leadership roles, whereas other early participants like Smedley moved away from Detroit, although she remained a consultant on the museum's exhibitions.

129. Nicholas Hood to Charles Wright, August 17, 1966; "IAAM, Inc. Board of Trustee's Meeting," minutes, April 2 and 18, 1969; Charles Wright to Jerome Cavanagh, August 29, 1969; Charles Wright to Coleman Young, November 26, 1973, all in Charles H. Wright Papers, CWMAAH. Also see James Graham, "Drive Launched to Build Black Culture Museum," *Michigan Chronicle,* June 16, 1971.

130. J. Thomas, *Redevelopment and Race,* 154–61.

131. R. J. Chambers to Charles Wright, September 11, 1978; "Case Statement Afro-American Museum of Detroit," October 1978, 5–10, both in Charles H. Wright Papers, CWMAAH.

132. Ulysses Hollowell, "Afro-American Museum Relocates," *South End,* September 28, 1983; Danton Wilson, "Day for Groundbreaking," "One Man's Dream Realized," editorial, *Michigan Chronicle,* May 25, 1985, 1.

133. "The Inaugural Exhibit of the Museum of African American History," press release, April 16, 1987, Charles H. Wright Papers, CWMAAH.

134. "International Afro-American Museum (A Statement of Purpose)," Charles H. Wright Papers, CWMAAH.

135. Michael Omi and Howard Winant, *Racial Formation in the United States: From the 1960s to the 1980s,* Critical Social Thought (New York: Routledge and Kegan Paul, 1986), 42.

EPILOGUE

1. *Afro-American Museum of Detroit Newsletter* 12, no. 3 (Fall 1977):, 4, 9–10, Charles H. Wright Papers, Charles H. Wright Museum of African American Museum, Detroit (hereafter CWMAAH).

2. Scholar Anne Friedberg identifies the "mobile virtual gaze" of the fair as the precursor to cinema and television. See Anne Friedberg, *Window Shopping: Cinema and the Postmodern* (Berkeley: University of California, 1993).

3. Charlayne Hunter-Gault, "Roots Getting a Grip on People Everywhere," *New York Times,* January 28, 1977, 43; "Roots," editorial, *Washington Post,* February 7, 1977, A22.

4. Conceptually, *Roots's* social impact was expressed as a long overdue refutation of *The Birth of a Nation,* challenging Thomas Dixon's racist narrative of his novel *The Clansman* (1905), which justified Jim Crow, and D. W. Griffith's translation of the book into a cinematic pageant of white supremacy. Novelist Margaret Mitchell claimed that Dixon's stories of the recuperation of southern integrity and honor were the basis for her novel *Gone with the Wind.* But *Roots* turned the table on the representation of blacks as rapists, ignorant brutes, and mulatto swindlers. Instead, as one reviewer wrote, "the whites have become the rapists, the beasts, the fools. The blacks are the ones with a clear idea of what constitutes honor, courage, love, and morality." Mary Beth Crain, *"Birth of a Nation* the other side of *Roots," New York Times,* February 13, 1977, N32.

5. Andreas Huyssen, *Present Pasts: Urban Palimpsests and the Politics of Memory,* Cultural Memory in the Present (Stanford, Calif.: Stanford University Press, 2003); Michael Kammen, *Mystic Chords of Memory* (New York: Knopf, 1991).

6. Kevin Walsh, *The Representation of the Past: Museums and Heritage in the Post-modern World* (London: Routledge, 1992), 137. Huyssen, Frederic Jameson, David Harvey, and others have asserted that this crisis in historicity did not slow late capitalism's advance in conquering new markets and maintaining social and economic disparities.

7. Ibid.

8. Herman Gray, *Watching Race* (Minneapolis: University of Minnesota Press, 1995), 78.

9. See Lee Margulies, "Roots Sets TV Record," *Los Angeles Times,* April 21, 1977, F1; and Kammen, *Mystic Chords of Memory, 672.*

10. It should be noted that Alex Haley's story, already a popular semiautobiographical book, was adapted to the small screen by a successful purveyor of American history for popular audiences, David L. Wolper, whose credits included a miniseries on the life Abraham Lincoln. Wolper, a seasoned producer, had worked on previous projects about black culture and characters; he had executive produced *Wattstax* (1973), which documented the soulful concert of Stax greats Rufus Thomas, Isaac Hayes, and others in Los Angeles; and he had also produced the watered-down blaxploitation TV series *Get Christie Love* (1974).

11. For those who wished to retrace Haley's journey, travel agents initiated special *Roots* tour packages to areas of Gambia and Senegal, regions highlighted in the miniseries. At the height of the *Roots* frenzy, parents even named their newborns Kizzy and Kunta Kinte to pay homage to Haley's main characters. Stanley Carr, "*Roots* Inspires Tours to West Africa," *Chicago Tribune,* March 8, 1977, A5; Thomas A. Johnson, "*Roots* Has Widespread and Inspiring Influence," *New York Times,* March 19, 1977, 30.

12. The AAMA and several museums, including Detroit's AAMD, were featured in an *Ebony* article. See "Keepers of the Story," *Ebony,* February 1981,

84–90. Also see *Profile of Black Museums* (Nashville, Tenn.: American Association for State and Local History in association with African-American Museums Association, 1988), 4. The AAMA would later be renamed the Association of African American Museums.

13. Ibid., 4–5.

14. In New York City there was no single museum dedicated to both art and history; these functions were split between the Studio Museum and the Schomburg Collection of the New York Public Library. Azade Ardali and Ford Foundation, *Black and Hispanic Art Museums: A Vibrant Cultural Resource; A Report to the Ford Foundation* (New York: The Foundation, 1989), 2, 37.

15. Neil Smith, *The New Urban Frontier: Gentrification and the Revanchist City* (London; New York: Routledge, 1996), 77–89.

16. Rosalyn Deutsche, "The Fine Art of Gentrification," *October* 31 (1984): 91–111.

17. The total population of Detroit decreased by almost a third between 1960 and 1980. As white residents moved out, the percentage of Detroit's black residents increased from 44 percent in 1970 to 63 percent in 1980, although many middle-class blacks also moved out of the city to suburban areas. Campbell Gibson and Kay Jung, *Historical Census Statistics on Population Totals by Race, 1790 to 1990, and by Hispanic Origin, 1970 to 1990, for Large Cities and Other Urban Places in the United States* (Washington, D.C.: U.S. Census Bureau, Population Division, February 2005). Also see "Whites Continue Suburbia Exodus," *Michigan Chronicle,* March 6, 1971, 7; "The Closing of GM's Fischer Body Plant," *Michigan Chronicle,* January 15, 1972; "Why Detroit is On Bankruptcy Brink," *Michigan Chronicle,* January 22, 1972, 10; and Thomas Sugrue, *The Origins of Urban Crisis: Race and Inequality in Postwar Detroit* (Princeton: Princeton University Press, 1996).

18. Sugrue, *The Origins of Urban Crisis.*

19. As June Manning Thomas brilliantly assesses his skills, Mayor Coleman Young "understood the symbolic importance of construction projects, and he seized upon redevelopment as the route to city salvation." June Manning Thomas, *Redevelopment and Race: Planning a Finer City in Postwar Detroit,* Creating the North American Landscape (Baltimore, Md.: Johns Hopkins University Press, 1997), 176.

20. Robert E. McTyre, "Wright Resigns from Museum of African American History," *Michigan Chronicle,* March 21–27, 1990, 1A; "Good Communication Left the Museum before Wright Did," editorial, *Michigan Chronicle,* March 21–27, 1990, 6A.

21. David Lyman, "Museum Celebrates, Struggles," *Detroit Free Press,* April 15, 1998, 1A, 6A.

22. "Coleman A. Young, 79, Mayor of Detroit and Political Symbol for Blacks Dead," *New York Times,* November 30, 1997, B7.

23. Joy Hakanson Cody, "African-American Museum Is Renamed after Charles Wright," *Detroit News,* March 31, 1998, 4D.

24. In 1971 the DuSable Museum moved from its original location in the heart of Chicago's Bronzeville to its current location in a park administration building in Washington Park near the University of Chicago. In 1993 it expanded its

facility twenty-five thousand square feet with a $3.5 million expansion. Margaret T. G. Burroughs, *Life with Margaret* (Chicago: In Time Publishing and Media Group, 2003), 156. Also see Kathleen E. Bethel, "Plenty Good Room: African American Museums at the Millennium" (unpublished paper, Alice B. Kaplan Center for the Humanities, Northwestern University Library, 2000).

25. See Michael C. Dawson, *Black Visions* (Chicago: University of Chicago Press, 2001), 37–38.

26. Ken Bradsher, "A Rich Museum and Its Poor Cousin: Detroit Institutions Are Entangled in the Politics of Race, Class and Labor," *New York Times,* May 15, 1997, B1.

27. Clarence J. Brown Jr. to Colleague, April 4, 1968; "News Release from the Office of Congressman Clarence J. Brown, Jr., Seventh Ohio District," April 8, 1968, both in Charles H. Wright Papers, CWMAAH.

28. *Profile of Black Museums.*

29. The campaign to establish a national black museum was initiated in 1984 by Tom Mack, a Washington, D.C., businessman. His efforts eventually linked up with the scholarly and museum communities to form the commission. See the excellent essay by Fath Ruffins, "Culture Wars Won and Lost, Part 2: The National African-American Museum Project," *Radical History Review* 70 (1998): 78–101. Mary Schmidt-Campbell, New York City commissioner of cultural affairs, and Claudine Brown of the Brooklyn Museum headed the commission. Historians and scholars joining the commission included Cornel West, Donald Bogle, David Driskell, and Lerone Bennett, plus representatives from top museums, including Bernice Regan, Gwendolyn Robinson, and Spencer Crew from the National Museum of American History; Deborah Willis and Howard Dodson from the Schomburg Center; James Mayo of the Anacostia Museum; and Joy Austin, president of the AAMA. See "Dr. Campbell Heads Panel on Museum for Blacks," *New York Times,* May 8, 1990, C19; and Charles P. Henry, "A True Revolution of Values," in *Long Overdue: The Politics of Racial Reparations* (New York: NYU Press, 2007): 164–78.

30. Claudine Brown, *Final Report of the African American Institutional Study* (Washington, D.C.: Smithsonian Institution, 1991).

31. Fred Wilson et al., *Mining the Museum: An Installation by Fred Wilson* (Baltimore, Md.: The Contemporary in cooperation with the New Press, distributed by W. W. Norton, 1994), 34.

32. Mike Christensen, "Helms Holds Up Museum; Black History Project Stalls" *Times-Picayune,* December 5, 1993, A28. Also see "A Voice from the Past; Helms Shows True Colors in Stalling Museum," *Buffalo News,* October 16, 1994, F10; and Jacqueline Trescott, "Helms Stalls New Museum; Backers Still Hope to Free African American Project," *Washington Post,* September 29, 1994, D1.

33. Ruffins, "Culture Wars Won and Lost, Part 2," 86.

34. Ibid., 91. Ruffins argues that putting the museum in Washington, D.C., was akin to asking to site the Holocaust Museum in Auschwitz, given that "the proposed museum would be erected within sight of locations where slave pens stood during the 1850s and the early years of the Civil War."

35. See Manning Marable, *Race, Reform, and Rebellion: The Second Recon-*

struction in Black America, 1945–1990, 2nd ed. (Jackson: University Press of Mississippi, 1991).

36. W. E. B. Du Bois, "The American Negro at Paris," *American Monthly Review of Reviews,* November 1900, 576.

37. Ibid., 577 (emphasis added). Also see Deborah Willis, "The Sociologist's Eye: W. E. B. Du Bois and the Paris Exposition," in *A Small Nation of People: W. E. B. Du Bois and African American Portraits of Progress,* ed. the Library of Congress (New York: Amistad and Harper Collins, 2003), 51–76.

Bibliography

ABBREVIATIONS

AAMA African American Museums Association
AAMD Afro-American Museum of Detroit
AME Church African Methodist Episcopal Church
AFL American Federation of Labor
ANA American Negro Academy
ANP Associated Negro Press
ASNLH Association for the Study of Negro Life and History
CIO Congress of Industrial Organizations
CLC Chicago Civil Liberties Committee
CORE Congress for Racial Equality
CPUSA Communist Party of the United States of America
CRC Civil Rights Committee
DHM Detroit Historical Museum
DIA Detroit Institute of Arts
DMS Detroit Medical Society
DPL Detroit Public Library
DUL Detroit Urban League
FAP Federal Art Project
FEPC Fair Employment Practices Committee
FWA Federal Works Agency

IAM International Afro-American Museum

MAAH Museum of African American History

NAACP National Association for the Advancement of Colored People

NACW National Association of Colored Women

NMA National Memorial Association

NMAAHC National Museum of African American History and Culture

NNBL National Negro Business League

NNMHF National Negro Museum and Historical Foundation

NUL National Urban League

NYA National Youth Administration

RAM Revolutionary Action Movement

SNCC Student Nonviolent Coordinating Committee

UAW United Auto Workers

USAID U.S. Agency for International Development

YMCA Young Men's Christian Association

YWCA Young Women's Christian Association

WPA Works Progress Administration

WSU Wayne State University

ARCHIVAL COLLECTIONS

Atlanta History Center, Kenan Research Center
California State University at Fresno, Special Collections Research Center, World's
 Fair Collection
Cedias-Musée Social, Paris, France
Chicago History Museum Research Center
Emory University, Manuscript, Archives, and Rare Book Library, Atlanta
Getty Research Institute, Special Collections, Los Angeles
Library of Congress, Prints and Photographs Division and Rare Books and Special
 Collections, Washington, D.C.
New York Historical Society, Patricia D. Klingenstein Library
New York Public Library, Schomburg Center for Research in Black Culture
South Carolina Historical Society, Charleston
Tuskegee University Library, Special Collections, Tuskegee, Ala.
University California at Berkeley, Doe Library

MANUSCRIPT COLLECTIONS

Atlanta-Fulton Public Library System, Auburn Avenue Research Library, Archives
 Division
 Atlanta University Research Papers

Atlanta History Center, Kenan Research Center
 Atlanta Cotton States and International Exposition Collection
Atlanta University Center, Robert W. Woodruff Library
 Horace Bumstead Papers
Charles H. Wright Museum of African American History, Detroit
 Charles H. Wright Papers
Chicago History Museum
 Claude A. Barnett Collection of Visual Materials
 Claude A. Barnett Papers
Chicago Public Library, Carter G. Woodson Branch, Vivian G. Harsh Research
 Collection
 Charles Bishop Papers
 George Cleveland Hall Library Papers
 Illinois Writers' Project: "Negro in Illinois" Papers
 Barbara Shepherd Photo Collection
 Madeline Stratton Morris Papers
City of Philadelphia
 Department of Records City Archives
College of Charleston, Avery Research Center for Afro-American History and
 Culture, Charleston, S.C.
 Research File South Carolina Inter-State and West Indian Exposition
Detroit Public Library, Burton Historical Collection
 Charles H. Wright Papers
DuSable Museum of African American History, Chicago
 Museum Archives
Emory University, Manuscript, Archives, and Rare Book Library, Atlanta
 Michel Fabre Archives of African American Arts and Letters
 Kelly Miller Papers
Hampton University, Hampton University Archives, Hampton, Va.
 Expositions and Exhibitions Collection
Howard University, Moorland-Spingarn Research Center, Washington, D.C.
 Bethel Literary and Historical Association Papers
 Thomas and William Dorsey Collection
 Alain Locke Papers
 Kelly Miller Papers
 Jesse E. Moorland Papers
 Daniel P. Murray Collection
 Mary Church Terrell Papers
 Dr. Audrey Smedley Personal Papers
Southside Community Center, Chicago
 Southside Community Center Papers
University of Chicago, Special Collections Research Center
 Frederick Starr Papers
 Ida B. Wells Papers
University of Illinois at Chicago, Daley Library Special Collections and Univer-
 sity Archives
 Century of Progress Collection

University of Michigan at Ann Arbor, Bentley Historical Library
 Kellogg African American Health Care Project, University of Michigan Medical School
Wayne State University, Walter P. Reuther Library, Detroit
 Arthur L. Johnson African American History Collection

MANUSCRIPTS AND PAPERS ON MICROFILM AND ONLINE

Claude A. Barnett Papers (microfilm), Stanford University, Stanford, Calif.
John Dancy Papers, Michigan Historical Collections (microfilm), Bentley Historical Library, University of Michigan at Ann Arbor
Detroit Urban League Papers, Michigan Historical Collections (microfilm), Bentley Historical Library, University of Michigan at Ann Arbor
W. E. B. Du Bois Papers, 1877–1965 (microfilm), University of California at Berkeley and Columbia University, New York
Papers of the NAACP (microfilm), Schomburg Center for Research in Black Culture, New York Public Library
Tuskegee Institute News Clippings File, Division of Behavioral Science Research, Tuskegee, Ala. (microfilm), University of California at Berkeley
Booker T. Washington Papers, www.historycooperative.org/btw

NEWSPAPERS AND PERIODICALS

Alexander's Magazine
AME Church Review
American Monthly Review of Reviews
Atlanta Tribune
Atlantic Monthly
(Baltimore) Afro-American
Black Dispatch
Buffalo News
Charities and the Commons
Chicago Bee
Chicago Defender
Chicago Daily Tribune
Chicago Inter Ocean
Chicago Herald
Christian Science Monitor
Cleveland Gazette
Colored American
Colored American Magazine
Crisis
Daily Worker
Detroit Free Press
Detroit Journal
Detroit News
Detroit Tribune

Ebony
Globe
Guardian
Industrial Advocate
Kansas City Call
Leslie's Weekly Illustrated
Los Angeles Times
Manufacturer and Building
Michigan Chronicle
Negro Digest
Negro History Bulletin
Negro Voice
New England Magazine
Newsweek Magazine
New York Amsterdam News
New York Age
New York Observer
New York Times
New York World
Outlook
Pittsburgh Courier
Pittsburgh Gazette
Richmond Times Dispatch
Savannah Tribune

South End Wall Street Journal
Times-Picayune Washington Bee
Tri-State Defender Washington Post
Voice of the Negro

PRIMARY SOURCES

Adams, Maude. "The Midway at the Atlanta Exposition." *Harper's Weekly,* November 23, 1895, 1109.

American Negro Emancipation Centennial Authority. *A Century of Negro Progress Exposition: McCormick Place, Chicago, Ill., August 16th—September 2nd, 1963.* Chicago: American Negro Emancipation Centennial Commission, 1963.

American Negro Exposition. *American Negro Exposition: Report by Diamond Jubilee Exposition Authority to Afra-Merican Emancipation Commissions of the State of Illinois and of the Federal Government.* Chicago, 1940.

———. *American Negro Exposition, 1863–1940: Chicago Coliseum—July 4 to September 2; Official Program and Guide Book.* Chicago: Exposition Authority, 1940.

———. *Exhibition of the Art of the American Negro, 1851–1940.* Chicago: Tanner Art Galleries and American Negro Exposition, 1940.

Anonymous. *Preliminary Prospectus of the Cotton States and International Exposition Company.* Atlanta: Franklin Printing and Publishing, 1894.

———. *Prospectus of the Cotton States and International Exposition to Be Held at Atlanta.* Atlanta: C. P. Byrd, 1895.

Ardali, Azade, and Ford Foundation. *Black and Hispanic Art Museums: A Vibrant Cultural Resource; A Report to the Ford Foundation.* New York: The Foundation, 1989.

"The Atlanta Exposition." *Bulletin of Atlanta University,* October 1895, 2.

Atlanta University. "Mortality among Negroes in Cities." In *Atlanta University Publications,* edited by Atlanta University and W. E. B. Du Bois, 1–51. New York: Octagon Books, 1968.

Austin, Erastus Long, and Odell Hauser. *The Sesqui-Centennial International Exposition: A Record Based on Official Data and Departmental Reports.* Philadelphia: Current Publications,1929.

Bacon, Miss Alice M. *The Negro and the Atlanta Exposition.* Occasional Papers. Baltimore, Md.: Trustees of the John Slater Fund, 1896.

Book of America's Making Exposition, 71st Regiment Armory New York, October 29 to November 12, 1921. New York: City and State Departments of Education, 1921.

Bowen, J. W. E., ed. *African and the American Negro: Addresses and Proceedings of the Congress on Africa.* Atlanta: Gammon Theological Seminary, 1876.

Brown, Claudine. *Final Report of the African American Institutional Study.* Washington, D.C.: Smithsonian Institution, 1991.

Calloway, Thomas Junius. "Booker Washington and the Tuskegee Institute." *New England Magazine,* October 1897, 131–47.

————. "The Negro Exhibit." In *Report of the Commissioner-General for the United States to the International Universal Exposition, Paris, 1900,* vol. 2, 404–14, 463–67. Washington, D.C.: Government Printing Office, 1901.

Carter, Rev. E. R. *The Black Side: A Partial History of the Business, Religious and Educational Side of the Negro in Atlanta, Ga.* Black Heritage Library Collection. Freeport, N.Y.: Books for Libraries Press, 1971.

Catalogue of the Exhibitors in the United States Sections of the International Universal Exposition, Paris 1900. Paris: Société Anonyme des Imprimeries Lemercier, 1900.

Clarke, J. B. *A Memento of the Emancipation Proclamation Exposition of the State of New York.* Emancipation Proclamation Exposition Commission, 1913.

Coons, F. H. Boyd. "The Cotton States and International Exposition in the New South: Architecture and Implications." Master's thesis, University of Virginia, 1988.

Cooper, Walter G. *The Cotton States and International Exposition and South, Illustrated.* Atlanta: The Illustrator Company, 1896.

Crawford, Remson. "The Atlanta Exposition." *Atlantic Monthly,* September 14, 1895, 873–74.

Crogman, William. "Negro Building at the Atlanta Exposition." *Atlanta University Bulletin,* February 1895, 3.

Cruse, Harold. *The Crisis of the Negro Intellectual.* 1967; New York: William Morrow, 1984.

Daniels, John. *America via the Neighborhood.* Americanization Studies. New York: Harper and Brothers, 1920.

Davis, Frank Marshall. "Official Answers Chicago Fair Critic." *Crisis,* February 1941, 49, 58.

Dodge, P. S. *Official Guide to the Cotton States and International Exposition: Held at Atlanta, Ga., U.S.A., September 18 to December 31, 1895.* Atlanta: Franklin Printing and Publishing Company, 1895.

Drake, St. Clair, and Horace R. Cayton. *Black Metropolis: A Study of Negro Life in a Northern City.* New York: Harper and Row, 1945.

Du Bois, W. E. B. "Address to the Nations of the World." In *W. E. B. Du Bois Speaks,* edited by Philip S. Foner, 124–27. New York: Pathfinder Books, 1991.

————. "The American Negro at Paris." *American Monthly Review of Reviews,* November 1900, 575–77.

————. "The College Bred Negro." In *Atlanta University Publications,* edited by Atlanta University and W. E. B. Du Bois, 1–63. New York: Octagon Books, 1968.

————. "The Conservation of Races." In *W. E. B. Du Bois Speaks,* edited by Philip S. Foner, 73–85. New York: Pathfinder Books, 1991.

————. "The Cultural Missions of Atlanta University." *Phylon* 3, no. 2 (1942): 105–15.

————. "The Freedman's Bureau." *Atlantic Monthly,* March 1901.

————. "The Health and Physique of the Negro American." In *Atlanta University Publications,* 1–112. New York: Arno Press and the New York Times, 1968.

————. "How to Celebrate the Semicentennial of the Emancipation Proclama-

tion." In *W. E. B. Du Bois Speaks,* edited by Philip S. Foner, 102–23. New York: Pathfinder Books, 1991.

———. "The National Emancipation Exposition (the Star of Ethiopia)." *Crisis,* November 1913, 339–41.

———. "The Niagara Movement." In *W. E. B. Du Bois Speaks,* edited by Philip S. Foner, 102–23. New York: Pathfinder Books, 1991.

———. *The Negro.* New York: Dover Publications, 2001.

———. "The Negro Common School." In *Atlanta University Publications,* edited by Atlanta University and W. E. B. Du Bois, 1–61. New York: Octagon Books, 1968.

———. "The Negro in Business." In *Atlanta University Publications,* edited by Atlanta University and W. E. B. Du Bois, 1–77. New York: Octagon Books, 1968.

———. "A Pageant in Seven Decades." In *W. E. B. Du Bois Speaks,* edited by Philip S. Foner, 21–72. New York: Pathfinder Books, 1991.

———. *The Philadelphia Negro.* Philadelphia: University of Pennsylvania Press, 1996.

———. "Strivings of the Negro People." *Atlantic Monthly,* August 1897, 194–98.

———. "The Study of Negro Problems." In *W. E. B. Du Bois Speaks,* edited by Philip S. Foner, 102–23. New York: Pathfinder Books, 1991.

Frazier, Edward Franklin. *Black Bourgeoisie: The Rise of a New Middle Class.* 1st Free Press paperback ed. New York: Free Press, 1965.

Garrett, Franklin M. *Atlanta and Environs: A Chronicle of Its People and Events.* Vols. 1 and 2. Athens: University of Georgia Press, 1969.

Gilbert, Bradford. "The Architectural Features of the Atlanta Exposition." *Harpers Weekly,* September 1895, 892–93.

Gordon, Selma. "75 Years of Negro Progress." *Crisis,* January 1941, 10–11, 20.

Grady, Henry W. "The New South—A Speech Delivered at the Banquet of the New England Society, New York, December 21, 1886." In *The Complete Orations and Speeches of Henry W. Grady,* edited by Edwin DuBois Shurter, 7–22. Norwood, Mass.: Norwood Press, 1910.

Grant, Madison. *The Passing of the Great Race; or, The Racial Basis of European History.* New York: C. Scribner, 1916.

History and Report of the Exhibition and Celebration to Commemorate the Fiftieth Anniversary of the Emancipation of the Negro: Held at the Coliseum, Chicago Illinois, August 22nd to September 16th, Nineteen Hundred and Fifteen. Fraternal Press, 1916.

House of Representatives, Committee on Public Buildings and Grounds, ed. *Government Exhibits at the Centennial.* House of Representatives, 1877.

———. *To Create a Commission to Secure Plans and Designs for and to Erect a Memorial Building for the National Memorial Association, Incorporated in the City of Washington, as a Tribute to the Negro's Contribution to the Achievements of America.* House of Representatives, February 1, 1928.

The Illinois (National) Half-Century Anniversary of Negro Freedom. Chicago: Fraternal Press, 1915.

Jackson, Giles B., and D. Webster Davis. *The Industrial History of the Negro Race of the United States.* Richmond: The Virginia Press, 1908.

Jones, LeRoi. "The Revolutionary Theater." *Liberator,* July 1965, 4–6.

Lincoln Institute: Centennial Exhibit 1876. Jefferson City, Mo.: Lincoln Institute, 1876.

Lincoln Jubilee Album: 50th Anniversary of Our Emancipation; Held in Chicago, August 22nd to September 16th, 1915. Chicago: National Half-Century Exposition, 1915.

Locke, Alain. "The American Negro Exposition's Showing of the Works of Negro Artists." In *Exhibition of the Art of the American Negro, 1851–1940,* edited by American Negro Exposition. Chicago: Tanner Art Galleries and American Negro Exposition, 1940.

———, ed. *The New Negro.* 1925; New York: Atheneum, 1936.

L. W. B. "Is He a New Negro?" *Chicago Inter Ocean,* September 28, 1895, 7.

Mabry, George S. *A Sketch of Alamance County, N.C. for the Colored Exhibit to the Cotton States and International Exposition, Atlanta, Ga., U.S.A.* 1895.

National Negro Museum and Historical Foundation, Inc., pamphlet, February 1946. Madeline Stratton Morris Papers, Vivian G. Harsh Research Collection, Carter G. Woodson Branch, Chicago Public Library.

Neal, Larry. "The Black Arts Movement." *The Drama Review: TDR* 12, no. 4 (Summer 1968): 33.

Northrop, Henry Davenport, Joseph R. Gay, and I. Garland Penn. *The College of Life or Practical Self-Educator: A Manual of Self-Improvement for African Americans.* Chicago: C. J. Harris, 1993.

The Official Catalogue of the Cotton States and International Exposition, Atlanta Georgia, U.S.A. September 18 to December 31, 1895. Atlanta: Clafin Mellichamp Publishers, 1895.

Pan-African Association. *Report of the Pan-African Conference: Held on the 23rd, 24th, and 25th of July 1900.* London, 1900.

Penn, I. Garland. *The Afro-American Press and Its Editors.* Springfield, Mass.: Willey and Co., 1891.

———. "The Awakening of a Race." In *The Cotton States and International Exposition and South, Illustrated,* edited by Walter G. Cooper, 58–63. Atlanta: The Illustrator Company, 1896.

———. "Negro Building at the Atlanta Exposition." *Bulletin of Atlanta University,* May 1895, 3. *Profile of Black Museums.* Nashville, Tenn.: American Association for State and Local History in association with African-American Museums Association, 1988.

"Political." *Crisis,* August 1912, 166.

Randall, Dudley, and Margaret Taylor Burroughs. *For Malcolm: Poems on the Life and Death of Malcolm X.* Detroit: Broadside Press, 1967.

Report of the Board of Commissioners Representing the State of New York at the Cotton States and International Exposition Held at Atlanta, Georgia 1895. Albany, N.Y.: Wynkoop Hallenbeck Crawford Company, 1896.

Report of the Board of Management: United States Government Exhibit; Cotton States and International Exposition Atlanta, Ga., 1895. Washington, D.C., 1897.

Report of the Commissioner-General for the United States to the International Universal Exposition, Paris, 1900. Vols. 1 and 2. Washington, D.C.: Government Printing Office, 1901.

Senate, ed. *Message from the President of the United States, Transmitting an Ex-*

hibit of the Result of the United States Centennial Exhibition and Celebration of 1876. Washington, D.C.: Government Printing Office, 1879.

Schoener, Allon. Harlem on My Mind: Cultural Capital of Black America, 1900–1968. New York: New Press, distributed by W. W. Norton, 1995.

Souvenir Album of the Cotton States and International Exposition, Atlanta, Ga., 1895. Portland, Maine: Leighton and Frey Souvenir View Co., 1895.

Stamps, James E. "Fifty Years Later." Negro History Bulletin 29, no. 3 (1965): 31–32.

Thomas, Jessie O. Negro Participation in the Texas Centennial Exposition. Boston: The Christopher Publishing House, 1938.

Towns, George A. "Phylon Profile 16 Horace Bumstead, Atlanta University President." Phylon 9, no. 2 (1948): 109–14.

"Two Negro Expositions." Negro History Bulletin 3, no. 6 (1940): 89.

Warren, Francis H. Michigan Manual of Freedmen's Progress. Detroit, 1915.

Washington, Booker T. "Education Will Solve the Race Problem. A Reply." North American Review, August 1900, 221–33.

———. Up from Slavery. New York: Oxford University Press, 1995.

Webster, E. H. "The Atlanta Exposition." Bulletin of Atlanta University, February 1895, 2.

Wells-Barnett, Ida B., and Robert W. Rydell. The Reason Why the Colored American Is Not in the World's Columbian Exposition. Urbana: University of Illinois Press, 1999.

Wesley, Charles H. "Our Fiftieth Year." Negro History Bulletin 28, no. 9 (1965): 172–73.

———. "The Story of Negro Progress in the United States." In A Brief History of 75 Years of Negro Progress, edited by Charles H. Wesley and John C. Dancy, 1–43. Detroit, 1940.

West Charleston Sertoma Club. Charleston and the South Carolina Inter-State and West Indian Exposition: An Illustrated Souvenir of the Beautiful Exposition and the Historical Places and Prominent Features of the City. Charleston, S.C.: Nelson's Southern Printing and Publishing, 1958.

Williams, Dorothy. "Adult Education in Public Libraries and Museums." Journal of Negro Education 14, no. 3 (1945): 322–30.

Winton, Ruth. "Negro Participation in Southern Expositions, 1881–1915." Journal of Negro Education 26, no. 1 (1947): 34–43.

Wright, Richard. "Introduction." In Black Metropolis: A Study of Negro Life in a Northern City, edited by St. Clair Drake and Horace R. Cayton, 17–34. New York: Harper and Row, 1945.

Writers' Program of the Works Progress Administration in the State of Illinois. Cavalcade of the American Negro. Chicago: Diamond Jubilee Exposition, 1940.

SECONDARY SOURCES

Abramovitch, Ilana. "America's Making Exposition and Festival (New York, 1921): Immigrant Gifts on the Altar of America." PhD dissertation, New York University, 1996.

Alexander, Leslie M. "Community and Institution Building in Antebellum New York: The Story of Seneca Village, 1825–1857." In *"We Shall Independent Be": African American Place Making and the Struggle to Claim Space in the United States,* edited by Angel David Nieves and Leslie M. Alexander, 23–46. Boulder: University Press of Colorado, 2008.

Anderson, Benedict R. O'G. *Imagined Communities: Reflections on the Origin and Spread of Nationalism.* Revised edition. London: Verso, 1991.

Andrew, John A. *Lyndon Johnson and the Great Society.* Chicago: Ivan R. Dee, Inc., 1998.

Appadurai, Arjun, Lauren Berlant, Carol A. Breckinridge, and Manthia Diawara. "The Black Public Sphere." *Public Culture* 7, no. 1 (1994): 11–14.

Appiah, Anthony. "The Uncompleted Argument: Du Bois and the Illusion of Race" In *"Race," Writing, and Difference,* edited by Henry Louis Gates, 21–37. Chicago: University of Chicago Press, 1986.

Ater, Renee. "Making History: Meta Warrick Fuller's 'Ethiopia.'" *American Art* 17, no. 3 (2003): 12–31.

Baldwin, Davarian L. "Black Belts and Ivory Towers: The Place of Race in U.S. Social Thought, 1892." *Critical Sociology,* no. 30 (2004): 397–450.

———. *Chicago's New Negroes: Modernity, the Great Migration, and Black Urban Life.* Chapel Hill: University of North Carolina Press, 2007.

———. " 'Chicago's New Negroes': Race, Class, and Respectability in the Midwestern Black Metropolis, 1915–1935." PhD dissertation, New York University, 2002.

Bayor, Ronald H. *Race and the Shaping of Twentieth-Century Atlanta.* Fred W. Morrison Series in Southern Studies. Chapel Hill: University of North Carolina Press, 1996.

Benjamin, Walter. "Paris, Capital of the Nineteenth Century." In *Reflections,* edited by Peter Demetz, 146–62. New York: Harcourt Brace Jovanovich, 1979.

Bennett, Tony. *The Birth of the Museum.* London: Routledge, 1995.

Bethel, Kathleen E. "Plenty Good Room: African American Museums at the Millennium." Unpublished paper, Alice B. Kaplan Center for the Humanities, Northwestern University Library, 2000.

Blackwell, James Edward, and Morris Janowitz. *Black Sociologists: Historical and Contemporary Perspectives.* The Heritage of Sociology. Chicago: University of Chicago Press, 1974.

Bogle, Donald. *Toms, Coons, Mulattoes, Mammies and Bucks: An Interpretive History of Blacks in American Films.* New York: Continuum, 1989.

Boime, Albert. "Henry Ossawa Tanner's Subversion of Genre." *Art Bulletin* 75, no. 3 (1993): 415–42.

Boles, John B., and Bethany L. Johnson. *Origins of the New South Fifty Years Later: The Continuing Influence of a Historical Classic.* Baton Rouge: Louisiana State University Press, 2003.

Bone, Robert. "Richard Wright and the Chicago Renaissance." *Callaloo* 28 (Summer 1986): 446–68.

Boyer, Christine. *Dreaming the Rational City: The Myth of American City Planning.* Cambridge, Mass.: MIT Press, 1983.

Bracey, John H., Elliott M. Rudwick, and August Meier. *Black Nationalism in America*. Indianapolis, Ind.: Bobbs-Merrill, 1970.

Brundage, W. Fitzhugh. "Meta Warrick's 1907 'Negro Tableaux' and (Re)Presenting African American Historical Memory." *Journal of American History* (March 2003): 1368–400.

Buick, Kirsten Pai. *Child of the Fire: Mary Edmonia Lewis and the Problem of Art History's Black and Indian Subject*. Durham, N.C.: Duke University Press, 2010.

Burroughs, Margaret T. G. *Life with Margaret*. Chicago: In Time Publishing and Media Group, 2003.

Clark, Kathleen Ann. *Defining Moments: African American Commemoration and Political Culture in the South, 1863–1913*. Chapel Hill: University of North Carolina Press, 2005.

Clark, Kenneth Bancroft. *Dark Ghetto: Dilemmas of Social Power*. 1st ed. New York: Harper and Row, 1965.

Coffey, Mary K. "The American Adonis: A Natural History of the Average American." In *Popular Eugenics: National Efficiency and American Mass Culture in the 1930s*, edited by Susan Currell and Christina Cogdell, 185–216. Athens: Ohio University Press, 2006.

Cohen, Harvey G. *Duke Ellington's America*. Chicago: University of Chicago Press, 2010.

Conn, Steven. *Museums and American Intellectual Life, 1876–1926*. Chicago: University of Chicago Press, 1998.

Cooks, Bridget R. "Black Artists and Activism: Harlem on My Mind (1969)." *American Studies* 48, no. 1 (2007): 5–39.

Crary, Jonathan. *Techniques of the Observer: On Vision and Modernity in the Nineteenth Century*. Cambridge, Mass.: MIT Press, 1996.

Crew, Spencer R. "African Americans, History and Museums: Preserving African American History in the Public Arena." In *Making Histories in Museum*, edited by Gaynor Kavanagh, 80–91. London: Leicester University Press, 1996.

Curran, Kathleen. *The Romanesque Revival: Religion, Politics, and Transnational Exchange*, Buildings, Landscapes, and Societies Series 2. University Park: Pennsylvania State University Press, 2003.

Currell, Susan, and Christina Cogdell. *Popular Eugenics: National Efficiency and American Mass Culture in the 1930s*. Athens: Ohio University Press, 2006.

Dancy, John C. *Sand against the Wind: The Memoirs of John C. Dancy*. Detroit: Wayne State University Press, 1966.

Darden, Joe T. *Detroit, Race and Uneven Development*. Comparative American Cities. Philadelphia: Temple University Press, 1987.

Davis, Harold E. *Henry Grady's New South: Atlanta, a Brave and Beautiful City*. Tuscaloosa: University of Alabama Press, 1990.

Dawson, Michael C. "A Black Counterpublic? Economic Earthquakes, Racial Agenda(s), and Black Politics." *Public Culture* 7 (1994): 195–223.

———. *Black Visions*. Chicago: University of Chicago Press, 2001.

Deburg, William Van. *The Black Power Movement and American Culture, 1965–1975*. Chicago: University of Chicago Press, 1992.

Denning, Michael. *The Cultural Front: The Laboring of American Culture in the Twentieth Century.* London: Verso, 1996.

Dennis, Raoul. "Who Axed the African American Museum on the Mall?" *Crisis,* February–March 1998, 8–13.

Deutsche, Rosalyn. "Art and Public Space: Questions of Democracy." *Social Text* 33 (1992): 34–52.

———. *Evictions.* Cambridge, Mass.: MIT Press, 1996.

———. "The Fine Art of Gentrification." *October* 31 (1984): 91–111.

———. "Questioning the Public Space." *Public* 6 (1992): 49–64.

Doyle, Don Harrison. *New Men, New Cities, New South: Atlanta, Nashville, Charleston, Mobile, 1860–1910.* Fred W. Morrison Series in Southern Studies. Chapel Hill: University of North Carolina Press, 1990.

Doyle, Laura. *Bordering on the Body: The Racial Matrix of Modern Fiction and Culture.* Race and American Culture. New York: Oxford University Press, 1994.

Eaton, Allen. *Immigrant Gifts to American Life.* New York: Russell Sage Foundation, 1932.

English, Daylanne K. *Unnatural Selections: Eugenics in American Modernism and the Harlem Renaissance.* Chapel Hill: University of North Carolina Press, 2004.

Fabre, Geneviève. "African American Commemorative Celebrations in the Nineteenth Century." In *History and Memory in African American Culture,* edited by Geneviève Fabre and Robert O'Meally, 72–91. New York: Oxford University Press, 1994.

Fabre, Michel. *The World of Richard Wright.* Center for the Study of Southern Culture Series. Jackson: University of Press of Mississippi, 1985.

Feldman, Eugene. *The Birth and the Building of the DuSable Museum.* Chicago: DuSable Museum Press, 1981.

Fine, Sidney. *Violence in the Model City: The Cavanagh Administration, Race Relations, and the Detroit Riot of 1967.* Ann Arbor: University of Michigan Press, 1989.

Fleming, John E. "African American Museums, History, and the American Ideal." *Journal of American History* 81, no. 3 (1994): 1020–26.

Foner, Philip S. "Black Participation in the Centennial of 1876." *Phylon* 39, no. 4 (1978): 283–96.

Fraser, Nancy. "Rethinking the Public Sphere: A Contribution to the Critique of Actually Existing Democracy." In *The Phantom Public Sphere,* edited by Bruce Robbins and Social Text Collective, 1–32. Minneapolis: University of Minnesota Press, 1993.

Friedberg, Anne. *Window Shopping: Cinema and the Postmodern.* Berkeley: University of California, 1993.

Gaines, Kevin Kelly. *Uplifting the Race: Black Leadership, Politics, and Culture in the Twentieth Century.* Chapel Hill: University of North Carolina Press, 1996.

Gates, Henry Louis. "The Face and the Voice of Blackness." In *Facing History: The Black Image in American Art, 1710–1940,* edited by Guy C. McElroy, 29–44. San Francisco: Bedford Arts Publishers; Washington, D.C.: Corcoran Gallery of Art, 1990.

Georgakas, Dan, Marvin Surkin, and Manning Marable. *Detroit, I Do Mind Dying*. Updated ed. South End Press Classics 2. Cambridge, Mass.: South End Press, 1998.

Gibson, Campbell, and Kay Jung. *Historical Census Statistics on Population Totals by Race, 1790 to 1990, and by Hispanic Origin, 1970 to 1990, for Large Cities and Other Urban Places in the United States*. Washington, D.C.: U.S. Census Bureau, Population Division, February 2005.

Glassberg, David. *American Historical Pageantry: The Uses of Tradition in the Early Twentieth Century*. Chapel Hill: University of North Carolina Press, 1990.

———. "History and the Public: Legacies of the Progressive Era." *Journal of American History* 73, no. 4 (1987): 957–80.

Goggin, Jacqueline Anne. *Carter G. Woodson: A Life in Black History*. Southern Biography Series. Baton Rouge: Louisiana State University Press, 1993.

Goldfield, David R. "The Urban South: A Regional Framework." *American Historical Review* 85, no. 5 (1981): 1009–34.

Goldfield, David R., and Blaine A. Brownell. *The City in Southern History: The Growth of Urban Civilization in the South*. Port Washington, N.Y.: Kennikat Press, 1977.

Goldin, Claudia Dale. *Urban Slavery in the American South, 1820–1860: A Quantitative History*. Chicago: University of Chicago Press, 1976.

Gonzalez, Robert. *Designing Pan-America: U.S. Architectural Visions for the Western Hemisphere*. Austin: University of Texas Press, 2011.

Grandison, Kenrick Ian. "The Black College Campus as a Cultural Record of Postbellum America." In *Sites of Memory: Perspectives on Architecture and Race*, edited by Craig Evan Barton, 55–96. New York: Princeton Architectural Press, 2001.

———. "Negotiated Space: The Black College Campus as a Cultural Record of Postbellum America." *American Quarterly* 51, no. 3 (1999): 529–79.

Grant, L. Donald. *The Way It Was in the South: The Black Experience in Georgia*. Secaucus, N.J.: Carol Publishing Group, 1993.

Gray, Herman. *Watching Race*. Minneapolis: University of Minnesota Press, 1995.

Green, Adam P. "Selling the Race: Cultural Production and Notions of Community in Black Chicago, 1940–1955." PhD dissertation, Yale University, 1998.

———. *Selling the Race: Culture and Community in Black Chicago, 1940–1955*. Chicago: University of Chicago Press, 2007.

Guzda, Henry P. "Labor Department's First Program to Assist Black Workers." *Monthly Labor Review* 105, no. 6 (1982): 39–44.

Haar, Charles Monroe. *Between the Idea and the Reality: A Study in the Origin, Fate, and Legacy of the Model Cities Program*. Boston: Little, Brown, 1975.

Habermas, Jürgen. *The Structural Transformation of the Public Sphere: An Inquiry into a Category of Bourgeois Society*. Studies in Contemporary German Social Thought. Cambridge, Mass.: MIT Press, 1989.

Haraway, Donna. "Teddy Bear Patriarchy." In *Primate Visions: Gender, Race, and Nature in the World of Modern Science*, 26–58. New York: Routledge, 1989.

Harris, Cheryl I. "Whiteness as Property." In *Critical Race Theory: The Key Writings That Formed the Movement,* edited by Kimberlé Crenshaw, 357–83. New York: New Press, distributed by W. W. Norton, 1995.

Harrison, Joanne K., and Grant Harrison. *The Life and Times of Irvine Garland Penn.* Philadelphia: XLibris, 2000.

Henry, Charles P. "A True Revolution of Values." In *Long Overdue: The Politics of Racial Reparations,* 164–78. New York: NYU Press, 2007.

Hine, Darlene Clark. *Speak Truth to Power: Black Professional Class in United States History.* Brooklyn, N.Y.: Carlson Pub., 1996.

Hirsch, Arnold R. *Making the Second Ghetto: Race and Housing in Chicago, 1940–1960.* Cambridge: Cambridge University Press, 1983.

Holt, Thomas C. "W. E. B. Du Bois's Archaeology or Race." In *W. E. B. Du Bois, Race, and the City,* edited by Michael B. Katz and Thomas Sugrue, 61–76. Philadelphia: University of Pennsylvania Press, 1998.

"Housing the Migrants." *Opportunity Magazine* (October 1923)." In *Up South: Stories, Studies, and Letters of This Century's African-American Migrations,* edited by Malaika Adero, 48–49. New York: New Press, distributed by W. W. Norton, 1993.

Huyssen, Andreas. *Present Pasts: Urban Palimpsests and the Politics of Memory.* Cultural Memory in the Present. Stanford, Calif.: Stanford University Press, 2003.

Jennings, James. *The Politics of Black Empowerment: The Transformation of Black Activism in Urban America.* African American Life Series. Detroit: Wayne State University Press, 1992.

Johnson, Daniel M., and Rex R. Campbell. *Black Migration in America: A Social Demographic History.* Durham, N.C.: Duke University Press, 1981.

Johnson, Joan Marie. " 'Ye Gave Them Stone': African American Women's Clubs, the Frederick Douglass Home, and the Black Mammy Monument," *Journal of Women's History* 17, no. 1 (Spring 2005): 62–86.

Johnson, Walter. *Soul by Soul: Life Inside the Antebellum Slave Market.* Cambridge, Mass.: Harvard University Press, 1999.

Jones, Beverly. "Mary Church Terrell and the National Association of Colored Women, 1896–1901." *Journal of Negro History* 67, no. 1 (1982): 20–33.

Kachun, Mitchell A. *Festivals of Freedom: Memory and Meaning in African American Emancipation Celebrations, 1808–1915.* Amherst: University of Massachusetts Press, 2003.

Kammen, Michael. *Mystic Chords of Memory.* New York: Knopf, 1991.

Katzman, David M. *Before the Ghetto: Black Detroit in the Nineteenth Century.* Blacks in the New World. Urbana: University of Illinois Press, 1973.

Kelley, Robin D. G. "Stormy Weather." In *Is It Nation Time?,* edited by Eddie S. Glaude, 67–90. Chicago: University of Chicago Press, 2002.

Kellogg, John. "Negro Urban Clusters in the Postbellum South." *Geographical Review* 67, no. 3 (1977): 310–21.

Ladner, Joyce A. *The Death of White Sociology.* New York: Vintage Books, 1973.

Larsen, Lawrence Harold. *The Rise of the Urban South.* Lexington: University Press of Kentucky, 1985.

Lefebvre, Henri. *The Production of Space.* Translated by Donald Nicholson-Smith. Cambridge: Blackwell, 1991.

———. *State, Space, World: Selected Essays.* Translated by Gerald Moore, Neil Brenner, and Stuart Elden. Minneapolis: University of Minnesota Press, 2009

Lemelle, Sidney J., and Robin D. G. Kelley. *Imagining Home: Class, Culture, and Nationalism in the African Diaspora.* New York: Verso, 1994.

Lewis, David Levering. "A Small Nation of People." In *A Small Nation of People: W. E. B. Du Bois and African American Portraits of Progress,* edited by the Library of Congress, 51–76. New York: Amistad and Harper Collins, 2003.

———. *W. E. B. Du Bois: Biography of a Race, 1868–1919.* New York: Henry Holt and Company, 1993.

———. *W. E. B. Du Bois: The Fight for Equality and the American Century, 1919–1963.* 1st ed. New York: Henry Holt and Company, 2000.

Logan, Rayford. "Carter G. Woodson: Mirror and Molder of His Time, 1875–1950." *Journal of Negro History* 58, no. 1 (1973): 1–17.

Loos, William H., and Ami M. Savigny. *The Forgotten Negro Exhibit: Buffalo's Pan-American Exposition, 1901.* Buffalo, N.Y.: Buffalo and Erie Country Public Library, 2001.

Lott, Eric. *Love and Theft: Blackface Minstrelsy and the American Working Class.* Race and American Culture. New York: Oxford University Press, 1993.

Lott, Tommy Lee. *The Invention of Race: Black Culture and the Politics of Representation.* Malden, Mass.: Blackwell, 1999.

Maleuvre, Didier. *Museum Memories: History, Technology, Art.* Stanford, Calif.: Stanford Unversity Press, 1999.

Marable, Manning. *Race, Reform, and Rebellion: The Second Reconstruction in Black America, 1945–1990.* 2nd ed. Jackson: University Press of Mississippi, 1991.

Marks, Carole. "Black Workers and the Great Migration." *Phylon* 46, no. 2 (1985): 148–61.

McClintock, Anne. *Imperial Leather: Race, Gender, and Sexuality in the Colonial Conquest.* New York: Routledge, 1995.

McElroy, Guy C., ed. *Facing History: The Black Image in American Art, 1710–1940.* San Francisco: Bedford Arts Publishers; Washington, D.C.: Corcoran Gallery of Art, 1990.

Meier, August. *Negro Thought in America, 1880–1915.* Ann Arbor: University of Michigan Press, 1988.

Meier, August, and Elliot Rudwick. *Black Detroit and the Rise of the UAW.* New York: Oxford University Press, 1979.

Mercer, Kobena. " '1968': Periodizing Politics and Identity." In *Cultural Studies,* edited by Lawrence Grossberg, Cary Nelson, and Paula A. Treichler, 424–49. London: Routledge, 1992.

———. *Welcome to the Jungle: New Positions in Black Cultural Studies.* New York: Routledge, 1994.

Meyer, Howard N. *Integrating America's Heritage: A Congressional Hearing to Establish a National Commission on Negro History and Culture.* College Park, Md.: McGrath Publishing Company, 1970.

Miller, Karen R. "Whose History, Whose Culture?: The Museum of African American History, the Detroit Institute of Arts, and Urban Politics at the End of the Twentieth Century." *Michigan Quarterly Review* 41, no.1 (Winter 2002): 136–54.

Mitchell, Timothy. *Colonising Egypt*. Berkeley: University of California Press, 1991.

Moon, Elaine Latzman. *Untold Tales, Unsung Heroes: An Oral History of Detroit's African American Community, 1918–1967*. African American Life Series. Detroit: Wayne State University Press, 1994.

Moses, Wilson Jeremiah. *The Golden Age of Black Nationalism, 1850–1925*. Hamden, Conn.: Archon Books, 1978.

———. "The Lost World of the Negro, 1895–1919: Literary and Intellectual Life before the Renaissance." *Black American Interest Forum* 21, no. 1/2 (1987): 61–83.

Moss, Alfred A. *The American Negro Academy: Voice of the Talented Tenth*. Baton Rouge: Louisiana State University Press, 1981.

Muccigrosso, Robert. *Celebrating the New World: Chicago's Columbian Exposition of 1893*. The American Ways Series. Chicago: I. R. Dee, 1993.

Mullen, Bill. *Popular Fronts: Chicago and African-American Cultural Politics, 1935–46*. Urbana: University of Illinois Press, 1999.

Omi, Michael, and Howard Winant. *Racial Formation in the United States: From the 1960s to the 1980s*. Critical Social Thought. New York: Routledge and Kegan Paul, 1986.

Park, Robert E., Ernest W. Burgess, and Roderick D. McKenzie. *The City (1925)*. Chicago: University of Chicago Press, 1967.

Patton, June O. "And the Truth Shall Make You Free: Richard Robert Wright Sr., Black Intellectual and Iconoclast, 1877–1897." *Journal of Negro History* 81 (1996): 17–30.

Patton, Sharon F. *African-American Art*. Oxford History of Art. Oxford: Oxford University Press, 1998.

Perdue, Theda. *Race and the Atlanta Cotton States Exposition of 1895*. Georgia Southern University Jack N. and Addie D. Averitt Lecture Series. Athens: University of Georgia Press, 2010.

Pieterse, Jan Nederveen. *White on Black: Images of African and Blacks in Western Popular Culture*. New Haven, Conn.: Yale University Press, 1995.

Pinder, Kymberly. "Black Public Art and Religion in Chicago." Unpublished manuscript, April 2011.

Porter, James A. *Modern Negro Art*. Washington, D.C.: Howard University Press, 1998.

Pryzyblyski, Jeannene M. "American Visions at the Paris Exposition 1900: Another Look at Benjamin Johnston's Hampton Photographs." *Art Journal* 57, no. 3 (Autumn 1998): 60–68.

Rabinowitz, Howard N. *The First New South, 1865–1920*. Arlington Heights, Ill.: Harlan Davidson, 1992.

———. *Race Relations in the Urban South, 1865–1890*. New York: Oxford University Press, 1978.

Rainwater, Lee, and William L. Yancey. *The Moynihan Report and the Politics*

of Controversy: A Trans-Action Social Science and Public Policy Report. Cambridge, Mass.: MIT Press, 1967.

Reed, Christopher Robert. *All the World Is Here! The Black Presence at White City.* Blacks in the Diaspora. Bloomington: Indiana University Press, 2000.

———. "In the Shadow of Fort Dearborn." *Journal of Black Studies* 21, no. 4 (1991): 398–413.

Register, Woody. *The Kid of Coney Island: Fred Thompson and the Rise of American Amusements.* New York: Oxford University Press, 2001.

Reidy, Joseph P. *From Slavery to Agrarian Capitalism in the Cotton Plantation South: Central Georgia, 1800–1880.* Fred W. Morrison Series in Southern Studies. Chapel Hill: University of North Carolina Press, 1992.

Rich, Wilbur C., and Roberta Hughes Wright. *The Wright Man: A Biography of Charles Wright, M.D.* Detroit: Charro Books, 1999.

Robbins, Bruce, ed. *The Phantom Public Sphere.* Minneapolis: University of Minnesota Press, 1993.

Ross, Andrew. *The Gangster Theory of Life: Nature's Debt to Society.* London: Verso, 1994.

Rudwick, Elliot, and August Meier. "Black Man in the 'White City': Negroes and the Columbian Exposition 1893." *Phylon* 26, no. 4 (1965): 354–61.

Ruffins, Fath. "Culture Wars Won and Lost, Part 2: The National African-American Museum Project." *Radical History Review* 70 (1998): 78–101.

———. " 'Lifting as We Climb': Black Women and the Preservation of African American History and Culture." *Gender and History* 6, no. 3 (November 1994): 376–96.

———. "Mythos, Memory and History: African American Preservation Efforts, 1820–1990." In *Museums and Communities: The Politics of Public Culture,* edited by I. Karp and C. M. Kreamer, 506–611. Washington, D.C.: Smithsonian Institution Press, 1992.

Russell, James Michael. *Atlanta, 1847–1890: City Building in the Old South and the New.* Baton Rouge: Louisiana State University Press, 1988.

Rydell, Robert. *All the World's a Fair.* Chicago: University of Chicago Press, 1984.

———. "Gateway to the 'American Century': The American Representation at the Paris Universal Exposition of 1900." In *Paris 1900,* edited by Diane P. Fischer, 119–44. New Brunswick, N.J.: Rutgers University Press, 1999.

———. *World of Fairs.* Chicago: University of Chicago Press, 1993.

Simmel, George. "The Metropolis and Mental Life." In *Rethinking Architecture,* edited by Neal Leach, 69–79. New York: Routledge, 1997.

Singh, Nikhil Pal. *Black Is a Country: Race and the Unfinished Struggle for Democracy.* Cambridge, Mass.: Harvard University Press, 2004.

Smethurst, James Edward. *The Black Arts Movement: Literary Nationalism in the 1960s and 1970s.* The John Hope Franklin Series in African American History and Culture. Chapel Hill: University of North Carolina Press, 2005.

Smith, Neil. *The New Urban Frontier: Gentrification and the Revanchist City.* London: Routledge, 1996.

Smith, Shawn Michelle. *American Archives: Gender, Race, and Class in Visual Culture.* Princeton, N.J.: Princeton University Press, 1999.

————. *Photography on the Color Line: W. E. B. Du Bois, Race, and Visual Culture*. Durham, N.C.: Duke University Press, 2004.

Smith, Suzanne. *Dancing in the Street: Motown and the Cultural Politics of Detroit*. Cambridge, Mass.: Harvard University Press, 1999.

Spear, Allan H. *Black Chicago: The Making of a Negro Ghetto, 1890–1920*. Chicago: University of Chicago Press, 1967.

Spillers, Hortense. "Mama's Baby, Papa's Maybe: An American Grammar Book." *Diacritics* 17, no. 2 (Summer 1987): 64–81.

Stetson, Erlene. "Black Feminism in Indiana, 1893–1933." *Phylon* 44, no. 4 (1983): 292–98.

Suggs, Henry Lewis. *The Black Press in the South, 1865–1979*. Contributions in Afro-American and African Studies No. 74. Westport, Conn.: Greenwood Press, 1983.

Sugrue, Thomas. *The Origins of Urban Crisis: Race and Inequality in Postwar Detroit*. Princeton, N.J.: Princeton University Press, 1996.

Taylor, Henry Louis, and Walter Hill. *Historical Roots of the Urban Crisis: African Americans in the Industrial City, 1900–1950*. Crosscurrents in African American History. New York: Garland Pub., 2000.

Teslow, Tracy Lang. "Reifying Race." In *The Politics of Display*, edited by Sharon MacDonald, 53–76. London: Routledge, 1998.

Thomas, June Manning. *Redevelopment and Race: Planning a Finer City in Postwar Detroit*. Creating the North American Landscape. Baltimore, Md.: Johns Hopkins University Press, 1997.

Thomas, Richard W. *Life for Us Is What We Make It: Building Black Community in Detroit, 1915–1945*. Bloomington: Indiana University Press, 1992.

Vogel, Shane. *The Scene of Harlem Cabaret: Race, Sexuality, Performance*. Chicago: University of Chicago Press, 2009.

Walker, Susannah. "Black Is Profitable: The Commodification of the Afro, 1960–1975." *Enterprise and Society* 1, no. 3 (2000): 536–64.

Wallace, Michele. "Modernism, Postmodernism and the Problem of the Visual in Afro-American Culture." In *Out There: Marginalization and Contemporary Cultures*, edited by Russell Ferguson, Martha Gever, Trinh T. Minh-ha, and Cornel West, 39–50. Cambridge, Mass.: MIT Press, 1990.

Walsh, Kevin. *The Representation of the Past: Museums and Heritage in the Post-Modern World*. London: Routledge, 1992.

Weiss, Nancy J. "The Negro and the New Freedom: Fighting Wilsonian Segregation." *Political Science Quarterly* 84, no. 1 (March 1969): 61–79.

Wesemael, Pieter van. *Architecture of Instruction and Delight*. Amsterdam: 010 Publishers, 2001.

Wilkins, Robert L. "The Forgotten Museum." Unpublished paper, 2002.

Williams Strong, Carline Evone. "Margaret Taylor Goss Burroughs: Educator, Artist, Author, Founder, and Civic Leader." PhD dissertation, Loyola University, Chicago, 1994.

Willis, Deborah. "The Sociologist's Eye: W. E. B. Du Bois and the Paris Exposition." In *A Small Nation of People: W. E. B. Du Bois and African American Portraits of Progress*, edited by the Library of Congress, 51–76. New York: Amistad and Harper Collins, 2003.

Willis, Deborah, and Carla Williams. "The Black Female Body in Photographs from the World's Fairs and Expositions." *Exposure* 33, no. 1/2 (2000): 11–20.

Wilson, Fred, Lisa G. Corrin, Leslie King-Hammond, Ira Berlin, the Contemporary [Museum], and Maryland Historical Society. *Mining the Museum: An Installation by Fred Wilson.* Baltimore, Md.: The Contemporary in cooperation with the New Press, distributed by W. W. Norton, 1994.

Wilson, Mabel O. "Between Rooms 307." In *Sites of Memory: Perspectives on Architecture and Race,* edited by Craig Evan Barton, 13–26. New York: Princeton Architectural Press, 2001.

———. "Making a Civilization Paradigm: Robert Park, Race and Urban Ecology." Unpublished paper, New York University, 1996.

Wolcott, Victoria W. *Remaking Respectability: African American Women in Interwar Detroit.* Chapel Hill: University of North Carolina Press, 2001.

Woodward, C. Vann. *Origins of the New South, 1877–1913.* Baton Rouge: Louisiana State University Press, 1951.

Wright, Charles H. *The National Medical Association Demands Equal Opportunity: Nothing More, Nothing Less.* Southfield, Mich.: Charro Book Company, 1995.

———. *Robeson: Labor's Forgotten Champion.* Detroit: Balamp Publisher, 1975.

Young, James E. *The Texture of Memory: Holocaust Memorials and Meaning.* New Haven, Conn.: Yale University Press, 1993.

Index

TEXT
10/13 Sabon

DISPLAY
Sabon

COMPOSITOR
Integrated Composition Systems

INDEXER
Barbara Roos